FLORENCE

Art and Architecture

S. BIETOLETTI E. CAPRETTI M. CHIARINI
C. CRESTI A. GIUSTI C. MORANDI
A. PAOLUCCI M. SCALINI A. TARTUFERI

FLORENCE
Art and Architecture

ULLMANN&
KÖNEMANN

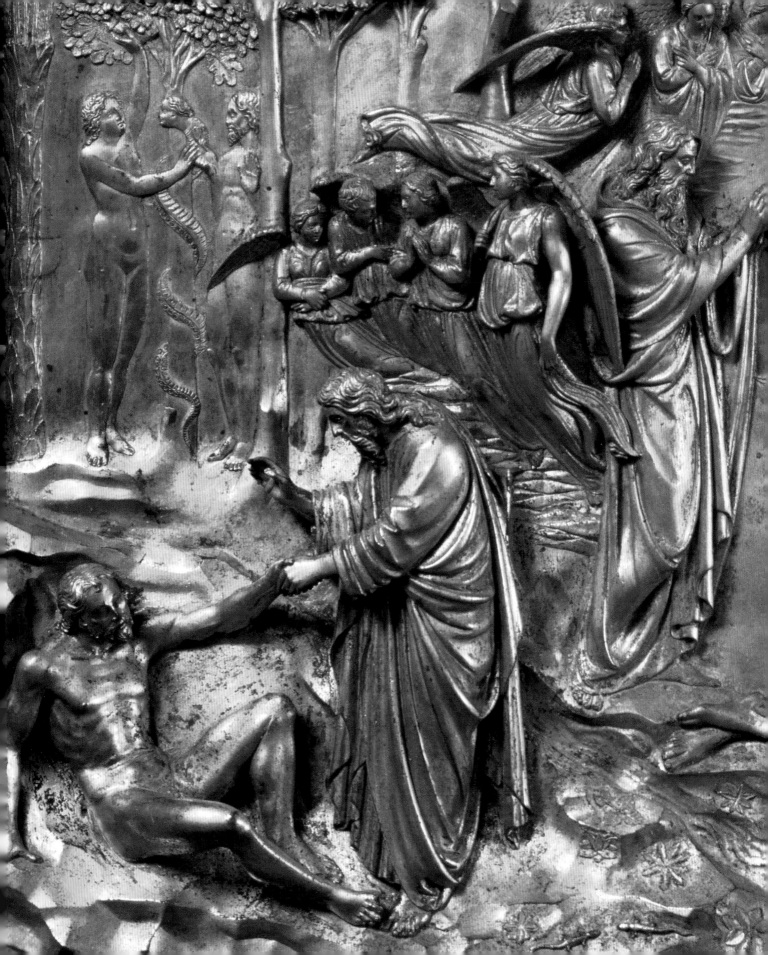

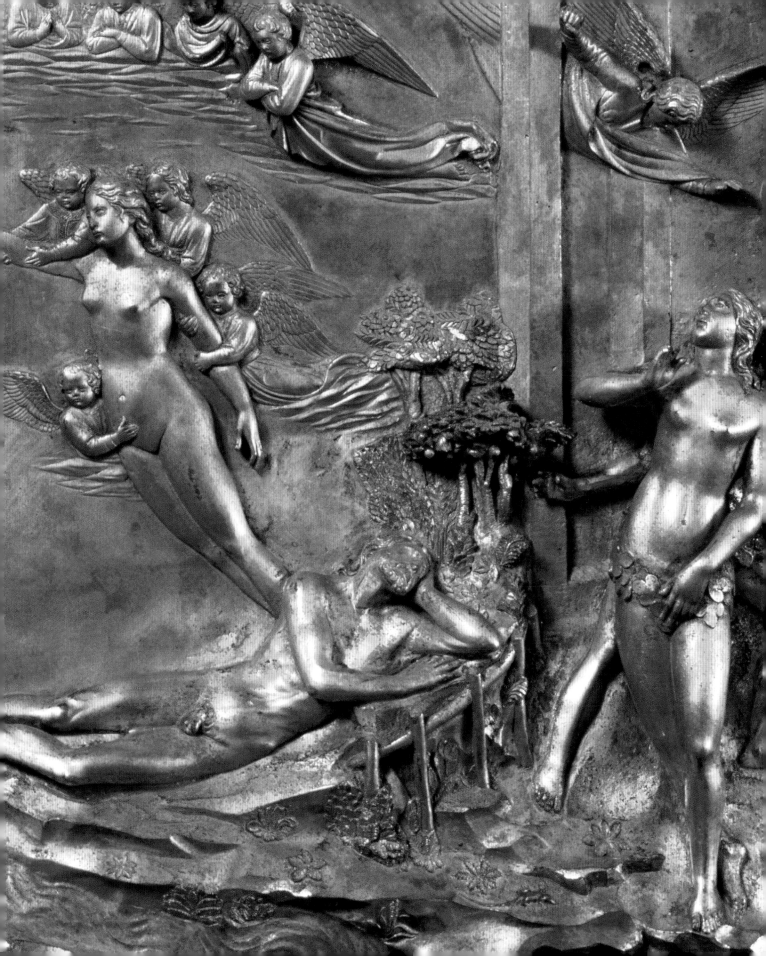

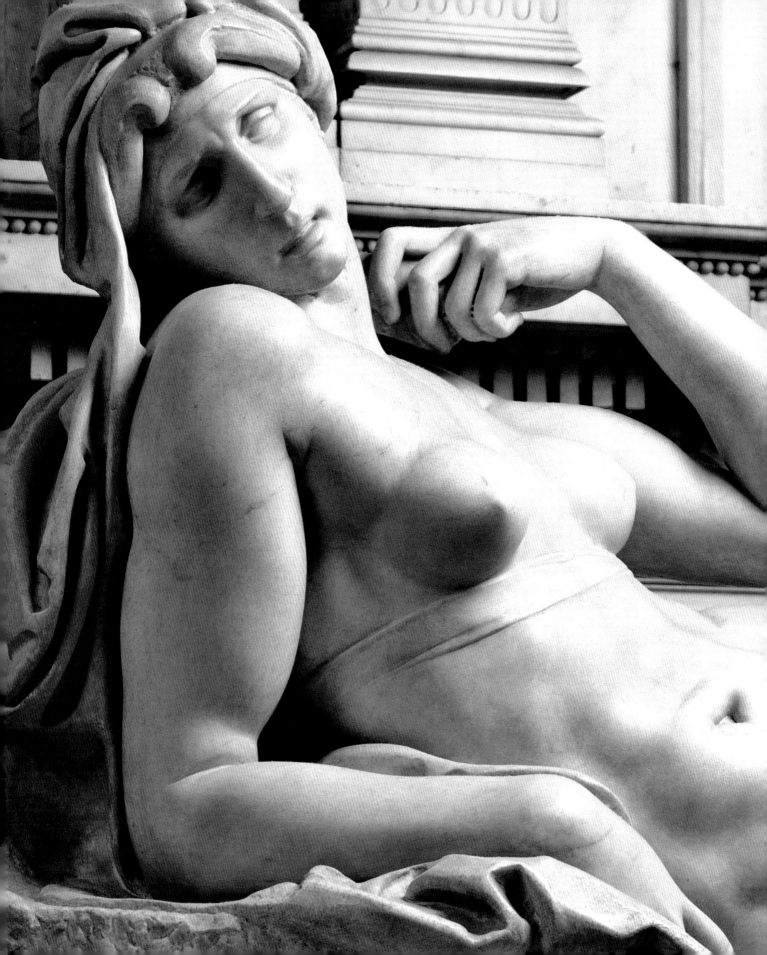

Front cover:
Cathedral of Santa Maria del Fiore
Photo: getty images
Back cover:
Sandro Botticelli, Primavera, c. 1478, Uffizi, Florence
Photo: © Scala, Florence

On the previous pages:

Lorenzo Ghiberti, Door of Paradise, Baptistery of
St. John, detail.

Benozzo Gozzoli, *The Procession of the Magi*,
c. 1459–1550, fresco, detail.
Palazzo Medici Riccardi (Chapel of the Magi).

Michelangelo Buonarroti, *Funeral monument to
Lorenzo de' Medici, Duke of Urbino*, detail. Basilica
of S. Lorenzo, New Sacristy (Medici Chapels).

Note:
Unless explicitly stated otherwise, the depositories
named in the picture captions are located in
Florence.

Editorial Director: Guido Ceriotti

Editorial Coordinator: Elisabetta Feruglio

Project Editor: Jessica Basso

Graphic Designer: Gilberto Brun

©2005 – MAGNUS EDIZIONI SpA, UDINE, ITALY
Original title: *Firenze. Arte e architettura*
ISBN 88-7057-186-6

©2005 for the English edition: Tandem Verlag GmbH
KÖNEMANN is a trademark and an imprint of
Tandem Verlag GmbH
ISBN 3-8331-1989-6

English-language edition produced by
Cambridge Publishing Management Ltd, Cambridge
Translated from the Italian by Leslie Ray,
Gray Sutherland, Kit Sutherland
and Jocelyn Holmes in association with
Cambridge Publishing Management Ltd, Cambridge
Edited by Lin Thomas in association with
Cambridge Publishing Management Ltd, Cambridge
Cover design: rincón2 medien gmbh, rincon.de, Cologne

Project Coordination: Lucas Lüdemann

© 2007 for this edition: Tandem Verlag GmbH
ULLMANN & KÖNEMANN is an imprint of Tandem Verlag GmbH
Special edition

Printed in China

ISBN 978-3-8331-3490-6

10 9 8 7 6 5 4 3 2 1
X IX VIII VII VI V IV III II I

CONTENTS

Art and history in Florence: an overview of five centuries

In Florence, in the Bigallo Museum, which once was home to the headquarters of a charity association, a fresco is conserved that has extraordinary symbolic significance. It is attributed to the studio of Bernardo Daddi, and shows the Madonna of Mercy in the act of protecting the city and its Christian population; it is dated 2 September 1342. What interest us here are the date and the view of Florence (the first known one) depicted at the Virgin's feet. We have before us Dante's "gran villa," great city, (Inferno, Canto XXIII), the wonder of Italy and Europe, in the Year of Our Lord 1342.

Hemmed in by its Arnolfian walls, the city displays monuments that were already famous at that time (the Baptistery, Palazzo Vecchio, Campanile di Badia), together with others that were then under construction. Of course, Brunelleschi's dome has not yet appeared, the facade of Sta. Maria del Fiore is incomplete and the Campanile of the Duomo is half-built. Crowded around, like a medieval Manhattan, are all the tower-houses. The impression is of something full, thriving, and powerful. Look at this portrait of Florence and consider that never again in its history was the city so great.

School of Bernardo Daddi, *Madonna of Mercy*, detail. Bigallo Museum. The fresco, dated 1342, is a portrait of Florence when it was at the peak of its economic power.

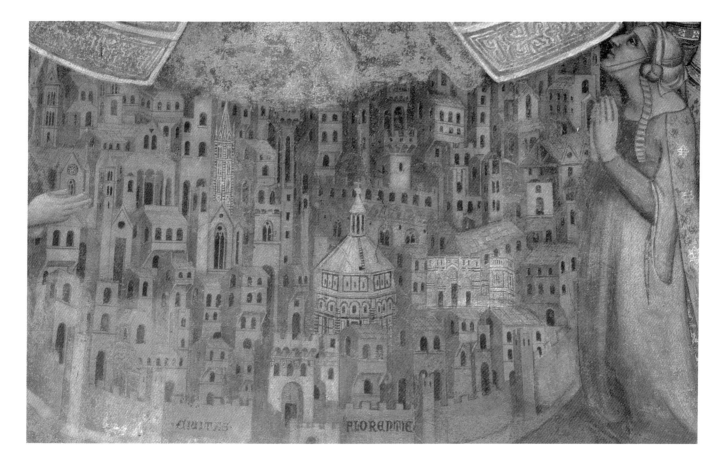

The gold florin, which entered
circulation in 1253, was for centuries
the most appreciated currency of
reference in Europe and on the markets
of the Mediterranean.

The fresco in the Bigallo is proof that the city was at its zenith.

In 1342, with 100,000 inhabitants, Florence was more populous than Paris. It had double the population of London and five times that of Rome. The gold florin (Dante's "lega suggellata dal Battista" ["The metal with the Baptist's form imprest"], Inferno, Canto XXX), minted for the first time in 1253, was the currency of the world's markets from Barcelona to Constantinople, from Bruges to Milan.

Florentine finance, industry, and commerce spearheaded the European economy. In the Florence of those years—according to Giovanni Villani, a historian writing at the time—"we find...from eight to ten thousand young boys and girls reading. From one thousand to one thousand two hundred young boys learning the abacus and algorithms in six schools. And from five hundred and fifty to six hundred learning grammar and logic in four large schools" (*Cronica*, book XI, chapter 94). Not until the 20th century were such high levels of school attendance to be achieved again in Italy and Europe.

The 1342 presentation in the fresco takes on a special symbolic value to our eyes because that date marked the end of a demographic, economic, and cultural growth that had continued until that time. Immediately afterward there began a decline that was destined to last for at least half a century. Between 1343 and 1346, the great Florentine banking companies of the Bardi, the Peruzzi, and the Acciaioli all collapsed in rapid succession. For Italy and Europe it was a kind of 14th-century Wall Street Crash. Then in 1348 came the Black Death, halving the population of the city and the region. Finally there followed a recession, strikes, and social upheavals until the end of the century (the Ciompi Uprising of 1378), but the year that interests us is 1342, the apex and culmination of an extraordinary era, the greatest in the two millennia of Florentine history. Dividing history into periods is always somewhat artificial and is therefore risky. Yet it is undeniably useful and instructive. Let us therefore consider the period between 1253 (the minting of the gold florin) and 1342, the date recorded on the Bigallo fresco. What happened, in the field of culture, letters, and

the arts, in the almost one hundred years between these two dates? What was happening in this city that was growing so fast, doubling its inhabitants with every generation, conquering the markets of Italy and Europe with its currency and its manufactured articles; a city that already knew the rhythms and logic of modern urban life, with all its opportunities, active learning, mental elasticity, flexibility, and speed of change? It so happens that in Florence, in that historical period comprising the second half of the 13th century and the first half of the 14th, both Italy's literary and its visual language took shape. Formulated in these terms, the statement may seem self-evident and superficial, yet it is impossible to deny the phenomenon in its astonishing obviousness. In the very same years in which the Florentine Dante Alighieri invented literary Italian by turning out the desiccated Latin of the University and the Church for the living words of the Tuscan vernacular and Romance idioms, Dante's contemporary and fellow citizen, Giotto di Bondone, changed "the art of painting from Greek to Latin" (Cennino Cennini) and, in the discovery of a reality and in the certainty of measurable space, invented Italian visual language—the language that, after him, was to be that of Masaccio ("Giotto reborn," according to Berenson's famous definition), Piero della Francesca, Raphael, and Titian.

The most radical and astonishing mutation involves the history of painting. Whether the Madonna of Sta. Maria Maggiore, recently restored by the Opificio delle Pietre Dure, is by Coppo or by Salerno, Coppo's son, or whether it was produced by an artist who is not Florentine, perhaps not even Tuscan, but Greek-speaking and trained in Constantinople, all this is open to discussion. The question is not an insignificant one. Must we place this admirable icon, rightly given as the starting point for the history of Florentine painting, in around 1260 or 1270, the time when Byzantine bas-reliefs encountered the greats of the West and the clash of two powerful cultures fighting for supremacy seems to be almost tangible in the work of Coppo and Cimabue? The "Latin" of Romance Europe that began to undermine the pictorial hegemony of Greek, the new visual language germinating under the shiny cuirass of the "hieroscripture" of the East...Or is the Madonna of Sta. Maria Maggiore to be placed a century earlier, in the gilded autumn of the empire of the East, at the time of Comnenian Byzantium? These are crucial questions regarding the origins of the history of painting, yet they do not shift the essential terms of these beginnings.

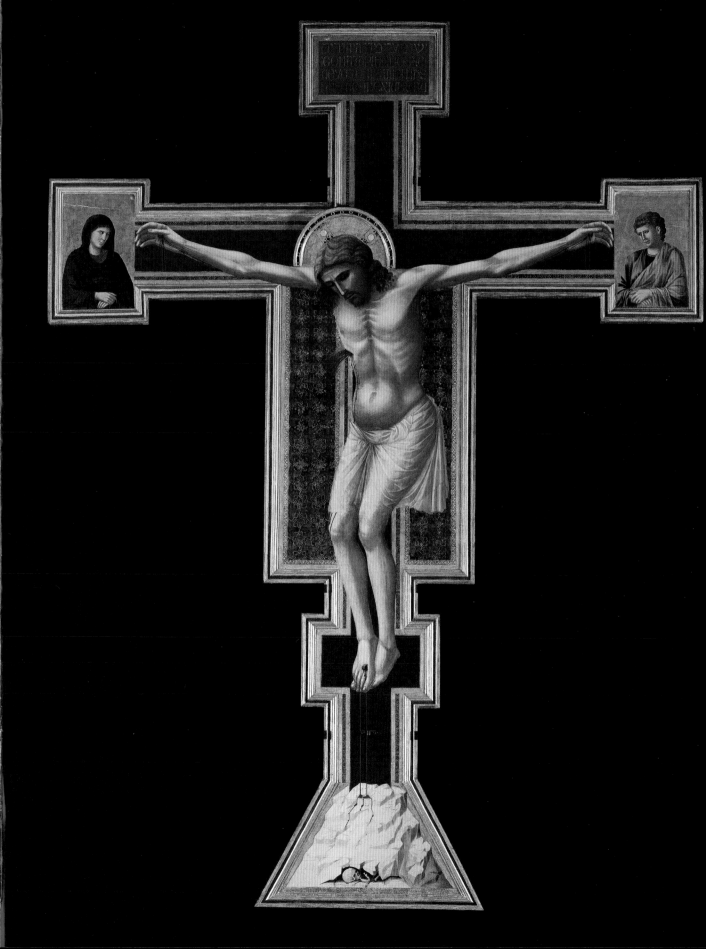

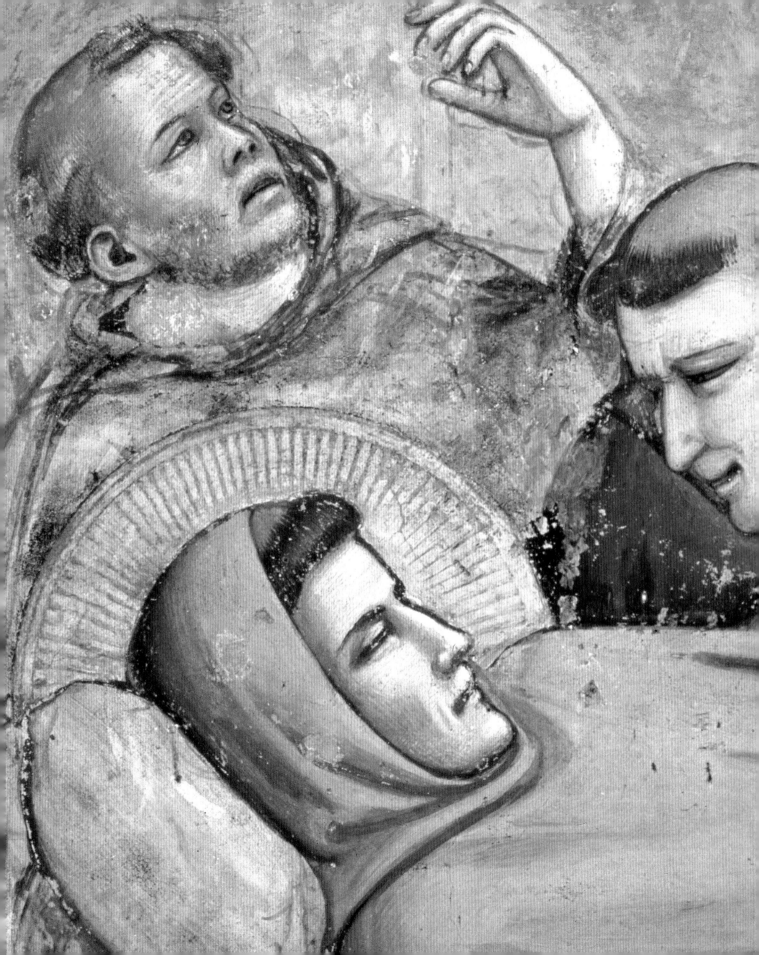

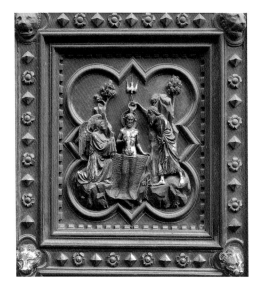

Whatever the truth of the matter is, in the mid-13th century Florence and Tuscany were still to a large extent a Byzantine province. The final Greek echoes were still present in the mosaics of the Baptistery and even in the powerful Romanesque language of Cimabue. But the century was not yet over and already we had the great Cross painted by Giotto in Sta. Maria Novella. According to the painter Previtali, "for the first time in history, he paints a man, a real man, crucified," thereby transcending the iconographic tradition of Giunta and Cimabue that saw the crucifix as a kind of heraldic symbol of the Passion. "For the first time in history" the affirmation is not a rhetorical exaggeration. Never so much as in this period have revolutions appeared so definitive and full of future prospects. In Florence, between the 13th and 14th centuries, the new was identified with momentous change.

There is a piece of Sta. Croce that very clearly explains the direction and the radical nature of the artistic revolution that began to take place in the period. It is the Bardi Chapel. On the walls are Giotto's fragmentary frescoes, *Scenes from the Life of St. Francis*. On the altar there is the image of the saint, in the form of a hieratic icon, painted by an unknown artist from the mid-13th century whom scholars refer to as Maestro del San Francesco Bardi. There is a gap of about 70 years between the painted panel and the mural paintings, yet it is as though two eras, far removed from each other, were set against each other; two civilizations, two ways of understanding and therefore of representing man and the universe. It is not so much a question of quality (sublime in Giotto's

case, mediocre in that of the iconographer of the late Byzantine culture), but of a radically different conception of the world of divinity and history. For the 13th-century painter, St. Francis is a hierogram, a sacred symbol. For Giotto, he is a man like us, a man who lives in a world entirely similar to our own, within the marvelous variety of the visible universe, in the midst of the emotions and feelings of other men. Giotto discovered visible truth, but also sentimental, affective, psychological truth, the world of nature, as Vasari would say, and the world "of attitudes and affections," and was able to represent them for the first time. The sublime variations emerging from the school of Giotto (Taddeo Gaddi, Bernardo Daddi, Maso di Banco, Giovanni da Milano) essentially confirmed and offered a new and modern vision of the world, in Florence and in Italy, from Assisi to Rimini to Naples.

In the Florence of this heroic age, everything had the character of radical innovation, of a challenge that was conceptual, technological, and stylistic, all at the same time. As in Giotto's case when, as master builder in the construction of the Duomo, he designed and commenced the cathedral bell tower, the Campanile; or Arnolfo when, along with the new and last circle of walls, he designed a town-planning scheme that was so grandiose that it did not need to be superseded until the second half of the 19th century; or Andrea Pisano when he installed the bronze door with the scenes from the life of St. John the Baptist, in the Baptistery. In order to understand what a major event the successful realization and installation of the door devoted to the Baptist

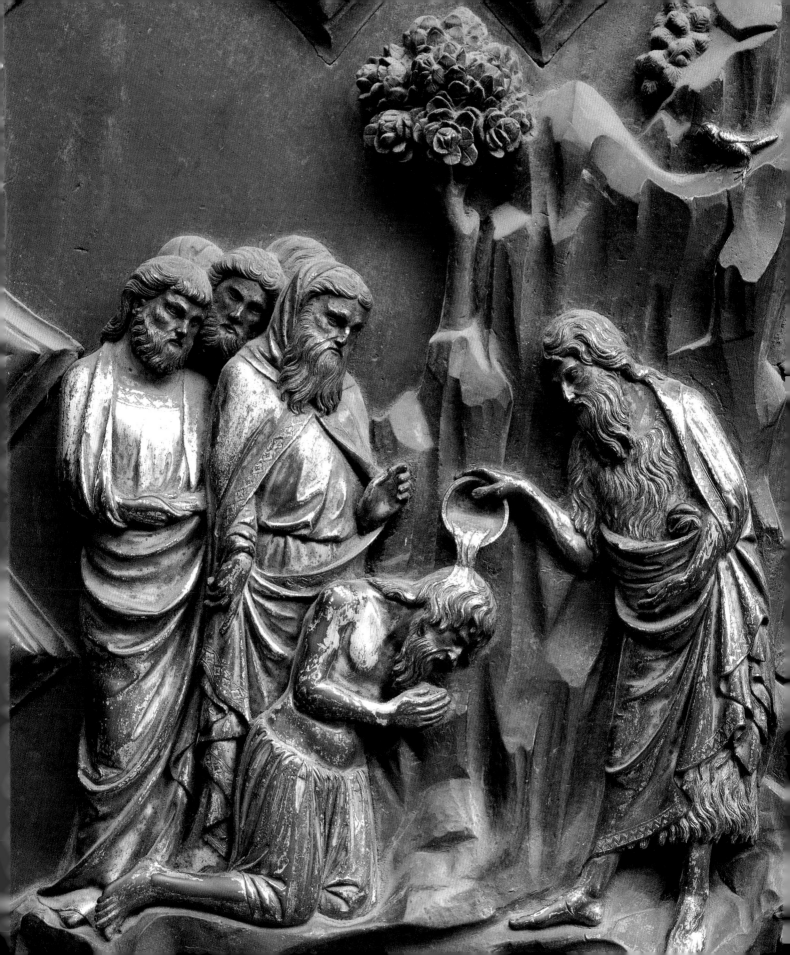

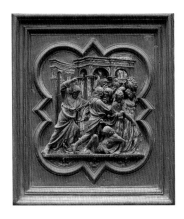

and the scenes from his life was for the city of Florence, we must read Giovanni Villani's *Cronica*, and his solemn turn of phrase, articulated like a memorial epigraph: "In that year of 1330, the very beautiful metal doors of S. Giovanni, so marvelous for their work and cost, began to be made; they were formed in wax and then cleaned, and the figures were gilded by Maestro Andrea Pisano, and fired in the furnace by Venetian masters...." It is known that the door was actually placed on its hinges in 1336, even though it is signed and dated 1330, the year of commencement of the work. But let us examine Villani's sentence carefully for a moment. Leaving aside the public official's understandable pride in knowing that, as commissioner of the Arte del Calimala, the wool workers' guild, he has made an important contribution to the successful conclusion of the enterprise, leaving aside his equally understandable emphasis on the aesthetic quality and financial importance of the result ("very beautiful...so marvelous for their work and cost"), it seems Giovanni Villani was proud above all of the technological feat. It is no coincidence that he stresses the working methods and the involvement of the Venetian master smelters.

For the Florence of 1330, at the zenith of its economic power, to construct a bronze door of such dimensions, moreover a gilded one (this was the first time this had happened in Italy for almost two centuries, since the time of Oderisio da Benevento), meant coming to grips with techniques that were experimental at that time and established a primacy by succeeding. Giotto died on 8 January 1337 (1336 according to the calendar of the Florentines, who made the calculation of the year begin *ab incarnatione domini*, that is, from 25 March). He died— writes Giovanni Villani in his *Cronica*—"and was buried by the City with great honors in Sta. Reparata." The small provincial man who came from the mountains of the Mugello, the humble shepherd boy whom (according to Vasari's apologue) Cimabue had made his pupil, "discovering him" while he was drawing the sheep in his flock, had become *cives florentinus*, an eminent notable of the bourgeois oligarchy, a wealthy entrepreneur, a famous artist sought-after all over Italy to the sound of clinking gold florins. He therefore richly deserved the state funeral to which Giovanni Villani refers. The funeral celebrated the great artist's individual talent and enterprise at the very time when these embodied the spirit of a city that had built its success upon such typically bourgeois and capitalistic values.

The second half of the 14th century saw not only the city's economic and political decline,

but also the exhaustion of the drive that had characterized the heroic years of Dante Alighieri and Giotto. If we leave aside the conspicuous exception of Giovanni da Milano, whose Lombard origins and Giottesque style, strongly imbued with Po Valley naturalism, justify his exceptional position, it cannot be said that the "academy" of the Orcagna brothers, dignified though it may have been, is comparable with the artistic era of Maso di Banco, Bernardo Daddi, and Taddeo Gaddi. Giotto's inheritance ran the risk of drying up in the technically impeccable repetition and cautious updating of illustrious prototypes. At the end of the 14th century, anyone wishing to forecast the future of Florentine art from the examples of Jacopo di Cione, Giovanni del Biondo, Niccolò di Pietro Germi, Agnolo Gaddi himself or sculptors such as Pietro di Giovanni, Jacopo di Piero Guidi, or Giovanni di Ambrogio would have had considerable difficulty in imagining the glorious era that was to come—the years of Masaccio and Brunelleschi, Donatello, and Alberti. This is the opinion of Pope-Hennessy (*Italian Gothic Sculpture*, London 1955), with which we fully agree. Yet because of one of those unpredictable deviations that make the study of history so fascinating, things went very differently from what could reasonably have been imagined. The early 15th century is the age that the art-history books call the "Renaissance." Florence once again became—as it had already been between the 13th and 14th centuries—the cultural and artistic laboratory of the avant-garde in Italy and Europe. These were years of social peace, political stability (the republic was governed by the haut-bourgeois oligarchy headed by the Albizi family), and renewed economic prosperity. Money was once again circulating in abundance. Through the initiative of the major religious orders, as well as of the city's economic political establishment (in 1391 the powerful Arte della Lana, the wool merchants' guild, launched the work on the Porta della Mandorla in the Duomo), the commissioning of artworks and therefore work opportunities abounded, and at an ever-faster pace in the years that followed—1404 was the year of the Proclamation of the Signory, which obliged the Guilds to place the statues of their patron saints in the niches outside Orsanmichele. Civic pride gradually increased along with feverish construction activity and numerous public commissions. As Eugenio Garin has memorably written, the personality and writings of the great humanist chancellor Coluccio Salutati wonderfully reflect the high moral temperature of the Florence of those years, with the celebration of an active life and the primacy of

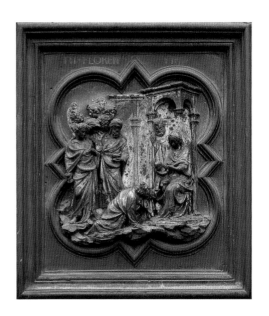

man's will in his terrestrial reality, with the political myth of *florentina libertas*, heir of *romana libertas* (E. Garin, *L'Umanesimo italiano. Filosofia e vita civile nel Rinascimento*, Bari 1964). It was in this particular climate that the phenomenon that we refer to, by convention, as the Renaissance, began to take shape.

It was in effect a rebirth of the arts oriented toward the attainment of certain fundamental objectives. These could be listed as follows: a renewed scientific attitude in relation to the universe and history; the search for an increasingly detailed and coordinated realistic rendering; the gradual establishment of a secular conception of man and his destiny, or at least one in which the latter is central; the rediscovery of the ancient or, to be precise, of what at that time, somewhat partially and inaccurately, was considered ancient. The unifying element of the new cultural universe was perspective, understood as a scientific instrument for the rational control of representable space. The application of the mathematical laws of linear perspective to the world of the visual arts is the truly revolutionary element, the credit for which must go entirely to Filippo Brunelleschi. In those years, in a cultural climate that favored the reclaiming of Giotto's teachings, indeed their rebirth, driven by Brunelleschi and through a band of great artists, including first and foremost Masaccio, vision according to perspective became the common denominator of the various disciplines and artistic techniques, reducing them all (painting, architecture, arts, and crafts) to shared objective principles of formal control and

proportionate harmony. Moreover, this vision became the ideal catalyst for the very elements that constituted the Renaissance ideology and poetics: the cult of the ancient, the search for realistic and humanistic values. Hence the unity and cohesiveness and the objectively "revolutionary" image that the Florentine and then Italian artistic renewal took on in the general European context: and so its value as a model that was theoretical and exportable precisely by virtue of its original scientific bases.

The 1401 competition for the second door of the Baptistery is emblematic of the destiny of Florentine art at the turn of the century; indeed, no one interested in identifying the divisions between historical periods could avoid seeing it as a fundamental watershed between the old era and the new. In the second door of the Baptistery the two tendencies called upon to inaugurate the Renaissance were measured against each other at the highest level. On one hand, Lorenzo Ghiberti with the group of other competitors known to be close to him in stylistic terms (Jacopo della Quercia, Francesco di Valdambrino, Niccolò Lamberti), all committed to the revitalization, or rather, the "modern" adaptation, of the Gothic tradition. On the other, Filippo Brunelleschi, with his proposal of a profound unitary vision, thanks to which—again as in Giotto—the relief becomes

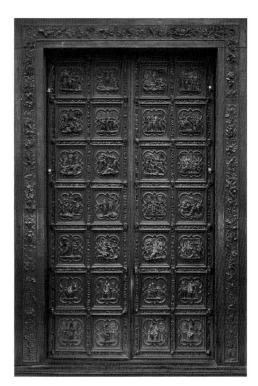

Opposite page:
Lorenzo Ghiberti, three panels, Baptistery of St. John (North Door).
Top:
Garden of Gethsemane: this is one of the panels telling the life of Christ, on the bronze door that Ghiberti was commissioned to design following his victory in the competition of 1401.
Center:
Christ Walking on the Waters: episodes from the life of Christ are justified by the fact that this is the door of the Baptistery, and that we enter into the sacrament of Baptism thanks to the incarnation of the Son of God.
Bottom:
Christ Driving the Moneylenders from the Temple: the selection of episodes from the gospels follows the catechism and criteria for effective teaching.

This page:
Top:
Lorenzo Ghiberti, panel with the *Adoration of the Magi*, Baptistery of St. John (North Door). The refined style of the final Gothic period was open to naturalistic suggestions that were already of the Renaissance and therefore "our own."
Bottom:
Lorenzo Ghiberti, Baptistery of St. John (North Door). The winner of the 1401 competition (his competitors were Filippo Brunelleschi, Jacopo della Quercia, Francesco di Valdambrino, and Niccolò Lamberti), Ghiberti worked on the door till 1425.

On the following pages:
Lorenzo Monaco, *Coronation of the Virgin*, c. 1414, detail. Uffizi Gallery. The Camaldolese artist represents the highest technical and stylistic level achieved by Florentine painting in the years prior to Masaccio's revolution.

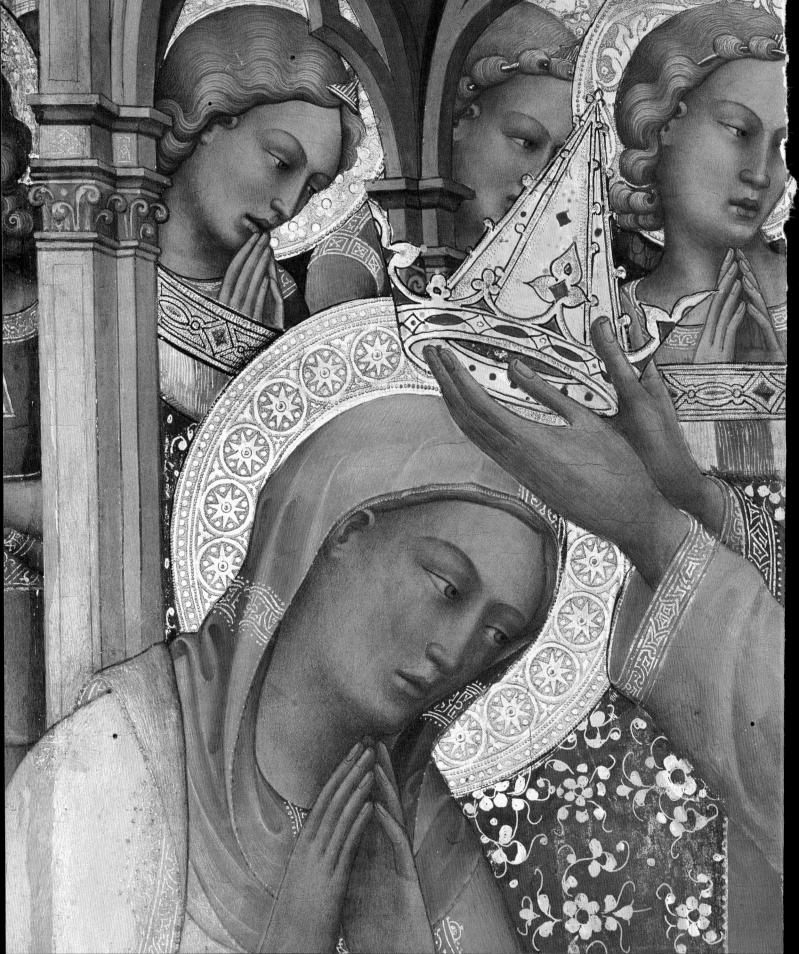

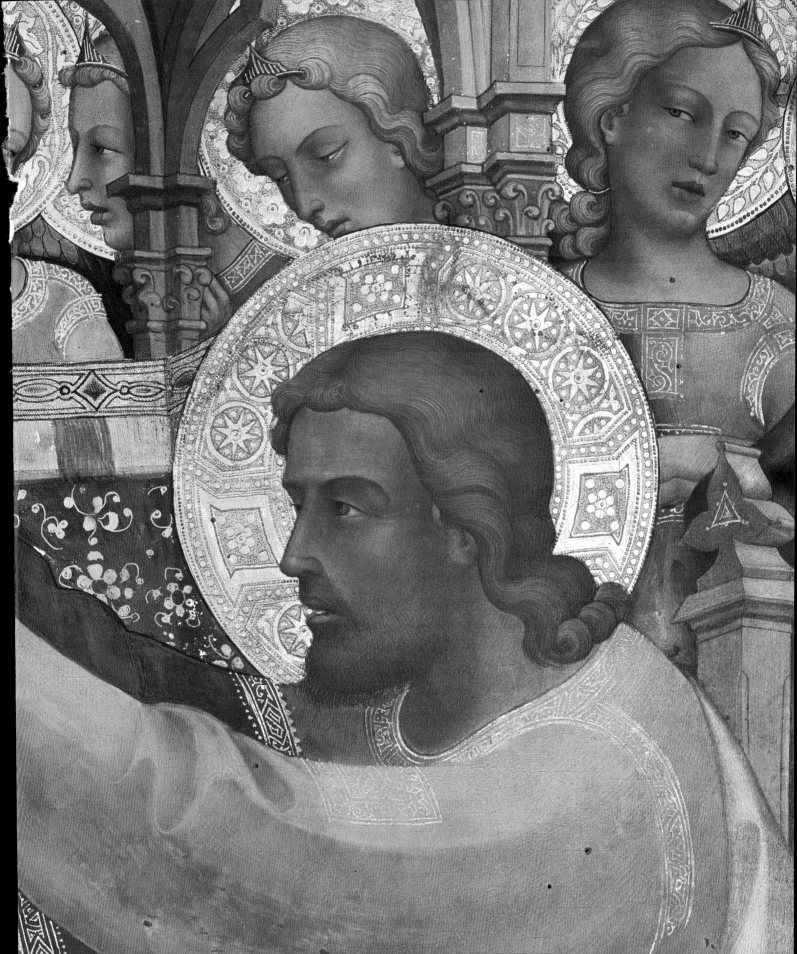

Opposite page:
Masaccio, *The Trinity*, c.
1425. Church of Sta. Maria
Novella. The revolution in
perspective inaugurated by
Filippo Brunelleschi was
spread by Masaccio in the
field of painting.

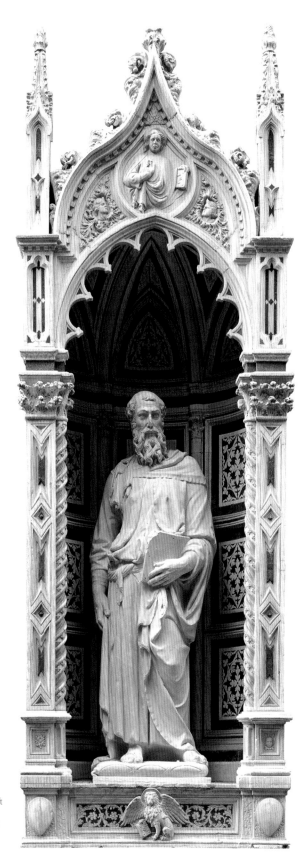

a kind of "spatial box" in which dramatic action
takes place.

Victory in the competition went to Lorenzo
Ghiberti, because the Gothic style that held
sway in Europe was also dominant in Florence,
with the exquisite elegance of Gherardo
Starnina and Lorenzo Monaco, with the
technical versatility, naturalistic mimicry, and
chromatic skill of both Gentile da Fabriano
and Masolino.

Yet Brunelleschi's debut as a goldsmith and
sculptor was not without significance; indeed,
of the two arts, it was sculpture that was first to
be open to the innovations of the Renaissance.
This was perhaps due to the professional
closeness of sculptors to Brunelleschi, perhaps
to the direct stimulus of classical statuary,
perhaps even to the more frequent
opportunities for work, and therefore for
experimentation and comparison, that a city in
a phase of building renewal, as was Florence in
the early 15th century, could offer. One thing is
certain: that in the first 20 years of the 15th
century, when painting in Florence was
dominated by the elegance of Gothic (*The
Coronation of the Virgin* by Lorenzo Monaco is
from 1414, the *Adoration of the Magi* by Gentile
da Fabriano is from 1423, both in the Uffizi), in
the construction sites of the Duomo and
Orsanmichele the linguistic renewal was already
under way and expressed with the works of
Nanni di Banco, Donatello, and Brunelleschi
himself. Donatello's *St. George* and even more

This page:
Right:
Donatello, *St. Mark*. Church
of Orsanmichele. Florentine
sculpture had a hegemonic
role in the early 15th
century: this statue can be
considered one of the first
examples of Renaissance
culture.
Far right:
In the Florence of the 14th
and 15th centuries,
Orsanmichele was the
building that housed the craft
and trade guilds. It was in
this building that the various
guilds were represented by
their patron saints.

his *St. Mark*—the latter considered "the first true statue in the sense of an autonomous figure in Western art since antiquity," as Rosenauer has rightly written (exhibition catalog, Florence 1986)—preceded Masaccio's "new" men in the Brancacci Chapel by about ten years.

In Florence there is a church that does not even seem to be a church, but a square fortress, built with a type of honey-colored sandstone known as "pietra forte."

It is Orsanmichele, the building of the Arti and Corporazioni, the Guilds, the headquarters of what today would be called the Confederation of Industry, the Federation of Merchants and Shopkeepers and the Labor Unions. It is exactly midway between the square of the seat of religious power, with St. John's Baptistery and the Cathedral of Sta. Maria del Fiore, and Piazza della Signoria, the center of political power. It is almost as though, in the symbolic urban planning of the city, it was meant to represent the autonomy, liberty and dignity of the world of work. All around the square form of Orsanmichele, on every side of its perimeter, are the statues of the patron saints of the Arti. Those of the major Guilds (the bankers, the wool traders) are bronze, those representing the lower-ranking professional sectors are marble.

It was precisely the latter (*St. George* sculpted by Donatello for the armor and swordmakers' guild, the *Four Crowned Saints* by Nanni di Banco, commissioned by the masons' and carpenters' union) that were the most revolutionary sculptures.

If you stand in front of the exedra consisting of the *Four Crowned Saints* (today replaced with casts, as are almost all of Orsanmichele's sculptures), you have the impression that you are looking at Masaccio's *Tribute Money* in the frescoes of the Brancacci Chapel of Sta. Maria del Carmine; yet these frescoes are dated about ten years later, in about the mid-1420s. In short, the "new" men of the Brancacci—those who cast real shadows on the ground and occupied the streets of the "modern" city as protagonists and transformed themselves into a colossus of limbs and determination when they decided to meet freely in the open air—have their older brothers in the heroes of Donatello and Nanni di Banco. If this is incontestable, as I believe it is, then it means that in Florence, at the birth of the Renaissance, the advanced points of sculpture precede the mutation that was to take place on the walls of the Brancacci in the mid-twenties of the century by at least a decade.

It is understandable that painting was slow in following the new representation of the visible universe theorized by Brunelleschi and displayed on the walls of the Brancacci and in

the *Trinity* in Sta. Maria Novella by Masaccio, his brilliant standard-bearer. It was hard in fact to break away from the fascination of those masters that art-history places under the heading of International Gothic. The tender grace of Lorenzo Monaco, the unpredictable elegance of Gherardo Starnina, the colored light of Masolino, the mimetic virtuosity of Gentile da Fabriano (he was the most famous and most highly paid painter in Christendom, and we need only look at his *Adoration of the Magi* from 1423 in the Uffizi today to understand why) continued to exercise considerable attraction for a long time. It was only from the 1430s and 1440s—with Beato Angelico, perhaps the first and certainly the most intelligent of Masaccio's followers, with Domenico Veneziano, Luca della Robbia, Filippo Lippi, the "metaphysical" Paolo Uccello, and Andrea del Castagno—that the vision of painting according

to perspective invented by Brunelleschi and then theorized by Leon Battista Alberti (*De Pictura*, 1436) became the winning option in Florence. It was then to be the job of Piero della Francesca, trained at the school of Domenico Veneziano, to make "colored perspective" the hegemonic language of 15th-century Italy in its most elevated variants: from the Rome of Antoniazzo and Melozzo, to the Urbino of Laurana, to the Venice of Antonello, Giambellino, and Carpaccio. But the responsibility for the image of the Renaissance was entrusted above all to architecture. The embryonic example of a new conception of constructed space is the Old Sacristy of S. Lorenzo, which Brunelleschi had already designed and partially built between 1428 and 1429. It is the manifesto of the Renaissance in architecture. It is geometry becoming measurable order and exact proportion. It is perspective in architecture taking on an inhabitable shape; a melodic, highly exact organization of space. Like the portico of the Ospedale degli Innocenti, decorated with glazed "tondi" (round plates) by Andrea della Robbia (pupil and nephew of Luca della Robbia); like the prototypes of noble dwellings represented by Michelozzo's Palazzo Medici, Rossellino's Palazzo Rucellai, by the famous Palazzo Strozzi, begun by Benedetto da Maiano and then completed by Simone del Pollaiolo, known as "Il Cronaca." No king or prince in the Europe of that time lived in buildings that were even remotely comparable to the houses of the

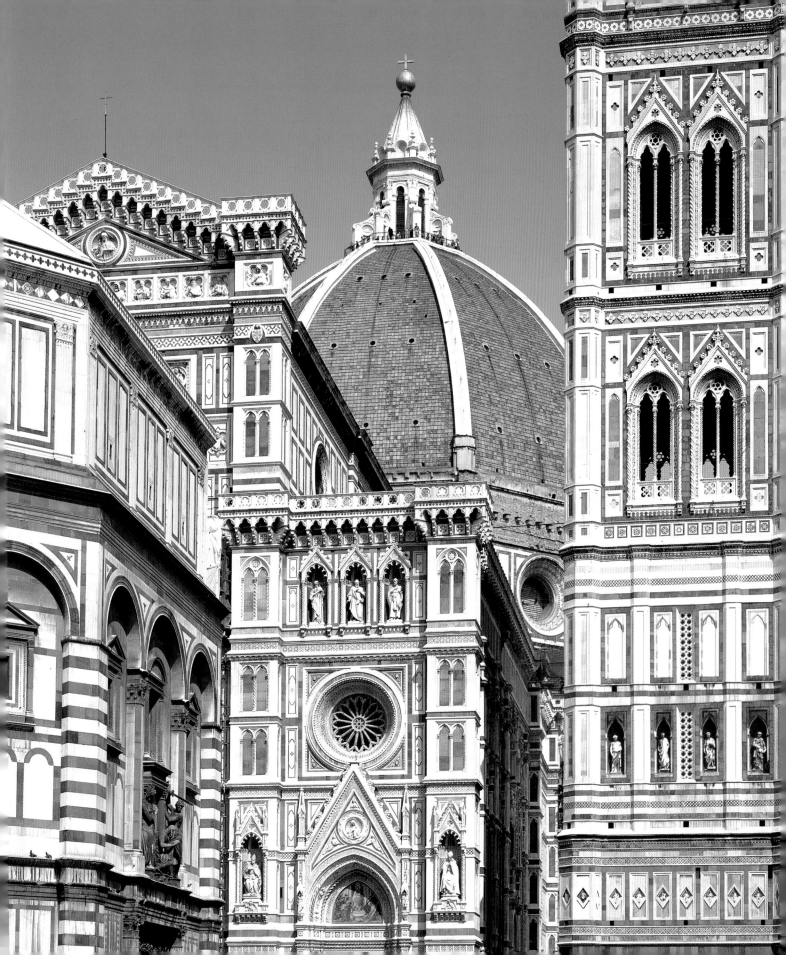

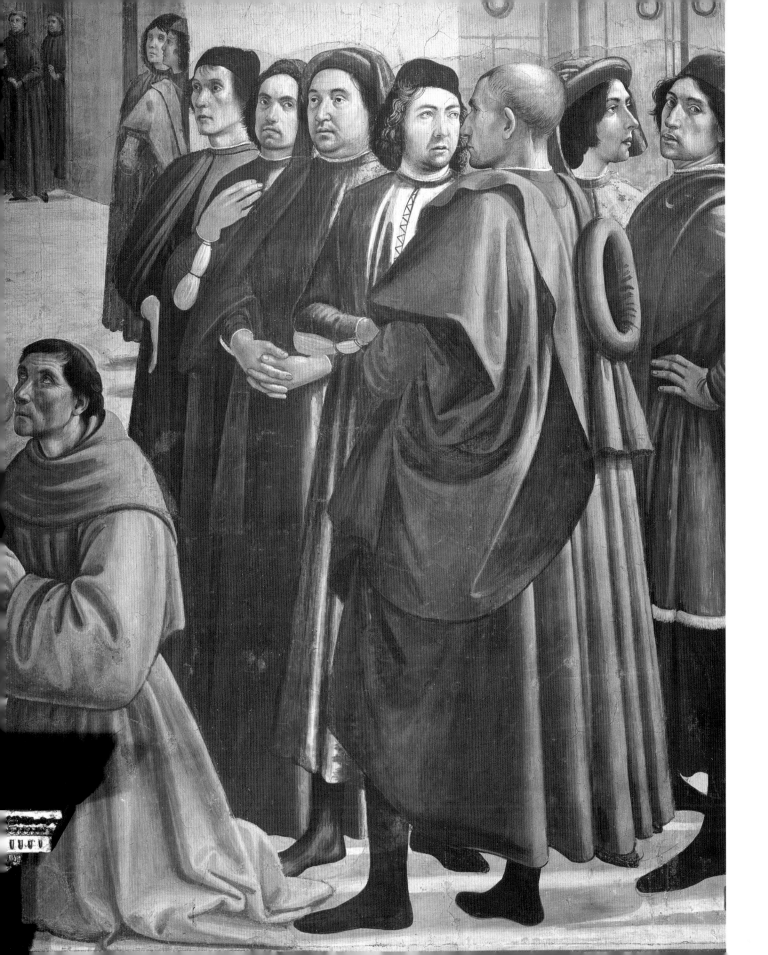

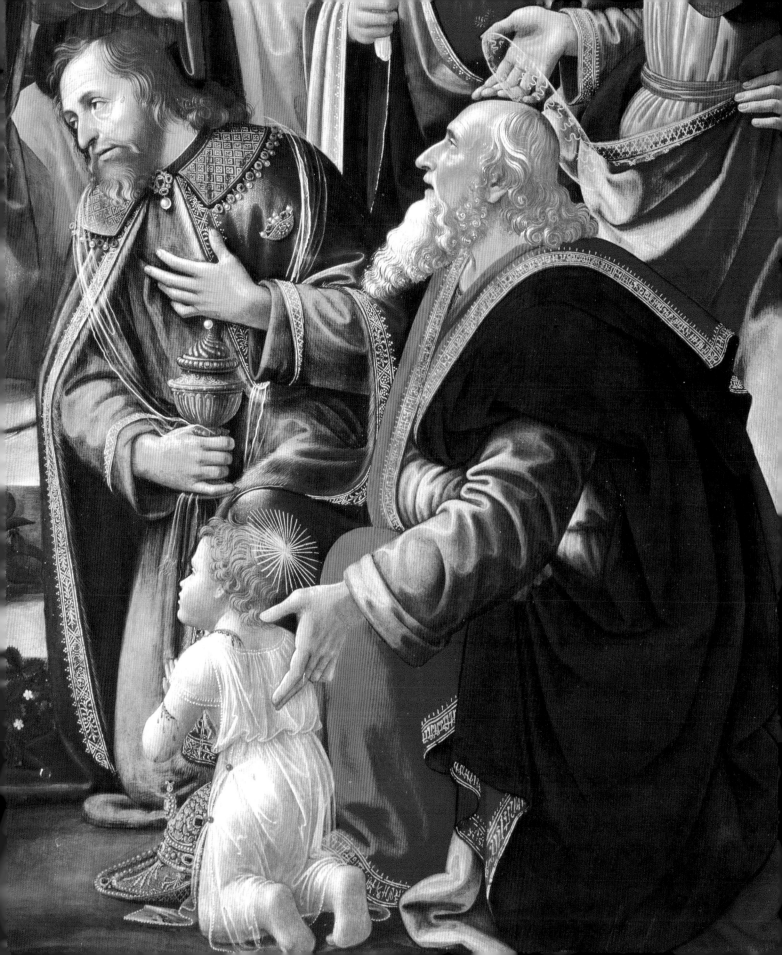

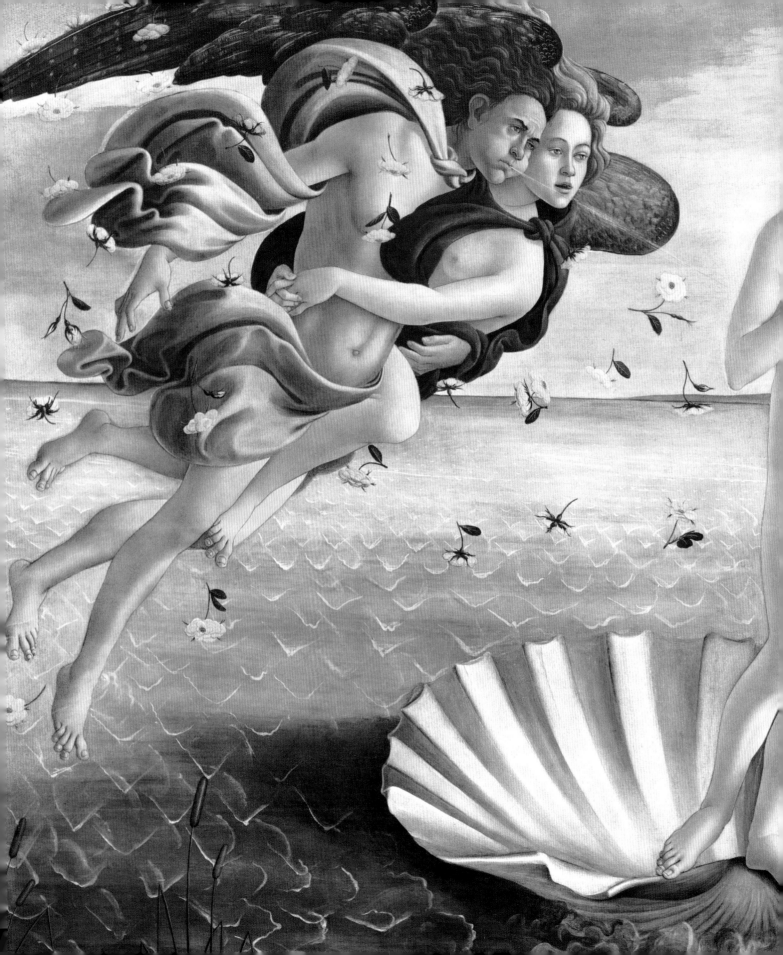

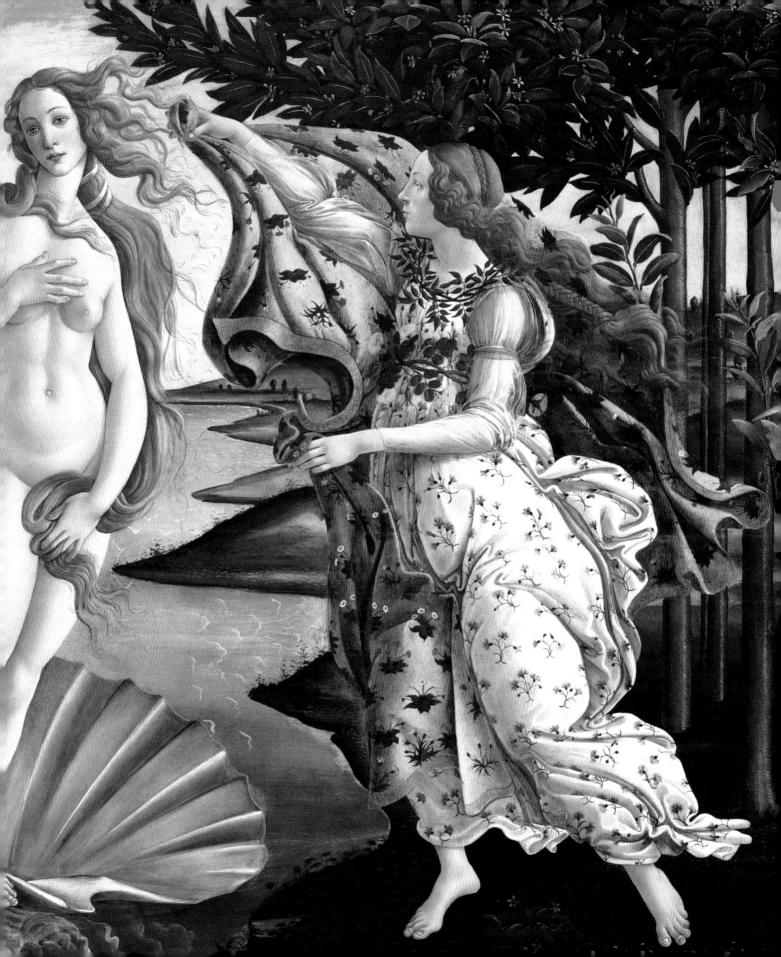

Michelangelo, *David*, detail. Museo dell'Accademia.

Florentine merchants and bankers: stone buildings as grand as royal palaces, with seats with inlaid backs, chests painted with Ovid's fables, Della Robbia terracotta friezes, furniture and furnishings that had the monumental and harmonious dimensions of the new architecture.

And what will the foreign guests of Florence have thought and said at the sight of the dome of Sta. Maria del Fiore, vaulted in 1436 and crowned with its lantern in 1461?

We are amazed at the sight of the skyscrapers of Manhattan, yet there are constructions, of similar shape and size, in every city in the world. In contrast, in the 15th century, the dome of the cathedral of the Florentines had no possibility of comparison. There was nothing comparable in terms of beauty and dimensions in the whole of Christendom. It was "magnificent and inspiring," as Alberti wrote with an admirable choice of words. Looking at it close up, it seemed to defy the sky. Seen from a distance, it gave the impression of truly covering "all the Tuscan people with its shadow." Not even the ancients had succeeded in conceiving, not to mention building, such a prodigy of art and engineering. The myth of Florence as the capital of modern art, the city of the avant-garde in developing models destined to conquer the world, arose in this period and the attraction exercised by the great works of architecture was undoubtedly decisive in this. The legacy of Brunelleschi, Masaccio, Donatello, Luca della Robbia and the first heroic generation of the Renaissance was destined to split into two fundamental tendencies. On one hand, there is the line that

we could define as traditionalist. This is represented by Ghirlandaio, the indefatigable illustrator of the Florentine society of his time in the great cycles of frescoes (the Sassetti Chapel in Sta. Trinità, c. 1483; the Sala dei Gigli in Palazzo Vecchio, 1482; the choir of Sta. Maria Novella, 1486–90), as well as by Sebastiano Mainardi, Bartolomeo di Giovanni and others. All these, and Ghirlandaio in particular, represent the more orthodox tendency of Florentine painting; the one that, born of Lippi's interpretation of Masaccio and subsequently updated through the research of Verrocchio, was open to a pragmatic eclecticism with an illustrative tone, sensitive to the fascination of contemporary Flemish artists. The influence of the triptych by Hugo Van der Goes on Ghirlandaio (and not only on him) is well known; formerly in Sant'Egidio, it was on display in the Uffizi, acquired by Tommaso Portinari in Flanders and sent to Florence in 1483. Leaving aside considerations of quality, Ghirlandaio's faction is important because it guaranteed the continuity, also in technical terms, of the great Florentine mural decoration. In this sense, it is significant that the decoration of the lower bands of the Sistine Chapel, executed at the wishes of Pope Sixtus IV in 1481—an episode that perhaps constituted the most important transplantation of the Tuscan Renaissance to Rome—was entrusted to a group of master fresco painters that included Signorelli, Perugino and Botticelli, Cosimo Rosselli and Domenico Ghirlandaio.

Alongside the traditionalist faction of the "illustrators" *à la* Ghirlandaio, we have that of the sculptor-painters represented by Antonio del Pollaiolo (1432/33–98) and Verrocchio (1435–88). The former, a bronzesmith, goldsmith, painter, and sculptor, was fascinated above all by the endless expressive possibilities of the human anatomy; in sculpture, this was expression through a tense and poised modeling, and in painting by the domination of the "functional" design (to use Berenson's term) releasing energy that evokes tactile values and movement.

As for Verrocchio, his studio was the synthesis and laboratory of all the most significant artistic influences of the time: from Domenico Veneziano to Lippi, from Donatello to the Flemish artists. Botticelli, Perugino, and Leonardo da Vinci all passed through his experimental workshop, just to name the most important. In sculpture, the century was associated with the elegance and psychological depth of Mino da Fiesole and Antonio Rossellino, while in painting it had its zenith in Botticelli. In his life and works, the painter who symbolized the Renaissance, idolized by the

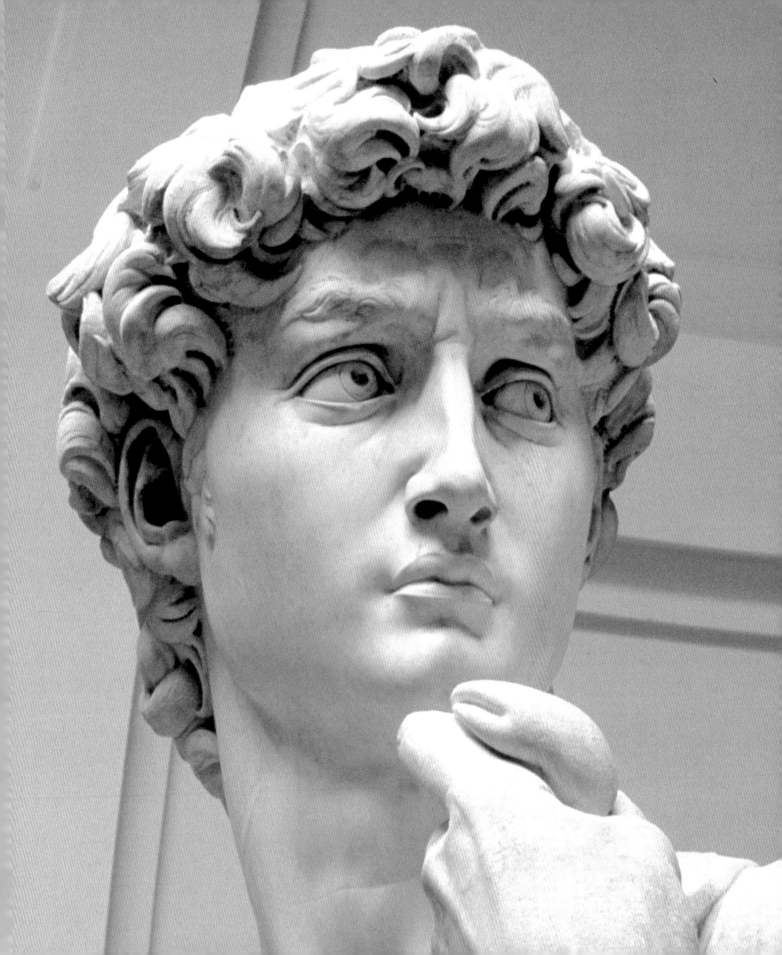

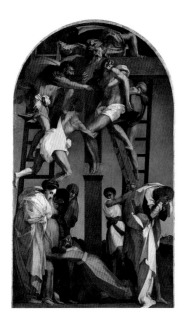

Rosso Fiorentino, *The Deposition*, Volterra, Musco Civico. The painting is one of the icons of the stylistic phase that art-history books call "Mannerism." It is thanks to Rosso Fiorentino that Florentine artistic culture became widespread in France at the court of Francis I.

Pre-Raphaelites of the 19th century and by 20th-century Symbolists and Art Nouveau painters, Sandro Filipepi, known as Botticelli (1445–1510), perfectly represents the course of Florentine culture and society between its Medicean apogee (the time, mythicized in the iconography and transfigured by the literature, of Lorenzo the Magnificent) and the republic of Savonarola. In tune with the political and cultural evolution of the Florence of his time, he moved on from the neo-pagan hedonism and platonic tendencies of the famous profane fables painted for Lorenzo (the *Primavera* and the *Birth of Venus,* both in the Uffizi) to the intense religiosity of the works of his later years (the *Pietà* in Munich, the *Mystic Nativity* in London) influenced by Savonarola's preaching.

Botticelli's "Romantic" shift away from the Florentine design tradition was not without its consequences in the Florence of the end of the century. One artist to profit from it was Filippino Lippi (1457–1504), with his eccentric linearism loaded with grotesque attitudes, with effects verging on what we might call "proto-Mannerist" in his final works (*Scenes from the Life of St. Philip* in Sta. Maria Novella, 1502). Another with a similar mental attitude was his contemporary Piero di Cosimo (1462–1521), an artist of great visual lucidity that was worthy of a Flemish painter, yet subtly uneasy in the roving interplay of the shadows, in the shifting light on faces and objects, in the visionary imagination that governs his famous mythological compositions.

Someone who was ahead of everyone at that time, but within an analogous experimental tendency—the 15th-century line—that he was undermining and contradicting subtly from inside, was Leonardo da Vinci (1452–1519). Beyond the aura of "universal genius" given him by the literary tradition and taking nothing away from the important role performed by him in the early 16th century, alongside Raphael and Michelangelo, it must be recognized that Leonardo the painter is to a large extent to be placed within the Florentine artistic context of the 15th century. And this not only through his place of origin, but in his specific training and culture. He served his apprenticeship, in fact, in Verrocchio's workshop when Florentine painting seemed to achieve the same superb effect with brushes and paint as the goldsmiths and engravers did with their tools and metals, and the study of the human anatomy, understood as a perfect living machine, the example of a kind of cosmic animism, was tinged with scientific and philosophical intents.

It is necessary to start from these premises to understand the qualities of valiant research, of spiritual adventure, continually poised between scientific investigation and mental speculation, that distinguished Leonardo's activities. Nevertheless he succeeded (and this is the measure of his greatness) in giving universal scope to the artistic tradition of his origins, to direct it toward an animistic and vital interpretation of the world. Thus the Florentine technique of *chiaroscuro* became, through tireless research and experimentation, the *sfumato* (delicate shading) of the *Virgin of the Rocks* (1493) and the *Mona Lisa* (1505), both now in the Louvre. And in his hands the drawings of Pollaiolo and Botticelli were in a certain sense transformed into a philosophical instrument to reveal the secret vitality of visible forms (*Adoration of the Magi*, Uffizi, 1484).

To the eyes of the world, in the early years of the 16th century, Florence truly seemed to be the New Athens, the capital of great new art, the laboratory of the "modern manner," as Giorgio Vasari was soon to say (the first edition of *The Lives* is from 1550). In 1501, following the Milanese glory of *The Last Supper*, Leonardo returned home to exhibit the cartoon of the *Virgin with St. Anne and Child* (London, National Gallery). On 8 September 1504 Michelangelo, not yet 30 years old, inaugurated his *David* on the parvis of Palazzo Vecchio. It is a sculpture—Vasari was to say, quite rightly— "that has left all other statues, modern or ancient, mute." High on its pedestal, imposing in size, almost blinding in the ivory-white splendor of a nudity never before represented on such a grand scale and with such realism, the *David* expressed the pride of the Florentines and, with this, the certainty that such masterpieces had never before been seen. A few years later, rivals Michelangelo and Leonardo were commissioned to decorate the Great Council Hall of Palazzo Vecchio with frescoes—the *Battle of Cascina* and the *Battle of Anghiari* respectively. When Benvenuto Cellini defined those frescoes, sadly lost to us, as the "school of the world"; never was a phrase more truthful. Meanwhile, studying in the city of the lily, in contact with events of such scope, was Raphael.

All the tendencies that were to make the century of the Italians great in the eyes of the world were present in the Florence of the early 16th century. The classical ideal that was to reach its peak with the Roman Raphael of the *Stanze* (rooms) in the Vatican Palace and the tapestries of the apostolic series was already in incubation in its devotional variant, in a Savonarolian vein, of Fra Bartolomeo and Mariotto Albertinelli, and was already unfolding in the design perfection of the balanced compositions of Andrea del Sarto, the artist whom Vasari claimed was "without errors."

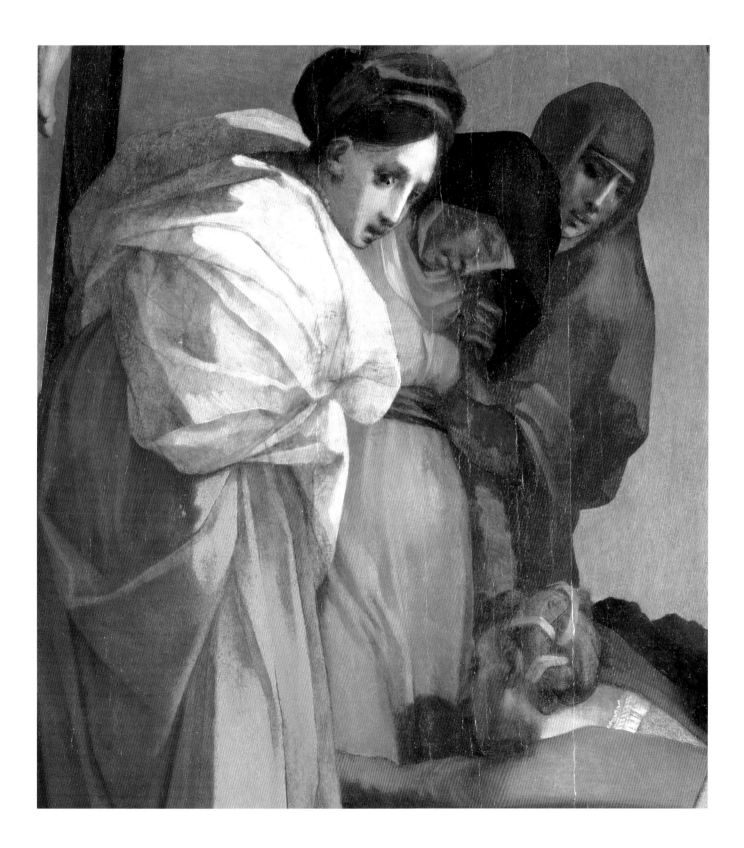

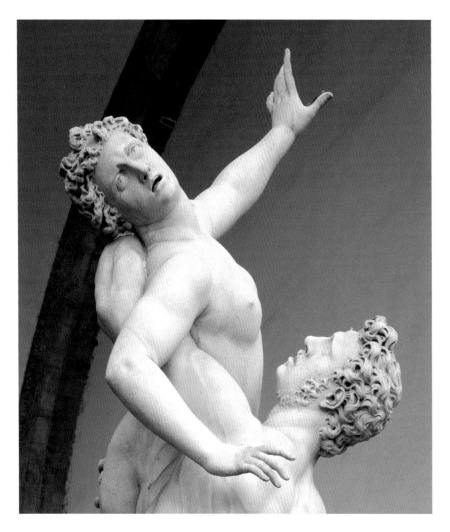

natural elements, at their symbolic and metaphoric interpretation, yet experimenting (with different outcomes depending on the psychological inclinations and the social and cultural spheres) with aesthetic, individualistic, eccentric or mystical orientations. According to the concepts theorized by the treatise writers and imposed with particular authority by Michelangelo, the artist's understanding was no longer or not so much the imitation of nature, but rather its transcending ideal. The guide for working was therefore to be "the inner image" contemplated with pleasure within the heart and dominated by the intellect. The necessary consequences were to be the emphasis of the intellectual character of art and, in parallel, an explicit invitation to formalism and artificiality. These ideas theorized by the critics (Vasari, Benedetto Varchi and Vincenzo Borghini, among others) were encountered within an astonishing variety of artistic personalities and styles. Architects such as Giorgio Vasari, Bartolomeo Ammannati, Bernardo Buontalenti; garden designers such as Tribolo; painters such as Agnolo Bronzino, Poppi, Naldini, and Allori; sculptors such as Rustici, Benvenuto Cellini, Vincenzo Danti, Bandinelli, De' Rossi, and Giambologna, all of whom are sufficiently important in their own recognizable stylistic autonomy as to deserve specific treatment. The number and excellence of the artists populating 16th-century Florence represent a phenomenon that is incomparable in the history of the arts. Even Vasari, himself a protagonist and

Giambologna, *Rape of the Sabine Women*, 1583, detail. Loggia dell'Orcagna. This the first sculpture that makes a plurality of viewpoints obligatory. Baroque helicoidal movement has its historical roots here.

The "modern manner"—as we have said— was born in Florence, and it was in Florence that it presented its fundamental documents with Leonardo and Michelangelo. But that intellectual variation of the Manner that modern art-history books call "Mannerism" was also born in Florence. If we take two primary works by Pontormo and Rosso Fiorentino, the *Deposition* in Sta. Felicita and that in Volterra (both datable to the third decade of the century), we will see the new tendencies in art perfectly exemplified.

The path first beaten by the Florentines— promoted by the soon-to-be-deified Michelangelo, sculptor for the New Sacristy of S. Lorenzo and architect of the Biblioteca Laurenziana—aimed at alienation from reality through the lens of difficulty and difference, arriving in many cases at the transcending of

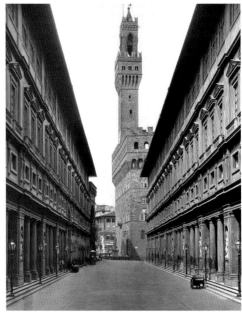

Built "over the river and almost in the air," the Uffizi complex is the masterpiece of architect Giorgio Vasari and is also the site of Italy's most important museum.

inimitable historian of his own century, is unable to explain this and resorts to unusual astral conjunctions, along with sociological, psychological, and even climatic justifications: the spirit of competition sharpening wits and skills, individualism, a formidable stimulus for success, the very air of Florence, which makes spirits free, restless and insatiable. The Florence of the 16th century was therefore crowded with artistic talents, and was obliged to export a not insignificant number of them in a diaspora destined to fertilize both Italy and Europe. So it was that Michelangelo found space and adequate opportunities in Rome, and that we find Rosso Fiorentino and Benvenuto Cellini at the court of the king of France, Torrigiano in England, and Jacopo Sansovino in Venice.

In 16th-century Florence, methods of organization and artistic production arose that would soon find active imitators in the Europe of absolutism: in Paris, Madrid, and Vienna. Thus we have the establishment of luxury state manufacturing with the Opificio delle Pietre Dure (Workshop of Semiprecious Stones) and Medicean tapestry weaving. Precious and semiprecious stone mosaics and inlays became the most evocative and easily recognizable symbol of Florentine style in Europe. The Medici adopted them as the emblem of their terrestrial and celestial glory, to the point that they wanted the Chapel of the Princes in S. Lorenzo, their cold, sumptuous Escorial, to be covered with semiprecious stones. The modern equestrian commemorative statue (soon cloned by Francavilla and Pietro Tacca in Paris and Madrid) was invented by Giambologna, casting Duke Cosimo on horseback in bronze in the Piazza della Signoria. The Salone dei Cinquecento in Palazzo Vecchio, frescoed by Vasari, offers the whole world the symbolic code and the figurative model for the exaltation of autocratic power. The Pitti Palace, with its imposing dimensions and its order, majestic and rational at the same time, with its Italian-style garden, an admirable synthesis of nature and human skill, is the prototype of what were to be the future dynastic palaces of Europe, from Paris to St. Petersburg. Likewise, Vasari's Uffizi building is the first modern structure specially conceived, with criteria of modular rationality, to house the services of the state. Nor can we fail to mention that Florence was one of the most important laboratories of Catholic reform in the field of sacred art (with Allori, Santi di Tito, Pierfrancesco di Jacopo Foschi, and Vasari, to name just a few) and that perhaps the most important model for the European diffusion of so-called "international portrait-painting" was Agnolo Bronzino, official painter of the Medici family and the Florentine elite of his time. The

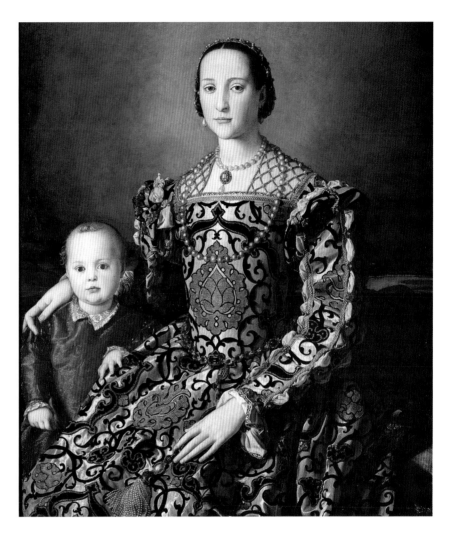

portraitists who provided the images of political power and class hegemony in the Europe of the Counter-Reformation and absolutism (Antonio Moro, Alonso Sánchez Coello, Bartholomaeus Spranger, Franz Pourbus, François Clouet, Hans van Aachen, Sante Peranda, Scipione Pulzone) all owe a greater debt to Bronzino than to any other. It is necessary to underline all this, since it serves to correct—or rather to reformulate—a concept that would otherwise run the risk of misleading us. It is said that the 16th century saw the gradual shift of centrality in art from Florence to Rome, to Venice, to the cities of the Po Valley (Parma, Mantua, Bologna). This is true if we consider the role taken on by the Rome of the Popes in the age of Raphael and Michelangelo. It is true even if we consider the potential wealth seen in the importance and value, in

Bronzino, *Portrait of Eleonora of Toledo*. Uffizi Gallery. Eleonora, wife of Grand Duke Cosimo, is represented here with unemotional objectivity and with all the visible signs of her rank. In the Europe of absolutism, Bronzino's work was one of the most important models of so-called "international" portraiture.

those years, of the paintings of Titian, Veronese, and Correggio; in the architecture of Palladio and Giulio Romano; in the Counter-Reformation naturalism of the Bolognese and the Lombards. There is no doubt that the most important roots of Bernini and Pietro da Cortona, of Caravaggio and Carracci, must be sought outside Florence.

Even if at least a dozen Florentines of the 16th century deserve front-rank positions in the universal history of the arts, it is no mistake to say that the Florence of the end of the century (after *Perseus* by Benvenuto Cellini, inaugurated in 1554 and after the *Rape of the Sabine Women* by Giambologna, dated 1583) had substantially exhausted its creative capacities, had lost its

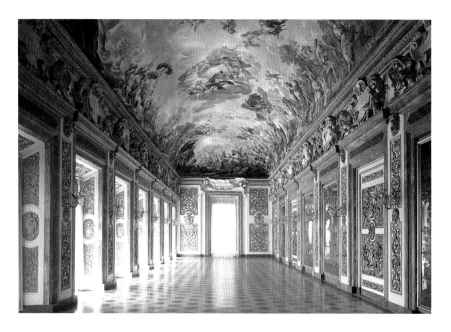

Luca Giordano, Gallery of Palazzo Medici Riccardi. Baroque civilization entered Florence with Pietro da Cortona in Palazzo Pitti (1637–47) and with Luca Giordano in Palazzo Medici Riccardi (1683–85).

revolutionary impetus. Yet never so much as in that period did Florence perform such an exemplary, even regulatory, role for European artistic tastes. The fact is that precisely in that period a phenomenon was taking shape that was to be decisive for the future history of the city. In the second half of the 16th century, Florence, the capital of a state with limited sovereignty, with an economy now in decline and in a marginal and subordinate political position, invented a very special status for itself in the sector of the arts—a status that Italy and Europe immediately recognized and accepted.

The operation was a clever one and deserves to have its key stages summarized. With the political unification of Tuscany under the Medici monarchy (1555), the visual arts were placed at the service of an ambitious cultural

and political project promoted by Duke Cosimo and cleverly executed by Giorgio Vasari. Let us consider the dates. Between 1581 and 1583 (at the wishes of Francesco de' Medici, Cosimo's son, known as the "prince of the studio") on the top floor of Vasari's Uffizi complex, with the Hall of Statues and the Tribuna del Buontalenti, the first modern museum in Europe was gradually taking shape. In Florence, in 1563, thanks to the commitment of Giorgio Vasari and under the auspices of Michelangelo, the Accademia del Disegno (Academy of Drawing) was created, this too the first modern institution to bear such a name in the West. From that time on, in a republic of equals entrusted to the benevolent protection of the prince, the artist would have a place to mitigate and sublimate his alienation, to theorize his culture, to improve and codify his specializations.

A few years later (1568), Vasari published the second edition of his *Lives*, the monumental work destined to become the model of modern art-historical scholarship. It is the concluding episodes of this story that art-history books call the Renaissance and Mannerism. In the city that had played the most important role in the history of figurative culture at the dawn of the modern age, in just a few years, the fundamental institutions came about that from then on were to govern the market, patronage and, with these, the activity of painters, sculptors, and architects in Europe and the world. That is to say, the museum, the academy, and art criticism as we know it arose. Given these premises, it is easier to understand the development of the arts in the Florence of the 17th and 18th centuries. The veneration of tradition theorized by Vasari and represented by the example of the "divine" Michelangelo (immediately after his death his family home, in Via Ghibellina, became the museum shrine that it still is today) aroused fascination and pride. It made excellence obligatory, yet at the same time it intimidated and conditioned. In fact it weighed heavily as an obstacle, putting lead in the wings of free invention, requiring a continuous and often embarrassing comparison with the past.

Seventeenth-century Florence, its beliefs and heroes recovered by recent studies (the monumental catalog in three volumes, edited by Mina Gregori, published on the occasion of the major exhibition in 1986, can be used as a basic source of data for this), abounded with excellent, often gifted artists. They were artists who were capable of giving a voice to the highest, most seriously motivated and nobly expressed ideals of the Counter-Reformation (such as Santi di Tito, the impeccable sketcher;

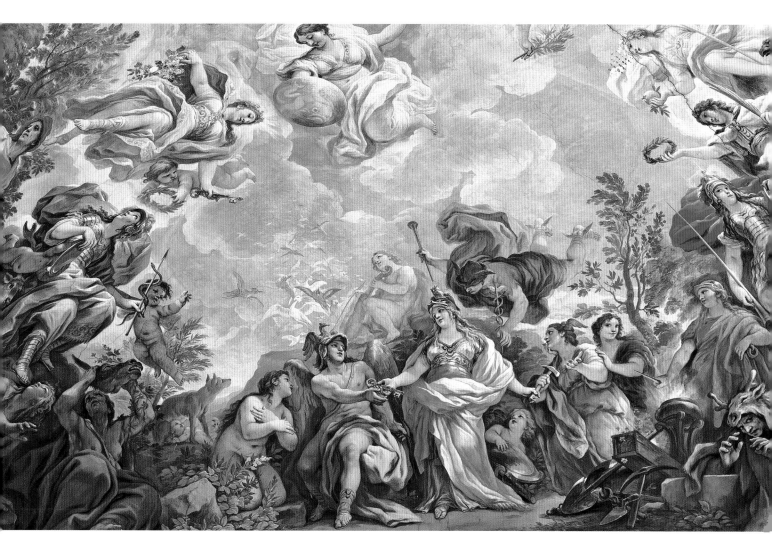

Jacopo da Empoli, the painter of still-lifes and austere naturalistic sacred scenes; Andrea Commodi; and Filippo Tarchiani) or those (such as Giovanni da San Giovanni and Cecco Bravo) who succeeded, with shrewd boldness and nimble intelligence, in adapting the eccentric and transgressive moods, the individualism and excess of Mannerism to suit the registers and themes of new expression.

These were artists who in some cases were sensitive to Venetian schemes of color (Cigoli, Passignano), in others to the Baroque movement (Volterrano), in others still to the pathetism and sentimentalism that were typical of the century (Francesco Furini, Cesare Dandini). In some cases (Giovanni Martinelli, Lorenzo Lippi), we see results of such moral seriousness and stylistic rigor that references to

Caravaggesque naturalism, to the Spaniards, to Philippe de Champaigne, spontaneously spring to mind. Yet the many and often admirable artists who dominated the Florentine and Tuscan scene in the 17th and then the 18th century (with Gherardini, Ferretti and Sagrestani, with Ranieri del Pace and Bonechi, to name just a few) did not succeed in creating a figurative language capable of imposing itself at national and international level. The appointment with Modernity (the naturalism of Caravaggio and the Baroque of Bernini and Pietro da Cortona, the classical ideal of Annibale Carracci and Guido Reni, the Rococo and the *vedutista* 18th-century of Pellegrini and Tiepolo, of Canaletto and Bellotto) was substantially missed by the Florentines. The frescoes of Pietro da Cortona in Palazzo Pitti

Luca Giordano, Gallery of Palazzo Medici Riccardi, detail. The Baroque style, which was splendidly represented by Luca Giordano, fascinated the Florentines, but did not fully convince them—the weight of a glorious tradition was too great.

On the following pages:
In about 1635, to celebrate the marriage between Vittoria della Rovere and Ferdinando II de' Medici, Giovanni Mannozzi, known as Giovanni da San Giovanni, together with a select group of Florentine painters, exalted in fresco form the intellectual glory and patronage of the House of Medici. Palazzo Pitti (Museo degli Argenti).

41

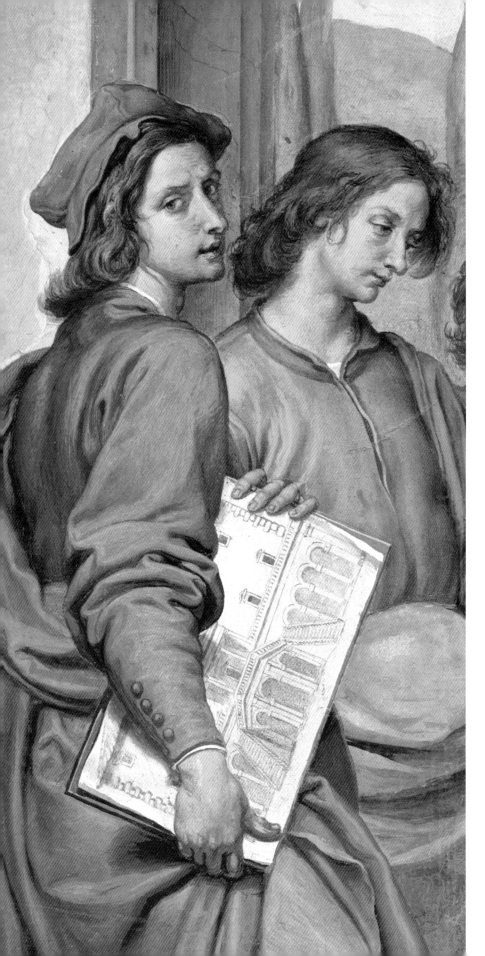

(1637–47) and those of Luca Giordano in the Palazzo Medici Riccardi (1683–85) did have their charm, and indeed prompted opportunistic imitations and moderate adaptations, but they were not entirely convincing. Just as the grafting-on of Baroque scenographic architecture (in the complex of the Philippine Fathers in S. Firenze, the church of S. Gaetano, the chapels of Santissima Annunziata) did not manage to modify substantially the city's medieval and Renaissance image. The fact is that the weight of tradition made itself felt decisively. There is not one sculpture by Caccini, Ferdinando Tacca, or Antonio Novelli behind which we cannot glimpse the shadow of Giambologna, Cellini, or Andrea Sansovino. There is not one piece of architecture by Nigetti or Gherardo Silvani that does not betray the nostalgia for Buontalenti and Vasari. There is not one fresco by Ferretti or Giovanni da San Giovanni, not a painting by Cigoli dell'Empoli or Furini, that does not carry with it the baggage of the wisdom of design or attention to composition, or some other reminder of Fra Bartolomeo, Andrea del Sarto, or Bronzino.

In Florence, the artistic history of the great centuries very soon became cultural policy. The Medici dynasty in power knew that they were rather insignificant in the eyes of European politics, but they also knew that the artistic glories of the past, if appropriately emphasized, could be translated into an effective instrument of prestige, renown, and international approval.

We have the perfect demonstration of this tendency in the Palazzo Pitti, a building destined to grow stronger over time, to the point of becoming the prevalent identifying feature of the city in the modern age. Those entering the so-called Salone di Giovanni da San Giovanni in the Palazzo Pitti, in what were formerly the summer apartments of the dynasty and today house the Museo degli Argenti, will be amazed at the extraordinary symbolic apparatus above them and all around them. In light, airy frescoes, speckled with gold-like silk tapestries, Giovanni da San Giovanni, assisted by a select team of Florentine painters from the early 17th century (Cecco Bravo, Ottavio Vannini, Francesco Furini) celebrated the marriage, in 1635, of Ferdinando II to Vittoria della Rovere, the last heir of the Urbino dynasty. In reality we immediately realize that the allegory of the union of dynasties (the leafy oak branch grafted onto the Medici coat of arms) is a pretext to exalt the destiny of Florence, cradle of the arts and heir to classical civilization. The frescoes tell how Western culture (the blind Homer and the Muses, Arts, and Letters), driven away by the triumphant Islam after the fall of

Constantinople, found a welcome in Italy, and particularly in the Florence of Lorenzo "the Magnificent". Mohammed is a warrior with a scimitar and a turban, leading the assault. His flag is the Koran in the shape of a winged Fury, a cloud of death looming over Europe. But here is Lorenzo, with his unmistakable features, dressed in the clothing of two centuries earlier. He welcomes Apollo and the Muses, converses with Prudence and, banishing Envy and War, makes Peace and Plenty reign. On the wall

Lorenzo, immortalized by the tree of Fame, from the Lethe, the river of forgetfulness. By now Florence had become its own myth and the principal concern of the last Medici (Cosimo III, Grand Prince Ferdinand, and Giangastone) was to preserve its image as a capital of the arts and culture, favoring the growth of art collecting, together with scientific, musical, and literary activities, in the melancholy decline of the grand duchy. Otherwise, in an age that saw the impoverished Italian princes sell their art

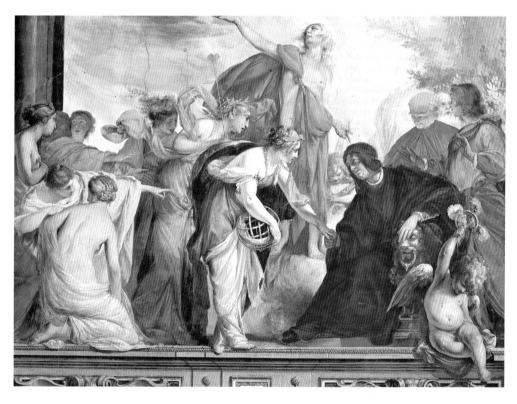

Cecco Braco, *Lorenzo the Magnificent Receives the Procession of the Muses*, detail. Palazzo Pitti (Museo degli Argenti, Salone di Giovanni da San Giovanni). This detail shows Lorenzo surrounded by artists. Florence's role as capital of the arts is now considered to be the city's distinctive characteristic.

opposite the entrance, "il Magnifico" is surrounded by a group of artists, recognizable among whom are, on the left, Giuliano da Maiano with the model of the Villa in Poggio a Caiano and, on the right, the young Michelangelo showing the bust of the famous classically inspired Faun. Elsewhere we have Lorenzo at the feet of the statue of Plato against the backdrop of the Villa at Careggi, the meeting place of the Neoplatonic circle evoked by the portraits of Marsilio Ficino and Pico della Mirandola and by the figures of Astronomy and Poetry. There is also the elegiac reminder of the death of Lorenzo the Magnificent, with the three Fates cutting the thread of life and the mystical swan recovering the memory of

collections to foreign potentates, as in the case of the Quadreria Estense (Este Gallery) of Modena, which ended up in Dresden, purchased by Augustus of Saxony, there would be no explanation for that sensational and sensationally providential event that was the famous "Family Pact" of 1737. Anna Maria Ludovica de' Medici, better known as the wife and then widow of the Elector Palatine in Düsseldorf, was the last heir of a dynasty that was destined to die out with her. The foreign offices of Europe had already established that the grand duchy of Tuscany would fall under the political influence of Vienna and therefore of the house of Lorraine. The last lady of the house of the Medici gave her consent, which

was formally necessary, subject to a sole condition: the dynasty taking over would only assume power with full legitimacy if they undertook to preserve the Medicean artistic heritage in Florence, inalienably, irremovably and in perpetuity. This is the "Family Pact" of 1737. We are heavily indebted to the provident determination of the Electress for the fact that the Botticellis and Piero della Francescas of the Uffizi, the Titians and Rubens of the Palatina, the illuminated codices of the Biblioteca

take on an increasing importance over the course of time. The message was this: the Florentine artistic nature—as it was molded over the centuries, celebrated by historians and men of letters, admired and imitated by foreigners, settled in famous and numerous works—is in itself a monument to be conserved, emphasized and, if possible, augmented. A monument that is both glorious and fruitful. Glorious because, if appropriately used, it can give glory to governors. And it was

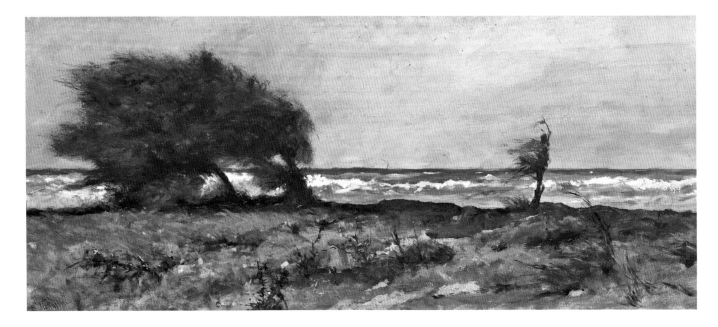

Nazionale, and the reliquaries of the Basilica of S. Lorenzo are still in Florence and not in Vienna or Prague.

Considering what the art treasures conserved in the city's museums mean today for the tourist industry and the economy, we can say that no mayor, magistrate, or politician in the last three centuries has had an importance for Florence that is even remotely comparable to that rightly attributed to the Elector Palatine's wife. Anna Maria Ludovica de' Medici shows us that, in the sentiments of ordinary people and therefore in cultural policies, artistic creativity tended to be replaced by the awareness of and pride in history. With the Electress Palatine, the Medici, who had contributed so much to the construction of the myth of Florence as the capital and laboratory of the arts, left the political stage while performing two fundamental operations: they saved the artistic patrimony that they had collected and financed and they delivered a message to us that would

indeed to give glory both to Elisa Baciocchi during the brief Napoleonic rule (on this subject, see the painting preserved in Versailles dedicated to her by Pietro Benvenuti between 1811 and 1813) and to the cultured sovereigns of Lorraine of the Restoration (Ferdinand III and Leopold II). Yet that monumental legacy could also be fruitful, because the Florentine artistic nature (as the Electress had rightly foreseen in her "Family Pact") was capable of being transformed into a valuable resource for the city and for the state.

At this point—we have now reached the mid-19th century—it is worthwhile to look backward and realize that the history of the arts in Florence is similar to a descending graph with revivals at intervals that become less important with the passing centuries. The point of departure and the highest peak is in the years of Giotto, Arnolfo di Cambio, and Andrea Pisano. Florence has never again been so great, revolutionary, and creative as it was then.

A conspicuous revival that approached the zenith touched in the first decades of the 14th century is registered at the beginning of the 15th century. These were the years of Brunelleschi, Masaccio, Donatello, Beato Angelico, and Luca della Robbia when the Renaissance was in its heroic phase. Also very important, if less decisive for the history of art, was the season of Lorenzo the Magnificent and Botticelli, Verrocchio, and the young Leonardo. Subsequently, when Rome increasingly took on the role of the capital of art, and the Venice of Titian, Sansovino, Tintoretto, and Palladio entered into conscious competition with the Florentines, the revivals became ever less conspicuous, although the years of the Mannerism of Pontormo and Rosso Fiorentino and those of the principate of Cosimo and the cultural policies of Giorgio Vasari were again successful artistic climates, with noticeable national and international impact. We could continue through the 17th, 18th, and early 19th centuries, recalling the patronage, scientism, and international interests of the last Medici and the wise, cultured administration of the Lorraines. Yet it is clear that the graph progressively descends, with less significant peaks.

The last revival of a certain importance in the artistic history of Florence was in the mid-19th century, the period of the Macchiaioli, whose heroes were Giovanni Fattori, Telemaco Signorini, Silvestro Lega, Odoardo Borrani, Vito D'Ancona, Vincenzo Cabianca, Cristiano Banti, and Raffaello Sernesi, to mention just the most important. These were artists who departed from the tradition. In the early 19th century, this meant history painting, in a patriotic and romantic vein. Giovanni Fattori began as a history painter with works such as *Mary Stuart in the Field at Crookstone*, dated 1861 (Florence, Galleria d'Arte Moderna). This was also the case with Borrani (whose *Galileo Before the Inquisition* was a prizewinner at the Promotrice delle Belle Arti exhibition in 1857), and with Vito D'Ancona (*The Exile of Giano della Bella*, Venice, private collection). Nobody would have thought that Silvestro Lega, for example, the admirable author of the landscapes of Piagentina and *Il canto dello stornello* (The Folk Song; Florence, Galleria d'Arte Moderna)—would have graduated from art college, in 1852, with a painting from biblical history: *David Calming Saul with the Sound of the Lyre*, inspired by the strict formalism of his teacher Antonio Ciseri (Florence, Galleria dell'Accademia). In fact, throughout the 1850s, the artists of the Caffè Michelangelo (the cradle and laboratory of the Macchiaiolo movement), even those who were to work so successfully *en plein air* in Castiglioncello and Piagentina, continued to

consider history painting their main and most demanding test bench. This happened for two fundamental reasons: one more general and of significance at European level, regarding vitality and durability, in the visual arts, in literature and in studies, of reflection on the more or less recent past. Almost as though the century that was by now on the eve of the great modernization, aware of the changes under way and concerned about loss of identity and references, wished to examine the historical, cultural, and spiritual roots that nourish and give meaning to the present. Then, to explain the special good fortune of the genre in the Italy of the Risorgimento and therefore also in the circle of the Caffè Michelangelo, there is a reason that we could define as "political" in a progressive sense. In Tuscany and in the circles of artists famous for their patriotic ideas, paintings with a medieval and Renaissance theme had ended up coinciding, in the artists' intentions and in the public's expectations, with ideological aspirations of national unity, social justice, and democratic reform. In Florence, between the eclipse of the Lorraines and the birth of the House of Savoy monarchy, history painting was generally understood as a medium for avant-garde, liberal, and nationalist sentiments. The process of modernization (not of contents, which remained—at least initially—traditional, but of techniques and styles) is described very well by Signorini (1862) and is often quoted: "the *macchia* (stain or spot) was an accentuation of chiaroscuro in painting, a way of freeing oneself from the polish and coldness of academic painting."

The truly innovative phase and the fully completed season of the "macchia" were realized when the technical innovations experimented with on the painting of a historical event or figure were applied to the landscape *en plein air* or to that special modern landscape that is the middle-class interior.

Thus the beautiful, brief season of the Macchiaioli began. A season that had its representative locations in Castiglioncello and Piagentina, two corners of Tuscany synonymous with the artistic movement in question. Castiglioncello, on the Tyrrhenian coast near Livorno, was a vast estate of over 800 hectares (1,975 acres), owned by Diego Martelli, a collector, art critic, and friend of artists. Staying in Castiglioncello, in the 1860s for varying periods of time, were Abbati, Sernesi, Borrani, and Fattori. Lega and Signorini were also occasionally present. Piagentina, on the other hand, was a "humble and modest" country area (as Signorini remembers it) just outside Florence, with orchards, gardens, and a few houses. Outlined in the background were the

famous hills of Fiesole, S. Miniato, and Arcetri, while beyond the lines of trees, toward Porta alla Croce, the city walls were still standing.

It was in these places, and in the spirit of them, in the brotherly association of cultural work and shared ideals, that the masterpieces of the "macchia" were born: the *View of Castiglioncello* by Giuseppe Abbati, Silvestro Lega's *The Visit*, Fattori's *Rotunda at the Palmieri Bathing Resort* and *La Libecciata* (South-westerly Wind), the *Roofs in the Sun* by Sernesi, the middle-class interiors by Adriano Cecioni, characterized by their extraordinary compositional clarity, the beautiful landscapes of Telemaco Signorini. The Macchiaioli movement deserves special attention because it was the most modern and European phenomenon in the Italian artistic history of the 19th century. It tried to approach the free, unbiased truth, sustained by optimistic ideals of progress and genuine moral seriousness. It gradually declined and then died out, due to what was very soon identified as a paucity of content and setting (the small world of rural and middle-class Tuscany of the late 19th century) and, almost, of political asphyxia. Sandra Pinto, describing the regressive phenomenon of the Macchiaioli, paints them as an intellectual class that moved from enlightened rationalism to positivism, leading them to democratic and patriotic ideologies. But all this did not prove easy, since there was a change from the "bright fervors" of optimistic and radiant images of the "macchia" and Castiglioncello to the "gray disillusionment" of the more melancholy representations, such as those of Piagentina, arriving at the more troubled solutions of the late Fattori and the late Lega. It would be difficult to describe more accurately than this the history of a disenchantment that saw the intellectual elites (the Tuscan Macchiaioli among them) who had hoped and worked for another Risorgimento defeated and marginalized. It is therefore no surprise, once the reasons, ideals, and politics that had encouraged the secular and progressive experimentation with a modern naturalism, open to Europe yet founded upon the awareness of tradition, had ceased to exist, if the "macchia" movement was to disintegrate as a significant artistic phenomenon. It only survived (suffering to no small degree from the critical blackout that lasted until quite recently) in the increasingly poor quality vernacular mannerisms of its countless followers. The personal destinies of the major protagonists of the Macchiaioli movement mirrored the defeat of their ideals. Starting from the 1870s, Telemaco Signorini spent time in France and England, quickly catching up with the registers of international culture. In the same years Cristiano Banti withdrew toward

idealizing, symbolist, and Pre-Raphaelite solutions. Silvestro Lega, always faithful to the republican and radical utopias of his youth, spent his last days in Gabbro, as a guest of the Bandini family, devoting himself to intimate, impassioned works—*The Owner of the Garden*, c. 1887 (Florence, Galleria d'Arte Moderna). Fattori's old age was afflicted by poverty and the critical incomprehension of his work.

In reality the Florence of the late 19th century was affected by a profound mutation destined to conclude, at an increasingly fast pace and practically unchallenged, over the course of the 20th century. In this period that the myth of Florence as the city of museums, capital and showcase of the Renaissance, the "room with a view" of the miracle of art, life, and nature harmoniously combined, was consolidated internationally. Cultivated and focused on particularly by the intellectuals of the English-speaking world, the idea of Florence came about that still endures today, as the stereotype of an effective and fruitful tourist attraction. The Americans and Japanese who patiently tolerate the endless lines at the Uffizi or the Accademia, in the implacable summer heat, to see Botticelli's *Venus* or Michelangelo's *David*; the foreigners prepared to pay huge sums to buy or rent renovated farmhouses in the dry Sienese Chianti countryside; the countless buyers of products "made in Florence" in the fields of fashion, leather, and hand crafted goods, all are the visible consequence of the establishing of that idea of Florence and Tuscany that took shape all over the world in the 19th and 20th centuries.

The *idea of Florence* still fascinates the world, because no city in Europe is the *showcase of art* more than Florence. Nowhere else does the voice of a glorious past appear so visible and still so eloquent. It is not possible to look at Florence with the eyes of an archeologist; you do not walk the streets of a dead city. The civilization that we encounter is not a buried civilization. At the Bargello or in Piazza della Signoria, inside the Uffizi or in the churches of the Oltrarno, we do not have the impression of being inside a time machine, guests of a spaceship of history uprooted from contemporary reality.

On the contrary, in the streets of Florence, inside the museums, in the squares and churches, we are forced to realize that the past is our present, that yesterday lives today, inhabiting our emotions, permeating our feelings, forcing us to become involved, inevitably and existentially. The artistic history that this book relates involves us all. Because Florence's destiny has been to mirror and represent the history of our civilization.

Antonio Paolucci

Medieval Florence

From the Baptistery to the Loggia dei Priori

Any review of architecture built in Florence over the centuries must begin with the Baptistery, that is, with the most representative "monument" in terms of its essential form and the quality of its structure, which expresses and epitomizes the unchangeable features of what was to be the best subsequent Florentine architecture, whether public or private, civil or religious. Constant features, contrasting the sobriety of the external walls with the ambitions of the interior, a key recognizable aspect of the exterior were facades with very modest three-dimensionality, achieved through the bas-relief treatment of the architectural surface schemes—in combinations of frames and moldings without load-bearing functions (pilaster strips, half columns, blind arches, frames, niches, coverings, etc.) marked by overhangs and recesses of limited relief. These were well suited to a confined, densely populated urban space, limited in dimension, as was medieval Florence. The architecture was primarily of the "wall" variety and not shaped masses; they were characterized by planes and segments, and by doors and windows, rather than by the thickness of articulated spaces.

If we begin by discussing the Baptistery building, the still unresolved question of its dating immediately arises. To be able to confirm when and by whom this inimitable octagonal building was built is certainly important, but it is much more important to consider the result as it has appeared to the observer since the day when the external marble covering became a finished reality, since there is no doubt that Florentine architecture can date its foundation from that day. Opinions concerning the period of construction and the original use of this prestigious architectural organism have been and continue to be various and contradictory. For the uninhibited and hasty writers of art-history books and tourist guides, the

Baptistery: detail of the two-tone external covering.

Florentine Baptistery is a so-called Romanesque building dating back to the 11th century. A recent study (Piero Degl'Innocenti, *Le origini del bel San Giovanni. Da tempio di Marte a Battistero di Firenze*), referring to previous proposals that hypothesize the 5th century as a dating for the building, and making use of convincing new arguments, develops the novel thesis that this construction was erected to commemorate the unexpected victory of Flavius Stilicho over the Vandal, Radagaisus, who was halted in AD 406 at the gates of *Florentia*. The octagon with its pyramid-shaped roof, later named in honor of the patron saint of the city, St. John the Baptist, would therefore be a Late Roman construction, a much older one than is usually supposed; not an expression of Christianity, but rather a commemorative manifestation with a pagan content, probably commissioned by Emperor Honorius and the product of the construction skills of workmen from Rome or overseas, who in the 5th century were the only ones remotely capable of building the walls for a large dome with an 82-foot (25-meter) base, perhaps also built by foreign workmen. At the time it was consecrated as a baptistery, and the Florentines chose the octagonal building as a genuine "place of the soul," the symbol of their religiosity, and as the origin and model of their architecture to come. They recognized themselves, in the rigorous austerity of the eight facades lined with white marble and green serpentine and were rightly proud of the uniqueness and originality of the white marble roofing; they made it the emblem of the boldness and culture of their municipal identity.

The very preciousness of the two-colored cladding materials, in geometric divisions, revealing the desire for differentiation from the usual stone or brick masonry, is the distinctive characteristic of the Baptistery facades and raises the further question of whether this covering was prior to or contemporary with the white and green marble encrustations that decorated the exterior of the destroyed portico outside the church of Sta. Reparata (according

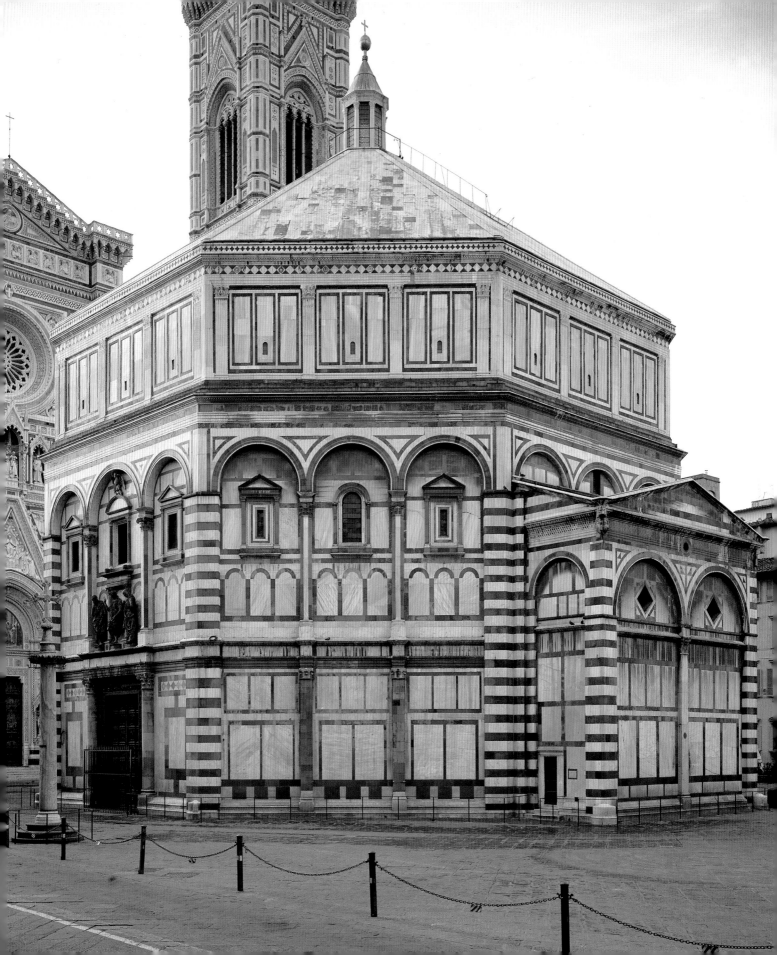

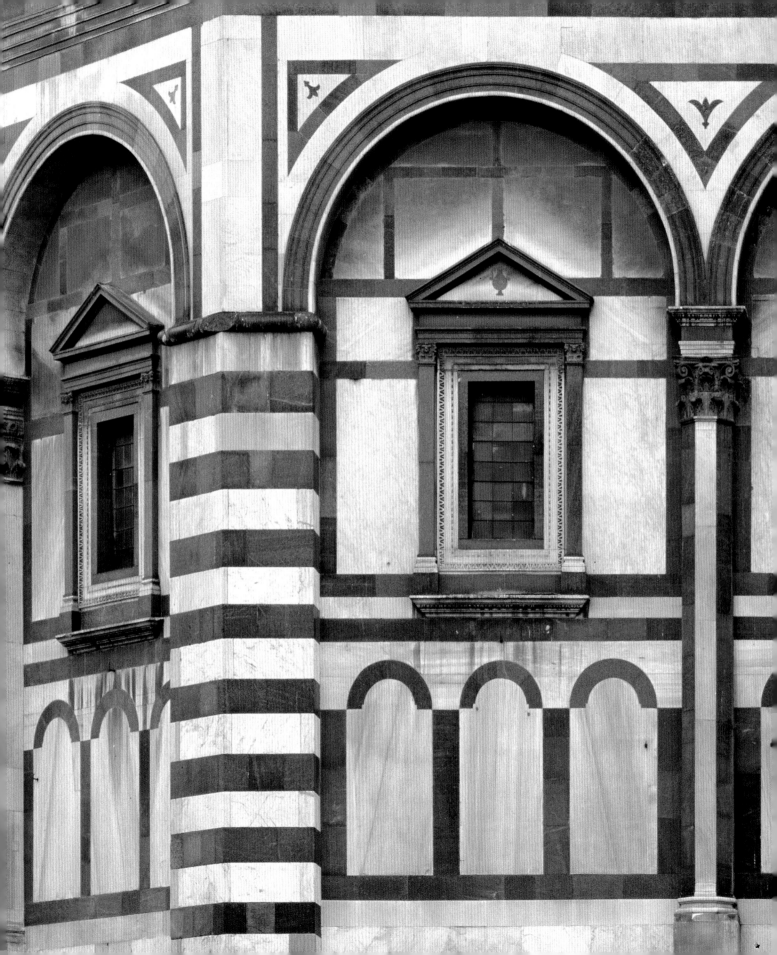

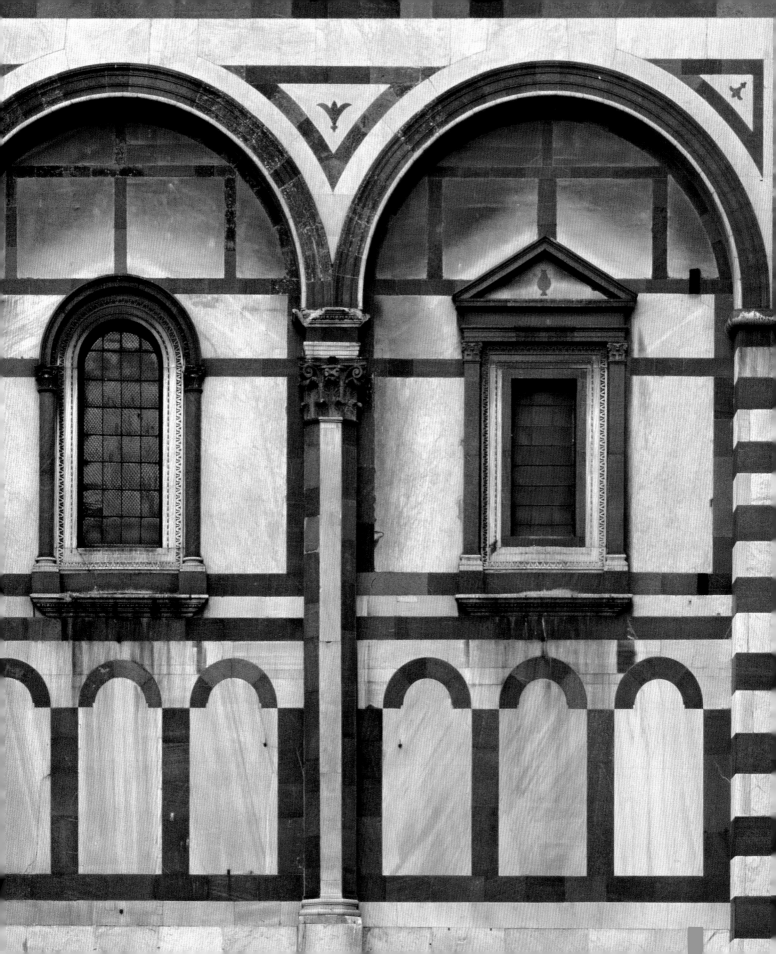

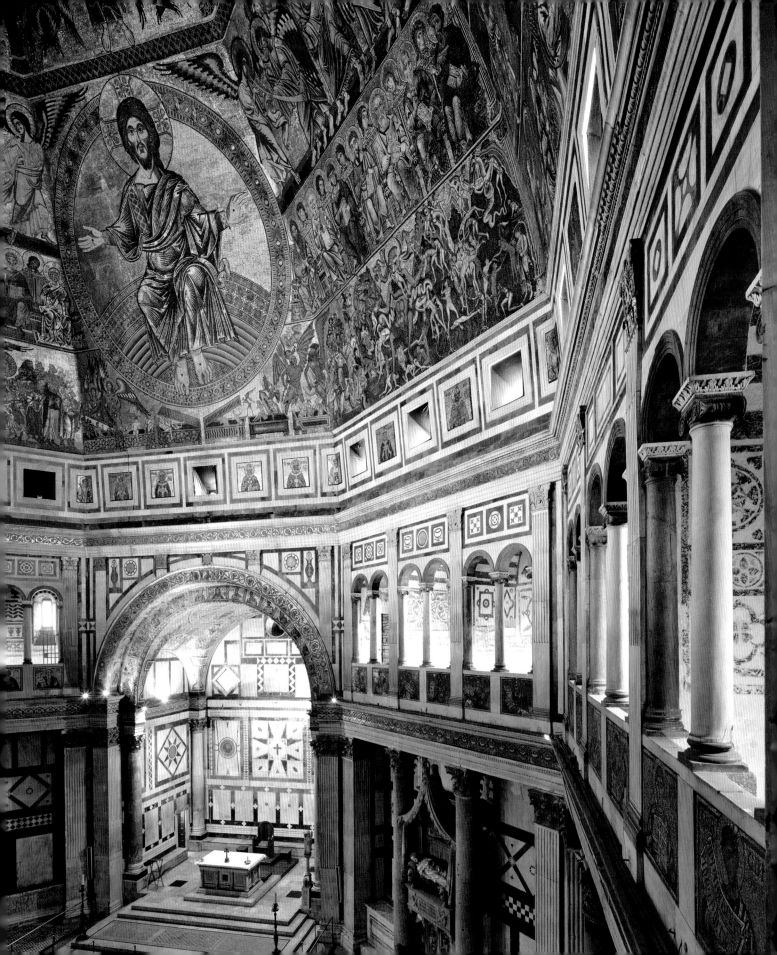

to the indications of the so-called *Disegno degli Uffizi* [Uffizi Drawing], inv. nos. 11728–11729, Santarelli), and that still cover the facades of the basilica of S. Miniato al Monte, the Badia Fiesolana, the church of S. Salvatore al Vescovo, the portico of the church of S. Jacopo sopr'Arno (transferred there, as enscribed on the lintel of the portal, from the demolished convent of S. Donato a Scopeto outside Porta Romana, and reassembled between 1575 and 1580), and

also frame the portal of the church of Santo Stefano al Ponte.

If we are to believe the reports by the 14th-century authors of chronicles, histories, and hagiographies on the subject of *lapides pretiosi*, of "marble come from afar" (slabs of Greek marble), or of "ancient marbles" as Giorgio Vasari wrote in 1568, on the subject of the "ancient temple," all "crafted in Corinthian marble, outside and inside," we could even think that the marble external covering of the

On the previous pages:
Exterior covering of the Baptistery, characterized by two-tone geometric divisions.

Opposite:
Detail of the interior of the Baptistery with view of the biforae of the gallery of the second order (matroneum), the "scarsella," and the mosaic of the dome.

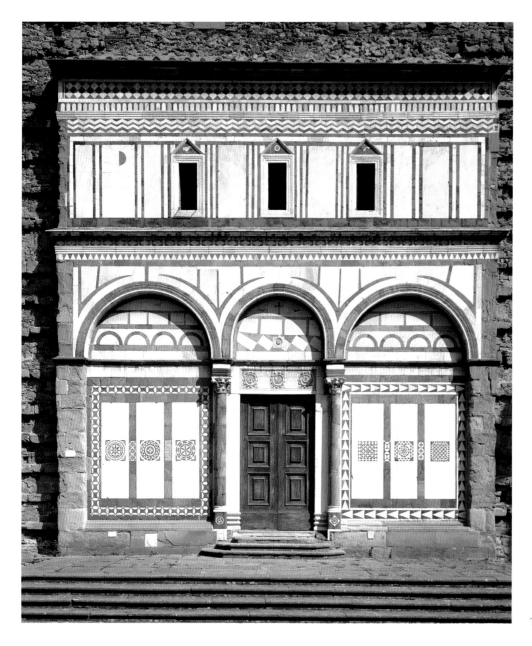

The old facade of the Badia Fiesolana.

Opposite:
Facade of the basilica of S. Miniato
al Monte.

Detail of two-tone decoration on the
facade of S. Salvatore al Vescovo.

Florentine Baptistery dates back to quite an
early age, and might even have been partly
laid at the same time as the construction of the
memorial in honor of Stilicho, in the 5th
century. On the other hand, comparing the
restraint of the two-tone geometries that
characterize the facades of the Baptistery with
the encrustations of the other facades
mentioned above, we must agree with the

view that it is only the cladding of the first
order of the front of the church of S. Miniato
al Monte that is comparable to the delimited
external areas of the Baptistery; the former
seems to have drawn from the latter the lesson
of the allusive effect of depth, the virtual
trompe-l'œil effect of the walls, accentuated
through the splays of the frames surrounding
the reflective white marble.

In the case of the Badia Fiesolana, as well
as of the second order and pediment of S.
Miniato, the shrinking and distortion of the
model of reference—the Baptistery—are
evident, since the jumbling together of the
decorations of the two-color inlay work, too
fragmented and distracting, tend to diminish
the legibility of the real and virtual
architectural pattern.

As regards the small facade of S. Salvatore al
Vescovo, leaving aside a rather unreliable
piece of information that it was executed in
1221, the slavish imitation of motifs deriving
from the cladding of the nearby Baptistery is
all too clear. This imitation is complicated by
the addition of inlays of "flowery" lozenges
and stylized candelabra.

The question of the age of the building that
was later to become the Baptistery, which can
reasonably be placed in the 5th century,
becomes even more pressing if we proceed to
compare the structural conception and the
architectural-decorative array of the interior of
this volume—of significant size and with an
octagonal plan—with the Latin-style "basilica"
structure of S. Miniato al Monte and SS.
Apostoli, together with the enlargements of S.
Piero Scheraggio and Sta. Reparata, which are
indicated as dating from the 11th century and
therefore commonly considered to be from the
same period as the Baptistery. The comparison
highlights the enormous difference between
the structural mastery of the dome of the
Baptistery, supported by rampant arch ribs in
a radial direction, connected up by small
vaults in the impost of the roof, and the
elementary construction systems (arches on
columns, simple bowl-shaped apsidal vaults,
gabled roofs supported by wooden trusses) of
the aforementioned churches. Even the two
"tympanum arches" in S. Miniato al Monte
(arches with masonry above inclined two ways
like the sloping layers of a roof) are certainly
not a significant innovation, but were among
the usual construction techniques of the time;
transversal to the central nave, that contributed
to the greater linkage of the structural whole
by being extended into corresponding arches
in the lateral aisles. It is therefore difficult to
imagine that the building of the majestic
Baptistery and that of the cited churches were

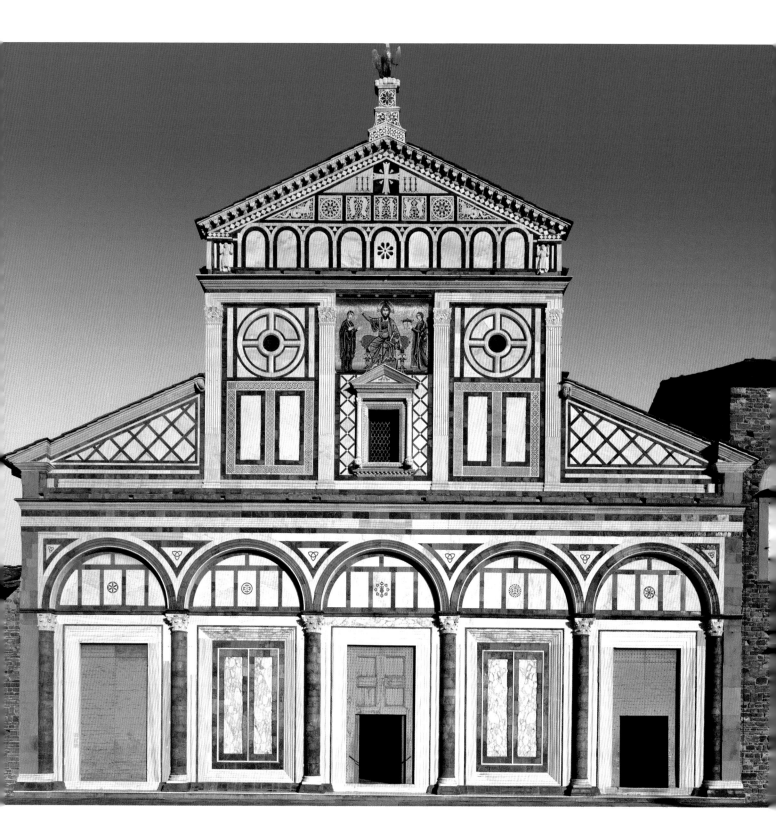

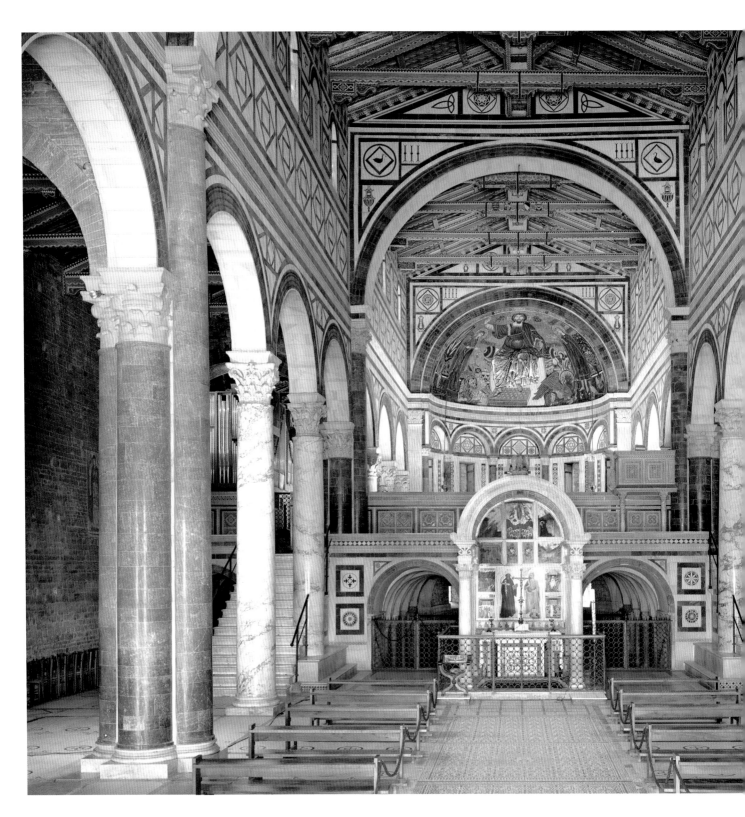

Interior view, toward the apse, of the basilica of S. Miniato al Monte.

contemporary, and that despite the differences between the two they shared the same disputable stylistic category of "Romanesque."

Having considered the old *ecclesia major* dedicated to Sta. Reparata, opposite the Baptistery, to be inadequate and "small compared with such a city" (as the excavations conducted between 1965 and 1974 have confirmed), in 1293 the Florentines decided to build a worthier cathedral "all in marble and with carved figures," and in 1296 they began the long adventure of the construction of the church that in 1412 was to be dedicated to Sta. Maria del Fiore (St. Mary of the Flower). Arnolfo del Cambio was appointed to supervise the construction work, as is proven by a document from April 1300 with which Arnolfo himself, as master-builder at the site of the new Sta. Reparata, was exempted from payment of taxes.

No information is available on how Arnolfo's appointment was arrived at. Although he is defined in the aforementioned document as "famosior magister et magis expertus in hedificationibus ecclesiarum," in fact, as an author of architectural works, he could only boast the constructions in Rome of the ciboria of S. Paolo fuori le mura (1284) and of Sta. Cecilia in Trastevere (1293). Neither do we have any information as to what the real characteristics of the ground plan and the vertical development proposed by him for the new Florentine cathedral were (the dome is not mentioned in documents prior to 1357). Analyzing the representation of the so-called Arnolfian 14th-century facade handed down to us by the 16th-century painter Bernardino Poccetti (bearing in mind that the death of the presumed author occurred on an unspecified date between 1302 and 1310), we can at most ascertain that, even if certain stylistic elements are to be found in the baldachins of the three portals of the new cathedral, especially the central one (trefoil arch, gothic crowning pediments, abundant use of sculptural decoration), that are recognizable in the Roman ciboria that were definitely by Arnolfo, nevertheless the dimensions of the frames that are valid for the harmonious overall effect of the ciboria lose their effectiveness when expanded in drafting to the size of a cathedral elevation; the vertical elements become too thin and unsuited to supporting functions, downgraded to an ornamental role and only tolerable in the case of a facade that is not particularly high. It is worth mentioning that Vasari provided little information on Arnolfo in the first edition of his *Lives* (1550), and in the second edition (1568), called him Arnolfo di Lapo.

On the following pages:
Detail of the marble cladding on the south facade of Sta. Maria del Fiore.

61

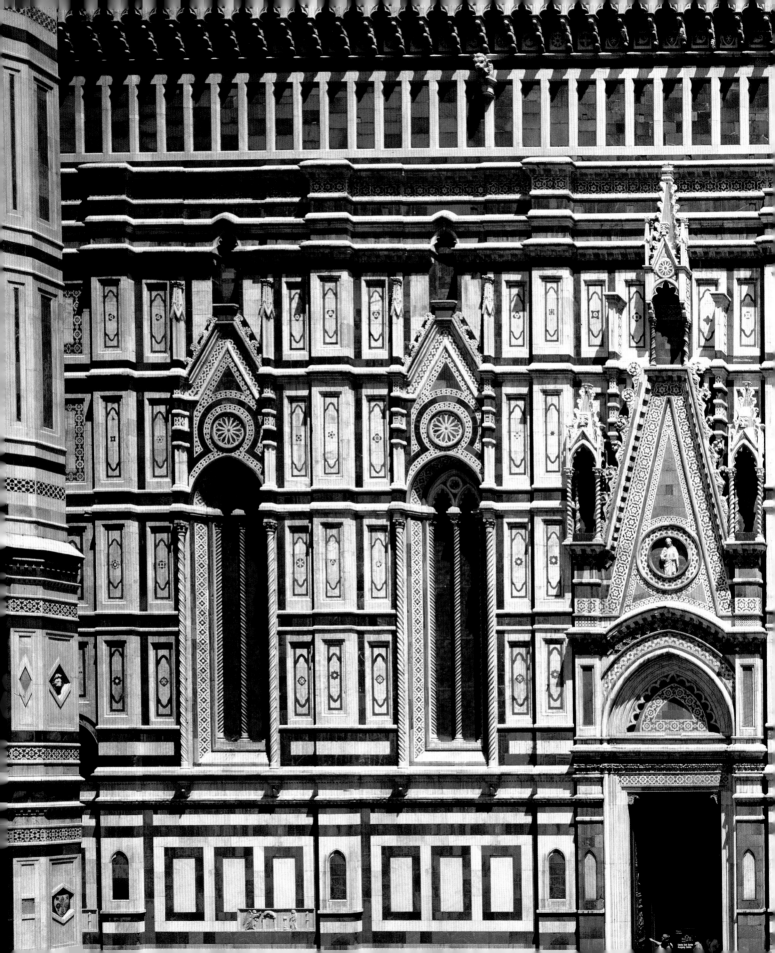

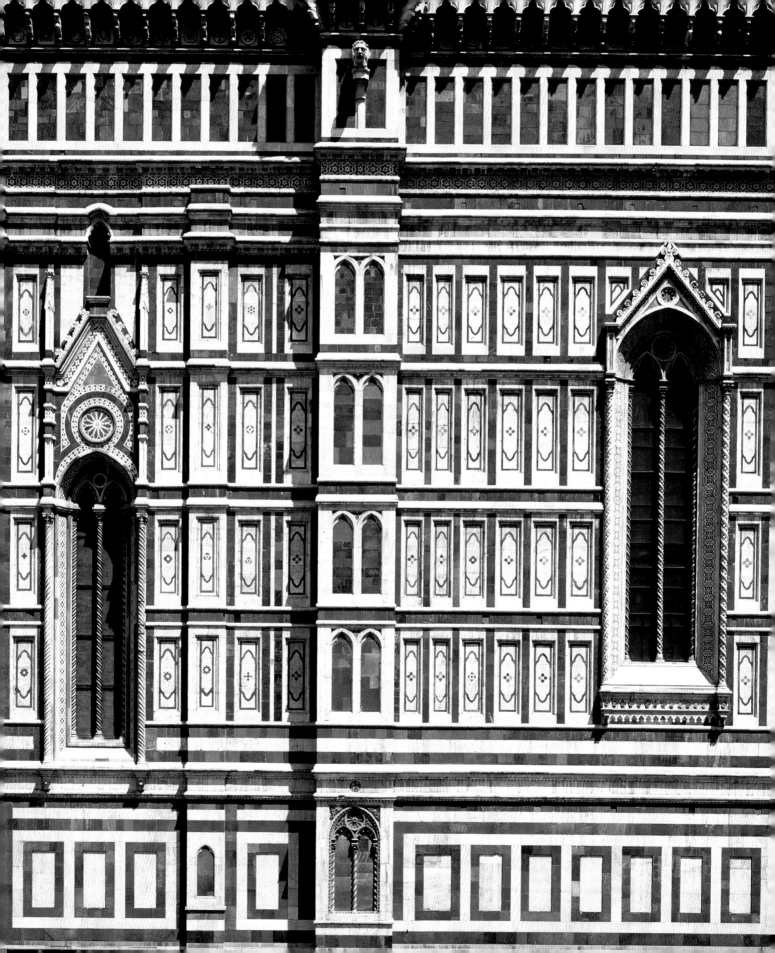

On the previous pages:
Southern side of the basilica of
Sta. Croce.

Opposite:
Interior, toward the apse, of the basilica
of Sta. Croce.

Even if Vasari used the incorrect patronymic, demonstrating a rather limited knowledge of the character, he did not hesitate to attribute the most important architecture of the Florence of that time to him: the last ring of city walls, the loggia in Orto S. Michele, the Loggia dei Priori, the renovation of the Badia Fiorentina, the Badia bell tower, the church of Sta. Croce, the Palazzo dei Priori, the green and white marble cladding of the eight facades of the Baptistery. In reality, leaving aside the certificate from 1300 regarding Sta. Reparata, there is no documented proof to support the attribution of all the other buildings to Arnolfo, and, even less to validate the fanciful hypothesis (a recent theory) of the possible configuration of an Arnolfian Florence.

Basilica of Sta. Croce, detail of the head of the right transept.

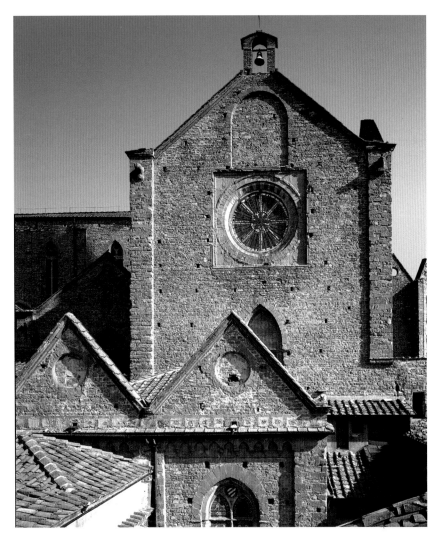

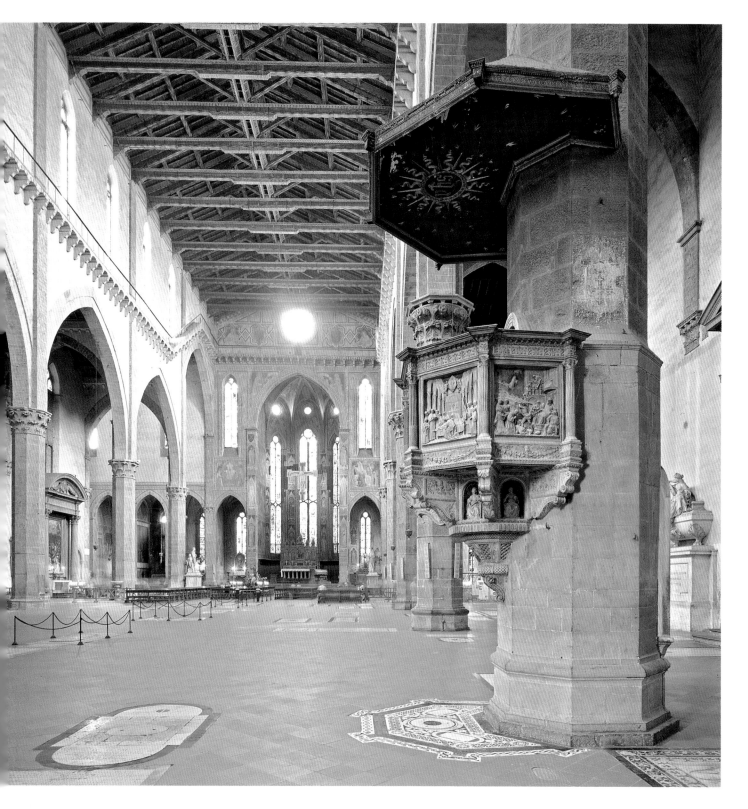

Apsidal part of the basilica of
Sta. Croce.

To prove such fanciful conjectures wrong, we need only rely on Dante, who glorified Cimabue and Giotto with a highly complimentary reference in the *Divine Comedy* (*Purgatory*, Canto X), and remember that, even though the great poet was able to witness the commencement of the building work on the new Sta. Reparata, the church of Sta. Croce (1294) and the Palazzo dei Priori (1298)—architecture destined to glorify the image of the city—all before his exile from Florence, he did not devote a single word to Arnolfo, who, judging by the generous attributions, should have overshadowed the fame of the other masters. It is also symptomatic that no mention of Arnolfo is made either in the 14th-century *Cronica* by Giovanni Villani (who indicates Giotto as "the most sovereign master in painting that was found at his time"), or in the

Commentari by Lorenzo Ghiberti (written between 1447 and 1455), or even in the Preface to the commentary on the *Divine Comedy* by Cristoforo Landino (1481), or the *Libro di Antonio Billi* (1506–30) written prior to Vasari's *Lives*. Evidently the excessive number of supposed projects by Arnolfi is the result of Vasari's powers of invention, and in fact these may amount to no more than the designing of some of the new Sta. Reparata, the extent of which, unfortunately, cannot be identified today in the overall three-dimensional plan. Even the attribution of the church of Sta. Croce to Arnolfo, which is supported by a vulgate still in existence, causes some perplexity, since we need only observe the huge difference between the modest dimensions of the choir or the charming chapels of the transept on the one hand and the spaciousness of the longitudinal hall, with its nave and two aisles, on the other, to recognize the coexistence of two different building organizations; the nave is so wide as to discourage the solution of a vaulted roof and to make a conventional gabled roof supported by wooden trusses preferable. We can again identify two distinct styles if we focus attention on the dissonance between the exterior of the polygonal apse (built first) and the sequences of external side walls of the hall marked by the large triangular pinnacles. Those stylistic components that could have made the involvement of the author of the Roman ciboria credible, at least on the facade of the new Sta. Reparata, are absent. It is also worthy of note that the construction of Sta. Croce began just a year after the execution of the ciborium of Sta. Cecilia and any change or simplification in Arnolfi's language must inevitably appear all too sudden and surprising. The same considerations also apply to the Palazzo dei Priori, commonly attributed to Arnolfi, despite the absence of any corroborating documentation. As the construction of the great new cathedral was under way, the administrators of the Florentine people deemed it necessary to provide a suitable residence for the Priori delle Arti [Representatives of Guilds] and the Gonfaloniere di Giustizia [Standard-bearer of Justice] and resolved to juxtapose the emerging symbol of religious power that was being built with an authoritative building to provide the appropriate image of civic power. The decisive construction to suit the pre-agreed symbolic purposes was not so much the solid, stone mass of the "Palagio" itself (later rebaptized Palazzo della Signoria and, in 1565, named Palazzo Vecchio), but "above it the tall bell tower that is seen there today"; this was not built from Arnolfo's project, but by "other masters," according to Vasari himself.

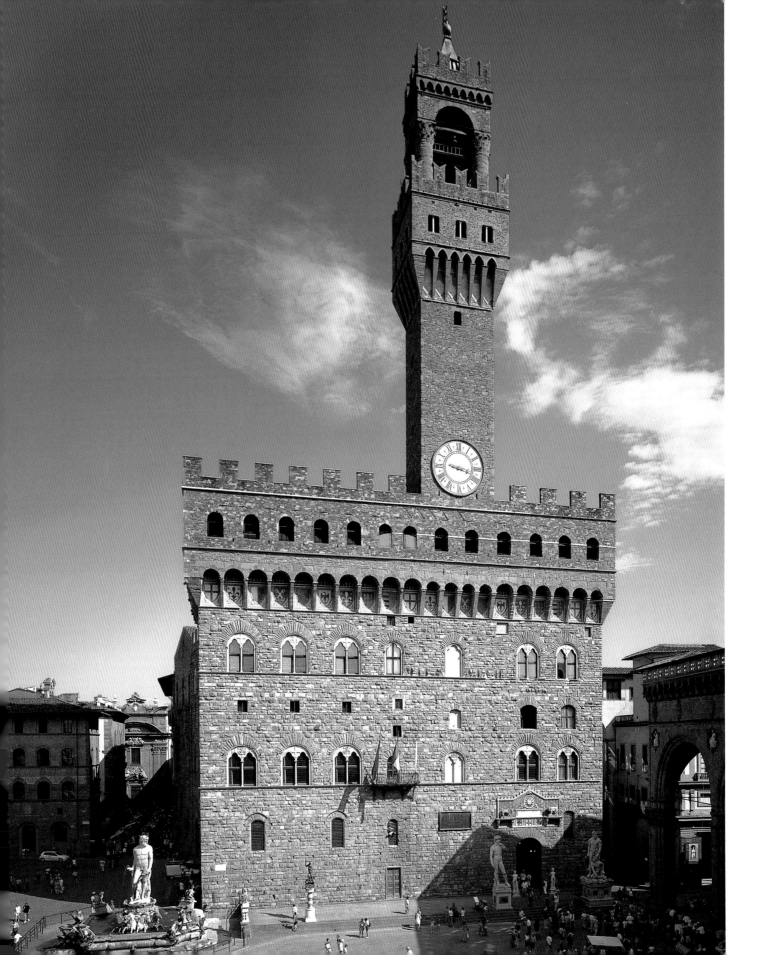

Opposite:
Detail of the top part of the bell tower of Sta. Maria del Fiore.

Right:
Detail of interior of Orsanmichele.

Overall view of Orsanmichele.

It is documented that the Council of the Hundred of the Commune of Florence, in a deliberation dated 16 August 1306, decided to allocate the funds for the construction of the tower. However, we do not know the names of the masters who built it in just four years. Yet we can admire the result of their ingenuity, in the boldness of the construction and in the original form of this vertically developed rectangular parallelepiped. Or rather, "stone skyscraper," which rises sleekly above the palace and does not restrict itself to resting abutted, with the long sides of its base, on

protruding corbels (made of sandstone) at the height of the gallery crowning the palace, but rather allows itself the further audacity of expansion of the gallery of the so-called "Rocca" [fortress] at the top, overhanging on corbels. That is to say, it is increased in size by an overhang that protrudes more than the corbels at the base. The tower therefore increases the overhang in two stages with respect to the underlying facade of the building, as though it wished to accentuate its domination over the space of the square below. Even the asymmetrical position of this tall "secular bell tower" took on an exceptional prominence in the overall characterization of the front elevation of Palazzo dei Priori; it was expanded at the summit, which was the consequence of the use—as support—of the pre-existing Torre de' Foraboschi (otherwise known as the Torre della Vacca), incorporated into the disposition of masses of the building. Rising up over the rooftops of the older central core of the city, the tower of the Palagio dei Priori was the structure with the most significant elevation, of exemplary and unchallenged expressive power, truly the distinctive sign of the city's pride. The hexagonal bell tower of the Badia and the quadrangular one of Sta. Maria Novella, both built in 1330 (and originally endowed with

ribbed pinnacles with climbing-leaf cornices), that were added to the busy skyline of the city, did not even touch the supremacy of the "secular bell tower." This until 1436, when Brunelleschi's dome, though not yet complete with its lantern, came to dominate the Florentine urban landscape absolutely.

After the completion of the last perimeter of city walls (1334), the reconstructing of the bridges of Sta. Trinità and Ponte della Carraia (destroyed by the disastrous flooding of the Arno in 1333), and the Ponte Vecchio (1345), Florence was enriched with another extraordinary building constructed in Orto S. Michele [St. Michael's Garden], to replace the previous loggia (1287) for the sale of wheat. The foundations for this new building, for use as the city's granary, were laid in July 1337 and it is particularly significant that this "utility" architecture was constructed on the street connecting the locations representing political and religious power, equidistant from them. Of decidedly unusual physiognomy, both in consideration of the function assigned to it, and due to its vertical development on pillars supporting the cross vaults (on round arches) that raise the square parallelepiped above up from the ground, the "grain building" that is better known as Orsanmichele commands the attention for the refinement of its perforated facades, transmitting externally the wholly Florentine delight in transforming even a prosaic building, albeit for the collection and storage of a foodstuff of vital importance, into an art form.

Taddeo Gaddi, Andrea Orcagna, Neri di Fioravante, Benci di Cione, Andrea Pisano, Francesco Talenti, and Maso di Banco were proposed as the architects of the project for Orsanmichele. Orcagna is certainly the creator of the architecture of the magnificent tabernacle (erroneously considered a work of sculptural goldsmithery). This was begun in 1352 and completed in 1359, and was housed in the public loggia, on the ground floor; its ten external arches were closed off, beginning in 1367, with walls and elaborate stone decorations designed by Simone di Francesco Talenti and two portals conceived by Ghiberti and completed in 1420. It is also documented that in April 1339 the Consuls and the Workers of the Silk Guild, responsible for the construction of Orsanmichele, obtained permission to decorate the facades of 13 of the 14 external pillars with aediculae to house the images of the patron saints of the Guelph party (then in power) and of the 12 major Guilds. These aediculae, as architecture of reduced dimensions, as well as being key elements of urban furnishing, became the pretext for the preparation of a permanent, prestigious open-air museum for the display of

Opposite:
Base band of the bell tower of Sta.
Maria del Fiore, detail of the multicolor
and sculptural decoration.

Detail of the multicolor marble covering
on the base band.

marble and bronze statues (today replaced by copies) specially executed by the greatest sculptors of the 15th and 16th centuries.

The Florentines wished to mirror themselves in a city that placed the cultivation of art and the "beautiful" among the primary necessities of dignified living. Unfortunately, today the city seems to have forgotten its past dignity.

Meanwhile, alternating between breaks and resumptions, the work at the Sta. Reparata site continued. In 1334 Giotto was named master-builder of the cathedral, but rather than interest himself in the new church, he preferred to devote his attention to the construction of the bell tower, which he directed up to the height of the first stringcourse. On Giotto's death (1337) the position of master-builder was given to Andrea Pisano (1340–43) and in 1351 Francesco Talenti took over the works management; in 1355 he was asked for a wooden model of "how the chapels must be at the back," that is, the project for the apsidal zone of Sta. Reparata "where the cupola must come," as written in a document of 19 June 1357. In 1357 it was he who completed the bell tower begun by Giotto. Thus another architectural expression of accentuated verticalism imposed itself upon the city skyline; its most attractive features were its multicolor marble covering and its abundance of bas-reliefs and statues, effective to the same degree—in terms of its representative function—as the Torre dei Priori. Yet it was the latter that retained the primacy not only in terms of height, but also from the standpoint of construction ingenuity, and as the most authentically Florentine architectural expression of strength and superiority. It was Talenti again, in June 1357, who began to develop the basilica part of the new Sta. Reparata (inside which the old church continued to operate), starting with the foundations of the sturdy internal pillars. The huge longitudinal and transversal ogival arches were to rest on these pillars. The arches were adequate for the envisaged bays, almost square and of large dimensions, covered by equally huge ogival vaults. This structural system, which involved the raising of the whole rectilinear volume of the new cathedral, is habitually defined as "Gothic" on account of the use of pointed arches and vaults (synonymous with "Gothic style" in books on art history and architecture). If the structure used for the Florentine cathedral (which suffered damage, to the point that the installation of chains was required) were to be presumed to be or referred to as Gothic, it would at least also be considered anachronistic (the vault of the first bay was completed in 1365), since this structural system had already been employed and

approved almost two centuries earlier in the great French cathedrals. Moreover, the structural scheme applied to Sta. Reparata would not appear to have respected the original model, as the external bracings clearly do not appear in the Florentine version (the rampant arches were executed subsequently, perhaps beginning from 1367, and concealed by raising the roof of the aisles and the lateral walls). Neither can we find the attenuation or elimination of the static function of the perimeter masonry to the benefit of large glazed openings (indeed the triforium and clerestory are missing). Rather the "solids" predominate over the limited "voids" of the windows in the external walls of the new Sta. Reparata. The bastardization of the structural prototype taken as reference and the disregard for, or lack of attention to, or understanding of, the characteristics and meanings of true Gothic architecture have been justified "patriotically" (also in the case of the church of Sta. Maria Novella) as Florentine interpretations of Gothic, or as adaptations of Gothic to suit Florentine taste. The autochthonous interpretation adopted for Sta. Reparata consists solely in having decided upon a square layout and considerable breadth for the ogival vaults covering the nave, compared with examples from across the Alps, which are endowed with vaults of smaller dimensions with a rectangular plan. This Florentine variant is limited to the incomplete application of a specific structural system and without the many consequent stylistic implications. Precisely the aspects relating to the importance of the dimensions of the structure complicated to no small degree the process of construction of Sta. Reparata, as well as the associated developments concerning the definition of forms and decorations, which were often questioned. Consider the lateral walls, which, imagined with terminations with Gothic pediments, were in fact concluded with horizontal crownings and the envisaged pinnacled windows of the attic that were replaced by considerably splayed oculi. It is therefore hard to assign an identity and a stylistic unity to a construction that grew slowly, directed by various master-builders, with the opinions of various experts, and despite the setbacks of continuous variations during the course of the work. Yet it is easy to recognize the "triconch" form of the apsidal part as one of the most successful results of the ingenuity and imagination of Florentine builders. This intense architectural piece, an organism almost independent from the rectilinear body of the cathedral, admirably articulated by a well-considered and consistent interplay of external polygonal convexities and corresponding internal concavities, does not belong to the

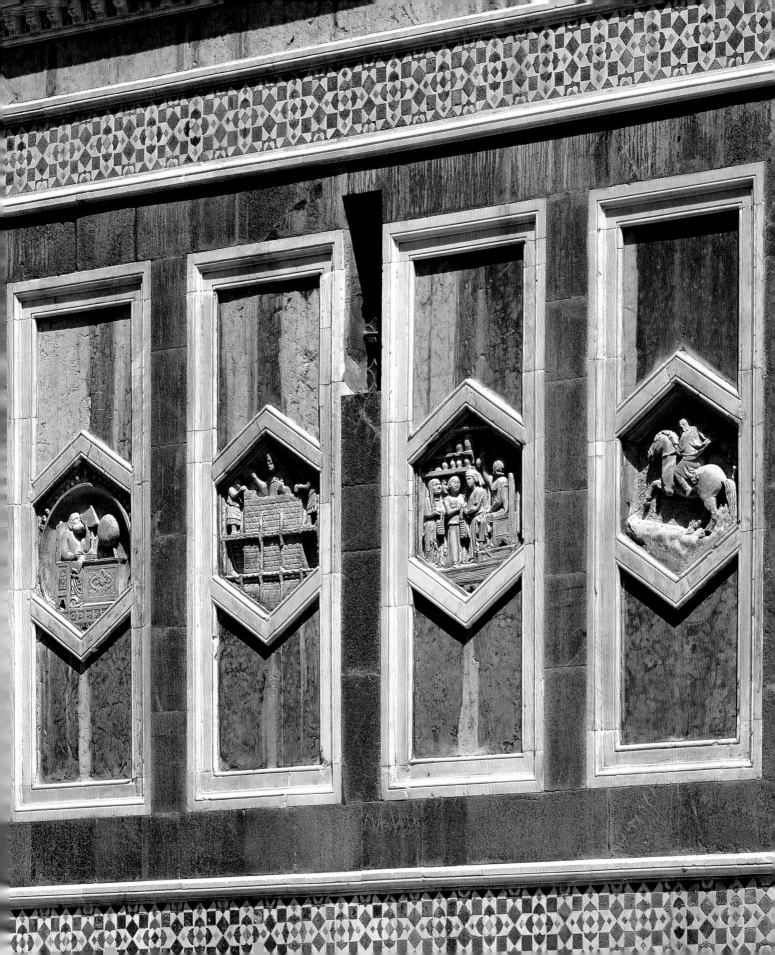

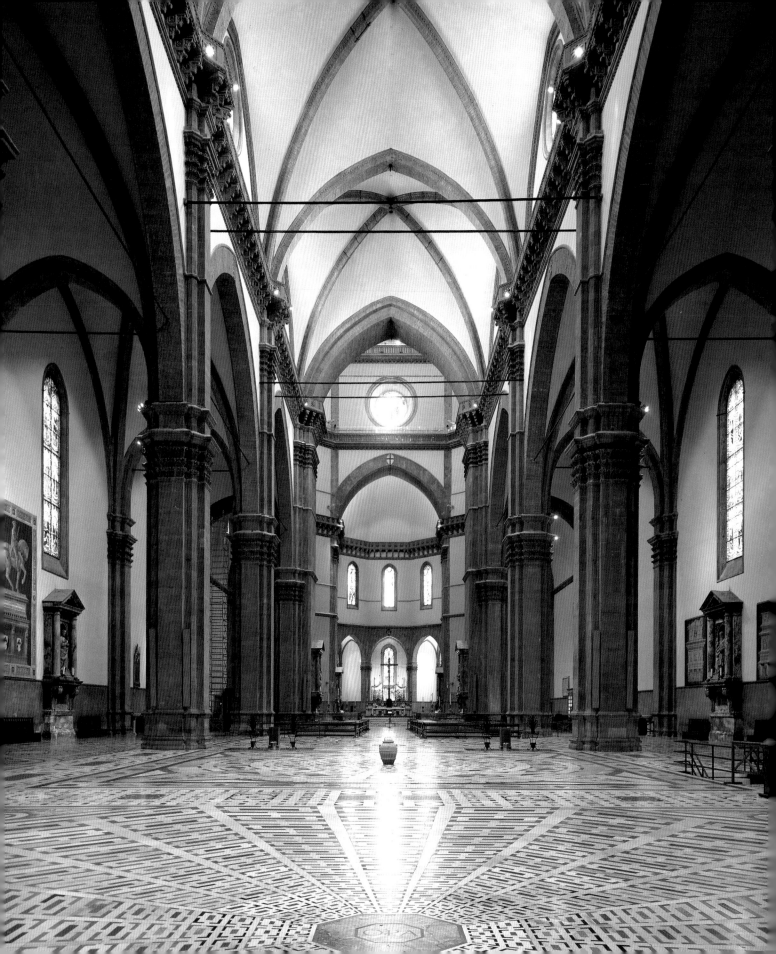

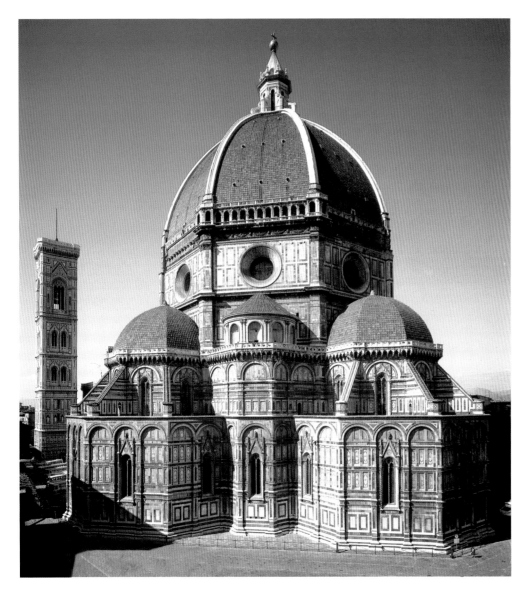

Opposite:
Interior, toward the High Altar, of Sta.
Maria del Fiore.

View of the external "triconch" structure
of the apsidal part of Sta. Maria del
Fiore, as the articulated podium for
Brunelleschi's dome.

design repertoire of one established architect,
but was proposed, in 1367, without excessive
fuss, by eight "masters and painters": Andrea di
Cione (Orcagna), Benci di Cione, Francesco
Salvetti, Neri di Fioravante, Andrea Bonaiuti,
Niccolò Tomasi, Taddeo di Gaddo (Gaddi), and
Neri di Mono. The apsidal triconch is the
perfect prelude-pedestal, the compositional
crescendo that announces, introduces, and
drives the top note of the great dome. It is the
structured platform from which emerges the tall
octagonal drum, completed in 1418, on which
the aerial "sails" of Brunelleschi's massive and
spectacular structure were to be positioned.

Finally, even if of lesser emotional impact, the
regal round arches that delimit the static space
of the Loggia dei Priori deserve careful
consideration. The loggia was built between
1376 and 1382 from the designs of Benci di
Cione Dami, Simone di Francesco Talenti, and
Taddeo Ristori. Leaving aside its intrinsic formal
qualities, this work is to be appreciated for the
decisive contribution it offers to the
configuration of the square in front of it, and is
to be valued as the concluding building of
significance of the Florentine 14th century.

Carlo Cresti

On the following pages:
The 14th-century Loggia dei Priori.

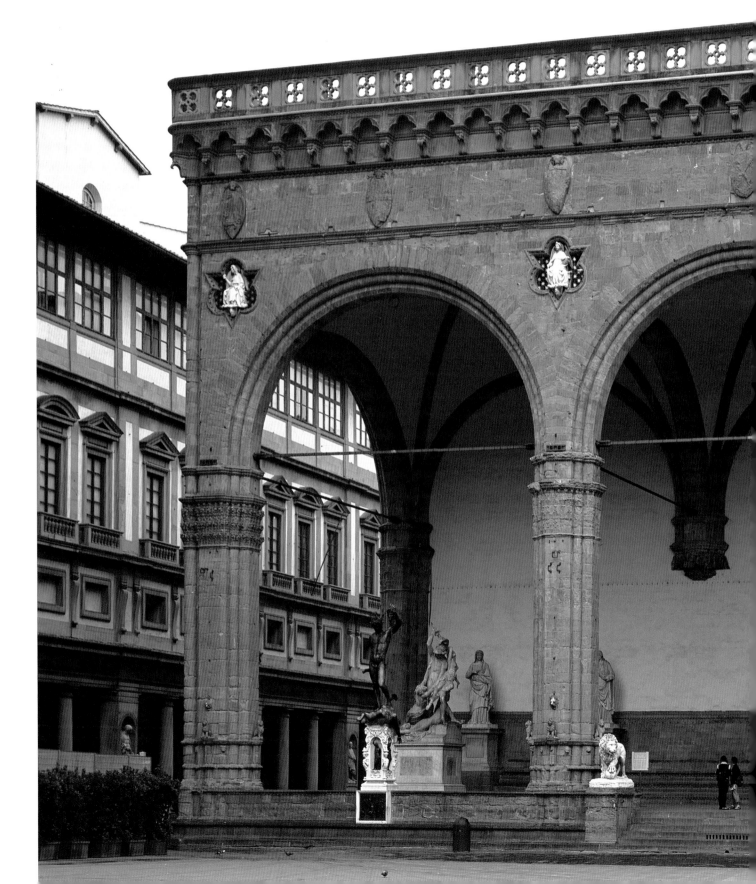

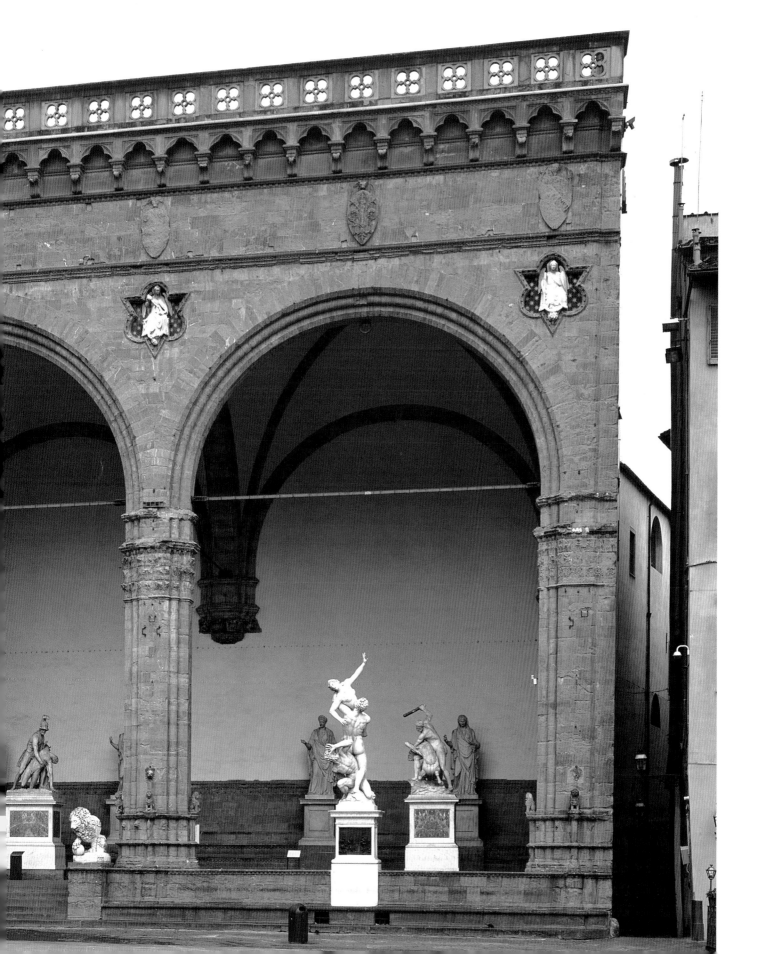

The Middle Ages and the statuary of the origins

At the origin of Florentine statuary is the legendary Roman foundation of the city on the ford over the River Arno. As the ancient sources often stated, and as partially confirmed by the archeological finds in more modern times, the walled perimeter of the settlement reflects the geometrical structure of the *cardo* and *decumanus* axes that were typical of military camps. The presumed Temple of Mars, on the site of which the octagon of the Baptistery St. John is supposed to stand, was long considered one of the hearts of the classical city and the presence in the medieval metropolis of that mythical aura, to a certain extent supported by monumental evidence, conditioned the development of local statuary to no small degree. It must not be forgotten that, generally speaking, every commune in the peninsula strove to identify evidence of the classical political authority in its past, in order to confirm the right to increased self-determination, echoing the actions of the universalistic institutions of the time—the empire and the papacy. It is therefore no surprise that, starting with the protomas that are used as dripstones for the "scarsella," the rectangular apse of the Baptistery, the austerity of forms betrayed the hesitant desire for an equilibrium between naturalism and medieval symbolism, which would inevitably have led to the search for a revisited classicism. It is not without a certain risk to interpret the tendencies of the time from the perspective of what was to happen later, and undoubtedly the development of the three-dimensional manifestations of Florentine art—but not only these—could well have been very different. Despite this, the few early medieval remains that have emerged from the excavations in Piazza della Signoria, which have provided us with just a few pilaster strips or proto-Romanesque marble jambs, show a formal equilibrium that justifies the sober but already powerful expressiveness of the slabs coming from the lunette of the original church of SS. Michele e Gaetano (today in the Antinori Chapel), reconstructed, according to Vasari, in 1221, based on a precedent building by Lapo Tedesco, Arnolfo di Cambio's father. Earlier perhaps, as Mario Salmi claims (1914), than the figurations on the pulpit of S. Leonardo in Arcetri (originally located in S. Pier Scheraggio) and from the same time as the telamones of the facade of S. Miniato. And it is precisely in this splendid temple, which is located on the most attractive of Florence's hills, that we find, from mid-century, the purest example of early local

Lion protoma on the corner of the rectangular apse, above a bearded human face in a similar position to that typical of animal "stilofori" (column supports). Baptistery of St. John.

Detail of the telamon supporting the eagle, the symbol of John the Evangelist, whose wings hold the lectern. Basilica of S. Miniato, Ambo.

Opposite:
Ambo and part of the pier, decorated with colored marble inlaying. Basilica of S. Miniato.

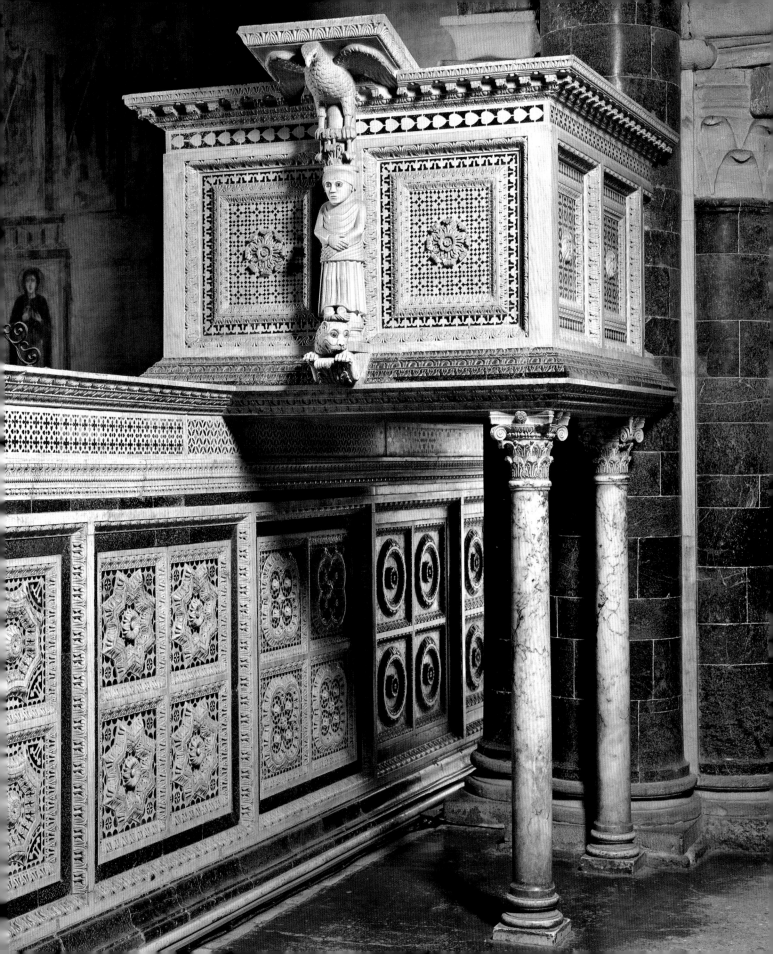

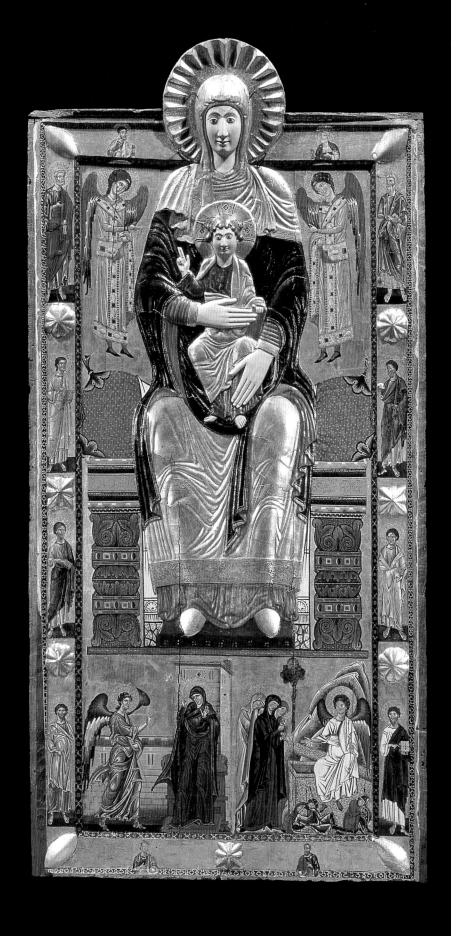

statuary, expressed, in a triumph of engravings
of plants and multicolor marble inlay, in the
figurations of the ambo or pulpit that towers
over the nave from the raised presbytery. Here
the wide open eyes of the fantastic lion, regular
in size and almost human, or those of the
deacon acting as a lectern, seem to want to
mesmerize believers, calling them toward
abstraction and at the same time to the solidity
of the Christian message.

Worthy of mention as one of the most
impressive manifestations of medieval statuary
in Florence is the ancona of Sta. Maria
Maggiore. The panel, of considerable
dimension, has a *Virgin in Majesty* at the
center. Its painted part has often been
associated, by critics, with the great Coppo di
Marcovaldo, who created the famous mosaic
representing hell inside the Florentine
Baptistery. There is little doubt that this was the
principal element of the original altarpiece
dedicated to the Virgin, but its soft modeling
and the pronounced richness in the
presentation of the Mother of God incarnate
place it in a kind of isolation with respect to
what is known—and there is not very much—
in the Florence of that period. In it there is now
no longer a Byzantine sacerdotal solemnity, but
the sober presence of the sacred image, which
is at the same time both imposing and intimate.
In that age it certainly constituted a
breakthrough, a leap forward toward naturalism
or, rather, toward a credibility that, sacrificing
none of the sacredness of the image, sought a
more direct and involving dialogue with
believers. The very choice of gilded and
painted wood, rather than colored stone or
marble heightened with gold and enlivened by
polychromy, as are often found in the statuary
of the peninsula, seems to aim to satisfy new
and complex demands. If the splendor of the
precious metal and the strong colors are
reminiscent of examples of the monumental
goldsmith's craft beloved by the Middle Ages,
such as the *Altarpiece of St. Mark* in Venice or
the older altar of St. Ambrose in Milan, the
modulation of the sculpted surfaces has nothing
of the sharp highlighting that the goldsmiths of
the time sometimes sought through embossing
or engraving. There thus resulted a modern
hybrid that formed a bridge between the
tradition of the overwhelming magnificence of
the universal Church and the wholly human,
commercial, and civic need to have before
one's eyes a theophany to whom one could
direct humble prayers for help without the
reverential fear of approaching an empyrean
too far removed from the everyday to heed the
supplications of mortals. Such a beginning was
not to be without its continuation in Florentine

art, in painting, and in statuary, and even in the almost marginal manifestations of both. On the other hand, the desire to gain a role of political hegemony in the Tuscan territory was not expressed, by Florence, in military aggressiveness pure and simple, but was accompanied and on occasions even substantiated by programmatic cultural growth. Art was one of the vehicles to legitimize this centralizing effort and visual manifestations ended up being functional to the aspirations of the city's powerful parties, the factions, the guilds, and even the individual inhabitants. With the construction of the last circle of walls and the completion of those of the Oltrarno, the definition of a precise urban plan began. The relief with St. George, once built into the wall of Costa S. Giorgio (and now in Palazzo Vecchio), and almost unanimously associated with the Pisan school, but more precisely with Giovanni Pisano (1284), exemplifies well the importance attributed to the symbols of the liberty of citizens in the powerful commune.

Opposite:
Altarpiece with the *Virgin* in the form of *sedes sapientiae*, amid angels and saints, attributed to Coppo di Marcovaldo (before the removal of the repainted faces of the 14th century). Church of Sta. Maria Maggiore.

Roman sarcophagus re-used to bury the standard-bearer *Guccio de' Medici* (1299). Baptistery of St. John, interior.

Cenotaph of *Guglielmo di Durfort* (died 1289), tutor of Amerigo di Nerbona, by an artist from the Byzantine culture who was active in Florence. Basilica and convent of Santissima Annunziata, (first cloister).

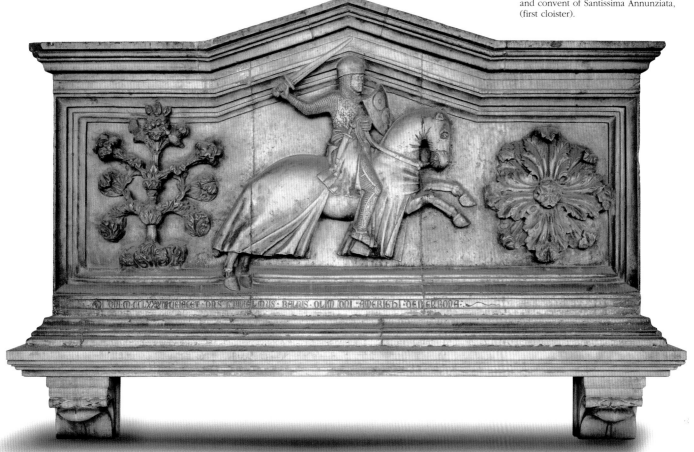

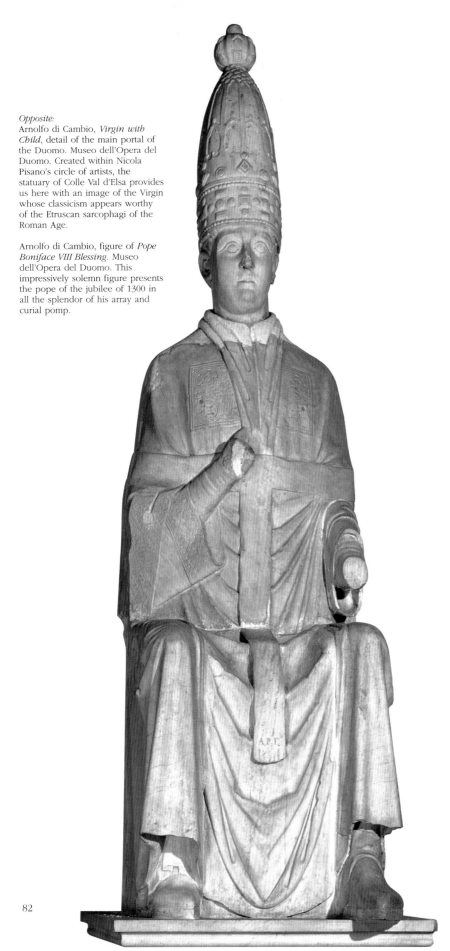

Opposite:
Arnolfo di Cambio, *Virgin with Child*, detail of the main portal of the Duomo. Museo dell'Opera del Duomo. Created within Nicola Pisano's circle of artists, the statuary of Colle Val d'Elsa provides us here with an image of the Virgin whose classicism appears worthy of the Etruscan sarcophagi of the Roman Age.

Arnolfo di Cambio, figure of *Pope Boniface VIII Blessing*. Museo dell'Opera del Duomo. This impressively solemn figure presents the pope of the jubilee of 1300 in all the splendor of his array and curial pomp.

The commissioning of the image of the warrior saint whose red cross adorned the city's flags from a master who was not local, perhaps even because he was not local, is the sign of this nonmunicipalist approach and, at the same time, constitutes a precious clue to the opening of the visual language of the flourishing city to innovative input from outside. A sign that is more political than artistic is the re-use of Roman sarcophagi for secular burials, as had already happened in Pisa, a community with an older and more international tradition that, with references to such genres and others harkening back to the art of Constantinople, had built up its image of proud autonomy of government. From the many that supposedly existed, a pair of examples remain that stood in the "bel San Giovanni," as Dante called the Baptistery, which today have been moved to the entrance of the Museo dell' Opera del Duomo, as well as that of Guccio de' Medici (standard-bearer of the republic in 1299).

The idea of actually portraying deceased nobles, rather than simply providing information in recognition of their fine achievements, as in fact happened in the burials of earlier times, became widespread in the last two decades of the 13th century, when the resumption of ancient classicism became a recurrent motif for local art. We certainly cannot talk of proto-Humanism; rather, it is significant that the first personality to be "faithfully" immortalized in marble was the Angevin Guglielmo di Durfort, who died leading the Florentines during the battle of Montaperti (1289). If the figuration as a whole, framed by crosses flory, a heraldic device, at the sides, appears to be nothing but the translation onto a different scale of an original aristocratic seal—like others, also Florentine, that we know from the mid-century—the decision to show the character with his face uncovered shows an inclination for portraiture. It is hard to establish whether this isolated specimen was the work of a non-Florentine, as might be suggested by the affinity of the ornamental motifs with those of the frontal sarcophagi of the Basilica of Sta. Maria Novella, where the two colors of the pointed arches and the facade are not without Pisan influences. One thing is certain: the extraordinary creation remained a point of reference for later artists to follow. So before the end of the first decade of the following century, when the radiant presence of Arnolfo di Cambio (in Florence from 1296 until his death, between 1302 and 1310) must have prompted the ornamental stone craftsmen to seek prestigious outlets for their relief work, we have the creation of an *Annunciation*, mounted on the side of Sta. Maria del Fiore, which is perhaps

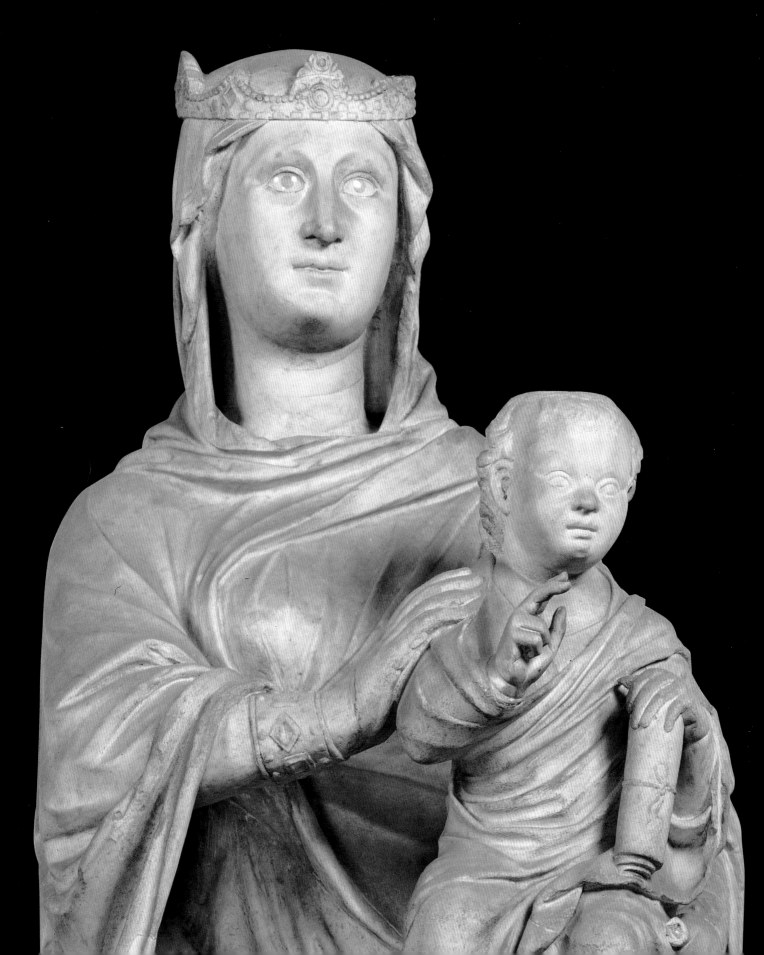

not as mediocre as certain eminent critics have judged it, considering that this was a newly developing sculptural school. Of course the Coppo-style icon of Sta. Maria Maggiore presents itself with rather more dignity, contributed to considerably by the beauty of the colors and the complexity of the technique, but less than 20 years were sufficient for us to witness the establishment of a genuine local language.

Indeed, in about 1328 the triptych of calcareous sandstone statues appeared, the work of Paolo di Giovanni, that were positioned on the Porta Romana, at one time painted and gilded to indicate to travelers coming from Rome that the fortified city that was about to welcome them did not feel inferior to that of the pontiff.

Over the course of the last 30 years, the Duomo had increased in size and the facade showed the work of the pope's favorite, Arnolfo; he has left an impressive standing portrait of Boniface VIII, today in Florence's Museo dell'Opera Metropolitana, which competes in majesty with the *Virgin with Child*, which stood out against the background of the main lunette of the facade of Sta. Maria del Fiore, with its multicolored mosaic inserts in a style reminiscent of Cosmati work. Having lost their glowing colors as a result of washing by the purists, these statues have an icy and distant fixity that is more accentuated today than it was originally. Yet without doubt the precision of the carving and the volumetric certainty that characterize it serve to explain creations such as the early-14th-century monuments in Sta. Croce, among which we must mention that already attributed to the Pisan Giovanni di Balduccio, in the Baroncelli Chapel at the head of the south transept (1327), where the refinement of the architectural structures combines well with the geometric rigor of the widely-spaced figurations. Even though in some ways the panorama of local or adopted Florentine sculptors should not have appeared so desolate, when the time came to commission the bronze door of the Baptistery of St. John, the problem was resolved by entrusting the work to artists from elsewhere.

Mario Scalini

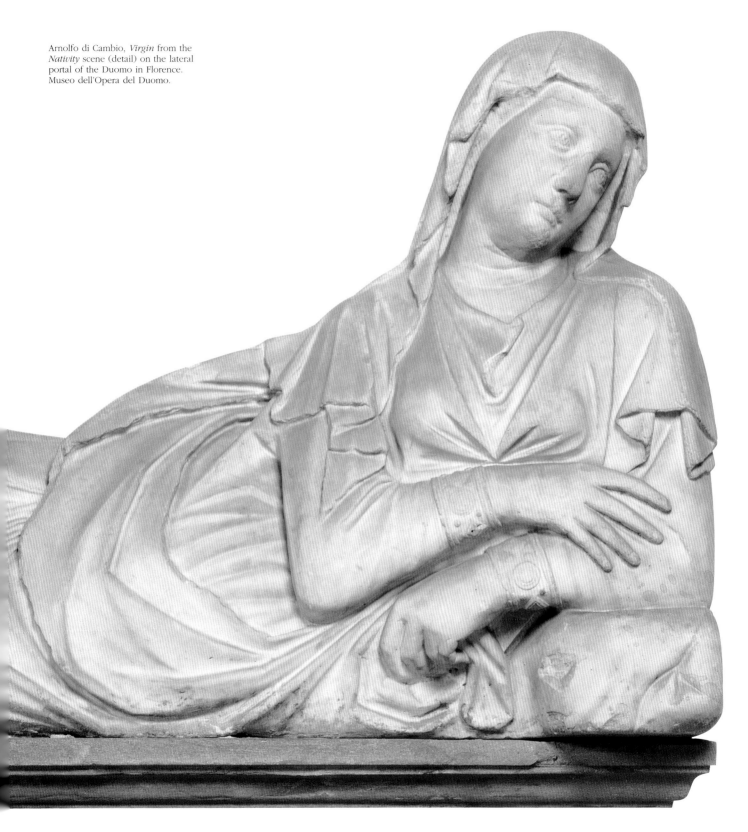

Arnolfo di Cambio, *Virgin* from the
Nativity scene (detail) on the lateral
portal of the Duomo in Florence.
Museo dell'Opera del Duomo.

From the origins to Coppo di Marcovaldo

Opposite:
Detail of *Christ's Face*. Rosano (Florence), Monastery of Sta. Maria, church of Santissima Annunziata.

Painted Crucifix with six scenes from the Passion of Christ, before restoration.

The first name of an artist that was almost certainly Florentine—or in any case undoubtedly active in the city—handed down to us today should be that of a certain "Rusticus," who appears in two notary's parchments dated 27 February 1066 and preserved in the State Archive in Florence, in relation to the ancient Florentine church of S. Pier Maggiore. Other names of "Florentine" artists appear in documents from April 1112—"Geronimo… filio Morelli," also "clericus et pictor" (Florence, State Diplomatic Archive, Badia di Passignano)—and 6 October 1223,

where there appears a certain "Adamo pictori, filio olim Guillielmi" (Florence, State Diplomatic Archive, Badia Fiorentina).

Nevertheless, we need to wait until at least the first quarter of the 12th century, and begin with the sphere of the miniated (illuminated) decoration of codices, to be able to discuss and analyze an artistic production that is definable appropriately and unambiguously as "Florentine." The decoration of a rather homogeneous group of codices kept at the Biblioteca Mediceo-Laurenziana in Florence, probably executed in the first quarter of the 12th century, attests to the establishing in the Florentine region of an artistic language characterized by a rigorous linear classicism, which seems to depend primarily on the contemporary culture of Rome and Lazio. This sector will be considered in greater detail later in the book in the section devoted specifically to the miniature.

Moving on to painting, we must immediately highlight that cultural reference to the fundamental sphere of Rome and Lazio is also necessary on the subject of the oldest and most revered paintings of those preserved in the Florence area, indeed, the one that is in all likelihood the oldest of all: the *Madonna with Child Enthroned* in the parish of Sta. Maria a Impruneta, 9 miles (15 km) or so south of the Tuscan capital, in a pleasant and picturesque hilly area. Unfortunately, only a very small part of the original work has survived to the present day. Another of the oldest paintings of the area that we must recall is the *Crucifix* in the Benedictine monastery of Sta. Maria di Rosano, in the territory of the municipality of Rignano sull'Arno, now just outside Florence, which in recent years has undergone significant and long-awaited restoration work. The cross has the uppermost part missing, while the two lateral panels depict *The Grieving Virgin* and *St. John* on the left and *Two Pious Women* on the right. As was typical of the age, the following episodes from the Passion of Christ are represented in the large central panel of the cross: on the left, the *Capture of Christ*, the *Descent into Limbo*, and the *Appearance on the Road to Emmaus*; on the right, the *Descent from the Cross*, *Burial in the Sepulcher*, and the *Three Marys at the Tomb*. Until 1204 the monastery of Rosano was the farthest point on Florentine territory of the dominion of the Counts Guidi, a powerful noble family from the Casentino—the historic natural region in the territory of Arezzo—and therefore the fact that the most similar work to our *Crucifix* is located a few miles from Arezzo appears particularly significant: it is the other fragmentary *Crucifix* in the Museo Civico of Castiglion Fiorentino.

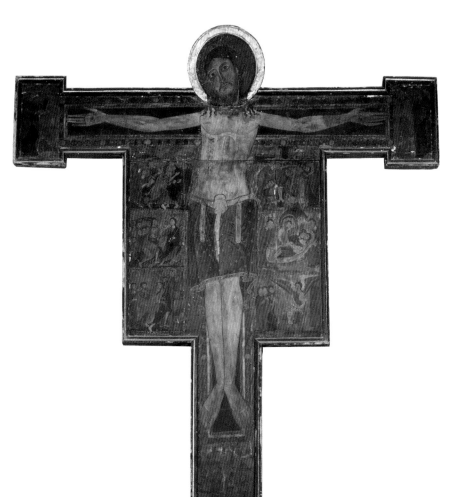

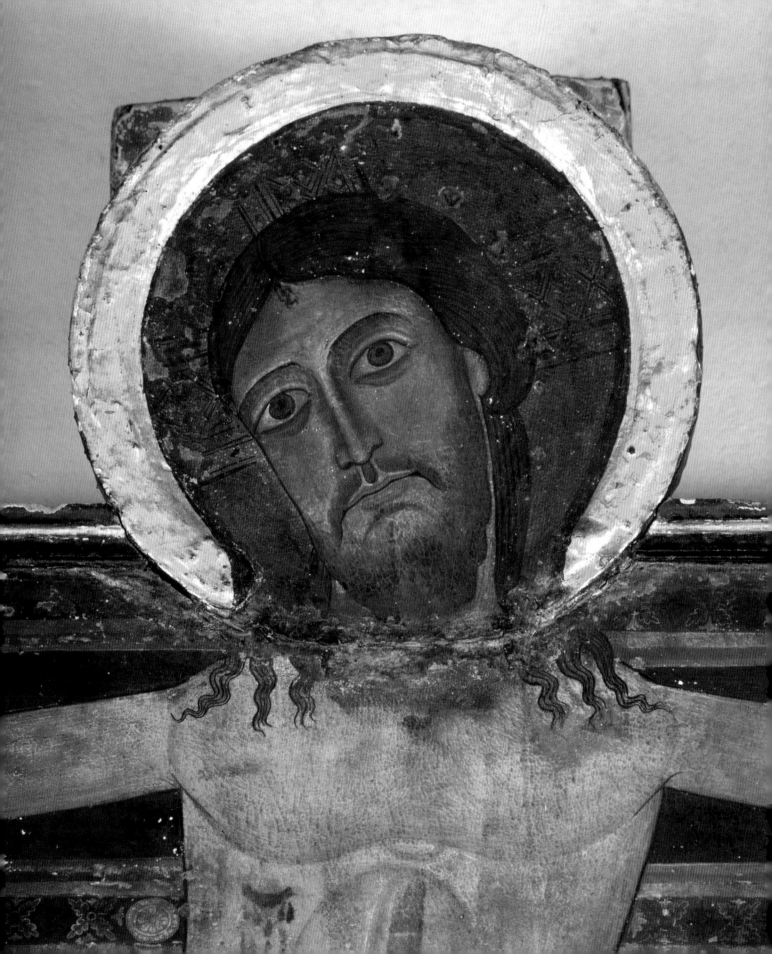

Opposite:
Fragment depicting the *Virgin with Child Enthroned with Two Angels.* Florence, from the church of Sant'Andrea a Rovezzano.

Full length *Cross no. 432.* Uffizi Gallery.

Detail of the fragmentary fresco revisiting the theme of the escape to Egypt. Pistoia, Museo della Cattedrale.

Virgin with Child Enthroned. Fiesole, Cathedral of S. Romolo.

Alongside this latter specimen, the cross of Rosano may perhaps be considered at the origins of Arezzo's painting tradition, of fundamental importance for the development of Margarito, the greatest Arezzan artist working in the first half of the 13th century. The dating of this rare and precious figurative work is still highly controversial; nevertheless, it would seem to date from the second half of the 12th century. Another work that might be from more or less the same period is the well-preserved *Madonna with Child Enthroned and Two Angels* from the church of Sant'Andrea a Rovezzano, on the outskirts of Florence, yet it is generally dated to the first half of the 13th century, which is immediately indicated also by its bright and vivid chromatic range. In spite of its rigid frontality, this fascinating work is pervaded by a serene equilibrium reminiscent of classical art, which is particularly evident in the two angels floating at the sides of the throne. The absolute stylistic uniqueness of this painting within the Florentine painting of the first half of the 13th

century and its pronounced linear accent, combined with the rigorous stylization of the drapery, encourage us to accept the critical hypothesis put forward in recent years, which puts the execution earlier, in the third quarter of the 12th century. The Maestro di Rovezzano can be indicated as the oldest, most authentic personality of painting in Florentine culture, to whom we must also certainly attribute another fragmentary *Madonna with Child*, which today belongs to the art collection of the Banca d'Italia.

Unfortunately we do not know the original provenance of the so-called *Cross no. 432* in the Uffizi Gallery, a genuine masterpiece of Italian medieval painting, which entered Florence's public collections from a monastery located not far from the city, following the enactment of a law for the removal of artworks from monastic orders in 1866. The uppermost part of the crucifix is missing, and it has significant gaps in the right arm and on the lower part. The central panel depicts six *Scenes from the Life of Christ*: on the left, the *Washing of Feet*, the *Capture of Christ*, and the *Flagellation*; on the right, the *Deposition from the Cross*, the *Burial*, and the *Descent into Limbo*; at the base of the cross is the *Journey to Calvary*.

Cross no. 432 in the Uffizi is among the works that contributed most to establishing the artistic physiognomy of Florentine painting in the first half of the 13th century; therefore, also in the light of this consideration, the most likely chronological placement of the work appears to be during the third and last quarters of the 12th century.

Scholars have long underlined the supreme qualitative importance of the work in the Uffizi, also highlighting the sophisticated culture of its author, who employed the most diverse figurative sources, from Bavarian to Syrian and Armenian miniatures, from the

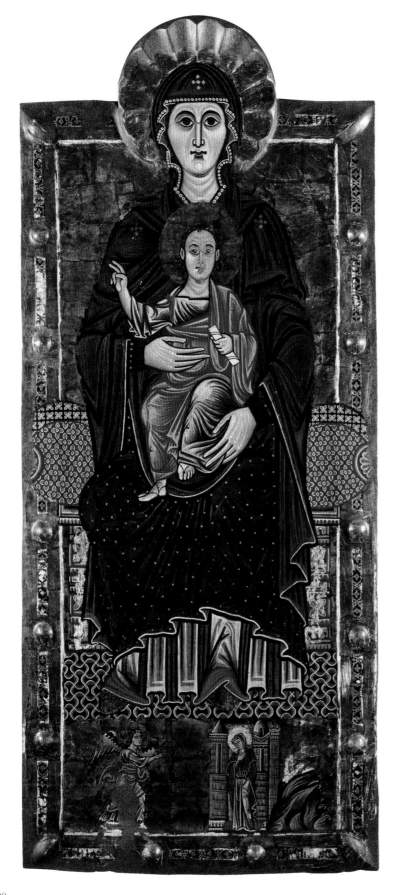

fundamentally important Pisan culture of the second half of the 12th century to that of the province of Constantinople, as well as the no less flourishing culture of Arab-Sicilian origin. Nevertheless, the most immediate and convincing stylistic comparisons are still to be found with two other painted crosses from the period: the one already indicated with no. 15 on the inventory (currently no. 1578) at the Museo Nazionale di S. Matteo in Pisa and the other from the Sanctuary of Sta. Caterina in Siena, which originally came from the church of Sta. Cristina in Pisa. We must also mention the truly surprising points of contact to be found with the mosaic decoration of the vault of the Palatine Chapel in Palermo—a work of collaboration between Arab-Sicilian craftsmen and those from the central Italian culture of about mid-12th century—that have been underlined in more recent times, and are interpretable in the light of the common basis of Eastern culture.

Among the main protagonists of the oldest phase of 13th-century Florentine painting, it is necessary to cite the artist of the *Madonna with Child Enthroned* and, in the lower part, the *Annunciation*, today in the Uffizi Gallery in Florence (inv. 1890 no. 9494), but originally from the oratory of Sta. Maria di Casale, a dependency of the church of S. Donato a Citille (Greve in Chianti). The restoration of the painting has recovered the original pictorial layout, which has been revealed to be in excellent condition. Not only the late repaintings from the 19th century were removed on that occasion, but also the results of an earlier attempt to adapt the image, in all likelihood dating back to the end of the 13th century or the beginning of the 14th.

The artistic historiography of the past underlined in particular the importance of the art of Lucca in the development of medieval Tuscan painting. Yet in recent decades the progress of studies has highlighted the key role of the flourishing artistic culture in Pisa, identified as the main driving force behind cultural progress in the whole region, as well as being the first and most important mediator in regard to contributions coming from the Mediterranean basin. The reference to great medieval Pisan painting also becomes obligatory against the background of the critical analysis regarding the so-called Maestro del Bigallo, who may be considered the most characteristic exponent of the Florentine painting of the first half of the 13th century. He gained this position on account of a painted *Crucifix* that is preserved in the Florentine museum of the same name overlooking the Cathedral of Sta. Maria del Fiore.

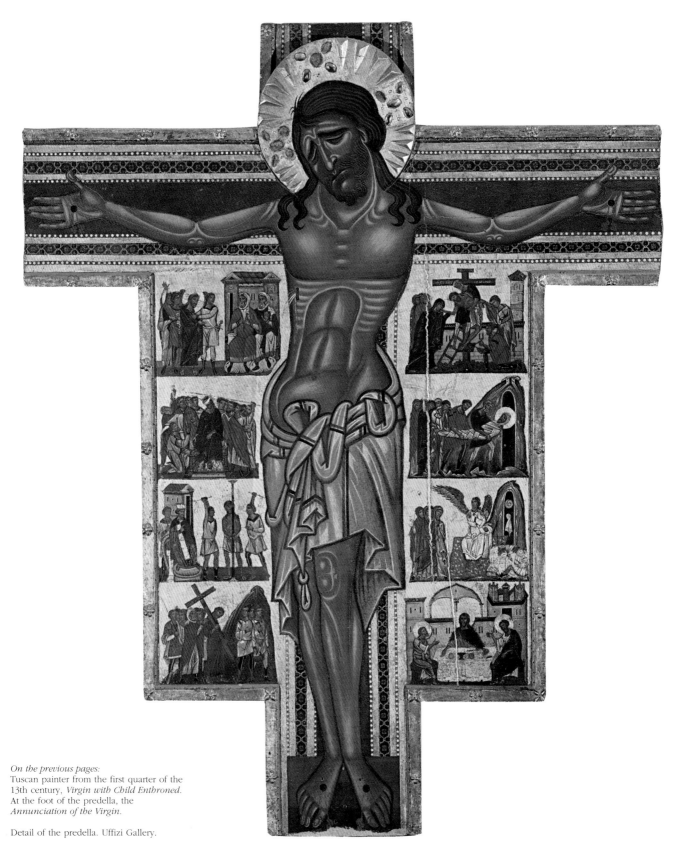

On the previous pages:
Tuscan painter from the first quarter of the
13th century, *Virgin with Child Enthroned*.
At the foot of the predella, the
Annunciation of the Virgin.

Detail of the predella. Uffizi Gallery.

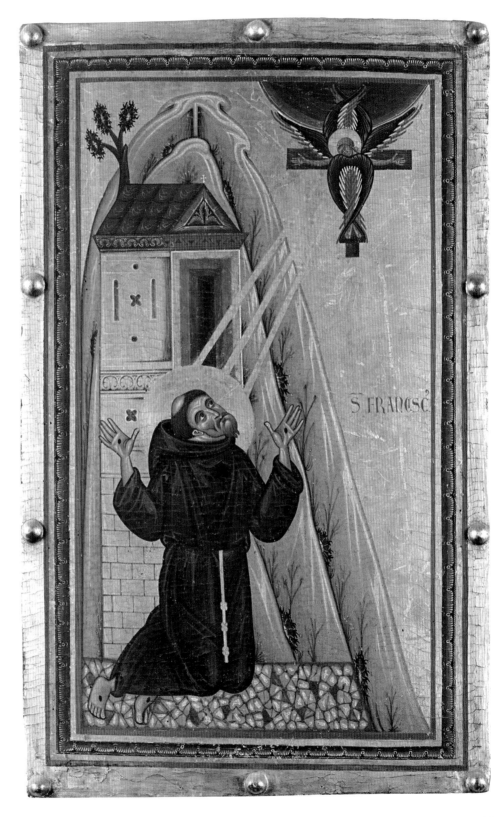

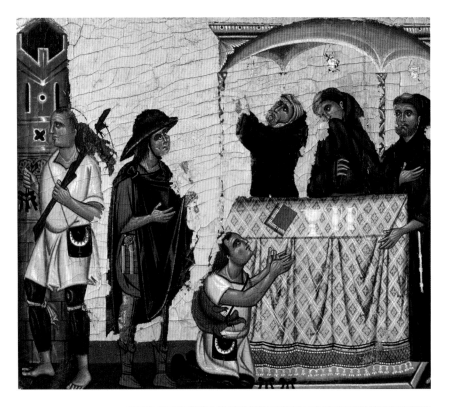

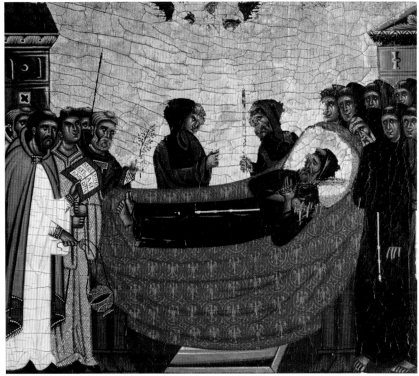

Active in approximately 1220–40, in the past the painter was considered to have been influenced mostly by the Luccan painting of the period, whereas he must have been particularly attentive to the developments of the Pisan painting of the time, particularly in the mature phase of his activity. Standing out among the most important and perhaps oldest works of those attributable to him is the great dossal in the Museo dell' Opera del Duomo in Florence, depicting *St. Zanobi Enthroned Between SS. Eugenio and Crescenzio with Four Episodes from his Life*, originally located on the altar erected over the tomb of the first bishop of Florence, in the crypt of the old Cathedral of Sta. Reparata. One of the most beautiful works of the large catalog of paintings associated with the artist—in which a series of *Madonnas with Child Enthroned* stands out—is the painted *Crucifix* in the Galleria Nazionale d'Arte Antica in Palazzo Barberini in Rome, which can rightfully be considered his masterpiece. The solemn and cadenced language that characterizes the painting and, above all, the free and vibrant layout of the painting would seem to be interpreted in the light of the important neo-Hellenistic phase of Giunta Pisano, circa 1240.

In 1933 Richard Offner, one of the major experts on Italian medieval painting of all time, indicated two fundamental tendencies within the Florentine painting of the first half of the 13th century. The first would supposedly have started with the Maestro del Bigallo and have been distinguished above all by its strong narrative character. The other tendency, more interested in expressing plastic and luminaristic values, would supposedly have had Coppo di Marcovaldo as its main interpreter. The renowned scholar also identified the key works of the latter, more progressive in tendency: the great panel on the altar of the Bardi Chapel in Sta. Croce in Florence, with *St. Francis with Two Angels and Twenty Episodes from his Life*, the already mentioned Crucifix no. 434 in the Uffizi Gallery and the dossal with *St. Michael the Archangel Enthroned and Six Episodes from his Life*, originally from the church of Sant'Angelo in Vico l'Abate and preserved in the Museo d'Arte Sacra in S. Casciano Val di Pesa. To this day this critical interpretation still retains a substantial basis in truth, yet scholars are still not in agreement in the attribution of the aforementioned paintings. The mysterious author of *Crucifix no. 434* in the Uffizi is one of the most interesting personalities in 13th-century Florentine painting, although recent studies lead us to believe that he had some artistic training in Lucca, almost certainly at the workshop of Bonaventura di Berlinghiero, as is

proven by the recently restored *Painted Cross* in the parish church of Tereglio (Lucca), on which the Maestro del Crocifisso no. 434 in fact collaborated with the most well known of Berlinghiero's children. The small core of works that have been attributed to him, which also includes the panel with St. Francis receiving the stigmata in the Uffizi Gallery (inv. 1890 no. 8574), another *Painted Crucifix*—this also recently restored and originally from the church of S. Jacopo a Ripoli—in the church of the Conservatory of the Montalve in Villa La Quiete, on the outskirts of Florence, as well as a fragmentary *Madonna with Child* in the monastery of Sta. Maria di Rosano, represents the real contribution of Luccan culture to the development of the Florentine painting of the first half of the 13th century, which certainly had a far from secondary role in the development of the young Coppo di Marcovaldo in the period of the great panel in the Bardi Chapel, as we will see in detail below. Even at first glance, the *Crucifix* in the Uffizi appears to be of considerable interest, especially if compared with the examples from the same time by the Maestro del Bigallo discussed above. Instead of the calming, measured representations offered by the latter, the Maestro del Crocifisso no. 434 did not hesitate to concentrate on the dramatic moment of the agonies of Jesus, giving life to a representation of extraordinary expressive force and great emotional impact. Nevertheless, the most interesting innovations concern the unusually numerous scenes of the *Passion of Christ*—four on each side—on the large central panel of the cross. In them the anonymous master shows that he possessed a marked compositional capacity, enabling him to produce very crowded, bustling representations, animated by lively, gesticulating characters, and also propose cohesive and sometimes complex architectural backdrops. If the *Crucifix* in the Uffizi is to be dated circa 1240–45, on the basis of the only comparative stylistic analysis, then the fine Franciscan panel in the Museo Civico in Pistoia would represent the end of his operational phase toward mid-century. The Pistoian altarpiece, pointed in shape, was originally in the local church of S. Francesco al Prato. It revisits the usual typology of images present in the Franciscan churches of the region since the beginning of the 13th century, of which one of the oldest prototypes would be the similar image conserved today in the Museo Nazionale of S. Matteo in Pisa—plausibly attributed to Giunta Pisano—which was followed by the other image in the S. Francesco di Pescia by Bonaventura di Berlinghiero and dated 1235.

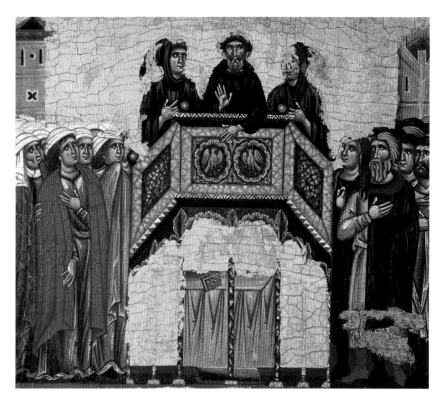

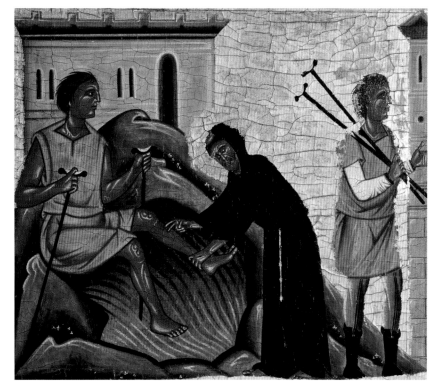

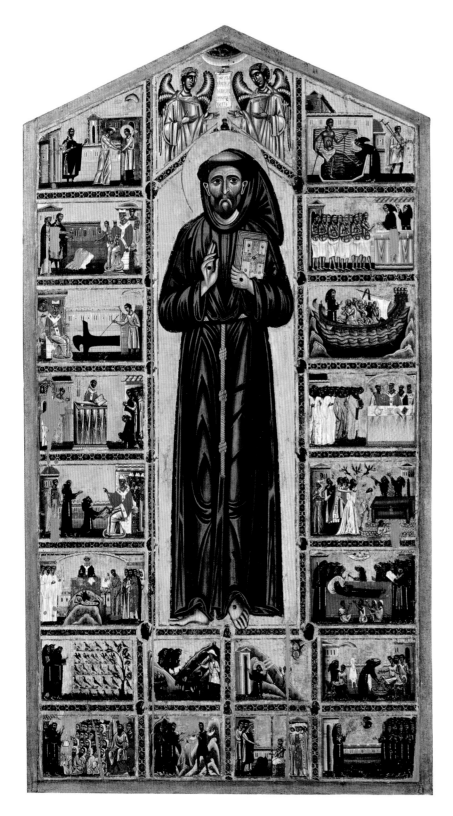

This intense direct link with Giuntesque culture is at the basis of the undeniable stylistic affinities that exist between the Maestro del Crocifisso no. 434's mature works and the so-called Maestro di Sta. Maria Primerana—to be discussed in detail in the following chapter—which nevertheless cannot in our view be confused with him, as has been authoritatively proposed.

One of the most fascinating works of the Florentine painting of the first half of the 13th century is the large altarpiece placed on the altar of the Bardi Chapel in the church of Sta. Croce in Florence in at least the early 16th century—in the presence, therefore, of Giotto's very famous frescoes. This is attributed by Vasari to Cimabue. As has been mentioned above, the painting has for some time been at the center of the critical hypotheses formulated by scholars attempting a reconstruction of the artistic circumstances of that period. After the initial emphasizing of the influence of Luccan art—which, moreover, still remains valid from the standpoint of the overall formulation and particularly for the main figure—the most recent studies have increasingly highlighted the typically Florentine character of the painting and its substantial stylistic homogeneity, although it is nevertheless possible to glean a certain diversity of plastic and luministic accents in the lower scenes, which appear significantly more incisive on the narrative plane and on that of luminarism and chiaroscuro. An American scholar whose work has been praiseworthy in the field of investigation into medieval Italian painting, Edward Garrison, introduced the provisional denomination of the "Maestro del San Francesco Bardi" into the critical literature for the first time for the author of the panel in Sta. Croce, to whom he also considered himself able to attribute the single panel with the *Stigmata of St. Francis* in the Uffizi Gallery, already cited in relation to *Crucifix no. 434* in the same gallery. Nevertheless, the significant increase in studies relating to 13th-century Florentine painting over the last 30 years has led to scholars denying the existence of this hypothetical master and in fact identifying him with Coppo di Marcovaldo in his later period. From the compositional standpoint and also for some iconographic details, the painting in Sta. Croce appears closer to the similar Franciscan panels from a much older date that have already been cited, that by Giunta in the Pisa Museum and the other signed and dated 1235 by Bonaventura di Berlinghiero in S. Francesco di Pescia. The other Franciscan altarpiece discussed, that in the Museo Civico of Pistoia, attributed to the Maestro del

Coppo di Marcovaldo, *St. Francis and Twenty Episodes from his Life*. Basilica of Sta. Croce (Bardi Chapel).

Coppo di Marcovaldo, *St. Michael the Archangel Enthroned and Six Scenes from his Life*, detail. Florence, S. Casciano Val di Pesa (Museo d'Arte Sacra).

Coppo di Marcovaldo (and Sienese painter from the first quarter of the 14th century), *Virgin with Child Enthroned and Two Angels*, signed and dated 1261. Siena, church of Sta. Maria dei Servi.

Opposite:
Last Judgment, detail of the mosaic
decoration on the vault of the
Baptistery of St. John.

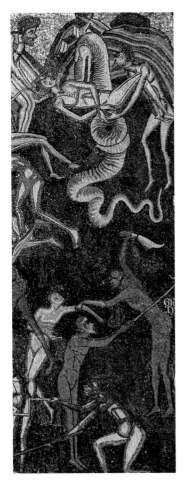

Detail of the *Damned* in the mosaic
decoration of the *Final Judgment* on
the vault of the Baptistery of St. John.

Crocifisso no. 434, has more complex
compositions and a more highly structured
attention to the relating of the various episodes.
Moreover, a provisional dating for the *St.
Francis* in the Bardi Chapel (known as the *San
Francesco* Bardi) of about 1240–45 would in
fact seem to be the most reliable.

A more detailed examination of the
numerous scenes placed around the figure of
St. Francis confirms the rather archaic tone of
the compositions, which almost never show
intents of a spatial nature, while the
architectural backdrops are generally
characterized by an archaically essential
conception. However, greater creative freedom
and expressive force shine through from the
method of representing the numerous
characters that crowd the rich biographical
sequence of the patron saint of Italy, mainly
characterized by thickset proportions and
smoothed masses, which always show
emotional accents of high drama.

Nevertheless, the true strong point of the
language of this high ranking artist consists, in
my view, in the powerful dramatic sentiment
that inspires and underlies another highly
peculiar characteristic of style: that is to say, the
particular plastic and luminaristic sense that
clearly distinguishes it in the artistic panorama
of the age. And the impassioned and almost
violent way of marking the light on the faces,
over the arch of the eyebrows or under the
eyes, or else on the chest or above the arms,
seems to herald the approach that is certainly
to be found in the works referable to Coppo,
starting with the *Madonna with Child
Enthroned and Two Angels* in the church of Sta.
Maria dei Servi in Siena, signed "COPP[US] D[E]
FLORE[N]TIA" and dated 1261, which
unfortunately had the faces of the Madonna
and the Child partially repainted by a Sienese
painter from the beginning of the 14th century
who was clearly influenced by Duccio. The
name of Coppo di Marcovaldo, the most
significant Florentine artistic personality prior to
the advent of Cimabue, is documented for the
first time in 1260 in the lists of Florentines who
were supposedly to fight against the Sienese at
Montaperti: "Coppus dipintore populi Sancti
Laurentii." At that time the artist was no longer
young, and so must have already enjoyed a
certain reputation, if he was commissioned the
following year to paint a large panel for the
important Chiesa dei Serviti (Church of the
Servites) in the fiercely hostile city of Siena,
where he was able to proudly proclaim himself
Florentine. The unrepainted parts of the signed
Madonna in Siena, and particularly the two
full-figure angels floating in the upper part of
the painting, are of primary importance for the

reconstruction of Coppo's activity. A
comparison between these and the analogous
angels in the *Madonna with Child* in the Chiesa
dei Servi in Orvieto—traditionally attributed to
Coppo—makes it possible, in my view, to
exclude this work definitely from the Florentine
painter's catalog, as is also proven by the
comparative examination of the X-ray images
taken during the restoration of the two panels.

Despite the misleading repaintings of the
early 14th century, in the so-called *Madonna
del Bordone* we can discern the signs of the
painter's considerable interest in a more
plausible spatial position of the image: the
figure of Mary is seen half-turned to the side,
the position of the legs clearly shows through
under the rich drapery, and also the slender
back of the "lyre-shaped" throne—the earliest
dated appearance in Italian painting—
contributes to making the space occupied by
the image airier and more structured. An
intense *Madonna with Child* from a private
Italian collection, datable about mid-century,
should belong to a previous phase of Coppo's
activity and a time soon after the execution of
the altarpiece of S. Francesco in Bardi; it has
already been plausibly associated in the past
with the author of the painting in Sta. Croce in
Florence. On the other hand, a comparison
with the radiographic image of the *Madonna* in
the Chiesa dei Servi in Siena reveals a definite
affinity, also of a typological nature, between
the two paintings.

The oval shape of the *Madonna*'s face is
traversed by sharp luminaristic passages
marking the main features of the face and neck,
with accents that seem to derive directly from
San Francesco Bardi and that reappear in the
two angels of the *Madonna* of the Chiesa dei
Servi in Siena.

In a similar way to the other major artistic
personalities working in the Italian peninsula in
that period, Coppo's power and originality lie
precisely in his attempt to adapt Byzantine
figurative formulas and, above all, to interpret
them critically, subjecting them to the scrutiny
of his language characterized by a strong
dramatic sentiment, as well as extraordinary
expressive vigor.

These latter qualities are evident from an
examination of the splendid dossal that is
today preserved in the Museo d'Arte Sacra in
S. Casciano Val di Pesa, 12 miles (20 km) or so
south of Florence, originally coming from the
local church of Sant'Angelo in Vico l'Abate. At
the center of the painting there reigns the
solemn and terrible figure of St. Michael the
Archangel, framed above by a splendid pair of
multicolored wings. Painted at the sides are six
scenes from his legend, depicting, starting

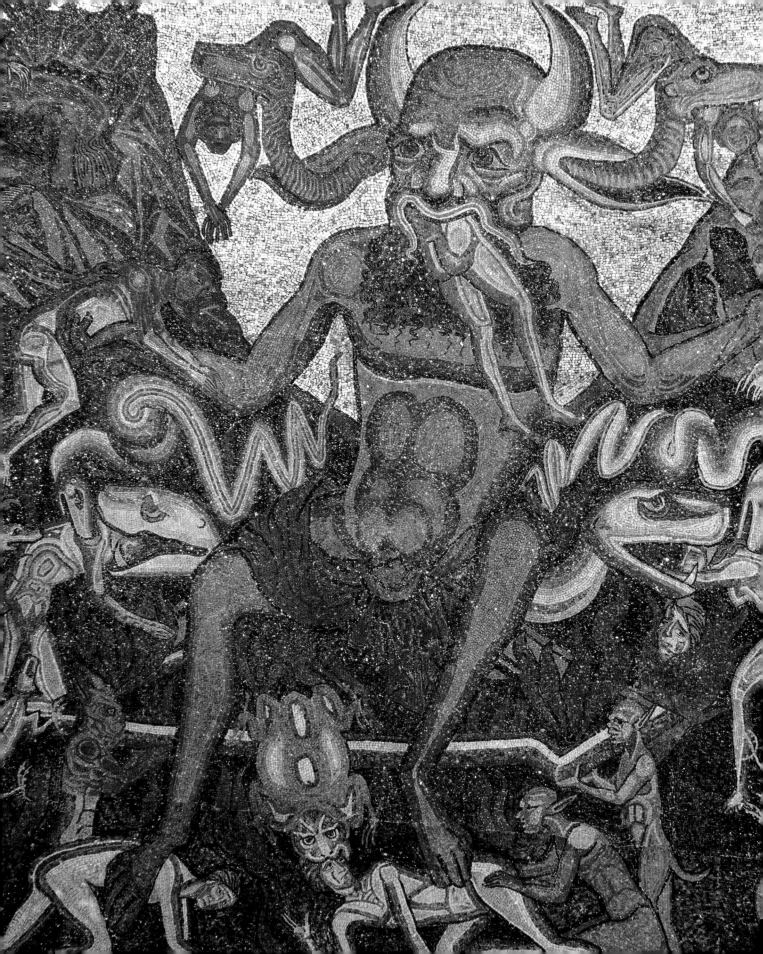

Overall view of the vault of the Baptistery of St. John, with its rich mosaic decoration.

from top left: the *Preparation of the Celestial Throne*, *St. Michael Destroying Lucifer*, *Gargan before the Bishop of Siponto*, the *Handing Over of the Shepherd's Crook in Bloom*, the *Bull on Mount Gargano*, and the *Appearance of St. Michael*. If the attribution of the dossal to Coppo can now be said to be definitely established among scholars, the task of inserting it into the appropriate place in the artist's career is somewhat trickier. Nevertheless, the significant affinities to be found with the Maestro del Crocifisso no. 434—in the facial types and in certain rather thickset and smoothed figures—and with the altarpiece of *San Francesco* Bardi, particularly as regards the organization of chiaroscuro, would make us incline toward a relatively early dating, in any case prior to the "*Madonna del Bordone*" of 1261 in Sta. Maria dei Servi in Siena.

Another clue to confirm such a dating of the dossal of Vico l'Abate is given by the extreme compositional simplicity of the lateral scenes, populated by a few figures characterized by slow, almost awkward movements. Nevertheless, on the chromatic plane, the work is fully redeemed from the standpoint of quality: the bright and intense colors present in it, in a vast range of gradations, seem to stand out to a greater degree against the dark background caused by the oxidation of the original silver. A fundamental work in the reconstruction of the Coppo catalog is the *Crucifix* in the Museo Civico in S. Gimignano (Siena), which was almost certainly painted for the convent premises of Sta. Chiara, founded in 1261. The painting has reached us complete in all its parts, including the tondo at the top with *Christ Blessing*, which, together with the end panels, is one of the parts that were usually removed first from painted crosses. Depicted at the upper end is the *Assumption of Mary* in the usual 13th-century iconographic scheme, while at the sides we find the *Virgin and St. John Mourning* on the left and the *Three Marys* on the right. The following six episodes of the Passion of Christ are painted on the central panel of the cross, from left to right and from top to bottom: the *Capture of Christ*, *Christ before the High Priest*, the *Flagellation*, *Christ Mocked*, *Christ Prepares to Suffer the Cross*, and the *Burial*. From the iconographic point of view, we must emphasize the uniqueness of the scene at the bottom left on the main panel of the cross, depicting the *Preparation of Christ for the Crucifixion*, which appears here for the first—and perhaps only—time on a painted crucifix. Some scenes of the Passion of Christ, particularly the *Capture of Christ* and *Christ before the High Priest*, have considerable affinity with the similar ones represented on

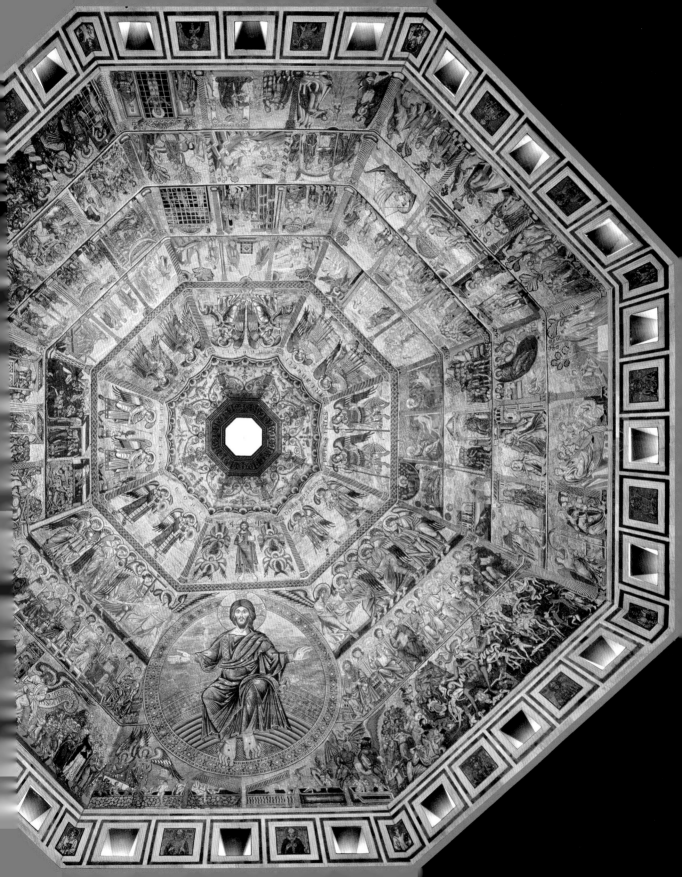

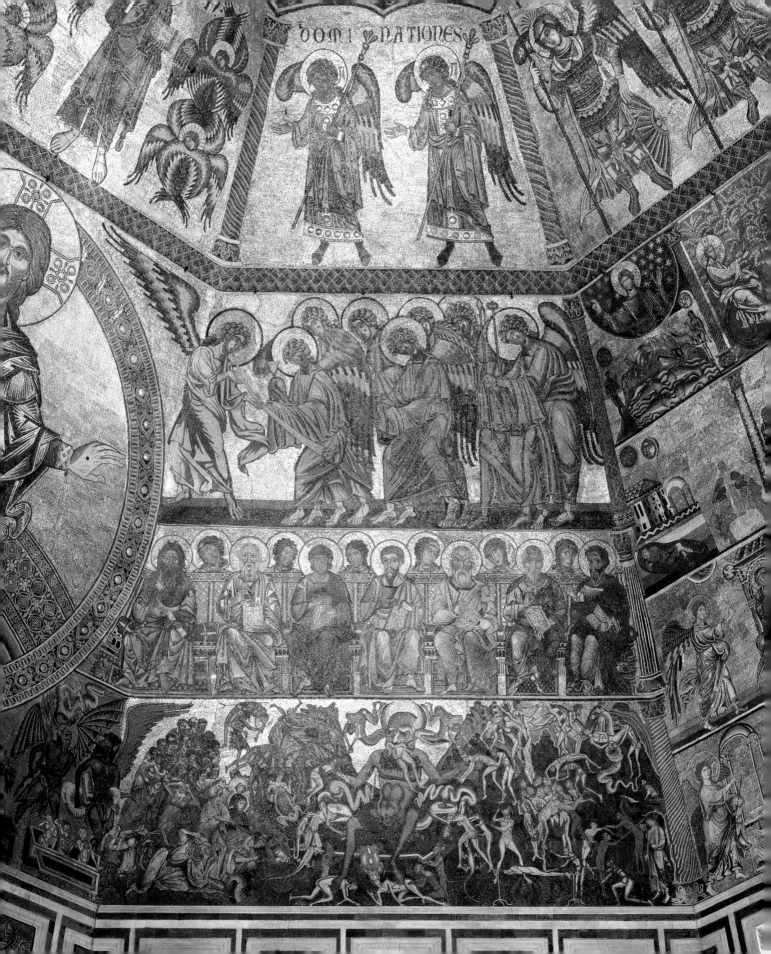

DOMI NATIONES

Cross no. 434 in the Uffizi, whose author may very well have played a central role in the training of Coppo di Marcovaldo. In any case, the painted scenes on the *Crucifix* in S. Gimignano represent the narrative peak of Coppo's art, which was sustained by an intense dramatic spirit.

The further developments of Coppo's activities are today still the subject of considerable debate among scholars, yet they overlap firstly with the attempt—this also highly controversial—to reconstruct a plausible artistic place for his son Salerno, remembered as a painter in the company of his father in Pistoian documents from the years 1265–69 and 1274–76. Of the works mentioned in the Pistoian papers—frescoes in the Chapel of S. Jacopo in the cathedral, two painted crosses and three panels—only the painted *Crucifix* that is still preserved today in Pistoia cathedral has reached us, or has been identified; it should be the same one that was executed for the altar of St. Michael, while the other was specially made for the chancel. The clues obtainable from the Pistoian documents, and the clear difficulty encountered in recent years by scholars in proposing a convincing reconstruction of the activity of Salerno di Coppo, would seem to reinforce the hypothesis, whereby his late work was produced in close collaboration with his son in the family workshop.

This possibility also appears very plausible for the large fresco with the *Crucifixion* in the chapter room of the church of S. Domenico in Pistoia, which was detached in 1968, so allowing the recovery of one of the most beautiful sinopites (reddish-colored preparatory sketches) from the 13th century, in which the figure of a centurion, which was not executed in the fresco itself, appears on the right-hand side.

The grandiose painting was part of a vast, articulated ornamentation inspired by plant life, while the architecture in the background is immediately reminiscent of that present in the *Crucifix* in the cathedral. The accentuated curvature of Christ's body has led to the hypothesizing of a presumed affinity with the *Crucifixion* fresco by Cimabue in the left transept of the upper church of St. Francis in Assisi, but in reality the fresco is closely linked stylistically—particularly as regards the elongated proportions of the figures and the flowing and sinuous design—to the painted cross cited above, and should also share its dating in the mid-1270s. The accentuated sentimentalism of the characters—but also see in particular the six angels positioned above the side arms of the cross—is again significantly reminiscent of the *Crucifix* in the museum in S. Gimignano. However, in the group of the paintings that lie within the critical discussion regarding the late works of Coppo di Marcovaldo, we must remember above all the icon in the church of Sta. Maria Maggiore in Florence, with the *Madonna with Child Enthroned* executed in painted bas-relief, with two angels at the sides and the two scenes of the *Annunciation*, and the *Pious Women at the Tomb* in the lower part, inserted into a frame in relief of exquisite Byzantine taste, with the images of the *Twelve Apostles*, eight of whom are full-figure, distributed over the two sides, and four busts in the two margins, upper and lower.

The restoration carried out in the workshops of the Opificio delle Pietre Dure at the Fortezza da Basso in Florence has returned to us one of the most attractive and significant paintings, not only of 13th-century Florence, but of the whole of Italian painting of the period, characterized by the extraordinary preciousness of the materials used, as well as by a prodigious and extremely refined technique of execution. Despite the arcane fixity and archaism of the central group in bas-relief, which could be reminiscent of the Maestro di Rovezzano, whom we discussed above, the other parts of the work have a style that is in line with the Florentine painting culture of the 1280s. The "ornate" exuberance of the painting falls well within the Coppesque taste beginning with the *Madonna del Bordone* from 1261: the throne is in effect closely related, in appearance on the right structure and decoration, to that of the Sienese panel, while the deep folds of the drapery of the characters in the lower scenes are reminiscent of those to be found on the dossal in Vico l'Abate; on the other hand, the variety of facial features of the painted *Apostles* on the frame could not be more Coppesque than they are. We may also place the collaboration by Coppo in the mosaic decoration of the vault of the Florence Baptistery, particularly in the grandiose scene of the *Last Judgment*, in the pauses during his stay in Pistoia. The far from secondary role played in the development of the young Cimabue and the influence exercised by Coppo over the main cultural areas of central Italy are indicative of the historical importance of his art, which still awaits the full recognition it deserves, partly hindered by the uncertainties that remain in the precise critical definition of the catalog of the paintings attributable to him.

Angelo Tartuferi

Opposite:
Mosaic decoration of the segment of the vault with the depiction of Hell, complete.

Below and on the following pages:
Two details of the *Last Judgment* on the vault of the Baptistery of St. John.

Cimabue and the "proto-Giottesques"

One of the main points of reference for the activities of the Florentine painters already active or undergoing training in the mid-13th century—including, as we have seen, Coppo di Marcovaldo himself—was Giunta Pisano. Studies in recent years have underlined the importance of the renewal in a neo-Hellenistic sense in which the great artist was a major player in the 1340s: his direct knowledge of the flourishing miniated production of the *scriptoria* of the Crusader Kingdoms of Palestine, together with his revival of the Byzantine classicism of the 10th and 11th centuries, enabled Giunta to propose a language of great emotional impact that was to influence the main cultural areas of the peninsula.

Among the leading Florentine artists who were already active in the mid-century, we must certainly count the so-called Maestro della Sant'Agata, given this name on account of the processional standard preserved in the Museo dell'Opera del Duomo in Florence,

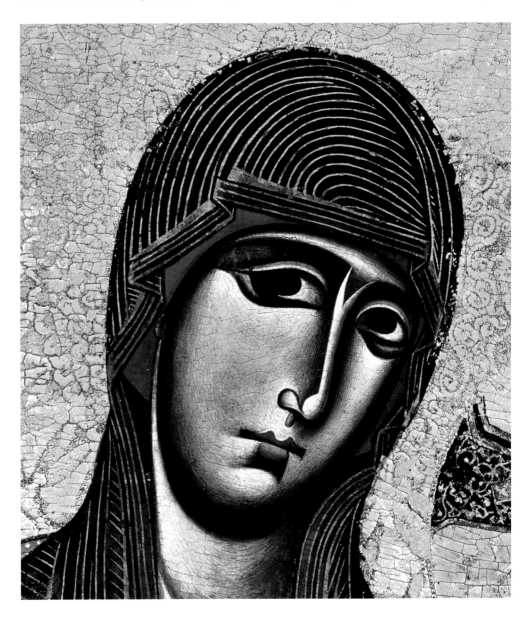

Maestro della Sant'Agata, *Virgin in Majesty*, detail with face of the Virgin. Church of Sta. Maria del Carmine, (Brancacci Chapel).

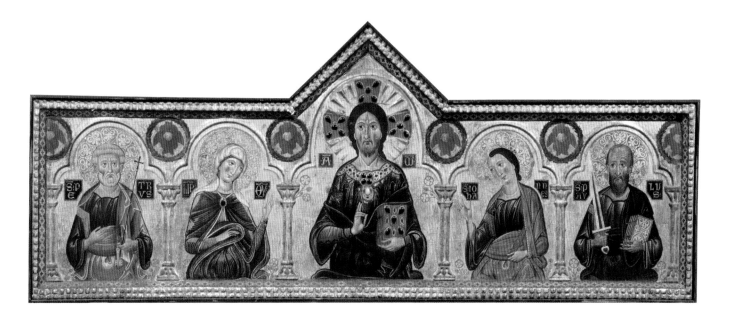

which in fact depicts this saint, painted approximately 80 years later, also on the rear, by Jacopo del Casentino. On the basis of its style, the large fragmentary *Madonna in Majesty* on the 18th-century altar of the Brancacci Chapel in the church of Sta. Maria del Carmine in Florence is certainly attributable to this powerful and original painter, undoubtedly the most acute and orthodox Florentine interpreter of the Byzantine-like stylistic elements of Pisan origin. Painted in all likelihood about 1270 for the high altar of the Carmelite basilica, which was founded in those years, this genuine masterpiece of Florentine pre-Giottesque painting has been recovered excellently by the restoration work carried out in the mid-1980s.

Some years ago I highlighted the relationship of stylistic affinity that exists between some parts of Cimabue's *Crucifix* in the church of S. Domenico in Arezzo—particularly the mourners on the side panels—and the work of the Maestro della Sant'Agata. Today I am even more convinced that the young Cimabue had a lively interest in the solitary and incisive language of this unknown artist, who must probably have appeared more congenial to him compared with the overly forced expressiveness of Coppesque paintings. The key importance of this artist would then be decisively confirmed if the thesis were proven—a thesis that is also plausible in stylistic terms—that the works of his later life are recognizable in the works until now attributed to the so-called Maestro del Crocifisso di S. Miniato al Monte, who is in fact the author of the cross preserved in the splendid Florentine basilica, and whose work has definitely been identified in some parts of the mosaics of the Baptistery vault. Another top-level figure active on the Florentine artistic scene during the third quarter of the century

was the Maestro di Sta. Maria Primerana, the painter of an intense *Madonna with Child Enthroned and Two Angels*, preserved in the oratory of the same name overlooking the Cathedral square in Fiesole, which from the stylistic standpoint betrays a direct knowledge of the neo-Hellenistic phase of Giunta at the time of the cross by him now in the Museo Nazionale di S. Matteo in Pisa. The Giuntesque elements appear particularly evident in some works that are certainly attributable to his hand, such as the small portable *Crucifix* painted on both sides, belonging to the Cini Collection in Venice—often mistakenly attributed to Giunta himself—or the attractive tabernacle with doors conserved in the Princeton University Art Gallery. The early works of Meliore di Jacopo, one of the characteristic representatives of Florentine painting culture of the second half of the 13th century, are also under the influence of the Maestro di Santa Maria Primerana. The pleasant narrative vein that characterizes all of his activity, also sustained by a healthy eclecticism, is fully grasped in the dossal of the parish church of S. Leolino in Panzano (Greve in Chianti).

In the central part, the figures of SS. Peter and Paul are pressed protectively close around the *Madonna with Child*, austere and captivating at the same time, while at the two ends we see four episodes relating to the saints represented: on the left, the *Liberation of St. Peter from Prison* and the *Crucifixion of St. Peter*; on the right, the *Conversion of St. Paul and the Regaining of his Sight* and his *Martyrdom*. The well known dossal in the Uffizi Gallery in Florence, on the other hand, signed "MELIOR ME FECIT" and dated 1271, depicting *Christ Blessing*, with the *Virgin, St. John the Evangelist, St. Peter*, and *St.*

Meliore di Jacopo, *Christ with the Virgin, St. Peter, St. Paul, and St. John the Evangelist*, dossal signed and dated 1271. Uffizi Gallery.

Maestro del Crocifisso di S. Miniato al Monte, *Painted Cross*. Church of S. Miniato al Monte.

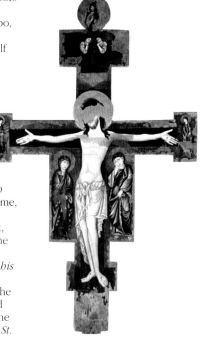

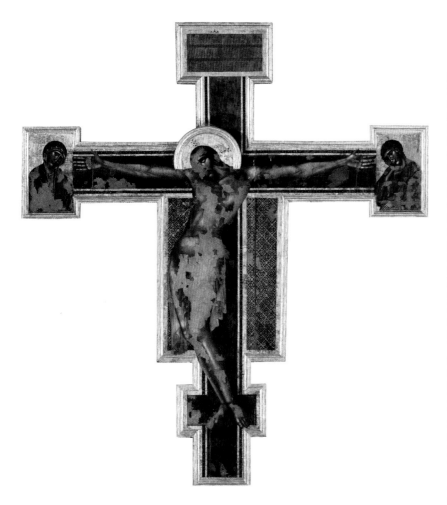

Paul at the sides, relates to the painter's mature
phase. The refinement in the execution of the
work—in particular the rich decoration of the
haloes, with the incision and the graining of
the gold priming, executed freehand—is also
found in a small group of paintings that were
originally distinguished from Meliore's catalog
and attributed to the "Maestro di Bagnano," but
that in reality are the work of the same artist—
as indicated for the first time by Roberto
Longhi—in a stylistic phase that should be close
to that of the execution of the dossal of the
Uffizi. It is also necessary to underline the
typological importance of the Florentine
example, one of the oldest rectangular dossals
with a pointed central part extant today, the
prototype of a genre that was to be much
repeated in Florence. It is likely that the
Florentine painter—identifiable as the *Meliore
dipintore, populi Sancti Jacobi tra le fosse*
("Meliore [Best] Painter, of the Parish of St.
Jacob between the Ditches"), mentioned in
1260 as being among those who were
supposed to fight in the battle of Montaperti—
was mainly active from 1260 to 1280.

The artist's late works should account for the
fragmentary panel in the Museo d'Arte Sacra in
Tavarnelle Val di Pesa (Florence), attached to
the parish church of S. Pietro in Bossolo, but
originally from the nearby oratory of S. Michele
in Casaglia. The painting clearly documents
Meliore's aware and growing proximity to the
art of Coppo, in what was now the mid-1270s,
as would seem to be indicated by the rather
elongated proportions of the Madonna and the
intense pictorial vivacity of the two angels,
while the figure of the Child seems embossed
in the metal. In any case, in the light of this
significant stylistic evolution on the painter's
part, we must, in my view, take account not
only of the likely influence of Coppo, but also
of possible reminders of the work of the
Maestro della Sant'Agata, as we seem to be able
to note from the pathetic gauntness in the
Madonna's face. Meliore's eclectic and
captivating style—characteristic of a "middle-of-
the-road master," to use the apt expression of
US scholar Edward Garrison—contributed, in
tune with the prolific production of the Maestro
della Maddalena, to establishing the more
traditional and folk-art-inspired thread in the
Florentine painting of the 1270–90 period,
which had considerable importance in the
formation of the younger artists. In the current
state of our knowledge, it has not been
possible to find any reminder in the work of
others in the 13th-century Florentine artistic
world of the influence of the activity of Cenni
di Pepo, better known by the nickname of
Cimabue, that is commensurate with the fame
and prestige that shines through from the early
sources concerning the leading Italian painter
of the 13th century. In all likelihood, he was
born in Florence, in around 1240, and had to
learn his trade in the Coppesque cultural
environment, but not without paying great
attention to the more explicitly Byzantine-
influenced artistic tendency represented by the
Maestro della Sant'Agata, as already mentioned.
Nevertheless, the grandiose development of his
extraordinary personality is only explained in
the light of a much more open and ramified
training. It is no coincidence, therefore, that the
first of the few extant documentary records
concerning him sees him present in Rome, on
18 June 1272 as a witness to a notarial act,
probably when he was no longer in the prime
of youth. The significant presence of the
Dominicans as witnesses to the aforementioned
act leads us to suppose that the renowned
artist's Roman stay was associated with
decorative work for this order; however, there
is an equally reliable alternative hypothesis that
Cimabue was working in the Papal city for the
powerful Orsini family, who in all likelihood

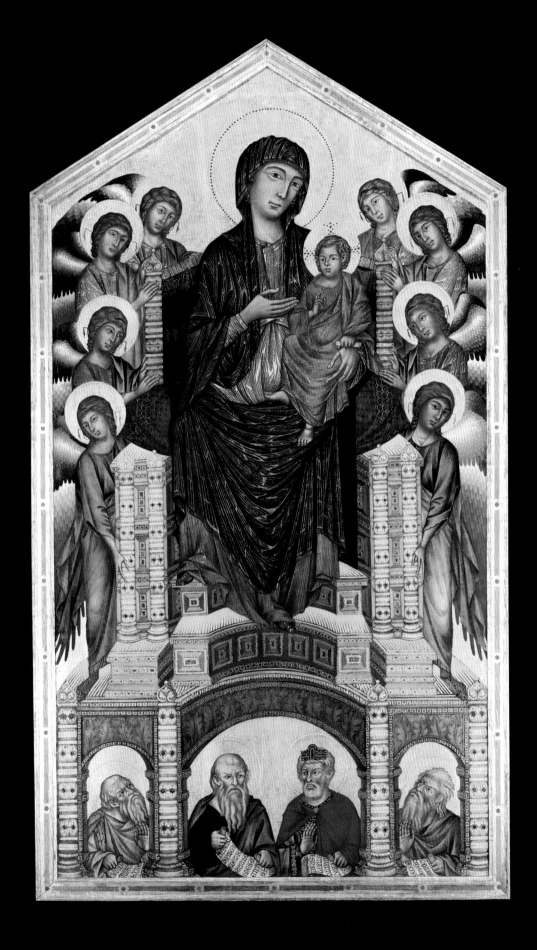

were also involved in the prestigious commission regarding the frescoes on the cross-vault and in the transept of the upper church of St. Francis in Assisi. Remembered from the beginning of the 14th century—through Dante's famous *terzina* (*Divine Comedy, Purgatory,* XI, 92–97) and from contemporary sources—as Giotto's teacher and precursor, it was probably Cimabue himself who introduced the young man from the Mugello into the 13th-century Roman artistic environment and also, as appears equally likely, to the site in Assisi that was to become so fundamentally important. As most of the Florentine works cited by the sources have been lost, the oldest to have reached us—after the superb specimen in the church of S. Domenico in Arezzo—is the other painted cross in the Museo dell' Opera di Sta. Croce. Irreparably damaged during the flood of 1966, this grandiose and solemn work had perhaps already been painted at least ten years earlier when in 1288 the Luccan painter Deodato Orlandi executed a faithful interpretation, which is to be found in the Museo Nazionale of Villa Guinigi in Lucca. The Florentine crucifix is characterized above all by an extraordinary naturalistic softness of modeling—the Christ shows an anatomical definition that was to remain unsurpassed until the work by Giotto in Sta. Maria Novella—and by a highly dramatic interpretation of pain. Nevertheless, Cimabue's most important Florentine work to have reached us is undoubtedly the powerful *Madonna in Majesty*, today in the Uffizi Gallery (inv. 1890 no. 8343), originally from the church of Sta. Trinità in Florence, belonging to the order of Vallombrosans. After the restoration of the work, carried out in 1992–93, it appears even more difficult to separate the painting from the stylistic phase of the frescoes in Assisi, with a dating that is hard to place after 1285. The powerful architectural structure of the throne is presented on the same axis as the painting, in a position of absolute frontality, with the unforgettable figures of the prophets Jeremiah, Abraham, David, and Isaiah placed with extraordinary naturalness at the base of the panel, almost as though they were lodged under the vault of a Romanesque crypt. A similar naturalness is also found in the eight angels that are pressed close to the serene divine group, almost clutching the robust frame of the throne. A masterpiece of this caliber cannot have failed to arouse a huge echo from the Florentine artistic world of those years, also by virtue of its prestigious destination. Indeed, significant reminders of the strong expressive Cimabuesque accents can be distinctly seen in some of the main protagonists of the Florentine

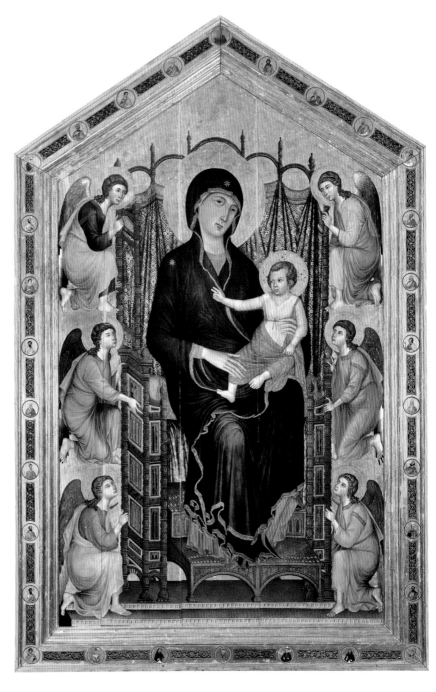

artistic scene. The prolific Maestro della Maddalena—so-called because of a panel of his depicting *St. Mary Magdalene and Eight Scenes from her Life* (Florence, Galleria dell'Accademia, inv. 1890 no. 8466)—the owner of one of the most established workshops of those open in Florence, in the years between about 1265 and 1290, also betrays interesting traces of the influence of Cimabue's art in some works from his mature period.

Duccio di Buoninsegna, *Virgin in Majesty* (from the Rucellai Chapel in the church of Sta. Maria Novella). Uffizi Gallery.

Opposite:
Duccio di Buoninsegna, *Virgin in Majesty* (from the Rucellai Chapel in the church of Sta. Maria Novella), detail with adoring angel. Uffizi Gallery.

Pacino di Buonaguida,
Tree of the Cross.
Galleria dell'Accademia.

earlier personalities of Florentine painting known to us, namely the Maestro di Rovezzano and the Maestro del Bigallo. In the works belonging to his earliest phase of activity—such as the dossal in the Yale University Art Gallery in New Haven with the *Madonna with Child Enthroned between SS. Leonard and Peter and Six Scenes from the Life of St. Peter* (inv. no. 1871.3), or the tabernacle with doors in the Metropolitan Museum of Art, New York (inv. no. 41.100.8)—the painter already shows certain salient characteristics of his language in a clearly defined way: the draperies of the figures are furrowed with deep channels that have clear plastic effects, as well as determining the chromatic layout in rigorously delimited zones, with accents that are

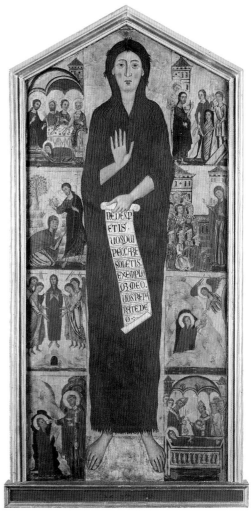

In the past, scholars have expressed diverging opinions regarding the critical definition and the overall evaluation of the activity of this important artist. There has been an attempt on the part of those who wish to play down his role in the development of Florentine painting of the period even to place his historical identity in doubt, attributing his paintings to various painters, also emphasizing the presumed artisanal character of this work. Yet it appears very difficult to deny the stylistic originality of the Maestro della Maddalena, certainly executed by a single personality, who ran one of the most important and well organized workshops in Florence at the time, in which there must have been no shortage of trusted collaborators capable of handling the huge demand for work, judging from the quantity of paintings that have reached us: the largest known to us in the sphere of Italian painting of the 13th century. A workshop also committed to satisfying the demands of a new secular and bourgeois clientele to an ever-greater degree, proved significantly by the frequent appearance in his works of the figure of the donor, a detail that was still relatively unusual for the period. The early works of the Maestro della Maddalena are dated to the sixth decade of the century, as part of a tendency to revive formal themes that were characteristic of the

Maestro della Maddalena, *St. Mary Magdalene and Eight Scenes from her Life.* Galleria dell'Accademia.

reminiscent of stained-glass window techniques. From its first years of activity, the workshop of the Maestro della Maddalena played a key role in disseminating the use of newly conceived "altaroli," small portable altars, that were to meet with considerable success in the last quarter of the 13th century and in the early years of the following one, and also new and unusual artistic manufactured articles, such as painted caskets. If the unknown artist seems to reflect the tense and impassioned language of Coppesque culture in the works that are datable in stylistic terms to the 1270s, in the paintings belonging to the later phase, about 1280, he demonstrated that he also knew how to interpret some inspirations of a Cimabuesque mold in an original way. In the splendid dossal of the Musée des arts décoratifs in Paris, in fact, the Maestro della Maddalena sets out the group of main protagonists decisively and with considerable moral authoritativeness, revealing an overt interpretation of certain formal themes—particularly in regard to features and spatial aspects—from the altarpiece of Cimabue for the church of Sta. Trinità.

Manfredino da Pistoia, *Christ in Glory among Angels*, detail. Pistoia, church of S. Bartolomeo in Pantano.

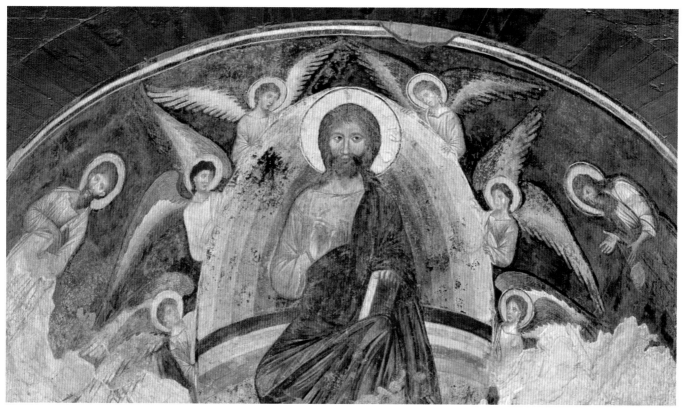

Among others, the eponymous painting in the Galleria dell' Accademia in Florence—the finest example of the fresh narrative and chromatic vein of this captivating artist—and the highly vivid *St. Luke the Evangelist with Two Donors Praying at his Feet* in the Uffizi Gallery in Florence are from the works of the artist's full maturity. It is important to point out not only the full importance of the far from secondary role played by the Maestro della Maddalena in the formation of the main proto-Giottesques, but also the significant influence exercised by him over the other Florentine artists considered closest to the Cimabuesque cultural mold operating in the last quarter of the century, starting with Corso di Buono, cited in a Florentine document from 1295 as "rectore pictorum," known above all for the frescoes in the former church of St. John the Evangelist in Montelupo Fiorentino depicting the *Blessing Redeemer between Two Cherubim* and two *Episodes of St. John the Evangelist*, signed and dated 1284. As already mentioned, the painter must have been trained in the circle of the Maestro della Maddalena, as can be deduced from the altarpiece with the *Madonna with Child Enthroned between Two Angels and Two Saints* in the church of St. John the Baptist in Remole, not far from Florence, which also documents Corso's interest in the use of bright and varied colors. The various reds that appear in the painting express a highly structured range of tones: from dark and intense on the Madonna's gown—which appears similar to that of the *maphorion* (veil)—to garish on the garment of the Child, which is repeated identically on the cushion of the throne, to that of the curtain on the back, a light red that fades tenderly into pink.

Yet the inclusion of this artist by current opinion within the Cimabue circle—he was defined very appropriately by Roberto Longhi as "an intelligent parallel" of Cimabue—is justified above all by the frescoes in Montelupo, in which his adherence to the methods of the great Florentine movement leader appears very marked indeed, although the strong dramatic charge that characterizes his works is barely evoked in what is a spontaneous and calm narration, yet conducted in a pictorially vibrant way. The developments of the late activity of Corso di Buono, now at the end of the 13th century, are likely to be best recognized in an interesting and rare representation of the *Madonna of Mercy* painted on the right wall of the church of S. Lorenzo in Signa. In this work the painter now appears to be a full participant in the fervid cultural climate of transition that characterized the Florentine

painting of the last quarter of the 13th century, in parallel with the other Florentine artists whom the critics of recent years usually define as the proto-Giottesques.

The personality of the Pistoian artist Manfredino appears more closely connected to Cimabuesque culture than Corso di Buono, who, despite what is usually claimed, was subject to the ascendancy of the great Florentine painter to a more limited degree. Manfredino d'Alberto, "pictor figurarum de Pistorio"—as he is called in a Genoese document from 1293—is mentioned in documents from his city in 1280 and 1291. He was trained mainly by reference to the noteworthy examples of Coppesque culture in Pistoia, to become subsequently one of the most convinced and attentive interpreters of Cimabuesque figurative culture; in the final phase of his activity, he was also not insensitive to the traces of Duccesque influence that interfered considerably in the Florentine artistic panorama of the 1285–95 decade. In the fresco of the bowl-shaped vault of the apse of the church of S. Bartolomeo in Pantano in Pistoia, with the *Christ Pantocrator between SS. Bartholomew and John the Baptist*, which should belong to a rather advanced phase of his career path, Manfredino offers us one of the supreme, most captivating examples of the spreading of Cimabue's language, marked above all by his original use

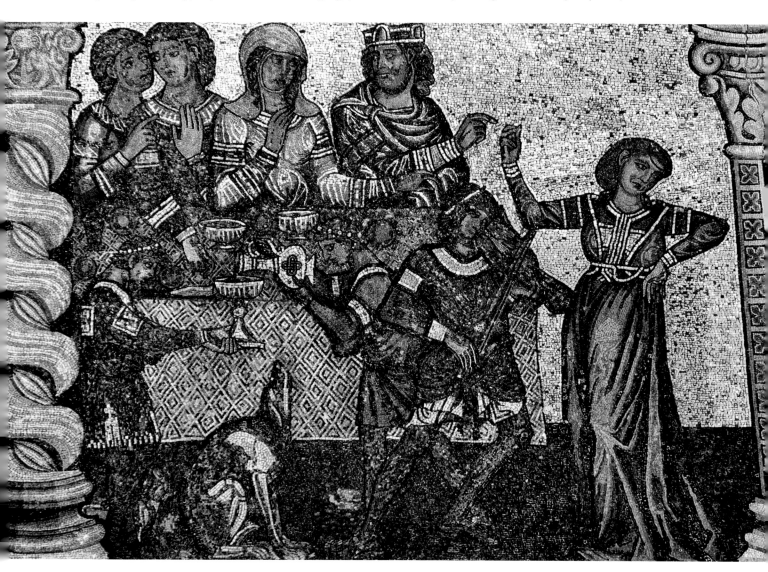

of colors. The Pistoian fresco is linked, through evident stylistic comparisons, with the panel in the church of Sant'Andrea in Mosciano (Florence) depicting the *Madonna with Child Enthroned and Two Angels*, the attribution of which is rather controversial, but which should nevertheless document the considerable impact of Duccesque culture on the final period of his activity. The scholars have long indicated the so-called Maestro di

San Gaggio—so-called from a *Madonna with Child Enthroned and Four Saints* conserved in the Galleria dell'Accademia in Florence, but coming in fact from the Convent of S. Gaggio— as one of the leading protagonists of

Florentine painting of the last 20 years of the 13th century and the very early years of the following one. The artist has been plausibly identified in recent years as the painter Grifo di Tancredi, mentioned in Florentine documents from 1295 and 1303, whose fragmentary signature has been read on a tabernacle with doors in a private English collection, which is certainly referable on stylistic grounds to the Maestro di S. Gaggio. The profile of his activity, as reconstructed to date, certainly appears to be among the most exemplary in terms of summarizing the Florentine painting culture of the age, since it allows us an insightful glimpse of the passage from the cultural beginnings of the local tradition, represented by the flourishing workshop of the Maestro della Maddalena— the environment in which Grifo must have been trained—to the fascinating elements of Cimabuesque origin, then followed by the unequivocal signs of precocious and aware adhesion to the earlier innovations proposed by the young Giotto. Among the main examples of this mature period of Grifo di Tancredi, we must cite the panel in the Galleria dell'Accademia in Florence, which we have already mentioned, in which the structure of the throne decorated with Cosmati-style motifs has now taken on a 14th-century scope, or else the surviving fresco passages in the old Chapel of S. Giacomo in Castelpulci (Florence), in which the painter appears to be in tune with the fundamental innovations proposed on the site of the upper basilica of St. Francis in Assisi.

Nevertheless, one artist included among the leading artistic personalities and those of the highest quality in this crucial period of transition between Cimabuesque culture and the progressive affirmation of the new Giottesque language is certainly the author of the mosaic showing the *Coronation of the Virgin* located in the lunette above the main door in the counterfacade of the Cathedral of Sta. Maria del Fiore in Florence, attributed by Vasari without hesitation to Gaddo Gaddi, father of the famous 14th-century painter Taddeo. Vasari's identification is not supported by any reliable data, but scholars have for some time linked the mosaic with certain works associated by a clear stylistic affinity: I am referring, for example, to certain mosaic scenes of the *Life of Christ (Slaughter of the Innocents, Dance of Salome, St. John the Baptist in Prison, Healing of the Paralytic, Last Supper,* and *Capture of Christ)* on the vault of the Florentine Baptistery, or the *Madonna with Child Enthroned and Two Angels* in the church of S. Remigio in Florence, attributed in

Gaddo Gaddi (attributed), *Coronation of the Virgin with Angel Musicians,* mosaic on the counterfacade. Cathedral of Sta. Maria del Fiore.

the past to Cimabue's workshop and even to
the young Duccio di Buoninsegna.

Above all, these works have in common the
strong design layout and the particular
interpretation of Cimabue's language that is
grafted onto a more traditional cultural
foundation linked primarily with the Maestro
della Maddalena, as appears particularly
evident in the *Madonna* of S. Remigio.
However, in the multifaceted Florentine artistic
panorama of the late 13th century,
characterized by extraordinary cultural vitality,
there was no shortage of other artistic
personalities who appeared even more
decisively oriented toward the "new art." One
of these was certainly the so-called Maestro di
Varlungo, the author of the fragmentary
Madonna with Child in the church of St. Peter
in Varlungo, just outside Florence. It was
Roberto Longhi who first underlined the role
of this precocious and original supporter of
Giotto's very early activity, in all probability
during the last decade of the century, and
perhaps even in the first years of the following
one. Nevertheless, even in the panel in
Varlungo there is no shortage of consistent
references—particularly in the fresh vivacity of
the characters and the bright coloration—to
the fundamental cultural tradition of the
Maestro della Maddalena. Toward the middle
of the last decade of the century, the concrete
influence of the earliest examples of Giotto's
work is found unequivocally in the *Madonnas*
in the parish churches of Romena and Stia, in
the Casentino region. In these paintings the
Maestro di Varlungo appears as a singular
alter ego of the young Giotto, interpreting his
oldest specimens, only documented today by
the fragment in the parish church of Borgo S.
Lorenzo (Florence), in very original forms,
almost "frozen" and knowingly archaic in style.
In a possible further phase of his career path,
in paintings that could also be his—unless
they are by another, different personality—
such as the *Madonna with Child Enthroned
and Two Angels* in the Metropolitan Museum
of Art, New York (inv. no. 49.39) or the dossal
with *St. Michael the Archangel and Four Saints*
in a private collection in Rome, the Maestro di
Varlungo—if it is really he—goes decisively
further in his allusions to the new culture of a
Giottesque mold. Of no less importance,
furthermore, is the likely participation of the
Maestro di Varlungo in the final phase of the
mosaic decoration of the vault of the
Florentine Baptistery, as has recently been
hypothesized by the critics. And in this last
fundamental enterprise, in the parts executed
at the very end of the 13th century, the
participation of another great anonymous

personality of the Florentine art of this period
must be highlighted, namely the so-called
"Ultimo Maestro del Battistero" (Last Master of
the Baptistery); besides executing some of the
Life of Christ, he is the author in particular of
some of the first scenes (*Joseph Tells of his
Dreams*; *Joseph Seeks his Brothers*) and the last
three of the narrative cycle devoted to Joseph,
the favorite child of the patriarch Jacob.

This was a highly gifted artist, distinguished
firstly by his strong propensity for naturalistic
research, who very willingly included motifs of
explicit classical derivation in the architectures
he imagined and in the decorative structures of
his stories. What is also astonishing is the
extraordinary naturalness with which he
defined the human figure in its physical-plastic
aspects, in the wider context of a style
characterized by great ease and narrative clarity,
which suggests an interesting comparison with
the author of the mosaic of the *Coronation of
the Virgin* on the counterfacade of the
Florentine Duomo, mentioned above. But this
painter of rank is now placed directly in
relation to Giotto's work of the same time, from
the *Madonna in Majesty* in S. Giorgio alla Costa
(today in the Museo Diocesano of Santo
Stefano al Ponte in Florence) to the polyptych
of Badia (Florence, Uffizi). The recovery in
relatively recent years of the extraordinary
fragment of *Madonna in Majesty*, today
preserved in the parish church of S. Lorenzo in
Borgo S. Lorenzo (Florence), demands to be
viewed as an event of exceptional historical
importance. This precious figurative fragment is
the earliest panel painting by Giotto that has
reached us, or at least to have been identified
as such. Its historical importance can never be
emphasized enough, since it documents, in the
heart of the Mugello, Giotto's native land, and
at the same chronological moment, the
revolutionary language of the well-known
Scenes of Isaac and the other frescoes with
episodes from the Old Testament in the first
bay of the upper basilica of St. Francis in Assisi.
In the past the undersigned has seen fit,
especially on the basis of this extraordinarily
evocative Mugellan fragment, to underline the
local roots of the art of Giotto, who, according
to some documents discovered in recent years,
had to move to Florence with his family at an
early age, to live in the parish of Sta. Maria
Novella, where his father worked as a
blacksmith. From a careful in-depth analysis of
Giotto's early activities, there are clear signs to
justify the view of there being a deep bond on
the part of the great master with the flourishing
13th-century artistic tradition of his home town.

Angelo Tartuferi

From Giotto to Late Gothic

The absolute primacy of Giotto in decisively promoting the complete renewal of the figurative language of the age was recognized, as is known, by the artist's own contemporaries, with testimonials of great historical and literary significance: from the very famous one by Dante Alighieri in around 1310—"Credette Cimabue nella pintura / tener il campo, e ora ha Giotto il grido, / sì che la

fama di colui è scura" [Cimabue thought he held the field in painting, but now the hue and cry is for Giotto, and the other's fame is dulled] (*Divine Comedy, Purgatory* XI, 94–96)—to that by Giovanni Villani from around 1340: "The most sovereign master to be found in the painting of his time, and the one who drew most naturally every figure and action." Giotto di Bondone—who is almost unanimously credited with the renewal in a 14th-century direction not only of Florentine painting, but also of Italian art in general—gained his first figurative experiences in the 13th-century Florentine tradition, as is documented above all by the fragment of a *Madonna in Majesty* from the parish church of Borgo S. Lorenzo. During his formidable career, Giotto was able to make his activity known well beyond the city walls, always working on highly prestigious projects. Indeed, he painted in the Basilica of St. Francis in Assisi, at the time the most important church in Christendom; he worked in Padua, in the Chapel of Enrico Scrovegni, the richest, most influential merchant in the city; in Rome he painted the polyptych of the high altar and frescoed the Cappella Maggiore of the old Basilica of St. Peter in the Vatican; in Naples, where he is documented as having been present from December 1328 to July 1333, he executed many frescoes for Robert of Anjou, while he was summoned to Milan to work for the ruler of the city, Azzone Visconti. In Florence there are two works in particular that testify to Giotto's new language in its initial phase, founded upon the recovery of a naturalistic vision and the cohesive spatial organization of people and objects. I am referring to the stupendous painted *Crucifix* in the church of Sta. Maria Novella and to the *Madonna with Child Enthroned and Two Angels* painted for the church of S. Giorgio alla Costa (Florence, Museo Diocesano), where Ghiberti—the most important and authoritative source for 14th-century painters—refers to a panel by Giotto. No less important is the polyptych that was originally on the high altar of the church of Badia (Florence, Uffizi), characterized by a language now completely renewed in a 14th-century direction, which was to be at the basis of subsequent developments in Florentine and Italian painting. Immediately after his return to Florence, following his stay in Padua from 1303 to 1305, he probably created two works of great beauty—the *Crucifix* in the church of S. Felice in Piazza in Florence and the very famous *Ognissanti Madonna* (Florence, Uffizi), in which the representation of the Madonna takes on an extraordinary, entirely material earthly clarity,

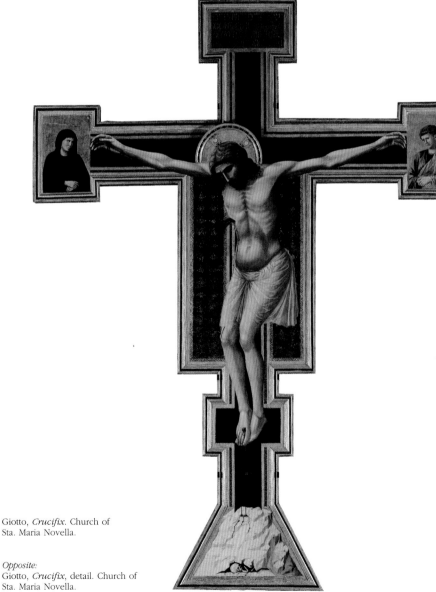

Giotto, *Crucifix*. Church of Sta. Maria Novella.

Opposite:
Giotto, *Crucifix*, detail. Church of Sta. Maria Novella.

120

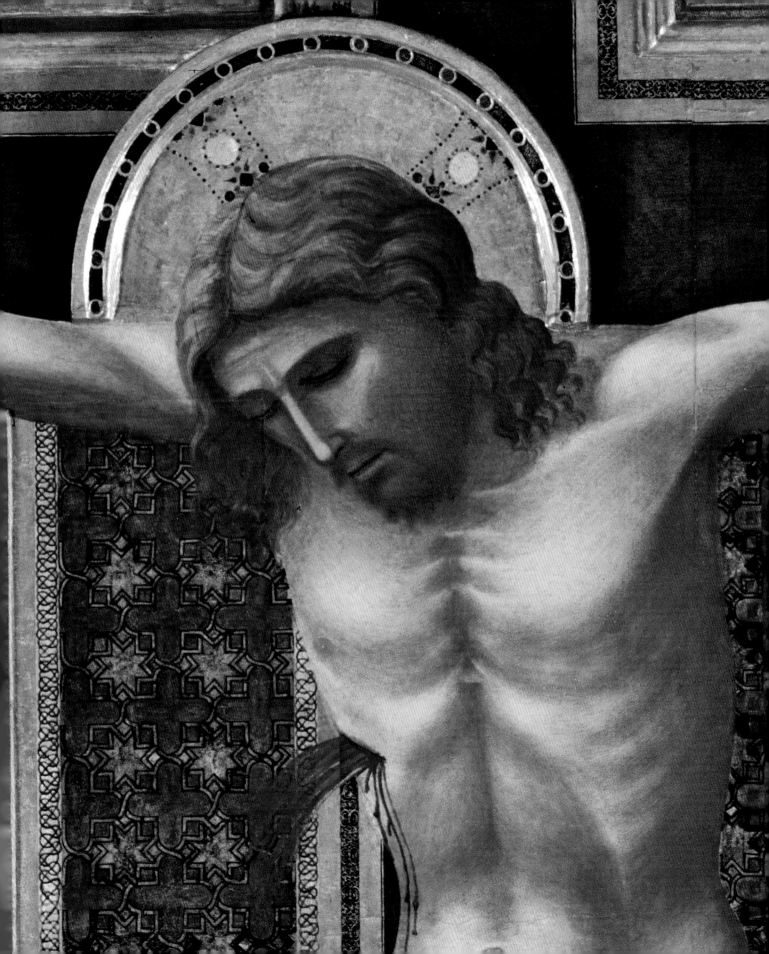

which must have impressed the artist's contemporaries to no small degree.

In 1311 Giotto is once again documented as having been in Florence, where his presence was attested to again in 1313 and in 1315. Certain works of great importance in the stylistic development of the great Florentine master can convincingly be placed in this period, such as the prodigious fragments of a stained-glass window (Florence, Museo di Sta. Croce) only recently identified by scholars, the solemn and

The artist worked above all on the project for the bell tower of the Duomo—which is in fact known as "Giotto's" bell tower—the construction of which was begun on 18 July 1334. According to Ghiberti, Giotto also worked sculpting the reliefs on the lower part of the bell tower, which depict *Biblical Episodes* and *The Works of Man*, but if anything the artist only supplied the designs. On 8 January 1337 (1336 in the Florentine calendar), Giotto died in Florence, "and was

Giotto, Polyptych of Badia. Uffizi Gallery.

refined *Dormitio Virginis* in the Gemäldegalerie in Berlin and, probably, the much damaged frescoes of the Peruzzi Chapel in Sta. Croce in Florence. The large polyptych with the *Coronation of the Virgin among Saints and Angels* positioned as originally on the altar of the Baroncelli Chapel in Sta. Croce, is likely to be from prior to his departure for Naples in 1328. Among the later works executed by Giotto in Florence, we can list, in all probability, the frescoes in the Bardi Chapel in the Franciscan basilica in Florence, in which the painter once again tested his abilities with the *Scenes from the Life of St. Francis*, many years after working on the frescoes of the upper church of St. Francis in Assisi. On 12 April 1334, Giotto was appointed by the Commune as "magister et gubernator" of the cathedral worksite and all the civil construction works, which is a testament to the huge prestige that he enjoyed not only with his fellow citizens, but also all over the country.

buried by the Commune in Sta. Reparata with great honors" (Giovanni Villani, *Cronica*, c. 1340). The first and greatest Florentine follower of the master may be considered to be the so-called "Maestro della Santa Cecilia"— who was almost certainly his contemporary and in practical terms followed his whole career in parallel—that is, as the fascinating anonymous author of the dossal depicting *St. Cecilia Enthroned and Eight Scenes from her Life* (Florence, Uffizi), datable to the very early years of the 14th century. He was in all likelihood the only one of Giotto's collaborators in the execution of the frescoes of the *Franciscan Legend* in the upper church of St. Francis in Assisi to have been convincingly identified. The Maestro della Santa Cecilia—who is certainly to be considered one of the greatest personalities of the Florentine painting of the first half of the century—was active until the third decade, yet his close adherence to Giottesque culture is manifested essentially in the earliest period of

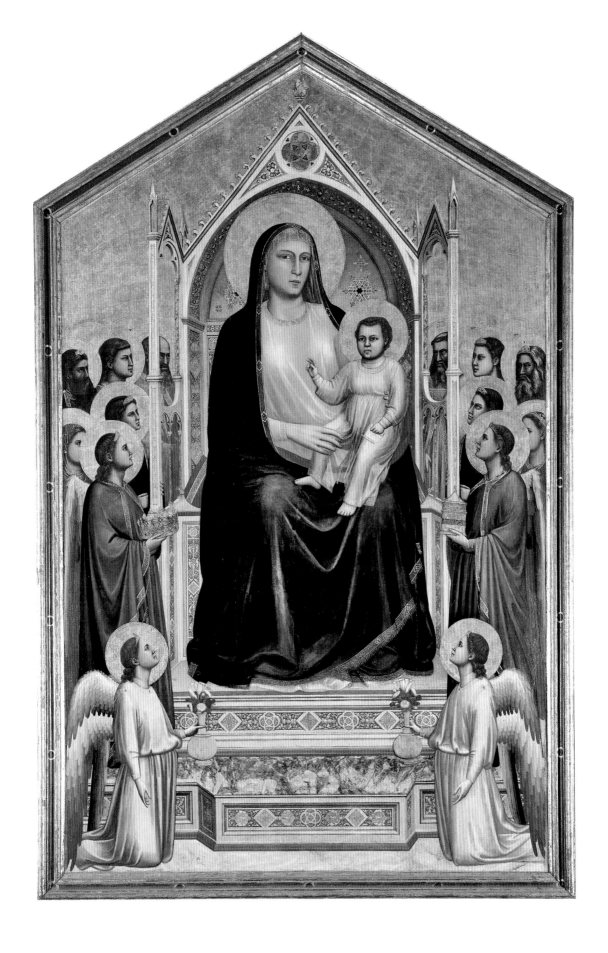

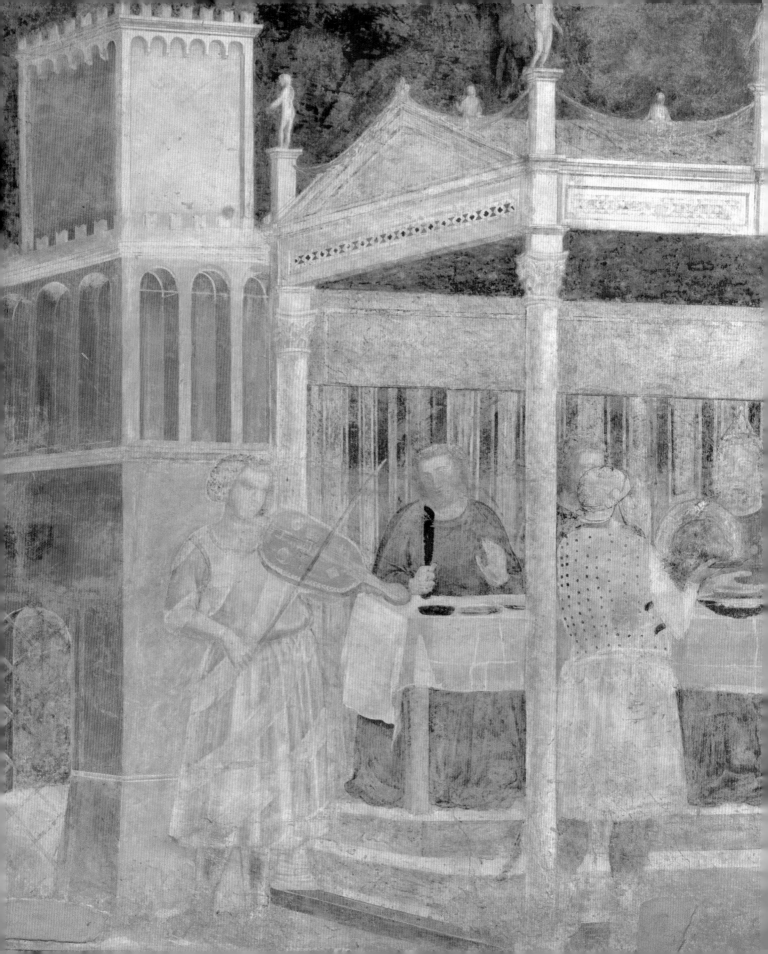

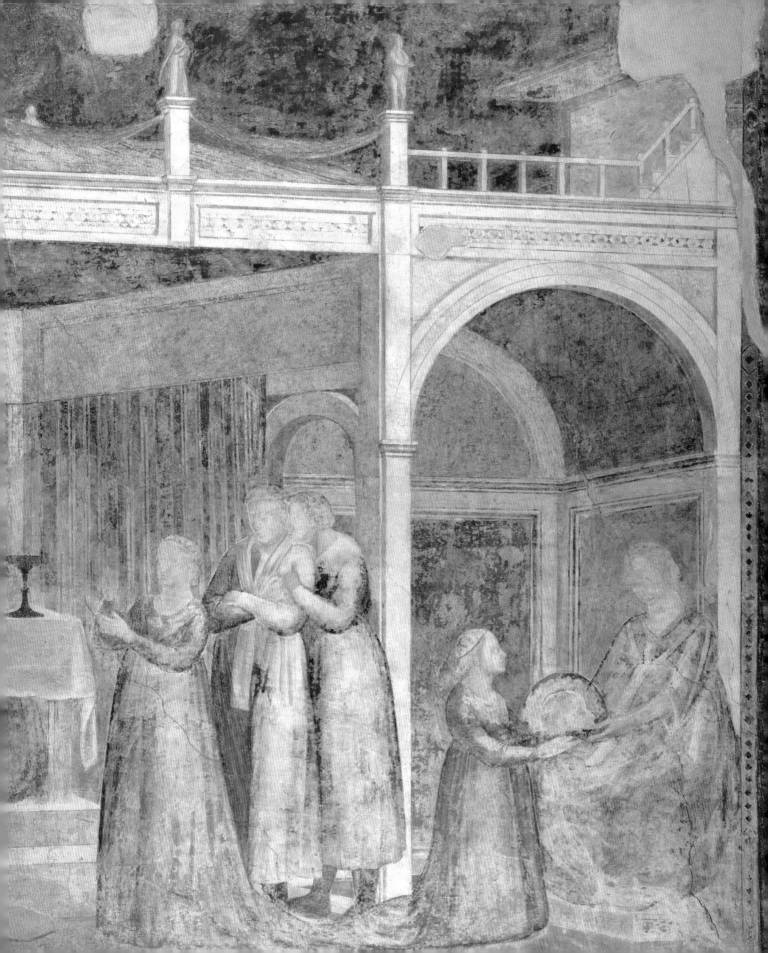

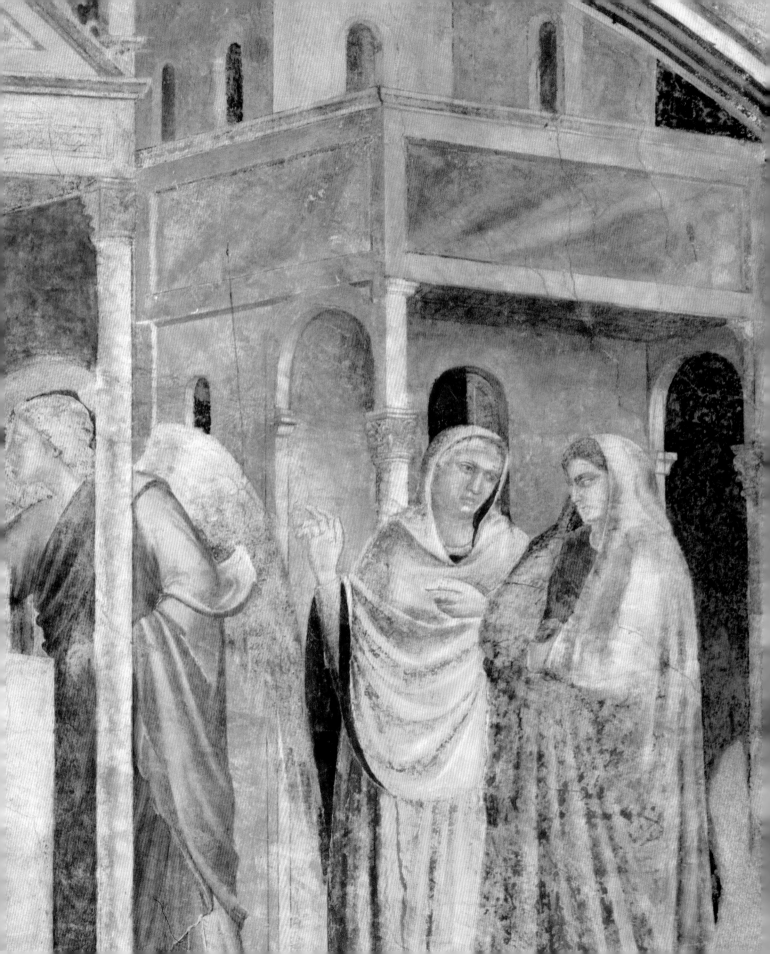

his activity, as is attested to by the other dossal with *St. Margaret and Scenes from her Life* and by the *Madonna with Child Enthroned and Two Saints*. Both paintings are conserved in the church of Sta. Margherita a Montici in Florence.

Among the oldest and most original interpreters of early Giottesque Florentine culture we must cite Lippo di Benivieni, he too a contemporary of Giotto, already mentioned as an established master painter in a document

Florence, which is differentiated very significantly from the fundamental Giottesque prototype of Sta. Maria Novella. The painters mentioned so far have been the focus of the more recent studies devoted to the paintings of 14th-century Florence, and indicated particularly as the main exponents of a hypothetical alternative tendency to that of the great Florentine movement leader. These artists were placed together by the renowned US scholar Richard Offner within a "miniaturistic

Opposite:
Giotto, *Annunciation to Zacharias*, detail. Basilica of Sta. Croce (Peruzzi Chapel).

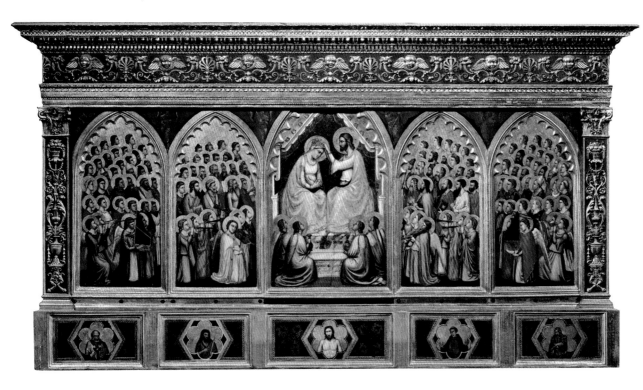

from 1296. Active until the third decade of the 14th century, the artist nevertheless always remained faithful to a passionate and strongly pathetic narrative language rooted in the 13th century. A figure who in many ways is still mysterious is that of the Maestro di Figline, another with great individuality, who has been identified by some critics as Giovanni di Bonino, an artist active particularly in the field of stained-glass windows, and a native of Assisi. The exquisite works of this artist, characterized by an extraordinarily refined design, are nevertheless also found in Florentine territory and in places of great prestige: the wonderful altarpiece of the Collegiate Church of Figline Valdarno, from which he was given his name by the critics, and the *Crucifix* hanging over the high altar in the church of Sta. Croce in

tendency," so-called to underline their predilection for representations with reduced formats. The critical concept of "Giottesque dissidents" has been introduced into the literature of art in more recent years. Like every other conventional definition, these too have many aspects that are both negative and even partially misleading on the plane of historical-critical judgment. Indeed, we have already seen how the leading representative of this team of artists—the so-called Maestro della Sta. Cecilia—was in reality one of the most genuine and aware followers in the earliest period of Giottesque activity. In the light of the studies of recent decades, which have led to the Florentine 14th century becoming one of the most investigated and well-known sections of the history of art, perhaps the time has indeed

Giotto and studio, *Coronation of the Virgin among Saints and Angels*. In the predella, *Vir dolorum* between four saints. Basilica of Sta. Croce (Baroncelli Chapel).

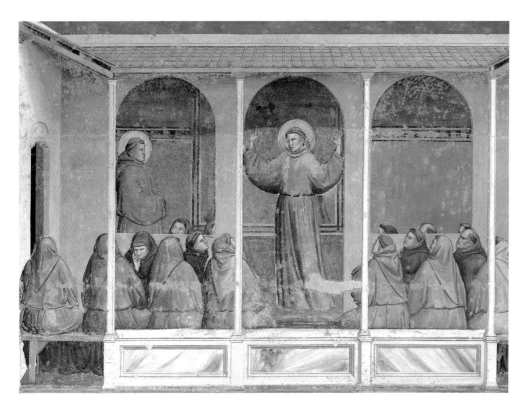

Opposite:
Giotto, *St. Francis Renounces his Worldly Goods*, detail. Basilica of Sta. Croce (Bardi Chapel).

Giotto, *Apparition of St. Francis at Arles*. Basilica of Sta. Croce (Bardi Chapel).

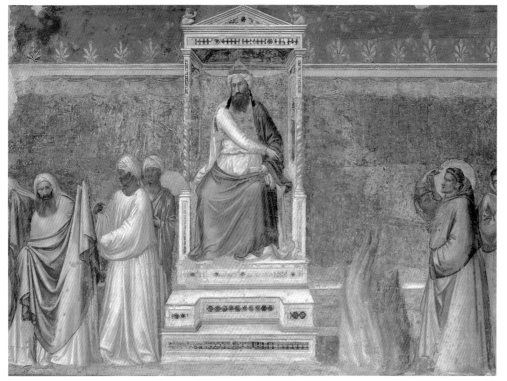

Giotto, *Trial by Fire Before the Sultan of Egypt*. Basilica of Sta. Croce (Bardi Chapel).

On the following pages:
Maestro della Sta. Cecilia, *St. Cecilia Enthroned and Eight Scenes from her Life*. Uffizi Gallery.

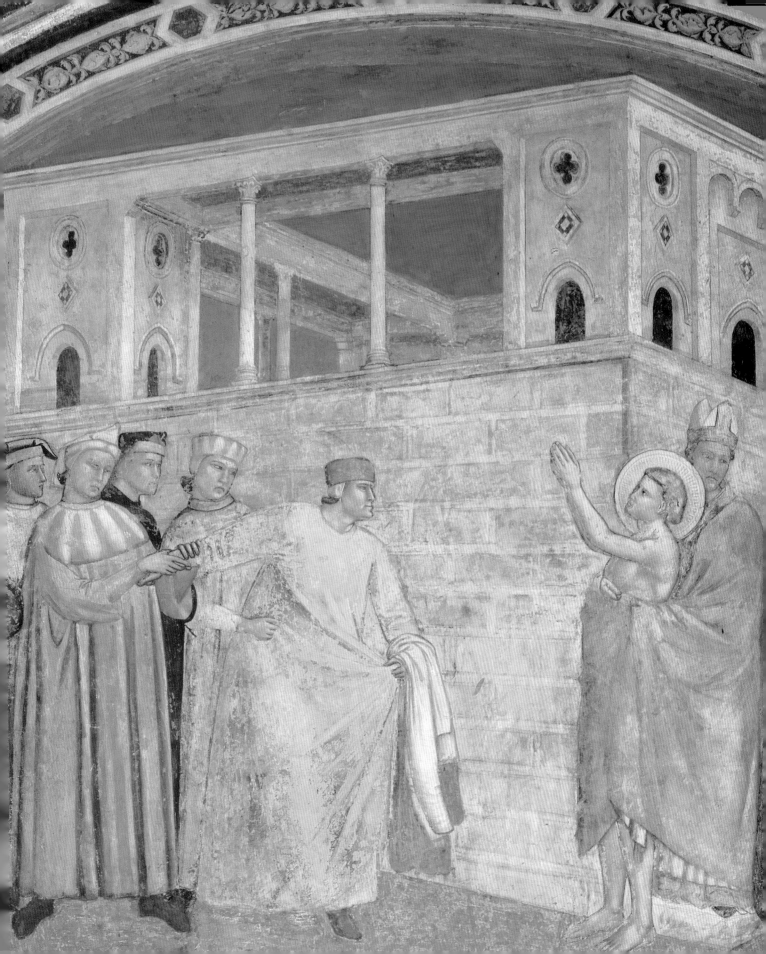

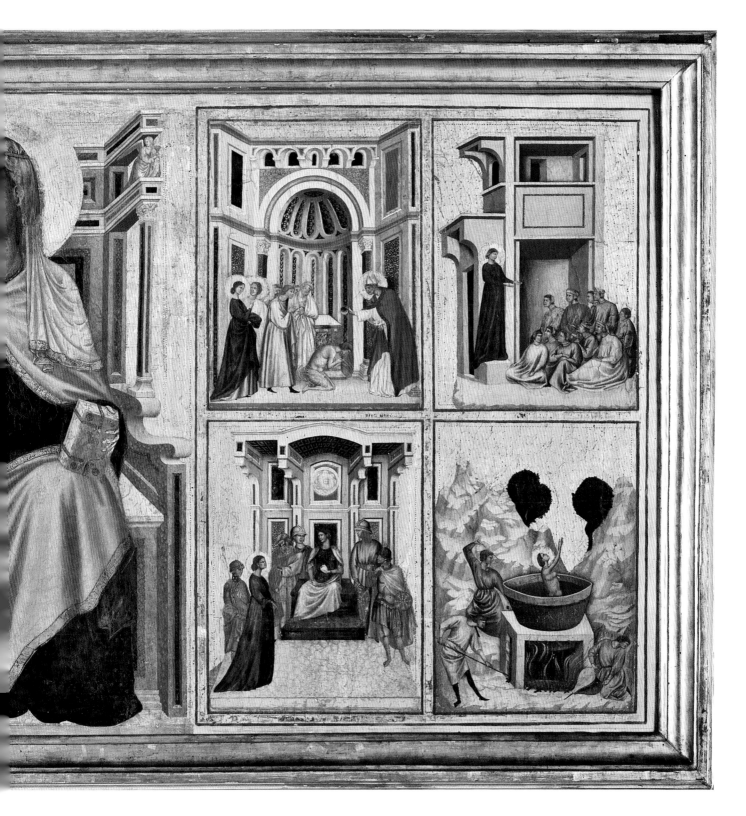

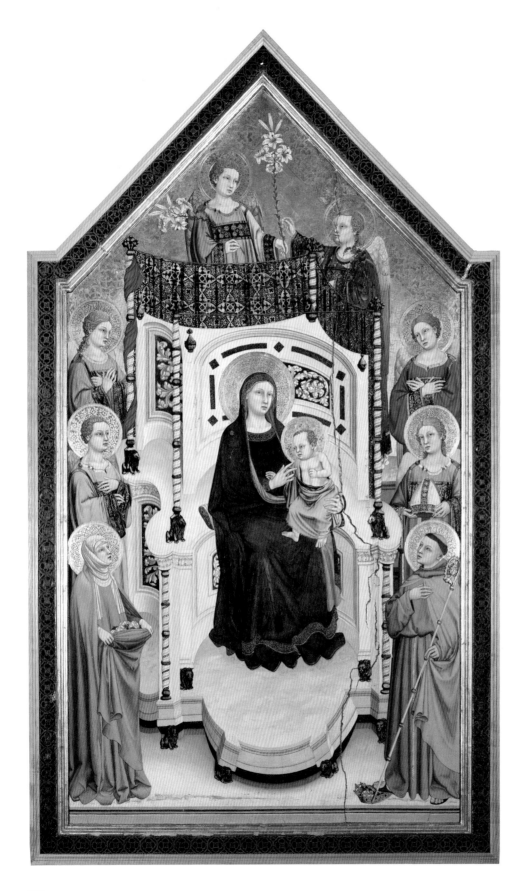

Maestro di Figline, *Virgin with Child among Two Saints and Six Angels.* Figline Valdarno (Florence), Collegiate Church of St. Mary.

Opposite:
View of the frescoes on the left wall of the Baroncelli Chapel, in the Basilica of Sta. Croce.

On the following pages:
Taddeo Gaddi, four polylobate panels with the *Scenes from the Life of St. Francis.* Galleria dell'Accademia.

Bernardo Daddi, *Madonna with Child Between SS. Matthew and Nicholas.* Uffizi Gallery.

Bernardo Daddi, portable triptych. Museo Bigallo.

Bernardo Daddi, *Birth of the Virgin.* Uffizi Gallery.

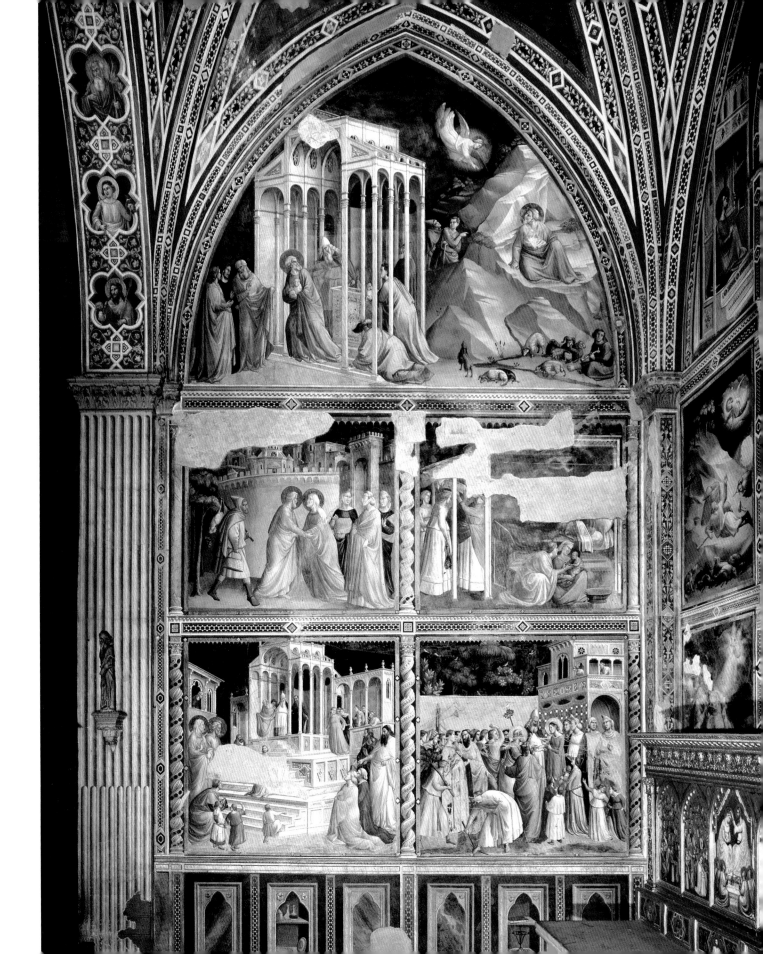

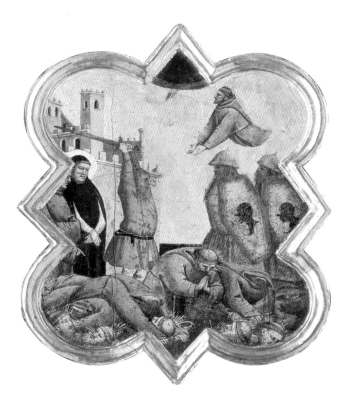
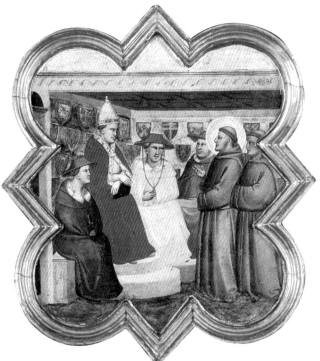
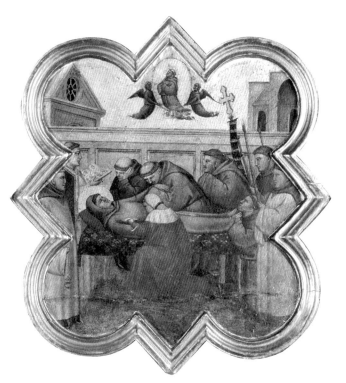

come to recognize—in the presence of the large band of more or less important painters active on the Florentine artistic scene of the first half of the century—the prophetic validity of the comment made many years ago by Roberto Longhi: "the only Giottesque in the 14th century was Giotto himself".

Early sources indicate that the authentic heir to Giotto is the Florentine painter Taddeo Gaddi—son of the painter Gaddo di Zanobi Gaddi and father of the well-known artist Agnolo Gaddi. Giotto was godfather to Taddeo Gaddi, who worked in the Master's workshop for 24 years, according to Vasari. The frescoes in the Baroncelli Chapel in Sta. Croce showing the *Scenes from the Life of the Virgin*, executed about 1327 or a little later, illustrate at the same time both the extent of Taddeo's commitment to Giottesque figurative canons and his ability to experiment with bold new spatial and chromatic solutions. The artist's special propensity to investigate acutely the recovery of space in painting is confirmed by what is probably to be considered Gaddi's masterpiece from among his extant works, namely the *Scenes from Job* frescoed in Pisa's monumental Camposanto (Cemetery). The artist died in 1366, having managed to propose his schemes of direct Giottesque derivation in an artistic environment that was now dominated by the Orcagna brothers and their followers. Yet a prominent position among Giotto's Florentine followers is certainly occupied by Bernardo Daddi, who was active from the second decade

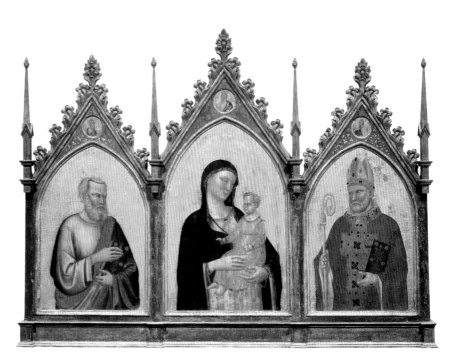

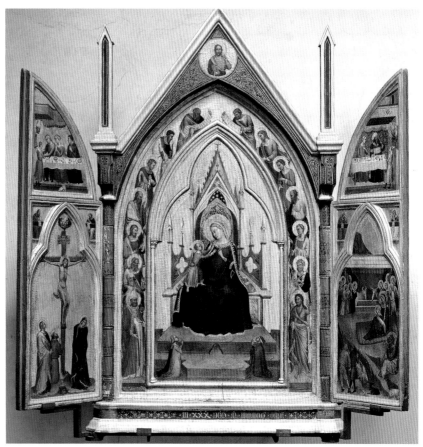

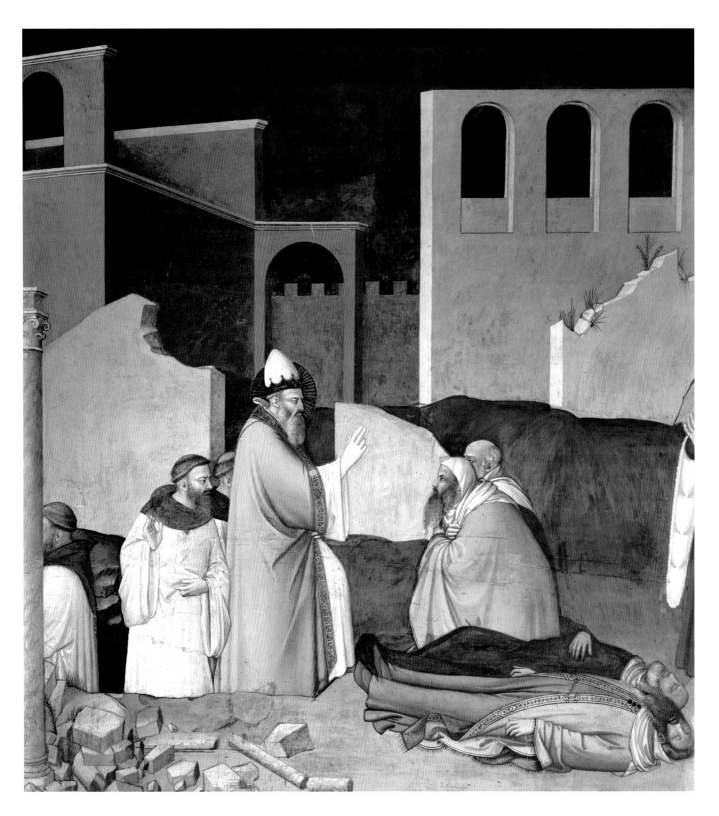

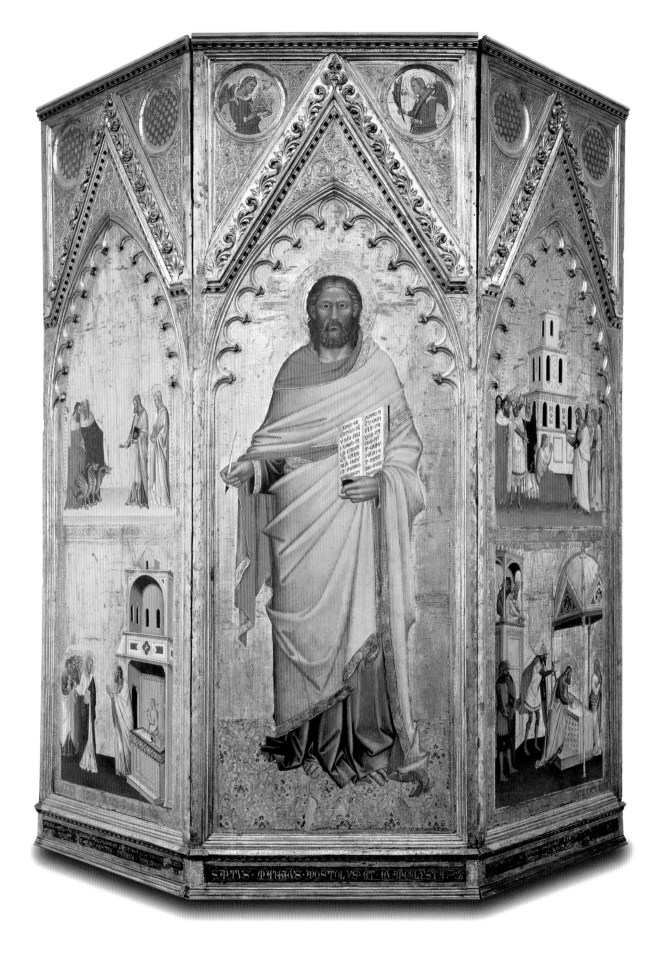

SANTVS MATHEVS APOSTOLVS ET EVANGELISTA

of the century and almost certainly died during the terrible plague epidemic of 1348.

The volume of work associated with the artist is almost certainly the most sizeable to have survived, as regards the painters of the 14th century. Daddi was met with unconditional acclaim by his contemporaries, yet the critical judgment of modern scholars diverges significantly from this view. The painter's profound adhesion to Giottesque culture is at the basis of the frescoes in the Pulci-Berardi

as is the *Madonna in Majesty* (1347) in the church of Orsanmichele in Florence.

In contrast, very few works have reached us of another follower of Giotto, cited in highly laudatory terms by Lorenzo Ghiberti in his *Commentaries*: Maso di Banco; we must thank the research of Richard Offner above all for the reconstruction of his activities. If we carefully study the painter's frescoes with the *Scenes from the Life of St. Sylvester* in the Bardi di Vernio Chapel in Sta. Croce in Florence, we can

On the previous pages:

Maso di Banco, *St. Sylvester's Miracle*, detail. Basilica of Sta. Croce (Bardi di Vernio Chapel).

Andrea Orcagna, *Triumph of Death*, detached fresco, detail. Museo dell'Opera di Sta. Croce.

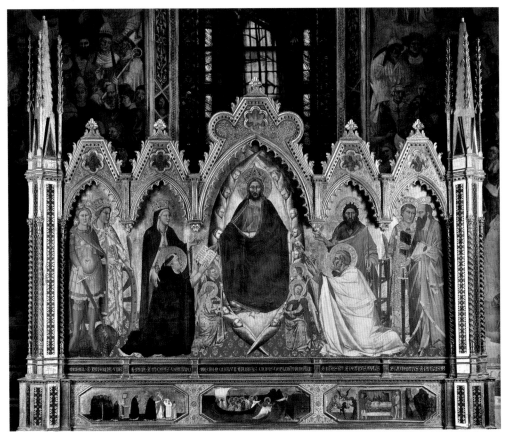

Opposite:
Andrea Orcagna and studio, *St. Matthew and Four Scenes from his Life*. Uffizi Gallery.

Andrea Orcagna, *Christ Gives the Keys to St. Peter with the Virgin, Saints, and Angels*. Church of Sta. Maria Novella (Strozzi Chapel).

Chapel in the church of Sta. Croce in Florence, from his youthful period, showing the *Martyrdom of SS. Stephen and Lawrence*, and in the austere triptych in the Uffizi Gallery in Florence with the *Madonna with Child and SS. Matthew and Nicholas of Bari*. Among his most famous works, the small portable triptych in the Bigallo Museum in Florence (1333), the grandiose polyptych executed for the Duomo in Florence (Florence, Uffizi), and the other polyptych in the Spanish Chapel in Sta. Maria Novella (1344) are at least worthy of mention,

easily ascertain that Maso was primarily interested in developing the chromatic aspects of Giotto's art and those related to the plastic relief of the human figure. The studies in recent years have identified the training of this rare artist, set slightly apart in the Florentine artistic panorama, as having taken place in a workshop close to the fundamentally important Daddo workshop, as is illustrated above all by the imposing altarpiece in the church of S. Giorgio in Ruballa (Florence), dated 1336. Knowledge about the figure of another great

On the following pages:

Nardo di Cione, *Crucifix and Saints*. Uffizi Gallery.

Jacopo di Cione and studio, *Coronation of the Virgin with Ten Saints and Two Prophets*. Galleria dell'Accademia.

Andrea di Bonaiuto, *Allegory of the Church*. Church of Sta. Maria Novella (Spanish Chapel).

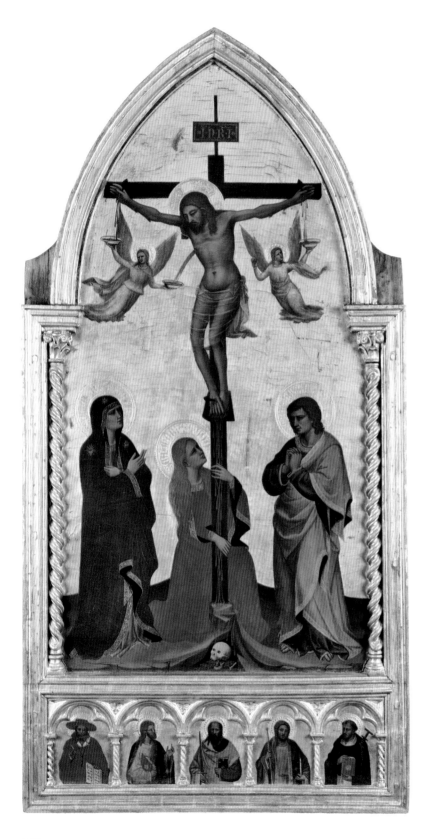

Florentine master, also praised by early sources and known through the literary citations of Boccaccio, Bonamico Buffalmacco, has only been gained relatively recently. This highly original artist with a powerfully dramatic narrative temperament has been identified as the author of the impressive cycle of frescoes in the Camposanto (Cemetery) in Pisa depicting the *Triumph of Death*, the *Last Judgment*, and the *Lives of the Holy Fathers*, today considered to have been executed in about the second half of the 1330s. Among the works that can be attributed to him with less uncertainty are unfortunately rather fragmentary remnants of the decoration of the Spini Chapel in Badia a Settimo, not far from Florence, which an inscription at the site states was executed in 1315. Among Giotto's eminent students, Filippo Villani and Lorenzo Ghiberti cite a master Stefano, perhaps the son of the painter Ricco di Lapo and Caterina, one of Giotto's daughters, and so a nephew of the great artist. And indeed an artist with this name is cited in a famous Pistoian document from c. 1347, in which the best painters active at that time in Florence are mentioned, as having a workshop with the Dominicans at Sta. Maria Novella in Florence.

In the current state of the research, there is considerable agreement among scholars in attributing the lost *Assumption of the Virgin* from the Camposanto in Pisa—which was destroyed as a result of bombing in 1943—and the frescoed *Coronation of the Virgin* in the "tiburio" (central tower) in the abbey in Chiaravalle Milanese to this mysterious artist. The Florentine phase of the activities of this elusive personality could be represented by the frescoes in the Chapel of the Annunciation in the Chiostrino dei Morti in Sta. Maria Novella in Florence, with the two majestic lunettes depicting the *Crucifixion* and the *Nativity*. These paintings, with their silent, abstract poetry—see for example the figures of the angels present in the *Nativity*—offer a synthesis at the highest level of the Florentine painting of that time, with basic cultural references to the culture of Giotto and Maso and significant traces of the influence of Nardo and Andrea di Cione. Among the very many Florentine artists active in those years, we must also mention Jacopo del Casentino, who for most of his intense activity strove to keep as closely as possible to the figurative principles of the Giottesque vision, but whose strong, kindly characters seem inspired above all by the art of Taddeo Gaddi. It was during the 1340s that the figure of Andrea di Cione, known as Orcagna, was established: painter, architect, and sculptor, he is documented from

1343 and died in 1368, undoubtedly one of the key personalities in the history of Florentine art of the 14th century.

As an architect and sculptor, his most famous enterprise is the magnificent monumental tabernacle that houses the *Madonna in Majesty* by Bernardo Daddi in the church of Orsanmichele in Florence (1352–59). Of his work as a renowned fresco painter, we must mention above all the fragmentary frescoes recovered along the walls of the aisle of the church of Sta. Croce in Florence, with the *Triumph of Death*, the *Last Judgment*, and *Hell*, attributed to him by Ghiberti and datable to about 1345. The best-known work of his mature phase is the majestic polyptych (1354–57) with *Christ Enthroned and Saints*, painted for the altar of the Strozzi Chapel in Sta. Maria Novella in Florence. Orcagna's painting is founded upon an original interpretation of Giottesque culture: his works—particularly those of his youthful period—in fact show traces of the influence of Taddeo Gaddi and, to an even greater extent, of Maso di Banco, from the point of view of spatial organization and the plastic relief of the figures. His predilection for the mainly frontal representation of the characters, his limited predisposition for spatial values, his taste for vast portions painted in rich, intense colors, are some of the characteristics of Orcagna's mature art that were to have a significant influence on the Florentine painting of the third quarter of the 14th century. Orcagna's brother, Nardo di Cione, was a member of the Arte dei Medici e dei Speziali—the official physicians' and spicemakers' guild, which at the time also welcomed painters—between 1346 and 1348; he dictated his will in 1365 and died on 16 May of the following year. The catalog of his work—based above all on the citation by Ghiberti, who definitely credited him with the frescoes of the Strozzi Chapel in Sta. Maria Novella in Florence, representing *Heaven*, *Hell*, and the *Last Judgment*—is mainly the result of the research conducted by Richard Offner. Nardo's art falls within the Giottesque tradition, with considerable affinities with the interpretation offered of it by Maso di Banco. His language nevertheless differs profoundly from the rather rough and harsh style adopted by his older brother. The artist concentrated his interest on the human figure and investigated its physiognomic and emotional features subtly and profoundly, as is splendidly documented by the fascinating gallery of portraits that is displayed on the crowded walls of the Strozzi Chapel. The challenge of representing the nuances of grief seems particularly to have involved the painter more profoundly; in this

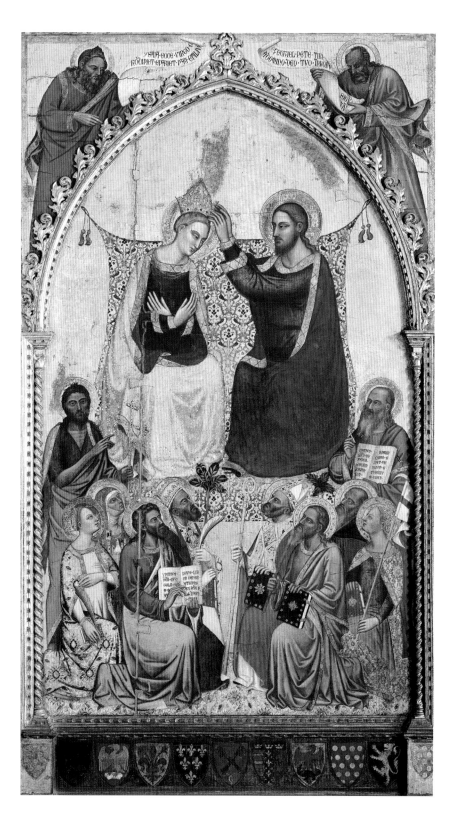

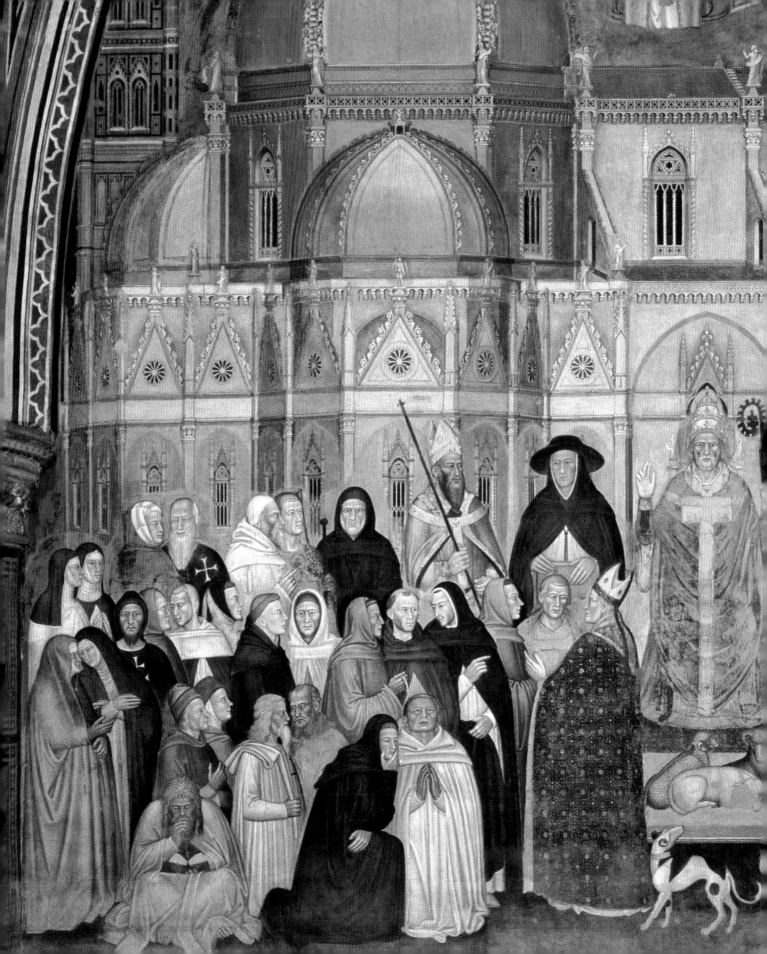

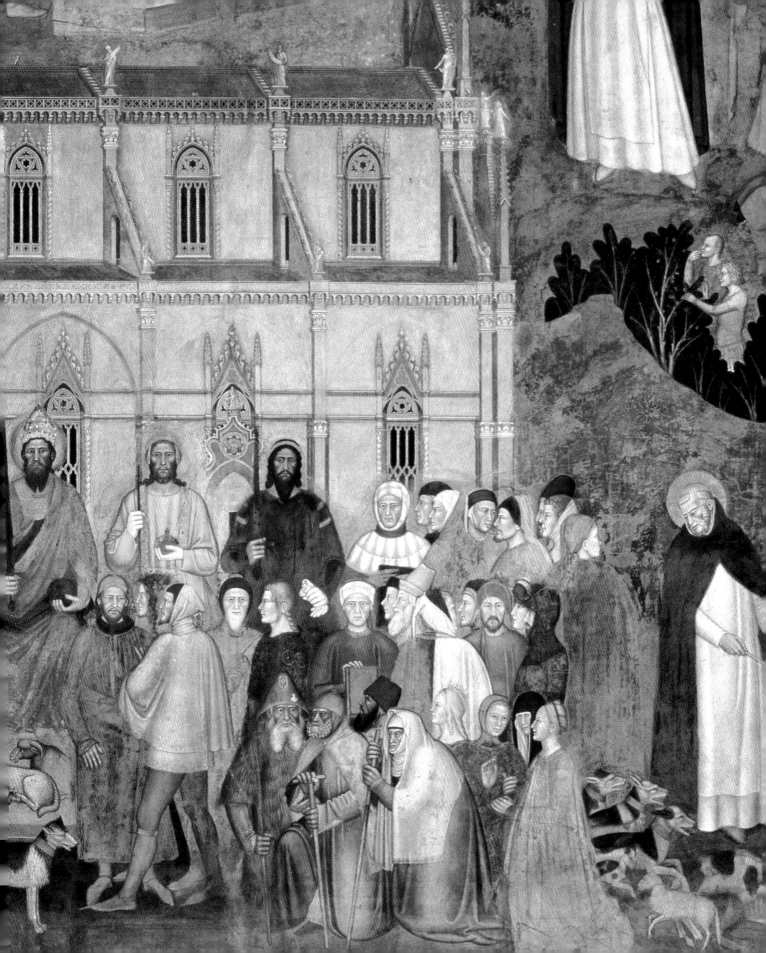

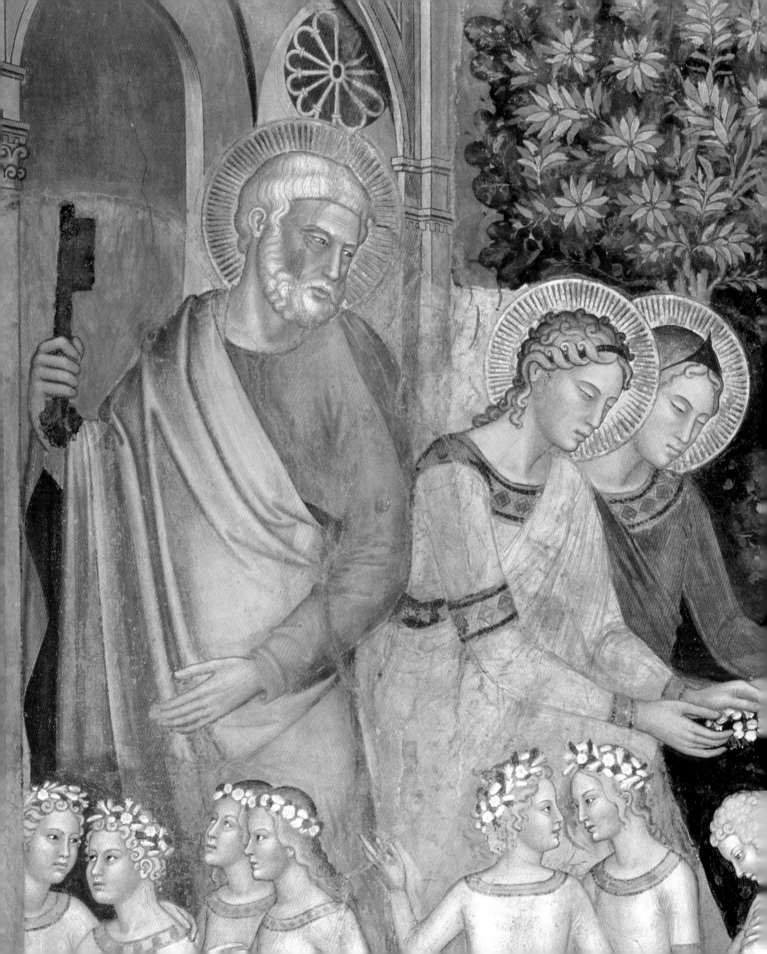

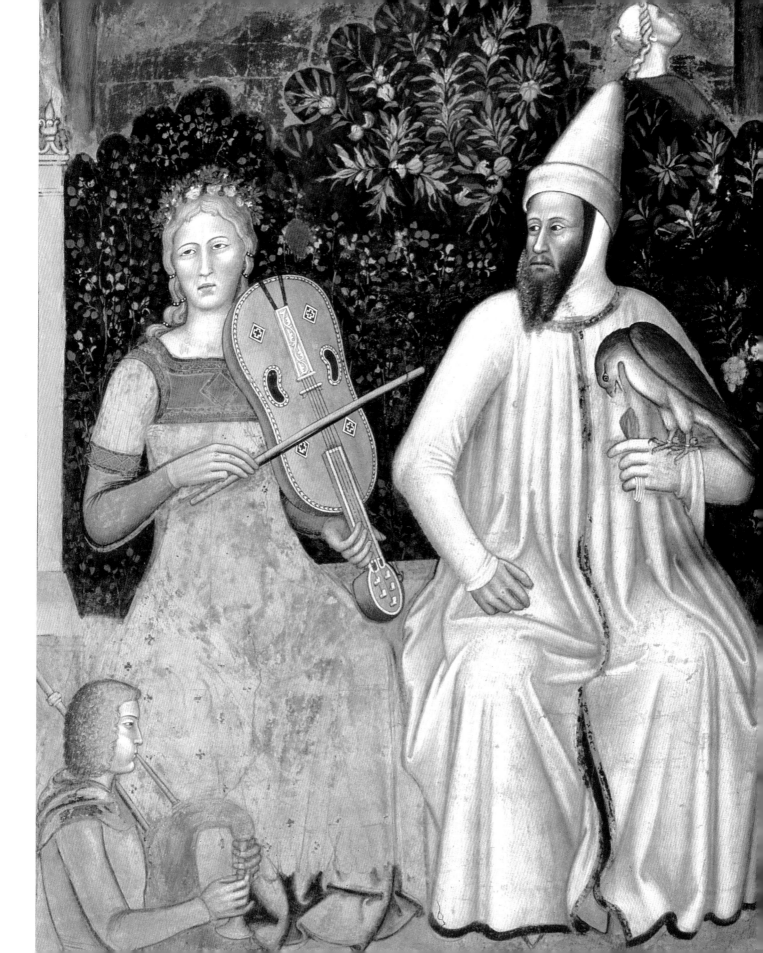

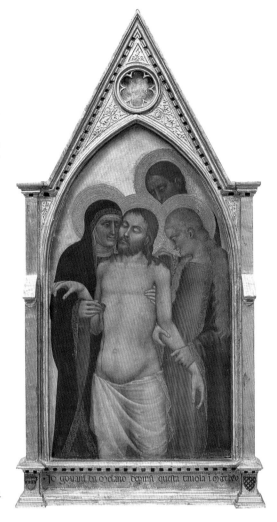

Giovanni da Milano,
Lamentation over the Dead Christ, 1365.
Galleria dell'Accademia.

imaginative *Allegories of the Dominican Order*, as well as *Scenes from the Life of Christ and St. Peter the Martyr*. Diverging considerably from the rigorous spatial division of the fresco surface imposed by the laws of the Giottesque tradition, he succeeded in unifying the decoration of the individual walls in vast compositions. These renovated compositional and spatial aspects, combined with some interesting naturalistic ideas introduced by him into panel paintings, ensured that Andrea di Bonaiuto—who nevertheless remains a background artistic personality—played an interesting role among the precursors of Late Gothic language within 14th-century Florentine painting. Very similar considerations are also merited for Niccolò di Tommaso, a collaborator of Nardo di Cione in the frescoes of the Strozzi Chapel, who was responsible for the delightful frescoes with *Scenes from the Old Testament* in the church of the ancient monastery of the Tau in Pistoia (1372), as well as some other frescoes in Florence and the surrounding area. This artist is distinguished above all for his narrative vivacity and his predilection for introducing acute observation of everyday life into his representations. Within the stylistic developments of the Florentine painting of the third quarter of the century, significant consideration is generally granted by scholars to the activities performed in the Tuscan capital by the great Lombard painter Giovanni da Milano (documented in Florence and Rome from 1346 to 1369). Though already proven to be present in Florence in 1346, his main undertaking is nevertheless dated about 1365: the fresco decoration of the Rinuccini Chapel in the sacristy of Sta. Croce with *Scenes of the Virgin and Mary Magdalene*. Compared with the very different approach that can be detected in the scenes painted by Taddeo Gaddi over 30 years earlier in the nearby Baroncelli Chapel, the Lombard painter mainly imagined his architecture parallel to the painted surface, and also marked by a sober character, even with a neo-Romanesque taste; these proved to be truly in contrast with the fantastic, tottering Gothic constructions previously imagined by his Florentine colleague. Giovanni da Milano concentrated his attention on the human figure, yet treated it in a way that we could almost define as impersonal and abstract, alien from particular investigations into emotion. These considerations seem partly contradicted, however, by the *Pietà* in the Galleria dell'Accademia, signed and dated 1365, originally from the monastery of S. Girolamo sulla Costa, in which the expressive grief of the characters seems to reach peaks of high dramatic intensity.

he often reached peaks of refined and concentrated elegance, as can be seen, for example, in the mourners and in the Magdalene at the foot of the *Crucifixion* in the Uffizi Gallery (inv. 1890 no. 3515).

The poetic language tinged with melancholy of Nardo di Cione exercised a major influence over the Florentine painters active in the third quarter of the century, indeed the fact is rightly underlined by scholars that many of the so-called "Orcagnesque" painters are more plausibly to be considered his followers. In this rapid summary we must at least recall Andrea di Bonaiuto, who was admitted into the Arte dei Medici e dei Speziali about 1346, among the many artists more or less directly orbiting the Orcagnas' entourage. This painter, with his pleasant, easy language, is known above all as the author of the vast fresco decoration of the chapter room in the convent of Sta. Maria Novella in Florence—better known as the Spanish Chapel—documented in the years 1366–68, representing complex and

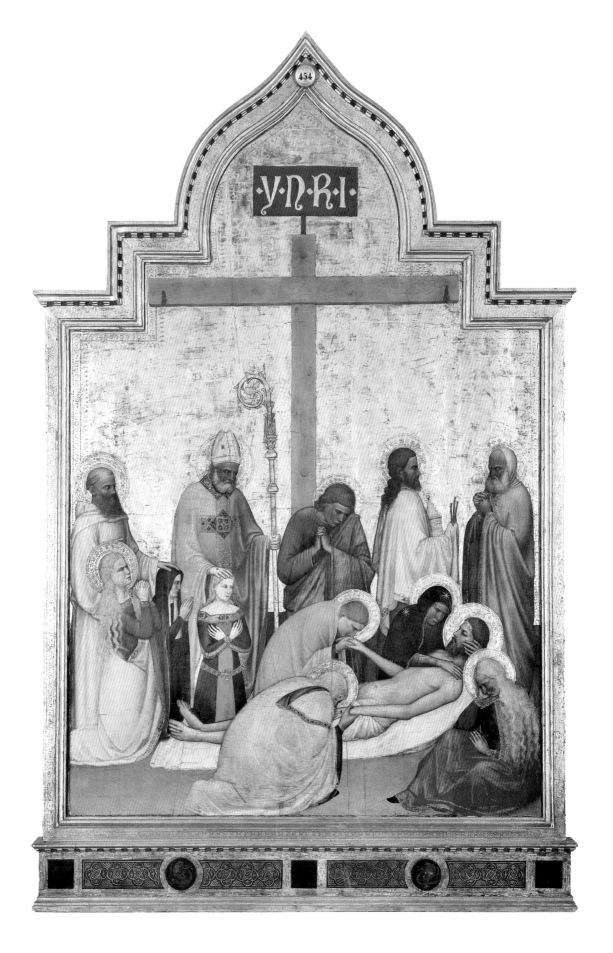

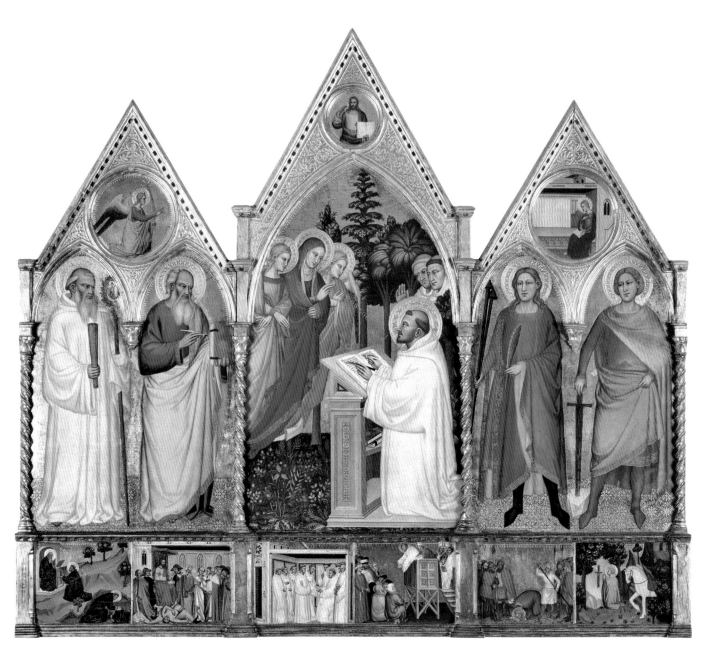

Matteo di Pacino, *Apparition of the Virgin to St. Bernard and Four Saints* (triptych). Galleria dell'Accademia.

Opposite:
Giovanni del Biondo, *St. John the Baptist and Eleven Stories from his Life.* Uffizi Gallery (donation by Contini Bonacossi).

The personality of another artist, whose image handed down to us by early sources is simultaneously flattering, confused, and incomplete, is still mostly shrouded in mystery. He is Giotto di Maestro Stefano, known as Giottino, who joined the registers of Florentine painters in 1368 and was cited in Rome the following year, involved with other artists in the fresco painting of the papal apartments in the Vatican. In all likelihood he was the son of Stefano, the nephew of Giotto di Bondone, whose life as we have seen is still without definitive clarification. In the current state of studies, only a few works are unanimously

attributed to Giottino, yet all are of high quality. The first is the intense, bright, detached fresco *Madonna with Child Enthroned with St. John the Baptist, St. Benedict and Eight Angels*, that was originally located inside a tabernacle datable in 1356 through an inscription and now positioned in the corner at the entrance to Piazza Santo Spirito in Florence.

The *Lamentation over Christ Removed from the Cross* in the Uffizi Gallery, coming from the church of S. Remigio and already highly praised in Vasari's time, is one of the greatest panel paintings in the whole of 14th-century Florence.

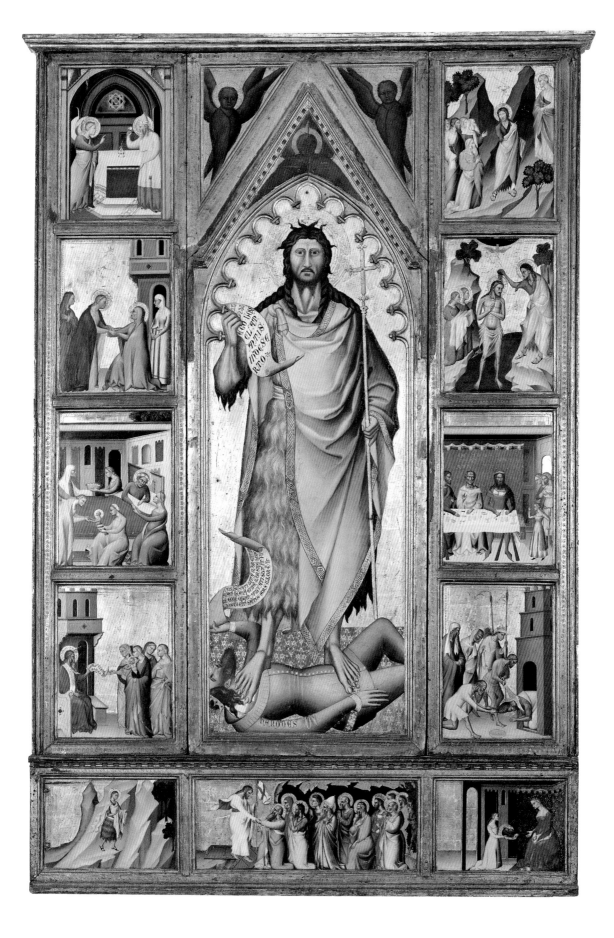

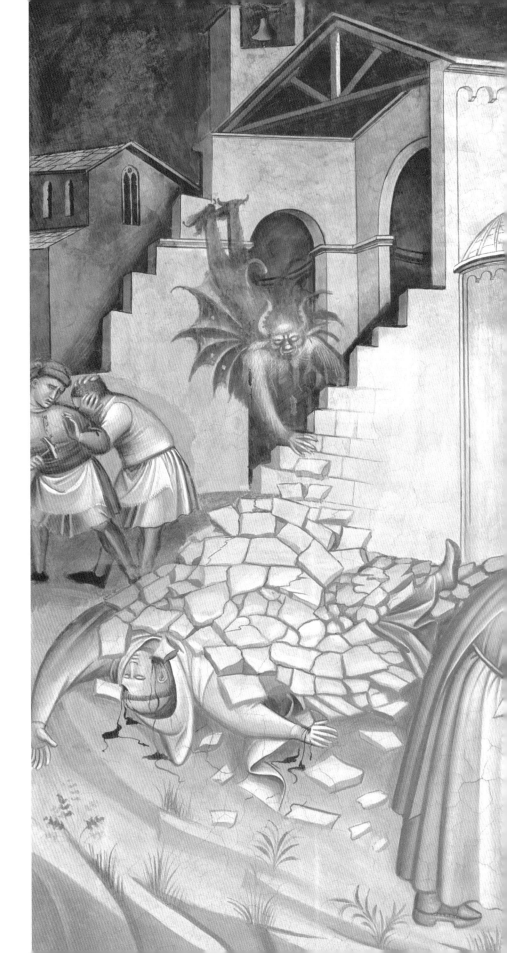

Spinello Aretino, *A Miracle of St. Benedict*, detail. Church of S. Miniato al Monte (Sacristy).

On the following pages:
Agnolo Gaddi, *Scenes of the True Cross*, detail. Basilica of Sta. Croce (Main Chapel).

150

It is especially with regard to this masterpiece that the general condemnation of the Florentine painting of the second half of the 14th century, expressed in the past, appears entirely inadequate and critically outmoded in the present.

Some parts of the frescoes of the Rinuccini Chapel, which were executed mainly by Giovanni da Milano, are by a Florentine artist identified in relatively recent years as the painter Matteo di Pacino (1359–94), who initially followed neo-Daddesque methods then moved to a convinced propagation of formulas that were more captivating on both the compositional and chromatic planes than were in vogue in the Orcagnas' workshop, as is documented by the successful triptych of the Galleria dell'Accademia with the *Appearance of the Virgin to St. Bernard with SS. Benedict, John the Evangelist, Quentin, and Galganus*, originally in the Benedictine monastery of Le Campora, near Florence.

Another interesting Florentine artist whose activities have been delineated more clearly

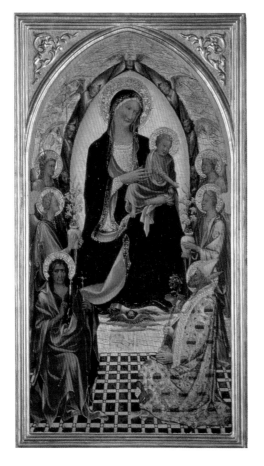

Gherardo Starnina,
Virgin with Child and Saints.
Galleria dell'Accademia.

with more recent studies is Giovanni Bonsi, documented to have been in Florence between 1351 and 1371. He too, like the vast majority of the painters working in the third quarter of the century, appears significantly associated with Orcagnesque culture, yet maintaining a strong stylistic individuality on account of his marked Gothic characterization, which in some aspects is a prelude to the activities of Agnolo Gaddi and the young Lorenzo Monaco. His main extant work is the polyptych in the Pinacoteca Vaticana with the *Madonna with Child Enthroned with SS. Onofrio, Nicholas, Bartholomew, and John the Evangelist*, signed and dated 1371. Among the personalities who most exemplify the general artistic level in the Florence of the second half of the 14th century, we must undoubtedly include Giovanni del Biondo (1356–98), whose first documented mention dates back to October 1356. In that period he was found to be collaborating as a young emerging artist with Nardo di Cione in the execution of the grandiose fresco cycle of the Strozzi Chapel in Sta. Maria Novella. The large body of paintings associated with the painter is studded with dated works, which makes the reconstruction of his career path much easier.

Among the paintings of his early adulthood that best illustrate the fundamental features of the painter's style between 1360 and 1365, we must recall the large altarpiece belonging to the Uffizi Gallery (Contini Bonacossi collection), depicting *St. John the Baptist in the Act of Crushing Herod at his Feet* at the center, the *Descent of Christ into Limbo* in the main element of the predella, surrounded by ten *Scenes from the Life of St. John the Baptist*, which originally comes from the church of S. Lorenzo in Florence. The qualitative decline that characterizes Giovanni del Biondo's late works, which ended up overly influencing the negative judgment of him by modern critics, can be grasped well in the *Madonna with Child* in the monastery of St. Francis in Figline Valdarno (Florence), signed and dated 1392: the painting documents the painter's effort to adapt his own language to suit the severe compositional and chromatic formulas of Jacopo di Cione, with whom he often happened to collaborate in that period. Also the Maestro della Misericordia (active from approximately 1365 to 1400), so-called after a painting in the Galleria dell'Accademia, which represents the *Madonna of Mercy* (Madonna della Misericordia) protecting a large group of Augustinian nuns under her cloak—undoubtedly those who lived at the time in the convent of Sta. Maria di Candeli, where the painting originally belonged—is a typical

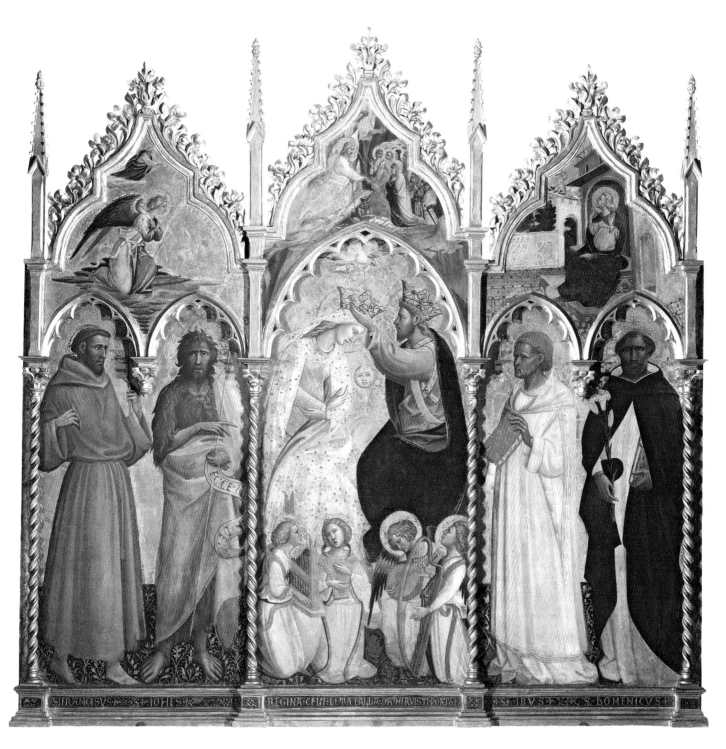

S·FRANCISVS· ·IOHES· REGINA·CELI·LETA·ALLA·OA·MERVISTI·PORTA· ·IBVS· S·DOMENICVS·

representative of the Florentine painting culture of those years. In the early phase of his career, he appears to have been still significantly attached to the stylistic elements of Giotto's "official" heirs, from Bernardo Daddi to Taddeo Gaddi, while in the middle phase of his activity he seems to have been attentive above all to the work of Giottino and Giovanni da Milano. In his late phase, however, c. 1380 onward, the Maestro della Misericordia appears to have been a parallel follower of Niccolò Gerini, the austere custodian of the Giottesque tradition in Florentine painting between the late 14th century and the beginning of the 15th. According to a very tempting hypothesis, which nevertheless still awaits confirmation, this anonymous artist could be identified as Giovanni Gaddi, brother of the better known Agnolo Gaddi, documented in Rome and Florence between 1369 and 1385. In around the beginning of the last quarter of the century, a "neo-Giottesque" tendency became established in the rich and diverse Florentine artistic scene that involved, at least for a phase of their activity, a large group of painters with very differing temperaments. There was, in substance, a significant revival of the formal,

typological, and iconographic approaches that were in fashion among the first Giottesque generations, before the 1330s. Among the most committed supporters of "neo-Giottism" were two great non-Florentine painters, who nevertheless considerably influenced the artistic developments of this city: Antonio di Francesco, cited in documents as "da Venezia" and in fact better known with the name of Antonio Veneziano, and Spinello di Luca, known as Spinello Aretino.

Antonio Veneziano is one of the dominant personalities of the Tuscan painting of the late 14th century. His highly original, strongly characterized style was marked by imposing figures, distinguished by a vigorous plasticism, which must have also impressed the artists of the generation of Masolino and Masaccio. Spinello Aretino is also one of the protagonists of the world of 14th-century painting in Tuscany. After his initial training in his native Arezzo, in the workshop of painter Andrea di Nerio, Spinello embarked upon what was to become an untiring journey among the main centers of the region, spreading a language characterized by its noble essentiality and clarity, yet enriched by an intense interpretation of the Florentine culture of Giottesque origin of the thirties: from Andrea Pisano to Maso di Banco. Among his most significant enterprises, we must at least recall the decoration of the sacristy of the church of S. Miniato al Monte in Florence with *The Life of St. Benedict*; the Camposanto in Pisa with frescoes depicting the *The Lives of SS. Ephysius and Potitus*, documented in the years 1390–92, which has unfortunately survived in very poor condition; and the polyptych dated 1401 executed for the church of Sta. Felicità in Florence (Florence, Galleria dell'Accademia), with the collaboration of Niccolò di Pietro Gerini and Lorenzo di Niccolò. The work of Spinello, who died in Arezzo in 1411, represented a fundamental point of reference for many of the Florentine painters operating in the last 15 years of the 14th century. Cited among the artists active in the Vatican, along with Giottino and Giovanni da Milano, we also find Agnolo Gaddi for the first time; he was admitted to the Arte dei Medici e dei Speziali in 1387.

The son of Taddeo Gaddi, Giotto's official heir, Agnolo headed an established workshop that was capable of meeting a conspicuous demand for panel paintings, but he was also widely active in the field of fresco painting: from the paintings in the Castellani Chapel in Sta. Croce in Florence to the vast cycle with the *Legend of the Cross* in the Cappella Maggiore (apse) in the same church, to the *Scenes from the Life of the Virgin and the Holy Girdle* in

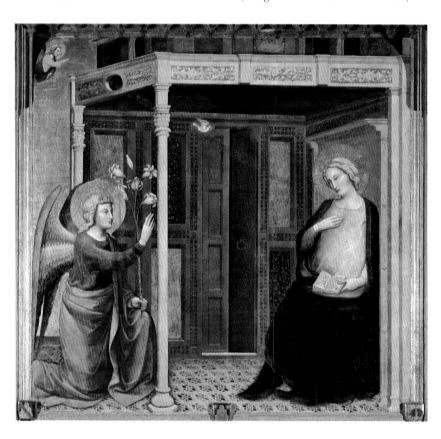

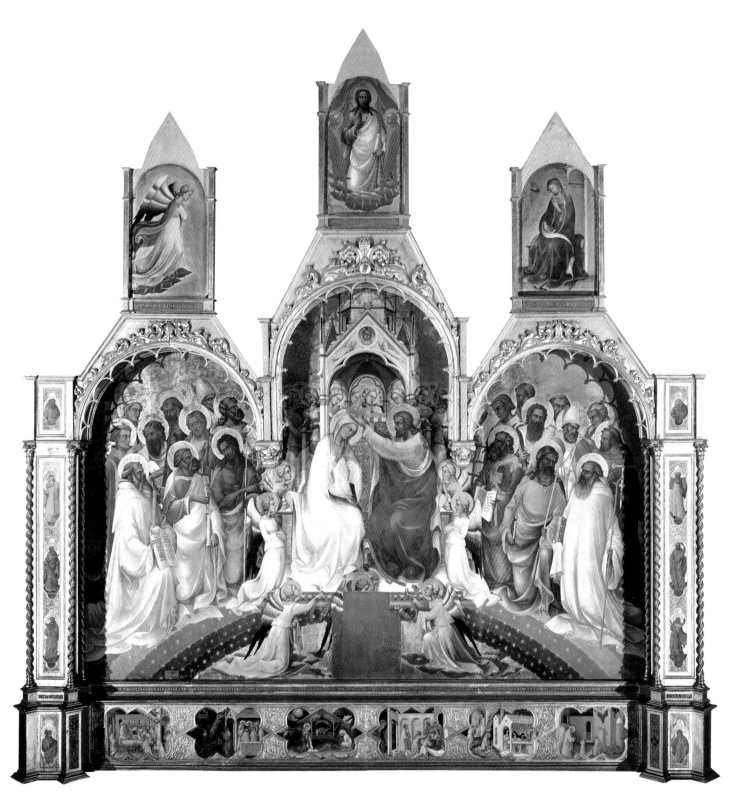

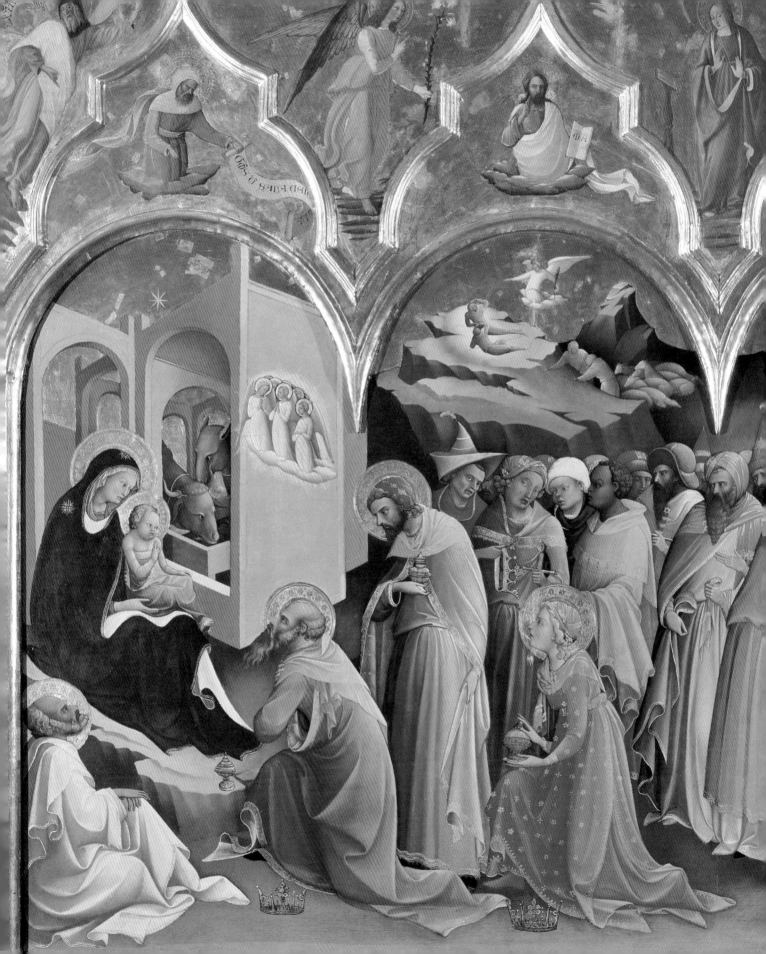

Prato Cathedral, documented from the years 1392–94, a few years before his death in 1396. During his successful career, Agnolo Gaddi was the main disseminator of Late Gothic tendencies in Florentine painting, anticipating the main local exponents of International Gothic, Gherardo Starnina and Lorenzo Monaco. Vasari devotes one of his *Lives* to the Florentine painter Gherardo di Jacopo, known as Starnina, in which, among other things, he affirms that he was a student of Antonio Veneziano and that he went to work in Spain. This information is confirmed by documents showing the painter to have been in Toledo and Valencia between the late 14th and early 15th centuries. In 1404 the painter had already returned to Italy to execute some frescoes in the church of Sta. Maria del Carmine. The identification of Starnina with the so-called "Maestro del Bambino Vispo" made relatively recently has allowed a reappraisal of one of the most fascinating and historically significant personalities in Late Gothic painting in Florence. Along with Starnina, the other fundamental figure of the Florentine painting of those years was painter and miniaturist Piero di Giovanni, who in 1391 became a monk and joined the Camaldolese monastery of Sta. Maria degli Angeli, taking the name of Lorenzo. This renowned artist was certainly trained at the workshop of Agnolo Gaddi and in a subsequent phase came under the influence of the miniaturists of the monastery, particularly Don Silvestro dei Gherarducci. The painter's earliest works betray the deep Florentine roots of his training through the still clear neo-Giottesque intentions of his compositions and the plasticism of his figures. Beginning with the triptych in the Pinacoteca in Empoli and the *Christ among the Mourners and the Symbols of the Passion* in the Galleria dell'Accademia in Florence, both from 1404, Lorenzo Monaco developed a highly refined graphic language in an International Gothic mold. The major works of this fascinating artist are the imposing altarpiece with the *Coronation of the Virgin*, painted in 1414 for the high altar of Sta. Maria degli Angeli (Florence, Uffizi), or the stupendous frescoes of the Bartolini Salimbeni Chapel in the church of Sta. Trinità in Florence, depicting the *Scenes from the Life of the Virgin*. Nevertheless, he achieved the peak of courtly elegance and formal refinement in the *Adoration of the Magi*, completed in 1422 for the church of Sant' Egidio in Florence (Uffizi, Florence).

Angelo Tartuferi

Lorenzo Monaco,
Adoration of the Magi.
Uffizi Gallery.

The illuminated manuscript

The difficulties encountered in indicating, in the field of painting, the beginnings of a style of production that is definable as "Florentine" in a historically plausible way arise again—however, with a greater level of difficulty—in the relatively lesser known sphere of the illuminated manuscript.

Among the earliest examples that definitely come from Florentine territory, we may include the Bible in two volumes preserved in the Biblioteca Laurenziana in Florence (Codex Edili 125 and 126), which originally came from the Duomo— probably written and decorated in the first quarter of the 12th century, it is its rigid linear classicism that makes it stand out. Very similar stylistic features are also to be found in a famous codex originally from the monastery of S. Michele a Marturi, not far from Poggibonsi, halfway between Florence and Siena (Florence, Biblioteca Laurenziana, Cod. Plut. XVII.3)—

Florentine miniator, *Christ in Glory with the Symbols of the Evangelists*, Codex Calci, ms. 36, c. 110. Biblioteca Laurenziana.

presumably datable to the third quarter of the 12th century—which also has illuminated manuscripts with large formats in strong frames in an "architectural" style

and initials decorated with complex interwoven plant motifs. However, the only example of Florentine miniating [the art of illuminating manuscripts] of this period that is datable with any certainty is the *Bible* written by the calligrapher Corbolino and dated 1140 (Florence, Biblioteca Laurenziana, Cod. Conv. Soppr. 630), coming from the monastery of Sta. Maria degli Angeli in Florence, but which originally belonged to another Camaldolese monastery. We can observe the drawing precision of the unknown miniator [manuscript artist] in the initial depicting *God Speaking to Moses*, while the flowing drapery in which the patriarch is wrapped, with deep folds, calls to mind those of the *Madonna with Child* in the church of Sant'Andrea a Rovezzano, on the outskirts of Florence, which according to recent critical hypotheses should be dated slightly later. Somewhat clear stylistic similarities with the latter painting are also to be found in another *Bible* that is datable to the 12th century (Florence, Biblioteca Laurenziana, Mugellan Codex 2), as I underlined some years ago. Analogous stylistic similarities with the important panel painting in Rovezzano are to be found in a illustration with *Christ in Glory with the Symbols of the Evangelists*, belonging to a Sacramentary (Florence, Biblioteca Laurenziana, Calci 36) originally coming from the Carthusian monastery of Calci, attributable to a fine Florentine miniator active in the 12th century.

On the stylistic level, these earliest examples of Florentine illuminated manuscripts have in common the significant prevalence of the linear element, which brings out the incisiveness and purity of the design, the elegance of the movements and the subtle rhythmic cadences of the drapery, yet neglecting to develop the modeling and the chiaroscuro. These stylistic indications immediately prompt comparison in particular with the great painting culture of Umbria and Lazio of the same period. It is still very problematic today to draw even a summary profile of Florentine miniating in the 13th century, due both to the meager amount of material available and to the objective difficulty of critical and philological classification.

God Speaking to Moses, Codex Conventi Soppressi 630, c. 52v. Florence (Corbolino's Bible, 1140). Biblioteca Laurenziana.

Opposite:
Maestro delle Immagini Domenicane, *Madonna with Child Enthroned and Four Angels*, Codex 470 (from Orsanmichele), c.1v. State Archive.

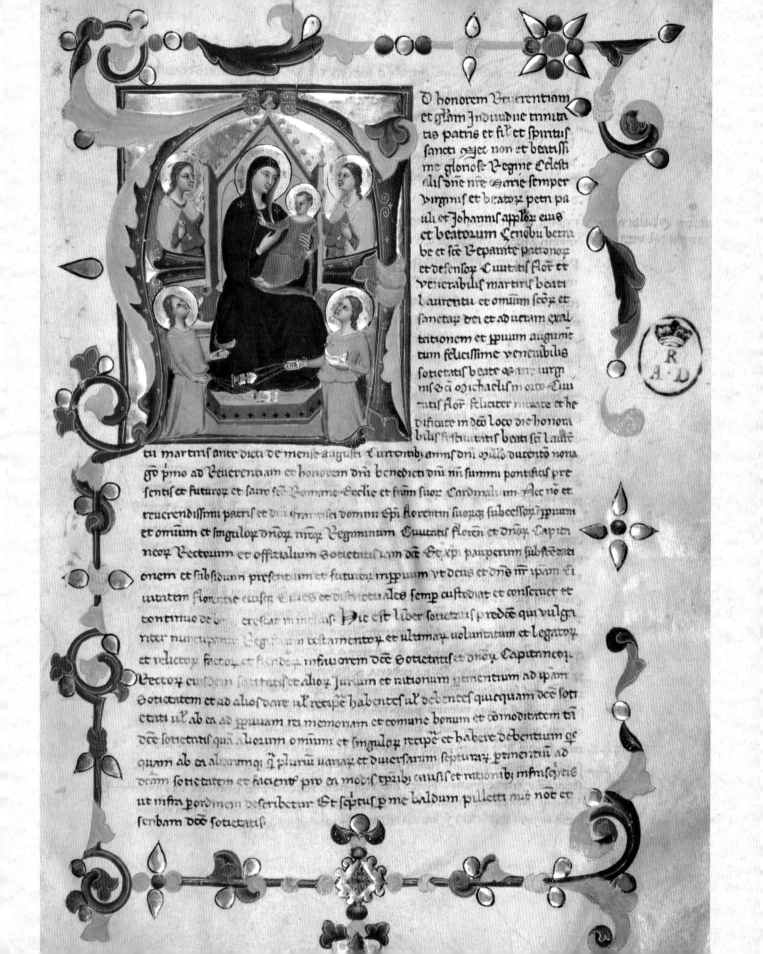

Ad honorem reuerentiam
et glam Indiuidue trinita
tis patris et fil et spiritus
sancti eyet non et beatissi
me gloriose Regine Celesti
alis dne nre Marie semper
virginis et beatox petri pa
uli et Johannis applox eius
et beatorum Cenobii benn
be et sce Reparate patronox
et defensox Ciuitatis flor et
venerabilis martiris beati
laurentii et omnium scox et
sanctax dei et ad uictam exal
tationem et ippuum augme
tum felicissime venerabilis
societatis beate Marie virgi
nis Cm micchaelis in orto Ciui
tatis flor feliciter nouate et he
dificate in dco loco die honora
bilis sctiuitatis beati sci laure
tii martiris ante dicti de mense augusti Currentib; anno dni millo ducento nona
gro pmo ad Reuerentiam et honorem dni benedicti dni nri summi pontificis pre
sentis et futurox et sacre scce Romane Ecclie et frm suox Cardinali; Nec no
reuerendissimi patris et dni Francisci dominii epi florentii suox; subcessox ippuum
et omnium et singulox dnox nrox; Regiminum Ciuitatis floren et dnox Capita
neox; Rectorum et offitialium societatis iam dce Et xpi pauperum substitati
onem et subsidium presentium et futurox ippuum ut deus et dns nr ipam Ci
uitatem florentie eiusq; Comes et districtuales semp custodiat et conseruet et
continuo de bono crescat in melius. Hic est liber societatis predce qui vulga
riter nuncupatur Regium testamentox et ultimax uoluntatum et legatox
et relictox factox et fiendax in fauorem dce societatis et dnox; Capitaneox;
Rectox eiusdem societatis et aliox Iarium et rationum ptinentium ad ipam
societatem et ad alios dare ul recipe habentes ul debentes quicquam dce soci
etati ul ab ea ad ippuam rei memoriam et comune bonum et comoditatem ta
dce societatis quam aliox omnium et singulox recipe et habere debentium qe
quam ab ea altarinoq; q plurix variax et diuersarum scripturax ptinentix ad
dcam societatem et facient pro ea modis tpibus; causis et rationib; mfinscptis
ut infra pordinem describetur Et scptus p me baldum pilletti nrii not et
scribam dce societatis.

Lorenzo Monaco, illuminated manuscript, 20v, 105, Choir Book 5 (Antiphoner dated 1394). Biblioteca Laurenziana.

credited the same author with the decoration of a codex in the Museo Civico in Pistoia (no. 231), with a cut-out illustrated manuscript with the *Last Judgment* in the Pierpont Morgan Library in New York and some codices in the Grosseto Museo d'Arte Sacra, as well as a *Bible* in the Biblioteca Nacional in Madrid (no. A25), which is signed by a certain "Johannes filius Jacobini" and dated 1272. This miniator is distinguished by a marked and lively narrative taste, and appears significantly linked to the Florentine painting culture of the third quarter of the century, particularly to Meliore. Another miniator, who is substantially responsible for the decoration of Choir Books A and B, is characterized by the more archaic tone of his language and his predilection for a decorative taste in a "Romanesque" vein. The most significant and culturally well-informed personality, however, seems to be the sophisticated author of certain miniated texts that only appear inside Choir Book E. The illustration of an intense and lively *St. Paul* documents well the complex culture of this miniator, who, besides revealing a component probably of Duccesque origin, seems to provide a prelude to the arcane and solemn language of Lippo di Benivieni, one of the main Florentine artists active at the turn of the century.

The Florentine painter Pacino di Bonaguida—documented in 1303—also assumes the role of one of the main exponents of 14th-century Florentine manuscript illumination.

Lorenzo Monaco, illuminated manuscript, 20v., 138, Choir Book 5 (Antiphoner dated 1394). Biblioteca Laurenziana.

One very significant case is the *Bible* (Florence, Biblioteca Laurenziana, Cod. S. Croce, Plut. V, dext. 1), considered for a long time to be a typical specimen of Florentine miniating, yet in more recent years related to the Umbrian—specifically Perugian—environment of the end of the century, inspired almost exclusively by the activities of Cimabue in Assisi. In the light of the considerable critical fluidity that still characterizes this specific sector of investigation today, we can well understand that even the most well known Florentine codices have recently been the object of revised opinions and/or further critical clarifications. Such is the case of the illustrations of the *Evangelistary* in the Biblioteca Nazionale in Florence (Cod. II, I, 167), originally from the monastery of Sta. Maria Nuova, which seem to be interpreted above all in the light of the activity of the Pisan-inspired Maestro di Sta. Maria Primerana, rather than in the context of the possible traces of the influence of the art of the Maestro della Maddalena, which was predominantly indicated in the past. On the other hand, the artist of the *Crucifixion* in the *Missal* from the church of Sta. Felicità in Florence (Florence, Biblioteca Laurenziana, Conv. Soppr. 233) seems to be reminiscent above all of the Pistoian activities of Coppo di Marcovaldo and of his son Salerno, c. 1275, rather than those of Cimabue.

A group of codices of fundamental importance in the sphere of Florentine miniating is that still preserved today in the Dominican monastery of Sta. Maria Novella in Florence; they abound in splendid illuminated initials, executed by a small group of artists of the highest level, mostly during the last quarter of the century.

Standing out among them is the artist responsible for the last illustrations of Choir Book E (no. 1354) and almost all those of Choir Book F (no. 1355). Scholars have

Don Silvestro dei Gherarducci, *A Bishop Consecrates a Church* (initial I), Choir Book Codex 2 (from Sta. Maria degli Angeli). Biblioteca Laurenziana.

Not by chance, for a long time the critical designation of "Pacinesque" in the sector of miniated decoration took on the all-embracing character, which, leaving aside differences of scale, "Giottesque" had in the field of panel and fresco painting in its own time. Nevertheless, in the multifaceted scene of 14th-century Florentine miniating, there was no shortage of other interesting personalities more directly inspired by the main protagonists active in panel painting. This was the case, for example, of the Florentine miniator who decorated a codex in the Biblioteca Riccardiana in Florence (Cod. 2418) containing *The Deeds of the Romans*, a text by an unknown author derived from an original version in French from the beginning of the 13th century, which consists of an unusual cento from Roman history drawn from various sources. The archaic cultural origin of this artist can be clearly seen in the illustration with *Pompey Sleeping*. The composition still appears typically 13th-century, while the sober, aligned architecture in the background is reminiscent of those that are visible in the contemporary paintings of the Maestro della Sta. Cecilia. In any case, it is appropriate to reaffirm the prominent role played in this field by Pacino di

Bonaguida, who certainly contributed decisively to the imposition of the illuminated manuscript as an autonomous expressive form in the context of 14th-century Florentine painting. He headed a large team of assistants, whose work is nevertheless only rarely clearly distinguishable from the master's successful stylistic formula. And this is the main reason why many of the subtler distinctions made by scholars within Pacino's abundant works prove to be critically meaningless. But the leading exponent of Florentine miniating in the first half of the 14th century was undoubtedly the so-called Maestro del Codice di San Giorgio, a fascinating anonymous personality who derives his well-deserved title from being the author of the rich miniated decoration of the splendid *Missal* in the Biblioteca Apostolica Vaticana (St. Peter Archive, Cod. 129), commissioned by Cardinal Jacopo Stefaneschi and donated to the Basilica of St. Peter's in the Vatican after his death (1341) in Avignon. Considered in the past to be a Sienese follower of Simone Martini or, more recently, as a painter of Roman training from the early 14th century, today it is generally recognized by scholars that this extraordinary artist belonged to the Florentine culture of the first half of the 14th century.

Among the most important figures in Florentine miniating in this period, we could certainly include—together with the Maestro del Codice di San Giorgio—the so-called "Maestro Daddesco," an unknown Florentine personality who was so-called on account of his undeniable link with the art of Bernardo Daddi, which is in fact more evident on the chromatic than on the general stylistic plane. This rather mysterious artist, endowed with great narrative versatility, is responsible for almost all the rich decoration of the famous *Missal* in the Biblioteca Laurenziana (Cod. Edili 107), originally coming from the Cathedral in Florence, which was undoubtedly one of the masterpieces of 14th-century Florentine miniating. Appearing on the right of the illustration that adorns the *Miracle of St. Zanobi* is one of the oldest representations of the facade of the Cathedral in Florence, but the miniator also depicts the clothing of the numerous characters crowding the scene in detail and with refined and masterly taste. An

artist certainly endowed with a less refined taste, but gifted with an extraordinary narrative effectiveness to make up for it, is the so-called "Maestro del Biadaiolo," who is responsible for the decoration of the famous manuscript in the Biblioteca Laurenziana in Florence (Cod. Tempi 3), which in fact contains a treatise on wheat and other grain, written by the corn vendor Domenico Lenzi. Some illustrations—for example that with the *Corn Vendor's Shop* or the depiction of the *Poor of Siena Welcomed to Florence*—offer slices of daily life in 14th-century Florence, the City of the Lily. The opinion is now widely held among scholars that the illustrated manuscripts and panel paintings attributable to the "Maestro del Biadaiolo" are in reality the early work of the Maestro delle Immagini Domenicane, an anonymous Florentine painter who was widely active in the fields of both panel painting and miniating.

Don Silvestro dei Gherarducci, figured initial, c. 149, Choir Book 19 (Antiphoner). Biblioteca Laurenziana.

"Maestro del Biadaiolo" (Maestro delle Immagini Domenicane), *Corn Vendor's Shop*, Codex Tempi, no. 3, c. 2. Biblioteca Laurenziana.

After the mid-14th century, more or less as had happened in the first half of the century, yet with qualitatively less significant results, Florentine miniating continued to reflect the main stylistic orientations present in the field of painting. Thus the Orcagnesque stylistic mold, derived especially from the work of the great and multitalented Andrea di Cione, known as Orcagna, and from the younger Jacopo di Cione, is echoed diligently in certain miniated manuscripts attributable to the so-called Maestro della Predella dell'Ashmolean Museum (Florence, Biblioteca Laurenziana, Choir Books 11 and 16), an unknown artist active particularly in panel painting and working in all likelihood in the Orcagnas' workshop.

The main protagonist of Florentine miniating between the third and last quarters of the 14th century was certainly the Camaldolese monk Don Silvestro dei Gherarducci, who was widely active in both painting and miniating in Florence, where he was born in 1339 and died in 1399. Active in the monastery of Sta. Maria

degli Angeli, which was already considered to be a full-blown school of Florentine miniating in Vasari's time, in most of his works Don Silvestro shows a profound knowledge of contemporary Sienese painting. In all aspects of the illustration depicting the *Consecration of a Church* (Florence, Biblioteca Laurenziana, Choir Book 2; from Sta. Maria degli Angeli), from around 1375, Don Silvestro shows the whole refined elegance of his language, in both the luxuriant and colorful interlacements and the sumptuous dress of the characters. Along with Gherarducci, the other protagonist of the Camaldolese school of the monastery of Sta. Maria degli Angeli is Don Simone, native of Siena, and even more comprehensibly linked to the artistic traditions of his city; his work has been reconstructed on the basis of the initial A at the beginning of the *Antiphoner* dated 1381 and originally from the monastery of S. Pancrazio, attributed to the artist in the explicit of the codex (Florence, Biblioteca Laurenziana, Choir Book 39).

The activities of Gherarducci and Don Simone brought to full maturity the presence of Late Gothic culture in Florentine illustrated manuscripts from 1370 onward and, even more importantly, contributed significantly to the affirmation

"Maestro del Biadaiolo" (Maestro delle Immagini Domenicane), *The Poor of Siena Welcomed to Florence*, Codex Tempi, no. 3, c. 58. Biblioteca Laurenziana.

Opposite:
Don Simone, initial A, c. 1v. of Choir Book no. 39 (from the church of S. Pancrazio). Biblioteca Laurenziana.

of Late Gothic language on the Florentine artistic panorama during the last 20 years of the century. They were also a definite point of reference—at least in the field of miniating—for the training of painter and miniator Piero di Giovanni, who, as we have previously stated, became a monk in 1391 and joined the monastery of Sta. Maria degli Angeli, taking the name of Lorenzo, so becoming known universally as Lorenzo Monaco, one of the greatest Italian personalities between the end of 14th century and the beginning of the 15th.

In the early years of his stay at the Florentine Camaldolese monastery, as well as painting devotional panels, mainly of modest dimensions, the young artist devoted himself above all to decorating the monastery's choir books. A precious testimony of this his early activity in the field of illustrated manuscripts is provided by the three *Antiphoners* that are preserved, unfortunately in rather damaged condition, in the Biblioteca Laurenziana in Florence (Choir Books 1, 5 and 8), dated 1396, 1394, and 1395 respectively. Already in these early examples there was the immediate imposition of extraordinarily incisive designs, which were soon to take on an increasingly lively and sinuous character, often to the limits of pure linear virtuosity and prodigious elegance, which this extraordinary artist later established as the unique, unmistakable traits of his vast miniated and painted works, on both panel and fresco. From the chromatic standpoint, it is interesting to underline that Lorenzo Monaco profoundly changed the clear and bright range that had been followed till then at the School of Sta. Maria degli Angeli, instead preferring rather cold, deep, sometimes almost metallic tones, with great plastic and emotive power. The influence of this master of miniated decoration was very widespread and long-lasting on the Florentine panorama of artists of varying extractions and historical significance: from the young Beato Angelico—as is clearly proven by the decoration of a codex in the Biblioteca Nazionale Braidense in Milan (Cod. Gerli 54) recently brought to scholars' attention—to Francesco d'Antonio.

Angelo Tartuferi

Spiciens alonge ecce

urdeo de i potentiam ve

From Gothic to Renaissance

From the invention of perspective to the building of the cathedral dome

Andrea di Lazzaro Cavalcanti, called Buggiano: *Portrait of Filippo Brunelleschi*, marble. Cathedral of Sta. Maria del Fiore.

The leading role that Filippo Brunelleschi would later assume in his native Florence emerged between 1413, when he perfected his graphic method for constructing "lifelike" perspective (by this time it was already recorded as "perspective" by Domenico da Prato) in the two celebrated experimental panels (now unfortunately lost), the one a view of the exterior of the Baptistery from inside the central door of Sta. Maria del Fiore, the other of the Palazzo dei Priori from the corner of Via Calzaiuoli, and 1418, when he submitted his design for the Cathedral dome to the Opera [commissioners of works] di Sta. Maria del Fiore, together with a brick model (the dome was to rise from the walls, 13 feet/4 m thick, of the octagonal drum completed by Giovanni di Ambrogio, and be built without any wooden armature). By 1418, it was clear what Brunelleschi's role would be.

With his invention of artificial perspective, Brunelleschi ushered in a new chapter in the virtual representation of space in painting and bas-relief (Donatello's *schiacciati*, or compressed reliefs, come to mind)—he had developed an innovative language that could also conveniently be used in conceiving and developing architectural designs. But even though it is still uncertain who originally had the idea of using a double shell, which the size of the drum—135 feet (41 m)—seemed to indicate in any case, it was the brick model that Brunelleschi constructed in front of the masons of the Opera, to simulate how the dome could be built, that led to him being awarded the commission, along with Ghiberti, to construct it.

Brunelleschi's instructions, which accompanied the model, included specifications for the shape of the dome as well as its structural weft and warp; his design for the curvature of the dome, calculated according to the so-called "acute fifth"; and specifications for the inner, load-bearing shell to be linked to the outer shell (in order to protect the dome from "damp and to render it magnificent and rotund"), and the 24 ribs, "8 at the corners and 16 in the faces."

When the building of the dome was under way, Brunelleschi's dominant role in directing the project and solving the main problems connected with its actual construction was quite clear—in January 1425, with Ghiberti's agreement, a request was sent to the Opera for "the manufacture of large bricks of between 24 and 29 pounds (11–13 kg) in weight but not more, to be embedded in the wall" in "herring-bone" fashion.

Over and above the technical skill involved in the construction of the dome—all of which, along with all of its structural secrets, is now hidden away in an impenetrable mass of masonry (to this day the object of much conjecture)—the fact remains that from its completion in August 1436, the cells of its immense octagon finally enclosed and made fast, Brunelleschi's so-called *mole* [huge mass] took on a meaning of its own and has become to this day the triumphantly over-scale center of gravity of the city, both emblematic and spectacular—a fact worth considering.

From the very beginning, the dome has had enormous symbolic power, both spiritual and temporal and has since dominated every view of the city, as if it were a focal point to which a vast range of emotions are attracted and indeed for which they yearn.

In the dome, Florentine architecture attained the most explosive, most all-encompassing architectural expression of the community as a whole in a form that seemed to gather within itself the entire city of the day. Like a spherical umbilicus, the symbol of a matriarchal hegemony, the golden ball at its summit alluding to a cosmic truth, the dome represented a limit, an achievement that could never be equaled, let alone surpassed. For sheer grandeur it dwarfed all previous buildings and urban spaces, and would dwarf all those to come.

Facing page:
Brunelleschi's dome, Cathedral of Sta. Maria del Fiore.

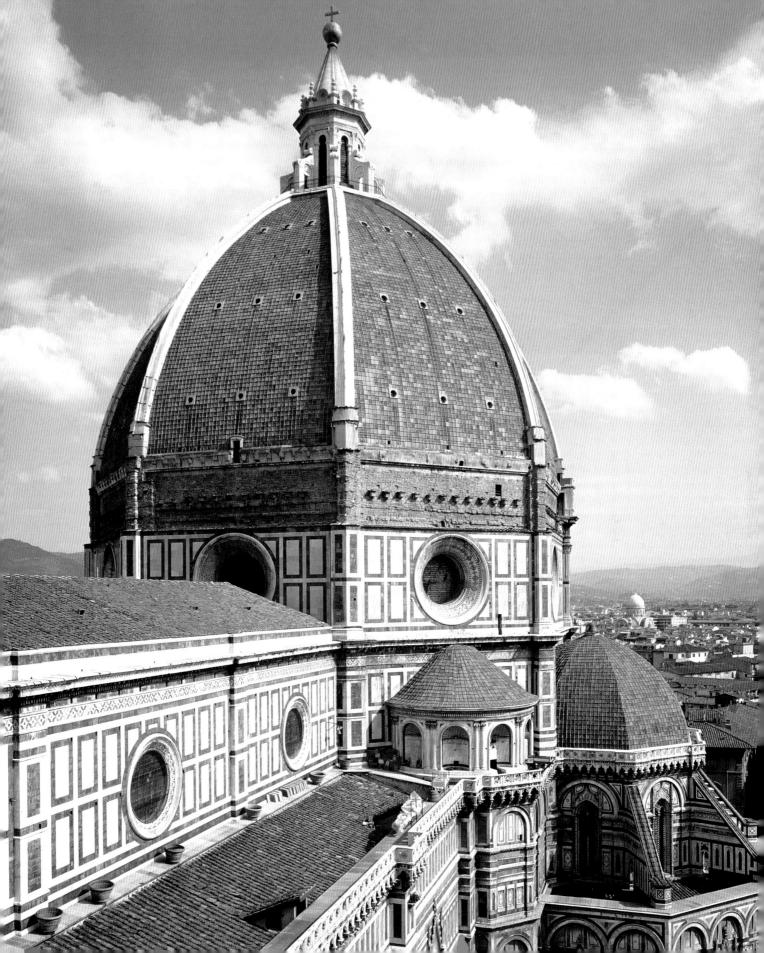

Portico of the Ospedale degli Innocenti.

The arrogance of the idea of erecting so huge a domed cathedral in the very midst of the city, as if thereby to immerse themselves in the truth of the divine light, also expressed the Florentines' desire to break out of their city walls and boldly create, by means of an artificial hill, both an alternative and challenge to the natural surrounding hills, and their pride at doing so. This notion was admirably expressed in 1754 by Giovanni Targioni Tozzetti, who wrote that the dome "is the equivalent of a small, man-made mountain, and thus deflects and directs the winds, overshadows and reflects the heat." This miracle of levitation, in which such a colossus of matter rises toward the

Interior of the Old Sacristy, S. Lorenzo.

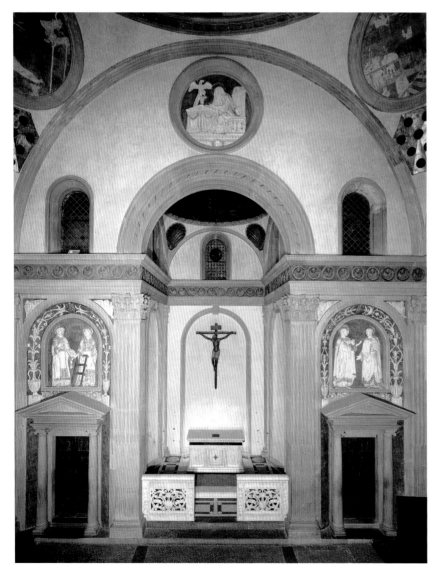

heavens and dominates the surrounding area, was primarily due, without wishing to denigrate the contributions of Ghiberti or of the workmen themselves, to Brunelleschi's genius as a builder, and his ability to adapt his building plans and procedures to take account of difficulties that emerged as construction proceeded.

It would be a mistake, however, to ascribe divine status to Brunelleschi and his work (for he also had his weaknesses, such as failing to see the effects of thermal expansion and contraction on his masonry, with the result that he was unable to predict the damage that this would cause to eight of the cells) or to yield to unbridled hyperbole, a habit that has lasted from the time of Jules Michelet, when he wrote of Brunelleschi in 1879, "there appeared a man of tremendous will... who had the soul of a Dante, and the universality of his spirit, but was dominated and guided by another Beatrice, the divine melody of number and visible rhythm..." until 1977, when Bruno Zevi defined Brunelleschi as "anticlassic" and lauded his "heretical..., anti-medieval but at the same time markedly anti-Renaissance content."

Likewise, it would be a mistake to give credit, as has often happened, to those who claim to have discovered a deep divide between the Middle Ages and the so-called Renaissance (a term that was coined in 1860 by the Swiss Jacob Burckhardt in his *Kultur der Renaissance in Italien* and that since has acquired mythical status as being synonymous

with an isolated "superior" period in the history of art, a time of revolt against the past, and the accompanying aesthetic yearning for that happy age).

Instead, it is enough to look at one of Brunelleschi's first buildings, the Ospedale degli Innocenti (started in January 1420), to realize that placing a portico in front of a hospital was not Brunelleschi's invention but the revival of an earlier, medieval type that had already been used in Florence for the Ospedale di Bonifazio in Via S. Gallo (1378) and the Ospedale di S. Matteo in Piazza S. Marco (1384), both just a few steps from the Innocenti building. There were also porticos in front of the old churches of S. Lorenzo and S. Bartolomeo in Via Calzaiuoli (demolished 1768), as the Rustici Codex recounts, just as it was no novelty to have a portico with columns supporting round arches. These can

be seen in the frescoes by an anonymous Florentine painter of episodes from the *Life of Tobias and Tobiolus* (c. 1360) now in the Bigallo Museum, and other frescoes such as those of the *Scenes from the Life of of Pope Sylvester* by Maso di Banco (c. 1340) in the Bardi di Vernio Chapel; *Joachim Expelled from the Temple and the Presentation of the Virgin in the Temple* by Taddeo Gaddi (1332–38) in the Baroncelli Chapel, both in Sta. Croce.

What can be stated without fear of contradiction is that in designing the Ospedale degli Innocenti, Brunelleschi increased both the number and size of the spans over earlier models, and the elegance of the pillars and the arches, presumably using as models certain formal aspects of the facades of the Baptistery and S. Miniato al Monte.

The Old Sacristy (1422–28) of the church of S. Lorenzo also shows the continuation of

Interior of the cupola of the Old Sacristy, detail.

Interior of S. Lorenzo.

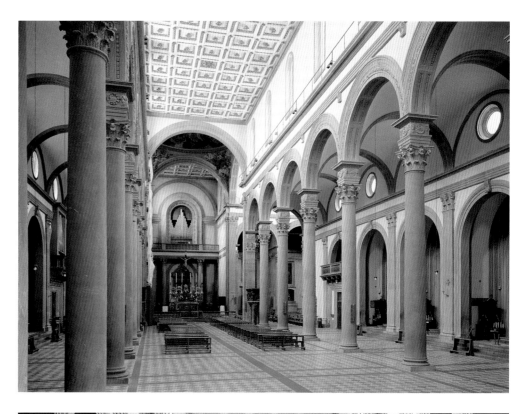

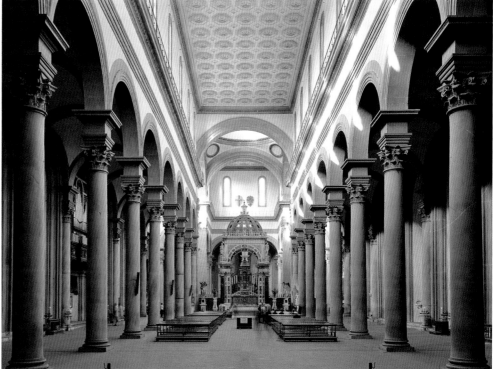

Interior of Santo Spirito, looking toward
the High Altar.

medieval building tradition in the main walls, which serve both bearing and weather-proofing functions, while the facing elements in *pietra serena* (the pilaster strips, capitals, trabeation, and arch frame) are innovative in their formal appearance, imitating structural functions while in reality they are merely ornamental (the arch frame leading into the *scarsella* protrudes from the pilaster strips below whereas it should be flush with them in the vertical plane). The structure of the umbrella dome, with its stone radial ribs and its conoidal masonry webs, also harks back to medieval types.

The "new and beautiful form" that Giovanni 'di Bicci' de' Medici had wanted to see Brunelleschi give to the Sacristy of S. Lorenzo must therefore be sought in the decorative architectural elements of the internal walls, namely in the fluted pilaster strips and the *libretto* strips in the corners; in the garland cornice of the arch; in the clay frieze with its red cherub heads against a blue background inserted between the cornice and the stone architrave of the trabeation; in the Medici crests; in the roundels with their reliefs by Donatello on the pendentives; and in the conch-shaped niches in the pendentives beneath the cupola in the *scarsella*.

These elements can be found in other buildings by Brunelleschi. In the church of S. Lorenzo (the first column for which arrived on site in 1447) fluted pilaster strips and garland cornice arches abound. Fluted pilaster strips and pendentive roundels can also be found in

Cupola, interior detail. Pazzi Chapel (Cloister of Sta. Croce.)

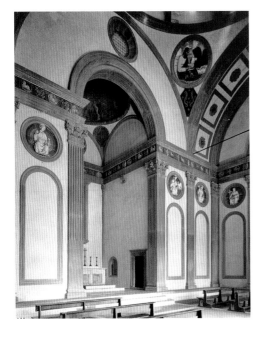

Santo Spirito [Church of the Holy Spirit] (started in 1444). The Pazzi Chapel, attributed to Brunelleschi by late 15th-century (Manetti) and 16th-century sources (the anonymous author of the Magliabechiano MS, the *Libro di Antonio Billi*, Gelli, Vasari), but completed after his death (1459–61), is like a summation of all these elements. It contains the same umbrella-shaped cupola on pendentives with inset roundels, the same garland cornice arches, the same frieze of cherub heads, this time both in the portico and in the chapel itself, and the same fluted and *libretto* pilaster strips.

Other recurring elements can be added to this list: the web vaults covering the spans in the loggia of the Ospedale degli Innocenti and the aisles in S. Lorenzo and Santo Spirito; the concave forms used to model the walls in the

Interior of the Pazzi Chapel.

171

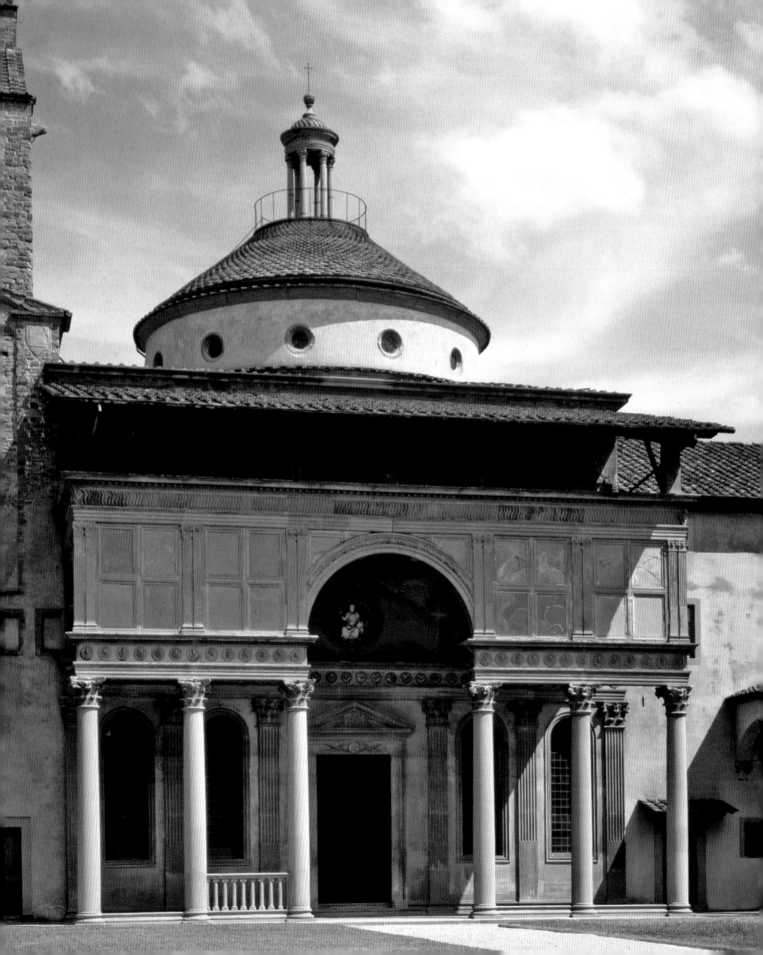

scarsella of the Old Sacristy of S. Lorenzo; the exedrae (designed in 1439) at the base of the drum supporting the dome; the chapels in S. Spirito; and the Rotunda of Sta. Maria degli Angeli (which can be dated to 1434–36).

The sequence of columns and arches in the Ospedale degli Innocenti may also be regarded, all in all, as yet another recurring element. Extended both lengthwise and vertically, with a dado inserted above the capitals, it becomes an architectural leitmotif, the thematic core of the mirror-like colonnades that define the aisle and the foreseeable spaces in S. Lorenzo and Santo Spirito. The reiteration and juxtaposition of these few characteristic elements and modular constants constitute the so-called modernity of Brunelleschi's design method and the recognizability of his stylistic vocabulary, aspects that would be inflated by those who continued in his footsteps and reduced to cliché and banality by his imitators.

In Brunelleschi's architectural development, therefore, the dome of Sta. Maria del Fiore stands out as something different, an exception, a work not constricted by these modular constants. It was not until 1447 that his splendid lantern was erected on the dome to crown it in appropriate fashion. For despite the prestige that Brunelleschi, now aged 59, enjoyed, he had to undergo yet another contest; which he won, thanks to the formal innovations he had devised so that he could bring his favorite architectural creation to fulfillment. Only then could he set about building this aerial marble jewel, this sublime, snow-white chapel, with its buttressing spurs attached by volutes to its octagonal body.

It should be noted that with the exception of the dome, the loggia of the Ospedale degli Innocenti and the elevation of the Palazzo di Parte Guelfa, Brunelleschi's other architectural work (the Sacristy and Church of S. Lorenzo, Santo Spirito, the Pazzi Chapel) was usually for interiors, within churches and monasteries, with only discreet sallies out into the open. If one bears in mind that his works were carried out for various clients and were completed by successors who often disregarded his original ideas, and that both churches and the rotunda of Sta. Maria degli Angeli (never completed) lacked facades that would probably have conveyed stylistic features into the city itself, it seems rather fanciful to imagine that Brunelleschi actually had a sort of urban master plan for Florence, and that his intentions can be reconstructed on the basis of the few buildings that he actually did design. In reality, compared with the imperious dome of Sta. Maria del Fiore, the structure on which

the architect really did leave his mark and the one that changed and glorified the image of Florence forever, the impact of Brunelleschi's other works is rather limited and does not lend itself to the idea that between them some sort of continuum of architectural correlations exists and can be retraced.

The hallmark of Renaissance Florentine architecture, the "manifesto" of the new stylistic direction, can be clearly perceived however, even before the Ospedale degli Innocenti was completed, in the refined forms of the Tabernacle of the Parte Guelfa, later called the Tabernacle of the Mercanzia, which was constructed in 1423 on an outside pillar of Orsanmichele to receive Donatello's gilt bronze statue of *St. Louis of Toulouse* (today replaced by Verrocchio's *Doubting Thomas*). The tabernacle, a marble niche of modest size, but by no means modest intentions, was designed to hold the Donatello. Unusually, it is supported on a braided marble cushion, and has the further originality of being a virtuoso composition in its own right, being made up of two fluted pilasters surmounted by a triangular tympanum, at the center of which is a roundel representing three faces; two further Doric columns with spiral fluting; a round arch with unusual cording, made up of small cylindrical checks; and a semicircular shell niche. These elements attest to the complete break made with the Gothic motifs characteristic of the other external structures of Orsanmichele, and ought really to be attributed to Michelozzo.

The facades that to a large extent determined the appearance of 15th-century Florence, however, were those of the stark, severe new *palazzi* that were built for both private citizens and the nobility. These buildings, with their massive, rusticated stone walls and windows set behind solid iron grilles far above street level in order to protect the inhabitants from likely attack by rival factions in the city, were little short of fortified dwellings. The archetype of the early 15th-century Florentine *palazzo* is the building erected in what is now the Via Larga by Cosimo de' Medici (the Elder), started in 1444: a single, closed-in block, faced with thick, strong, downward-sloping, rusticated stone as far up as the cornice, its inner courtyard surrounded by loggias, arches and columns, it was a type of dwelling not entirely devoid of medieval overtones, one might say, if only because of the mullioned windows perforating the upper floors of its outer shell. The powerful walls of the *palazzo*, which clearly signaled the boundary between the public and private spheres, expressed the owner's mistrust

Opposite:
Exterior view of the Pazzi Chapel.

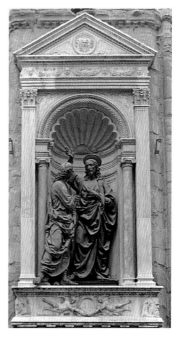

Tabernacle of the Mercanzia on the exterior of Orsanmichele.

of the city, and embodied the traditionally parsimonious nature of the Florentines—a care not to make undue show of what might well arouse the envy of their fellow citizens. So it was to avoid "too sumptuous an expense," that Cosimo the Elder abandoned the project for which he had commissioned Brunelleschi, the palatial house "which was to have been situated in the Piazza di S. Lorenzo." This information, from a 16th-century source, gives no indication regarding the features of the *palazzo* or the square; consequently, it remains impossible to hazard a guess as to what, if any, Brunelleschi's town-planning ideas might have been.

Yet the ability to depict from imagination an otherwise unrecorded piazza in full perspective exists beyond any shadow of a doubt: Donatello's bas-relief on the high altar of the church of S. Antonio, Padua, which contains the scene of the saint performing the *Miracle of the Penitent Son* (1447), is eloquent proof. It is worth pointing out that the setting in this bas-relief is the most astonishing hypothetical urban space in the entire 15th century. For a moment or two, Donatello has put aside his sculptor's habit and put on that of an architect, and has designed a square surrounded on three sides not by the usual backdrop of buildings but by a series of diagonals representing steps in order to take advantage of the increased space created by the various levels and the multiple viewpoints they offer. Donatello has succeeded in replacing the usual planimetric orderliness of a static, box-like square by a dynamic articulation of levels and views. Those who have sought through verbal gymnastics to compare his concept to the types mentioned in Alberti's later treatise (*De Re Aedificatoria*) or some plan or other of a Roman amphitheater only succeed in demonstrating their inability to see the anti-traditional meaning of this terraced *agora*, for its absolute originality lies in the fact that nothing like it exists either in the real world or in the works or plans of 15th-century Florentine or other Italian painters. What Donatello has done here is to invent a piazza, an imaginary urban space, in which the various potential daily events, encounters, and moments of rest are depicted (as can be seen, moving from one step to the next) as they open the way to the participation by the citizenry, both as choir and as community. As the background to his terraced piazza, Donatello has placed a monumental, cube-like building instead of an angle, and this building, too, differs in appearance from the palazzi built in Florence during the period—the Strozzino (c. 1457), the

Pazzi (c. 1469), the Antinori (started in 1469), the Gondi (1498), as imitations of the Palazzo Medici, or the immense Palazzo Strozzi, started in 1489, which set out to compete with it. As far as the formal character of these palazzi is concerned (their ashlar stone facings conceived as metaphors of natural rock or defensive barriers; the horizontal molding cornices dividing their unadorned facades into floors; their regularly spaced mullioned windows; and their markedly projecting cornices and roofs) a sufficient number of departures can be seen from the houses of Luca Pitti (c. 1457–69) and Giovanni Rucellai (started c. 1455 and completed 1460), when Filarete, passing through Florence, wrote of a "house recently built in a section of the city, that of Via Vignia, whose entire facade is of dressed stone and all in the antique fashion."

In the Pitti Palace, which originally had only the seven central window bays, the extent of the rustication, while no doubt reassuring for defensive purposes, seems in stark contrast with the great arches lining the upper two floors—themselves also increasingly set back in comparison with the ground-level floor, in each of which stands a French window, hinting at a rather more trusting attitude toward the city. This contrast with the colossal stone of the ground floor is heightened by the balconies running the whole length of the building, or the flush facings, both of which are quite exceptional features in Florentine palazzi of the period.

The Palazzo Rucellai, on the other hand, is of modest external dimensions and, with its more graceful facing, quite unlike other more usual noble houses of the day in appearance. These qualities result from the flattening of the stone facing and the inclusion of three orders of pilaster strips. Nonetheless, these vertical and horizontal elements have no structural role—they are merely ornamental reliefs, altogether without three-dimensionality, parts of an elegant, harmonious shell placed around a building that was already partially there. The dressing of the flat rustic stone facing, too, remains a mystery, for its face was carved after its stone blocks were put in place. In other words, the vertical and horizontal grooves

On the following pages:
Palazzo Pitti, showing the facade with
its original dimensions.

Opposite:
Palazzo Rucellai, showing the ground
floor facade, detail.

Right:
Palazzo Rucellai, commissioned by
Giovanni Rucellai.

between the blocks do not match up with the
real joins between the blocks. Of the three
levels of the Palazzo Rucellai, the most
noteworthy in terms of originality and rigor of
construction is the ground-level floor. This is
because of the brilliant placement of the
square windows (which are essentially
different from the involved design of the
antiquated mullioned windows on the upper
floors) and the use of *opus reticulatum* for the
back of the stone seat, which further highlights
the link between the building and the ground
it stands on. The fascinating and even
welcoming appearance of the Palazzo Rucellai,
so clearly expressed in its facade, leads one to
consider the man for whom it was built and
the man who is assumed to have built it. In
turning his back on the cliché of the fortified
palazzo, Giovanni Rucellai opted for a
building with an affable, typical appearance
that would serve as symbol of the family's
good fortune. He also had an oversize loggia
built on the small triangular square facing the
palazzo "in honor" of the family name and "to

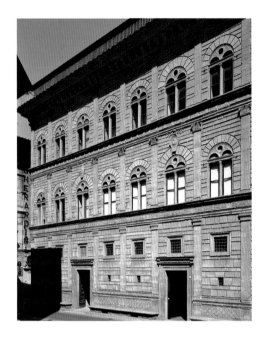

strive hard in joy and sorrow"—and as a
public showcase where he could display,
advertise, and sell the products of his wool-
dyeing industry. As far as the architect is
concerned, although Vasari identifies him as
Alberti, we are duty bound to point out that
15th- and 16th-century Florentine sources
earlier than Vasari make no mention of Alberti
at all. He is not even recorded in the
Zibaldone Quaresimale, which after 1457 was
written by Rucellai himself, the man who
commissioned the house, who would have
been delighted to have an architect as
prestigious as Alberti to design it. Neither does
the *Zibaldone* mention the presumed builder,
Rossellino. But it does contain a flattering
reference to Brunelleschi, who is described as
"master of sculpture and architecture, perfect
geometer, of great natural genius and
imagination in the said arts as no other hath
ever been since the time of the Romans,
resuscitator of antique walls after the Roman
manner." Neither is Alberti mentioned by
Filarete when he refers to the Palazzo Rucellai
as "made in the antique manner." Neither does
the "Anonymous Biographer," otherwise so
zealous in recording all expressions of esteem
concerning his subject, mention Alberti's
portentous "dedication" to Brunelleschi in *De
pictura* (1436). Nor are there mentions of
Alberti in the *Libro di Antonio Billi* (which can
be dated between 1506 and 1530) or by the
anonymous author of the Magliabechiano MS.
On the other hand, the latter clearly states that

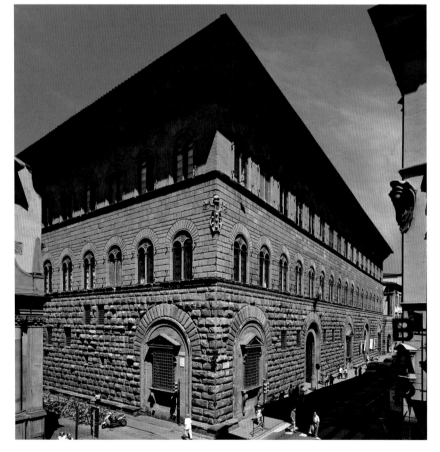

Palazzo Medici Riccardi.
The Medici family crest is clearly visible
on the angle.

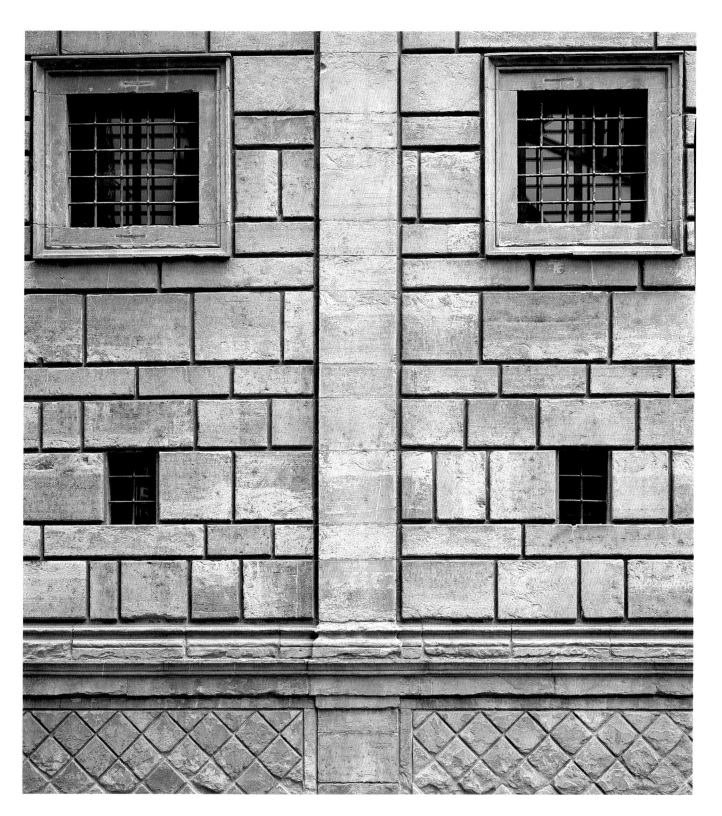

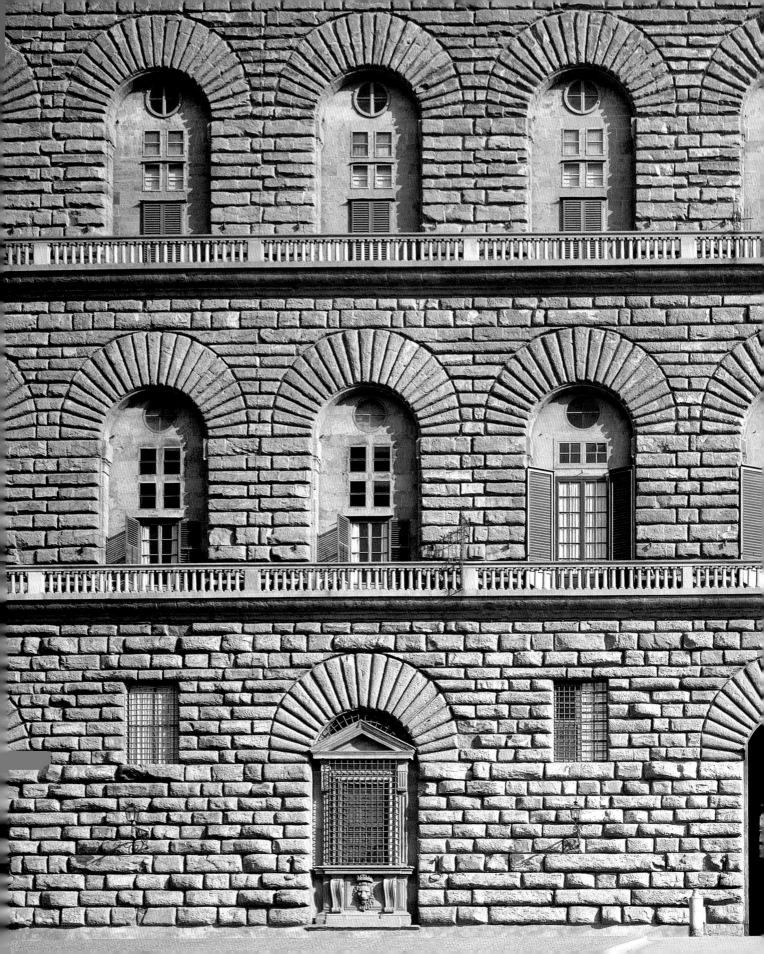

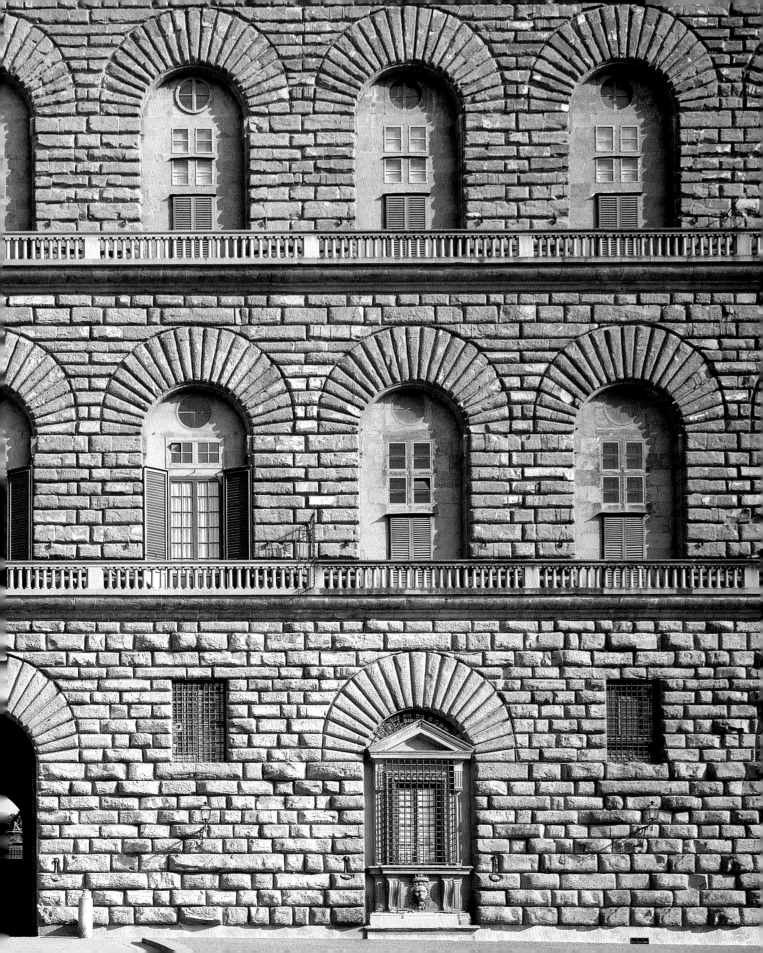

Rucellai family crest ("sail of fortune"), marble inlay. Facade of Sta. Maria Novella.

Sta. Maria Novella, detail of the facade, the radiant sun in gray and white marble crowning the tympanum (see page opposite).

Bernardo Rossellino "made the model of the house of the Rucellai; and of the loggia of the Rucellai Antonio di Migliorino Guidotti made the model." Alberti's acolytes, following Vasari's "gospel" and primarily seeking to impart mythical status to their "star," argue that "model" should be understood as being a

wooden mock-up constructed following someone else's design, and refuse to admit that a minor architect like Rossellino could have designed something as sublime as the Palazzo Rucellai, even if out of the goodness of their hearts they do concede that he was the builder. But to retain some credibility the acolytes need to explain how on the one hand they can trust the statement in the *Libro di Antonio Billi* that it was Michelozzo "who made the model of the Palazzo of Cosimo de Medici" while on the other rejecting the affirmation that "it was Bernardo [Rossellino] architect…who made the model of the house of the Rucellai." The same Bernardo, curiously enough, who is recognized as having designed the Palazzo Piccolomini in Pienza (1459–63), a building that while larger and in a different setting nonetheless shares stylistic elements in common with the Palazzo Rucellai, with the variation of Roman-style cross windows and an elegant, airy loggia with three tiers of arches looking out over the Val d'Orcia. Once

Opposite:
Facade of Sta. Maria Novella.

180

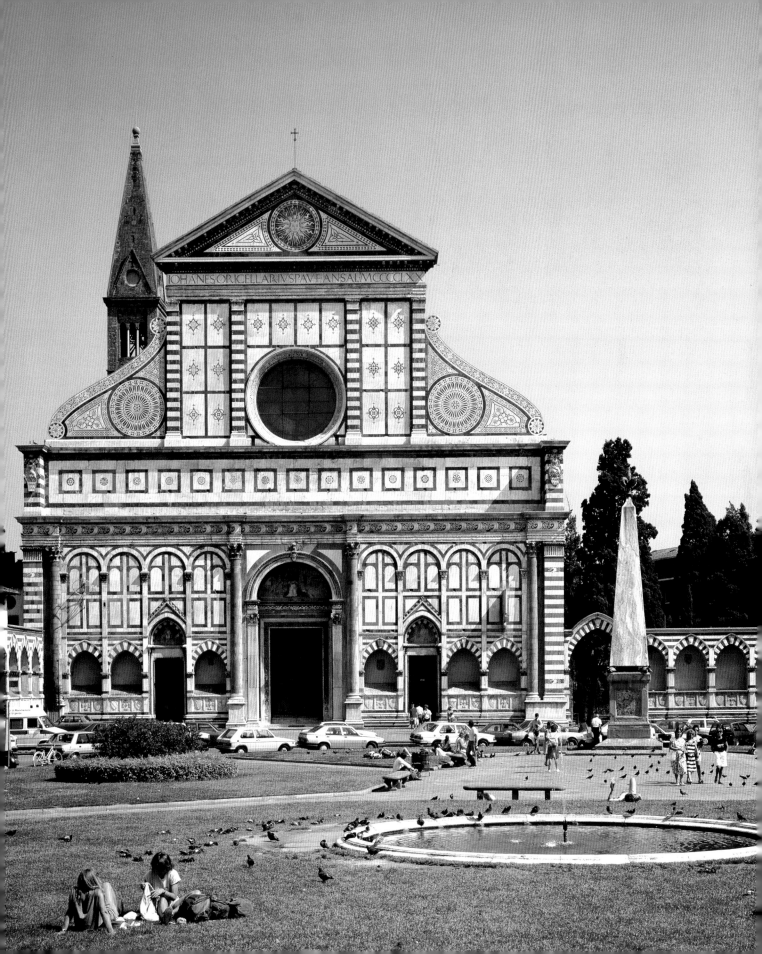

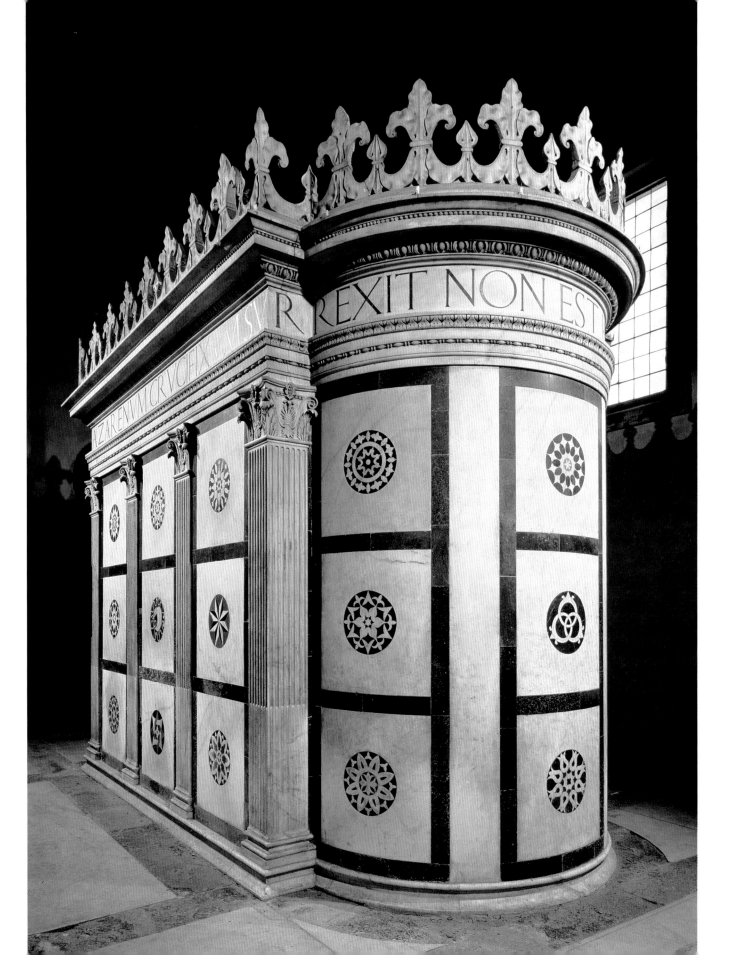

again, the acolytes need to explain why a humanist pope, a connoisseur of architecture, and a man as proud as Pius II Piccolomini, who instructed Rossellino to adhere to the German *Hallenkirche* typology for the interior of Pienza Cathedral, and who further entrusted him with the ambitious project of redesigning much of the town, would have accepted from his trusted architect (whom he described as "worthy of great honor among all the architects of our century") a design for his

residence that was no more than a vulgar copy of a Florentine palazzo that had been designed by another architect (Alberti).

When it comes to the facade of Sta. Maria Novella, however, there is no doubt that it really was designed by Alberti. As Girolamo Mancini (*Vita di Leon Battista Alberti*) and the Dominican friar Giovanni di Carlo (who actually lived in the monastery at the time when the marble facing was being placed on the facade) both relate, this was "the work of

Opposite:
Copy of the Holy Sepulcher, housed in the old church of S. Pancrazio (Rucellai Chapel).

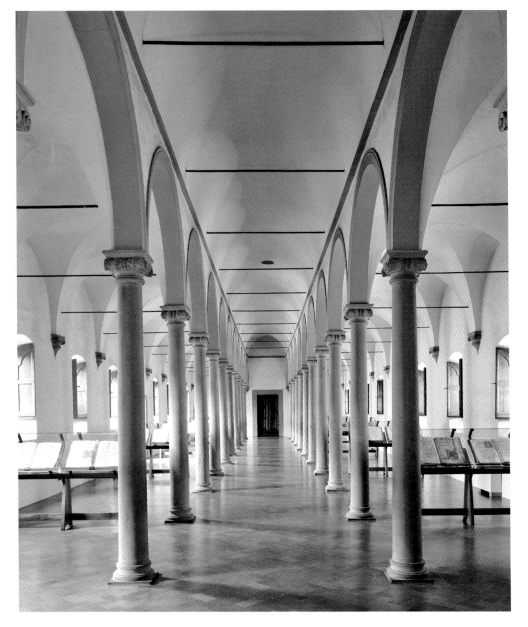

Michelozzo, Library of the Monastery of S. Marco.

the most celebrated architect L.B. Alberti." On the basis of recent studies, it would seem that Giovanni Rucellai's desire to complete this project, which had been interrupted in 1356, and to build a shrine in Sta. Maria Novella in imitation of the Church of the Holy Sepulcher in Jerusalem, coincides with the presence of Pope Eugenius IV in Florence from 1439 to 1442, for the Council whose task was to celebrate the union between the Eastern and Western Churches. To link the two sections, the older and the newer, Alberti not only used green and white marble as a unifying material, but also, more importantly, a stylobate flush with the surface and fixed to the footing of the upper section, as a mezzanine high across the facade, and decorated it with squares. On this base, he created a facade alluding to a temple (somewhat reminiscent of S. Miniato al Monte), incorporating the existing great oculus and crowning it with a triangular pediment, apparently held up by four gigantic pilasters. The highly decorative temple crowning the church was then attached to the stylobate, which both separated and connected the two sections of the facade, by means of two volutes (the so-called ears) to conceal the sloping roofs of the side-aisles. Another characteristic aspect of Alberti's facade is the cosmological symbolism evident in the marble inlay, the work of Giovanni di Bertino, the marbler, who executed the work "con l'arte sua" (using his art) from 1458 to 1470. The symbolism can be recognized in the great radiant sun in the center of the tympanum, the solar circles and stars inlaid in the volutes (the right-hand one was completed in the early 20th century), and the stars centered on the panels between the pilasters and the squares on the stylobate. Alberti's facade, for all its two-dimensional limitations, constituted a strong, impressively intellectual presence in a city otherwise devoid of church facades.

Giovanni di Bertino, whom Rucellai recorded among the artists from whom he collected "more things of sculpture and painting in intarsia and mosaic," was also the craftsman who created the decorative marble work of the shrine of the Holy Sepulcher, which was completed in 1467, not in Sta. Maria Novella, but in the Rucellai Chapel in S. Pancrazio. In a letter to his mother, Giovanni Rucellai wrote, "I am pleased to inform you that yesterday I sent off the expedition to the Holy Land, having sent there two vessels, all at my own expense, together with an engineer and men in order that they may obtain for me the true design and measurement of the Holy Sepulcher of Our Lord Jesus Christ and with the greatest speed

possible return thence and bring it to me, that I may fulfill my desire to have one built similar to that here in our own chapel." And although the Florence shrine bears no resemblance either in shape or in dimensions to its Jerusalem prototype, nonetheless it does have a sort of "ideal spiritual assonance" with the original—the fact of going back to the real Sepulcher "becomes the pretext for creating an authentic, autonomous invention, a work that lives its own life." (Dezzi Bardeschi). The votive chapel within which the Florence Holy Sepulcher stands resembles that in Jerusalem only in the number of painted background panels that stand for the compartments of the facade, and in its entire marble facing. On the Sepulcher itself, the panels, decorated with marble inlay, are divided by fluted pilasters along the straight sides and by vertical bands of white marble around the false apse. Next, above the uninterrupted white trabeation along the top of the little temple, runs an astonishing row of pointed leaves alternating with fleurs-de-lys, like some extraordinary battlement. And above it all, crowning the Rucellai Sepulcher, is a slender lantern of upwardly converging spiral lines, of the same type as the Brunelleschi lantern that crowns the Old Sacristy of S. Lorenzo. What, however, makes this little temple the jewel that it is, are the 30 ornamental motifs, each set in its own green marble square, which recall the decoration of the facade of Sta. Maria Novella, and support the attribution of this admirable work to Alberti.

And with this splendid achievement, Alberti's Holy Sepulcher, we close our chrestomathy of 15th-century Florentine architecture. Other examples of architecture that are not included here, however delightful they may be, belong to the category "Works of Secondary Importance." Michelozzo's little triple-aisled library in the Monastery of S. Marco (1444) is an example. Although certainly not lacking in grace and sobriety, and notwithstanding the fact that it is a prototype, it is hard not to admit that its treatment of space (an effect not helped at all by the recent rediscovery of the original green wash used on the walls) and its structural layout are simply routine. Its static structural nature proved to be its weakness in the earthquake of 1451, when part of it collapsed, and other parts were damaged.

The funerary wall niches, too, in which architecture and sculpture combine not always felicitously, seem to be the expression of a rather limited formal vocabulary, since following Bernardo Rossellino's somewhat unfortunate start with the tomb of Leonardo

Bruni in Sta. Croce (1445–47), in which the arch seems to crush the piers under its weight and the extrados is out of line with the vertical of the trabeation below, the other funerary monuments are all virtually identical, except for minor variations in sarcophagus form and in the use of the reflective properties of marble bases.

Similarly, the brothers Benedetto and Giuliano da Maiano, Giuliano da Sangallo and Simone del Pollaiolo, better known as *Il Cronaca*, are all secondary figures. Once one refuses to be swayed by too facile ascriptions of genius washed down with generous doses of local patriotism, one can realistically describe Giuliano da Maiano as a modest architect—as can be seen in the facades of the Palazzo Antinori and Palazzo Pazzi and the box-like church of S. Salvatore al Monte, traditionally ascribed to him, and see his brother Benedetto as an eclectic journeyman whose formal references derive from Michelozzo. There is no escaping the fact that the Palazzo Strozzi, the one building in Florence that stands out most as an invasive cube, is the definitive result of a cultural approach that by 1489 (the date when it was started) belonged to the past and was irrefutably anachronistic.

As for Giuliano da Sangallo, although he could rely on a solid background as a craftsman, he lacked sufficient inventiveness and tended to be a popularizer—after he returned from Rome in 1479—seeking to transplant the odd bit of quasi-archeological remains into Florentine soil. His portico in front of Sta. Maria Maddalena de' Pazzi, his church of Sta. Maria delle Carceri at Prato (no more than the vertical expansion of the Greek cross used by Brunelleschi for the floor plan of his Pazzi Chapel, and after 40 years even imitating its drum and the conical outer shell of the dome), or again his facade for the Palazzo Gondi (based on the same old type of facing—rustication—albeit with some intention toward simplification), none of these succeeds in turning around the creative slump, the flattening out in terms of both creativity and content, of Florentine architecture of the late 15th century.

Nor do the buildings erected for Lorenzo "il Magnifico" (the Magnificent) make one swell with pride. For although Lorenzo's is often described—and often with excessive emphasis—as a golden age, as far as architecture is concerned it needs to be admitted that the use of the adjective "golden" is decidedly inappropriate. Although at the beginning of the 16th century it is true that Niccolò Valori could see his way, following in the apologetic steps of Lorenzo's architectural successors and supporters, to write that Il Magnifico "was most learned in matters and especially in that which was closest to the antique, as witness the building at Poggio a Caiano, which almost emulates and represents the magnificence of the ancients." Yet it is also true that the more reliable and objective Francesco Guicciardini, still referring to Lorenzo, took pains to point out in his *Storie fiorentine* that "compared with the many walls that Cosimo (the Elder) built, one could say that he built nothing." As is well known, Medici propaganda succeeded in creating the myth of Lorenzo il Magnifico immediately after his death, in the face of the onslaught by Savonarola and his supporters. But if we turn specifically to architecture and try to list the buildings that were built between December 1469 (when Lorenzo, then aged 21, was asked to assume the "care of the city and the state") and April 1492, when he died, we have to admit that Guicciardini was right. The list is rather meager and, when it comes to the quality of the buildings, singularly lacking in splendor. The buildings that are documented as having been commissioned by Lorenzo are limited to the villa at Poggio a Caiano (1483), the church of Sta. Maria delle Carceri at Prato (1485) and, as far as Florence itself is concerned, the sacristy and vestibule of Santo Spirito (designed by Il Cronaca in 1488) and the church and cloister of S. Gallo (started in 1448 and demolished in preparation for the siege of 1529). Nor is there much to be gained from overrating unfinished initiatives in the hope of bolstering Lorenzo's architectural achievements, such as the contest he promoted for the facade of the Duomo or the plan for a Royal Medici Palace, or rather the utopian addition to the city, which was supposed to be built near the Piazza della Santissima Annunziata and to be used as a model for export to other cities in Italy. On the other hand, not a single drawing for the facade of Sta. Maria del Fiore has been thus far traced and the planimetric design for the Medici Palace, which dates after 1498 (as documented by Giuseppe Marchini), may well not be attributable to Lorenzo's initiative, for he had died six years previously. It would be misleading to claim on such a flimsy basis that Lorenzo was an architectural *maître à penser*, even though someone has recently seen fit to do so, and to advance the rebirth of Florence's primacy in the world of architecture as a result.

On the contrary, the buildings themselves, with their unoriginal formal language and lack of innovative treatment of space, refute such

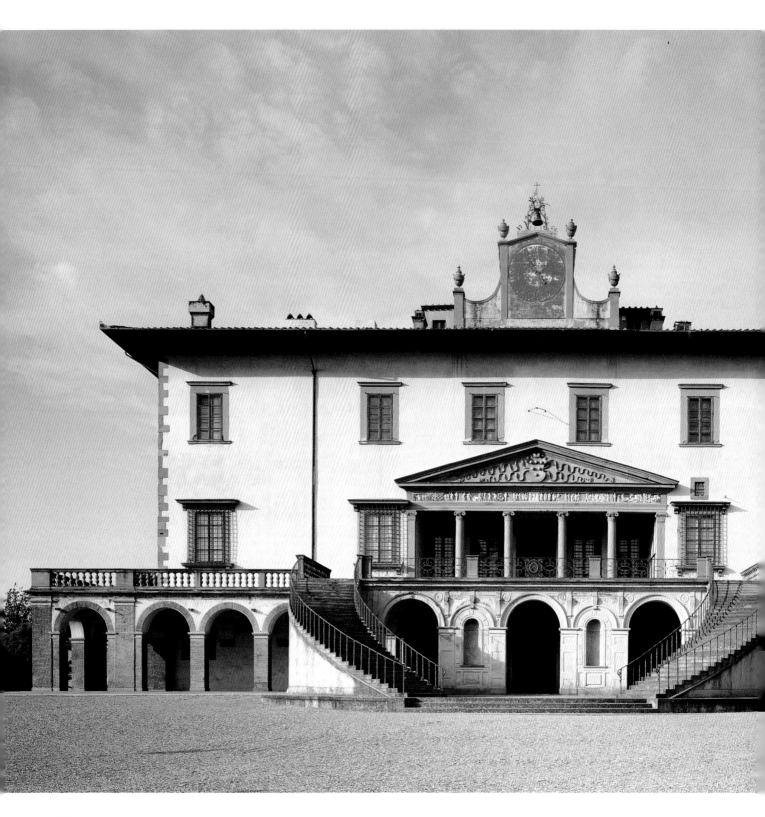

primacy—Sta. Maria delle Carceri, as I have already said, makes widespread use of remnants of Brunelleschi's much earlier modeling style, while the sacristy of Santo Spirito is merely a banal imitation of illustrious earlier examples of octagonal interiors, starting with the Baptistery itself. As for the Medici Villa at Poggio a Caiano, it is a veritable frieze of "classical" references (suffice it to mention the trabeated loggia crowned with a triangular pediment, and the *basis-villae*, which might have been inspired by Roman examples). Yet with all these, Giuliano da Sangallo was incapable of giving life to his masses, which remain substantially rigid, or to a facade whose composition is relatively conventional, or of correcting the imperfect relationship between the crushing mass of the villa and the portico below, even though the curved staircase (added in the early 19th century by Pasquale Poccianti) does go some way to help unite the two masses and confer on the building as a whole a certain undeniable majesty. All of which leads one to the conclusion that to use the name Lorenzo adjectivally to define a style or period of architecture amounts to little more than wishful thinking. To justify doing so, we should first have to determine what meaning such use would entail, and then demonstrate in concrete terms how its use would be consistent with specific architectural types and spaces that can be traced back to Lorenzo's supposed "neo-platonically demiurge-like" creativity (as some present-day academic has intoned, sententiously). These types and spaces would need to possess particularly distinctive characteristics, but nobody thus far has managed to explain what these might be. From the pontificating of those who advocate the notion of a Lorenzo style, it would appear that the common denominator of these characteristics might be a return to "classicism," but it is worth recalling that using the language of classicism has not always been synonymous with magnificence and progress, and neither has it been a guarantee of a drive toward innovation. In February 1498, when Girolamo Savonarola was burning "naked bodies…heretical books, Lorenzo's presumed ambitions for Florence's tired and resigned late 15th-century *Morganti*, mirrors and many vain objects" he might have added architecture to his "Pyre of Vanity".

Carlo Cresti

Villa Medici, Poggio a Caiano. General view showing the curved staircase added to the building in the early 19th century by the architect Pasquale Poccianti.

Andrea Pisano, *Bronze South Doors*, Baptistery. 15th-century door jambs by Vettore Ghiberti.

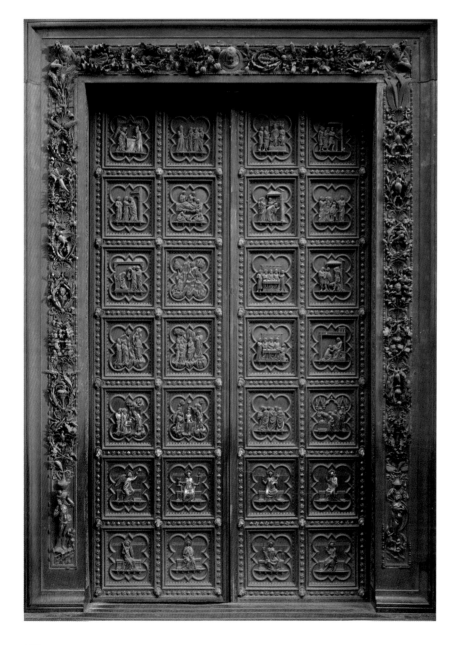

International Gothic from Orcagna to Ghiberti

The heyday of the Giottoesque style, which reached the zenith of its glory in the chapels painted by the Master himself in Sta. Croce, did not leave the sculpture of the 14th century unaffected; for while Arnolfo's poetic vision skillfully extended across the facade of the Duomo, dominating the appearance of the still-unfinished building, sculptors were concentrating on the "Bel S. Giovanni"—the Baptistery opposite the Duomo—and the Campanile. Andrea Pisano (who came from Pontedera), the heir to the tradition initiated by Nicola and Giovanni Pisano, but the softness of whose modeling brought him closer to Nino Pisano, was called to design the reliefs for the great bronze south doors of the Baptistery, those facing the Duomo. The execution in metal of his designs, a series of scenes from the *Life of St. John the Baptist* and statues of the Virtues, all set within gilded Gothic quatrefoils, would be the task of a team of Venetian founders working under Lionardo d'Avanzo. He followed detailed studies by the Bonanno workshop associated with the cathedral in Venice, although the cleanness of his forms and the abstract character of his backgrounds would tend to suggest that he might have used wooden rather than wax models. The completion of Andrea's work and the opening of the doors in 1336 marked a glittering, unprecedented display of Florence's determination to display its economic and cultural power, its superiority over the other Tuscan cities, with which it had earlier struggled for regional supremacy.

This was probably why Andrea found himself engaged to decorate the upper registers (above those of Giotto) of the marble-inlaid Campanile not just as an architect, but also as a master mason. He, Aroldi, and a group of lesser-known or now completely obscure masons and carpenters then executed a complex program of carving, flanking the earliest history of humankind (in the lower row) with emblems of the Liberal Arts, figures in classical style of the Planets, the Virtues, and representations of the Sacraments, the entire work representing the cycle by which human civilization came into being. At the same time, the artists (among whom, according to Ghiberti, was also Maso di Banco, otherwise known only as a painter of frescoes and panels) shaped solid, concrete figures of prophets for the time when they, too, would be placed in their assigned niches in the third row of the Campanile. Of all the figures carved for the Duomo and those attributed to Andrea, one still appears sublime even to modern eyes—that of Sta. Reparata, the patron saint to whom the earlier basilica had been dedicated. Her gentle, almost shy attitude, the manner in which the volume of her figure is rendered, are both characteristic of a Gothic style that was not limited to masterpieces in France or Germany. Ties with the House of Anjou immediately spring to mind, and it is hard to resist the thought that the seigneury of Gualtieri di Brienne, duke of Athens, which

dates from the same years (1342–43), also had
some effect on the development of the plastic
arts in Florence. Nevertheless, it would be
wrong to ignore the fact that the closest parallel
now known for a figure like that of Sta.
Reparata is the statue of Uta von Naumburg.
Although the statue of Uta differs from that of
Reparata in the naturalism of her expression,
and although it is from a different period, it
demonstrates the degree to which the late
Middle Ages could conceive of a vision of
woman as gentle and courteous as she is also
mysterious and powerful.

Andrea imbues his female figures with an
expressiveness of gesture that he achieves by
placing their limbs in counterpoint with one
another and by rendering the folds of their
robes in a sequence of crescents—an
expressiveness that is both naturalistic and
ritualistic and that makes it seem as if the statue
is quite prepared to recount her life story,
though in words still soft and rhythmic.

A far more orthodox follower of the tradition
of the great Arnolfo was Tino di Camaino, who
was also called upon to provide models for the
bronze doors and who achieved "archaic"
overtones in his strictly proportional, almost
cubist, column-like representations of the
human figure. Returning to Nicola Pisano's
sober interpretation of the Roman spirit, Tino
simplifies the erudite ecclesiastical language of
Nicola's central and southern Italian prototype
and deliberately plays with it, transforming its
formal eloquence into a powerful vulgar tongue
full of provincialisms and Germanisms. One
feels the presence of Giotto and of his greatest
followers, Taddeo and Agnolo Gaddi, very
close at hand. Yet even though Tino still fills his
spaces with figures of saints from famous
Florentine polyptychs of the first half of the
century—from the time before the Black Death
almost devastated the productive capacity of
the local workshops—and although his bearded
prophets with their pointed wooden frames
have shed their foreign, glazed colors, a new
formal common denominator is emerging here
from the imagination of local artists, a sort of
would-be classicism, something not yet
anchored in specific references to authoritative
classical sources (if one looks closely) and yet
something striving boldly toward the definition
of a new canon based on the reconquest of the
human body. Tino has succeeded in inventing
a figurative vulgate; and his prototype will go
on to assume mythical proportions. It is no
coincidence that Giotto is celebrated in the
Divine Comedy as the man who "held the
field," meaning he who routed all other ways of
expressing taste in Florence. Suffice it to look at
the remains of the magnificent monument to

Andrea Pisano, *Sta. Reparata.* Museo dell'Opera del Duomo. The figure seems to recall the same ideals of reticent elegance that are found in the celebrated statue of Uta in Naumburg Cathedral, Germany.

Bishop Orso (d. 1321) in the counterfacade of the Duomo (now faithfully reassembled in its original form by using the canopies and telamones from some of Tino's Neapolitan tombs as reference material) to see how the solidity of the figure never slackens, given the experience of the years, never becomes rougher, let alone slovenly, as do some of the works prepared by his workshop for other parts of Italy. The tomb of Francesco Pazzi, though from another workshop and another hand, and despite its unfortunate position outside Sta. Croce—right beside the door near the north arm of the transept—gives a good indication of how many of the noble funerary monuments scattered among early-14th-century Florentine churches ought to appear. The works produced during the second half of the century can hardly, if at all, be described as being the product of exquisite artistic culture. Even nearby Siena, thanks in part to the lively school in Pisa, and also perhaps because it never severed its ties with the lands beyond the Alps, proves to have been a more stimulating place for sculptors than staid old Florence. Artists like Tino, who was active in both cities, seem to have been more at ease with the black and white *Balzana* (horse's white "sock") of Siena than the lily of Florence, leaving works such as the monument to Cardinal Petroni (c. 1320), in Siena Cathedral, that were fully in tune with the international Gothic style and thus more inspiring for the following generation.

Florence's most original creation of the second half of the 14th century is without doubt Orcagna's marble tabernacle in Orsanmichele. Dated 1359 but actually completed in 1360, this great architectural structure, admirably enlivened by statues, reliefs, and both gilded and polychrome glass inserts, now seems hemmed in and almost crushed by the building within which it stands. The tabernacle was originally conceived to hold Bernardo Daddi's great altarpiece of the *Holy Virgin* (1347), which was venerated by those who carried out their business in the loggia. At the time the spaces between the great external arches had yet to be walled up and the light in the covered space would have glittered over the colored inserts of Orcagna's richly variegated surface. Today it is impossible, even with the greatest mental effort and using photographic aids, to recreate the cumulative effect the project as a whole must have created when it was first completed. Nevertheless, one can easily appreciate the sophisticated play of light and shade over the ornate reliefs and the profusion of spiraling, inlaid plants that enrich the molded cornices, friezes, dentils, and ribbing on the tabernacle, from its base to the

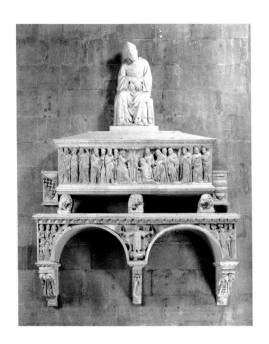

tympana and pointed cupola above. The plastic rendering of all the elements making up these marble screens is clear and incisive; no less identifiable are the forms and details of the figures that enliven the composite pilasters at each corner, or the rich relief of the *Dormition* and the *Assumption of the Virgin*, in which the Madonna appears within a giant mandorla borne aloft by angels against a background encrusted with gold and blue like some sumptuous Gothic drapery. This Virgin with girdle (she no longer has her girdle, having handed it to St. Thomas some time previously, but which we can imagine as a masterwork by some Gothic goldsmith), is depicted wearing a cap beneath her veil, exactly as Florentine ladies did at that time, in accordance with the dictates of contemporary international fashion.

The volumetric clarity of the figure and the measured gesture that subverts its almost abstract majesty are stylistic traits of the master himself, and can be retraced among his talented and not so talented contemporaries and followers. Suffice it once more to look at the splendid tomb slab of Lorenzo Acciaiuoli (d. 1353) in the Charterhouse of Galluzzo. Lorenzo was the son of Niccolò Acciaiuoli, Grand Seneschal of the Kingdom of Sicily, who possibly commissioned the tomb slab from Simone Talenti, the son of Francesco. This is without doubt the finest reclining figure that has come down to us from those years (even though it is not an isolated example, bearing in mind its resemblance to that of Milano de' Raserettli in Sta. Croce, now badly worn), and it bears eloquent witness to an activity that must have been both flourishing and profitable to Florence's sculptors. For during these years, the interiors of Florence's churches were increasingly embellished with monumental sepulchers and memorials as an outlet for the pride of its aristocratic families, who were growing ever more frustrated by the republican government. So too in Pisa, Naples, and Rome, where even more such monuments were raised, but they have been much less eroded by the feet of visitors although it must be admitted that they were often carved in the round or in high relief. On the contrary, as the old burial lists show, the growing number of seals from the tombs of artisans or members of the minor nobility, bearing nothing but their family crest, which adorn the internal and external walls of Florence's churches in ever-increasing numbers, may well have a credible counterpart in the growing size of the funerary monuments of noblemen from ancient families. These tombs, their families' permanent memorial, were denied their place within the church interiors because of the hegemony of the 15th-century mercantile caste, to be later removed during the 16th century and Baroque rebuildings, finally

Tino di Camaino, *Funeral Monument to Bishop Orso*. Counter facade, Duomo. Tino was perhaps the most original of the sculptors who trained in the workshop of Giovanni Pisano and the one who most effectively interpreted, in sculpture, the innovative grotesque volumetric ideas.

Tino di Camaino, *Funeral Monument to Bishop Orso*. Counterfacade, Duomo. Detail of the relief on the front of the sarcophagus

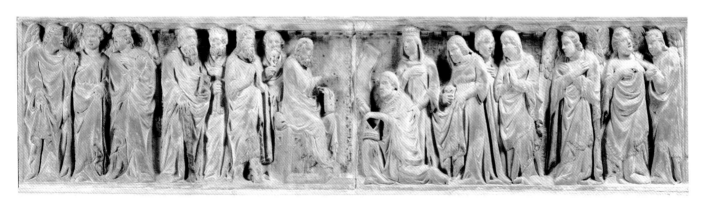

Opposite:
Andrea Orcagna, Marble tabernacle containing Bernardo Daddi's *Majesty*. Orsanmichele.

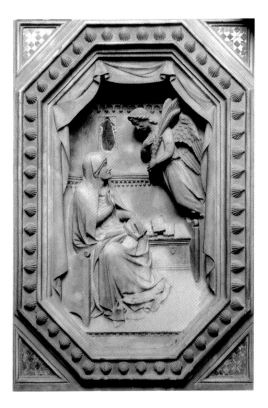

Andrea Orcagna, *Annunciation*. Detail of the relief on the tabernacle. Orsanmichele.

Andrea Orcagna, *Presentation in the Temple*. Detail of the relief on the tabernacle. Orsanmichele.

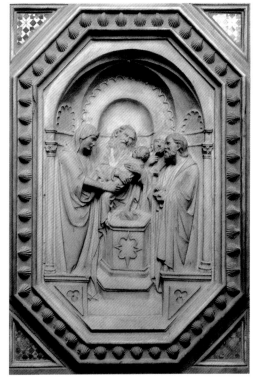

Overleaf: Page 194
Andrea Orcagna, *Dormition of the Virgin* and *Madonna of the Girdle in Nimbus Borne by Angels*. Detail of the rear face of the tabernacle. Orsanmichele. The rich, varied ornamentation and the modulation of the relief, now rough, now smooth, depending on the degree of monumentality with which he places his image, are typical traits of Orcagna's work, whose workshop also produced paintings.

ending in being banished from memory altogether, damned by 19th-century neoclassical and academic taste as barbarisms from the Dark Ages.

The man whom art historians from the first half of the last century regard as certainly the most typical sculptor active in Florence before the advent of the Ghiberti school was trained not in the city but in the north. Some critics maintain that most Florentine sculptors of whom records remain from the late 14th century worked from designs created by painters. For this reason it has been repeatedly affirmed that Pietro di Giovanni, also known as Giovanni Tedesco, Giovanni Teutonico, Giovanni di Fierinburg or Giovanni di Brabante, had no cause to shine for his originality. But the critics' opinions are contradicted by the facts—the numerous commissions he received during the building of the Duomo and his marvelously inventive tabernacle of the *Madonna of the Roses*, in Orsanmichele. Even conceding that the idea of covering a tabernacle with a stone canopy owes its origin to others, the statue itself has formal qualities that were extremely innovative in comparison with Florentine stereotypes. Although she has the same oval face, it has lost the pointed chin and cheekbones hailing back to Orcagna, and the thin nose that betrays too close a dependence on two-dimensional drawings, and shows a new way of conceptualizing a statue and its relationship with its viewers. From his work in the lunette of the Porta dei Canonici (1402) on the north side of the Duomo, compared with that of Lorenzo di Giovanni d'Ambrogio, our northern artist immediately reveals himself as being capable of a softer, more rhythmical interpretation than the style common to the time. The angel on the left, its hair a mass of ringlets, flaunts its robes, whose deep folds make the volumes of the statue more compact while at the same time more fluid, a characteristic that would shortly become evident in the proto-naturalistic work of Masolino and Masaccio, the first of the reformers. Pietro, on the other hand, uses a northern sculptural language with contemporary parallels principally in the Low Countries, but also in Burgundy. His extensive use of vivid polychromy and of gold and silver to decorate his figures succeeds in enlivening their broad, carefully-defined planes in the most naturalistic manner, and they, in turn, despite seeming to be impoverished because they are left colorless, convey that effect of ice-cold precision of workmanship that left critics from later centuries grimacing at the sight. But to see these works through fresh eyes, discarding the prejudices spawned by an obsessive fascination with Canova, we rediscover

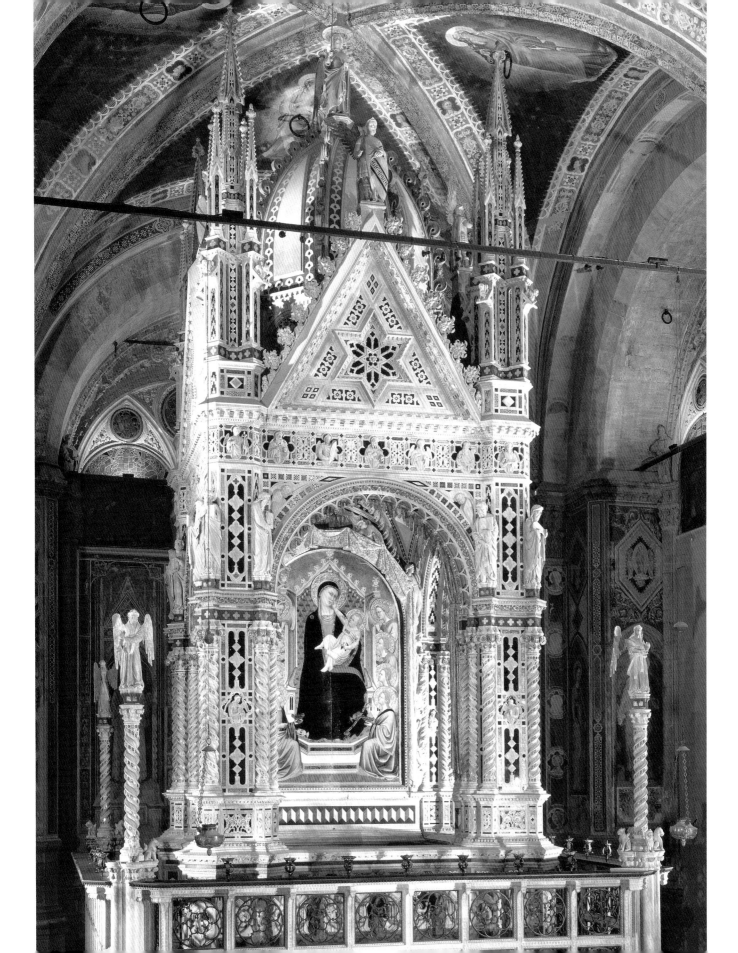

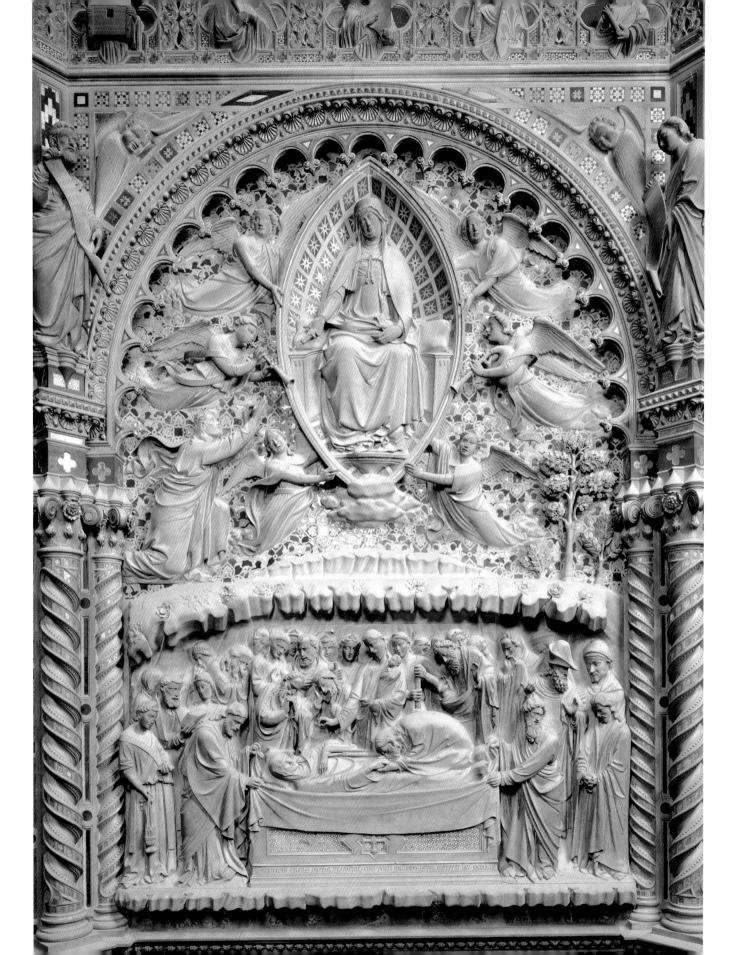

an artist who may well have been the point of reference for local painters and sculptors, Ghiberti included, as well as the hitherto misunderstood link with the court culture in the entourage of the greatest goldsmith and sculptor of the beginning of the century, which had such a following in Florence.

The only wooden sculpture known to me that could be referred back to Pietro di Giovanni is in a private collection. But in tone it almost anticipates Pisanello, and the language it speaks is of a different—one too frequently regarded as inferior—renaissance from that of a scholarly return to the classics, and this despite the fact that it was more innovative and disruptive, and its tone favored by major patrons such as the Strozzi. For although Pietro's work may have been overlooked in the squabbling of Florentine critical studies, out of it was born the formal sophistication of Lorenzo Ghiberti (1378/81–1455), who, with his father Bertoluccio, accepted the task of creating the bronze north doors for the Baptistery. Ghiberti won this immensely important commission in a competition held in 1401 over Filippo Brunelleschi (1377–1446)—who withdrew in the face of the well-organized Ghiberti workshop—and other famous figures, such as Jacopo della Quercia, Francesco di Valdambrino, Niccolò di Pietro Lamberti, Simone da Colle, and Nicholò d'Arezzo.

Except for the last two figures, whose works are unknown, all these artists can be said to share in idealized, turn-of-the-century style. None of them, not even Brunelleschi, departed

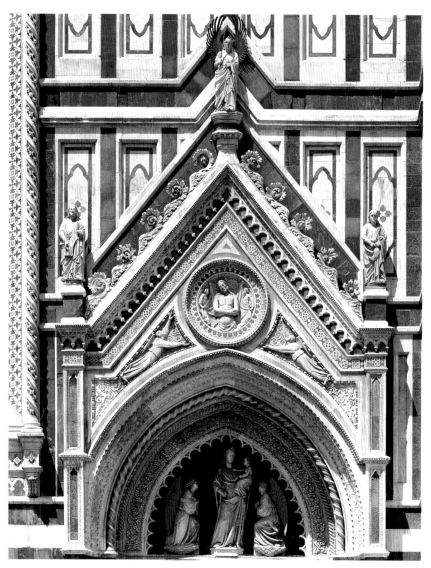

from elegantly articulated work wholly in keeping with the international court style derived from France and the Rhineland, any further than the occasional, half-hearted attempt at the treatment of a figure. But once we look back to the "beau style" of the Parlers and the work of the goldsmiths of the Île de France, it becomes clear that what Ghiberti obtained from Cologne was not just the bronze he needed, already alloyed, to cast the panels for his wonderful doors. For although no masterworks by Gusmin of Cologne, whose artistry Ghiberti praises highly in his *Commentaries*, have yet been identified, it is still evident that, if not for the stimulus Ghiberti received from artists like

Giovanni di Pietro Tedesco and Giovanni d'Ambrogi, Porta dei Canonici. Duomo.

Andrea Orcagna, Tabernacle. Detail of a spiral column with lions and lionesses at its base. Orsanmichele.

decoration of the Baptistery. Many young artists received their training in the workshop that Ghiberti set up to make these doors, who would later go on to enliven the Florentine scene around the middle of the century; the training they received from Ghiberti was decisive for their careers. Based on wax models, most of which he designed and molded himself, Ghiberti's gilded bronze panels of the *Life of Christ* constitute an iconographic and artistic gospel and would henceforth become an essential point of reference. For this reason, artists, whether they worked in metal or not (such as Nicola di Guardiagrele, who created the silver antependium for Teramo), ended up echoing or even reworking Ghiberti's masterpiece, thereby creating an Italy-wide Ghibertianism, which became a constant counter-theme to more "subversive" tendencies, and which lasted even after his death.

In Ghiberti's north doors, the eight lower panels, which in Andrea Pisano's door represented the Virtues, depicted instead the *Four Evangelists* and the *Four Fathers of the Church*. In a further departure from the earlier 14th-century model, Ghiberti arranged the narrative in his other panels so that the story unrolled upward, from bottom left to top right. The reason for this was primarily iconographic because, just as Andrea and the Opera had wished to give pride of place to the *Baptism of Christ* in their earlier doors, Ghiberti and the Opera of his time wanted the *Annunciation*, *Adoration of the Shepherds*, *Adoration of the Magi*, and *Christ in the Temple* to be most clearly visible. Of particular interest are the corymbs and vine leaves in the decoration within the sheet-bronze panels, boldly cast as a single piece, and the characterization of the tiny human heads that emerge from the little compasses placed at the intersections of the framework. Among the many heads Ghiberti chose to represent, some are a reinvention of exotic physiognomies—often Eastern, but sometimes also Nordic—that symbolize the fact that salvation through Christ is for all men. At the same time, direct quotations from classical examples probably already in the Medici collections are not lacking, first and foremost the head of Julius Caesar, taken from a basalt head that is still in the Museo degli Argenti in the Palazzo Pitti. Now, however, the head is hard to recognize, since it has been painted white to allow it to fit in with the other marble portraits of Caesar. Among the others, however, are portraits of the proud pioneers, Lorenzo and Bertoluccio, who created so magnificent a work for their own city.

Pietro di Giovanni, his work would not have been what it is. Thus while Isaac's youthful chest and flaming hair in Ghiberti's winning competition panel recall and even quote from classical Hellenistic statues that were known then, but now have no attested provenance, and although the onrushing figure of the Christ in *Driving the Merchants from the Temple* derives from Lysippus' attacking Heracles, the folds of Christ's robes dilate with the passion of his movement, and spread out in deference to sophisticated courtly taste with an admirable fluidity that we seek in vain among even his most outstanding contemporaries. In 1424, after 20 years' work, the north doors were completed and, like Andrea Pisano's before them, were installed, as part of the continuing

Mario Scalini

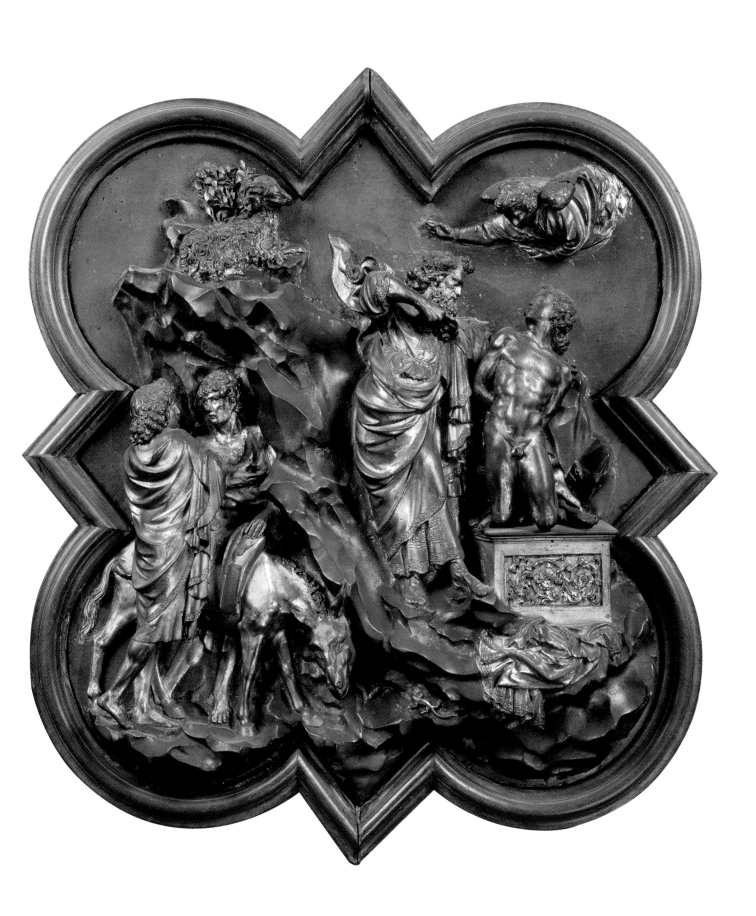

Opposite:
Lorenzo Ghiberti, *Doors of Paradise*,
Baptistery. Now under restoration, the
doors are shown here before being
dismantled, in part already in the
Museo dell'Opera del Duomo.

On the following pages:

Lorenzo Ghiberti, left, *St. John the
Baptist* (original in the niche of the Arte
della Seta) and, right, *St. Matthew*
(original in the niche of the Arte del
Cambio). Orsanmichele. Both works are
shown as they were before being
moved inside the museum.

Lorenzo Ghiberti, *Story of Joseph*, panel
from the east doors of the Baptistery.
Museo dell'Opera del Duomo.
A complex composition in which
Ghiberti suggests the depth of space
by graduating the depth of relief in
which the architecture and the figures
are rendered.

Toward the new classicism

To the people of the time, the north doors of
the Baptistery must have seemed not only an
artistic wonder, but also a technological marvel.
Within a very short time after the start of the
new century, so many changes in lifestyle had
intervened not only in Florence, but also in
Europe as a whole, that objects that barely two
generations before had been quite ordinary
now seemed to be little more than curiosities.
The decisive element in the new direction
taken by the decorative arts was the taste for
and interest in Greek and Roman antiquity. In
and of itself, classical antiquity was no novelty.
By the 14th century, the brightest and most
advanced minds in both literature (Petrarch
springs to mind) and the visual arts (how could
we forget Giotto?) were already showing an
interest in the remains of the classical world,
with the result that the artists were already
copying classical statues in their work and
accurately reproducing buildings that were
believed to some extent to have belonged to

Roman civilization. Those who had been to
Rome found themselves unable to shake free
from the fascination exerted by the magnificent
ruins of the buried empire, whose marble
bones stood out white among the hills of the
Eternal City like the skeleton of some beached
whale, stripped clean by the salt air and
glowing rose in the Latin sun.

The accounts of medieval pilgrims and
travelers, now frequently of great interest to
historians and art experts, are almost like
guidebooks in the way they always record the
best preserved and most illustrious of the ruins.
The Meta of Romulus (the Pyramid of Cestius);
the Vatican Obelisk surmounted by its gilt-
bronze globe, containing the ashes of Caesar;
the Spinario (the boy plucking a thorn from his
foot), the statue of Marcus Aurelius (believed to
be of Constantine), the Dioscuri on the Quirinal
(now renamed Monte Cavallo), one of which
was fancifully attributed to Phidias, the other to
Polycletus—these were just a few of the many
attractions one could admire when visiting the
city. The artists in Florence, who must have
heard the travelers spinning their tales of
wonder, soon enough saw objects just as
worthy of attention being unearthed in their
own city—silver, gold, and bronze coins
bearing the heads of Roman emperors, which
they mistakenly took for medals; carved and
engraved gems such as the famous carnelian
representing Diomedes holding the Palladium,
which belonged to Niccolò Niccoli, or another,
believed to have been Nero's seal, which was
mounted by Lorenzo Ghiberti. These were soon
followed by other wonders: vases in *pietra
dura*, miniature bronzes, and marbles.

We know from Vasari, as well as other
biographers, that the early humanists were
seized with such a passion for the remains of
antiquity that they would happily walk 6 or
12 miles (10–20 km) just to see a sarcophagus
that had been recently unearthed. Many of them
stayed in Rome for lengthy periods in order to
take the most accurate possible measurements
of the remains of ancient buildings, including
their moldings and decorations. One of them
went so far as to have himself let down in a
basket from the top of Trajan's Column (which
in fact is hollow, having an internal spiral
staircase) so that he could study the style of the
frieze and the way its narrative unfolds. Not
every artist was equally enthusiastic about the
mania for archeology that swept the early 15th
century; in reality, the trend manifested itself
not so much in scholarly activity as in a mania
for visiting Roman remains (Greek remains,
especially after the Turks captured
Constantinople in 1453, being virtually
inaccessible). This applied especially to Roman

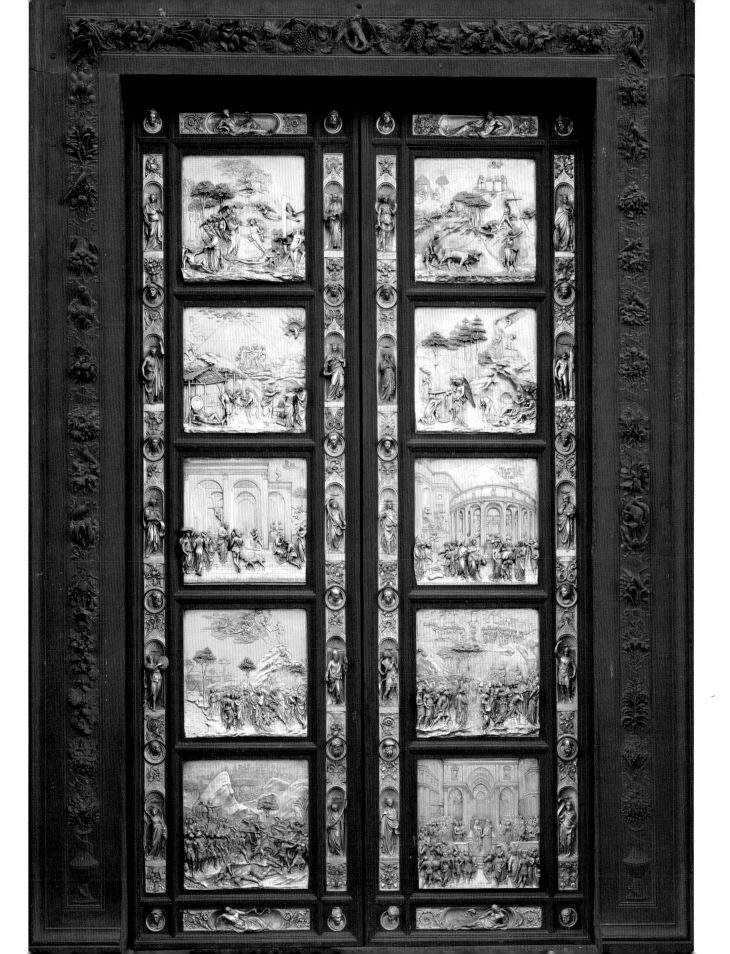

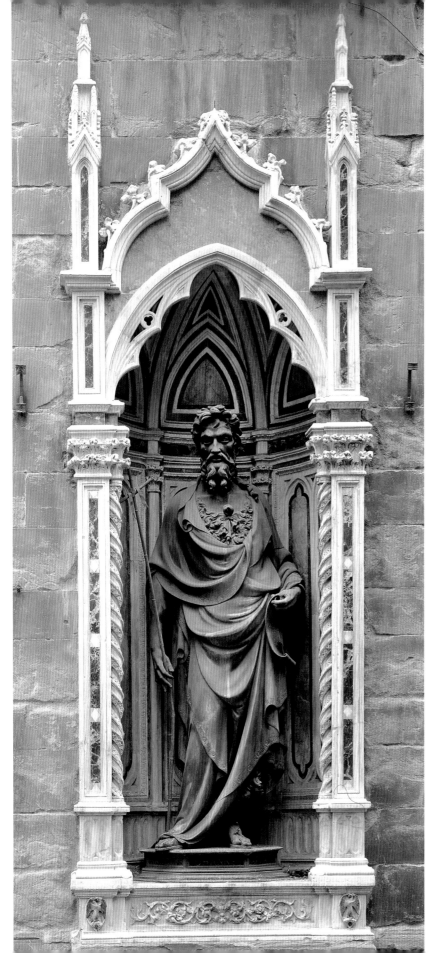

decoration, rather than the depiction of the human figure and its expressive representation. In reality, many patrons were still very much attached to Gothic taste, with its canonical elegance and its sinuous ornament, so that the workshops where artists were experimenting with the new, Renaissance language found life to be hard. This explains why a number of important patrons preferred to remain faithful to those working within the established tradition, and why it was that without thinking the commission for the third pair of doors for the Baptistery was awarded to Lorenzo Ghiberti, who was to work on them for a quarter of a century, finally completing them in 1452.

In a stylistic sense, the doors could be described as squaring the circle of Renaissance art; which explains why no less a figure than Michelangelo would revere them as worthy of the name "the Gates of Paradise." Here Ghiberti combines a mode of constructing perspective based on a mathematical theory of the representation of three-dimensional space in a two-dimensional plane, which he borrowed from Brunelleschi. This theory was based on the hypothesis of what a motionless viewer looking at the image with one eye would perceive, combined with a method of graduating horizontal space by diminishing the degree to which the figures projected from the surface in proportion to their distance from the viewer, just as Donatello had done in his narrative representations. The harmonious cadence, the manner in which the full and empty spaces in the composition complement each other, is little short of musical, and owes much to the matrix of International Gothic within which Ghiberti's thought came to maturity. At the same time, the exquisite burnishing, the work of a superlative goldsmith, speaks volumes of a search for technical perfection that transcends history. The "Gates of Paradise" mark the zenith of Ghiberti's career. They come at the end of the long, complicated path he took as an artist that led him to execute a number of highly prestigious commissions decorated with reliefs, such as the urn containing the relics of SS. Protus, Hyacinth, and Nemesius Protomartyrs, or the equally important urn containing the relics of St. Zanobius in the Duomo in Florence. Elements recalling Byzantine culture are visible in these works, of which Ghiberti can only have become aware from the presence in Florence of the Orthodox delegation to the Council of 1439. But the core of Ghiberti's language also comes from Paris, or at the very least the Rhineland school. He probably became aware of the works of these schools by seeing examples that had been shipped to Rome or Florence for devotional reasons. Today, unfortunately, these works have

almost entirely vanished without trace. At the
same time, the large statues in the Orsanmichele
were equally important, such as the statue of
St. John the Baptist, which he made for the
Guild of Silkworkers, and those of St. Stephen
and St. Matthew (1419–23), which he made for
the Guild of Bankers—clearly helped by
Michelozzo di Bartolomeo (c. 1396–1472) with
the latter. Michelozzo was a nobleman by birth.
Besides being a first-rate sculptor and carver of
reliefs in marble and other stone, he had
become one of the most skillful casters of
bronze; because of his exceptional skill he
would work with Donatello (1386–1466) from
1425 to about 1438, first with the monument to
the Anti-Pope John XXIII, whose real name was
Baldassarre Coscia (c. 1360–1419) in the
Baptistery, and then with other works, including
the external pulpit for Prato Cathedral, one of
the loveliest pieces of Renaissance stone
furniture. Circular, it recalls the later internal
pulpit in Sta. Maria Novella (1443–48), which is
normally attributed to Brunelleschi and Il
Buggiano (Andrea Cavalcante di Lazzaro,
Brunelleschi's natural son, whom he adopted
early in 1419) and can be interpreted as a
development from the medieval ambo, which,
during the Gothic period, had become six-sided,
with the exception of Giovanni Pisano's pulpit
in Pisa Cathedral, which is the first real
storiated drum.

Nevertheless, just as Luca della Robbia and
Donatellos' tympana over the Sacristy and
Canons' doors of the Florence Duomo are
overshadowed by the building's architecture, so
too, even here, in this exceptional work, the
statues are secondary to the volumetric
structure of the object and exist merely to
heighten its decorative function. It seems that
no statues surviving in Florence can be dated
with any certainty, or even any probability,
from before the mid-point in the century that
are so triumphantly three-dimensional to the
point that they are justified simply as being
objects in the round. The only exceptions are
the pillar statues obviously derived from the
famous Spinario in the Capitoline Museum or
the equestrian statues modeled on the statue of
Marcus Aurelius (Constantine).

From documents, chronicles, and other written
sources, it is clear that Donatello was the only
sculptor who designed statues to be viewed
from different angles, such as *Abundance*
(sandstone covered with gilded lead, in the Old
Market) and the *Marzocco* (the lion emblem of
the city of Florence, formerly gilded, which used
to stand by the railings outside the Palazzo
Vecchio, where public meetings were held).
Each of these figures has its own precedents and
intrinsic reasons for existing. For the *Marzocco*,

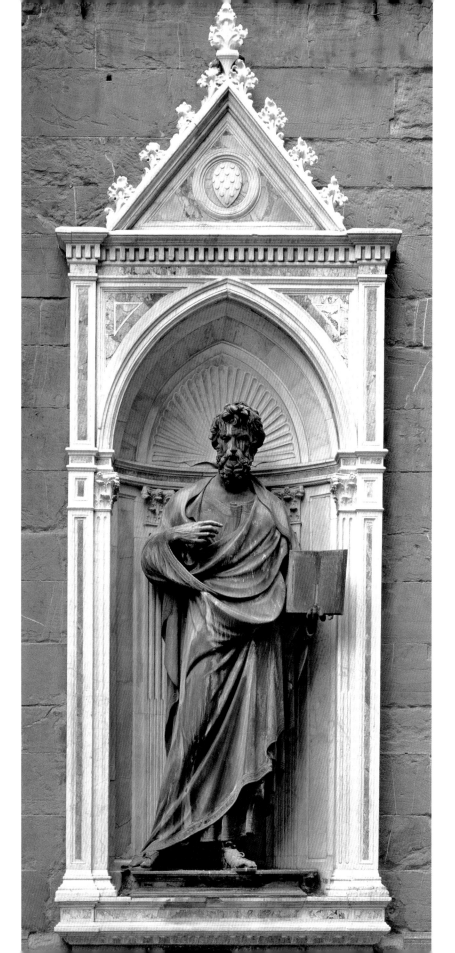

Opposite:
Luca della Robbia, Cantoria, Duomo.
Detail, depicting youths and putti
playing the psaltery. Museo dell'Opera
del Duomo.

On the following pages:

Filippo Brunelleschi, *Crucifixion*. Santa
Maria Novella.

Michelozzo di Bartolomeo Michelozzi,
Cappella del Crocifisso (Chapel of the
Crucifixion). San Miniato a Monte.

Right:
Filippo Brunelleschi and Andrea di
Lazzaro Cavalcanti, called Baggiano,
Presentation in the Temple (panel, detail
of the pulpit). Santa Maria Novella.

Below:
Luca della Robbia, Cantoria, Duomo.
Museo dell'Opera del Duomo.
Designed to form a pair with that
commissioned from Donatello, Luca's
cantoria clearly refers to classical
sculpture from the time of Augustus.

suffice to recall the multitude of little lions from the 14th and earlier centuries that stand guard on galleries, balustrades, etc., displaying the coat of arms of their houses. To be sure, Donatello's *Marzocco* has a naturalistic vitality that, far from being a mere imitation of the lions that the Signoria (the Republican government) used to maintain at its own expense in the via dei Leoni as a symbol of the citizenry, speaks volumes about humanistic aspirations connected with sculpture. The words of admiration for Brunelleschi's wooden *Crucifixion* (Sta. Maria Novella) that Vasari puts into Donatello's mouth, in which he describes his own "heroes" as "farmers" when compared with the elegance of his contemporary, are worth recalling, however familiar or even misquoted they may have been; for they tell us a great deal about how the artists went about their business.

A comparison with the first quarter of the century reveals how the market for paintings commissioned by members of the middle classes, the artisans, and small merchants, was dominated by painters such as Bicci di Lorenzo and even Gentile da Fabriano (whose customers, however wealthy, still preferred the

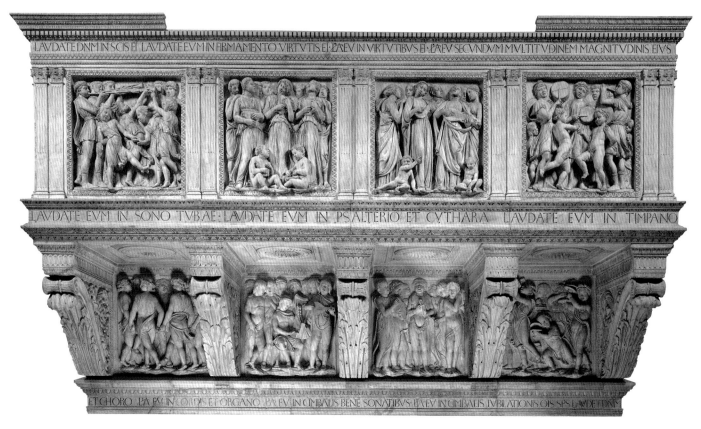

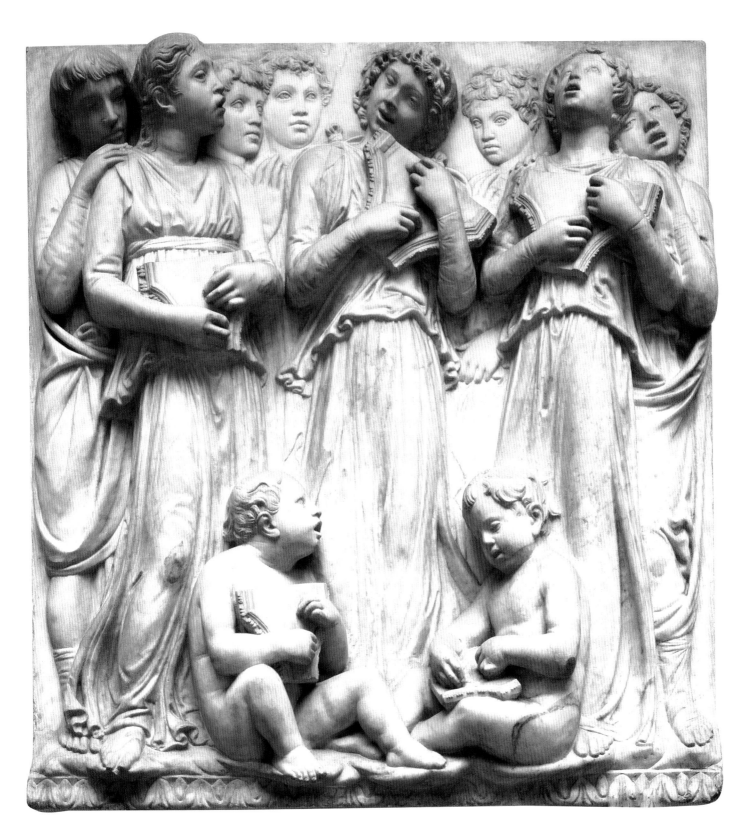

elegant international style), so that the private market for devotional sculpture was the private reserve of sculptors like Michele da Firenze (and later relief carvers who exploited Ghiberti's formulas) and Nanni di Bartolo, called Il Rosso. The aesthetic canon was to change only later in the century. A significant part of this change in the general feeling can be traced back to the diffusion of models from the principal Florentine workshops, thanks to series production methods that kept costs down without sacrificing quality. What finally made the new language of the humanists, harking back to archeology, acceptable to the first generation born in the 15th century was the balance it struck between form and expressive power. In this sense, the closest figure to Brunelleschi is undoubtedly Michelozzo di Bartolomeo. Other major sculptors such as Nanni di Banco, who used masculine, almost rough language to imbue their figures of Christian saints and martyrs with almost senatorial dignity, were successful only within the busier context of public and lay commissions. Only Michelozzo was able to marry a Hellenizing classicism with a feel for proportion that deviated little from the Gothic. Michelozzo's first achievements were as a goldsmith, a craft he continued to practice throughout his life. Moreover, once he had created a physical type for a given sacred figure, he preferred to remain faithful to the prototype, even when working in different materials and on different scales, as can be seen in his statues of St. John the Baptist, of which there are versions in silver (the Baptistery altar), bronze (holding a stoup), and terracotta (Santissima Annunziata). All this clearly shows how it was that Michelozzo came to be assistant to Ghiberti, when he was working on his *St. Matthew* for Orsanmichele, and immediately afterward to Donatello, who was certainly the liveliest innovator of the time, as can be seen in just a few of the more unusual works of his youth— the *St. Louis of Toulouse*, which he created for the Arte di Por Sta. Maria, or the more mature *Chellini Madonna*, which, considering the speed with which it was conceived, in technical terms, seems to have been used as a model, or again the wonderful *Virgin of the Cordai*, now in the Museo Bardini, in which he marries a commonplace plaster technique with a bold attempt at imitating noble, glass mosaic backgrounds by using gilt-varnished leather tiles sealed with glass. But Donatello (full name Donato di Niccolò di Betto Bardi) could express himself in all the traditional media then in use, from sandstone to *pietra serena* and from terracotta to marble. Underlying his career as an artist, his path to self-expression, is surely Ghiberti's experience, immediate confirmation of

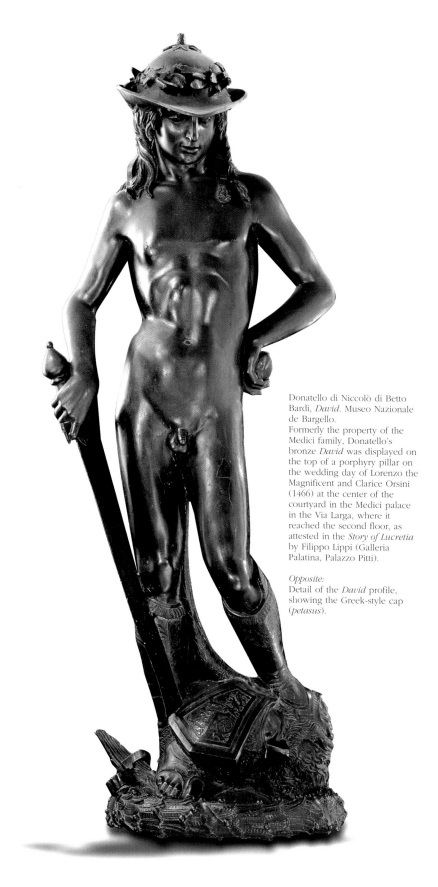

Donatello di Niccolò di Betto Bardi, *David*. Museo Nazionale de Bargello.
Formerly the property of the Medici family, Donatello's bronze *David* was displayed on the top of a porphyry pillar on the wedding day of Lorenzo the Magnificent and Clarice Orsini (1466) at the center of the courtyard in the Medici palace in the Via Larga, where it reached the second floor, as attested in the *Story of Lucretia* by Filippo Lippi (Galleria Palatina, Palazzo Pitti).

Opposite:
Detail of the *David* profile, showing the Greek-style cap (*petasus*).

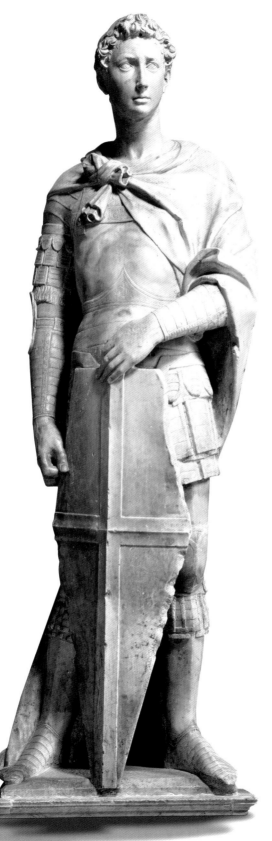

Opposite:

Donatello di Niccolò di Betto Bardi, *St. John the Baptist.* Originally in the Campanile, now in the Museo dell'Opera del Duomo.
One of the clearest examples of how perspective is achieved. Here, to offset the apparent distortion that would result from the statue being seen from below, the Baptist's body has been made disproportionately long for his legs and thighs, which project little from the surface of the statue.

Donatello di Niccolò di Betto Bardi, *David.* Museo Nazionale del Bargello. Possibly taken from one of the spurs of the Duomo, the figure of David is clothed and unarmed. The gigantic head of Goliath lies at his feet, the fatal stone slung by the boy visible in the forehead.

Donatello di Niccolò di Betto Bardi, *St. George.* Museo Nazionale del Bargello. Formerly situated in the niche of the Arte dei Corazzai e Spadai in Orsanmichele, Vasari described this as one of Donatello's most vigorous works.

Donatello di Niccolò di Betto Bardi, The *Marzocco* or Lion of Florence, holding the shield of the city. Formerly situated in front of the Palzzao Vecchio, now in the Museo Nazionale del Bargello.

which we can see in the marble *David* (Museo Nazionale del Bargello), which is also claimed to have been the work carved for the spurs of Florence Cathedral, and for which the artist was paid. Whatever the truth of that, it cannot be denied that the statue is by Donatello. Indeed, his young biblical hero might be regarded as the brother of his celebrated *St. George*, which in 1418, was placed on display in the niche belonging to the Guild of Armor and Swords, the awkward exedra on the north wall of the "temple" that had been formed by walling up the arches of the 14th-century Loggia del grano on the orchards dedicated to St. Michael the Archangel. The serenity of David's face, with its eyes gazing far into the distance, perhaps even into his own grand destiny, and its features, a distillation of classical practice that will be found again in other work before Donatello entered his Padua period, demonstrate the intensity with which he had

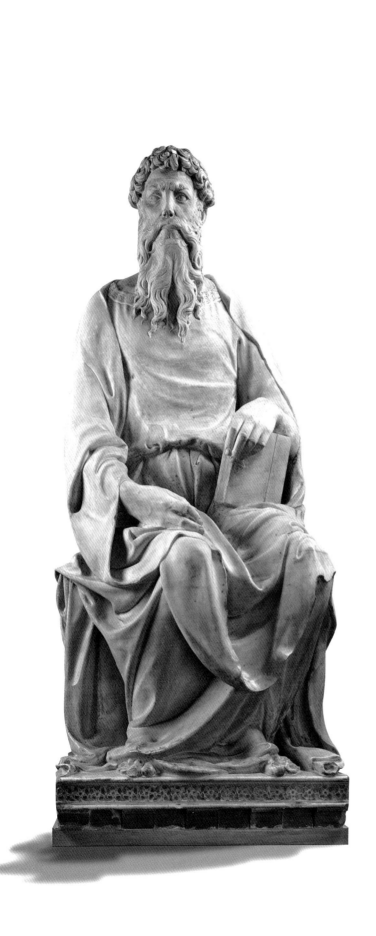
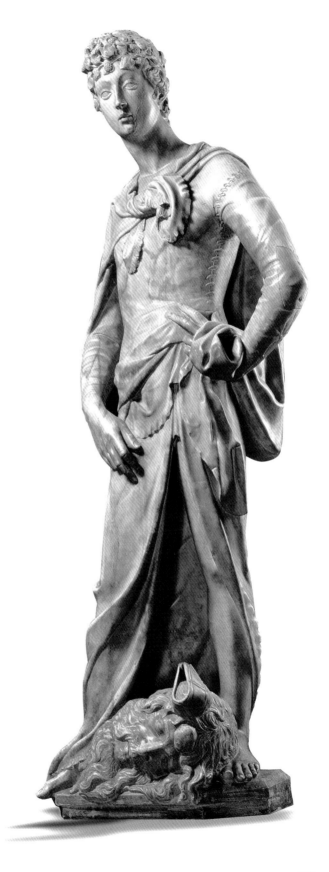

209

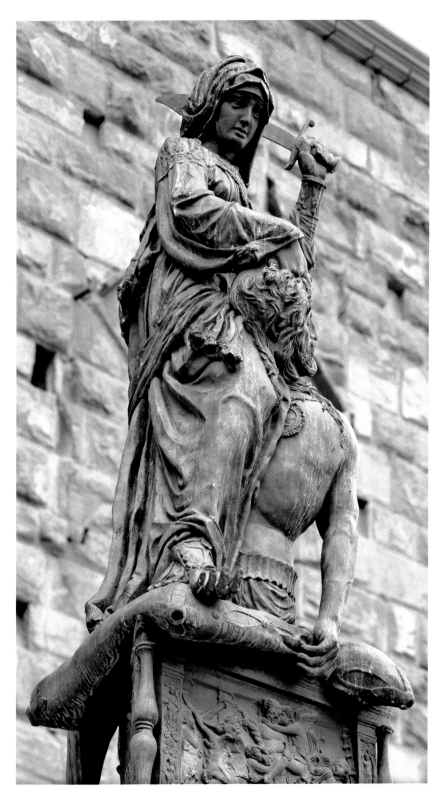

studied ancient Roman work. Moreover, the elongation of the figure attracts attention to the phenomenon, not unknown to Gothic artists, of visual deformation due to natural perspective, already present in Roman stylistic habits, which Brunelleschi took into consideration when developing his theories for the planar representation of solid bodies.

When carving his so-called grim statue of St. John, which he executed for the facade of the Duomo, Donatello lengthened the trunk and upper limbs of the statue while compressing it from front to rear so that he could bring the forward or outer plane closer to the rear or inner one (which, this being a seated figure, led to him shortening the thighs). Yet the deformation in no way detracts from the psychological vigor of the apostle, still less from his moral pride and dignity, which Donatello strongly expresses by his incisive treatment of the material.

It is possible to follow Donatello's creative development through his vigorously carved statues for Giotto's Campanile, one of which stands out, despite being less appreciated by the critics: *The Sacrifice of Isaac* (1421). This slender, almost lifeless group was Donatello's first experiment in combining two figures within a single narrative moment. To propose a new treatment of this theme, he must have been very determined, for it had been the subject of the 1401 competition, and the memory of the quadrilobe bronze panels that Ghiberti, Brunelleschi, and the other Tuscan geniuses had produced was still fresh in local memories. The space within the niche was challenging indeed and virtually determined the shape of the composition and the attitudes of the figures, but one can see what power Donatello has managed to convey, what tension he has expressed in the figures. It is almost as if their muscles have been stretched and squared off by the effort of being forced within the barrel vault. At the same time, he has given his marble the appearance of granite, the reflection of Abraham's rock-solid faith in God's justice and in the need to obey.

One of Donatello's mature works, *Judith*, also derives from—indeed, it might almost be said to be the direct descendant of—this earlier attempt. Cast in bronze, her figure looming majestic above the defeated, slumped figure of Holofernes, *Judith* is a composite work made up of pieces cunningly joined, probably using techniques that Donatello had discovered when examining ancient Roman works. The statue originally stood on a pillar, perhaps at the top of a fountain in the Medici pleasure garden. Later, when the Medici were expelled from Florence, *Judith* was moved to the forecourt of the Palazzo dei Signori as a valuable trophy

On the previous pages:

Donatello di Niccolò di Betto Bardi,
Judith and Holofernes. Palazzo Vecchio.
This monumental bronze, formerly part
of the inventory of the Medici palace
on the Via Larga (now Via Cavour), has
private (Judith was an example of the
feminine virtues) as well as public
symbolic value.

Donatello di Niccolò di Betto Bardi and
colleagues (including Bertoldo di
Giovanni and Bartolomeo Bellano),
Pulpit, Cathedral of S. Antonio, Padua.
Originally intended as one of the two
cantorias in the apse, Donatello's pulpit
features crowded reliefs that tell
episodes from the Life of Christ and
depict miracles by St. Anthony.

Luca della Robbia, *Funeral Monument
to Cardinal Benozzo Federighi.*
Sta. Trinità. The tomb is conceived as a
wall piece, in the same way as early
Christian burial niches. The two angels
on the sarcophagus derive directly from
4th-century late Byzantine classical
prototypes, while the frame is highly
innovative, being composed of
bouquets of flowers incised and painted
within ovals formed by twisting
ribbons. The whole is set against a
background of vitrified terracotta set in
a ground of gold, with the coat of arms
of the deceased in the upper corners.

Opposite:
Luca della Robbia, *Cupola of the Chapel
of the Cardinal of Portugal, Prince
Jacob of Lusitania.* S. Miniato al Monte.
The figures of the four Virtues, in
vitrified terracotta, include that of
Fortitude, who holds an oval shield
decorated with the coat of arms of the
commissioner. The Paschal Dove,
within the ring formed by the
candelabra of the Revelation at the
center, is a clear allusion to the Trinity.

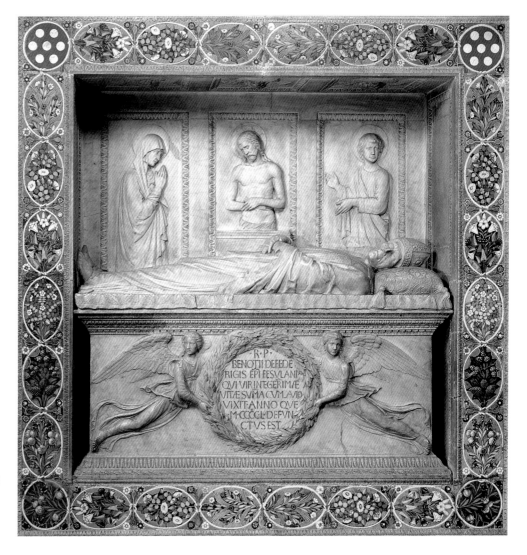

taken from a man who had imagined he could
substitute his own arbitrary will for the
unanimous judgment of the citizenry. There,
brandishing her sword with its untarnishable
gilded blade, she served as a warning to rioting
citizens and the enemies of the city's freedoms,
and as a shining example of self-sacrificing
patriotic virtue. Although of modest dimensions
(the statue was at the limit of what was then
technically possible), *Judith* is impressive and
imposing. She is also a good example of how a
symbolic figure, originally intended to convey
allusive personal meaning, could take on a
greater role and become a political symbol in
the eyes of future generations, who would read
into it universals whereas originally there had
only been erotic or erudite allusions.

From the beginning, the meaning of
Renaissance statues has occupied scholars
seeking to reconstruct their original context—
religious or profane. When faced with the
multitude of Florentine marbles, the subject
becomes an impenetrable forest or a thundering
chorus of voices. If one looks just at the
Campanile, one cannot help being struck by
the variety of the work adorning its sides and
forming a magnificent anthology of the work of
generations of Florentine sculptors, until pieces
had to be removed for restoration. For on that
gray and white marble cypress, which stands in
splendid isolation, sparkling with red and green
and set like a jewel in the crown of an ancient
and venerable effigy, are carved the thoughts
and dreams of an entire people.

213

Luca della Robbia, *Madonna of the Roses*. Museo Nazionale del Bargello. One of Luca's most graceful, classicizing sculptural works, in a format designed for private devotion. Much less costly to produce than stone sculpture, terracottas such as this were also astonishingly weather-resistant and could therefore be used as outside religious decoration. As a result, they saw considerable distribution.

The reliefs of Luca della Robbia (1399/1400–82), whose *Cantoria* marks the last time a craftsman was allowed to carve marble, also speak the language of Humanism. A recognized classicist, Della Robbia sets his seal upon and provides the key to the renaissance of Florentine sculpture. His funeral monument to Bishop Benozzo Federighi in Sta. Trinita, an architectural ornament within a glazed terracotta frame facing the viewer (like parts of his earlier tabernacle in the Church of Sta. Maria, Peretola) and comprising floral motifs within the ovals formed by a pair of intertwining bands against a background of gold, is one of his greatest works and is certainly one of the most original Florentine cenotaphs of the century. The monument closely resembles an early Christian burial niche, and within it, behind the tomb, stand the figures of the Virgin, Christ and St. John carved in relief. The lying figure of the bishop, his face toward the apse, sleeps the suspended, serene slumber of those beings who exist outside history. It is hard to be unaware of the distant vein of classicism in

Luca della Robbia, *The Resurrection*, lunette. Duomo (over the Sacristy Door). Despite its obviously stereotypical effect, this symmetrical, balanced composition was a constant source for similar subjects.

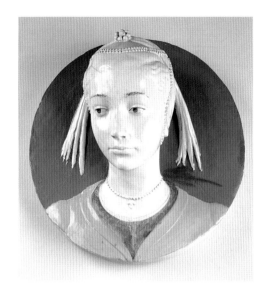

(The gilt has often been lost from original works by Della Robbia although sometimes it has been preserved, even on the backgrounds of figures of the Virgin and Child destined for private use.) This use of gilding makes them resemble not only the much smaller Gothic ivories which came from France in the previous century, but also the marble or plaster works that they often sought to imitate, with their metallic glazes and ultramarine highlights.

Mario Scalini

Andrea della Robbia, *Portrait of a Girl*. Museo Nazionale del Bargello. An excellent example of the range of applications for vitrified terracotta in the plastic arts, even in areas where preference had traditionally gone to works in marble or bronze in the ancient style.

Andrea della Robbia. *Portrait of a Girl*. Museo Nazionale del Bargello. The tone of familiarity and captivating simplicity of this work made it a favorite in the 19th century.

this piece; yet Luca also seeks to place it in a direct line leading back to the 4th-century Constantinople school and thus forge an ideal link between the ancient and modern worlds, between its primitive faith and the ecclesial dignity of the modern clergy, in a synthesis of Christian motifs expressed in the courtly language of the Eastern court, which seems to have been thought fitting to the needs of the times.

This work, executed between 1454 and 1456, maintains the link with a much more typical monument, that to the antipope John XXIII, which Cosimo Vecchio de' Medici had commissioned from Donatello and Michelozzo. But the simple form of the sarcophagus recalls Ghiberti's urn containing the relics of SS. Protus, Hyacinth, and Nemesius Protomartyrs, with the tall figures of Victory and the Roman garland that also appear on the sarcophagus that used to stand in the cemetery of the Twelve Apostles in Byzantium (Constantine's burial place), which has the figures of the Evangelists on its short sides while along the long side stand pairs of angels bearing a garland in the shape of Constantine's monogram. Luca's great innovation, however, was in his use of imperishable, glazed materials, especially his invention of the marvelous vitrified terracotta that is impervious to the weather. This, perhaps, is why the dazzling cupola with the figures of the four Virtues above the Chapel of the Cardinal of Portugal, Jacob of Lusitania (d. 1459), inspired generations of artists and seems just as fresh today.

What is worth particular attention here, however, is the gilding of the glazed surfaces.

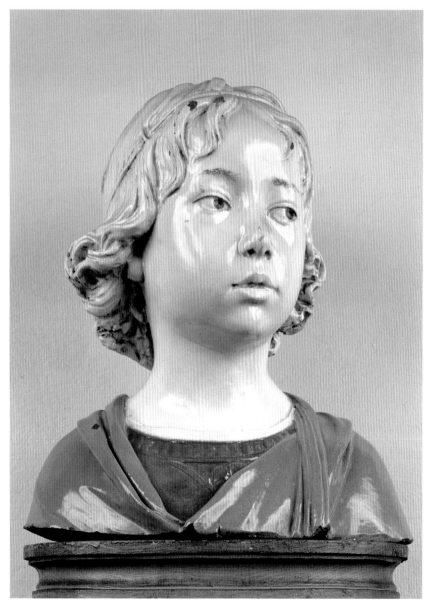

Opposite:
Bernardo Rossellino, *Funeral Monument to Leonardo Bruni, Chancellor of the Republic.* Sta. Croce. The monument as it was before the recent restoration, which has brought to light its original framing.

Benedetto da Maiano, Chapel of Sta. Fina (overall view and detail). Collegiate church of Sta. Fina.

Splendor proudly regained

From the 1460s, what art historians would later enjoy describing as "sumptuary taste" becomes increasingly evident.

This may be explained in various ways, depending on the area in question, and within Florence itself, on the different social groups that were competing for power. Slowly, starting at the beginning of the century, a new understanding of the relationship between art

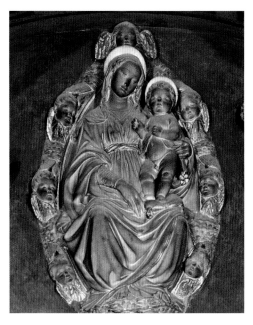

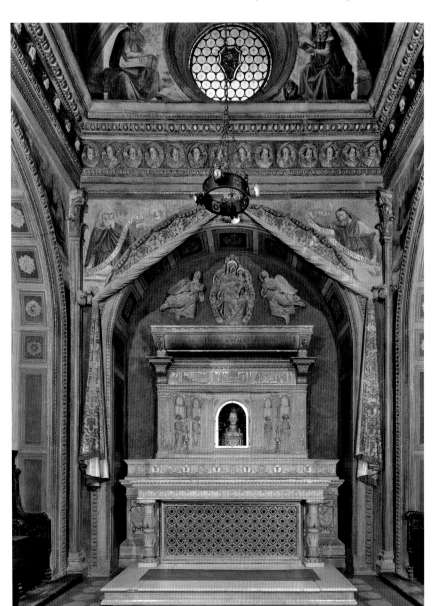

and society emerges; and gradually, bearing in mind the customs of the times and making due allowance for the inevitable exceptions, we start to find a gradual diversification in the market, which now turns increasingly toward private commissions, and concentrates on works—and this applies equally to religious commissions—that are closely tied with the prestige of individual clans and families. When it comes to architecture, it is no coincidence that now there appear complete, self-contained funerary monuments, such as the Pazzi Chapel, or others built into existing, older structures, such as the Cardini Chapel in the church of St. Francis in Pescia. The sculptures decorating these complexes were basically taken from a new reading of and a closer familiarity with classical decoration, from which emerge new and different types of awareness of the relationship between form and symbolic or allusive content. It should come as no surprise, therefore, that we see the building of such elaborate structures as the Chapel of Sta. Fina (1472–75) in the Cathedral of San Gimignano, which was then under Florentine control. The chapel, the work of Giuliano and Benedetto da Maiano (1444–97), is so exquisitely carved that it seems to have issued from a goldsmith's, not a sculptor's, hand. In many respects, it bears comparison with the tomb of the cardinal of Portugal, previously mentioned, or the tomb of Mary of Aragon in the Piccolomini Chapel, Sta. Anna dei Lombardi, Naples, which Benedetto

worked on after Antonio Rossellino (1427/28–c. 1479).

One way or another, all of these works can be traced back to the *Monument to Cardinal Rinaldo Brancacci* in the church of Sant'Angelo al Nilo, in Naples (1426–33), which Michelozzo executed in collaboration with Donatello, or the famous *Aragazzi Monument* at Montepulciano, which was subsequently dismantled and many parts removed from the cathedral, some finishing as far away as in the Victoria & Albert Museum in London.

These works from the first half of the century can be described as grandiose, but not monumental. Rich in figures and sometimes narrative in intent as they are, they have abandoned the large symbolic statues of the medieval tradition.

This seems to correspond to a closer awareness of Roman decorative sculpture, especially triumphal arches, and in particular, perhaps, the Arch of Constantine in Rome, which is decorated with a large number of reliefs, some carved specially for it, some recycled from other structures. The gradual reduction in the scale of the figures, which obviously become lifesize whenever they need to be strictly proportional to the figure of the deceased, is designed to achieve a specific purpose, to create a coherent, overall impression of architecture in the eye of the viewer; as a result, it is clearer in cases where the architect and the sculptor or carver worked in close collaboration, as can perhaps best be seen in the work of the Maiano workshop. Nonetheless, we should not overlook the fact that a genuine model for a humanist cenotaph already existed before this delicate style emerges, fine examples of which can be found in the work of Bernardo Rossellino (1407/10–64) who carved the *Monument to Leonardo Bruni* (1448–50) and Desiderio da Settignano (c. 1430–64), who carved the *Monument to Carlo Marsuppini* in Sta. Croce, Florence (1453–54. Despite their differences in style, which can be explained by the fact that they used different models, both ancient and modern—Desiderio going so far as to use Byzantine originals for the decoration of the lacunars in the archivolt and Bernardo more frequently referring to imperial and even republican Rome for his figures—the two men shared the same intentions in choosing the arcosolium to be the leading motif in their architectural compositions.

In both cases, what we see is a growing taste for color and a tendency to use gold leaf as an embellishment. This latter is seen more markedly in the Marsuppini tomb, of which part of the original painting of the pavilion-like

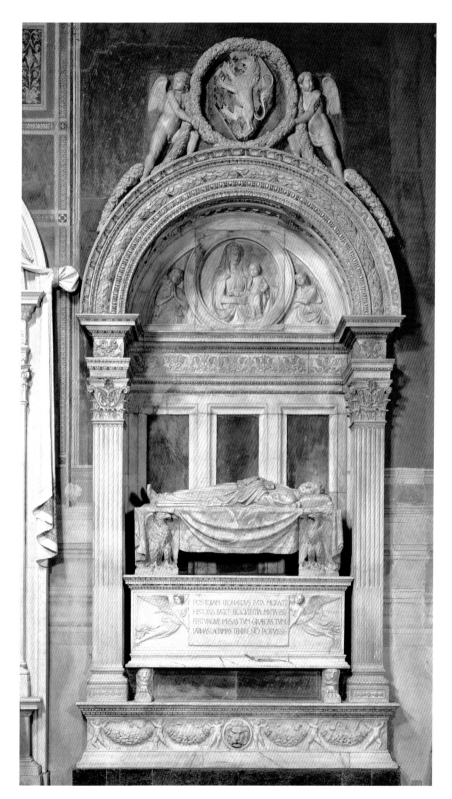

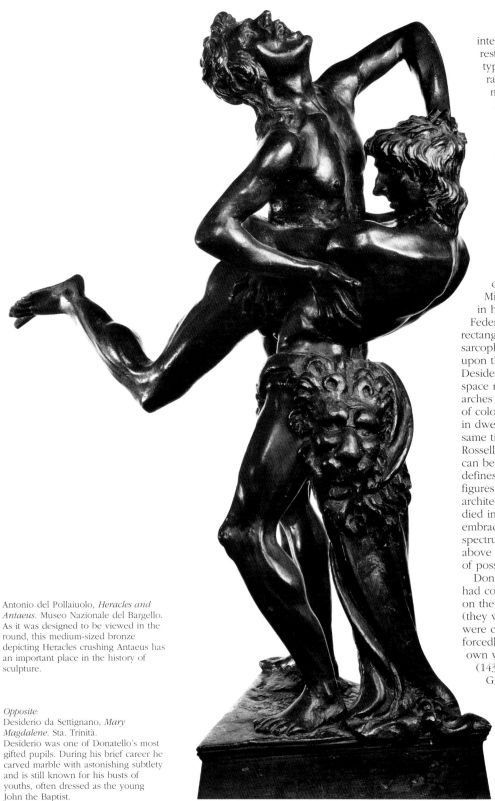

Antonio del Pollaiuolo, *Heracles and Antaeus*. Museo Nazionale del Bargello. As it was designed to be viewed in the round, this medium-sized bronze depicting Heracles crushing Antaeus has an important place in the history of sculpture.

Opposite:
Desiderio da Settignano, *Mary Magdalene*. Sta. Trinità.
Desiderio was one of Donatello's most gifted pupils. During his brief career he carved marble with astonishing subtlety and is still known for his busts of youths, often dressed as the young John the Baptist.

interior was discovered during recent restoration. Within a few years, this type of construction and even the range of motifs used on these monuments would become the norm. This was also thanks to Mino da Fiesole (1429–84) (*Monument to Count Hugo of Tuscany*, Badia Fiorentina), who, during his prolific Roman period, would carry the model far beyond the borders of Florence. A close, detailed comparison of these works could bring forth all manner of ideas because, despite appearances, the differences between them are very slight; each one open to interpretation as being no more than another characteristic trait of the artist.

Mino's originality lies, for instance, in having borrowed from Luca's Federighi monument the idea of using a rectangular niche in which to enclose the sarcophagus with its recumbent figure upon the bier, while Bernardo and Desiderio preferred an empty vaulted space made of round or longitudinal arches with background divisions of slabs of colored marble, similar to those used in dwellings in imperial Rome. At the same time, the close attention that Rossellino had paid to Donatello's work can be seen in the way in which he defines the compact volumes of his figures and the Masaccio-like rigor of his architectural designs. When Donatello died in 1466, Florentine sculpture embraced an immensely complex spectrum of styles and trends and shows, above all, an open attitude to a vast range of possible developments.

Donatello's followers, some of whom had come with him from Padua to work on the so-called pulpits of S. Lorenzo (they were originally choirs or *cantorie*), were capable of flaunting their arrogant, forcedly expressive style. Each in his own way, Bartolomeo Bellano (1437/39–96/97) and Bertoldo di Giovanni (c. 1400–91) were deeply imbued with a crude neo-Roman language that the master, from whom they had learned their craft, had absorbed from a careful study of honorary columns and then had recast in his own narrative language, using the principle of affinity. Luca della Robbia, one day to

be succeeded by his nephew Andrea as the head of one of the most prominent sculpture workshops in the West, advocated a classicist's conception of sculpture that reworked Gothic subtleties around models borrowed from first-century Roman neo-Hellenism. At the time, these models were regarded as being Greek originals, the only point of comparison being Byzantine sculpture from the time of the Palaeologoi. It was not until much later that they were identified as neo-Hellenistic. Between these two extremes, aside from the alternatives proposed by Desiderio (c. 1430–64) and Bernardo Rossellino, the former dying at a tragically young age, there were paths trod by artists like Benedetto da Maiano (1442–97) and Mino da Fiesole (1429–84), as well as other, far more independent figures, like Antonio del Pollaiuolo (1432/33–38), who more than any other may be regarded as the jewel in the crown of what Florentine sculpture might have been, had it not taken another direction. Pollaiuolo, who worked almost always with his brother Piero (c. 1441–96), owned a flourishing workshop devoted not only to painting and sculpture, but also to metalworking and the production of brocades, ceremonial arms, and other objets d'art. Indeed, it may be said that in the 15th century the Pollaiuolo family were the true heirs to Florence's Gothic handcraft tradition, which following the start made by Giotto and Ghiberti, produced a variety of objects, all of which shared the formal stylistic coherence that nowadays we would describe as Florentine style. What interests us here, however, is the original approach taken by Antonio with regard to figurative, especially three-dimensional, representation, for its characteristics are hard to grasp without close attention to the way in which he renders the image in general and the human body in particular. We should remember the central place occupied by drawing in Florence's workshops, where both masters and pupils would draw using pen and ink as well as the more sophisticated silverpoint technique, which made it possible to trace the finest lines in luminous gray on prepared colored paper. Neither medium truly lent itself to the volumetric definition of images, but rather to a graphic linearity where the roundness of the body could be suggested through the sinuous use of line or, more innovatively, by squaring and fragmenting the lines, superimposing and intersecting them so as to produce a sensation of multiple visual planes. This is not the place to investigate further the vital importance of drawing in the development of Florentine art, for its role is more than evident from the

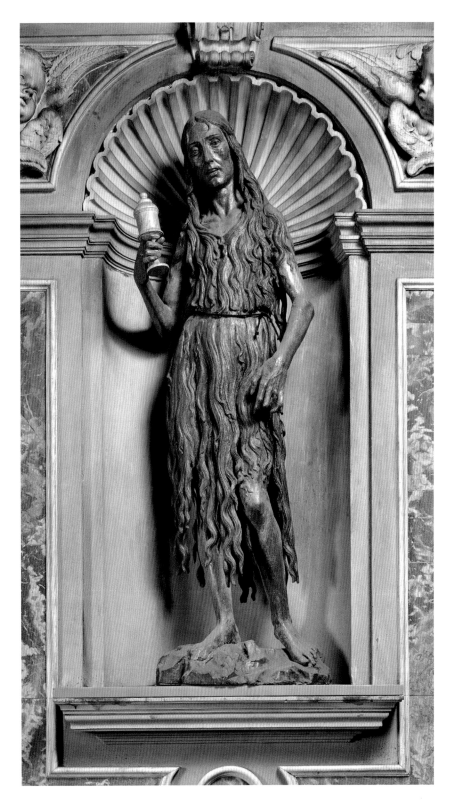

contemporary debate that led to the foundation of the Accademia delle Arti del Disegno—the Florentine academy. Of the many sculptors active during the 15th century, Antonio del Pollaiuolo was the one who most effectively translated into volumes the conceptual upheaval that was also affecting painting during the third quarter of the century. The pronounced linearity of the work produced during the 1470s by the Pollaiuolo workshop, which included among its numbers such promising youngsters as Sandro Botticelli, translates, in plastic terms, into a nervous, almost vibrant slimming-down of the nude in works that seem almost fleshless; Pollaiuolo's vibrant line defines the stretching and contracting of the musculature, indicating the point of departure for future generations. Anatomical knowledge also becomes an indispensable tool, an essential part of the artist's baggage, analogous to a mastery of Brunelleschi's linear perspective. It is enough to look at the figures of his *Hercules and Antaeus* (Museo Nazionale del Bargello), locked in mortal combat, to see where the way indicated by Pollaiuolo might have led and how startlingly innovative was his departure from the kind of reworked classicism that already seemed to have had its day.

It was the misfortune of this artist that, for no reason other than his extraordinary talent, he was co-opted by the papal court. There, submerged in countless honors, he found himself obliged to work within constricting demands that he make exact likenesses. As a result, whatever contribution he might have made to the debate on figuration was irremediably limited.

In reality, being a sculptor in 15th-century Italy meant being active in a variety of different fields. Without necessarily reaching the apparent eclecticism of a Pollaiuolo, a sculptor might find himself carving capitals or other architectural elements for monuments that he or indeed another might have designed; find himself carving wood to create works needing a particularly light hand, or cork, or even modeling papier mâché; or making plaster models for goldsmiths or ironworkers to cast in bronze. He might find himself obtaining a commission to paint a niche; to carve or model parts of a piece of furniture that were made of paste; to emboss a metal crest or make one from leather; or carve decorations in marble that more commonly were made in a less costly and more easily transported material.

Tuscan sculpture in particular was profoundly influenced by the theoretical writings that were emerging from a profound, wide-ranging rethinking of the materials of art, and on the nobility and durability inherent in the use of marble and bronze.

The *Trattati* by Leon Battista Alberti (1404–72)—a Roman lawyer and scion of a noble Florentine family, born in Geneva because his father had gone into exile—or Antonio Averulino (c. 1400–c. 1469), renowned during his lifetime as "Filarete," left an indelible mark on three-dimensional art from

the second half of the 15th century not just in Florence, but also in Rome and Venice. One of the reasons why the demand for works of art in these three centers, and to a lesser extent Naples as well, gradually but inexorably fell into line with the masters of the time, can be found in the broader context, such as the relative ease of obtaining marble for statues, or the rise in domestic wealth and peace that made it possible to divert metal from arms production at a time when weapons manufacturers were already turning to the production of firearms.

One thing, however, is clear: no attempt would have been made to divert precious or costly raw materials had there been no underlying ideal or ideological reason to support the plastic arts. During this period, Rome, Florence, Venice and Naples were locked in a struggle for political dominance in

Andrea del Verrocchio, *Monument to Francesca Tornabuoni (Presentation of the Newborn Child to her Father)*. Francesca Tornabuoni died in childbirth in 1477. Both of the narrative reliefs from her funerary monument (the other shows her in childbed) are in the Museo Nazionale del Bargello.

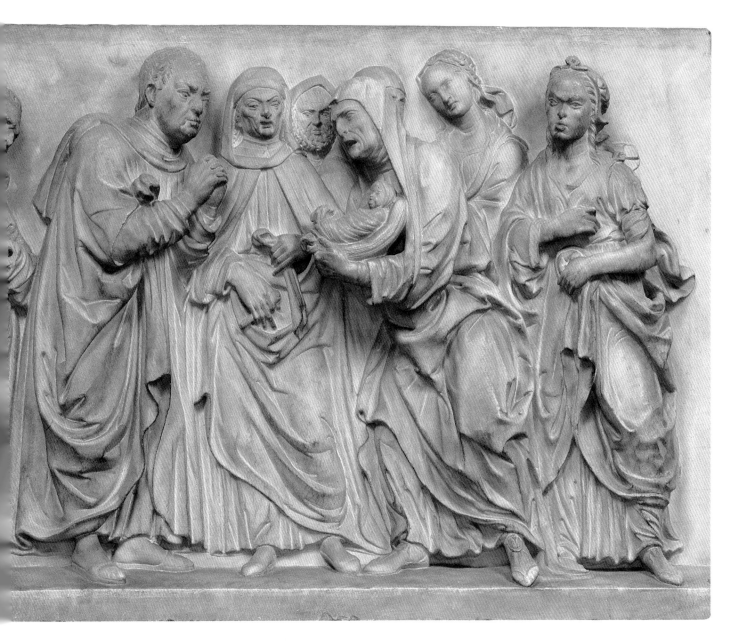

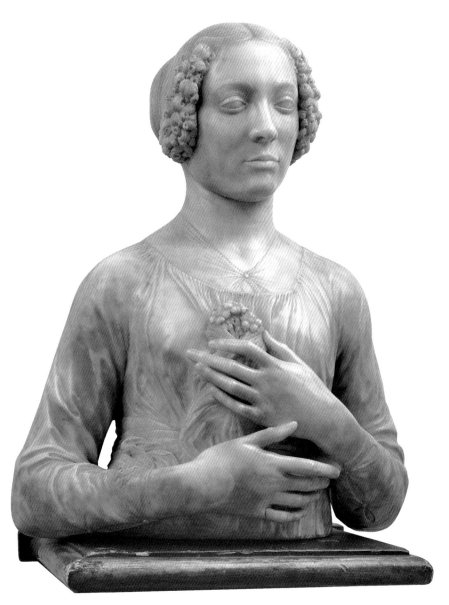

Andrea del Verrocchio, *Bust of a Young Woman* (known as the *Lady with Nosegay*). Museo Nazionale del Bargello. One of the images of Renaissance women in which critics claim to see the origins of later works by Leonardo, who studied in Verrocchio's workshop.

Opposite:
Andrea del Verrocchio, *David*. Museo Nazionale del Bargello.
Recent restoration has revealed the old gilding on the bronze blade of the sword. This monumental bronze, owned by the Medici, once adorned the entrance staircase to the Palazzo della Signoria. It is clear evidence of the fascination that Hellenistic art exercised in the field of sculpture.

Italy—as was Milan, though in rather a different way—in a pitiless struggle that could very easily have ended with foreign rulers well established on the peninsula. Incapable of forming stable alliances, always ready to defend their own special interests, and in any case doomed to ruin or to be left behind by a world soon to be transformed by the age of discovery, the Italian regional states acted out their rivalries as much on the battlefield as in the boastful splendor of their cities. Venice continued to adorn itself with marble from the Eastern Mediterranean. Rome regained its magnificence, digging up its own ancient remains, rediscovering a universal splendor that for centuries it had been unable to see in lay or civil terms, and dispersing the dense perfumed cloud of incense with which

generations of chanting priests had engulfed not just the ruins of its classical buildings but also their sumptuousness. Florence, already in serious economic decline, continued to embellish its medieval urban fabric through the initiatives of its last ruling families, now all firmly united in a compact group around the Medici following the defeat of the anti-Medici conspiracy of 26 April 1478 headed by the Pazzi family. Large public commissions were few and far between in late 15th-century Florence, before a new but no longer independent princely state, one subject to the Holy Roman Empire, took root in the dying lilies of the republic. Yet at a time of grave political difficulty, the light of artistic patronage still glowed, keeping artists and workshops alive and sustaining them with the hope of obtaining prestigious, lucrative commissions to add to the never-ending beautification of the Duomo. The artist who supplanted Donatello in the esteem of the Florentines was Andrea del Verrocchio (c. 1435–88). What we think of Verrocchio today is inextricably tied up with how we regard his most brilliant pupils, Lorenzo di Credi and Leonardo da Vinci. Yet for his contemporaries his artistic career was a sort of exemplary path that led him to work on a wide range of subjects and themes in an equally wide variety of materials. Leaving aside his work as a goldsmith, the only known example of which today is the splendid relief *The Beheading of St. John the Baptist* on the altar in the Baptistery, and without entering into the merits of his work as a painter, which went so far as to include the banners for the annual tournament held in honor of the patron saint of the city, let us not forget his work in the field of religious sculpture in wood, to which he devoted himself and in which he used a variety of materials, as has recently been confirmed with the extraordinarily lifelike polychrome processional crucifix that is now in the Museo Nazionale del Bargello. We also know of his skill as a sculptor, attested in his *Virgin and Child*, also in the Bargello, a rarity, compared with the number of busts of Christ attributed to him with varying degrees of certainty, but which stands up very well when compared with the two *Angels* in the Louvre (in which the hand of a promising assistant can be detected that many have wanted to see as that of the young Leonardo), or again the polychrome Careggi lunette, in the Bargello as well. Verrocchio's greatest achievements are the marble reliefs that he carved in the manner of the Hellenistic sculptors, whom he must have loved without even knowing them, and whose levity he was able to emulate: the

Monument to Forteguerri in Pistoia, and the
violent plastic expressiveness, so reminiscent of
Scopas, that surges from the mourners in
Monument to Francesca Tornabuoni, who died
in childbirth in Rome in 1477. Yet the high
point of this virtuosity is surely the famous *Bust
of Young Woman*, whose anonymous figure,
the very incarnation of nobility, the critics now
agree to assign to the period of his
masterpieces in the late 1470s. This bust, which
rises from its base with a sweetness and
abstract purity without equal in Italian
Renaissance sculpture, has inspired torrents of
words; yet all seem meaningless beside the
simple fact of just standing and looking at the
sophistication of formal detail of which
Verrocchio was capable. In this work, he
reached a mimetic perfection that not even the
worn-out 19th-century academicians could
hope to approach. Nonetheless, Verrocchio
owes much of his fame to three bronzes: *Eros
with a Dolphin*, from the Medici villa at Careggi,
David (c. 1465–70), which he made for the
Medici, who relinquished it to the republican
government, and *Doubting Thomas*, which
replaced Donatello's St. Louis of Toulouse in
the niche in the facade of Orsanmichele that
the Parte Guelfa had sold to the Arte della
Mercanzia (merchants' guild) in 1466. Unlike
the bronze, porphyry and marble Medici
sarcophagus in S. Lorenzo, these are works that
make no erudite references. Rather, through
Verrocchio's striving toward an absolute and
elegant artistic ideal, they seem to tremble with
the spirit of the ancients—with which
Verrocchio, as the restorer of the Roman
marbles in the Medicis' archeological garden,
was closely familiar. Here too, the critics have
sought to reproduce through their writings the
depths of emotion one feels in the face of a
language so rounded and so inspiring, so
precious and so sophisticated, which places
Verrocchio's statues in a dimension that is
almost transcendent. These masterpieces, some
of the most sublime works at which people
could marvel during the closing quarter of the
15th century, were the yardstick against which
any future attempt to reach even dizzier heights
would be measured. At the same time, they
stimulated a thirst not just for acquiring
knowledge of classical works, but also for
devising new formal and poetical motifs on
which a clear, gratifying debate on aesthetics
and content could be based.

In a word, these works, the greatest
achievements of the final generation of the
15th-century Renaissance, constitute the
paradigm of the beautiful.

Mario Scalini

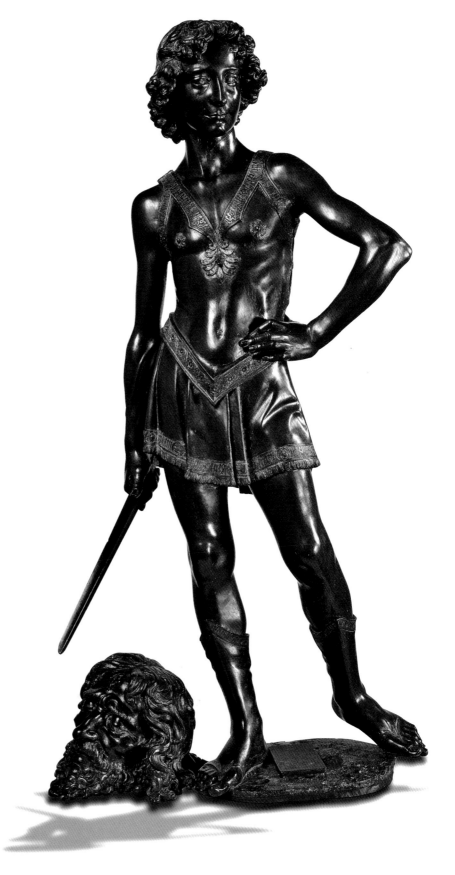

Masaccio's revolution

Opposite:
Gentile da Fabriano, *Adoration of the Magi*, 1423, tempera on panel, detail showing two of the three kings and part of their entourage. Uffizi.
The ornate, fairytale-like language typical of the end of the Gothic style reaches an apex of narrative elegance in this work.

Gentile da Fabriano, *St. Mary Magdalene*, 1425, tempera on panel, from the Quaratesi Polyptych, formerly in Nicolò Oltrarno. Uffizi. A gracious image from the late Gothic period.

On the following pages:

Pages 226–227
Masolino and Masaccio, *St. Anne Metterza*, tempera on panel, from S. Ambrogio. Uffizi.
Here the difference between Masolino's linear style and Masaccio's plastic power is clearly evident.

General view of the Cappella Brancacci with frescoes by Masolino, Masaccio, and Filippino Lippi framed by a perspective structure based on ideas originally from Filippo Brunelleschi.

Pages 228–229
Masaccio, *St. Peter Distributing the Goods of the Church to the People* and *Death of Ananias*, detail. Fresco in the Cappella Brancacci, Sta. Maria del Carmine.
The power of Masaccio's language reveals his deep awareness both of Brunelleschi's perspective and of Donatello's sculpture.

Masaccio, *St. Peter Healing the Sick with his Shadow*, detail. Fresco in the Cappella Brancacci, Sta. Maria del Carmine. Like Donatello, Masaccio creates a new world in the representation of heroic figures.

Pages 230–231
Masaccio and Filippino Lippi, *Resurrection of the Son of Theophilus*, detail. Fresco in Sta. Maria Novella.
The plastic power of the parts painted by Masaccio are in sharp contrast with Filippino's linear language.

1401 and 1492 are two crucial dates in Florentine history, dates that would have a decisive impact on European civilization, determining not just the shape that its history and economic development would take but also its artistic future.

Why 1401? Because that was the year in which the Duomo's commissioners for works (the Opera) held its competition for the new bronze doors of the Baptistery, an event that marked a new departure for Florentine art. The Baptistery, an ancient building dating back to the 5th century and one of the greatest monuments in the city, was Florence's pride and symbol, because St. John the Baptist had been chosen as its patron saint. Many of Florence's citizens, both illustrious and obscure, were baptized here, as Dante Alighieri (perhaps the most illustrious of all) records in the *Divine Comedy*. The competition attracted some of the most talented artists of the time, including Lorenzo Ghiberti and Filippo Brunelleschi—who just a few years later would astound the world with the dome he built on the Cathedral of Sta. Maria del Fiore—and Jacopo della Quercia from Siena. The winner was the bronze panel submitted by Ghiberti, who combined with superlative elegance the traditional language of International Gothic and the new classicizing trend that had already started to emerge in Florence in the previous century. And yet the Renaissance was still to come! Men would have to wait until the third quarter of the new century before the first signs of the pure Renaissance language were to be seen in Florence that would later spread throughout Europe.

Brunelleschi in architecture, Donatello, Ghiberti, Nanni di Banco and Luca della Robbia in sculpture, Masaccio, Filippo Lippi, Domenico Veneziano, Paolo Uccello and Andrea del Castagno in painting, these artists founded a visual language based on the study of perspective as well as of the monuments of classical civilization, which in the following century would blossom into the grandiose style that in the work of Michelangelo and Raphael in Rome marks the High Renaissance.

The name of Masaccio is not at the head of the list of painters by chance. Despite the brevity of his career (he died in Rome in 1428, at the age of just 27) he exercised a sort of fascination for succeeding generations of artists, who saw genius in the commissions he executed in Florence, Pisa, and Rome. The true impact of Masaccio can be ascertained by a comparison with the work of Gentile da Fabriano (c. 1370–1427), the greatest exponent

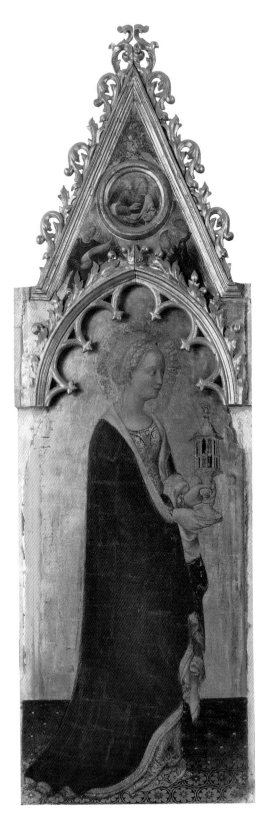

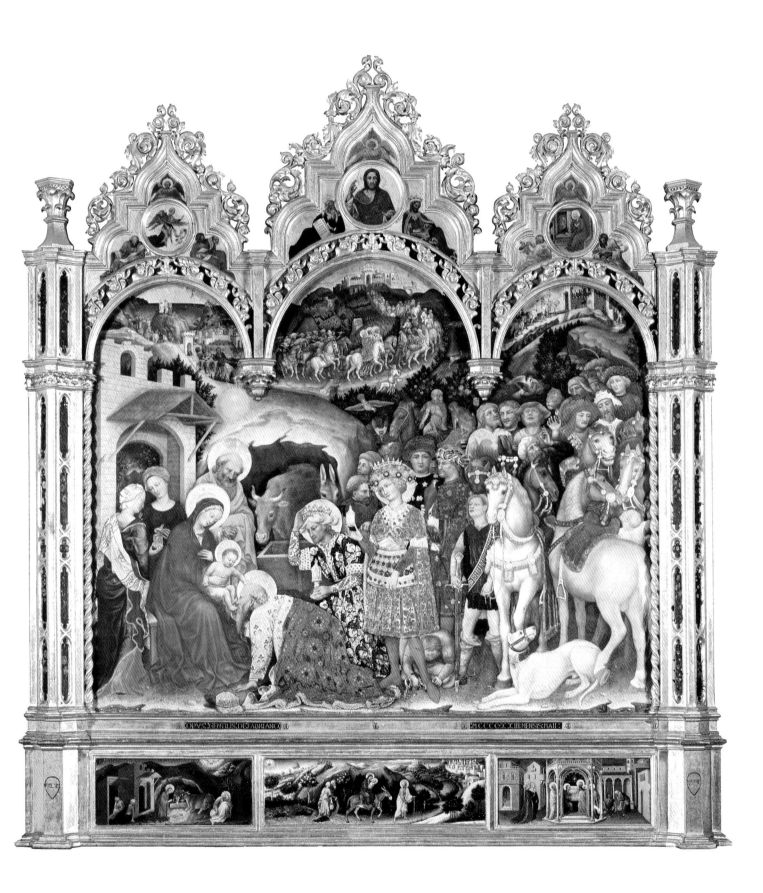

of late Gothic or International Gothic in Italy. A renowned painter who was primarily active in Lombardy and in the service of the Doge in Venice, Gentile's fame attracted the attention of Palla Strozzi, a rich Florentine merchant who commissioned him to paint the *Adoration of the Magi* (Uffizi) for his chapel in the Church of the Holy Trinity, for which he had also commissioned Lorenzo Monaco to paint a large altarpiece of the *Deposition* (completed by Fra Angelico some years later, after Monaco's death). Gentile's great ancona (altarpiece), with its sumptuous frame in flamboyant late Gothic style and predella representing three episodes from the early life of Christ (the *Nativity*, the *Flight into Egypt*, and the *Presentation in the Temple*), was finished in 1423, and is one of the high points of "court" culture in Europe. Strozzi, the Medici family's bitterest enemy, who would later be driven into exile by them, clearly sought to leave a tangible sign of the rank he had acquired through his wealth as a counter to Cosimo de' Medici the Elder's impact on the Florentine political scene. And it would seem that he represented the refined, courtly "conservative" taste that contrasted with what Brunelleschi and his followers were imposing on Florence, under Medici patronage. Be that as it may, the *Adoration of the Magi* is a masterpiece. Gentile tells his tale as a story of wonder without any hint that he might have been aware of the radical changes taking place right under his nose (Donatello had created his *St. George* for Orsanmichele in 1416); the polyptych he painted two years later for the Quaratesi family chapel in the church of St. Nicholas, however, which is now divided between the Uffizi and the National Gallery, London, seems to reflect these changes, and Gentile to have acknowledged the existence of Masaccio.

Born in San Giovanni Valdarno in 1401, Tommaso di Ser Giovanni Cassai, known as Masaccio, died in Rome in 1428 after a brief but intensely productive career. All his works, from the triptych *Madonna and Child with Saints* in San Giovenale, in Cascia di Reggello, which he painted at the age of 21, perhaps with the help of his brother Giovanni, known as Lo Scheggia, are impregnated with the new language based on Brunelleschi's rules of perspective and Donatello's plasticism, and are in sharp contrast to the elegant world of Gothic art.

The evanescence of courtly society was well represented by the frescoes and panels by Lorenzo Monaco, Gentile da Fabriano, Masolino and a host of minor figures extending into the 15th century, who placed the panel and the fresco on the same level and embellished both with the brilliant, unnatural colors and elegance of line that are characteristic of late Gothic.

Slowly, however, this style gave way before the vigor of Masaccio's new language and his brusque invocation of the real, day-to-day world, albeit in the guise of historical and religious subjects. Masaccio takes as his point of departure that his task is to represent reality in images conceived in terms of their plastic and spatial values, a task admirably served by the indication of space—a problem that Giotto, too, had already partially tackled—by means of linear perspective, following Brunelleschi's studies, and color as architecturally constructed masses, not just painted in, in abstract areas, as was typical of Gothic style. Masaccio also rejected the elegant, worldly details of the Gothic style in their entirety, concentrating all his powers on representing an existential reality based on moral and spiritual values, which he found in Giotto and his immediate followers. The contrast between the two ideals is brought out particularly clearly through a comparison of Masaccio's scenes and Masolino's nearby frescoes in the Brancacci chapel. Following the example set by Donatello in sculpture, Masaccio emphasizes the rational connection between different kinds of space (real and figurative), reality (pictorial and spiritual), and strength (moral and plastic), a connection expressed by the masses molded by light in contrast to shade and in his consistent rejection of the use of any superficial, gratifying color or sophisticated affectation. Bearing this in mind, it seems a natural move for Masaccio to turn to portrait painting, meaning the faithful representation of the individual, thus placing man at the center of each act of representation, as the witness of his time.

Such intentions are still only latent in the San Giovenale triptych (1422), constrained as it is by the traditional Gothic tripartite division and perpendicular panels. Nonetheless, in the central panel, *Virgin and Child Enthroned, with Two Kneeling Angels*, the first attempts at rendering perspective can be detected. Two years later, they are intentions no longer, as can be clearly seen in the *Sant'Anna Metterza* panel that he and Masolino painted for the church of St. Ambrose (Uffizi). Here the contrast between the stylized figure of St. Anne and the powerful mass incorporating the Virgin (almost a *Mater Matuta*) and Child (already identifiable as a little hero from the classical world), as well as the rendering in perspective of the graystone base on which the figures stand, with its Latin dedication in gilt letters, all show in the clearest possible way the extent to which the path that Masaccio had taken was fundamentally different from that taken by his contemporaries.

Thus began Masaccio's partnership with Masolino. It would bring the young painter to

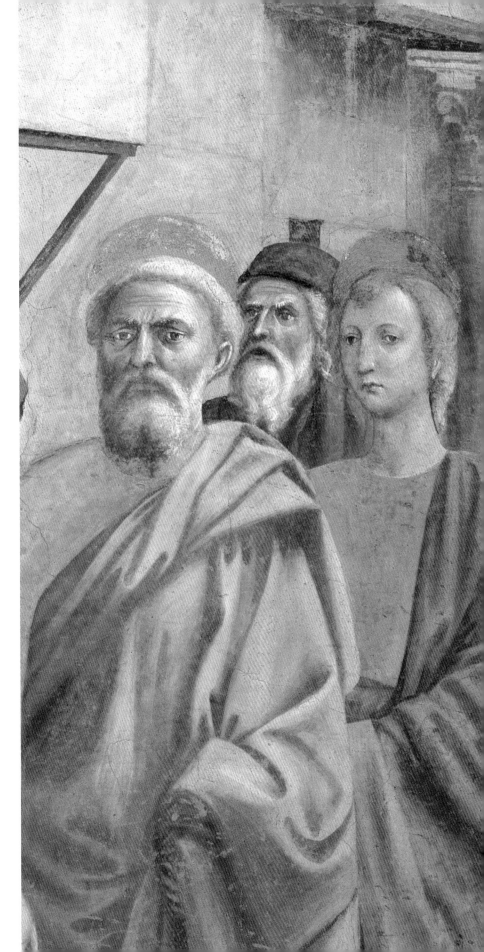

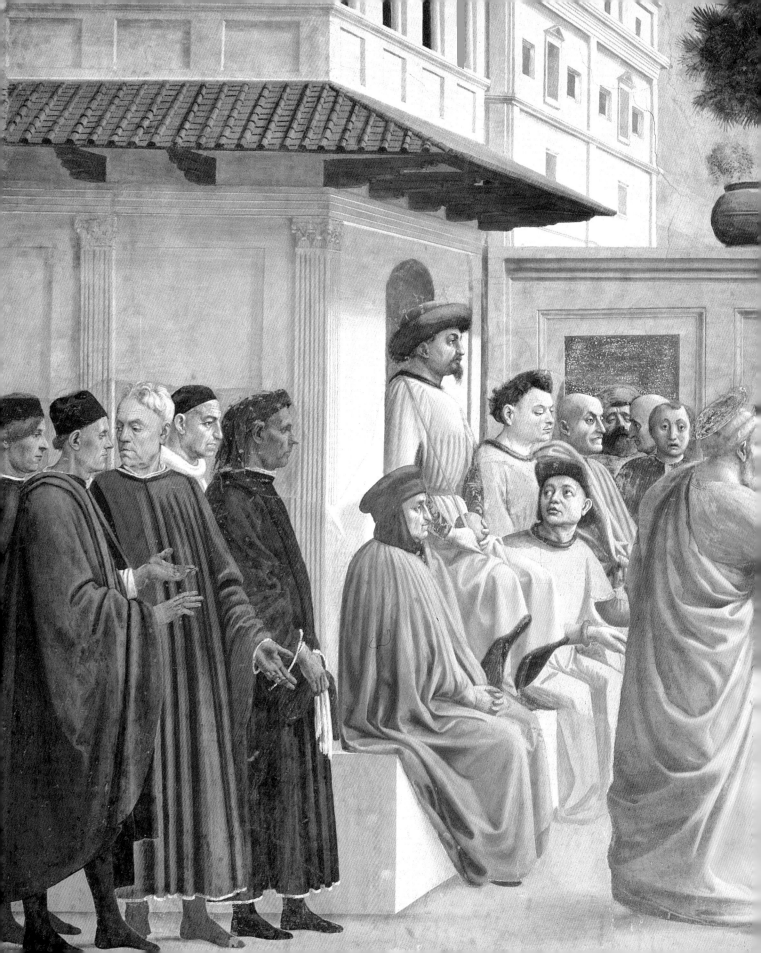

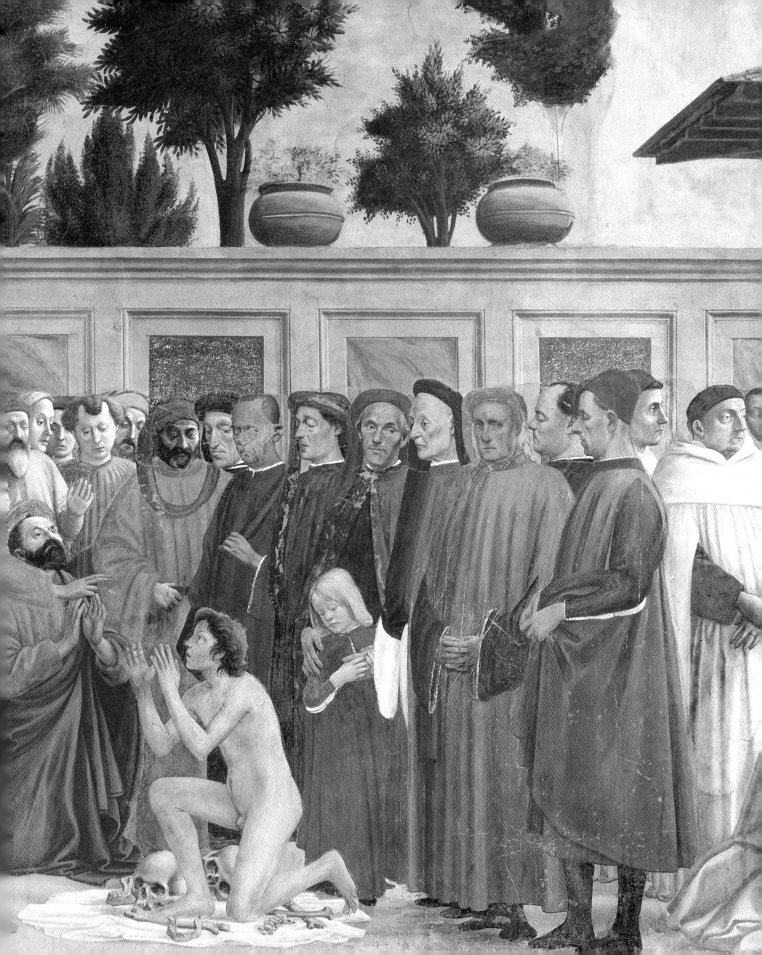

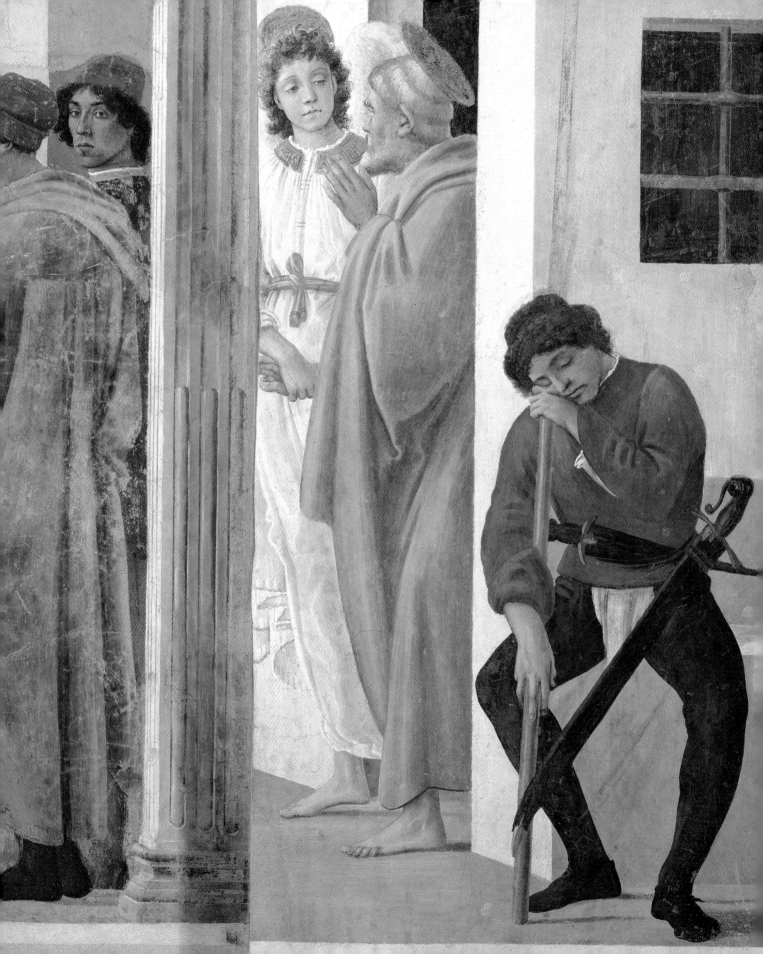

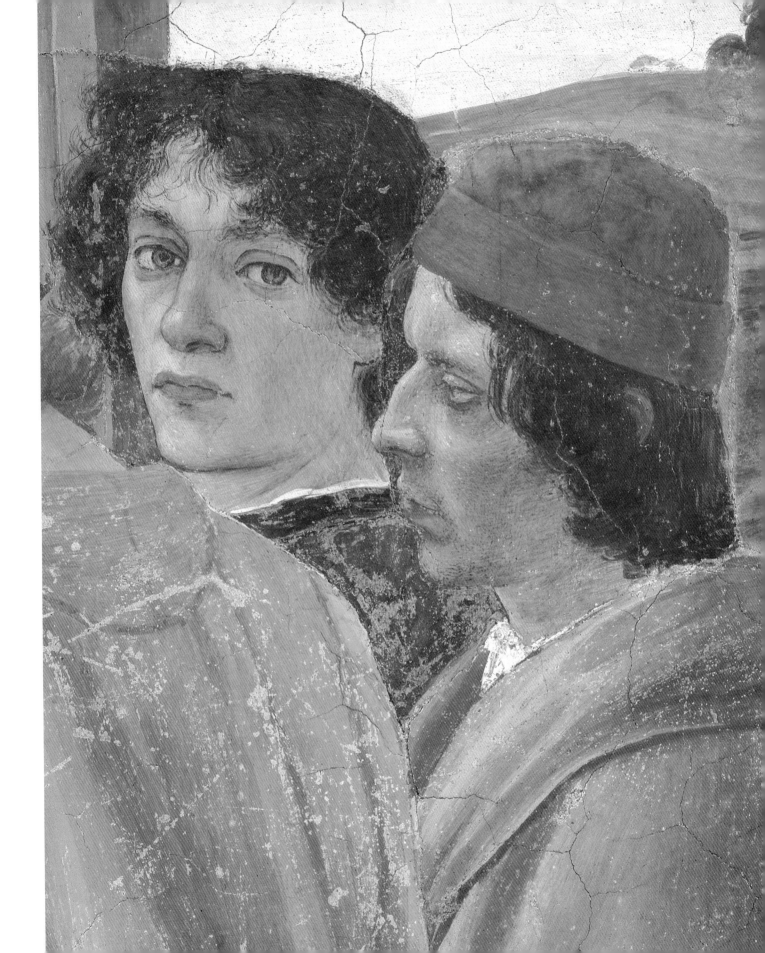

climb the scaffolding in the Brancacci chapel in Sta. Maria del Carmine to continue the work Masolino had started before he left in 1425, first for Hungary and then for Rome, whither Masaccio would follow him, he in turn leaving the painting unfinished. Eventually, 50 years later, it would be completed by Filippino Lippi, one of his earliest and most beloved disciples. The story of Adam and Eve on the pilasters by the entrance and of St. Peter on the main walls and the smaller ones flanking the Gothic window (the lunettes of the vault were destroyed in the 18th century during rebuilding) are the most important monument to the change of direction Masaccio sought. Released from the specifications of the commission, which still wanted works intended for the Church to respect the traditional forms, as was the case with the Carmine polyptych in Pisa with its figures painted against a gold background, the use of fresco allows the artist complete freedom of expression; this takes shape in sculpture-like figures that recall classical models and, in particular, Donatello. The dramatic intensity is determined not by the movement of the bodies but their static quality, which makes them appear enormous against a landscape background that is almost too small for them, and heightened by their eyes, which gaze into a distance far from the surrounding scene and place them in a world different from ours, a heroic world inspired by classical antiquity. In comparison with Masolino's frescoes of scenes from the life of St. Peter: *The Healing of the Cripple and Raising of Tabitha, Temptation (Original Sin)* and *St. Peter Preaching*, Masaccio's scenes: *The Expulsion from the Garden, St. Peter Healing the Sick with his Shadow, Tribute Money, Baptism of the Neophytes, Distribution of Alms* and *Raising of the Son of Theophilus* (this last left unfinished and completed by Filippino Lippi), reveal a pictorial power and formal density based on a realistic interpretation of light that is almost a prelude to what Piero della Francesca would later accomplish, and go far to explain why the cycle would resound like an echo through Florence for generations to come. (This has been abundantly clear since the recent restoration.) A further fresco, *Trinity with Donors*, in Sta. Maria Novella, which probably dates from 1427, is Masaccio's last work and virtually his testament before he finally left for Rome, where he would die the following year. This work documents the artist's conversion, as it were, to the rules of perspective that Brunelleschi had applied to architecture, a conversion that contained enormous innovative potential. Painted on a scale hitherto unknown, this work was conceived as a great tabernacle,

based on forms taken from Brunelleschi, its monumental quality in no way diminished by the light red in which many of the architectural elements are rendered. The Trinity is represented on three levels: that of the Donors, who stand behind two Corinthian pilasters beside the great Renaissance niche, an idea that inspired many artists of the following generations, from Leon Battista Alberti to Bramante and the Raphael of the *School of Athens*; next, foreshortened, the level on which stand the figures of the Holy Virgin and St. John; and finally, slightly farther back, that which is dominated by the vision of God the Father supporting the Cross on which hangs a Christ whose body is depicted with stark anatomical realism, a figure whose origins lie with Donatello, in an image whose sacredness is heightened by the Ionic columns and the solemn, vaulted caisson ceiling that bound the space. At the foot of the composition is an altar painted in perspective, and beneath it the tomb of Adam, from which was supposed to have grown the tree from which the Cross was hewn; and upon the tomb, his skeleton, adding a solemn, realistic note to one of the loftiest representations of the Mystery of the Trinity.

One of the first artists to understand Masaccio's message was the Carmelite monk Filippo Lippi (born in Florence c.1406, died in Spoleto in 1469). Lippi began his apprenticeship in the same church, Sta. Maria del Carmine, where Masaccio had painted the scenes of the life of St. Peter, and consequently had before his very eyes the frescoes in the Brancacci chapel and the *Consecration of the Church of Sta. Maria del Carmine* in the church cloister, which Masaccio had painted in *terra verde* (unfortunately destroyed in the 17th century). In 1432, Lippi painted his first known fresco, scenes of Carmelite life, in another part of the same church. Only fragments survive, but as Vasari records, they showed the direct influence of Masaccio. During the next years, Lippi disappears from Florence and in 1434 is to be found in Padua at the same time as Cosimo the Elder, who was in exile there. Perhaps this was why Lippi was there too.

That Lippi's early work is resolutely Masaccesque is clearly evident in the *Tarquinia Madonna* (dated 1437), which he painted on commission for Archbishop Giovanni Vitelleschi of Florence (Rome, Galleria Nazionale). Yet even here the colloquial humanity and joviality typical of Lippi's work are already evident as well, the characteristics that give his painting its rich, humorous, human touch and involve the viewer in a sort of sacred representation that transforms the sacred image, in such works as the *Virgin and Child with St. Fredianus and*

Masaccio, *Trinity with the Virgin and St. John the Baptist*, detail. Sta. Maria Novella. The obvious architectural perspective in this fresco underlines the imposing vision of the divine figures.

Filippo Lippi, *Coronation of the Virgin*, 1444–47, tempera on panel, from S. Ambrogio. Uffizi.
Masaccio's lessons find joyful narrative force in Filippo Lippi.

St. Augustine, formerly the altarpiece in the church of the Holy Spirit and now in the Louvre, which was commissioned in 1437; and the *Coronation of the Virgin*, painted between 1441 and 1447 for the high altar in the church of St. Ambrose (Uffizi), where more than 20 years before Masolino and Masaccio had left their *Sant' Anna Metterza*, aspects of which resurface in Lippi's tondo *Virgin and Child and Scenes from the Life of St. Anne* (now in the Pitti), such as the busy groups of different individuals, each with its own personality, who crowd into spaces defined by perspective, but using a scansion that only distantly recalls Brunelleschi's rules. Often, too, the viewpoint is considerably raised so as to drive the figures up rather than submerge them in a definite space, while his landscapes, rich in descriptive imagination, still have an archaic, Giottoesque flavor to them, albeit one glowing with Angelico's transparent coloring. Lippi's articulation of space becomes more coherent in the Pitti Tondo (also known as the "Bartolini Tondo" after its supposed commissioner), in which the figures of the Virgin and Child, placed in the foreground, loom upward, an effect enhanced by the converging lines of

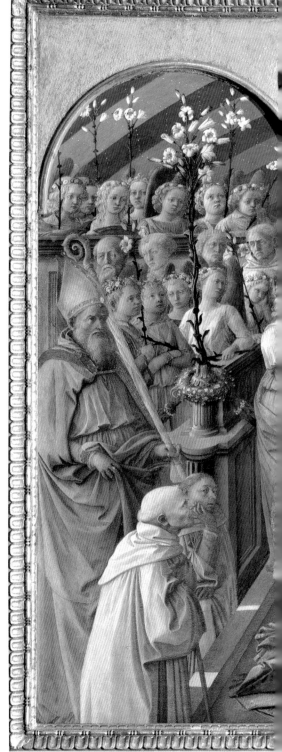

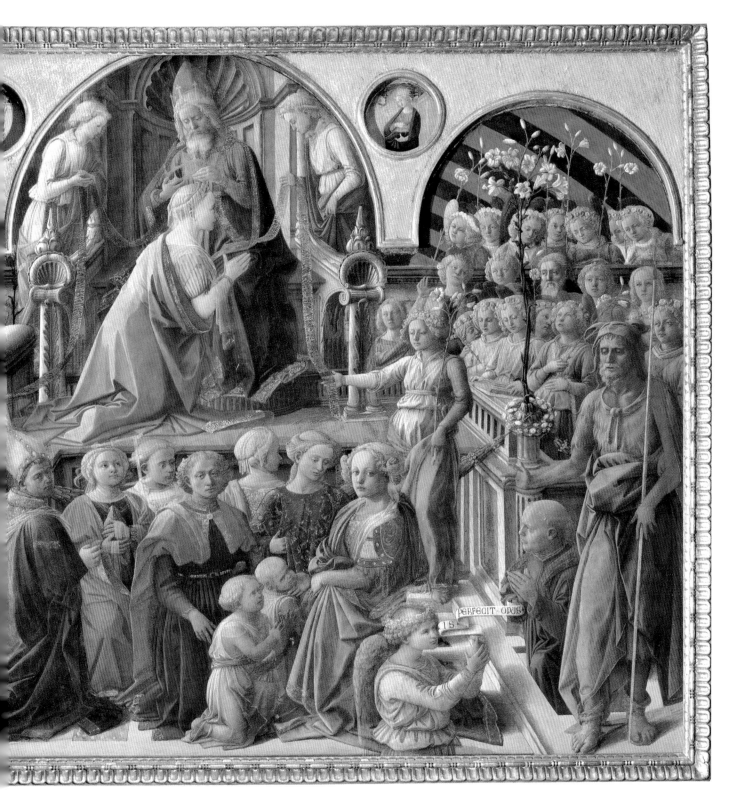

PERFECIT·OPUS

237

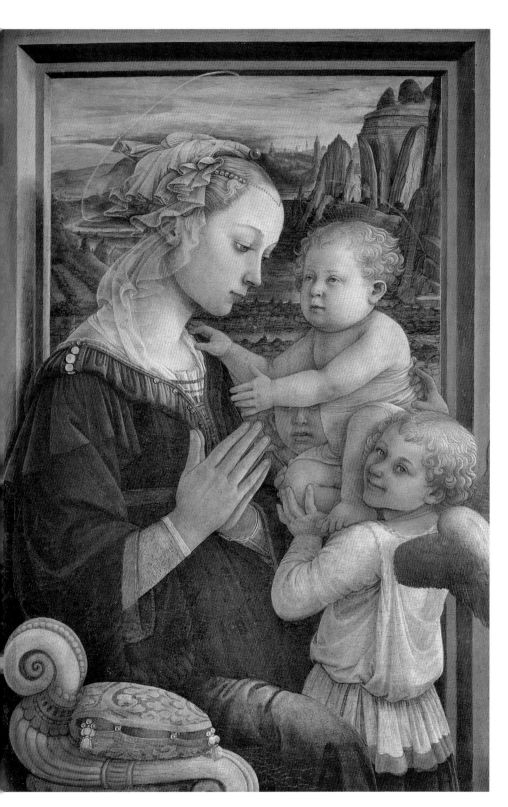

perspective created by the open surrounding spaces in which are depicted scenes from the *Life of St. Anne*; and particularly in the cycle of frescoes showing scenes from the lives of St. Stephen and St. John the Baptist, which he painted in 1452–64, at a key juncture in his career, in the choir of Prato Cathedral (a commission that had been turned down by Fra Angelico).

(It was during this period that Lippi became acquainted with a lay sister by the name of Lucrezia Buti whom, after obtaining the necessary papal dispensation to leave the cloth, he married. The couple had a son, whom they named Filippino; he would become a disciple first of his father and then of Sandro Botticelli, and become an innovator and painter of genius.)

The *Bartolini Tondo* and the Prato frescoes represent the mature period of Lippi's style. In these works he concentrates on the representation of a few solemn events, such as the *Funeral of St. Stephen*, and looks both back to Masaccio and forward to future developments, such as would be made by Ghirlandaio or Andrea del Sarto, while in others (the *Dance of Salome* and *Presenting the Head of St. John the Baptist to Herod*) his style already announces new traits, such as the use of dynamic line to bring his figures to life, which lie at the origin of the style of Lippi's most talented pupil, Sandro Botticelli.

The emotional charge that lies at the core of Filippo Lippi's art comes to the fore in his more mature works. It radiates from the bond Lippi forges between his Madonna and Child, whose figures are projected against an imaginary landscape that prefigures the work of the young Leonardo; and in the smiling angels who herald a new world of emotion, a world that Botticelli will explore far more deeply. The final works of his career see Lippi working with assistants and mark a mystical withdrawal that would be reflected in the work of Fra Angelico on the frescoes in the Niccolina chapel in Rome. It can be found, albeit without Angelico's spatial clarity, in Filippo's last work, *The Life of the Virgin*, a cycle of frescoes in the apse of Spoleto Cathedral.

A talented pupil of Lippi's was Francesco di Stefano, called Pesellino (c. 1422–57). Among the works of this artist, whose career was cut short by his early death, are the predella beneath the altarpiece that Lippi painted for the Cappella Medicea del Noviziato in Sta. Croce (part of which is

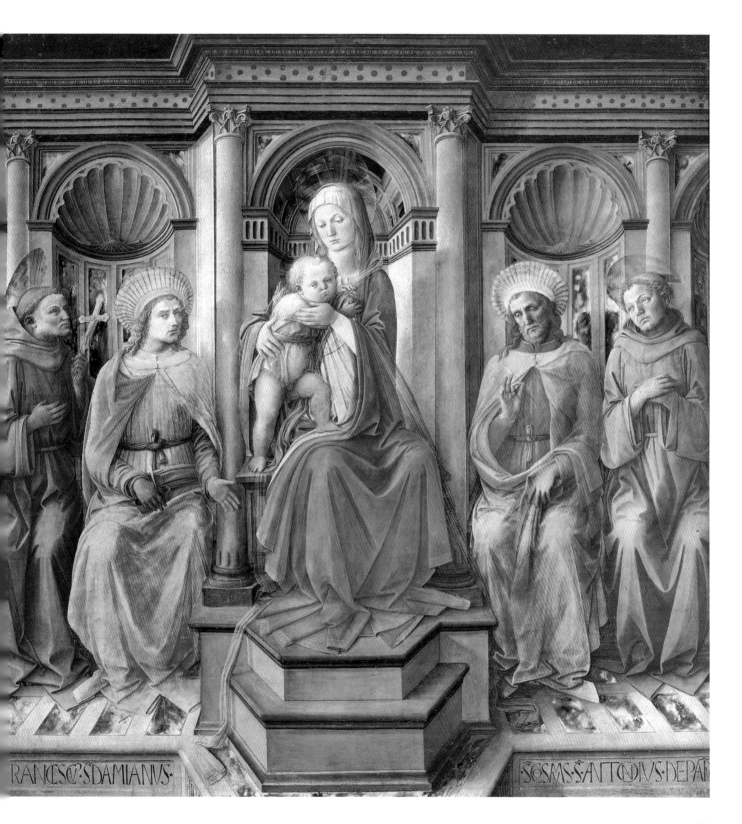

RANCESC̄Ō ·S̄·DAMIANVS· ·S̄·COSMS·S̄·ANTO̅NIVS·DE·PA̅

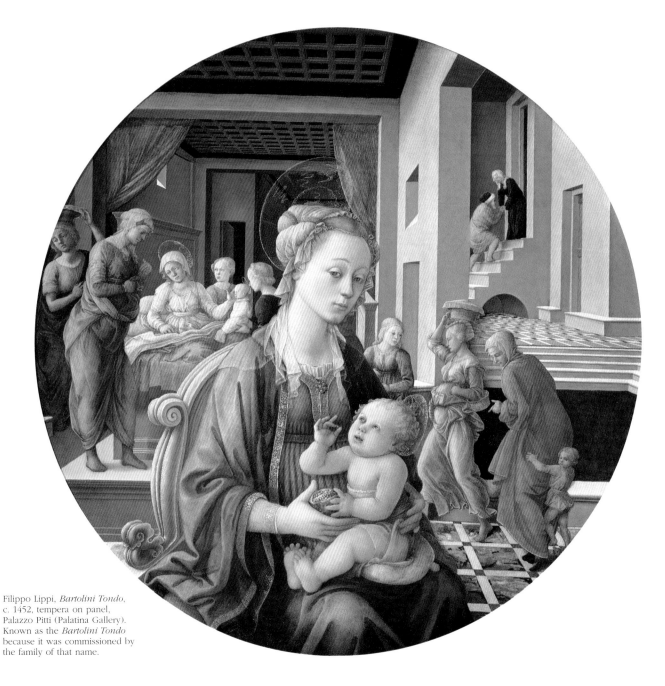

Filippo Lippi, *Bartolini Tondo*, c. 1452, tempera on panel, Palazzo Pitti (Palatina Gallery). Known as the *Bartolini Tondo* because it was commissioned by the family of that name.

On the preceding pages:
Filippo Lippi, *Virgin with Child and Angels*, 1457–65, tempera on panel, detail. Uffizi.

Filippo Lippi, *Virgin Enthroned with Four Saints*, from the Novitiate Chapel in Sta. Croce, 1441–50, tempera on panel. Uffizi.

now in the Louvre, and part in the National Gallery, London), where his simplified forms, brilliant coloring, and miniature skills show how close he was to Angelico as well; and *Holy Trinity with Saints*, his last work (also in the National Gallery), which he painted (dying before he could complete it) for the Company of the Priests of the Trinity of Pistoia, and in which he adopts formal solutions proposed by Andrea del Castagno.

Andrea del Castagno (c. 1420–57) was one of the younger followers of Masaccio. He followed his master's example closely in his earliest work—the frescoes in the vault of the S. Tarasio Chapel in S. Zaccaria, Venice (1442) and those (fresco was Andrea's favorite medium) in the Pazzi Chapel in the Castello del Trebbio, the *Madonna Enthroned with Angels and SS. John the Baptist and Jerome* (Uffizi, Contini Bonacossi collection), which is generally dated about 1443. In this work Andrea is still struggling to coordinate his composition, with Brunelleschi's rules of linear perspective making rather an obvious appearance. But by the time

he comes to paint the *Crucifixion* for the monastery of the Angels, very shortly thereafter, he is in command of a vigorous, sculptural style, his drawing has become more plastic, and he displays a feeling for relief in his forms, which derive from Donatello. Even here, though, his approach to the figure of Christ, for instance, shows his closer allegiance to the work of Masaccio. In the flawless architectural perspective of the great fresco of the *Last Supper* in the refectory of the monastery of St. Apollonia in Florence (1447) and the three scenes above, the *Crucifixion*, *Deposition*, and *Resurrection*, we can see a scansion of space that seems to be a prelude to Piero della Francesca's work in Arezzo. In the decorations of the salon in the Villa Carducci at Legnaia (Florence), with sibyls and figures from history and literature all enclosed in a frame that is redolent of the classics, his drawing is more dynamic, prefiguring later developments in this area by Pollaiuolo. His final works (the frescoes in Santissima Annunziata of the *Savior with St. Julian, Trinity with St. Jerome and Pious Ladies*, the *Crucifixion* in Sta. Maria Nuova, and the monument to Niccolò da Tolentino in the Duomo) all betray tormented forms that reflect the late work of Donatello.

Although something of a case apart, Paolo Uccello (1397–1475) also harks back to Masaccio, for he lived so long that he was exposed to the widest range of experiences in the artistic life of Florence. Born at the end of the 14th century, Paolo started his artistic career as one of the assistants of Lorenzo Ghiberti, working on the restoration of the first of the bronze doors for the Baptistery, which ended in 1425. He was only entered in the Company of

St. Luke, the Florentine painters' guild, in 1424. His first monumental work, the *Story of Genesis*, the *terre verte* frescoes in the first cloister of Sta. Maria Novella, datable before 1436, owes much to Ghiberti's elegant formal solutions straddling the Gothic and the Renaissance: the Gothic elements to be found in these frescoes, not yet supplanted by Brunelleschi's perspective, give the work its distinctive character. Yet perspective became the area in which he strove to achieve perfection. It was already increasingly evident in the *Annunciation* for Sta. Maria Maggiore (now lost), which Vasari

Paolo Uccello, *The Flood*. Fresco (removed). In this lunette in the Green Cloister of Sta. Maria Novella, Paolo Uccello shows himself to be a master of perspective in possession of a powerful, expressive language and a precursor of Michelangelo.

Pesellino, *Decapitation of St. Cosmas and St. Damian*, tempera on panel. A panel from the predella of the altarpiece by Filippo Lippi for the Novitiate Chapel. Uffizi.

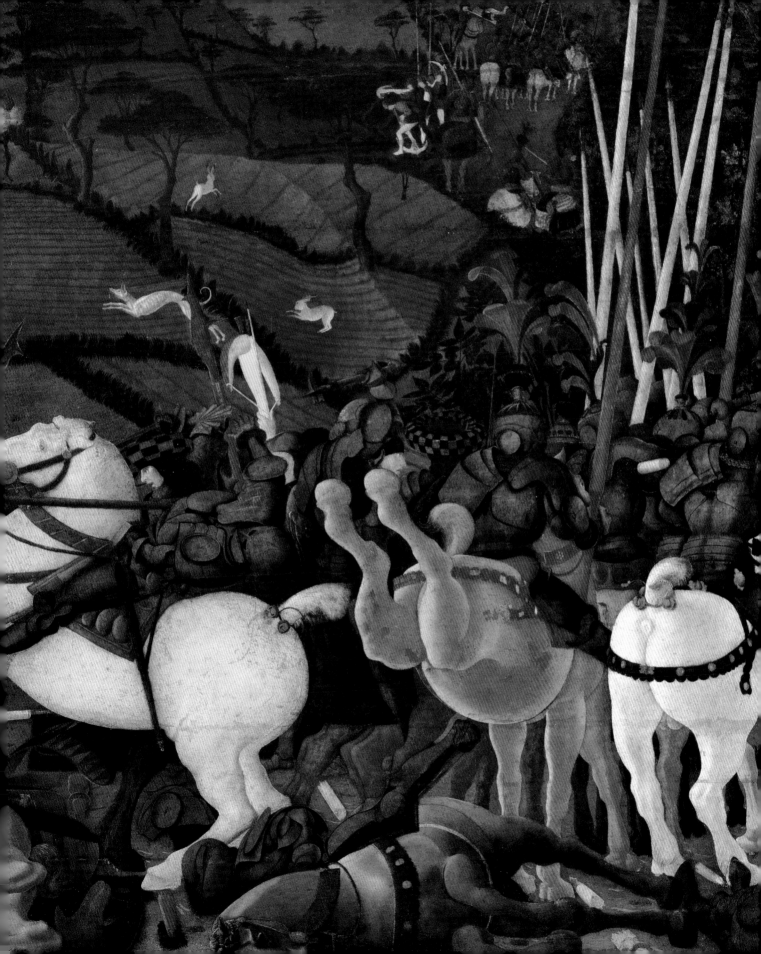

Paolo Uccello (attributed to), *Nativity of the Virgin*, fresco. Chapel of the Assunta, Prato. Now almost unanimously attributed to Paolo Uccello, these frescoes show how the artist progressed, placing fairy-tale-like narratives within frames drawn in flawless perspective.

Opposite:
Paolo Uccello attributed to, *Nativity of the Virgin*, detail.

On the previous pages:
Paolo Uccello, *Battle of San Romano*, central panel, 1456–60, tempera on panel. Uffizi. The panel shown was the central panel of a triptych painted for the Great Hall of the Medici palace. Paolo Uccello brings lofty intellectual gifts to his depiction of a story that borders on the fantastic.

much admired for its perspective study, and can be seen in the series of scenes of hermitic life in the monastery of S. Miniato al Monte, and more deliberately in the memorial fresco in the Duomo to the English condottiere Sir John Hawkwood (Giovanni Acuto), dated 1436, which he painted on commission for the Seignory. At this point Paolo starts to receive commissions from Florence's Opera della Primaziale, between 1443 and 1445 supplying the cartoons for two stained-glass windows (a *Nativity* and a *Resurrection*) to be placed in two oculi in the drum of Brunelleschi's dome, executing an *Annunciation* (now lost), and painting the decorative frescoes on the great clock in the counter-facade of Sta. Maria del Fiore, in which he placed the heads of *Four Prophets* (or the Evangelists) in the four oculi at the corners of the cornice. In all these works Paolo makes use of perspective, which assumes such a dominant role that it almost transmutes his forms into abstract geometric profiles, a phenomenon that will be evident in the *Battle of San Romano*. In his *Prophets*, apart from the illusions created through the play of perspective in the oculi that contain the figures, what is noteworthy is his use of emotionally charged plastic form, which recalls the sculptures of Donatello and the latent expressionism of Andrea del Castagno. Paolo Uccello reaches the height of his dogged study of perspective in the fresco *The Deluge* (unfortunately now damaged)

in the Green Cloister of Sta. Maria Novella. These frescoes, painted virtually in monochrome, make radical use of perspective (look at the way the black-and-white checked "*mazzocchio*" is represented, itself the subject of a drawing by the artist in the Uffizi). This is especially true of the *Deluge*, where the perspective underlines the abstract, static quality of Paolo's representation of figures and brings them into relief, giving them a grandeur that derives from Masaccio and Donatello while pointing the way to Michelangelo's heroic style.

Yet his most famous work is the *Battle of San Romano*, which he may have painted the commemorative celebrations held in honor of the Florentine commander, Niccolò da Tolentino, who had defeated the Sienese in 1433 at the *Battle of San Romano*, and as part of which the Seignory decreed that an equestrian monument to him be painted in Sta. Maria del Fiore. This painting was executed by Andrea del Castagno in 1456. As suggested, these celebrations probably lie behind Paolo's *Battle of San Romano*, which he painted in three panels. The work is first recorded in 1492 as part of the inventory of the Medici Palace, which was drawn up on the death of Lorenzo the Magnificent. The panels, now separated (the central panel in the Uffizi, the left-hand panel in the National Gallery, London, and the right-hand panel in the Louvre) can be dated to 1456–60, and are regarded as Paolo's masterpiece. They have had a considerable influence, down to and including the modern era. The intricate interweaving of the geometric forms of the horses; the irregular triangles formed by the weapons and the foreshortened armored warriors and their horses; the diagonals running parallel to the surface of the painting or into the distance to indicate planes leading toward the raised horizon (the panels were originally to be hung at a considerable height); the unnatural, almost abstract color and the virtual absence of shadow—all these elements create an atmosphere both dream-like and one of lively intellectual play that is far removed from reality and to this day can still exert a profound fascination over the viewer. Having become famous for these and other works which he had created earlier in Venice and Padua (now mostly lost), Paolo moved to Urbino in 1465, where he painted the predella depicting the *Story of the Profaned Host* (now in the Galleria Nazionale delle Marche). By 1469 he was sick and disabled, as he complains in his tax return for the year. Within a few years, as Vasari recounts, he would die poor and forgotten.

Mario Chiarini

The light of Fra Angelico

Fra Giovanni da Fiesole (c. 1395–1455), whose lay name was Guido di Pietro and who was later dubbed Fra Angelico (the angelic), painted some of the most sublime religious paintings of all time. He also forms an indissoluble bond between the medieval world of contemplation and the new, rationalistic impulses of humanism, the study of ancient monuments, represented in architecture and sculpture by Filippo Brunelleschi and Donatello, and later in painting by Masaccio. Despite the fact that he was some years older than Masaccio and was trained in the Gothic world of the distinguished miniaturist and painter Lorenzo Monaco, Angelico did not spurn the new Masaccesque pictorial language, seeing in it the potential for a simplification of form that would make his work more accessible to the public. From his first attempts in the world of miniatures, Angelico, who had already been registered as a Florentine painter in 1417, developed a typically Gothic decorative style in which delicacy of drawing combined with brilliance of color. This then opened out under the influence of Masaccio to become a blend of the characteristics and sense of atmosphere with which the younger artist had imbued his frescoes in the church of Sta. Maria del Carmine. Their naturalness and humanity cannot have left Angelico unmoved, nonetheless, the manner in which he interpreted the humanist venture unfolding on all sides about him was fundamentally determined by his own personal situation and deep religiosity (he became a Dominican in about 1420), the increasingly conspicuous role played by the Medici in Florence, especially after Cosimo the Elder's triumphant return from exile in Padua in 1434, and all the new cultural trends led by Cosimo himself. In fact, after a few works like the *Last Judgment* (Uffizi) that still recall the old, courtly style— though the spacing of the groups around the central, dominant perspective vista of the opening of the tombs shows that he is already quite aware of the new, Renaissance way of constructing a picture—with Masaccio's death Angelico takes his place as the leading figure in the early Florentine Renaissance, with his stupendous *Descent from the Cross*, completed in 1432. The work had originally been commissioned from Lorenzo Monaco by Palla Strozzi to hang with Gentile da Fabriano's masterpiece *Adoration of the Magi* in the sacristy of the Holy Trinity, but Lorenzo had painted only the pinnacles. From the admirable, measured rendering of the receding

Fra Angelico, *Last Judgment*, 1430–35, tempera on panel, detail. Museo di S. Marco. Fra Angelico incorporates the new elements of Renaissance perspective into a luminous abandon that transfigures his interpretation of religious subject matter.

Following page:
Lorenzo Monaco (cusps) and Fra Angelico, *Deposition*, 1432, tempera on panel. Museo di S. Marco. This great altarpiece, created for the Sacristy of Sta. Trinità, is a lucid Renaissance vision of the drama of the Life of Christ. Started by Lorenzo Monaco, who painted the cusps, it was completed by Fra Angelico.

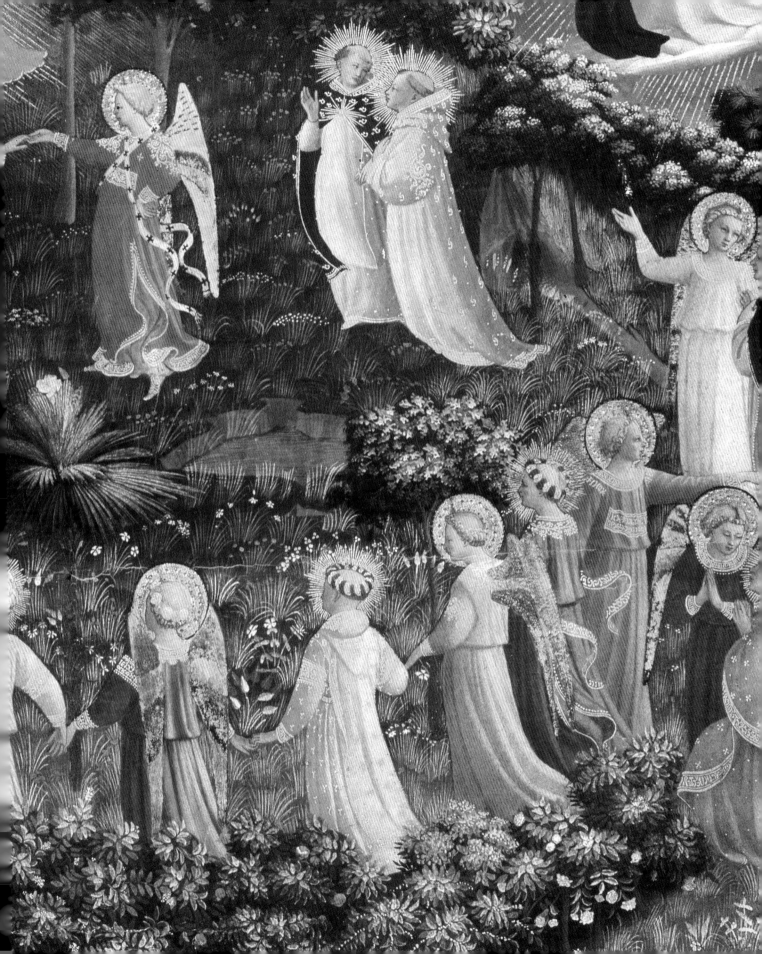

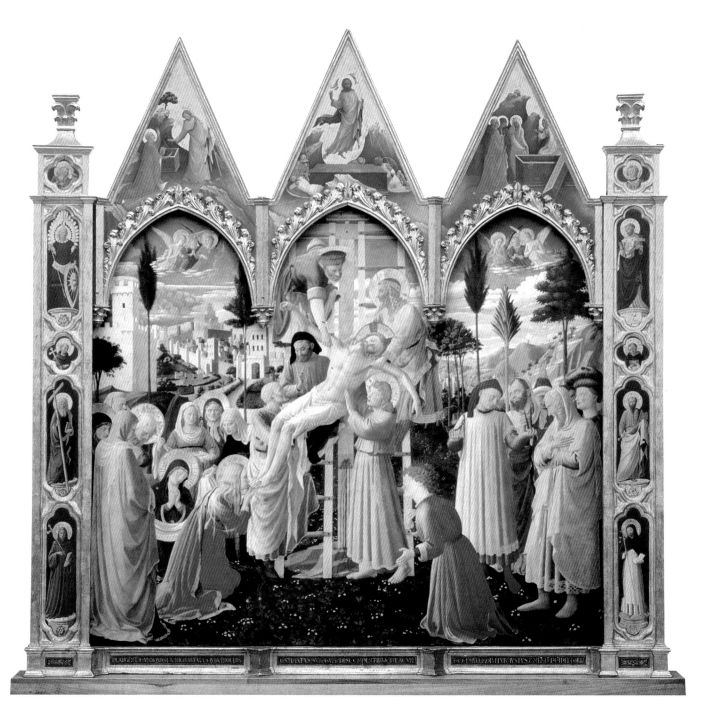

background, against which can be seen the city of Colonna, to the hills, brimming with light and color, which form an exedra about the main scene, the *Descent from the Cross*, is a scene crowned with onlookers whose Giottoesque ancestry is clearly visible. Fra Angelico has put together all the necessary elements to create a coherent language of serenity and candor lying midway between fable and reality, a language that must have enraptured the youthful Piero della Francesca just a few years later in Florence. The path on which Angelico thus set out, in which he combined the flamboyance of late Gothic with the new rational approach that studies into perspective had already well established, closely resembled that of Lorenzo Ghiberti, who was already working on the second pair of doors for the Baptistery, the doors that would later be dubbed the "Gates to Paradise."

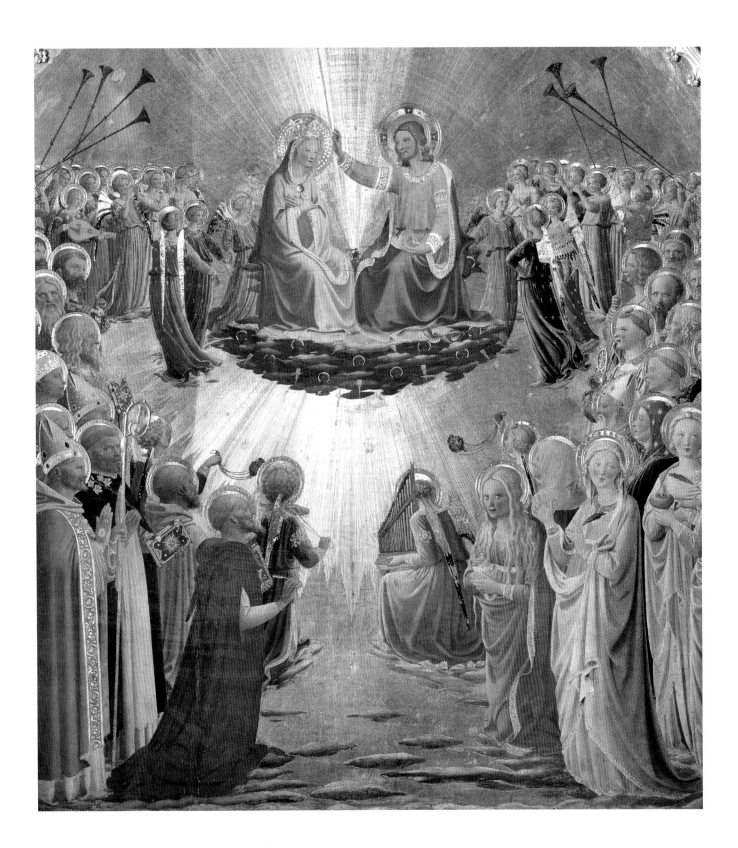

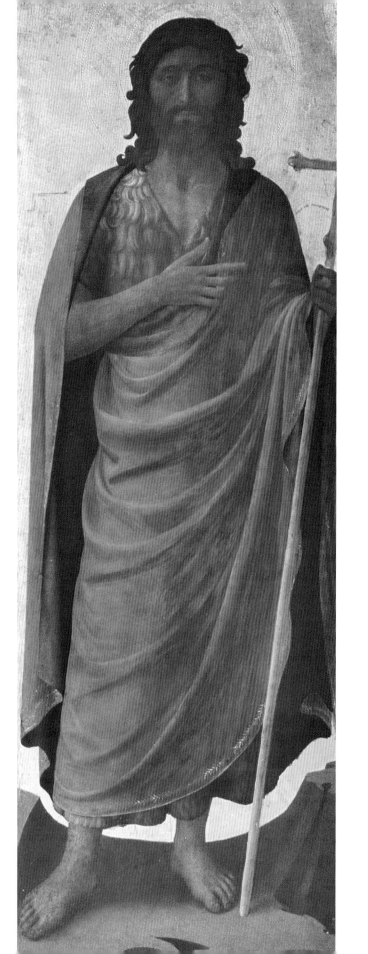
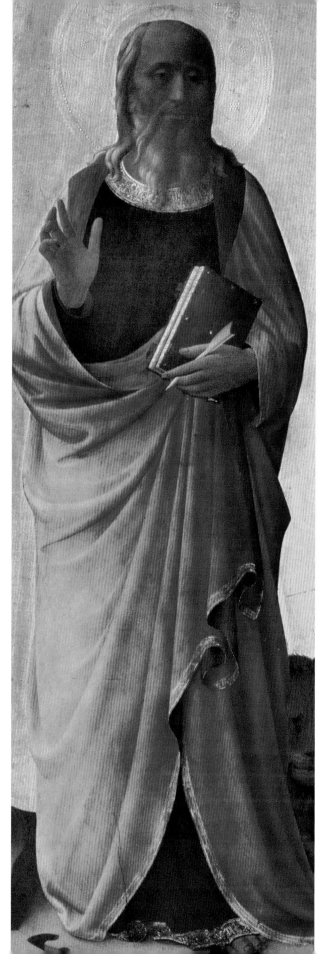

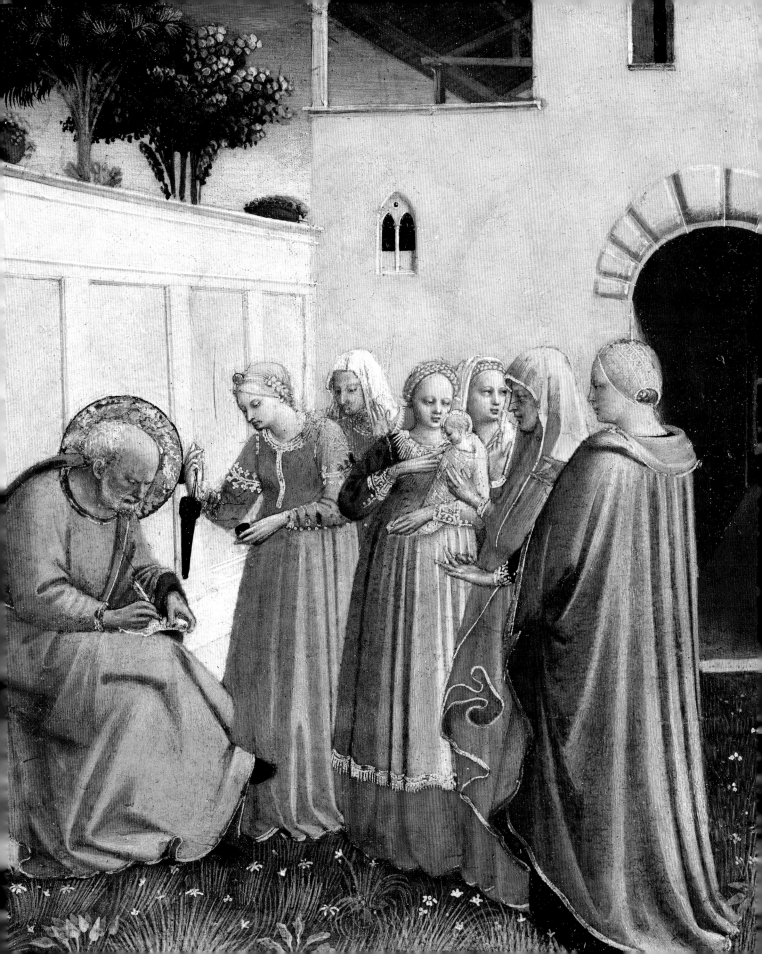

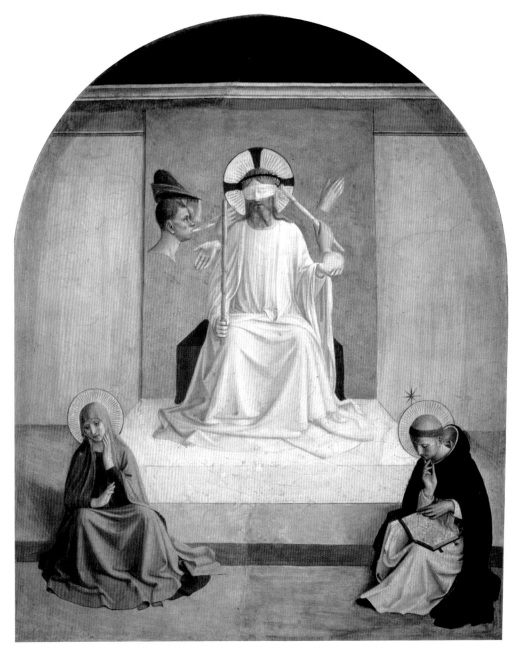

Together with his *Descent from the Cross*, Angelico's next work, the *Linaiuoli Tabernacle*, which he painted immediately afterwards, in 1433, for the Arte dei Linaioli (the Guild of Wool), in a marble frame decorated in Ghiberti's workshop, would be his manifesto. In the majestic group of the *Madonna and Child*, and even more in the figures of St. John the Evangelist and St. John the Baptist painted on the wings, Angelico's debt to Masaccio is noticeable, as it is in his measured use of space in the narrative panels in the predella, which enhances the majesty of the figures.

In 1436, the Dominican church in Fiesole, where Angelico had been regularly working, was amalgamated with the monastery of San Marco in Florence. The architect Michelozzo, a follower of Brunelleschi who had become Cosimo the Elder's favorite artist, renovated the church and the connected monastic areas on his orders, in a style consistent with what Angelico was doing in painting. It was probably for this reason that Cosimo asked him to decorate the chapter house, the cloister, and the monk's cells with frescoes. Angelico started to work on them in 1438. The cycle of frescoes

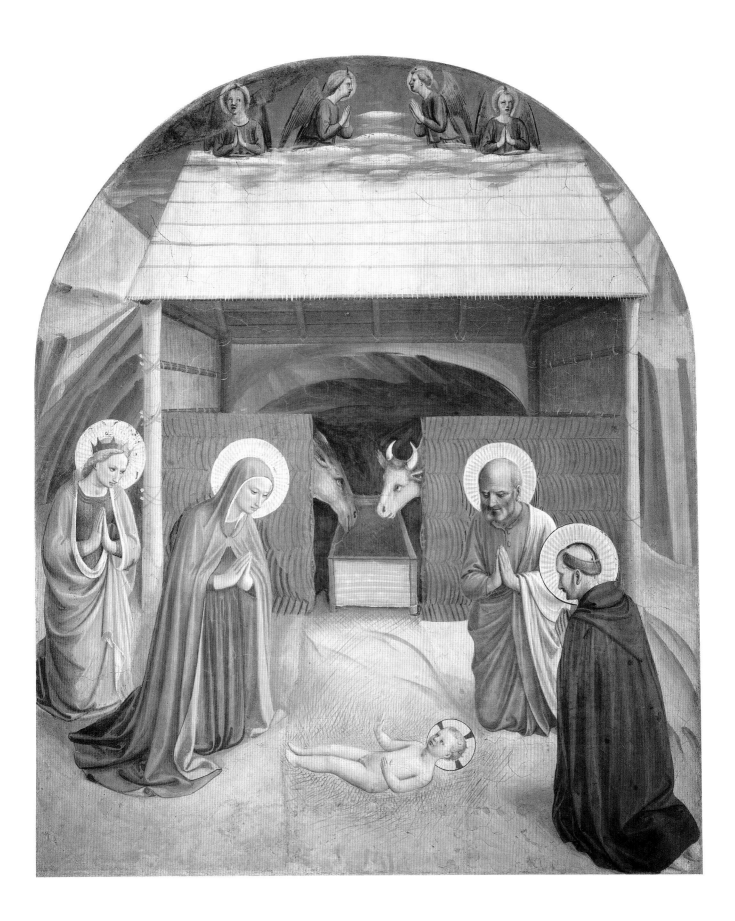

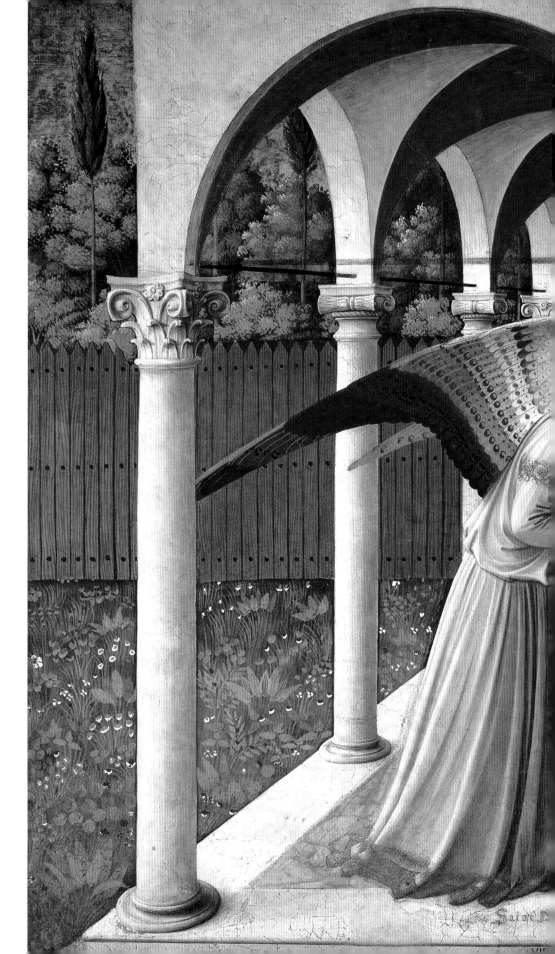

Fra Angelico, *Annunciation*, 1435–45, fresco. Convent of S. Marco. One of the most famous of Fra Angelico's many compositions.

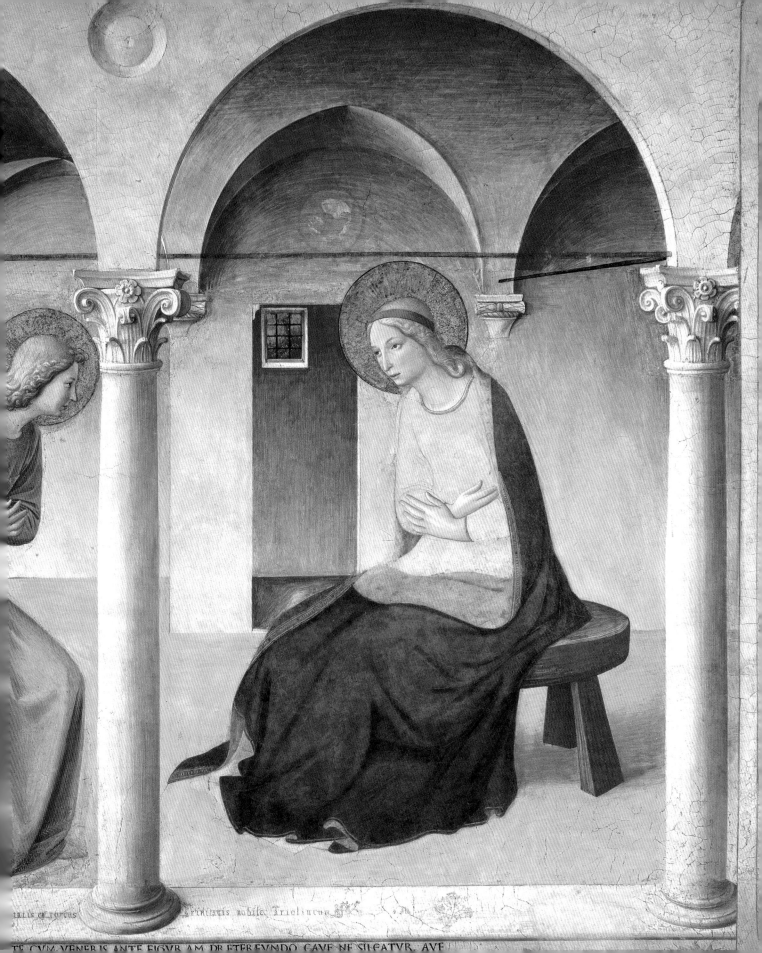

TE CVM VENERIS ANTE FIGVR AM DE ETEREVNDO CAVE NE SILEATVR AVE

in S. Marco, in the execution of which
Angelico was supported by a number of
assistants, including Benozzo Gozzoli, took
several years to complete, because of the many
commissions he received in the meantime,
such as that for the high altar in the church of
S. Marco, which was being renovated by
Michelozzo and which would be reconsecrated
by Pope Eugenius IV, in 1443. Steeped in
intense religious feeling and conviction, the
frescoes in S. Marco are without doubt one of
the high points of painting—of any period.
Revealing at every moment their maker's
immense skill and eloquence, they reflect his
determination to communicate the message
depicted in each episode with the clear light of
day, a light that transfigures even the most
dramatic scenes, and renders them serene.
Some of the frescoes have become
paradigmatic of Angelico's simplicity and his
profound religious faith. Even today, the
unadorned language of the *Annunciation*, the
Madonna and Saints known as the "Madonna
of the Shadows" and the scenes from the
Passion of Christ, far removed from rhetorical

trickery, are still deeply moving; and they can
help us to understand its importance to the call
for a return to a world of purity which the
Dominican Girolamo Savonarola, who grew up
in the monastery of S. Marco, preached to the
people of Florence somewhat later.

Angelico's fame spread far beyond the walls
of his monastery. By the end of 1445 he had
traveled to Rome and then Orvieto to discuss
the decoration of the chapel of S. Brizio in the
Cathedral. At the same time he also worked on
a chapel (now destroyed) for Pope Eugenius
IV with Benozzo Gozzoli. Returning to
Florence in 1449 he was made prior of the
monastery of St. Dominic in Fiesole, continued
to work on the decoration of S. Marco, and
painted the wings of the *Armadio degli argenti*
in Santissima Annunziata (S. Marco museum),
which have a more dense coloring and a more
accentuated plastic sense, elements he would
use in the frescoes of *St. Stephen* and
St. Lorenzo for Pope Nicholas V in the Vatican.
It is likely that he completely devoted the last
years of his life to his work, since he refused
to paint the choir of Prato Cathedral—a
commission that went to Filippo Lippi—and
other commissions that took him to Perugia
and then Rome, where he died early in 1455.

The importance of Angelico's activity, which
grew out of the example of Masaccio, and his
determination as a painter of murals, the point
at which real architecture and figurative space
coincide, is borne out by the volume of work

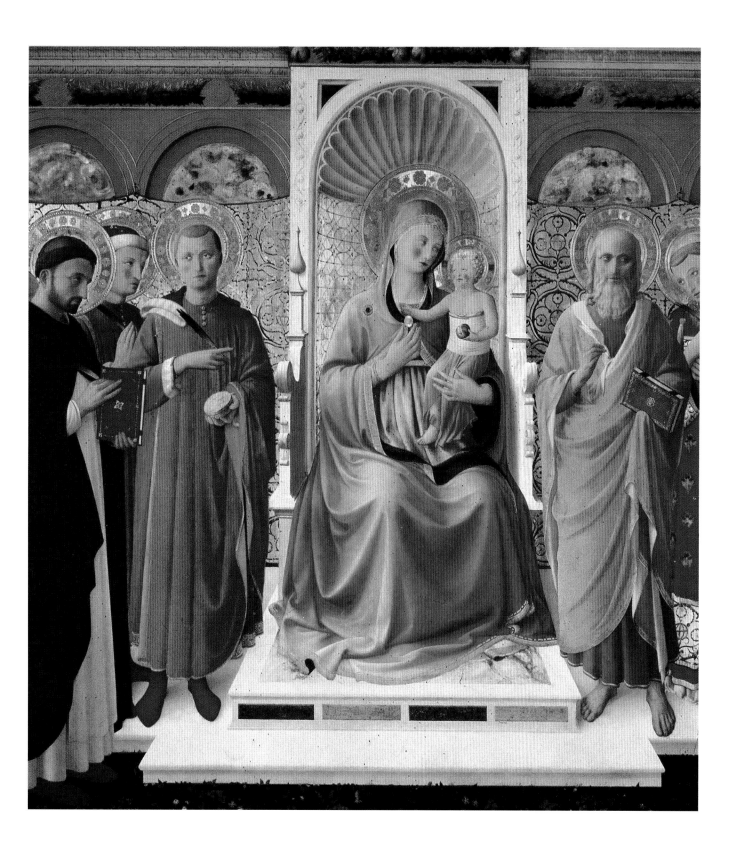

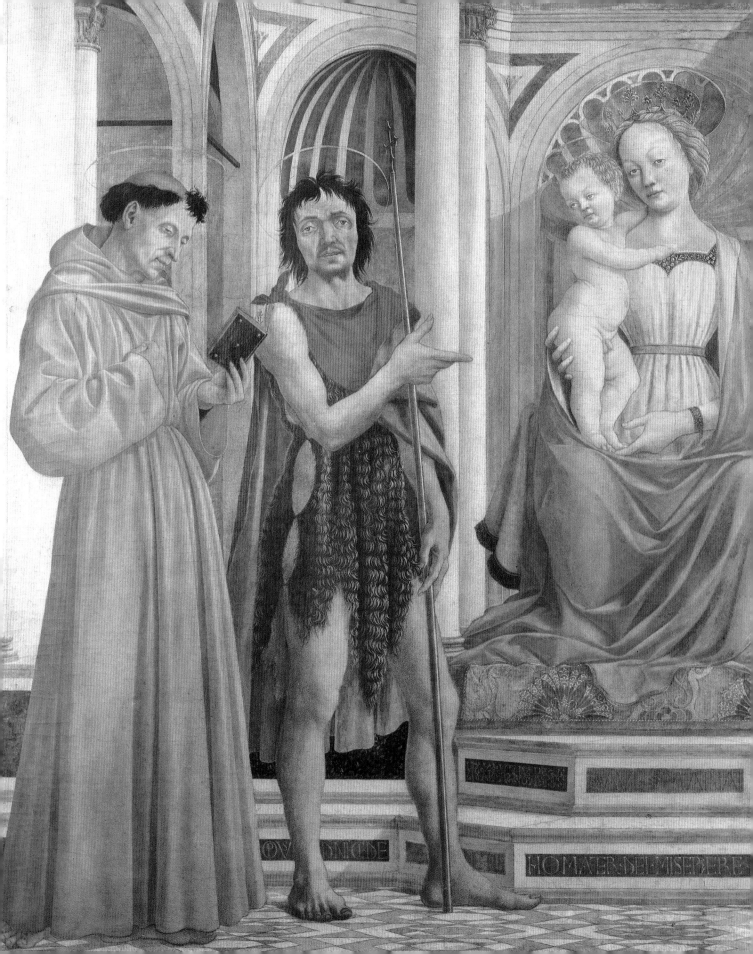

QUO (V?)INCE

HOMAE(R)·DE(L)·MISE(R)ERE

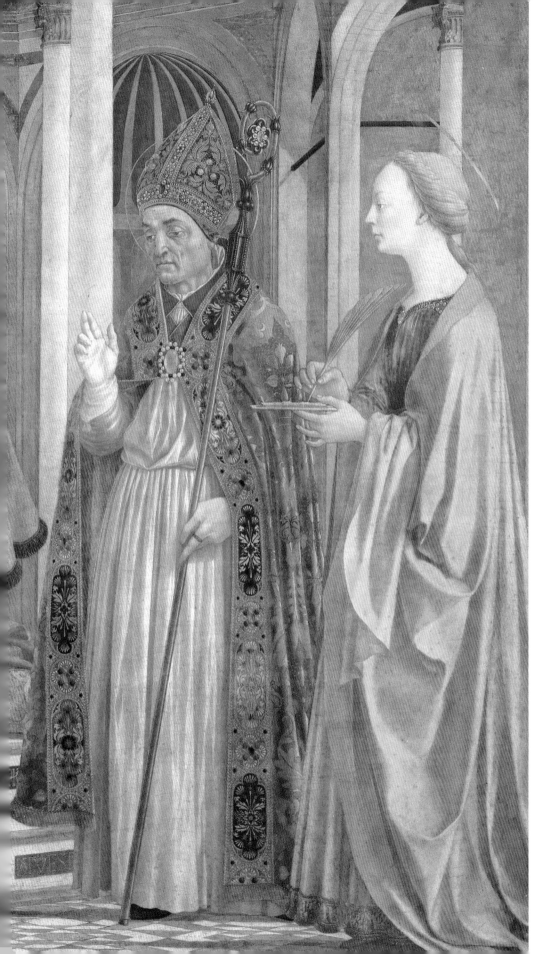

Domenico Veneziano, *Virgin and Child Enthroned with Saints*, from Sta. Lucia dei Magnoli, 1445, tempera on panel. Uffizi. Although clearly inspired by works by Fra Angelico, the natural light anticipates Piero della Francesca's tonal values.

produced in Florence by painters such as Filippo Lippi, Domenico Veneziano, Benozzo Gozzoli, Alesso Baldovinetti, and especially Giovanni di Consalvo Portoghese, who seems to have been a convert to the Dominican order at Fiesole and who from 1436 to 1439 painted the fascinating cycle of frescoes depicting the *Life of St. Benedict* in the Chiostro degli Aranci in the Badia Fiorentina, in one of the earliest examples in which the influence of Angelico's language can be seen.

Benozzo Gozzoli, *St. Augustine Teaching in Rome*, 1464–65, fresco. Church of St. Augustine, San Gimignano (Apsidal chapel).
The fairytale tone of Gentile da Fabriano's *Adoration* returns here in Gozzoli's fresco.

Among Angelico's direct followers and associates in commissions both great and small were Zanobi Strozzi, Andrea di Giusto, Domenico di Michelino, Mariotto di Cristofano, and Francesco d'Antonio, all of whom in one way or another reflected their master's achievements, especially in the variations on his style, an interpretation in color of Masaccio's language.

In 1438, Domenico di Bartolomeo, called Domenico Veneziano (born in Venice, moved to Florence in 1438, died in 1461), wrote a famous letter to Piero de' Medici in which he sought a commission for an important work to rival those of Fra Angelico and Filippo Lippi. Piero may have been the driving force behind Domenico being granted a commission by the Portinari for frescoes depicting *Scenes from the Life of the Virgin* to decorate the left-hand wall of the choir in the church of Sant'Egidio, the family chapel for which Hugo van der Goes was supposed to have painted the great triptych *Nativity* (Uffizi) in 1483. The frescoes were left unfinished by Domenico and completed by Alesso Baldovinetti, while the right-hand wall was frescoed by Andrea del Castagno. Unfortunately, the entire cycle was destroyed in 1567. Yet, remembering that Domenico was assisted by the young Piero della Francesca during his only stay in Florence, we can imagine the importance of these frescoes to the later development of Florentine (Baldovinetti, Gozzoli, Pesellino, Giovanni di Francesco) and Umbrian painting. The only altarpiece by Domenico, *Virgin and Child Enthroned with Standing Saints*, which he painted for the church of Sta. Lucia dei Magnoli in Florence (now in the Uffizi, its predella broken up and scattered among various museums), dates from a few years later. Dated variously between 1440 and 1450, its composition is conventional but its tone is more monumental and more worldly than Angelico's, more one of a *sacra conversazione*. In addition, the use of perspective to delineate the space in the portico enclosing the figures, the light coming from the right, which enfolds the divine group in an impalpable, mysterious shadow, while it lights up the saints in the foreground, making them transparent, and the grace with which they act out their roles, all these explain the artist's success and the influence he would have on his contemporaries in Florence, explanation already mentioned above. Yet why this masterpiece is almost alone in the work he did in Florence defies explanation, because the only other large-scale work of his known is the fresco *St. John the Baptist and St. Francis* (Museo dell'Opera di Sta. Croce), which because it was painted for the partition in Sta. Croce and follows the later, more "expressionistic" works of Donatello must be dated toward the end of his life. (In fact, the fresco formerly in the Carnesecchi Tabernacle is now in the National Gallery in London, in pieces and in very poor condition.)

Another figure in this current of Masaccesque coloring is Benozzo Gozzoli (1420/22–97), a faithful follower and assistant of Angelico's, in particular on the Rome and Orvieto frescoes, who kept the great Florentine fresco tradition alive in Tuscany and Umbria. In 1459, on the

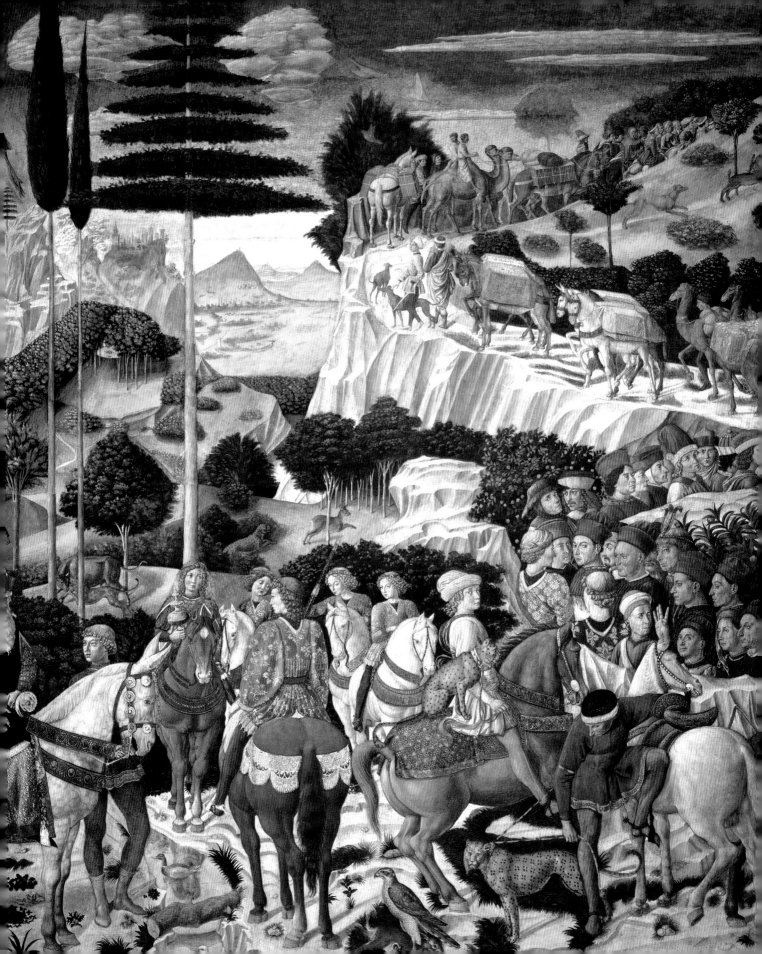

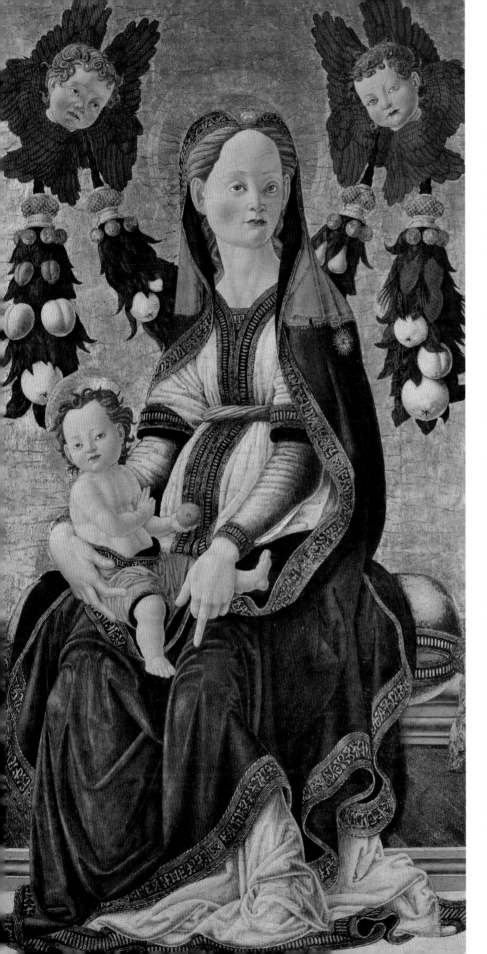

request of Piero de' Medici, Benozzo decorated the chapel in his palace on the Via Larga in Florence (today the Palazzo Medici Riccardi), which Michelozzo had built for Cosimo the Elder. In this fresco, the sumptuous splendor of the entourage of the Magi seems almost intended as an apologia for and consecration of the power of the Medici—Benozzo depicts the members of the Florentine house together with their friends in a phantasmagorical scene that stretches over the walls like a rich, brilliantly colored tapestry. Over the altar hung a *Nativity* by another artist favored by the Medici, Filippo Lippi (Berlin, Gemäldegalerie).

A lesser-known figure, although one with a marked personality, was Giovanni di Francesco del Cervelliera (fl. c. 1459). His work, terse but clearly drawn, is notable for its close study of the midday sun, which shows an awareness of the frescoes by Domenico Veneziano and Piero della Francesca in Sant'Egidio, and for its marked narrative sense, especially in the scenes depicted on his predellas, which show his awareness of Domenico and Piero. At the same time, the influence of Andrea del Castagno is

evident in the nervous drawing and tense line that structure his forms, as can be seen in his better-known works—the triptych in the Bargello Museum (Carrand Collection), the *Madonna with Child* (Uffizi, Contini Bonacossi Collection), and the fresco of the *Eternal Father* in the lunette over the entrance to the Ospedale degli Innocenti in Santissima Annunziata. Alesso Baldovinetti also acquired his first experience as a painter in Angelico's workshop, working with him on the *Armadio degli argenti* for Santissima Annunziata, although he was also influenced by the rougher style of Andrea del Castagno and the sense of atmosphere and luminous space created by Domenico Veneziano, whose unfinished fresco *Marriage of the Virgin* in Sant'Egidio he had the good fortune to complete. Despite starting his career in fresco, Baldovinetti found panel painting more to his liking and received important commissions from the Medici, like the *Madonna Worshiping the Child with Saints,* which he painted for the chapel of the Castello di Cafaggiolo (Uffizi) and from Florentine religious orders, for one of whom he painted a splendid *Annunciation*

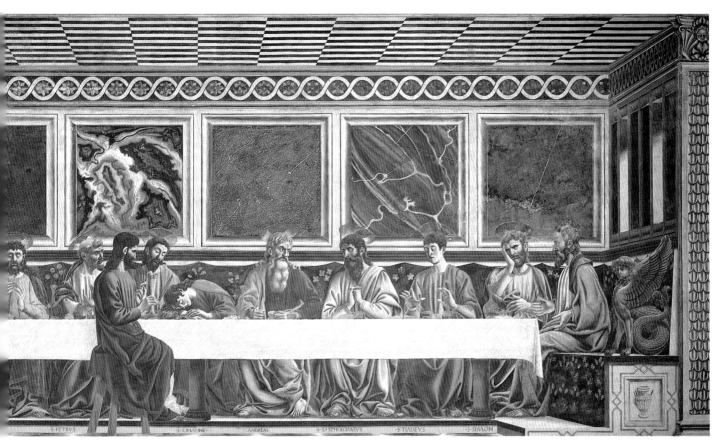

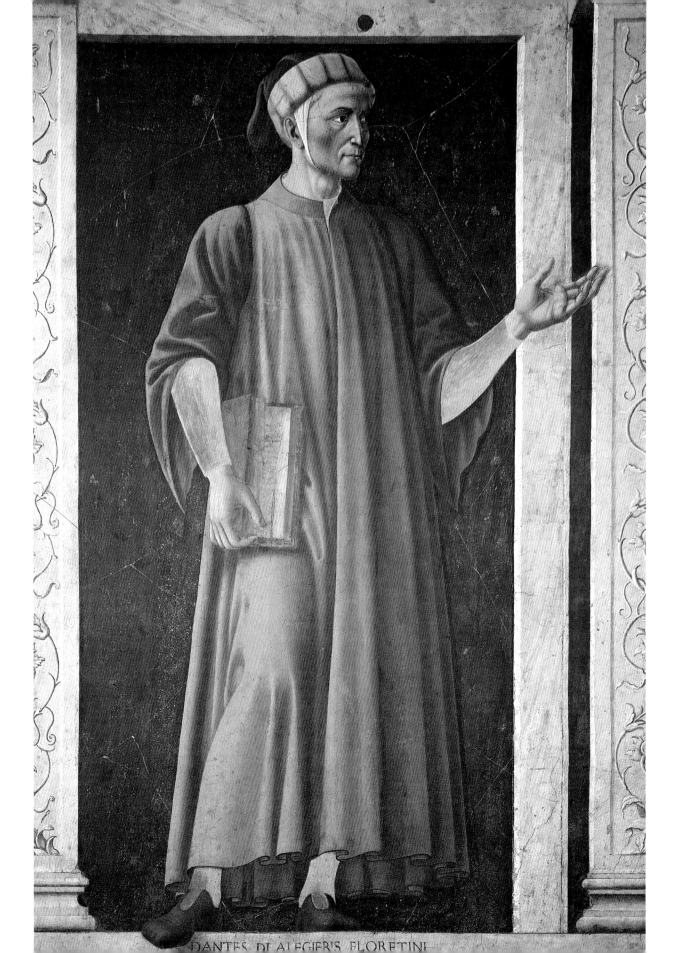

DANTES DI ALEGIERIS FLORETINI

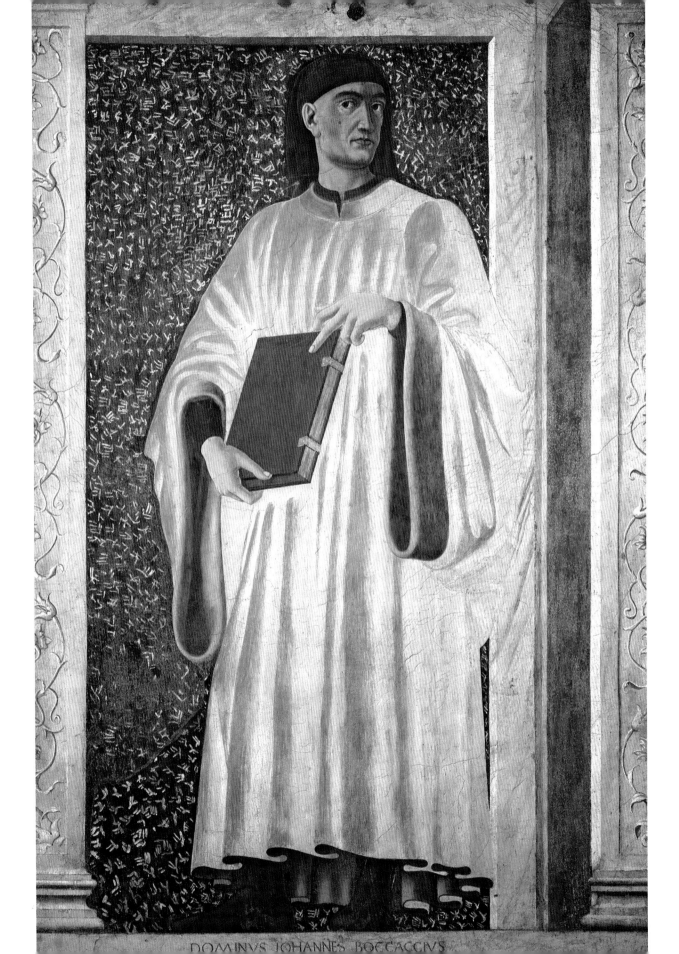

DOMINVS IOHANNES BOCCACCIVS

On the previous pages:

Page 264
Andrea del Castagno, *Dante Alighieri*,
1449–51, fresco (removed from the Villa
Carducci at Legnaia). Uffizi (Contini
Bonacossi bequest). In these
paradigmatic images, Andrea brings us
portraits of the great poets of the past.

Page 265
Andrea del Castagno, *Boccaccio*,
1449–51 (removed from the Villa
Carducci at Legnaia). Uffizi (Contini
Bonacossi bequest). A new realism
brings life to Andrea's figures.

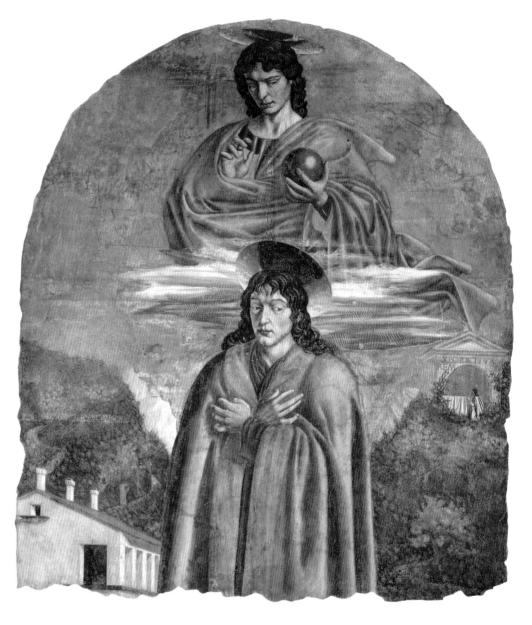

Andrea del Castagno, *St. Julian*, before
1453, fresco. Church of Santissima
Annunziata. As effectively expressed in
the background landscape here, Andrea
reduces his language to the bare
essentials in his late works.

(Uffizi) in about 1457, in which his use of
resonant, airy, chromatic space clearly recalls
Domenico Veneziano's altarpiece in Sta. Lucia
dei Magnoli. A new formal articulation is already
evident in these works, one that imparts a
dynamic feeling to the figures, a feeling
underlined by the complex play of the
draperies. It points to the years just ahead and
the achievements of Pollaiuolo and Botticelli.
The same might be said of the fresco of the
Nativity in the Chiostrino dei Voti in Santissima
Annunziata (c. 1460–62), where the view toward
the horizon of the valley of the Arno
disappearing into the distant hills anticipates the

more daring vision of infinite space that
Pollaiuolo would soon define. In 1466–67,
together with Antonio Rossellino, Luca della
Robbia, and Antonio and Piero del Pollaiuolo,
Baldovinetti worked on the most perfect funeral
chapel that has come down to us from Medician
Florence, the chapel of the Cardinal of Portugal
in S. Miniato al Monte, a marvelous composite
work in which architecture, sculpture, painting,
and vitreous majolica combine to create a
harmony of forms that embodies all the ideals
of humanistic perfection sought by the Medici.

Marco Chiarini

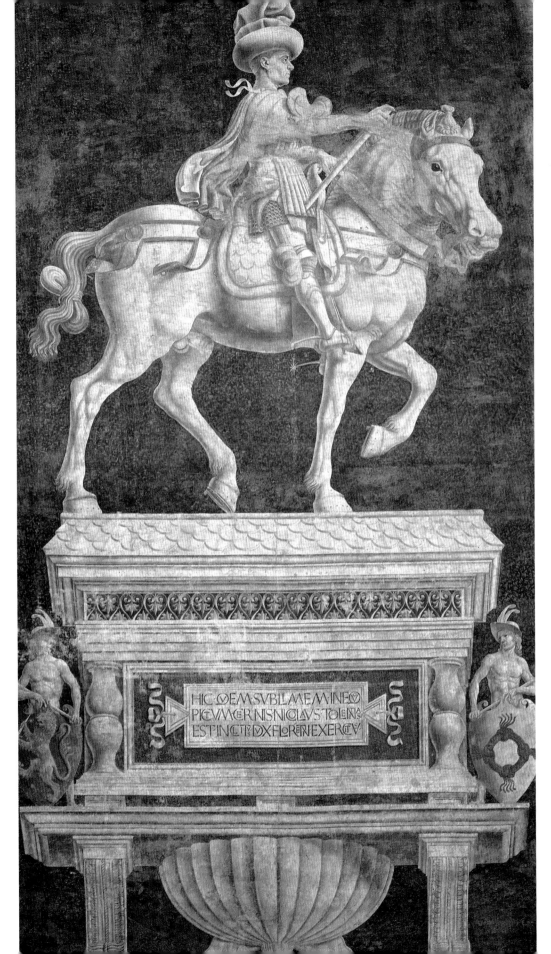

Andrea del Castagno, *Niccolò da Tolentino*, 1456, fresco (lifted). Duomo. Beside Paolo Uccello's memorial fresco in honor of Sir John Hawkwood (Giovanni Acuto), Andrea del Castagno's has a mobility of line that is emblematic of Florentine art in the second half of the 15th century.

On the following pages:

Alesso Baldovinetti, *Virgin and Child with Saints (the Cafaggiolo altarpiece)*, c. 1454, tempera on panel. Uffizi. In the simplicity of its composition, this *Sacra conversazione* shows the influence of Fra Angelico.

Alesso Baldovinetti, *Annunciation*, c. 1457, tempera on panel. Uffizi. Baldovinetti elongates his figures and architectural structures, giving them a lightness and elegance midway between Fra Angelico and Antonio del Pollaiuolo.

The dream of the ancient world

From the 1460s, a new generation of artists emerged no longer interested solely in painting panels and frescoes. In an earlier version of the universal Renaissance man who would be embodied in Leonardo da Vinci and Michelangelo Buonarroti, these artists turned to other activities, like goldsmithing and engraving, but most of all to sculpture.

As a result, the workshop of Antonio Pollaiuolo (1432/33–98) and his brother Piero (c. 1441–96), the sons of Jacopo Pollaiuolo (the name means "poultry-keeper"), was a constant hive of activity—Antonio would design the works, often leaving their execution to Piero. A highly skilled goldsmith and modeler, Antonio gained distinction for the quality and elegance of his work. In a constant search for new effects of light and shade, he deployed a nervous, dynamic line and had a fluid style of modeling that left their surfaces shimmering with light—so too in his painting. Although his great *Labors of Hercules*, the three paintings

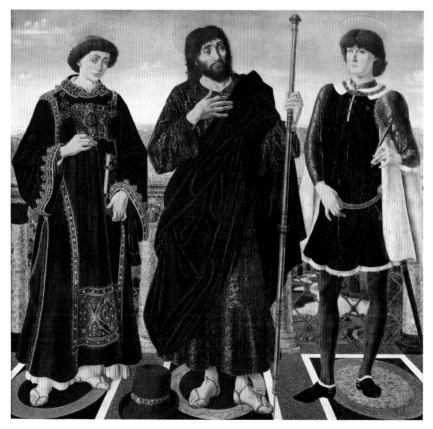

commissioned by Piero de' Medici in 1460, are now lost, two tiny panels (*Hercules and the Hydra* and *Hercules and Antaeus*, now in the Uffizi) are evidence of the innovations he brought to the language of painting. They show the effort Antonio made to express the movement of the bodies and the importance he attached to it. The bodies strain against the background of an infinite landscape, its bird's eye vantage point perhaps betraying a familiarity with contemporary Flemish painting. In this fairytale world of the Humanist Renaissance, which, largely fomented by Lorenzo de' Medici, sought to revive the world of the ancient myths through classical thought and letters, the representation of the human nude was emphasized as an expression of strength and movement—let us not forget Antonio's *Rape of Deianira* (Yale University Art Gallery, New Haven, Conn.). In his *Battle of the Nudes* (Metropolitan Museum, New York), Antonio Pollaiuolo expresses this perfectly, to the point that the engraving seems almost a manifesto of the new expressive aspirations of painting and sculpture. The same can be said of his bronze of *Hercules and Antaeus* (Bargello National Museum), made for the Medici. Yet this new departure was not limited to secular work. Even in religious works such as the *Altarpiece of SS. Vincent, James, and Eustace*, which he painted for the chapel of the Cardinal of Portugal in S. Miniato al Monte (now in the

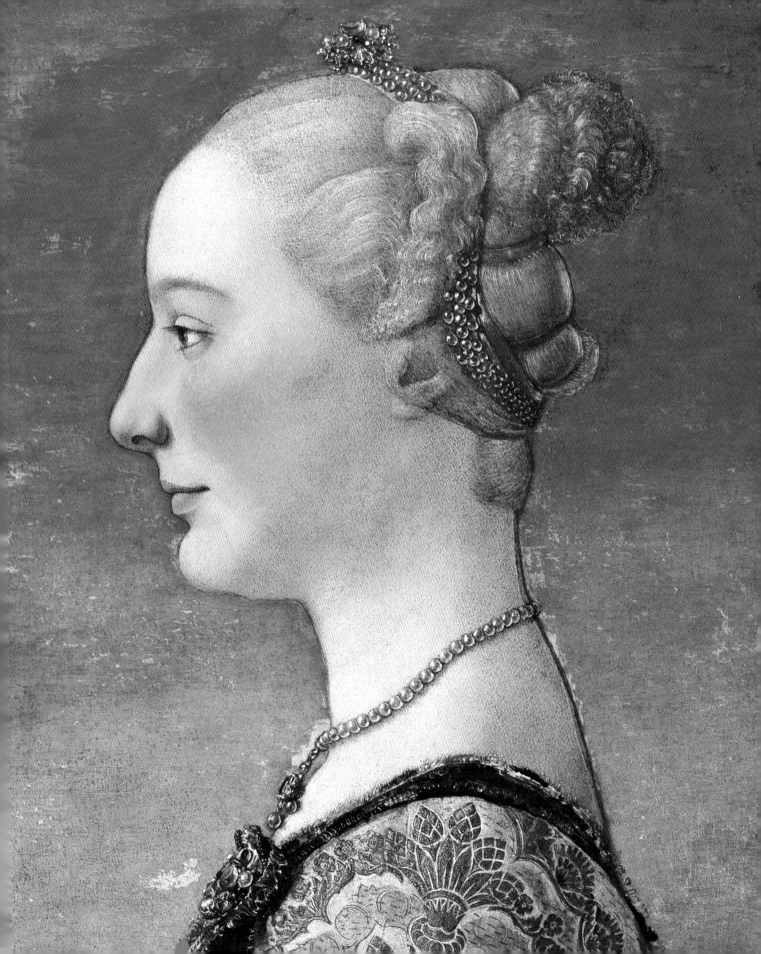

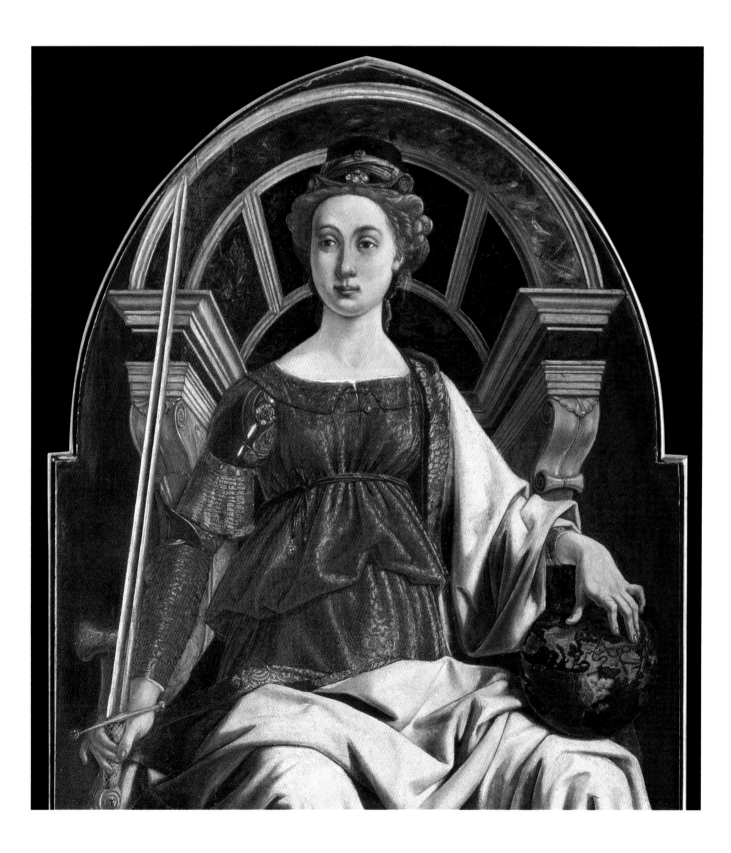

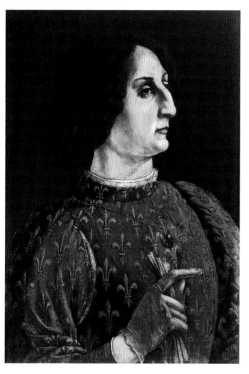

said of Verrocchio's rare paintings. They, as well as his superb drawings, illustrate the impact he would have on the younger generation of artists who frequented his workshop: Leonardo, Lorenzo di Credi, and Perugino, as well as the influence they had not only on Ghirlandaio and Botticelli, but also on the wider, national stage. It should not be forgotten that he produced his masterpiece, the equestrian monument to Bartolommeo Colleoni, for the Venetian Republic. Verrocchio's few surviving paintings are seminal works, starting with the *Baptism of Christ* that he painted for San Salvi (now in the Uffizi), on which the young Leonardo first tried his hand and with whose predella Lorenzo di Credi and Perugino probably collaborated, and ending with his *Madonna and Child* (Berlin, Gemäldegalerie) in which he created a new thematic type. Verrocchio's personality is expressed powerfully and with a certain roughness in the way his plastic forms seem to insist on their origins in

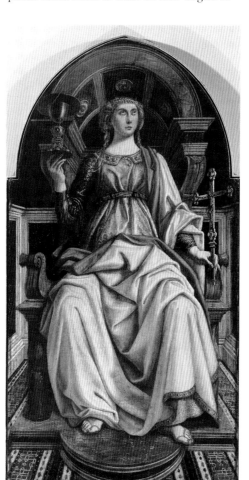

Uffizi), and the marvelous *Martyrdom of St. Sebastian*, painted for the Pucci Chapel in Santissima Annunziata (London, National Gallery), Antonio never missed a chance to leave behind the iconography of the past and imbue his compositions with movement and dynamism. Moving from the model of Masaccio and Paolo Uccello, and followed by his brother Piero—whose *Portrait of Galeazzo Maria Sforza* and *Portrait of a Young Woman* (Uffizi), bear mention—Antonio created a new, mainly feminine type of portrait, of which the *Portrait of a Girl* in the Museo Poldi Pezzoli, Milan, is a prime example, which developed from Baldovinetti's work in the same field.

A similar if not even stronger influence was exercised in the field of sculpture by another eminent artist, Andrea del Verrocchio (1435–88). Highly esteemed by the Medici, Verrocchio achieved renown for his youthful *David* (Museo Nazionale del Bargello), which he cast for the family, and his famous *Putto with Dolphin*, intended as the centerpiece of a fountain at the Medici villa at Careggi, but later moved to the courtyard of the Palazzo Vecchio on the wishes of Cosimo I de' Medici. In these works the influence of the classical world instills the figures with a new vitality—the surfaces are polished and taut with a dynamism that while repressed is only skin deep. The same can be

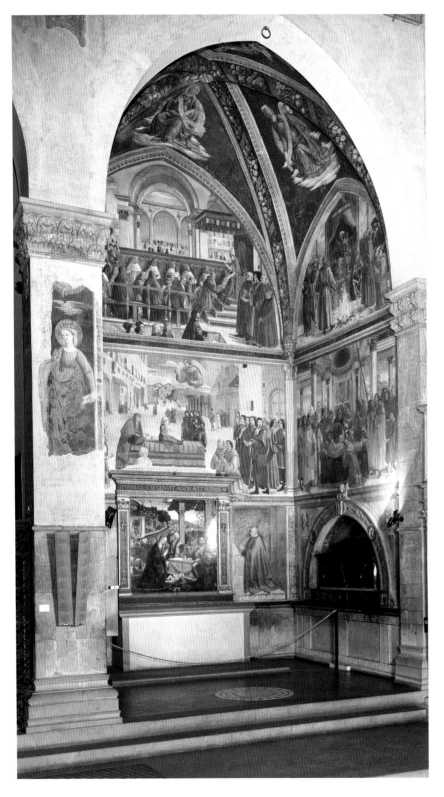

metallic surfaces—the counterpart in painting to his work in bronze, they seem to point back to Andrea del Castagno.

Despite the fact that Verrocchio's workshop was a crucial step on the way to the future of Florentine art (Leonardo), the more traditional path of wall decoration leading back to Masaccio and Fra Angelico would also re-emerge as a collective enterprise. At the same time, this was a sign of the times, for the frescoes were painted not in Florence but in Rome. Indeed, the Eternal City was fast becoming the second pole of Renaissance art, and would eventually surpass even Florence, once the Church supplanted the Medici as the main patrons of the arts in central Italy. In this respect, the decoration of the Sistine Chapel is the most important event in the history of mural painting in the second half of the 15th century. What the Basilica of St. Francis in Assisi was for the 13th and 14th centuries, the Sistine Chapel became for the 15th century. Constructed by Pope Sixtus IV, the chapel became a focus in which generations of painters encountered each other and the greatest figures of the time came to work: from Domenico Ghirlandaio to Pietro Perugino, and from Sandro Botticelli to Luca Signorelli and Cosimo Rosselli.

Domenico Bigordi (1449–94), called Ghirlandaio (the garland maker) after his father's occupation, was not only the most skillful fresco painter of his time and the owner of a Florentine workshop deluged by commissions for portraits, altarpieces, and entire chapels, but also the heir to a grand tradition in mural painting going back to Giotto, revived in a new and monumental style by Masaccio. Even though in terms that were already diverse—including the influence of Flemish painting, which had become familiar in Florence through Rogier van der Weyden, Hans Memling, and Hugo van der Goes—and which suggested new ways of representing landscape in space, as well as new narrative and descriptive passages that go far beyond Masaccio's concision, Ghirlandaio succeeded in maintaining his own tone of monumentality softened by a fluidity of line, which underlies the later innovations of Pollaiuolo and Botticelli. Ghirlandaio's career was punctuated with commissions from important patrons, whose family chapels he decorated (the Vespucci Chapel in Ognissanti, the Sassetti Chapel in Sta. Trinità), reaching its height with the decoration of the Cappella di Sta. Fina in San Gimignano Cathedral and the Sistine frescoes. Returning to Florence in 1482, he and his workshop produced a series of altarpieces and frescoes. The most celebrated of these were for

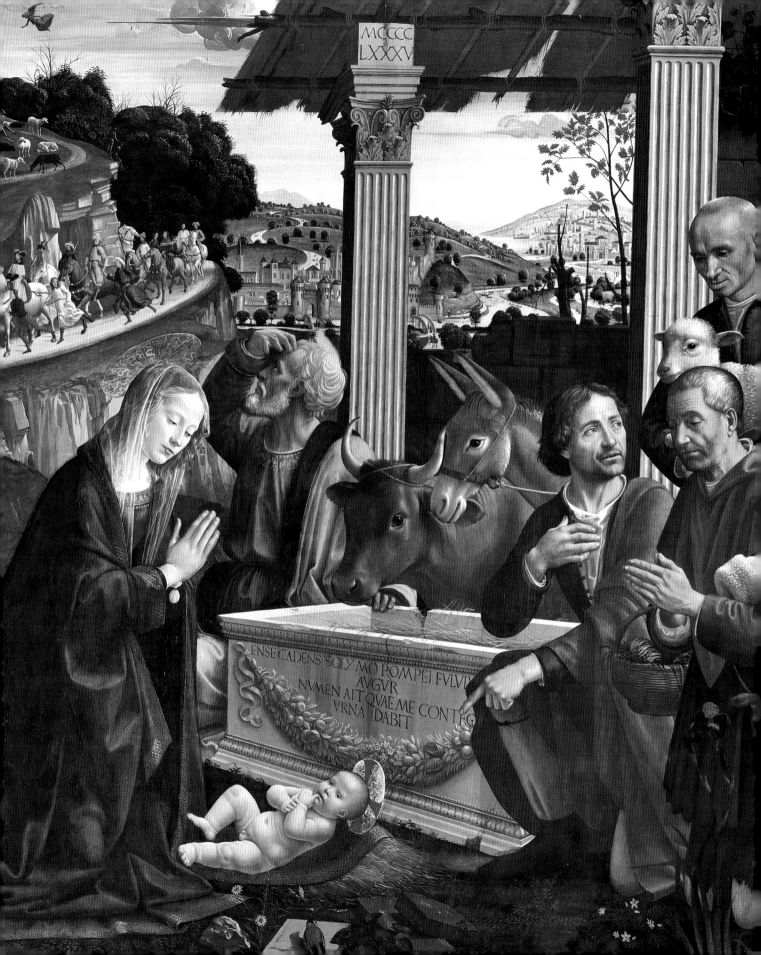

MCCCC
LXXXV

ENSE CADENS SOLYMO POMPEI FVLVI·
AVGVR
NVMEN AIT QVAE ME CONTEG·
VRNA DABIT

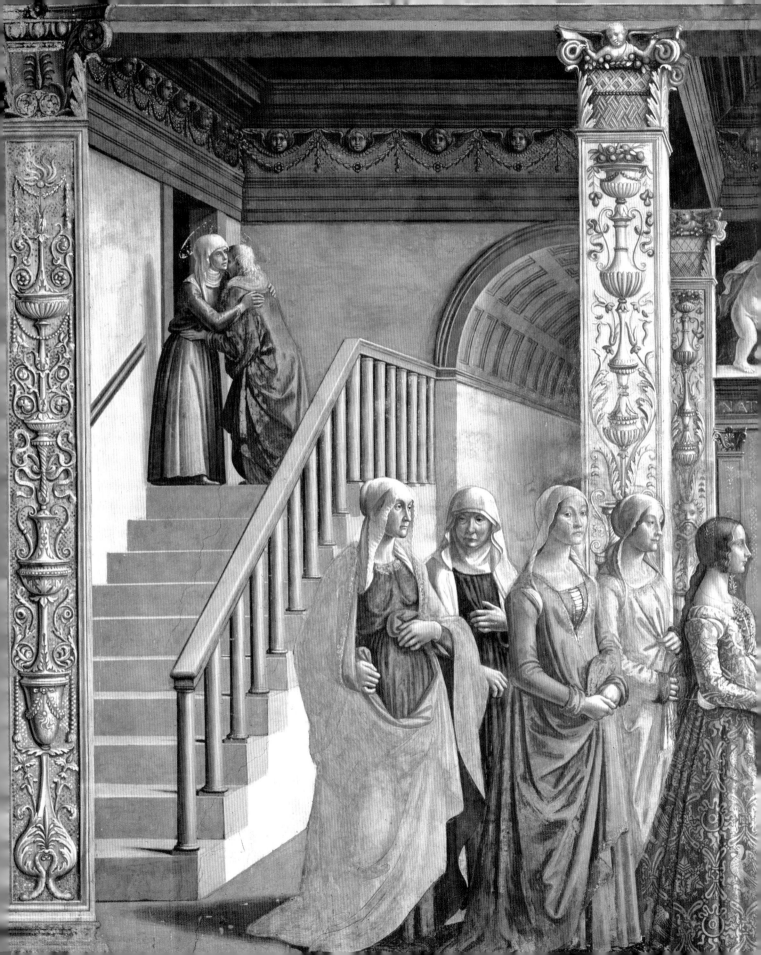

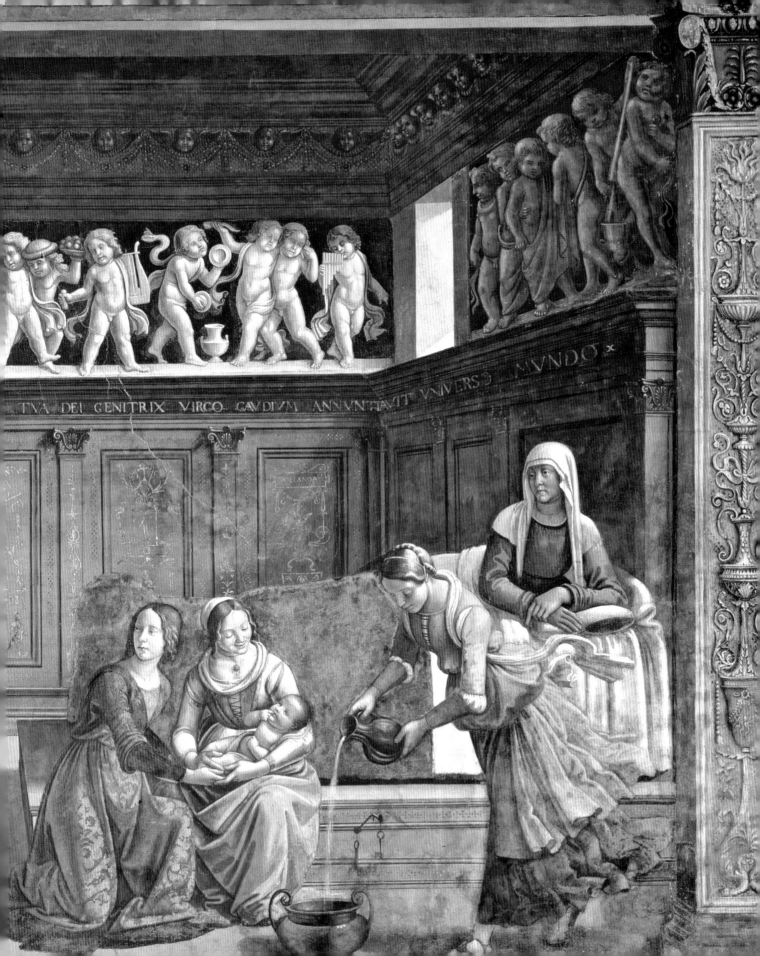

TVA DEI GENITRIX VIRGO GAVDIVM ANNVNTIAVIT VNIVERSO MVNDO

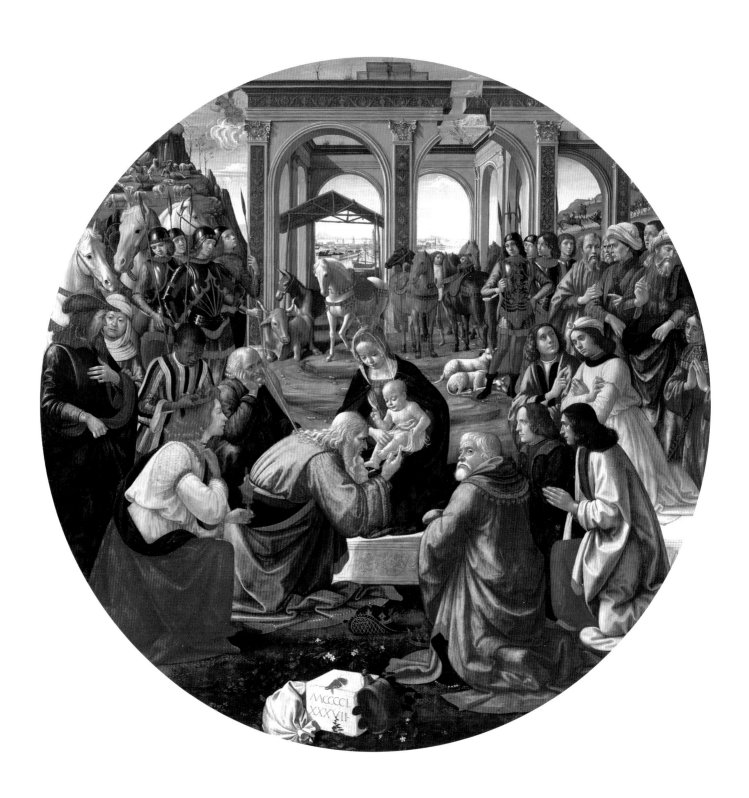

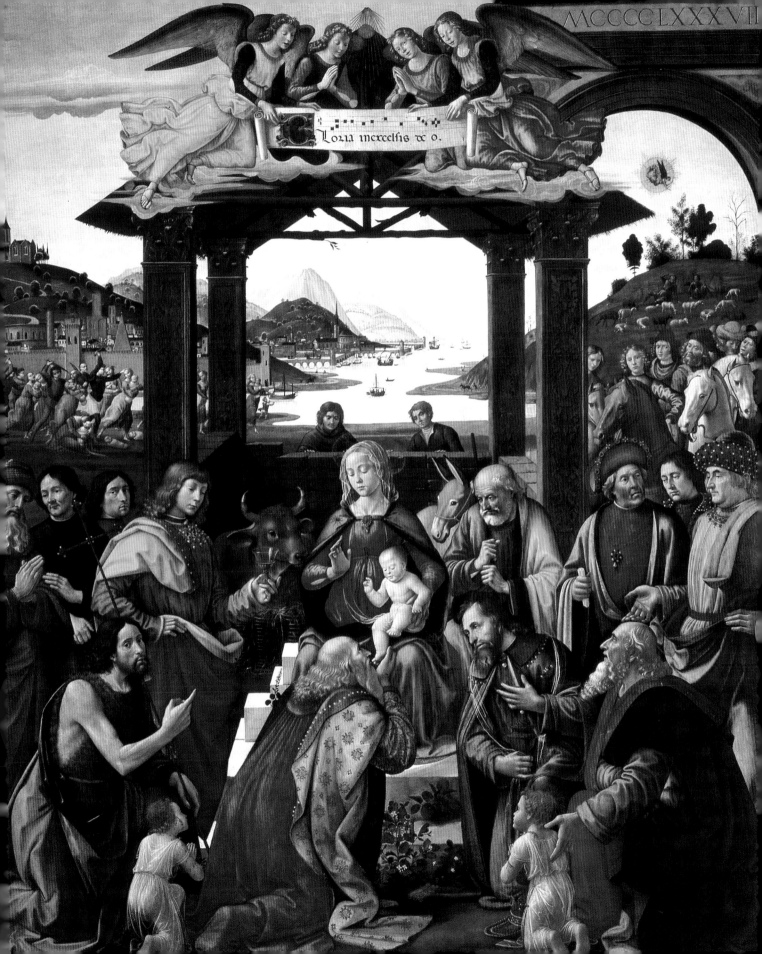

MCCCCLXXXVII

Loria mexcelfis ℈ o.

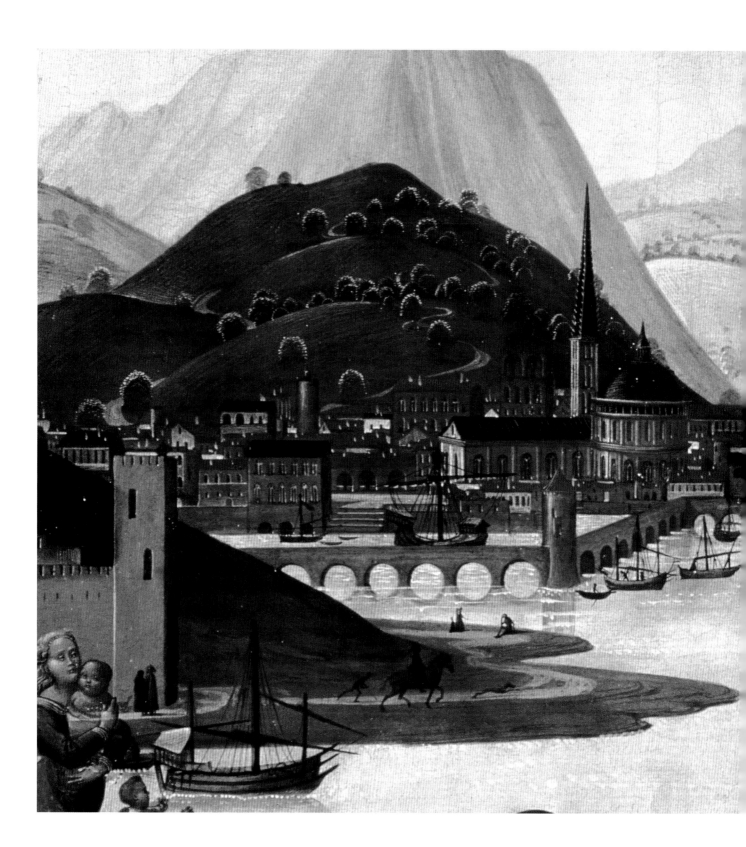

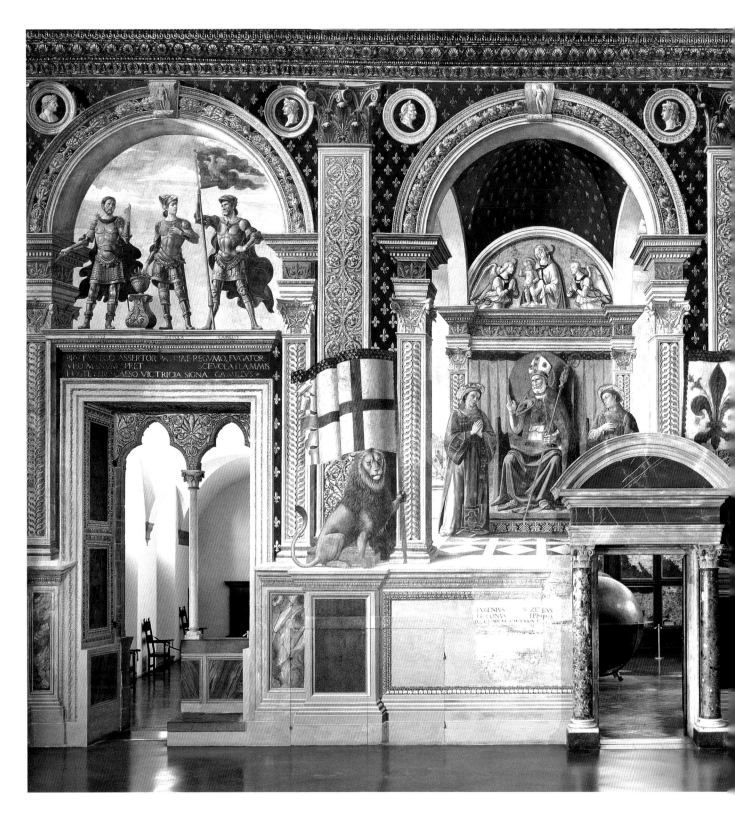

the Sala dei Gigli in the Palazzo Vecchio (with his brother Davide) and the choir of Sta. Maria Novella, for which he also designed a two-leaf, multicompartmental altarpiece for Lorenzo and Giovanna Tornabuoni, most of which was executed by his assistants. It was broken up in the 18th century and the pieces are now in various museums. He painted a splendid portrait of Giovanna Tornabuoni (Madrid, Thyssen-Bornemisza collection), a masterpiece of iconography and a *summa* of the intellectual and social aspirations of the Medici circles. Other famous works by Ghirlandaio include his *Last Suppers* (San Marco and Ognissanti), which opened the way to the *Last Suppers* of the following century. Vasari's comment seems appropriate: "...who for the excellence, size and multitude of his works deserves to be considered one of the best masters of his age...".

Alessandro Filipepi, called Sandro Botticelli (1445–1510), is the most complex and sophisticated character on the Florentine painting scene in the 1460s. Botticelli trained with Filippo Lippi from whom derives the mobile, musical line seen in some of the Prato frescoes, as well as in other works of his maturity such as the *Pitti Tondo*. At the same time, however, he was not left untouched by Verrocchio, seen in a series of *Virgin and Child*, in which motifs from both Lippi and Verrocchio can be found—albeit in a new, complex form—as well as in other paintings, such as the two small panels of *Judith Leaving the Tent of Holofernes* and *The Discovery of the Murder of Holofernes* (c. 1470) in which the relationship between the figures and the landscape (the latter still retaining a certain naturalism that would shortly disappear) also recalls Pollaiuolo. The freshness, the elegance, the brilliant inventiveness of these early works could not escape the attention of the Medici and their circle, as can be seen from the presence of SS. Cosma and Damian, the Medici family's patron saints, in the Sant'Ambrogio altarpiece, the earliest *Virgin and Child Enthroned with Saints* known from his hand (c. 1470, Uffizi) and the *Nativity* for the Cappella Del Lama in Sta. Maria Novella (Uffizi), which is a little later. Here the presence of Medici family portraits—from Cosimo the Elder to Piero and Giovanni, Lorenzo and Giuliano, and their friends and relations—speaks eloquently not only of Botticelli's ties to the powerful dynasty, but also of his skill as a portrait painter. Indeed, he created a new type of portrait, as can be seen in the posthumous portrait of *Giuliano de' Medici* (Washington, National Gallery) and his *Portrait of a Man with a Medal of Cosimo the Elder* (c. 1475, Uffizi). The naturalism still evident in these works would gradually give way to what we now regard as Botticelli's pure

On the previous pages:

Pages 278–279
Domenico Ghirlandaio, *Adoration of the Magi*, 1487. Uffizi. This tondo seems to show the influence of similar works by Botticelli.

Domenico Ghirlandaio, *Adoration of the Magi*, 1488, tempera on panel. Ospedale degli Innocenti. Perhaps Ghirlandaio's most famous painting of this subject.

Pages 280–281
Domenico Ghirlandaio, *Adoration of the Magi*, detail. Ospedale degli Innocenti. In this artist's work landscape always plays an important role, through the influence of Flemish painting.

Domenico Ghirlandaio, Sala dei Gigli. Palazzo Vecchio. The structure of the perspective used in this fresco from c. 1482–84 is impressive.

On the following pages:
Domenico Ghirlandaio, *The Last Supper*, 1480. Ognissanti. The narrative character of Ghirlandaio's work is clearly brought out in this fresco.

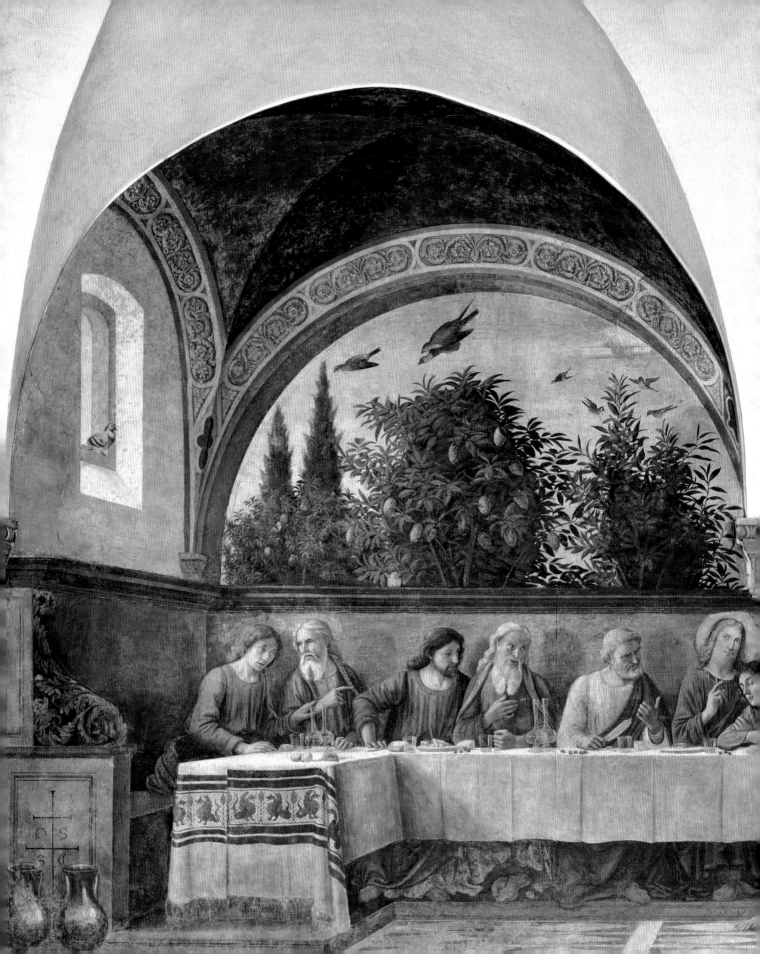

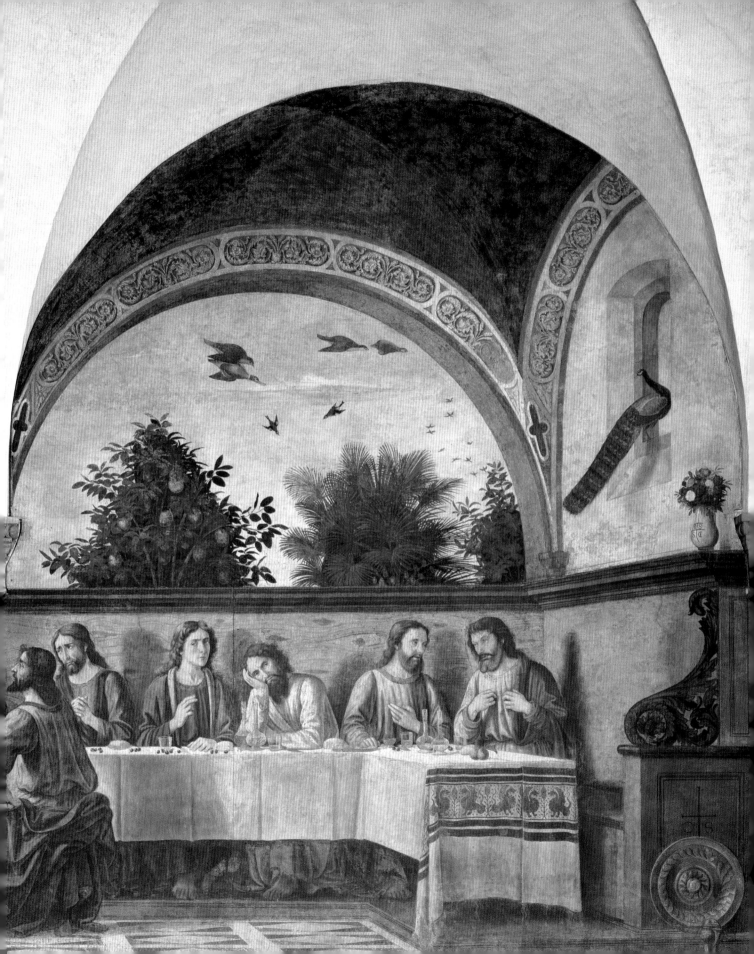

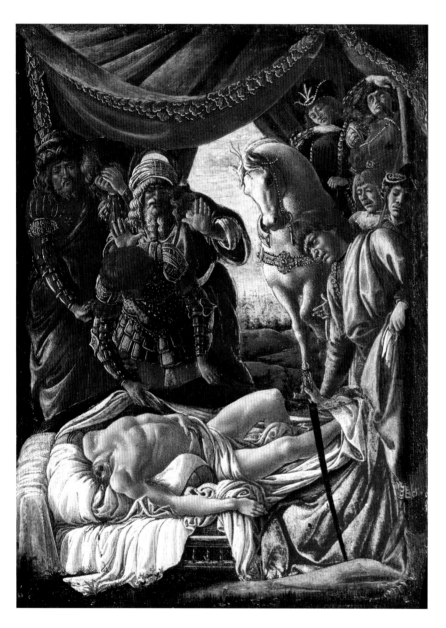

Sandro Botticelli, *Discovery of the Murder of Holofernes*, c. 1469–70, tempera on panel. Uffizi.
This youthful work is already full of typical Botticelli stylistic elements.

Opposite:
Sandro Botticelli, *Judith*, c. 1469–70, Uffizi. The origins of this little gem-like panel are still a mystery.

style, the inexpressible grace, almost musical elegance, and decorative subtlety that embody the quintessence of the Florentine renaissance.

Inspired by the voluptuous ambience in the Medici palace on Via Larga and the villa at Careggi, Botticelli became the "painter of the lyricizing, new, allegorical mythologies" (André Chastel), although the inspiration he drew from his surroundings was sophisticated and unlike that of Mantegna. Thus were born the masterpieces of Botticelli's core years, which he spent in the shadow of Lorenzo the Magnificent

and his circle, works that seem to be pictorial transpositions of Angelo Poliziano's *Stanze* and Lorenzo's own verses. These are the great works he painted for Lorenzo di Pierfrancesco de' Medici, the cousin of the Magnificent, now in the Uffizi but then in the Medici palace or in the Villa di Castello: *Primavera* (c. 1478–80), in which the dancing figures of Flora and the Three Graces, Zephyrus in pursuit of Cloris, Venus, Cupid, and Mercury brush the surface of the glorious flowering meadow; *Pallas and the Centaur* (c. 1482), a Medician allegory (Minerva's robes are decorated with three interlocking rings, one of the Medici symbols) of Reason prevailing over Instinct; and the *Birth of Venus* (c. 1484), which is virtually an illustration of the same episode, as told by Poliziano in his *Stanzas Begun for the Tournament of the Magnificent Giuliano de' Medici*. In this imaginary scene a sea breeze ruffles the robes of the approaching Hour, one of Venus's attendants, and of Zephyrus and Aura on the left. Most importantly, it catches and twirls the flowing, gold-flecked hair of the goddess, who rises from a huge shell. At the same time, Botticelli created unequaled religious paintings such as the *Madonna del Magnificat* (c. 1481–85) and the *Madonna of the Pomegranate* (1487), both sophisticated, wholly new compositions that would inspire Raphael to paint his *Madonna of the Chair*; the *Annunciation* of 1489; the great S. Marco altarpiece the *Coronation of the Virgin* (c. 1490), and other altarpieces, all now in the Uffizi.

Botticelli's fame was now such that he was compared to Apelles, the legendary Greek painter who had achieved perfection in imitating real likeness and whose *Calumny*, well-known from the sources, Botticelli recreated in his 1495 panel, a work André Chastel described as a "stupendous 'literary' representation." While in his two frescoes of biblical stories in the Sistine Chapel (1482) his composition—but not his drawing or rich coloring—seems a little out of control, perhaps because of the sheer dimensions of the work, as the century ended he tended toward a mystical abstraction that would take him into the new century with works such as the *Mystical Nativity* (1500, London, National Gallery). Although deeply poetic, because of their programmatic intent (which followed the guidelines of Girolamo Savonarola) these works tend to lack stylistic innovation.

A complex yet simple man by nature, it was natural that Botticelli should find acclaim in the artistic field and the society of his time. His elegant, articulate language, his tapered, weightless figures, his abstract color sense, and harmonious lines, all of which embodied the

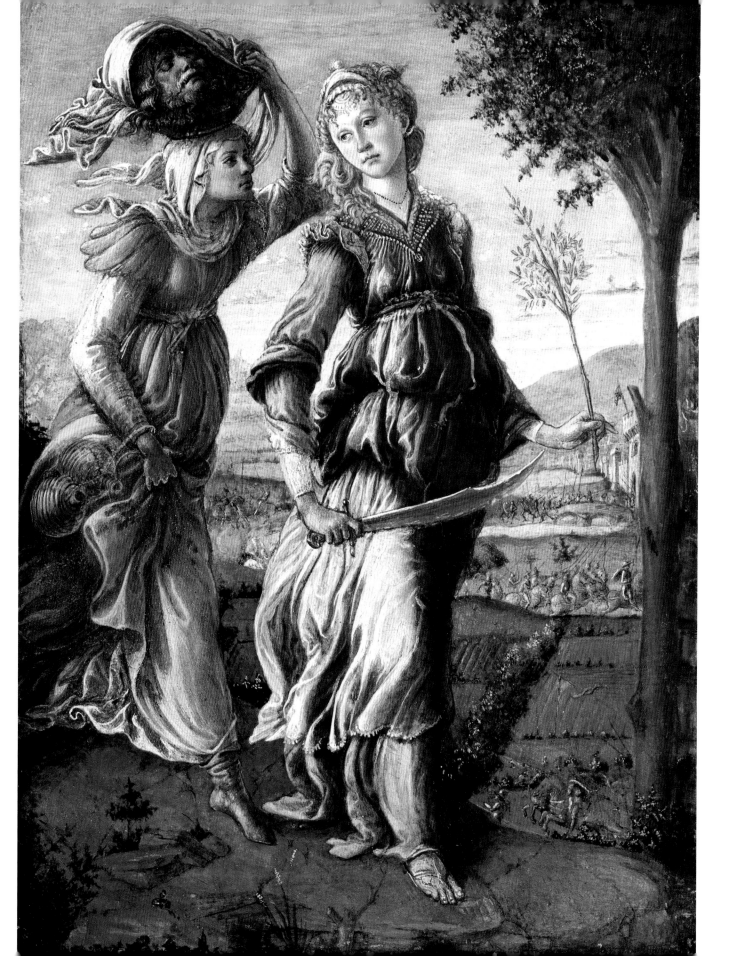

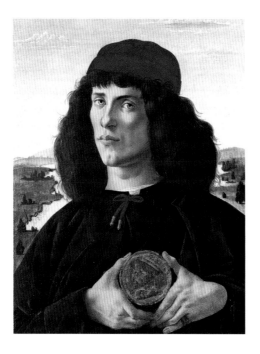

Sandro Botticelli, *Portrait of a Man with
a Medal of Cosimo the Elder*, c. 1475.
Uffizi. The influence of Antonio del
Pollaiuolo and the Flemish painters is
evident in Botticelli's use of landscape
as a background.

Sandro Botticelli, *Annunciation*, c. 1481.
Uffizi gallery.

aesthetic ideals of his time, so open to
references to the classical world, found
immediate echoes in many minor figures who
tried to meet the demands of a rich class
seeking to emulate the taste of the dominant
families of Florence during the second half of
the century, starting with the Medici. There
emerged a taste for narrative representation free
of dramatic intent, but suffused with idyllic
overtones, in which the influence of Botticelli
merges with that of Ghirlandaio. Examples of
this are the works of Jacopo del Sellaio
(c. 1441–93), as skilled in the composition of
religious paintings in traditional Florentine
tondi as he was in decorating trousseau chests
with scenes from classical history or mythology;
of Francesco Botticini (1446–98), which were
mainly intended for private devotion, but also
as chapel altars, for instance, his *Three
Archangels* (Uffizi), and whose agile drawing
betrays a familiarity with Pollaiuolo and
Verrocchio; of Apollonio di Giovanni (1415–65),
who specialized in decorating chests; of
Raffaellino del Garbo (1466–1524), who carried
the graceful line of Botticelli and Filippino Lippi
into the 16th century; of the prolific Neri di
Bicci (1419–91), who succeeded in reconciling
rich International Gothic taste with a rational
sense of form and space; and of his pupil
Cosimo Rosselli (1439–1507), a painter of lively
frescoes of contemporary history as well as of
tondi and altarpieces that almost seem to
announce a new style, one replete with
naturalistic elements, like that of Fra
Bartolomeo. Yet the follower closest to the
spirit of Botticelli's art was Filippino Lippi
(c. 1457–1504), the son of Filippo Lippi, whom
Bernard Berenson, early in his career and at
a time when he was still developing, dubbed
"Friend of Sandro." Indeed, Filippino's first
works, such as the *Adoration of the Magi*
(London, National Gallery), bear the mark of
the master with whom he trained, albeit with

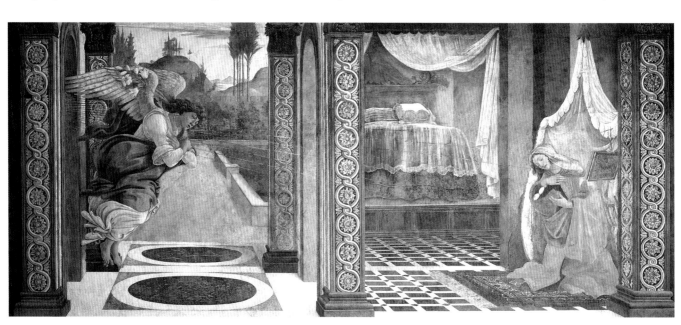

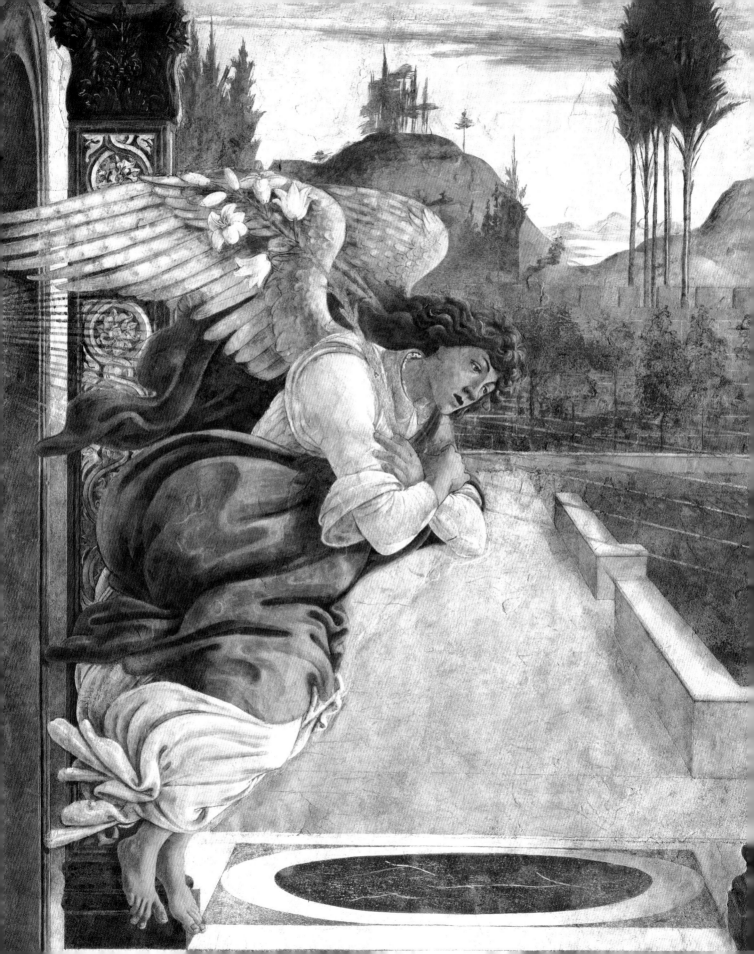

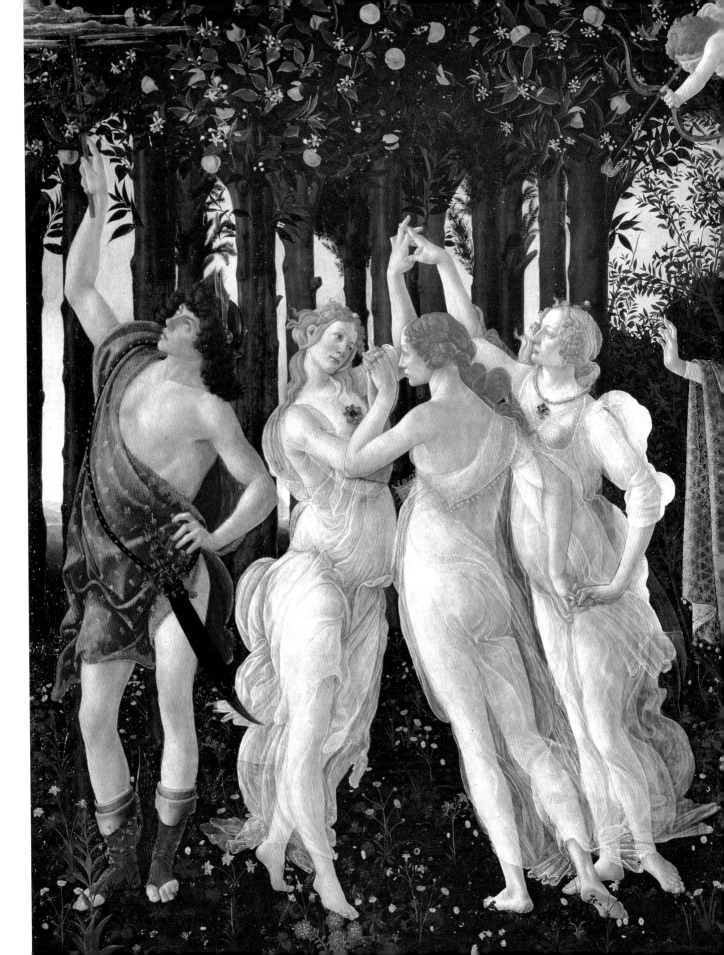

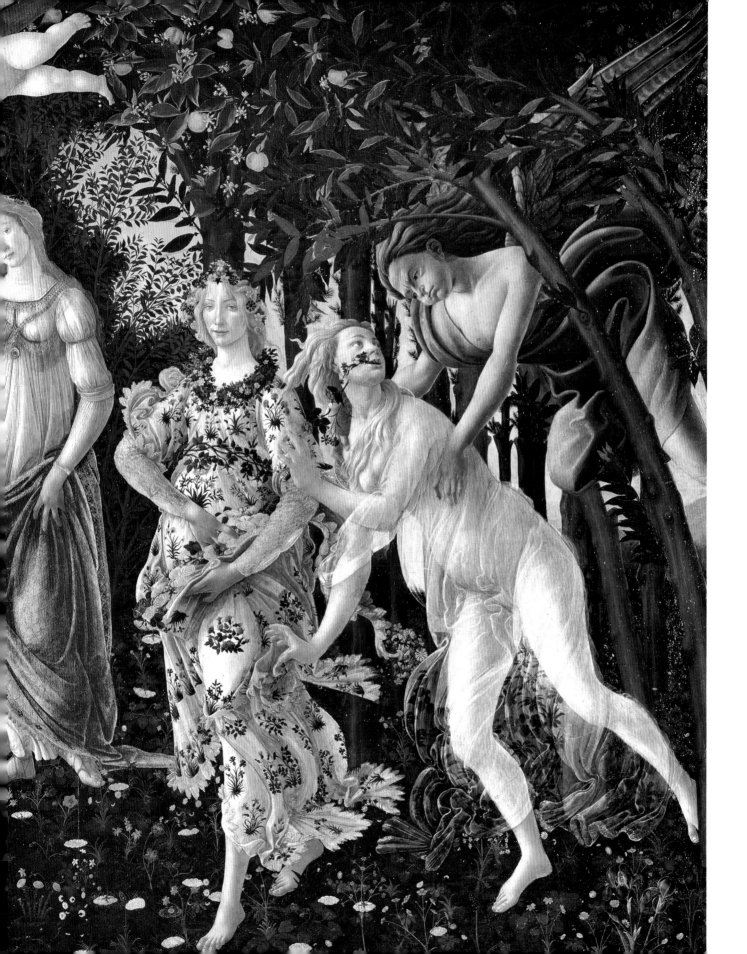

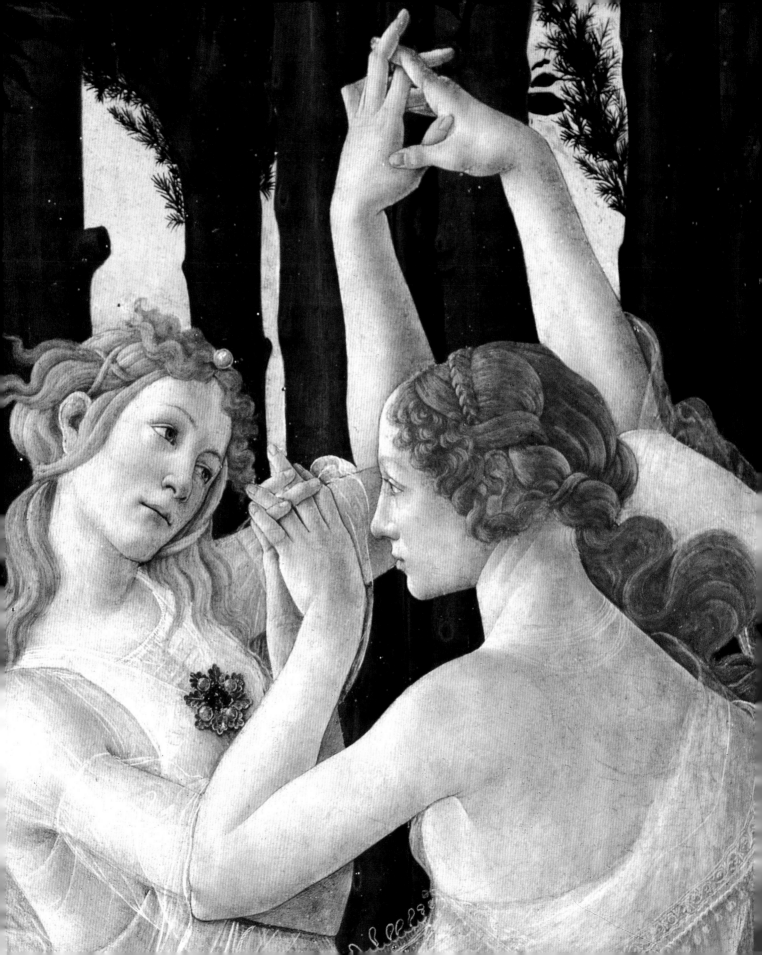

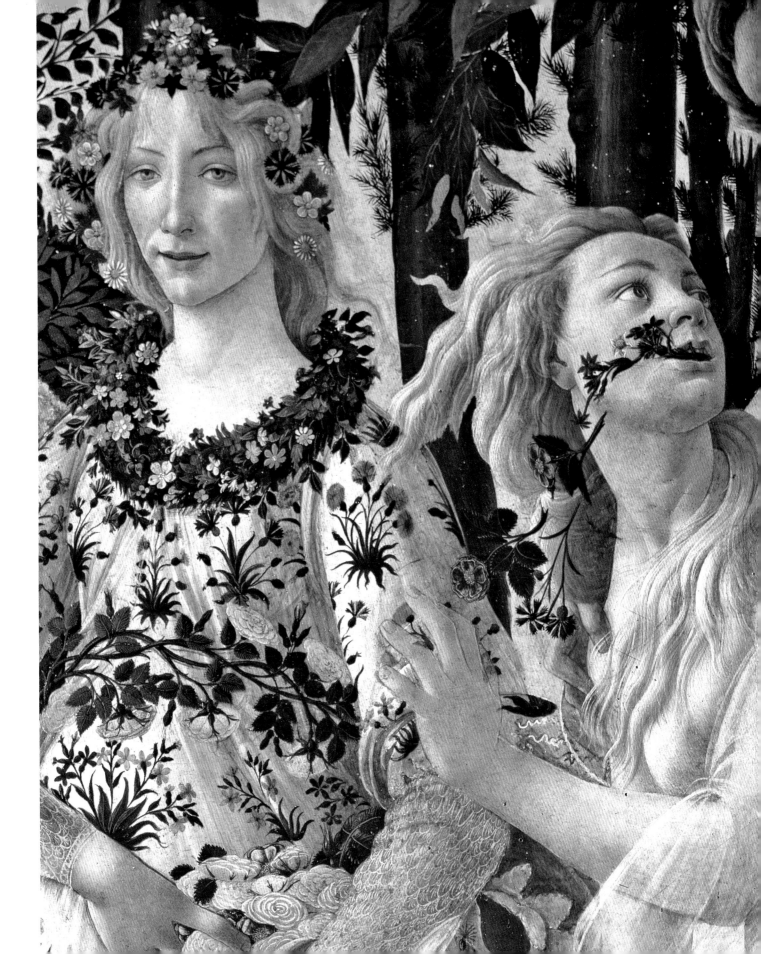

On the previous pages:
Sandro Botticelli, *Primavera*,
tempera on panel. Uffizi.
The masterpiece of Botticelli's
maturity; painted for Lorenzo
di Pier Francesco de' Medici
c. 1482.

Sandro Botticelli, *Primavera*,
details. Uffizi. These two details
reveal the work's extraordinary,
ineffable elegance.

Sandro Botticelli, *Pallas and the
Centaur*, c. 1485, tempera on
panel. Uffizi.
Originally painted for the
Medici, as the symbol of the
three interlocking rings on
Minerva's robe shows. This is
not an easy work to interpret.

Opposite:
Sandro Botticelli, *Madonna del
Magnificat*, c. 1482, tempera on
panel. Uffizi. The most perfect
version of this subject in tondo
form before Raphael's *Madonna
of the Chair.*

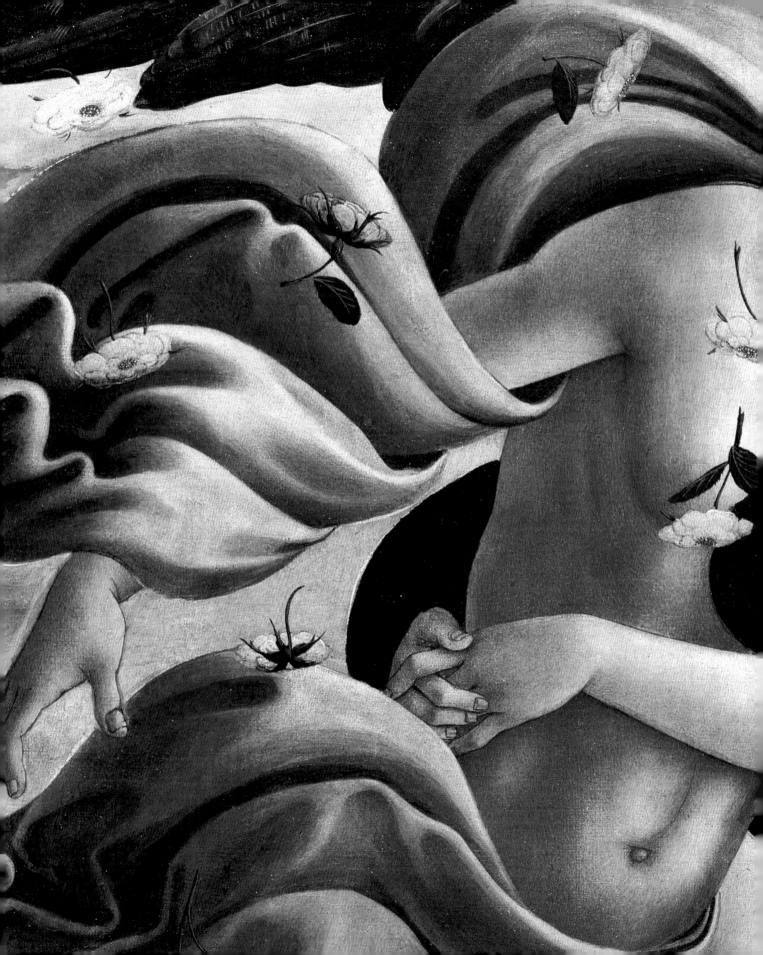

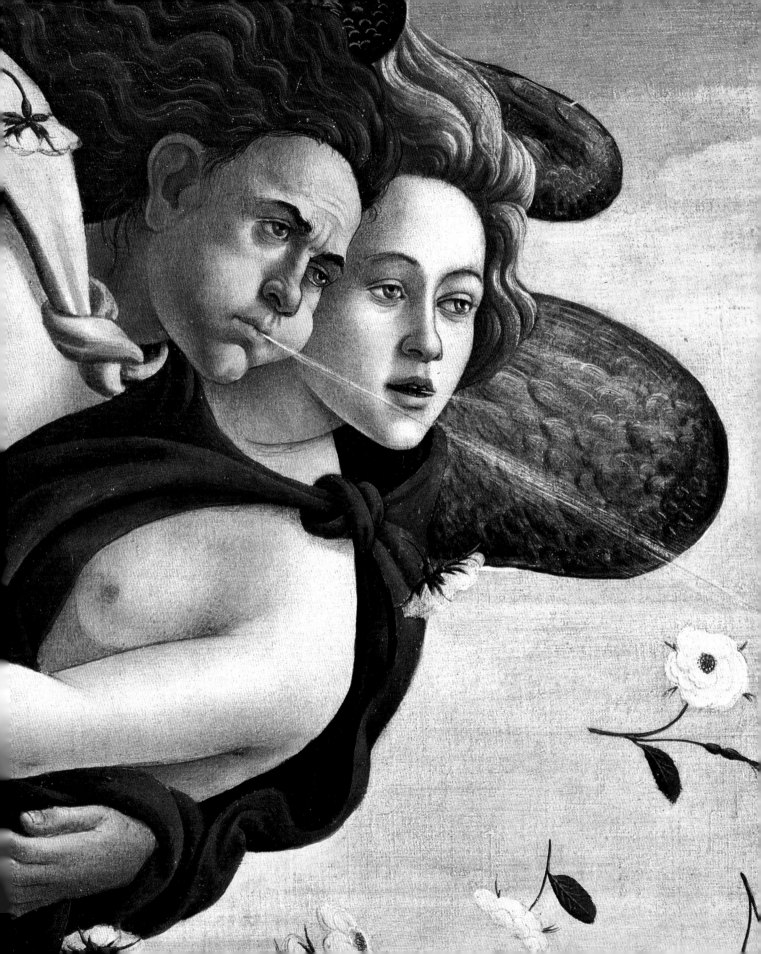

an attention to landscape that obviously comes from his father. Filippino very early demonstrated his mastery of fresco technique, so much so that in about 1484 he was invited to complete Masolino and Masaccio's commission in the Brancacci Chapel in Sta. Maria del Carmine. It was a happy choice, for the young artist adapted his own style to that of the earlier masters, thus bringing the older and newer parts of the work together in a felicitous fusion. Nonetheless, his fertile imagination and lyric sense, which also encompassed landscape, were to come to fruition in works that were completely his own, such as his *Three Scenes from the Story of Virginia* (Palazzo Pitti and the Louvre) and *Three Scenes from the Story of Esther* (in various museums), originally intended as decorations for chests; youthful works such as the *Corsini Tondo* (Florence, Cassa di Risparmio); and especially the *Vision of St. Bernard* in Badia Fiorentina, painted for Piero del Pugliese, in which there are echoes of contemporary Flemish painting. From this point on, Filippino's language emerges unambiguously in its own right with a degree of pathos that almost matches Piero di Cosimo's, but comes equally from his mobile, enveloping, almost tremulous line and from his color, which sometimes, when he is seeking a somber note to render a face veiled with melancholy, achieves a livid quality. These signs are found in the works of his first maturity, such as the *Rucellai Altarpiece* (c. 1484–85, London, National Gallery); the *Altarpiece of the Otto di Pratica* (1485–86, Uffizi); the *Altarpiece of Tanai de' Nerli* (Santo Spirito), and the *Christ and the Virgin Interceding for Humanity* (Munich, Alte Pinakothek). Yet the presence of Piero di Cosimo and especially the young Leonardo da Vinci was starting to upset the balance that had characterized his earlier works. The colloquial, descriptive sense of the former and the increasingly evident influence of Flemish descriptive realism are found in works such as the *Adoration of the Magi* (1496, Uffizi), painted to replace the unfinished work of the same title by Leonardo (Uffizi), the *Meeting of Joachim and Anna at the Golden Gate* (Copenhagen, Statens Museum for Kunst), the frescoes in the Carafa Chapel in Sta. Maria sopra Minerva, Rome (completed in 1493), and those in the Strozzi Chapel in Sta. Maria Novella (completed in 1502), in which Filippino's bizarre, proto-Mannerist talent for fantastic decoration departs from rationality and leaves the overlapping of real and painted space in pieces. Later Piero di Cosimo would take this approach to its ultimate conclusion. But the conversion to a modern stylistic language that points toward future

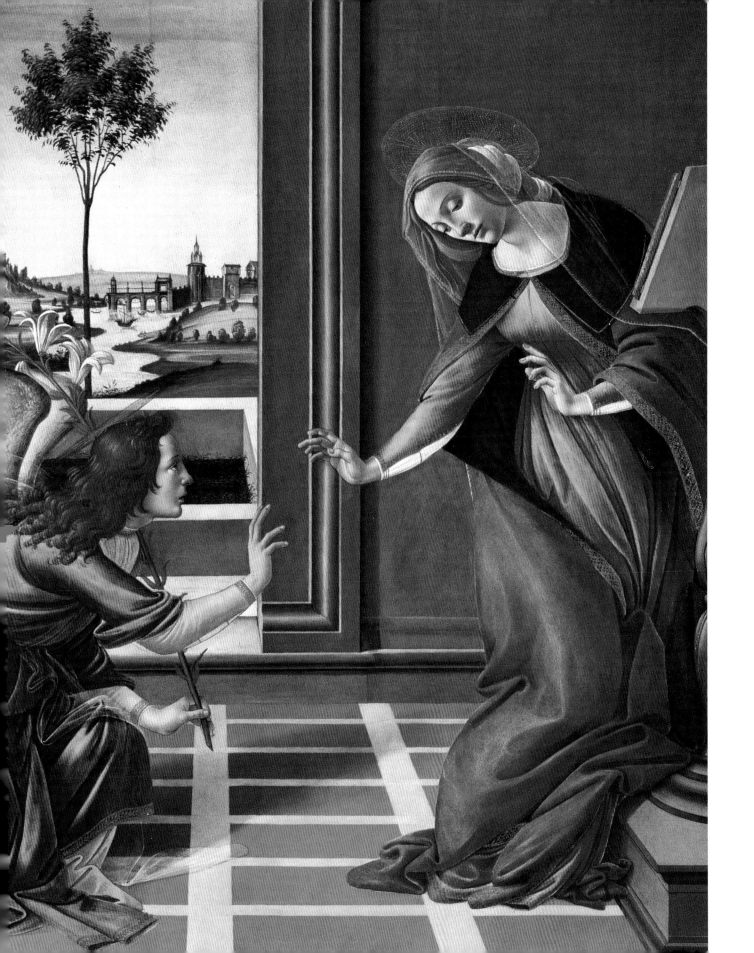

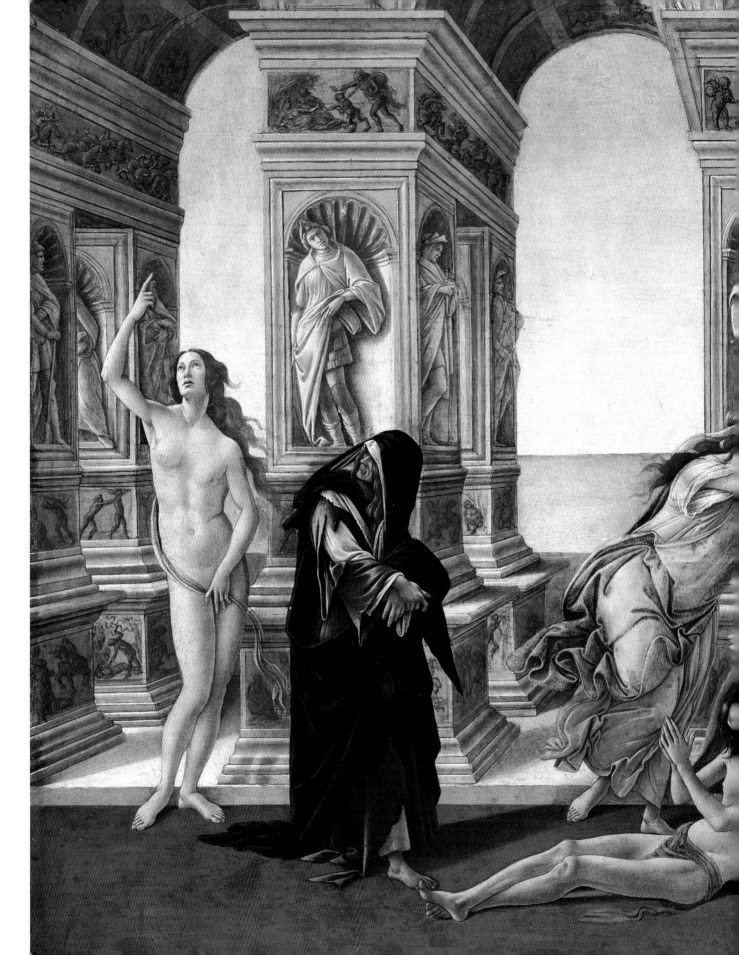

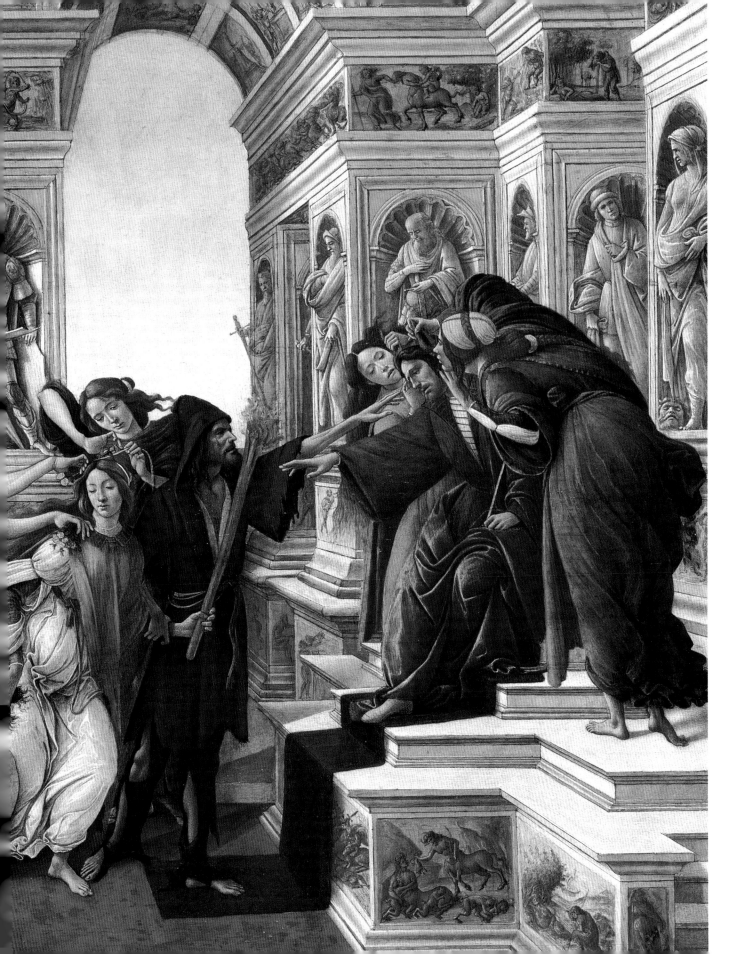

developments, took place in probably the most important workshop in Florence in the 1470s, that of Andrea del Verrocchio, whose skill not only as a sculptor, draftsman, and painter of commissions, but also as a goldsmith and decorative artist was appreciated by the Medici. It would be unthinkable not to mention the marvelous silver relief he made for the altar in the Baptistery. Andrea's workshop was the forge on which a new generation of young geniuses came into being, starting with Leonardo da Vinci, and Lorenzo di Credi and Perugino, all of whom were destined to change the direction of painting not only in Florence, but also in Rome and beyond.

Leonardo da Vinci (1452–1519) came straight from Verrocchio's studio, as can be seen in his early work before the break in 1482, when he moved to Milan. In his *Baptism of Christ* for S. Salvi (Uffizi), in which Andrea was assisted by the 18-year-old Leonardo, whose hand is clearly evident in the angel on the left and the landscape in the distance, both of which prefigure the formal canon that Leonardo would adopt as his own and that would come to the fore in his first solo work, the *Annunciation* commissioned by the monks of the monastery of Monte Oliveto (Uffizi). Here the two figures are placed in a humanized landscape that for Leonardo represents the summit of cosmic involvement in the human story.

The same can be said of the *Adoration of the Magi*, painted for S. Donato, Scopeto (Uffizi), but left unfinished when Leonardo went to Milan in 1481–82. In this work we can see the artist's intelligence playing with perspective in the background reminiscent of Paolo Uccello, but he leaves his figures brimming with emotion on a superhuman scale that announces the heroic style of Michelangelo. Leonardo's companion in Verrocchio's workshop was Lorenzo di Credi (c. 1459–1537), Andrea's faithful pupil and assistant, who may have been responsible for painting the lovely *Altarpiece with Virgin, St. John the Baptist, and St. Donatus* in Pistoia Cathedral from the cartoon by his master. Yet he too fell under the spell of Leonardo's genius and was profoundly influenced by him, in a neo-15th-century manner that is visible in the numerous versions of the *Nativity* and the *Virgin Adoring the Child* he painted, as well as his masterpiece, the *Annunciation* in the Uffizi. In the predella of the Pistoia altarpiece can be seen the hand of yet another of Verrocchio's pupils and assistants, Pietro Perugino (Città della Pieve, c. 1450– Fontignano 1523). During his frequent stays in the city, Perugino was an important figure in the artistic developments in Florence toward the end of the century. Following in the footsteps of

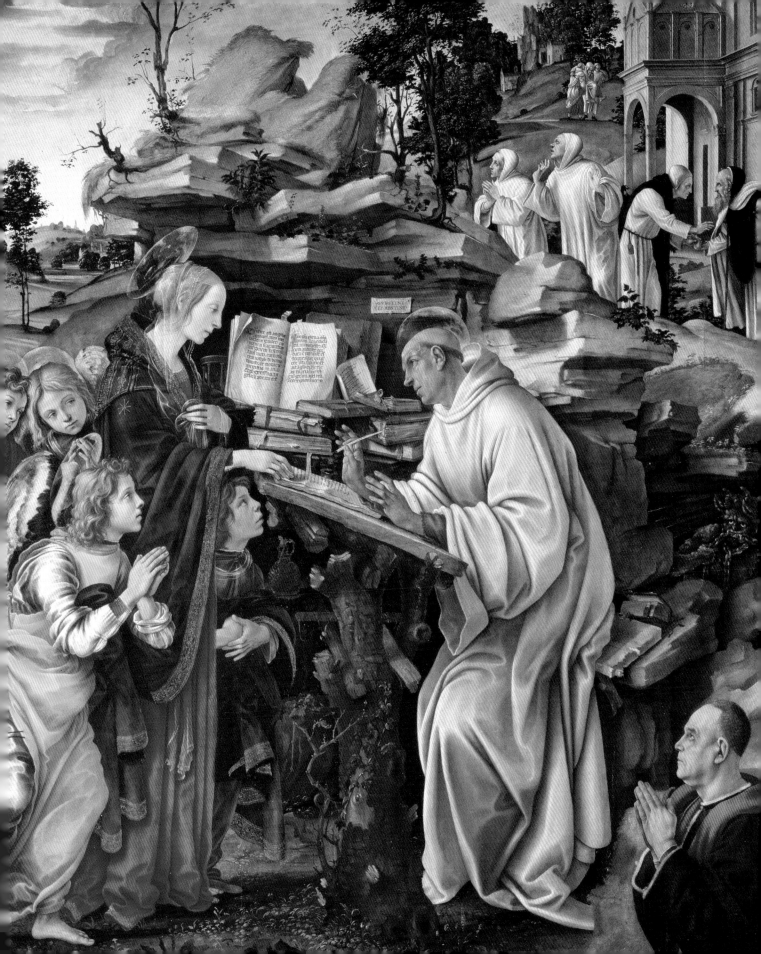

Domenico Veneziano and Piero della Francesca,
he introduced a way to render atmospheric light
and space that was a prelude to the classicism
of his pupil Raphael. While in Florence,
Perugino produced a number of frescoes, such
as that in the refectory of Sta. Maria Maddalena
dei Pazzi, and panels that demonstrate why his
"sweetness united in color," as Vasari described

his work, was so appreciated. The prime
example of this sweetness must be the
Deposition (Mourning the Dead Christ), which
he painted for the convent of Sta. Chiara in 1495
(Palazzo Pitti), in which Vasari admired the
sweep of the landscape, inspired by the
Umbrian countryside, the coloring, the human
quality of the facial expressions, and the

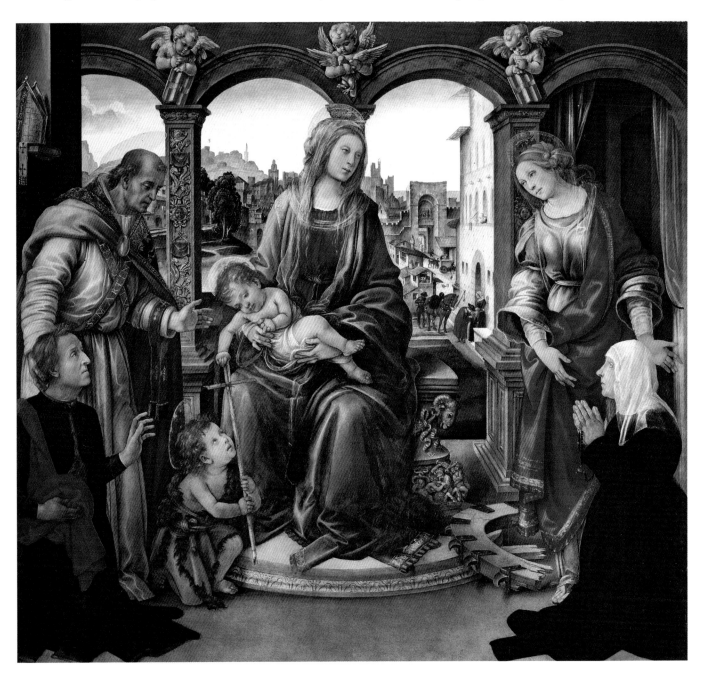

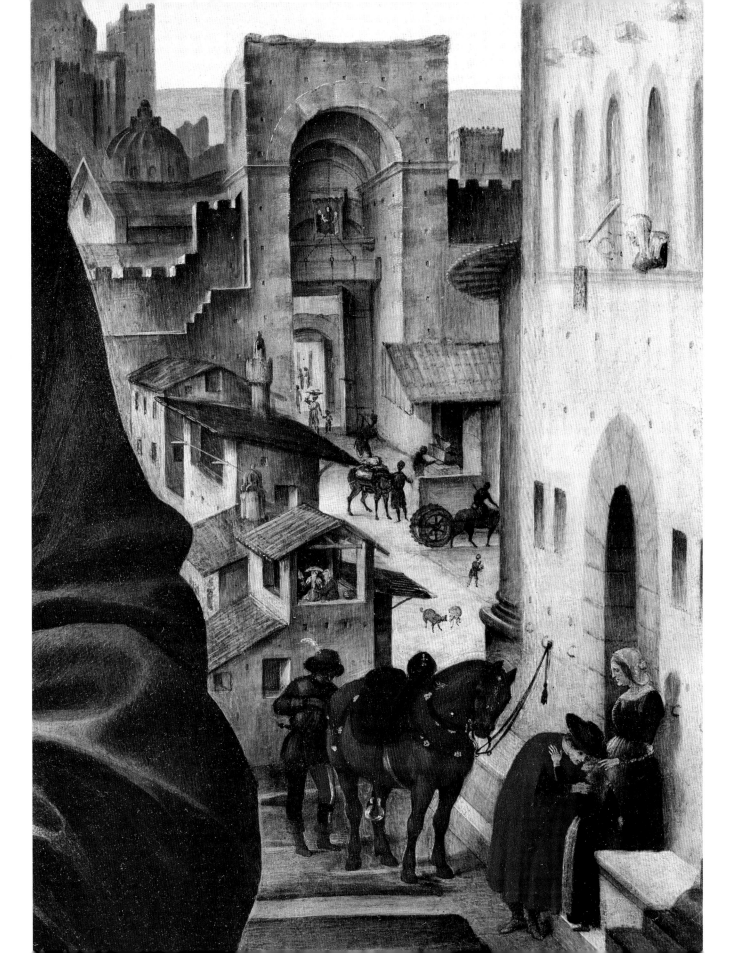

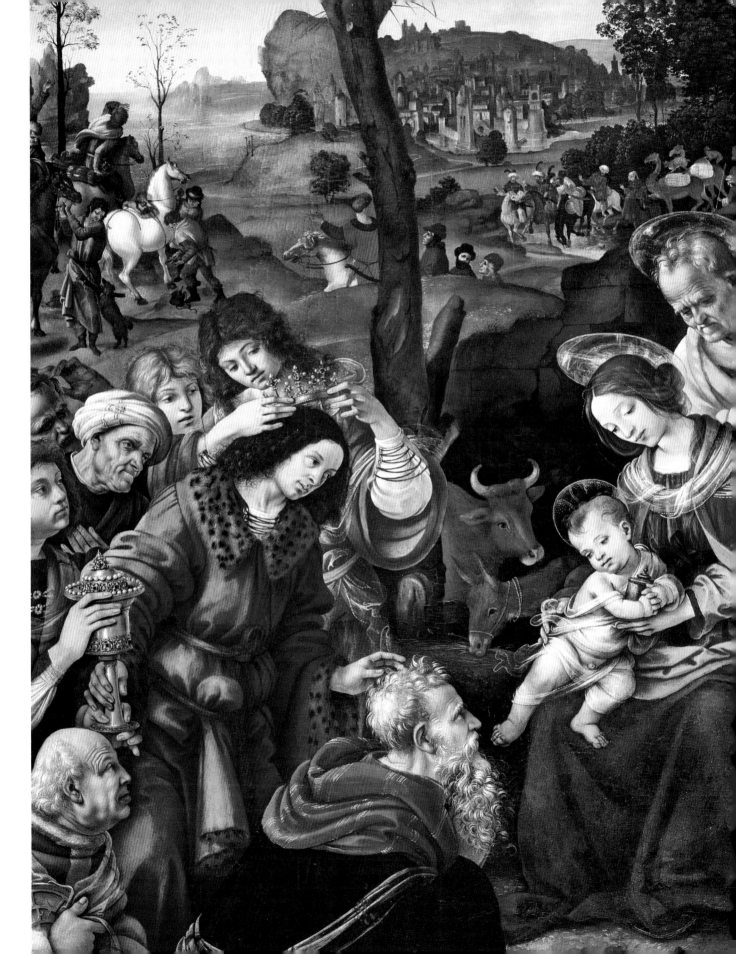

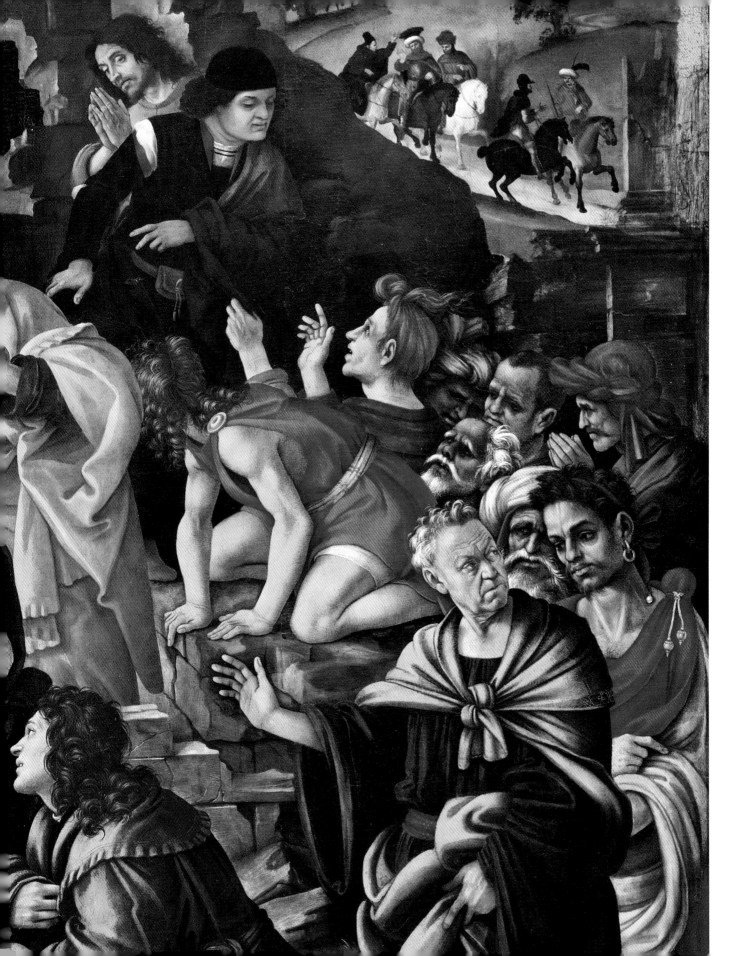

On the previous pages:
Filippino Lippi, *Adoration of the Magi*, c. 1496, tempera on panel, detail. Uffizi. The mark of Lippi's style is clearly visible in this panel, which was commissioned by the monks of San Donato, Scopeto, to replace the one that was left unfinished by Leonardo (also in the Uffizi).

Opposite:
Filippino Lippi, Frescoes, 1497–1502. Sta. Maria Novella (Strozzi Chapel). Departing from Brunelleschi's rules of perspective in the composition of these frescoes, which depict the lives of St. John the Baptist and St. Philip, Lippi arrives at a disquieting pictorial language that points toward Mannerism.

Filippino Lippi, *Signoria Altarpiece* (Pala degli Otto di Pratica), 1486, tempera on panel. Uffizi. In this grave *Sacra Conversazione*, Lippi points the way to compositional developments that Raphael would later use in his *Madonna del Baldacchino*.

On the following pages:
Leonardo, *Annunciation* (after restoration), c. 1472–75, tempera on panel. Uffizi. Formerly attributed to Ghirlandaio, this work shows, in the attention that Leonardo, like Botticelli, pays to nature, the side of his mind given to scientific investigation.

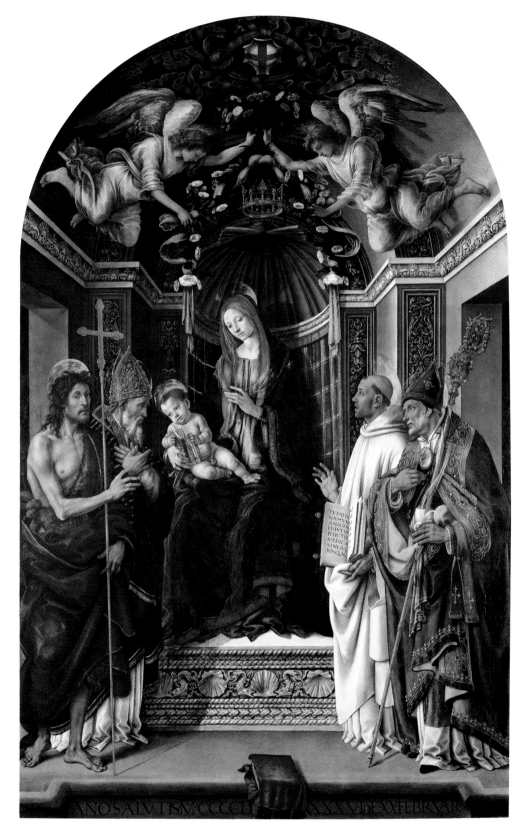

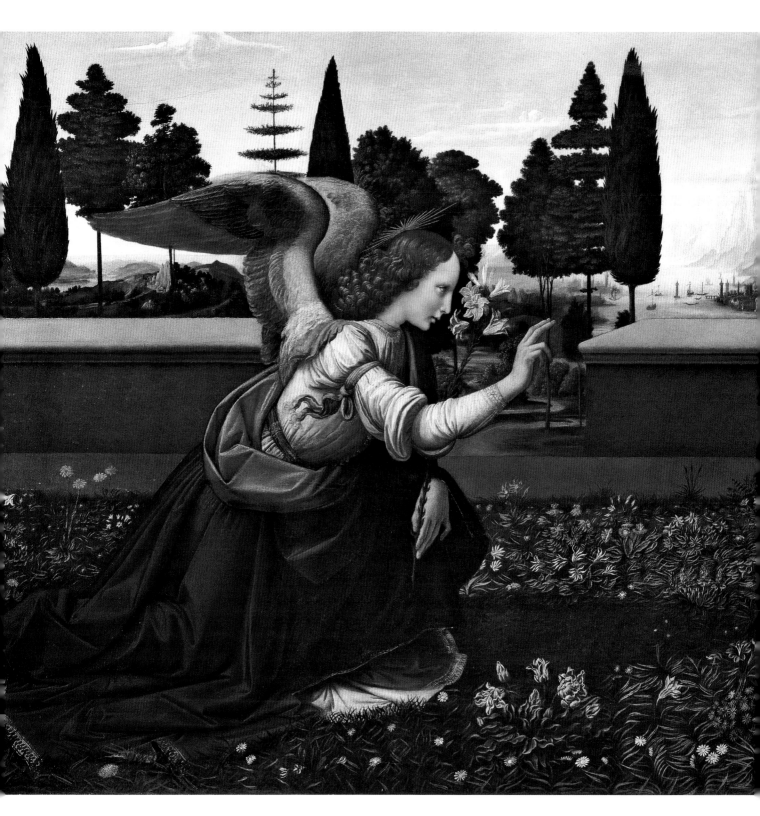

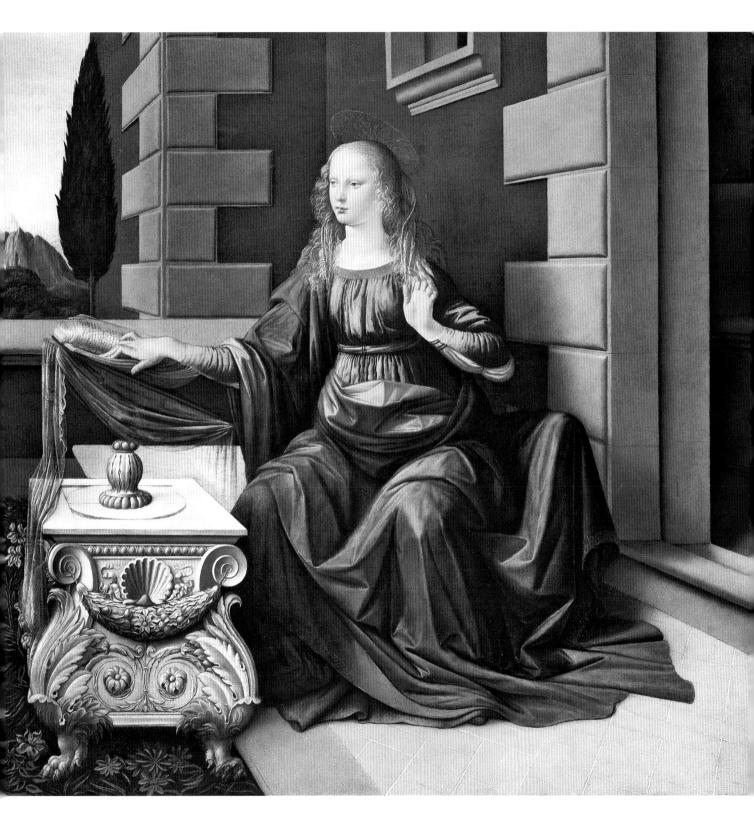

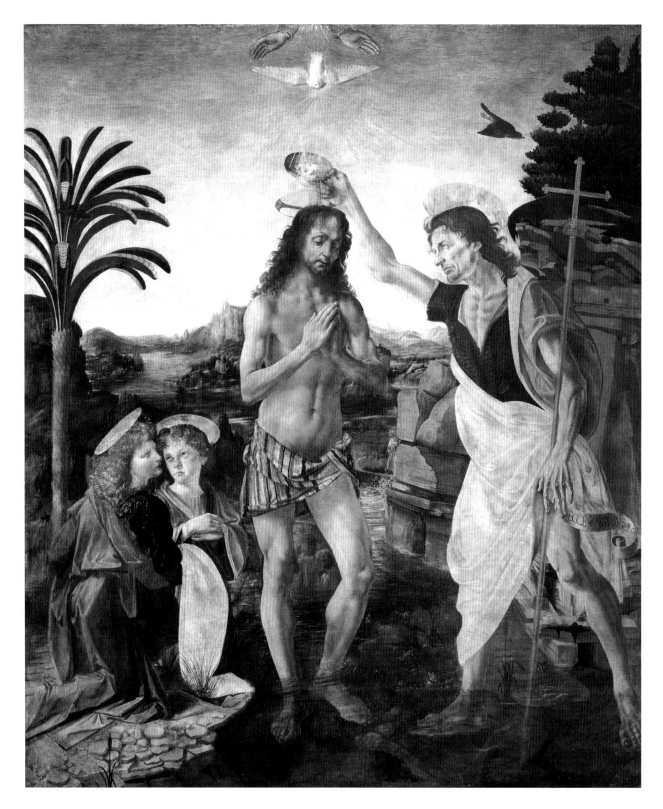

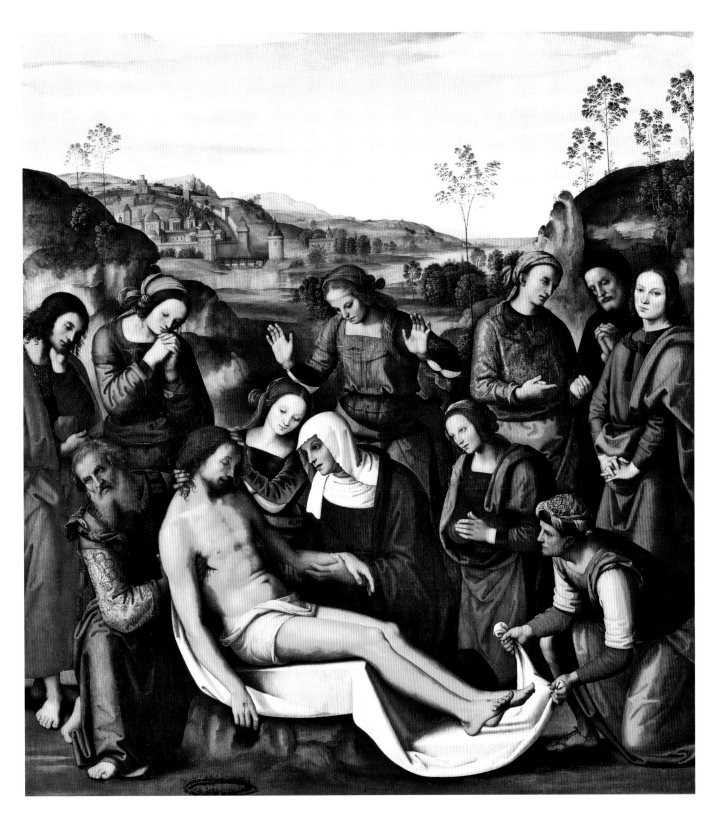

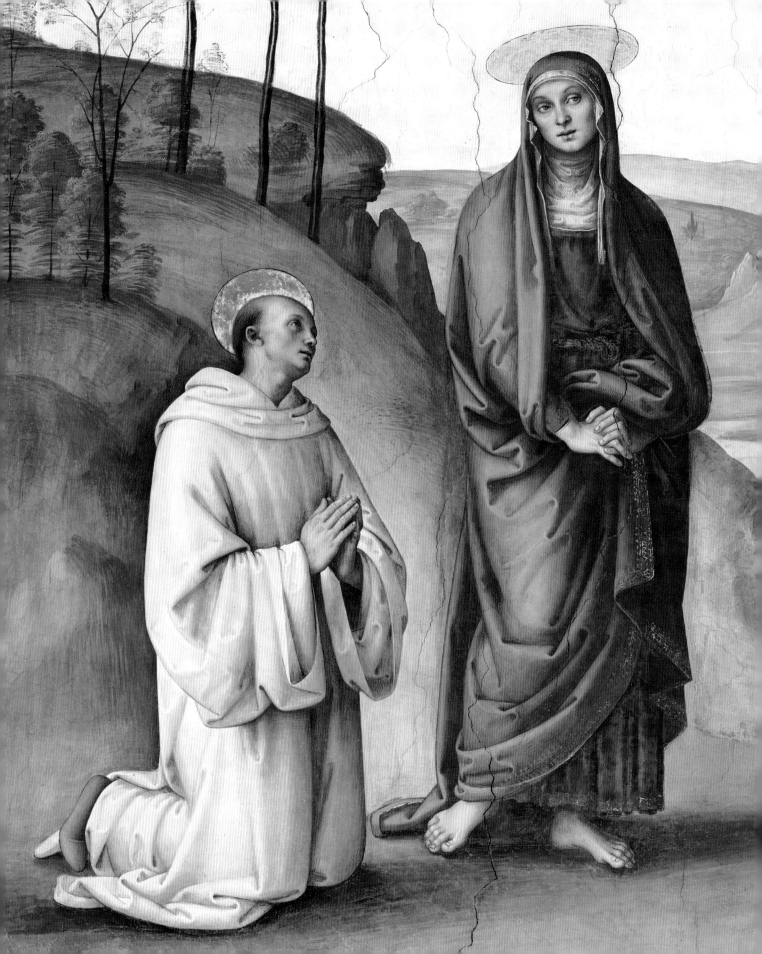

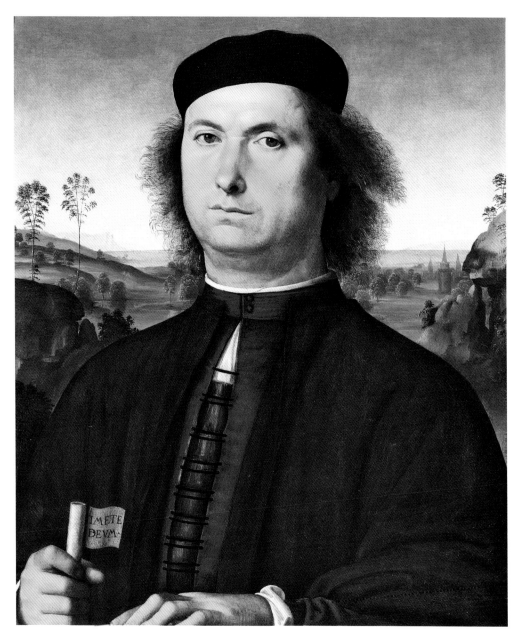

composition as a whole, which would inspire further versions in the following century, not just in Florence (Fra Bartolomeo, Andrea del Sarto), but also in Rome (Raphael).

But before we step into the new century let us mention the bizarre figure of Piero di Lorenzo, called di Cosimo (c. 1462–1521), who almost belongs to it. Piero has the same eccentric, anticlassical characteristics as Filippino Lippi, even though he specialized in scenes from mythology set in the open country whose startling light and fantastic inventiveness recall the work of Paolo Uccello. The innovation of Piero's language can be seen at its best in his *Immaculate Conception* (Uffizi), in which light streams vertically down on a landscape taken from pure fantasy, giving the work an air of unreality.

Marco Chiarini

The Cinquecento

From Michelangelo's project for the facade of S. Lorenzo to Buontalenti's Manneristic flights of fancy

Right:
Drawing of the new facade of the Basilica of S. Lorenzo, which was attributed to Raphael.

Wooden model of Michelangelo's project for the new facade of the basilica of S. Lorenzo.

There are many historical accounts relating to 16th-century Florentine architecture, a period that, for our purposes, it is useful to date from 1537, when the 17-year-old Cosimo I di Medici took over the reins of power in Florence and its surrounding area. The date is significant for two reasons: firstly, because the Principality of

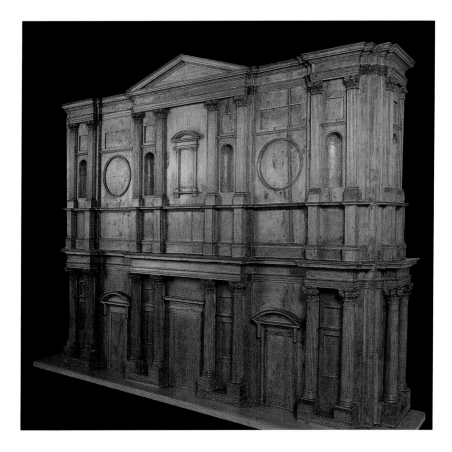

Florence had been established five years previously and this consolidation would be marked by a long cycle of commissions, the outward manifestation of the absolute power of the Medici dynasty; secondly, the art and architecture that now began to appear were interconnected and the two would develop in a steady continuum as a result of an explicit, realistic, cultural design.

Before Cosimo I was crowned prince and began his government, however, change was already underway. It is important to note that during the previous 37 years, which included the brief period of the last Florentine republic (1527–30), notable events had already occurred in architecture. These had been sporadic, uncoordinated, and even perhaps contradictory, but interesting nevertheless.

Normally, general studies of Michelangelo's work and projects in Florence (1516–34) tend to gloss over the total Florentine context of that period, but if the work of Michelangelo is placed within the political and social context of Florence of the first 30 years of the 16th century, then the effects of both the stimuli and the inhibiting factors of that environment upon local architectural development become apparent.

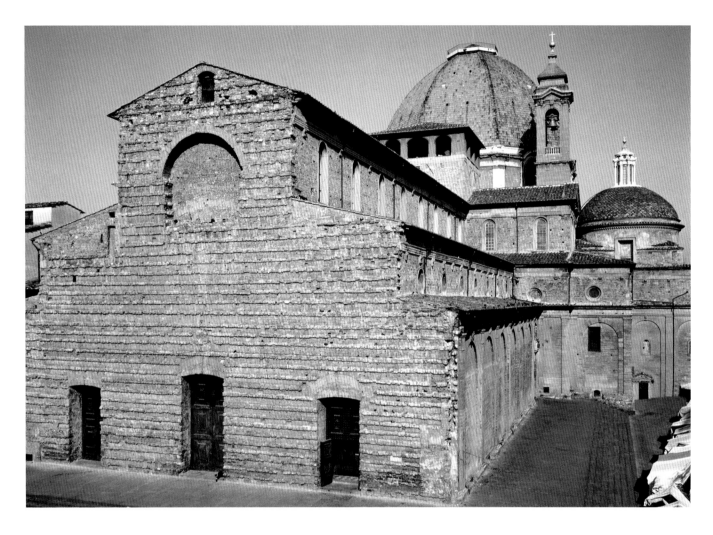

Already in 1502 when the then anachronistic structure of Palazzo Strozzi was still being erected, the writing was on the wall—Filippino Lippi's architectural notions could be seen in the Strozzi chapel inside the church of Sta. Maria Novella. It was clear that the time of Brunelleschi and his followers was over. In the Florence of that time, architecture was being complemented by all manner of ornament, excessive as the day demanded, ranging from trusses surmounted by sphinxes, bizarre creatures, triumphal pediments and inverted pyramids that served as drains. A tour around Florence offered a veritable pot-pourri of figures, a mix and match of elements from the animal and vegetable worlds including diabolical monsters and human deformities—a preview of the disquieting characters and features that would run riot through Mannerist architecture.

Filippino Lippi's exedra in his painted scene of *St. Philip and the Dragon* shows an extraordinary building, a gem of architectural potential, eloquent in its use of space—the way it enfolds the convex stairway at the front and, with a sideways swing, exploits the empty space between the sides of the altar and the two theatrical columns. The exedra suggests how space can be used dynamically to create counterpoint between concave and convex elements and contains within itself the precocious symptoms of what would explode in the Baroque period. It was a brilliant idea, but it went unheeded.

It was followed, in 1507, by the competition for the commission to build the external gallery around the cupola of the Duomo, Sta. Maria del Fiore, which would see the involvement of Giuliano and Simone del Pollaiolo, Baccio d'Agnolo, and the Antonio da

The unfinished facade of S. Lorenzo. In the distance can be seen the 18th-century bell tower, the small 16th-century cupola of the New Sacristy, and the large 17th-century cupola over the Medici Chapel.

Sangallo brothers. The result was a balcony with two superimposed walkways built around one of the points of the octagon, but the conservative Florentines did not appreciate it. Indeed, such was their disapproval that the Opera del Duomo (cathedral works commission) decided to stop the construction. In 1515, the Medici stables along the side of the church of S. Marco were completed. Attributed to Leonardo da Vinci, they were too elegant to house horses and otherwise too conventional in their mundane distribution of columns, arches, and consecutive cross vaulting. They were later destroyed, only to reappear, in a reincarnation, in a series of rooms created in the 17th century on the ground floor of what is today the Istituto Geografico Militare.

In August 1516, Antonio da Sangallo the Elder and Baccio d'Agnolo set about erecting the Loggiato dei Serviti. This was none other than a duplication of the portico of the Ospedale degli Innocenti, designed by Brunelleschi in 1419, on the other side to the square of the Santissima Annunziata. Finally,

on 30 November 1515, the solemn entry into Florence of Pope Leo X, the second son of Lorenzo the Magnificent, hailed the start of better things to come. In September 1512, as cardinal, he had already made formal entry

Filippino Lippi, *St. Philip and the Dragon*, fresco. Sta. Maria Novella (Strozzi Chapel).

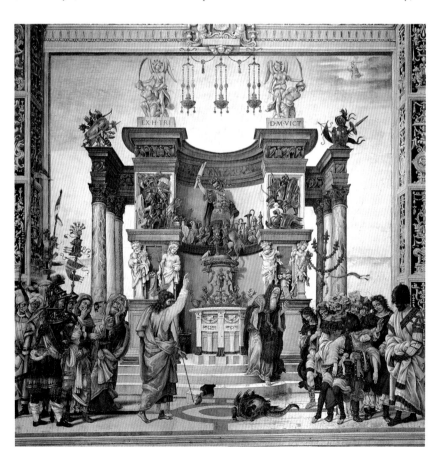

into the city, when, escorted by Spanish troops, he had reasserted the rule of the Medici after a hiatus of 18 years. Once the power had been re-established, albeit temporarily, in 1512 with his brother, Giuliano the third son of Lorenzo the Magnificent was followed by his nephew Lorenzo, the son of Piero, in 1513. The first Medici pope was welcomed with great celebrations and the focal points in the city lining the route that the

Michelangelo Buonarroti, interior of the New Sacristy, S. Lorenzo.

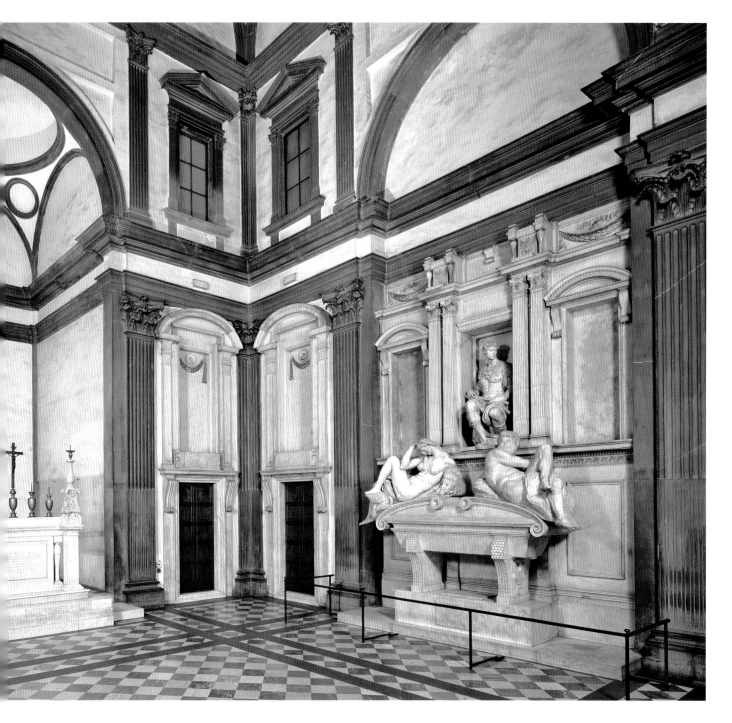

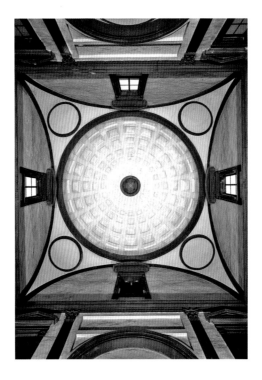

View inside the cupola of the
New Sacristy.

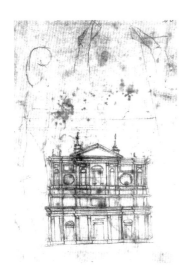

Michelangelo Buonarroti, study for the
new facade, S. Lorenzo.

pope and his entourage followed were
festooned with elaborate decorations.

These decorations included seven triumphal
arches, two of which were four-sided; in
addition, there was an elliptical castle, an
obelisk, a spiral column, a colossal Hercules,
and a huge horse with a seemingly defeated
armed figure mounted on it. To round off the
splendor, there was an entry "palace" to the
Papal apartments and even a temporary facade
for the cathedral of Sta. Maria del Fiore. The
structures were built of wood and stucco and
were such that "no other city or lordly domain
in the world could have made." The
decorative elements embellishing them
included 500 gilded or painted columns,
architraves, pediments, cornices, festoons, and
other painted and sculpted decorations all of
which were created or made by Jacopo
Sansovino, Antonio da Sangallo, Baccio
Bandinelli, Giuliano del Tasso, Francesco
Granacci, Aristotele da Sangallo, Ridolfo del
Ghirlandaio, Perin del Vaga, Andrea del Sarto,
Pontormo, and Rosso Fiorentino.

The elaborate display in honor of Leo X
acted as a sort of consecration of the lord of
Florence of that moment. However, as has
been observed, they were also seen as an
intentional allegory of the return of the Medici,
of the rebirth of the city, and an
announcement of urban renewal that would

soon occur. These abstract wishes were
chronic in the Florentine psyche and were
linked to the idea of renewal in religion,
moral attitudes, and politics and had been
advocated by Savonarola who had made them
his ideology.

Decisions such as the one made to set up a
public competition for the marble facade of
S. Lorenzo appear to have been in answer to
the desires of Leo X who wished to give new
importance to Florence with a markedly
Medicean tone. It is no coincidence that the
first actions of the pope (in contrast to the
many lost opportunities in the 15th century
that had left a plethora of unfinished
churches) were aimed at a new city image
starting with the symbolically important church
of the patron saint of the Medici.

The projects of Jacopo Sansovino, Raphael,
and Michelangelo, designed for the 1516
competition, required three-dimensional
models of the facade, something that had been
unheard of in the 15th century and,
consequently, the promise of a totally new
outlook in architectural design.

Sansovino put forward a design that was
substantially the same as the already executed
1515 temporary facade for Sta. Maria del Fiore,
as described by Vasari. This included a lower
part with double columns and other projecting
elements as well as deep niches, the whole
giving an effect of high relief. From what can
be seen from the drawing in the Uffizi
(2048 A), Raphael planned a triple narthex at
ground level and a space behind the serliana
of the pontifical loggia, which opened to the
second order to give a hitherto unseen (in
Florence) depth to the church of S. Lorenzo.
Even the 41-year-old Michelangelo in this, his
first architectural experience, gave his
imaginary facade a sculptural quality that was
entirely new in Florence. His design was
based on ideas of combining the opposing
tensions between the strongly projecting
elements of the building, the depressions
made by the niches, the jutting shrines at the
ends, and a planned excess of sculptures. It
was a design that completely ignored the
profile of Brunelleschi's church, but that,
Michelangelo proudly contended, was the
reflection of the architecture and sculpture of
the whole of Italy.

It is easy to suppose that, if Michelangelo's
project for the facade had been carried out,
architecture in Florence, as well as elsewhere,
would have developed very differently.
However, as things turned out, Leo X changed
his mind and, in a papal bull of 1520,
canceled his 1518 contract for the erection of
the facade of S. Lorenzo and instead, gave

Giorgio Vasari, Giovanni Stradano, *Esther Receiving the Crown from Ahasuerus*. Palazzo Vecchio (ceiling decoration in the Hall of Esther).

Michelangelo the commission for the Medici funeral chapel within the New Sacristy of the church. In order for his design to harmonize with the style and materials of the Old Sacristy, Michelangelo opted for a design using a type of *pietra serena*, which Brunelleschi had favored. He inserted eight doors topped by elongated tabernacles and, into the unusual wall structures in marble, he set the tombs of Lorenzo, Duke of Urbino and son of Piero, and Giuliano, Duke of Nemours and brother of Leo X. In this internal work, Michelangelo ignored, or even opposed, previously established rules of composition. Notwithstanding the limits imposed, he still managed to make extraordinarily dynamic use of the box-like space allotted to him, causing it to implode between the two facing marble monuments. The funerary monuments were articulated in three superimposed orders: the lowest contained the large sarcophagi surmounted by the highly original curved vaults supporting the allegorical statues; the intermediate order held the figures of the dukes in deep rectangular niches; and the uppermost order was decorated with festoons and jutting pairs of balusters. The dynamic, upward sweep of space is reinforced by the verticality of the windows on the second order

and the four openings placed in the middle of the upper lunettes. Space seems to converge toward the light-filled hemispherical cupola (completed in 1524) with its prospective coffers. The lantern atop the cupola, with its crown of slim columns, and the trabeation with its outwardly radiating juttings constitutes the only (and difficult to see) external evidence of Michelangelo's work.

The other work relegated to an interior, and even more provocative, is the staircase inside the haven represented by the Biblioteca Laurenziana, commissioned by Clement VII, the second Medici pope. Begun in 1524, it is without doubt the most in keeping with the new trends. Michelangelo took advantage of the small, enveloping space to develop an eccentric staircase design involving sets of bearing twin columns (even in the corners) that are set into the thickness of the wall beside niches decorated with tapering, pilaster strip abutments. The whole is punctuated by the jaunty curlicues of the double corbels underneath. The design is even more effective than that of the New Sacristy. It gives the viewer an exhilarating impression that the walls are actually falling in around the exuberant, waterfall-like staircase created by Michelangelo as if it were a sculpture. A terracotta model of it was sent to Bartolomeo Ammannati in 1559, who would execute it with a few variations.

Thus Michelangelo made his architectural debut in 1516 with three proposals that were completely different from the then standard Florentine, two-dimensional designs still visible in the facade for the Bartolini Palace completed by Salimbeni in 1523. The architectural language used by Michelangelo was nonconformist and subversive.

In contrast to the previous static notions, he introduced sculptural models whose muscular dynamism transmits the force of movement to the surrounding space. He demonstrated that architectural orders and rules were merely instruments of design that had become useless and antiquated. It was not without reason that he wrote, "It is a certain thing that the members in architecture depend upon the members of man. He who has not been or who is not a master of the figure and of anatomy cannot understand this." The difference between him and the treatise-writers of the 15th century lay in the fact that Michelangelo did not attribute abstract or symbolic meanings to the proportions of the human body, such as the figure of a man inserted in a square or a circle. Neither did he give credence to the interpretation of human proportions in numerical terms. By referring to

architecture in terms of human anatomy, he exalted the concept of movement and the emotions that movement can inspire. Michelangelo the wayward, the impatient, favored license within the rules as the free expression of creativity; consequently, his architecture was illuminated by flashes of a highly fertile imagination and it progressed to a dimension where it would be difficult to follow.

On 11 May 1527, the news of the Sack of Rome reached Florence. Taking advantage of the confusion among the Florentines, the faction opposing the Medici rose up and forced into flight the cardinal of Cortona, Silvio Passerini, along with his Medici heirs, the bastards Ippolito and Alessandro, sent by Clement VII in 1523 to rule the city. The following year, Niccolò Capponi was elected head of what would be the final Florentine republic. During the three difficult years (1527–30) during which the Florentines ruled their own city—perhaps exaggeratedly called a time of popular rule, although the people who had risen to the magistrature were indeed, for the most part, average citizens and small tradespeople—dissident factions continued inexorably to rebel. While the pro-Savonarola faction, the Piagnoni, as well as the Ottimati, the Arrabbiati and the pro-Medici faction, the

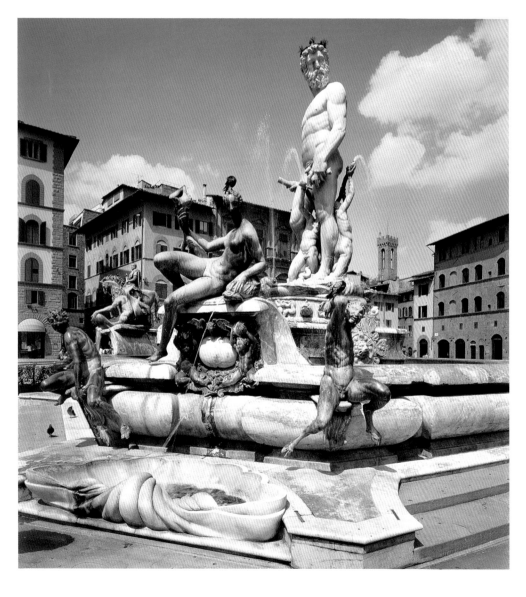

Bartolomeo Ammannati and Giambologna, *Fountain of Neptune*, also called *Piazza Fountain*.

Palleschi continued to dissent, the imperial papal army threatened to lay siege to the city and the plague carried off 30,000 victims, the Grand Republican Council found nothing better to do than to restate useless, old Savonarolian prophecies and, on 9 February 1528 declared Christ to be king of Florence.

Amid a morass of political intransigence—where those who did not accept the "popular" directives were suspected of conniving with the enemy and attacking the freedom of the city, demagogical attitudes, religious fundamentalism, and the pretence of democracy—the Florentines managed to find the will to hold off their enemies until 12 August 1530 when the city was finally forced to surrender.

In the post-republican period, Cosimo I took power in January 1537 and a new era of political stability and cultural activity began. And yet, this new phase has been considered by some to be the start of a new time of moral, ideological, social, and artistic crisis. Manfredo Tafuri was of the opinion that, following the loss of republican freedoms (especially presumed freedoms), Vasari,

Ammannati, and Buontalenti worked to satisfy the cultural requirements of the "despotic paternalistic grand duke" by "exalting the virtues of the imagination and by substituting intellectual tension with wasted intelligence." As this writer does not share the either or approach, which seeks to establish which commissions were morally correct and culturally valid, it would seem more appropriate to take an unprejudiced look at the post-republican intentions with a view to appreciating local realities. In regard to architecture, was it really possible or practical to follow in the footsteps of Michelangelo? Was the failure to do so in fact symptomatic of a moment of crisis and a waste of intelligence, or was it time to follow other paths? One could argue that, while Vasari, Ammannati, and Buontalenti did not appear to be competing for a new distinctive use of space and, indeed, did not apply unlimited imagination to the development of volume, it would be dishonest to deny their attempts to change both the interiors and exteriors of buildings. In particular it does not seem that they "wasted their intelligence" by trusting

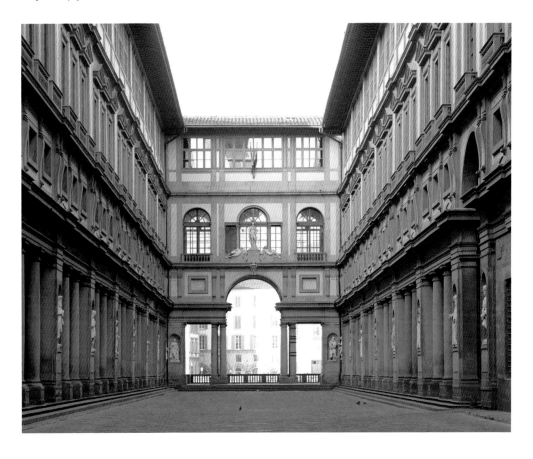

Giorgio Vasari, the square of the Uffizi looking toward the Arno River.

their imaginations to develop new semantics in architectural ornamentation and symbol. Examine, for example, Vasari's 1556 pergola of Constantine, which is nothing more than a review of the twisted, tendril columns, complete with their original symbolic meaning, used 40 years earlier by Raphael in his *Healing of the Lame Man*. The pergola can also be seen in the Palazzo Vecchio fresco painting, *Leo X in Council* where it is seen as a loggia supported by tendril columns, which gives unusual movement to the surrounding space and offers a taste of bombastic formalism that was unknown in Florence at that time. There is also the 1561 Giovanni Stradano ceiling painting in the Sala di Ester in Palazzo Vecchio after a cartoon by Vasari. It shows a baldachin supported by four spiral columns demonstrating an awareness of how the twisting movement causes a vortex in the surrounding space creating the impression of spatial dynamics. These examples illustrate how Vasari, like a seismographer, was highly sensitive to details in architectural elements, which gave a hint of the spectacular changes occurring in the whole conception of the

dynamics of space. Surely, if Vasari's hypothesis of a new feeling for the monumental was correct, he showed no lack of intellectual tension. The problem lay rather within the city itself: urban spaces where imagination could have taken wing were confronted by static urban policies that offered neither the opportunities nor the encouragement for Vasarian projects to achieve their full scope.

One way that the various architects and artists could express their creativity was in ephemeral projects such as the wildly extravagant decorations designed for the entry of Leo X into Florence. To celebrate the marriage of Prince Cosimo I to Eleonora of Toledo in 1539, Tribolo set the city with sumptuous scenery and decked it out with decorations fit for the princely occasion. In 1565, Vincenzo Borghini and Vasari designed the adornments for the marriage of Francesco de' Medici to Johanna of Austria and, in 1582, for the marriage of Ferdinando I to Christine of Lorraine, Niccolò Gaddi designed the decorations, which were then executed by Giovanni Antonio Dosio.

Bernardo Poccetti, *sgraffiti* on the facade of the Bianca Cappello house in the Via Maggio.

According to Riguccio Galluzzi, author of *Istoria del Granducato di Toscana sotto il governo della casa Medici* The History of the Grand Duchy of Tuscany under the House of the Medici, published in 1781, Grand Duke Cosimo had a "singular passion" for "ornamenting the City." The embellishment of the city, whether the results would be long or short-lived entailed getting the task done quickly and required obtaining the maximum effect usually for fairly limited costs. It also involved creating effects that would meet with the approval of the citizenry who would not hold the costs they had to bear against the duke. The decorations did not have any real, lasting effect upon the city's urban layout but did appear to enhance it. The ambitious idea of creating large city squares or wide-open roads was alien to Cosimo. As already explained by Giorgio Spini in his 1976 book, *Architettura e politica da Cosimo I a Ferdinando I* Architecture and Politics from Cosimo I to Ferdinando I, the most important thing was a cautious political line in which the duke (and later his successors) would aim at maintaining the status quo by protecting the interests of the powerful Florentine families, and avoiding giving the citizenry cause to become upset or rebellious. To demonstrate his affection for the city, while avoiding any controversial changes to the city itself, Cosimo would revert to a clever ploy—every now and then he would erect statues, fountains, celebratory columns, or other superficial decorative elements that did not alter the essential and familiar layout of the city.

A list of the major ornamentations and decorations ordered by Cosimo up to his death in 1574 provides examples of the way he made impressive, stately contributions to the appearance (but not the layout) of the city.

In 1554, he placed Cellini's statue of *Perseus* under the Loggia of the Palazzo della Signoria; in 1565, in the square of the Holy Trinity, he decided to put up a column to commemorate the victory of Montemurlo; in 1572, the attempt to raise a commemorative column for the victory of Marciano in Piazza S. Marco having failed, Cosimo had the column of Peace, as it was also called, raised in Piazza

Bartolomeo Ammannati, Palazzo Pitti (the courtyard looking up toward the Boboli hill).

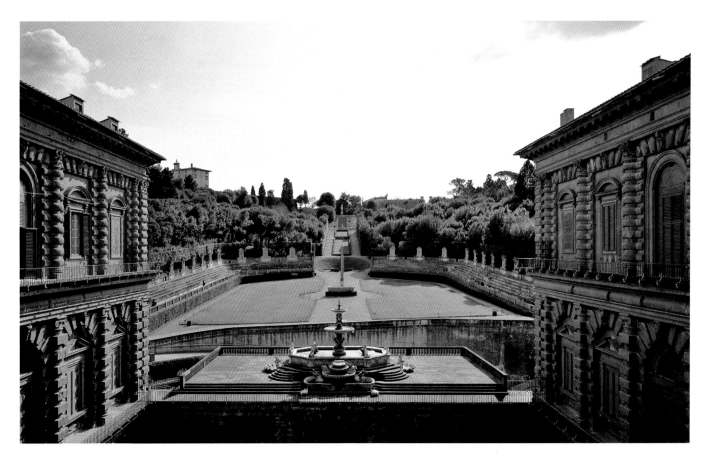

San Felice. The colossal statue of *Neptune* sculpted by Ammannati was placed in the fountain in the Piazza della Signoria in 1565. The *Equità* and *Rigore* statues, as well as the *Beheading of John the Baptist* sculpted by Vincenzo Danti were placed respectively outside the Uffizi in 1567, and above the South door of the Baptistery in 1571. In 1569, Andrea Sansovino's *Baptism of Christ* was placed above the horizontal beam of the trabeation over the "Paradise" door of the Baptistery.

Some of these embellishments left Cosimo's personal touch on what were already famous city landmarks with important links to local traditions. The columns raised to honor the victories of Montemurlo and Marciano joined the older columns of *Abbondanza, S. Zanobi, Croce al Trebbio* and *Sta. Felicità.* And there were also many statues already placed around the city. We need only recall the protector saints of the modeled arts, statues sculpted by Donatello, Ghiberti, Verrocchio, and Nanni di Banco; the statues standing in the niches at the church of Orsanmichele; Donatello's *Prophets* housed in the niches in the bell tower of Sta. Maria del Fiore, the cathedral of Florence, Donatello's bronze statues of *Judith and Holofernes* placed in 1495 on the *aringhiera*, the popular assembly point, in the Palazzo della Signoria where Michelangelo's *David* and Bandinelli's *Hercules and Caco* group of sculptures would be placed in 1504 and 1534 respectively.

Cosimo's program included the use of varicolored marble from Serravezza, and, after 1566, it would become the preferred Medici marble. It was used for the basin of the fountain in the Piazza della Signoria, the column of S. Felice, the covering of the base of the column of the Holy Trinity and the choir and high altar in the cathedral. With regard to the fountain in the Piazza della Signoria, it is interesting to note that Cosimo chose to erect a pagan monument near the spot where Savonarola was hanged and burned. It was a point not lost on the friars of the Dominican monastery of S. Marco with whom the duke was on poor terms. More importantly, by placing the fountain at the corner of Palazzo Vecchio, the city's seat of

In the foreground, the beginning of Vasari's "Corridor," a part of which passes over the Ponte Vecchio. In the background, the bridge at the church of Sta. Trinità, reconstructed "as it was, where it was."

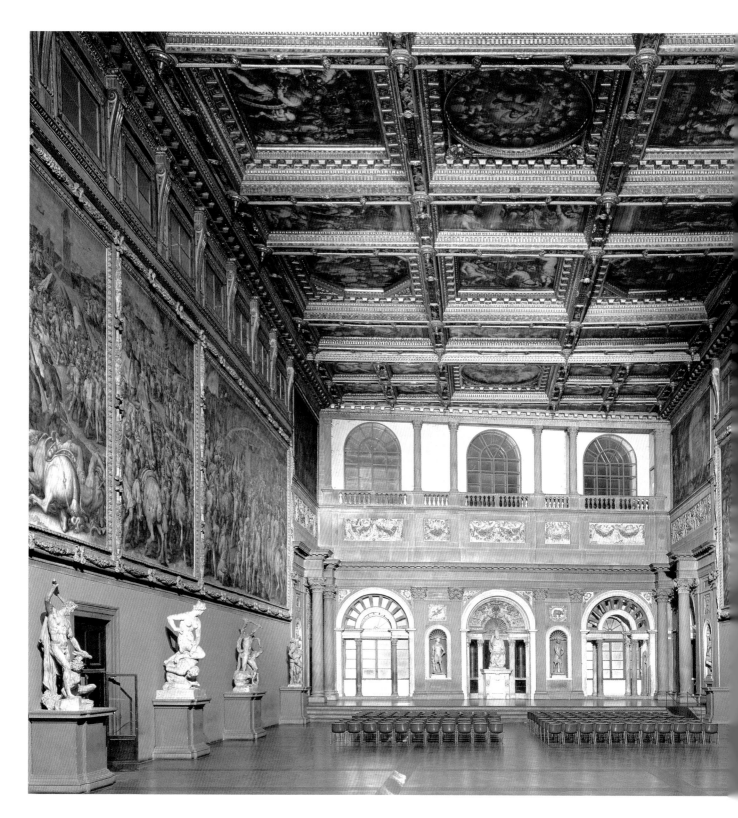

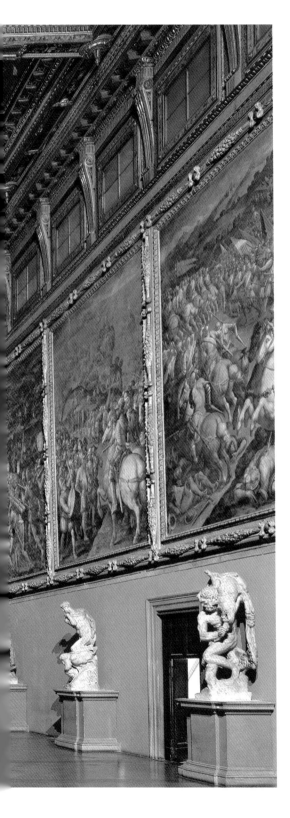

power, it became the focal point between the two areas of the square: on the one side, opening out toward the river and the hills via the gallery of the Uffizi and on the other, toward the heart of the city symbolized by Brunelleschi's dome.

To the decorative embellishments imposed upon the city's previously somewhat severe aspect, this external livening up of the older, traditional, and, let it be said, perhaps unimaginative compositions of doors and windows, the wealthy families now added the facades of their palatial homes, complete with allegorical frescoes or graffito work. In 1554, Vasari designed chiaroscuro figures for Palazzo Sforza Almeni in the Via de' Servi. Painted by Cristofano Gherardi, they have since disappeared. In 1568, he supplied the graffito drawings (which would only be executed in 1573) for the facade of Palazzo Ramirez de Montalvo in Borgo Albizi. At the same time, Bernardino Poccetti was doing the sgraffito decoration on the facade of the home of di Bianca Cappello, which was located in Via Maggio. These were followed in 1575 by the paintings on the facade of Palazzo Benci in Piazza Madonna degli Aldobrandini; the paintings on the small Palazzo Pitti in Via Santo Spirito (which have now been removed); and the decoration of Palazzo Mellini located in Via de' Benci where the frescoes were executed by the Dutch artist J. Stolf based on drawings by Francesco Salviati.

Thus the much denigrated so-called ornamentations played a role that was far from insignificant. It is enough to remark that, of the 12 obverses of the medals coined in 1567 in honor of Cosimo I, two featured the column of the Holy Trinity and the fountain of Neptune, one featured the Uffizi building, and two were dedicated to the theme of the fortifications built to protect the Medici dominions. One cannot fail to note that the importance attributed to the embellishments appearing throughout the city was equal to that assigned to other types of works, such as buildings to house public officials and the construction of fortresses in strategic points throughout the grand duchy, both of which were essential in the management and defense of the ducal state.

In addition to the Uffizi, the new seat of the government, designed by Giorgio Vasari, there were other public buildings such as the bridge of the Holy Trinity, erected between 1567 and 1570; the loggia of the New Market based on a design by Giovan Battista del Tasso (1546–64) and the fish loggia in the Old Market also designed by Vasari in 1568. While the two

Opposite:
Salone dei Cinquecento, in the Palazzo Vecchio.

loggias would not win prizes for quality, the first being exaggeratedly massive and the second overly modest, the bridge, with its three wide-open curving arcs constitutes an exceptionally elegant formal structure. The Uffizi complex was begun in 1560 and was originally designed as a two-story building. Its imposing facades delimit the corridor-type square, which, despite its scene-setting value, still recalls narrow, medieval streets.

Among the extensive military works undertaken during this period, mention should be made of the rearrangement of the fortress of S. Miniato al Monte and the provision made for a new defense system for Florence. This included the future fort of the Belvedere; the three fortresses of Portoferraio (Cosmopoli, the so-called city of Cosimo); the foundation in 1564 of Terra del Sole (Eliopoli) in the Romagna-Tuscany border area; the fortress of S. Martino sopra San Piero in Sieve, based on a project by Baldassarre Lenci (1569); and the city-fortress of Sasso di Simone (1548–65) built along the border between Tuscany and Marche and designed by Giovanni Camerini.

In regard to architecture in the private sector, Cosimo I chose to follow the practice of maintaining the external iconography of buildings. At the beginning of 1540, the grand duke make the politically significant choice of moving from the Medici home in Via Larga to the Palazzo della Signoria. Instead of opting for a new "modern" complex, Cosimo considered it more suitable to preserve the existing outward appearance of the ancient building, the Palazzo dei Priori, which had later become the Palazzo della Signoria. He believed that it would have been inopportune to alter "the foundations and maternal walls of this place, and thus within this old form began his new government." In other words, Cosimo felt that his setting up shop in a building which symbolized the civic traditions of Florence was equivalent to guaranteeing (even if only in appearance) the continuity of the republican institutions through his system of government. In order to prepare the building to house his prestigious government within its "maternal walls" Cosimo did not, however, balk at making notable transformations. He charged his favorite architect and painter, Giorgio Vasari, to adapt some parts of the building for his private quarters and to draw up plans for a great hall for public ceremonies, which would take on the name of Salone dei Cinquecento. Between 1563 and 1565, the great hall that represented the Medici court and by consequence, the entire city, was given a huge decorated, coffered ceiling, which was supported by an ingenious linear structure above it. The walls were decorated with enormous frescoes executed between 1567 and 1571 illustrating scenes from the victories Florence had won against Siena and Pisa. The apartments on the second floor were decorated from 1555 to 1562 by "commanding the paintbrush to produce things from philosophy and fables" with allegories surrounded by grotesques, scrolls, and medallions. When Cosimo moved to Palazzo Pitti, he confirmed the Florentine inclination of not indulging in counterproductive external exhibition on the facades, but rather by taking license—indulging a few personal whims on the interior of the residence. In the case of Palazzo Pitti, this license consisted of developing the courtyard to please himself.

In the foreground, the porphyry statue of Justice; in the background, the facade of the church of Sta. Trinità by Buontalento.

directives for spectacular exteriors as they could have offended the sensibilities of the latent penitential tendencies of the Piagnoni faction (the "Weepers") faithful to Savonarola's teachings. Therefore, he quickly busied himself with alternative cheaper, but nevertheless, high profile variations in the most prestigious churches of Florence. The first of these post-Council of Trent commissions was for new altars, which Vasari designed for the churches of Sta. Maria Novella and Sta. Croce (1565–66). Erected on the walls of the side aisles, these niche-like constructions appeared not dissimilar to the doors of ordinary town buildings. To the mortification of the creative mind involved, they constituted a very minor chapter in the annals of architecture.

Following the plans of Bartolomeo Ammannati who had arrived from Rome, work began in 1560 only to end 17 years later. The three-sided courtyard, designed to exclude prying eyes, looks up toward the hill of the Boboli gardens. With huge, dynamic features that derive in form and size from Roman models, it stands unique in the annals of Florentine architecture. To connect Palazzo Pitti, his residence, with the administrative offices in the Palazzo della Signoria, Cosimo asked his trusted architect Vasari to design a private gallery between the two buildings. Designed and built in just five months in 1565, the highly original design "on the river and nearly up in the air" involved a linear, corridor-like structure following the river, which it crossed at Ponte Vecchio to connect up with Palazzo Pitti. It provided a safe, covered getaway route that could be used in time of need.

Returning from the more limited area of private architecture to the public arena, it is interesting to note that an event as tumultuous as the Counter-Reformation would in the Florence of Cosimo be slanted to fit in with the grand duke's overall political contingencies. In this case, the desire to see an increase in his subjects' religious fervor was inextricably linked with the need to increase their consent to (and thereby the legitimization of) the Medici form of absolute government. It is true that Cosimo was the first of the Italian princes to publish, in 1564, the decrees produced by the Council of Trent, but it is also true to say that his observance of Christian duties and the obedience he showed toward the Church at that time owed less to his religious zeal and rather more to carefully studied political maneuvering. So much so, that the duke felt it was in his greater interest not to build new churches that embodied the

Buontalenti, window timpany in Palazzo Nonfinito, in the Via del Proconsolo.

Interior of the large grotto of the Boboli gardens.

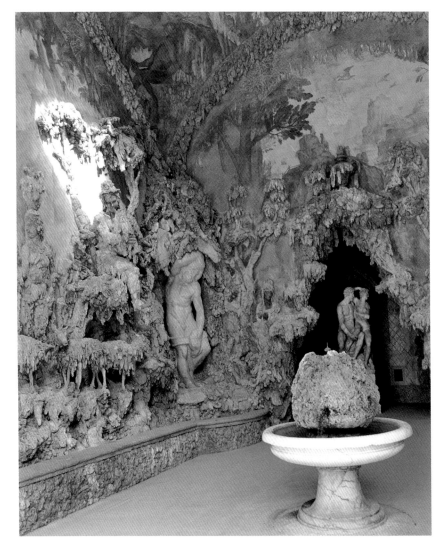

331

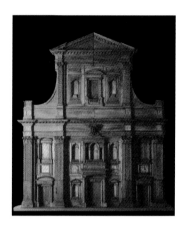

Wooden model for the new facade of the cathedral of Sta. Maria del Fiore, attributed to Giovanni Antonio Dosio.

The other architectural projects to be erected during Cosimo's Counter-Reformation program were limited in number, quality, and character. Suffice it to consider the banality of the box-like space in the rooms of the Oratory of St. Thomas Aquinas in Via della Pergola (1569), and of the church of the Congregazione dei Pretoni in Via S. Gallo (1570–80). The sole exception to these formal, characterless, unornamented expressions of Cosimo's Counter-Reformation, indeed, the only triumphant Florentine example of architecture following the dictates of the Council of Trent, can be found in the great wooden ciborium, which was positioned on the high altar of Sta. Croce in April 1569.

The fact that Vasari, like other architects, craftsmen, and artists, was applying his creativity in a limited fashion raises the question—was the intelligence of the court-salaried architect being used wastefully by the duke and his regime? Or, depending on the different opportunities offered by a duke he may have considered a despot, was the architect evaluating what types of clues to leave to posterity? The answer, from debates as well as from the evidence, seems to point to the wisdom of the architect who was well aware that, while regimes have a habit of passing, good architecture lives on. It can be no coincidence that the heavy octagonal ciborium supported on great corbels with their anthropomorphic figures is an even more imaginative expression of volumetric articulation than the small Temple of Victory— also octagonal—which Vasari erected in 1572 in Marciano in Valdichiana. Dominating the scene with a height of 20 feet (6 m), the ciborium sets the tone for ceremonial splendor. Gilded from top to bottom, and visible from every part of the nave, it was designed to be the focal point in an emotionlly-charged setting. It was fully capable of symbolizing the centrality of the Eucharist and commanding the attention of the faithful as required by the Council of Trent.

With the assumption of power by Francesco I in 1574, the new grand duke, who had acted as regent for his father since 1564, oversaw no significant changes in the way the government in Florence was run, or in the type of architecture commissioned. Francesco I was certainly more interested in the profane than the sacred and paid little heed to the decrees issued by the Council of Trent. He preferred to continue in much the same vein as his father had, assigning the so-called ornamentation the role of serving the state and enhancing the aesthetics of power all for the glory of the Medici regime. In 1581, he commissioned

Tadda to execute a porphyry statue of *Justice*, which was then erected atop the column in the Piazza della Sta. Trinità; in 1583, he decided to place Giambologna's sculptural group, *The Rape of the Sabine Women* below the loggia of the Palazzo della Signoria, and, in 1585, he placed the statue of Cosimo I at the front of the Uffizi.

In the same way, it was urban enhancement rather than Counter-Reformist devotion that provided the impulse in 1587 from January to July to pull down the medieval facade of Sta. Maria del Fiore, and replace it with a new one in the "modern taste." There is no way of knowing for sure whether it was the widespread poverty and unemployment besetting Florence following the great famine of 1585 or the encouragement of Bernardo Buontalenti, who hoped to receive the commission for the project, that led the grand duke into the "gross impiety" of ruining the old facade of the cathedral of Florence. What is clear is that, in the two linear models proposed by Buontalenti and Dosio, there were superimposed orders, examples of columns, gigantic pilasters, great doorways, windows, niches, and decorative elements galore—a veritable exercise in massed mixing of styles and formal rules.

The extent to which the architectural recommendations of the Council of Trent were followed was dependent less on the interference of the grand duke and rather more on the personal inclinations or periodic whims of the individual architects. Consequently, taking advantage of the way nature and artifice can be combined with unexpected results, in 1574 Buontalenti allowed himself the profane transgression of the marvelous double sunburst of steps forming the entrance stairway into the presbytery of Sta. Trinità (today in the church of S. Stefano al Ponte). A combination of the converging furrows of a shell and the nerved membranes of a bat, the rays can also be compared to two symmetrical stone whirls bursting out of spiral conches.

In an altogether different vein, between 1581 and 1584, in a period of senile righteousness and penance, Buontalenti oversaw the construction of the church hall of S. Giovannino in Via Larga, based on the design of Bartolomeo Ammannati.

An introvert, Francesco I had a markedly secular outlook that influenced his every action, cultural or otherwise. Once he had completed his daily state duties, he gave himself over to his preferred activities—in the world unto itself of the Studiolo (the "Study") in Palazzo Vecchio (1570–72), known for its

nocturnal life and where he kept his collections of artistic and natural rarities. He would also be found in the "Fonderia" or the "Galleria" where he gave himself over to the pleasures of empirical research into new techniques of working materials to create exceptionally beautiful decorative articles. After 1574, Francesco I would be found in the "Casino Mediceo," a sort of arsenal, where he had his "alembics and every sort of artifice" and where he and a variety of painters, sculptors, architects, and artisans perfected their skills and coordinated experiments in every sector of the arts using a wide range of materials in a sort of proto-Bauhaus experience. The comparison should not appear frivolous, but rather useful in helping us appreciate the results of the extensive artistic work carried out in Florence in the last 30 years of the 16th century. For instance, the corbels of the windows, with their outwardly curving bars, ending in hairy monsters, or the monkey-like creatures peering out from under a shell in the lunette of the wooden studded doors of Casino Mediceo are outward reflections of a propensity for symbols, the inclination toward the semi-magical methods and alchemical practices underway in the building and which satisfied the grand duke's yearning for escape.

Caprice, mystery, and pleasure went hand in hand in the saturnine indolence of Francesco I and found leeway in Buontalenti's imaginative interpretations. A playmate of the prince from a very tender age, he gave vent to their shared imagination in the garden and grottoes in Villa di Pratolino (1569–79); in the door of the Suppliche (1577); in the great grotto of the Boboli Gardens (1583); in the Tribuna (1584), and in the Teatro degli Uffizi (1586).

The eclectic creativity of Buontalenti would express itself with increasing invention in these architectural projects commissioned by Francesco I and, as Francesco de' Vieri would describe in 1586, astound and delight with their autonomic movement, the variety of the unexpected water games and the sounds emitted from hydraulic organs installed in the grottoes (later destroyed) of Villa di Pratolino, where the gigantic statue of the *Appennino* executed by Giambologna (1579–80) still towers. Buontalenti would give ample expression to architectural heresy in the daring upside-down pediment of the door of the Suppliche, which looks like two vaults sprouting out of a huge grinning mask, pointing upward like wings. Then there were allusions and illusions with intriguing ambiguity in imitating nature, when he sculpted artificial stalactites hanging down

from the vaults of the three intercommunicating rooms of the Boboli grotto. He also designed the small, mother-of-pearl encrusted cupola in the octagonal tribune inside the loggia story of the Uffizi intended to be the grand duke's museum and containing an ebony chest at its center, a variant of the sun in the Studiolo. He was also responsible for producing scenery and costumes for *L'Amico Fido*, a comedy presented in the Teatro Mediceo in the Uffizi on the occasion of the marriage of the half-sister of Francesco I on 16 February 1586.

In terms of architecture as a means of conceiving space, however, Buontalenti has left many critics perplexed. One has only to see the ordinariness of his plans and his common use of space in buildings such as the Casino Mediceo, the Villas of Pratolino (now destroyed) and Artimino (1596), or notice the flatness of the facade of Sta. Trinità (1593) to realize that, in these buildings, he was lacking in terms of innovative composition or type. Buontalenti was at his best in designing decorative components where he was able to give full vent to his creative virtuosity, where all manner of lively human and animal creatures came to life, where he was able to take a fairytale delight in unusual forms and where his mischievous attitude led him to insinuate bizarre supernatural beings. With distorted and surprising details, he was a master of the unexpected. One only has to think of how cartilage is turned into marble or stone parchment unrolls, or how the bats of the underworld hide under windowsills (as they do on the facade of the Bianca Cappello house) or fly out of the scrolls in the tympanums of the ground floor windows in Palazzo Nonfinito in Via del Proconsolo (1593); or indeed, if one thinks of the fabulous underground chambers in the grottoes of Pratolino and Boboli, then Buontalenti's genius for metaphor in the game of contradictions that typifies Mannerism becomes only too clear.

The enormous attention that Buontalenti received, the overflowing of his distorted imagination and his virtuoso way of turning standard images and symbols to his own use could only cause damage to the rationality so deeply rooted in Florence. It would lead to the beginning of the concept that architecture has to do with more than mere construction and would thus open up the way to new horizons and new potentials in architectural planning.

Carlo Cresti

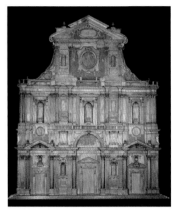

Buontalenti, wooden model for the new facade of Sta. Maria del Fiore.

Line and form

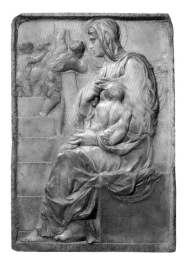

Above:
Michelangelo Buonarroti, *The Madonna of the Stairs*. Casa Buonarroti.

Opposite:
Michelangelo Buonarroti, *The Battle of the Centaurs*, detail. Casa Buonarroti.

Below:
Bertoldo di Giovanni, detail of fireplace decoration. Museo Nazionale del Bargello.

Among the happy events that defined the development of the three-dimensional arts in Florence, one must count the almost complete generational turnover that occurred at virtually the same time that Lorenzo the Magnificent (1449–92) died. The great patron of the arts, who died the same year that America was discovered, had believed, for a time, that it was India that lay across the Atlantic.

One of the key people at the end of the century that had been under the wing of Donatello was the sculptor, Bertoldo di Giovanni. He died in 1491 at about 70 years of age. From Vasari, we learn that, once the young Michelangelo (1475–1564), had learned the art of fresco painting from Ghirlandaio, he went on to be guided by Bertoldo in the Medici garden of S. Marco. This sculptor, the keeper of Lorenzo de' Medici's collection of antiquities, was a focus for many literary figures of the day. Both Bertoldo and Donatello would play a role in the development of Michelangelo's style. Recently a small bronze head of a satyr, which answers a description given by Vasari of a work he recalled as being made by the young Michelangelo, was re-examined by experts. It has led to comments that it bears the distinct influence of Donatello.

The art of Bertoldo, on the other hand, is very expressive materially. The artist used bronze, his favorite material, to reflect the strength and physical vigor of the metal itself. His solid bronzes depict weighty figures whose heaviness is counter-balanced by a light gesture, a flighty movement, or a delicate stance. Bertoldo's works were impressive and the young Michelangelo, along with the other Florentine artists who sought to do well and to receive recognition, could but do what their skill bade them to do, and that included emulating their master's style.

It was amid this atmosphere that Michelangelo's famous sculpture, *The Battle of the Centaurs* (1490–92), came into being. It provided a perfect companion piece for the group depicting the battle between the Romans and Barbarians sculpted by his mentor, Bertoldo.

Comparing the marble relief made by the young artist with the bronze made by the old teacher, one is aware of the similar poetic obsession that seized both artists. On the one hand, Michelangelo seemed to bring forth a newborn out of the shadows, shaping and smoothing the stone with his hands, almost modeling it to the light that highlights or shades the different depths of the material. On the other, Bertoldo digs into the metal, forcing his way in, tormenting and folding it as if he were wielding a spatula, or, better, a chisel or a scalpel. Both artists free a form, or a writhing mass of forms, from the material. However, while the first allows his figures to throw off the cumbersome marble, the second weighs his nervy figures down with the bronze. The two techniques depend on the different materials, but both sculptors played on the Platonic idea of form—the notion of it being contained within the raw material. In the case of the sculptor working in bronze, this is the same as the first cast, which is rougher than the preliminary studies. Behind this innovative mental process, which effectively negates the physical act of the craftsman, stands Platonic philosophy—the knowledge that the idea is formed and exists in itself before a creative act gives it form. Man, be he sculptor, painter, poet, or writer, is merely the instrument by which the idea takes shape. The line, the drawing, becomes the hub from which each formal experience springs before it takes on shape with color and form.

The early progress followed by Michelangelo is well known: *The Madonna of the Stairs* (c. 1490), a low relief with a waxy appearance that breathes life into the marble; the *Pietà* in the Vatican (c. 1497–1501); the

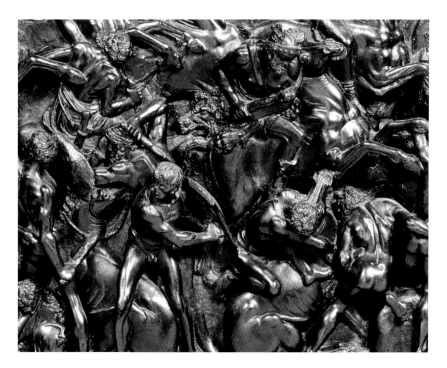

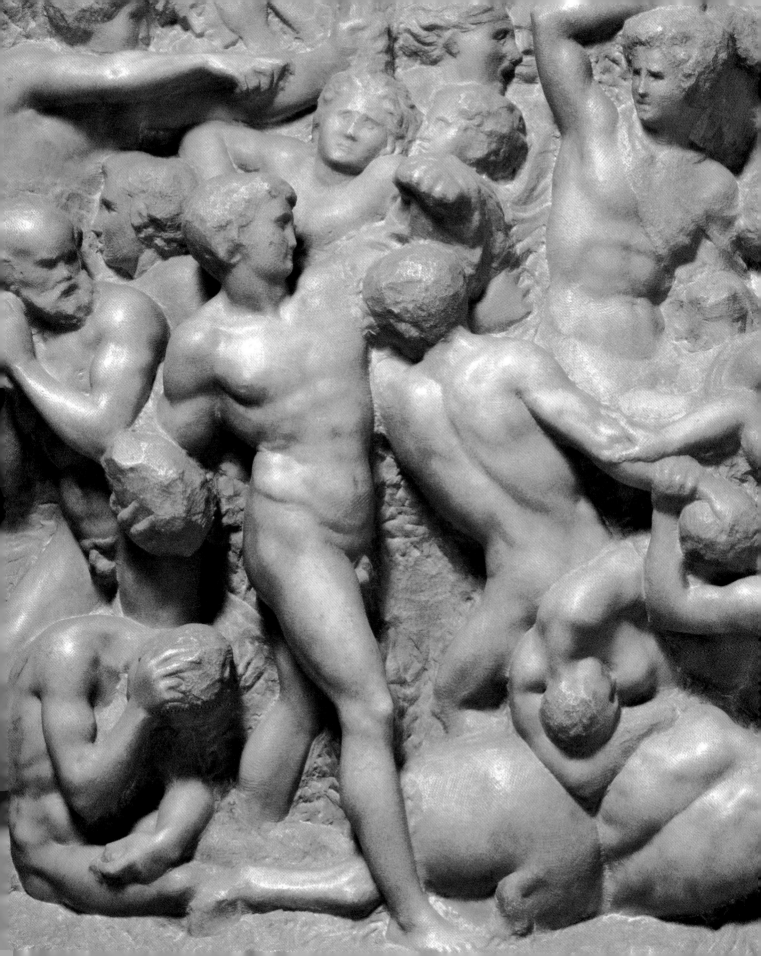

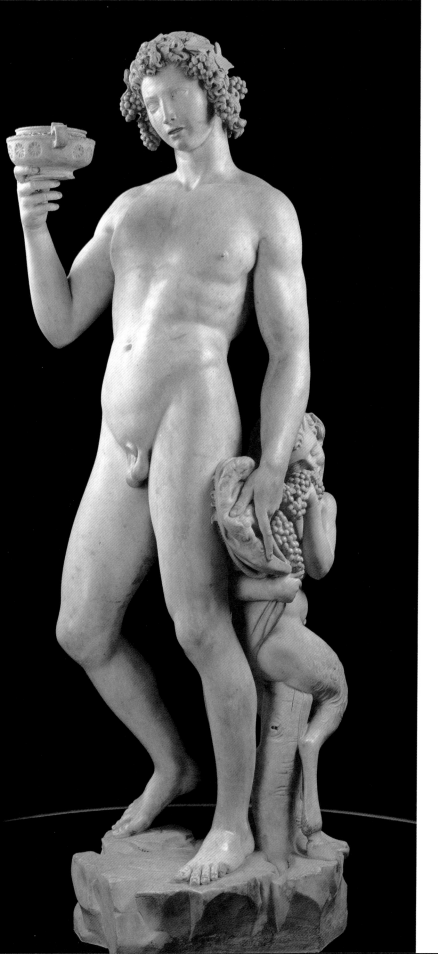

Bruges Madonna (1503–04) in highly polished alabaster-like marble; and the huge *David* (1501–04), the symbol par excellence of the powerful will of man, hero of then and for all time. Before the colossal statue was erected, Michelangelo had also been experimenting with recent statuary in finishing the incomplete Monument to *St. Domenico* (1494–96) and working on the Piccolomini altar in the cathedral of Siena (1501–pre-1504). However, the most important of his youthful works is undoubtedly the tipsy *Bacchus* (1496–97), which he made in Rome for Jacopo Galli, a dealer in antiquities, and which is now in the Museo Nazionale del Bargello. The figure, intended to be the young sculptor's visiting card, was designed to win commissions for restoring classical marble statues. However it speaks a modern tongue with its clear, classical references and was purposely placed among pieces of ancient statuary, where it appeared to be an ancient Greek original.

There is no doubt that Michelangelo would have seen and been influenced by the splendid statues placed around the Belvedere in the Vatican, in particular, by the *Apollonius* torso, one of the most impressive examples of the Hellenistic school.

It was this, and other statues like it, that encouraged the young Michelangelo to work fully in the round rather than from a single, set point of view. In this sense, his *Bacchus* represents the first, truly modern sculpture, summing up as it does a love of the classical world, technical expertise, psychological study of the subject, and a keen awareness of the need to balance moral and formal requirements. One could go so far as to say that the statue set the pattern for the way Michelangelo would develop his style and way of thinking.

The *David* originally stood in the square before the Palazzo della Signoria, but later, it was moved to the Gallery of the Accademia. An excellent 19th-century copy now stands in the place of the original. Designed as a political statement, it was commissioned by the Signoria, the rulers of Florence, as a warning to would-be despots desirous of overthrowing the ancient republic. The success of the statue that had been hewn out of a single block of marble, recovered after a failed attempt by Agostino di Duccio, also lies in its pleasing formality.

For almost 20 years, Michelangelo worked on the ceiling of the Sistine Chapel, commissioned by Julius II, the della Rovere pope, whose unfinished tomb the sculptor also worked on intermittently, as time permitted. Subsequently, he would labor on the altar wall

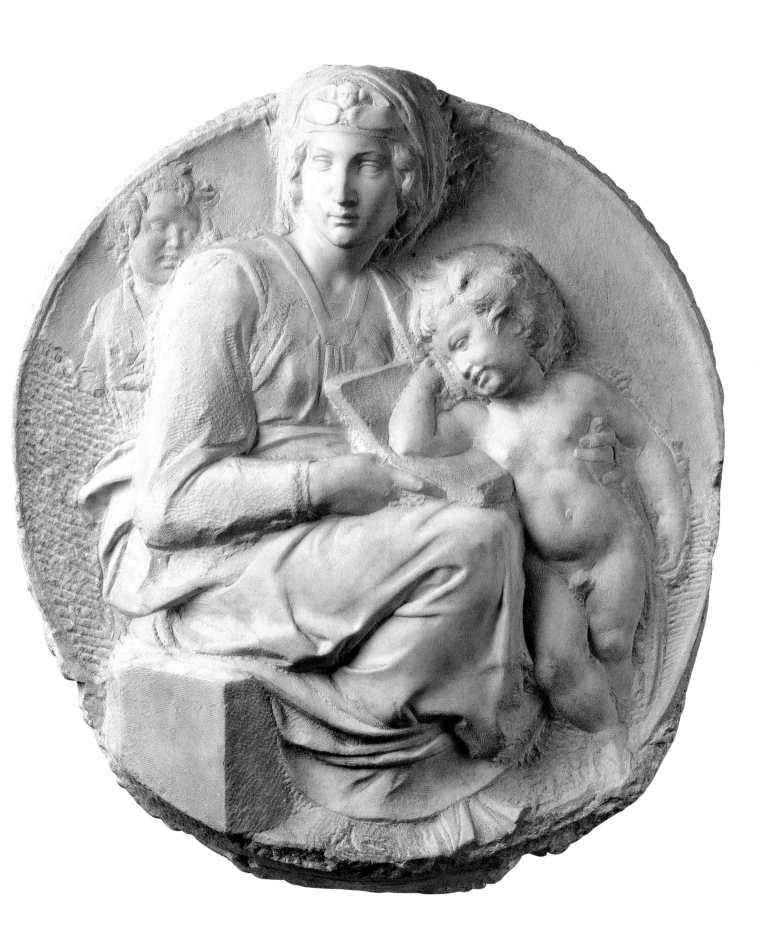

Preceding pages:

Michelangelo Buonarroti, *Bacchus*, Museo Nazionale del Bargello. Later restored, the left hand was damaged while the statue was on display in the garden belonging to the Roman antiquities dealer, Jacopo Galli.

Michelangelo Buonarroti, the *Pitti Tondo* or *Madonna with Child*. Museo Nazionale del Bargello.
This masterpiece follows in the tradition of round paintings. Michelangelo varied the relief and the chisel marks over the surface of the work so that light would play over it to the fullest effect.

This page:
Michelangelo Buonarroti, the unfinished *Bearded Slave*. Galleria dell'Accademia.
A statue originally designed for the tomb of Julius II, the della Rovere pope who was one of Michelangelo's most important patrons.

Opposite:

Left:
Michelangelo Buonarroti, *St. Matthew*. Galleria dell'Accademia.

Michelangelo Buonarroti, *Atlas*. Galleria dell'Accademia.
In this angular figure, more than in any of the other Telamon statues planned by the sculptor for the tomb of Pope Julius II, the spectator is aware of the strength required to support the weight of the architectural elements above it, an allusion to the moral weight of all humanity that is borne by the pope.

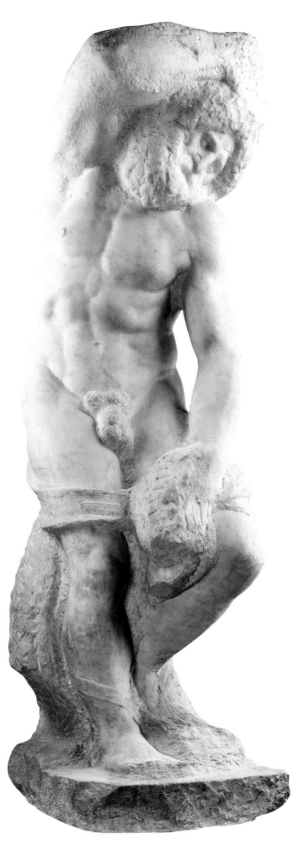

in the same chapel before moving on to the Paolina Chapel. Later, Michelangelo returned to Florence summoned by the Medici pope, Leo X, and became involved in the project for the facade and counter-facade of the church of S. Lorenzo (1516 and later). He also worked on the design and execution of the library in the same building complex and in the execution of the New Sacristy, the funerary chapel of the two dukes, Giuliano of Nemours and Lorenzo of Urbino. For the sculptor and architect, this would be his most difficult commission in Florence. Here, as in the vestibule of the Laurentian Library, Michelangelo called upon his evocative sense of architecture. He borrowed Brunelleschi's notion of solid weaving in stone, or the idea of a cage that clearly defines internal and external areas, constantly shifting between the solid and the void, even in the screening walls, to create a real diaphragm between the interior and exterior. The statues, which were not positioned during Michelangelo's lifetime, were much admired and were continuously sketched even as they lay on the floor of the chapel. Part of a project never equaled, they were designed specifically for the exact location and conceived to dramatize the ability of the immortal soul to free itself from the burden of the flesh.

The statues of *Day* and *Night*, *Dawn* and *Dusk* (1521–34) represent heroic yet exhausted human figures, but so imposing as to have an almost divine aspect.

Their reclining position above the broken arcs of the sarcophagi of the Medici dukes recalls that of Adam in the Creation scene on the Sistine ceiling, and makes reference to the same subject as treated by Ghiberti in the second set of doors of the Baptistery, now affectionately called the S. Giovanni by the Florentines. These powerful nudes set a pattern that would appear frequently in Mannerist paintings, setting the stage as gigantic deities, river gods, or Herculean spectators at a drama, playing the dual role of limit and link between the real and the imaginary.

This was the work of Michelangelo the Florentine that was best known among the artists and thinkers, even though the Medici collections already included the *Slaves* (c. 1520–30), today in the Galleria dell'Accademia, but then visible in different forms in the spongy, moss-like architecture of the Buontalento grottoes in the Boboli Gardens, or the dynamic *David-Apollo* (c. 1530), which Cosimo de' Medici I liked to keep in his bedchamber, and now in the Museo Nazionale del Bargello.

Among the masterpieces produced by Michelangelo, the *Brutus*, 1539–40, is

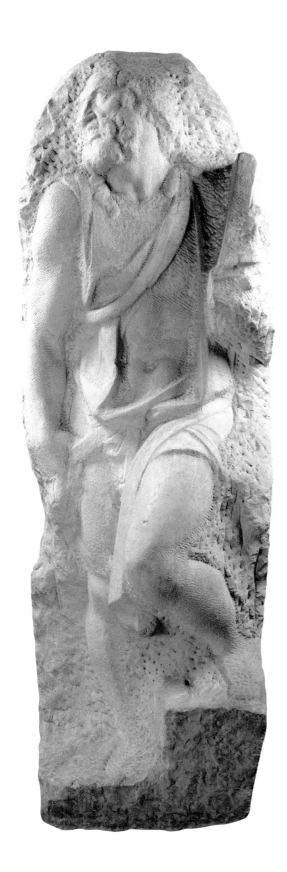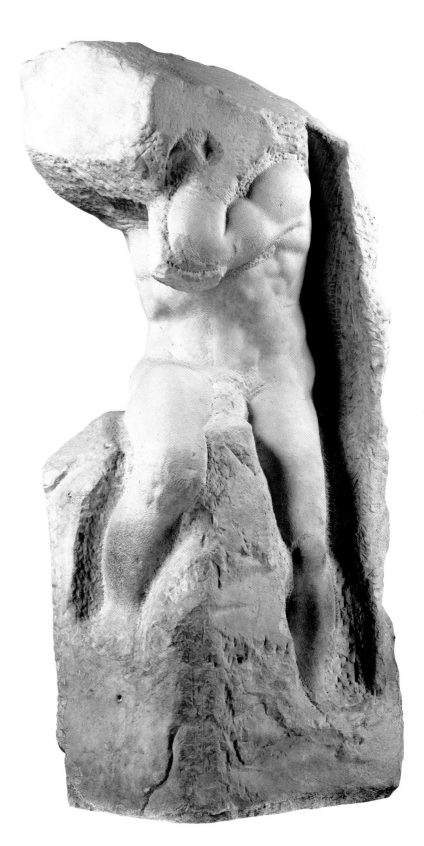

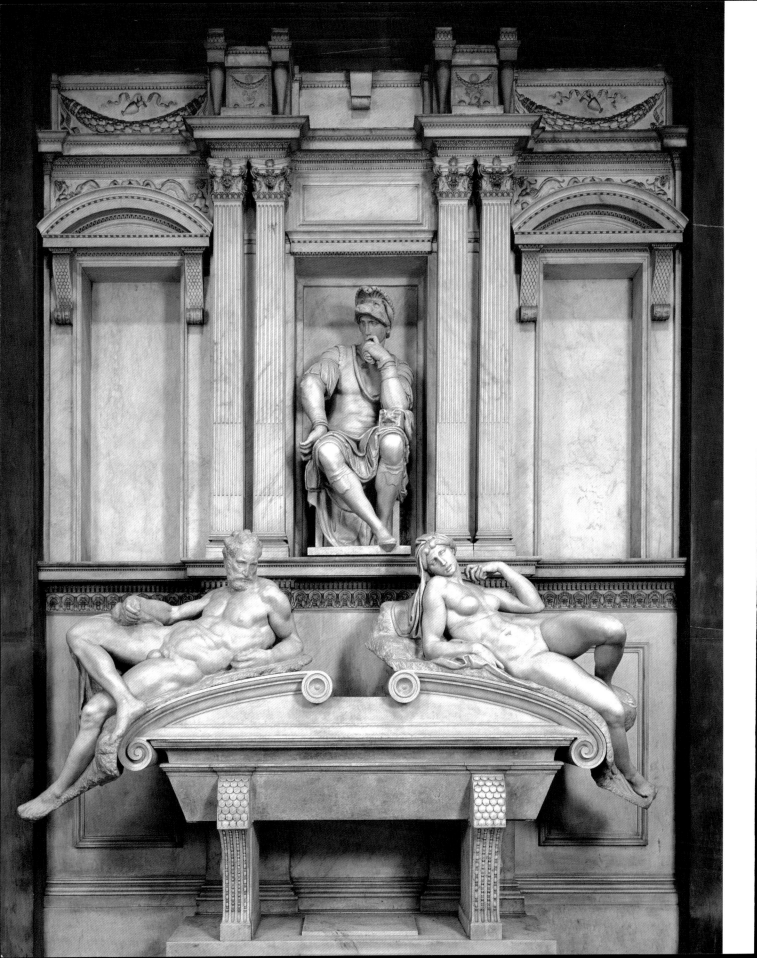

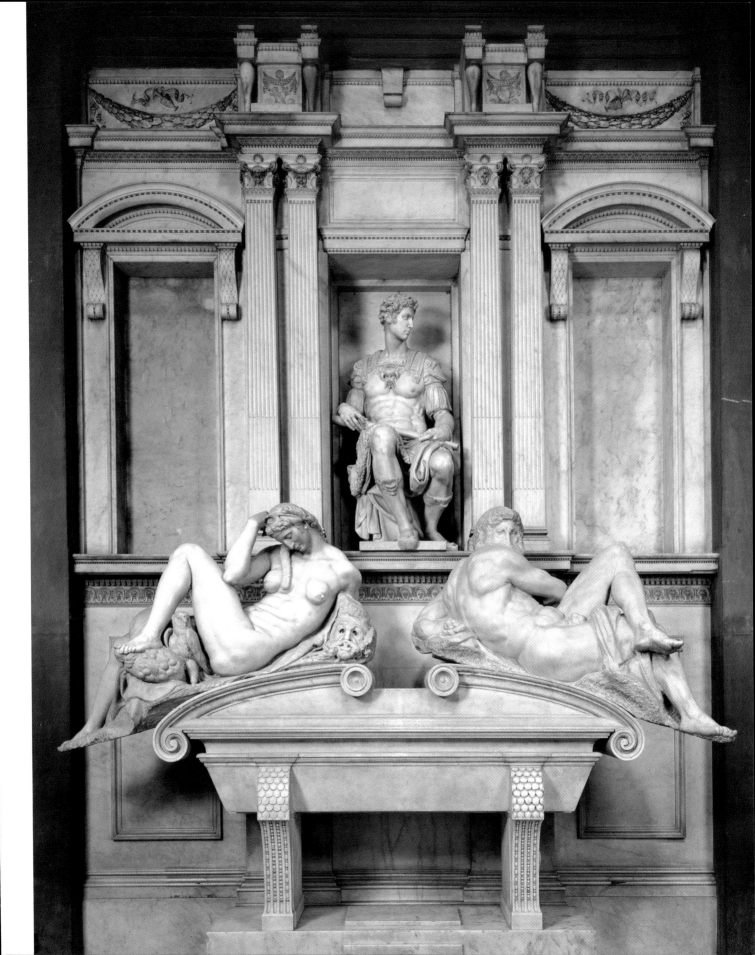

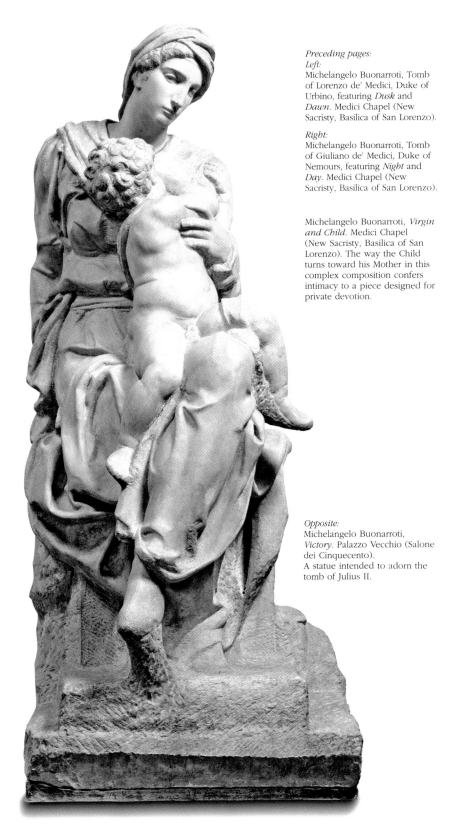

Michelangelo Buonarroti, *Virgin and Child*. Medici Chapel (New Sacristy, Basilica of San Lorenzo). The way the Child turns toward his Mother in this complex composition confers intimacy to a piece designed for private devotion.

Opposite:
Michelangelo Buonarroti, *Victory*. Palazzo Vecchio (Salone dei Cinquecento).
A statue intended to adorn the tomb of Julius II.

outstanding as a reinterpretation of the Roman bust and for its artistic and psychological strengths. Housed in the Bargello, it is one of the sculptor's most important so-called unfinished pieces. Here, more than in the group pieces, it is easier to appreciate the progress from the blocked-out study to the fine chiseling, the hewing away of marble that Michelangelo exploited, much as a draftsman makes a preliminary charcoal drawing on lined paper, to obtain a range of vibrant, silky to roughly faceted surfaces that would capture the light in different ways.

Notwithstanding Michelangelo's overshadowing most of the other sculptors of the High Renaissance with his impressively heroic works, his was not the only expression of a time that was deeply marked by formal changes in the style and content of statues. Florence had other artists of significant skill and imagination like Baccio da Montelupo, who at the time was so in demand that the silk makers guild awarded him the commission for a bronze statue of St. John the Evangelist (1514–15) that was to be placed in a niche in the cathedral where all the important corporations worshiped.

Quickly forgotten, this sculptor has only recently become the subject of study. He provides an excellent example of how in its later years the Florentine republic could look back for inspiration to the style of Ghiberti with its strong Gothic overtones, which were still sought after in statuary by conservatives and which Raphael would exploit in painting.

In the same vein, but with greater success and, for us, easier to appreciate, is Andrea Sansovino, who rose to fame with his measured composition *The Baptism of Christ* (1502) set on the front portal of the Baptistery. It is the only marble group on the outside of the octagonal building and it features finely worked figures, which, in simple, fluid forms, express an ideal of beauty far removed from either the antique or the then contemporary model. The addition, in 1792, of Innocenzo Spinazzi's late Baroque angel seems somewhat inappropriate. However it is in the Corbinelli altar (c. 1490–92), in Santo Spirito that the young Andrea Sansovino would make his exceptional talent clear, also designing the wonderfully coherent formal architecture that surrounds it.

Two major influences immediately become apparent: the first, which came from antiquity, was the triumphal arch of Constantine in Rome from which the scenes of armed figures in the upper part of the architectural decoration clearly derive; the second contains a contemporary reference to the now lost

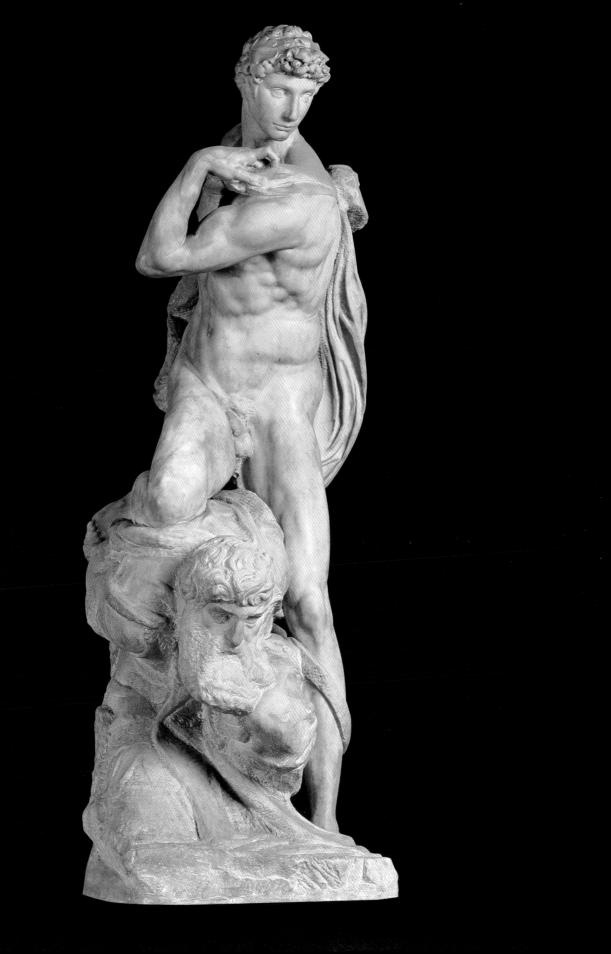

Monument to S. Giovanni Gualberto, the most
important work by Benedetto da Rovezzano
who would not see his work completed. The
different pieces, commissioned by the
Vallombrosano Order were, while awaiting
removal to the church of the Holy Trinity
where they were to be placed in position,
damaged beyond repair by soldiers quartered
in San Salvi during the siege of Florence.

Giovan Francesco Rustici (1474–c. 1554),
who was cited by Pomponio Gaurico in 1504
as being one of the best Florentine sculptors
alongside Andrea Sansovino and Michelangelo,
worked in an entirely different style. One of
the very few works that can be attributed to
him without doubt is the 1506–11 bronze
figure of *St. John the Baptist Preaching,* which
is located on the north door of the Baptistery.
A reconstruction of his artistic career has
brought to light a considerable number of
terracotta works, some of which are glazed,
mostly in yellow and white, such as the *Noli
me Tangere,* originally in the Monastery of
S. Gallo, but now in the Bargello National
Museum. His small terracotta groups of
soldiers armed and mounted on horseback are
of particular interest. In all probability, they
derive from Rustici's study of Leonardo's ill-
fated great work, *The Battle of Anghiari,*
commissioned for a wall in the great council
hall, the Salone dei Cinquecento as it is
known today, in Palazzo Vecchio. In these
statues, particularly the bronze triad, Rustici
attempted to transpose to sculpture the soft
edges typical of Leonardo's chiaroscuro
painting technique. Rustici's vigorous statues
probably represent the first three-dimensional
example of Mannerism with their artfully
intricate draperies clinging like silk or hanging
heavily like coarse fustian and whirlpools of
chiaroscuro modeling the surfaces. While they
suggest a meeting point between the
Herculean proportions of a Michelangelo and
the complicated articulations of Leonardo's
paintings, they fail to rise to the sophisticated
level of a Raphael or the moral dignity of an
Andrea del Sarto, an artist from whom Rustici
certainly drew his inspiration.

From the point of view of the themes they
treated, all of these artists mirrored the
Florentine civic ideals of a proud republic as
heroically represented by Michelangelo's
marble *David,* which, unfortunately, was now
all but extinct.

Considered to be extraordinary by all who
saw it, Michelangelo's colossal statue was
chronicled in detail from the very start. The
marble block was originally assigned by the
Opera (cathedral works commission) to
Agostino di Duccio who had left his work

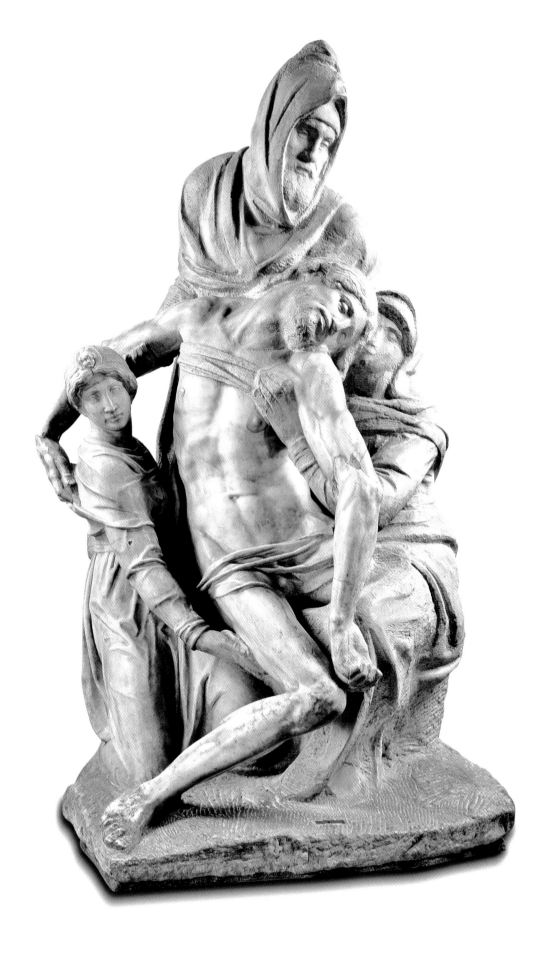

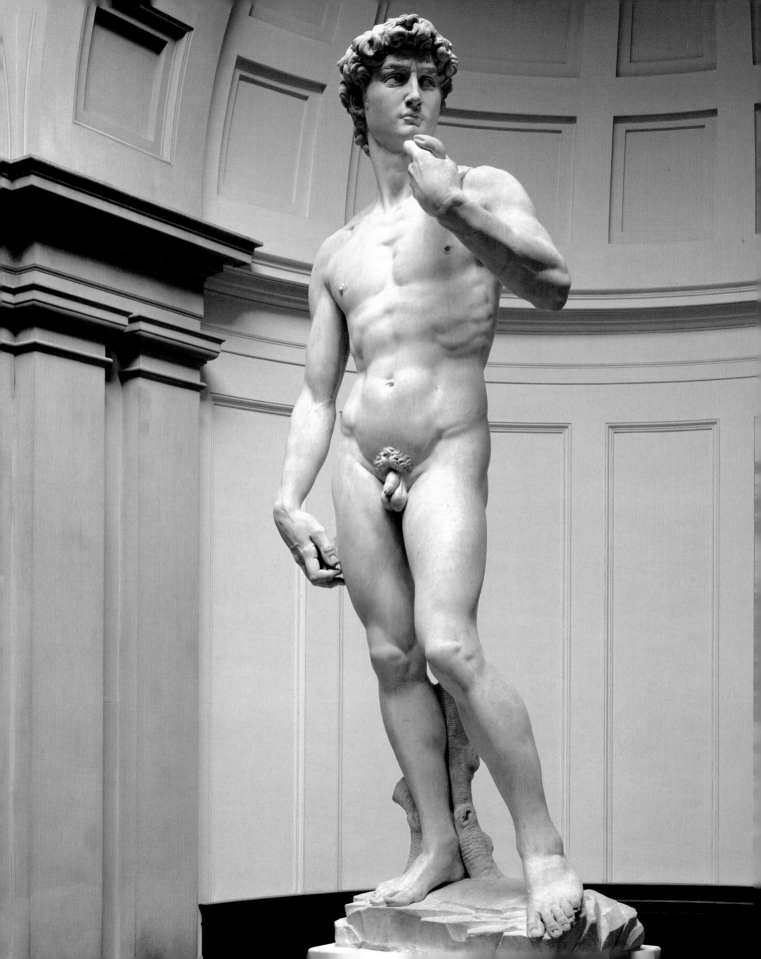

unfinished. No one had felt confident enough to start again upon the massive block until Michelangelo conceived his project for what would become the *David*, portrayed for the first time as a heroic nude.

Donatello's version of the biblical hero, David, takes its cue from different iconographical sources—although his hat and sandals derive from the Hellenic tradition, his jaunty appearance sets him apart from classical statuary. In the case of the youth standing in the Piazza della Signoria, with the exception of the sling carelessly hanging over his shoulder, references to previous examples are set aside. This David's determined eyes seek out his target as he almost seems to keep watch over the Roman bridge (now the Ponte Vecchio), crossing the Arno, ready to protect the city of Florence against those wanting to seize power.

The political message was very clear and artfully translated by the sculptor who ignored set formulas and instead relied entirely on the massive statue's conspicuous presence to make itself felt.

Michelangelo had opened a new road in sculpture and although many of his peers made impressively large statues, they were incapable of approaching his universal genius. A hackneyed term perhaps, but in this case it is totally fitting. The genius of Michelangelo also opened the way for other virtuoso experiments that would be called Mannerist.

The *Victory* group (1520–25), which once again stands in the Palazzo Vecchio, was designed with the four *Slaves* (now in the Accademia) to be included in the monumental tomb of Julius II. In 1564, Vasari reported that it was still in Michelangelo's studio in Florence. After his death, the sculptor's nephew Lorenzo proposed positioning the marble piece on the funerary monument to Michelangelo planned for Sta. Croce, and which Daniele di Volterra was supposed to design. It appears that Vasari considered the *Pietà* (now in the Museo dell'Opera del Duomo) a more appropriate crowning to the work, but the question remains whether Vasari's comment that, "Michelangelo was never a soldier who was beaten by anyone," was more probably an ill-concealed move aimed at his (eventually Lorenzo's) being able to offer the *Victory* to Duke Cosimo di Medici, who was destined to inherit the grand duchy and which became his five years later, in 1569.

The *Victory* group would quickly gain the stature of an icon, setting the pace, as critics have variously agreed, in the development of the serpentine, or intertwined, composition. This artistic device, which provides a solid base for a group, also makes the sculpted

figures interesting from several viewpoints. This enhancement of in-the-round statuary appealed to several artists who immediately set to work intertwining figures that they cut from a single block of material. Such was the case with Pierino da Vinci (*Sampson Defeating the Philistines*, courtyard of Palazzo Vecchio) and with Vincenzo Danti (*Honor*, Museo Nazionale del Bargello). In the case of Giambologna's statue of *Florence Triumphing over Pisa* (previously housed in the Bargello, but now in the Salone dei Cinquecento in Palazzo Vecchio), the artist made an almost virtual copy of the pose. A comparison between the two works is revealing because it allows us to understand how Flemish art influenced the Mannerist tendency throughout Europe—although the modernity of the work of the Master of Douai did not fail to captivate the artists of the time, Michelangelo's *Victory* still remains a unique masterpiece. Unmatched for its powerful originality, it shows the desolation of an old vanquished man, the memory of whom already fades indistinctly into the marble, while from the mist enveloping the world of neoplatonic ideas, a youthful, heroic embodiment of energy emerges. The obvious victor in an unequal battle where no details have to be explained and the nature of the victory remains unspecified, the sheer size of the victor tells it all.

Mario Scalini

Statuary in the "new" Rome

The person who held the field at Florence when Alessandro de' Medici took power with the help of the imperial army was Baccio Bandinelli (1488–1560). Son of a Medici follower and already a frequent guest in the Via Larga residence in the time of Lorenzo the Magnificent (il Magnifico), he was in possession of and intended to leave to his descendents a goodly part of the collection of vases made of marble and semiprecious materials, many mounted in silver and gold, that had belonged to Lorenzo. They were the same ones that in the time of Leo X had been placed, along with many others, near the tombs designed by Michelangelo in the counter-facade of the church of S. Lorenzo.

Alessandro, the new lord of Florence, faced a problem that would not be easy to solve—one of legitimizing his own power. In Italy, from the 15th century onward, the various lords who had risen from the lower ranks of the aristocracy had done so with military assistance. They felt a need to enhance their new status with a classical touch. In this, they were undoubtedly helped by the humanists who were well acquainted with the tradition by which the centuries-old, princely power of the Church of Rome descended from the authority of the emperor. It was a matter of

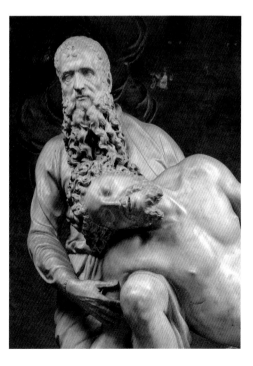

Baccio Bandinelli, *Nicodemus supporting Christ*. Basilica of the Santissima Annunziata. The sculptor-architect made this group for his own tomb. The face of Nicodemus is probably his own, idealized, while the body of Christ competes with that sculpted by Michelangelo.

tracing the right sort of genealogical lines, making one's coat of arms more noble and impressive, and conferring moral authority upon the prince by making him a fine example of noble culture.

If this complicated system of legitimization could be channeled via literature, legal systems, or poetry, so that a ruler's peers doffed their hats or even endorsed a genuine investiture by one of the medieval institutions that had conveyed power from the emperor or the pope via their representatives since time immemorial, so be it. The easiest and showiest way to receive the required obeisance, while communicating the direction the new power would be taking, was through the visual arts and architecture. Particularly useful was architecture in underlining magnificence, the indispensable trappings of a ruler, while painting and sculpture played their role in disseminating other concepts. The illusions created through the colors and forms of two-dimensional art transposed history into a readable form. By other means and in different forms, they created a simple link with the traditional iconography of religion, a truth that had bolstered itself with the repetition of compositional and iconographical models.

Statuary, which had always played an important role for the Roman Catholic Church, represented one of the most effective ways of communicating political messages to the masses.

This simple idea became clear following archeological discoveries that brought dozens of busts and statues of toga-clad emperors and matrons to light. It was abundantly obvious that huge statues would be an excellent way of increasing the stature of the rulers of the new Italian princely states. In Florence, in particular, where there was an existing school of sculptors and stone workers, it was thought that statuary could be put to appropriate use.

There are far older instances when highly symbolic single or group figures had been put to use in this way. For example, we can mention the classical horses on the roof of St. Mark's basilica in Venice, the Scaligere Arches in Verona, the equestrian statue of Barnabò Visconti, and the bronzes of Gattamelata and Colleoni, which Donatello and Verrocchio had cast. No less important had been the more accessible symbolic figures of religious connotation made before classical mythology had been rediscovered and its message had re-entered popular lore.

If considered in that light, the statue of *Hercules and Cacus* sculpted by Baccio Bandinelli for Duke Alessandro takes on a somewhat different meaning. The composition,

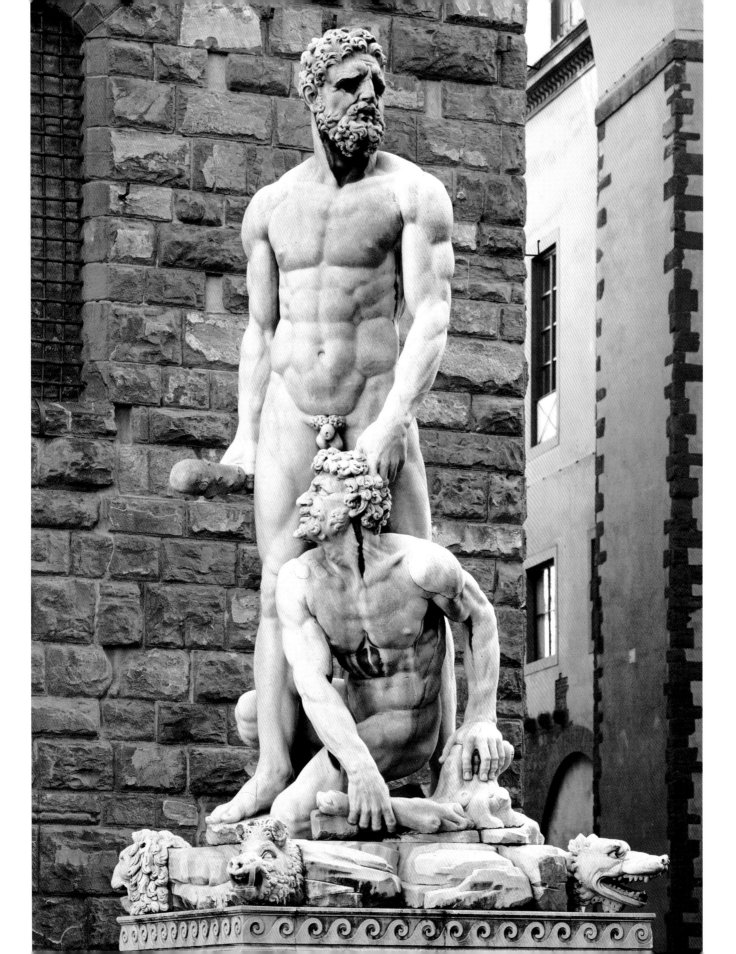

dated 1534 on its elegant base, was a direct challenge to the republican *David*. However, the comparison to Michelangelo's masterpiece did not exalt Bandinelli's work as the rippling muscles drew critical comment like 'looks like a sack of potatoes.' It must be noted, however, that the merciless, if subjective, criticism of the artistic worth of the colossal group was also due largely to the hatred the Florentines bore toward a lord whose authority they did not recognize. One has only to realize how the marble could easily have broken or shattered during the long period of constant chiseling and working, or of the complex calculations required to produce a group of this size and kind, with its extensive undercutting, from a single block of marble. These considerations also lead one to be left in wonderment about the daring of Michelangelo (compared with his contemporaries) when we count the statues that were left unfinished after he damaged them during their making—the *Florence Pietà*

in the Duomo on which one of the legs of Christ is a replacement and the *Rondinini Pietà*, a marvelous roughed-out group on which the scantiness of the marble made it impossible to develop the desolate vertical Mother and Son composition any further.

Baccio Bandinelli was undoubtedly an able sculptor and a shrewd court follower, but his tendency to please his patron often prevented him from rising to the heights of truly great art. His style took its oversize aspects from Michelangelo, but his interpretation focused on massive muscular bodies rather than abstract, heroic ideas.

Indeed, his best work is the group *Nicodemus Supporting Christ* (1554–59), which he designed for his own tomb in the Santissima Annunziata church. This desolate scene, which features all the normal Baccio Bandinelli characteristics, can be compared with the artist's youthful work, the *Orpheus* which he made for Leo X. The path that this

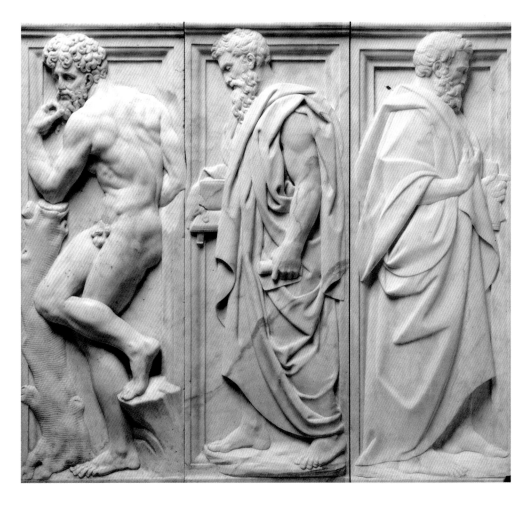

Baccio Bandinelli, *Prophets*. Duomo (Chancel screen).
The low relief of notably synthetic features was made with the collaboration of Giovanni Bandini, also called dell'Opera. The way Michelangelo's ideals have been adopted is interesting.

artist and indeed most Florentine sculptors had followed becomes quickly apparent.

The influence of Michelangelo was felt on all Italian sculpture during the Cinquecento and spread beyond the Alps. It began in Florence with his work on the San Lorenzo complex (1520–34) when the four reclining figures, *Day*, *Night*, *Dusk*, and *Dawn*, destined for the tombs in the Medici Chapel, were still lying incomplete on its floor.

After the 1530s, elegant, balanced, classical works such as Jacopo Sansovino's *Bacchus* (1510–12) began to be considered superficial and outdated. This artist, who was nevertheless highly sensitive to the new message, had made an early start on demonstrating it in Rome, in his *St. James of Compostela* (1518–19), a work originally destined for the chapel of Cardinal Giacomo Serra in the church of S. Giacomo degli Spagnoli in Rome. It is now in the church of Sta. Maria of Monserrato in the same city. Jacopo Sansovino would make his own independent, lyrical way during his long stay in the Veneto where he was the most talented of the local sculptors for the remaining part of the century, and would produce his famous statue of *Victory*.

The language of Michelangelo, sublime, as it would be dubbed in the 19th century, which made a romantic reading of his style, lent itself, albeit superficially, to exalting worldly glory. The century-long taste for gigantic works is the clearest demonstration of how dynastic logic took possession of grandiloquence and turned it to its own political use.

The idea of using form as a parallel to, or a way of supporting and explaining ideas is not new. Religious art has always used this simple, essential, silent means of getting its message across through images. The Renaissance exploited this idea fully, and, as time matured its non-religious ideals, figurative art was found to be the best form of expression. The dynastic houses ceased to look to religious models for the means of celebrating their centuries of existence; in the classical world, they discovered models that suited the times. It is no coincidence that Cosimo I wished to transmit an image of himself that recalled the emperors of antiquity whose busts he collected and exhibited along the corridors of the Uffizi. It was almost as if he wanted their empty, sparkling eyes to confirm that he, the Tuscan grand duke, was a direct descendent of theirs.

The best illustration of this is the bronze bust of Cosimo housed in the Ny Carlsberg Glyptotek, Copenhagen. Doubtless executed

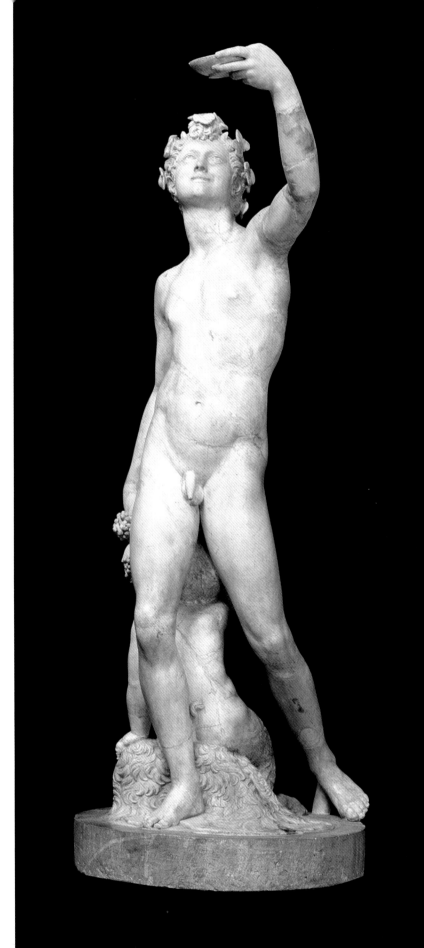

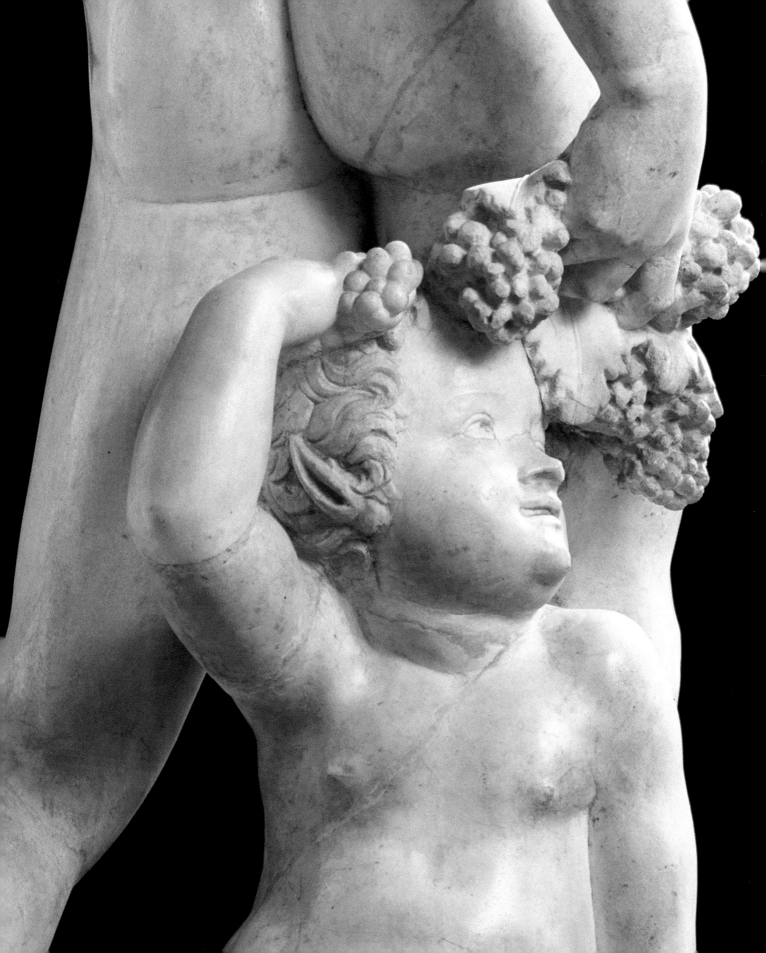

by Ludovico Lombardo, as the base informs us, it is in the style of antiquity and fairly typical of the sculptor's production.

Thus, the policy of public patronage started by the Medici in the 15th century continued unabated, with the encouragement of the entire dynasty and especially with the overwhelming support of Leo X and Clement VII. An indication of the special relationship that Florence shared with Rome for the period that extended beyond the two papacies is given by the fact that Vincenzo Danti (1530–76), a native of Perugia, went to Florence immediately after Cosimo won the war against Siena and stayed there for the rest of his life, serving the grand duke to whom he also dedicated his 1567 work entitled *Trattato delle perfette proporzioni* (Treatise on Perfect Proportions).

One can also recall how, during his visit to Pius IV de' Medici di Marignano (1559–65) in Rome, Grand Duke Cosimo was given the *Paris and Elena* statuary group by Vincenzo de' Rossi (1525–87) who no doubt hoped to ingratiate himself with the pope as well. The group has remained in the larger grotto of the Boboli Gardens since 1587. Compositionally, the two entwined figures demonstrate one of the most famous Mannerist characteristics—the group rather than the single sculpted figure. In all probability, they were inspired by the *Aeneas and Dido* group. The two figures take their place in the symbolic context of a series of artificial rooms that range from the rusticated to the naturalistic and feature sponge-walled, stalactite-hung, shell-encrusted areas decorated with a variety of other products of the Creator, artistically contrived by the imaginative genius Bernardo Buontalenti (1536–1608) and his collaborators. It is here that Michelangelo's *Slaves* become Telamon figures, alluding to the reigning house whose origins surely went back to the Etruscans, to Troy and to such illustrious ancestors that the memory of them and the authority conferred by them went back even further. *Aphrodite*, whose image (by the hand of Giambologna) features in the last room, the 'holy of holies' of the grotto, keeps watch over their tortuous, troubled love.

The strongly symbolic content of Cinquecento statuary, expressed in Mannerist terms and the contrived classicism that reflected the high sounding ideas court society had of itself, were essential aspects in the creation of statuary and groups that demonstrated to the people of the time how splendid power was, how civic magnificence could come from a strong but fair government run by a refined aristocracy of superior culture

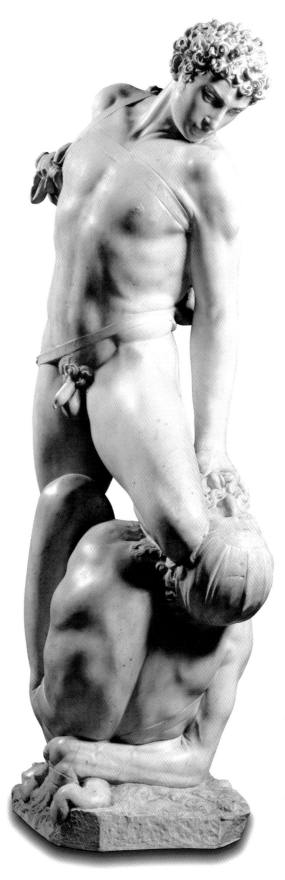

Opposite:
Jacopo Tatti, known as 'il Sansovino,' *Bacchus.*
Detail of the little satyr. Museo Nazionale del Bargello.

Vincenzo Danti, *Honor.* Museo Nazionale del Bargello.
Danti's statue is a variant of the two-combatant composition as seen in Michelangelo's *Victory* and in his now lost *Samson.*

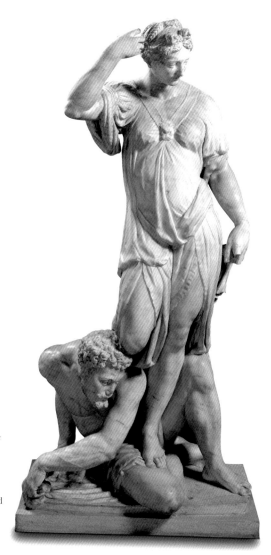

Bartolomeo Ammannati, *Victory*.
Museo Nazionale del Bargello.
This statue group is perhaps one of the
most noble and graceful works made
by the sculptor. So light is the step of
the symbolic Victory that it barely
seems to be felt. The weight of the
female figure dominating the
vanquished male seems to be measured
in moral and idealistic rather than
merely physical terms.

Opposite:
Bartolomeo Ammannati, *Neptune*.
Piazza della Signoria.
The large fountain, commissioned for
the marriage of Francesco I de' Medici
to Joanna, the natural daughter of
Charles V the Habsburg emperor,
features a huge statue of the sea god
surrounded by triton spouts and
standing on a chariot pulled by sea
horses. At the corners of the great basin
there are groups of bronze nymphs and
river gods.

under an exemplary ruler. In the Italian
peninsula and more particularly in Florence,
this person was like Machiavelli's Prince,
presented in an up-dated version following the
civil dictates laid down by Baldassarre
Castiglione's Courtier.

It was from this complicated mix to which
the Florentines added timely attributes of
erudition that the previously hinted at, purely
Italian idea, of Caesarean majesty sprang.

The way these ideas were made visible in
Florence was so marvelous and spectacular
that within the space of half a century, or of
slightly more than one generation, the very
face of the city changed and became what it is
today. One of the most significant and visible
of these changes was the placing of the
fountain in the Piazza della Signoria. The idea
of putting a fountain in the biggest open space
in a city goes back to Roman traditions. 'The
center of the world,' as Rome the capital of

the empire and later the seat of the papal state
had always been called, was an urban mass
where plentiful waters were conveyed by
engineering ingenuity 'for the use and comfort'
of the city's citizens—language that was not
lost on 16th-century townspeople. With
running water readily available to assure the
city was kept clean, the people refreshed in
the summer, the horses watered and rested,
Florence was ready to set itself up as a rival
city to Rome.

The fountain project was linked to the
marriage on December 18, 1565 of Francesco,
son of Cosimo I, and Joanna, duchess of
Austria, the natural daughter of the emperor
Charles V.

The competition, which even Benvenuto
Cellini (1500–71) and the young Giambologna
(1529–1608) had taken part in, had been
opened in 1559–60, indirectly to celebrate the
new naval powers of the grand duchy.

When, at the marriage of Francesco, the
gigantic figure of Neptune rose from the
temporary basin of the fountain, located at the
corner toward the center of the square, the
chariot and other details of the monument had
to be made in a hurry out of bricks, mortar,
and stucco, and, as the contemporary record
shows, it quickly fell apart. It was only in 1572
that the work was able to be carried out in a
proper, lasting manner.

Despite the damage over time and
substitution of one of the satyrs decorating the
shelf of the outermost basin of the fountain,
the monument still presents itself today as it
did then—the chariot bearing the sea god has
wheels and the hub shows rudder-like rays
decorated with the signs of the zodiac.

The water overflows from the inner basin
into the outer until it reaches the catch-alls
that are slightly below the ground level of the
square so animals can drink from them. The
innumerable waterspouts, once 70 in number,
but many of which are now blocked, are
directed to spray upward so that the huge
statue seemed to be rising out of a foamy
cloud, which, one can imagine in the summer
sunshine, would have been colored like so
many rainbows.

The care taken in creating a solemn,
powerful image, albeit it in such a decorative
manner, gives a clear indication of how, in this
case, as indeed in the whole program of
sculptural adornment, the Medici were aiming
to underline their royal and dynastic caste by
the means of a city-wide placing of statues
permeated with heroic and allusive content.

Cosimo was not content to limit himself to
commissioning works from contemporary
artists; he filled Florence with rare,

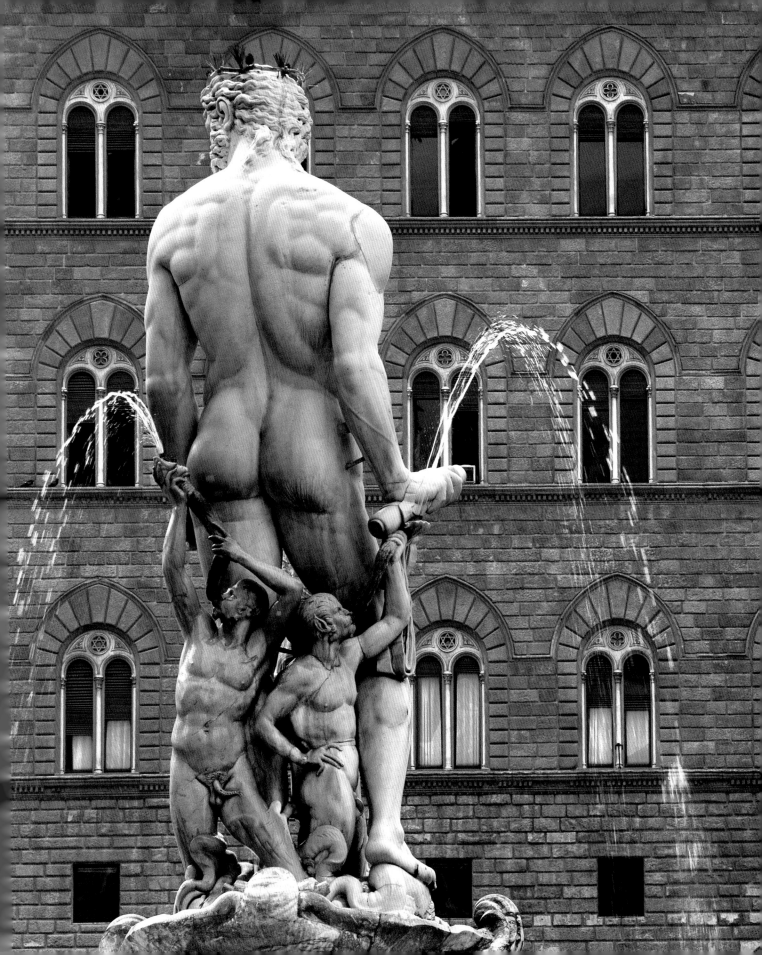

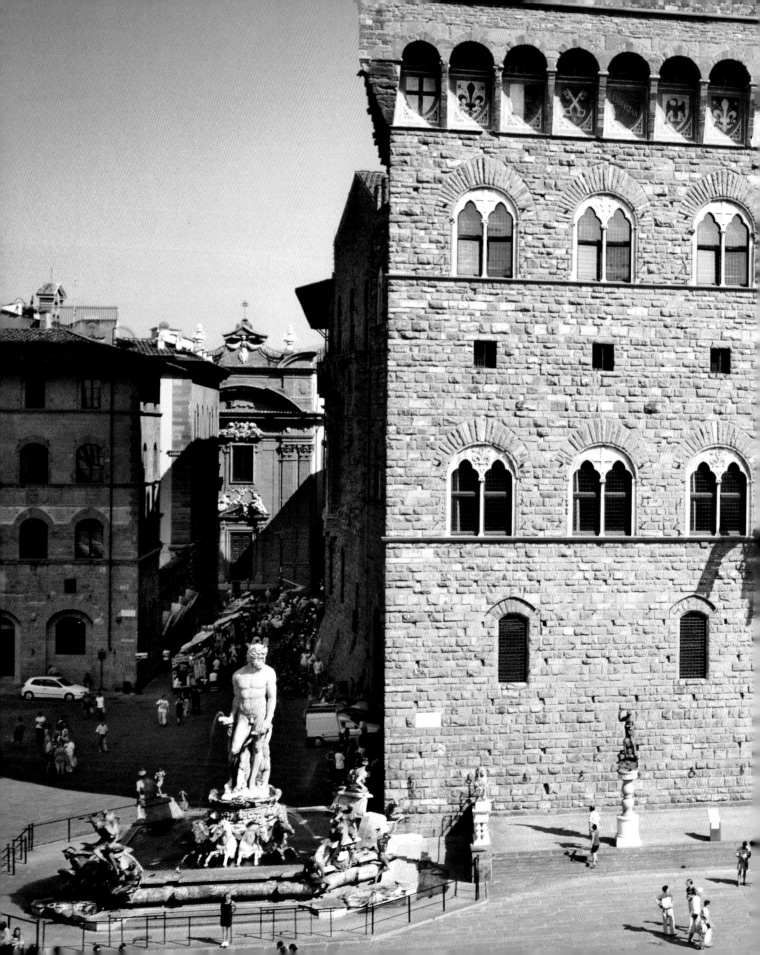

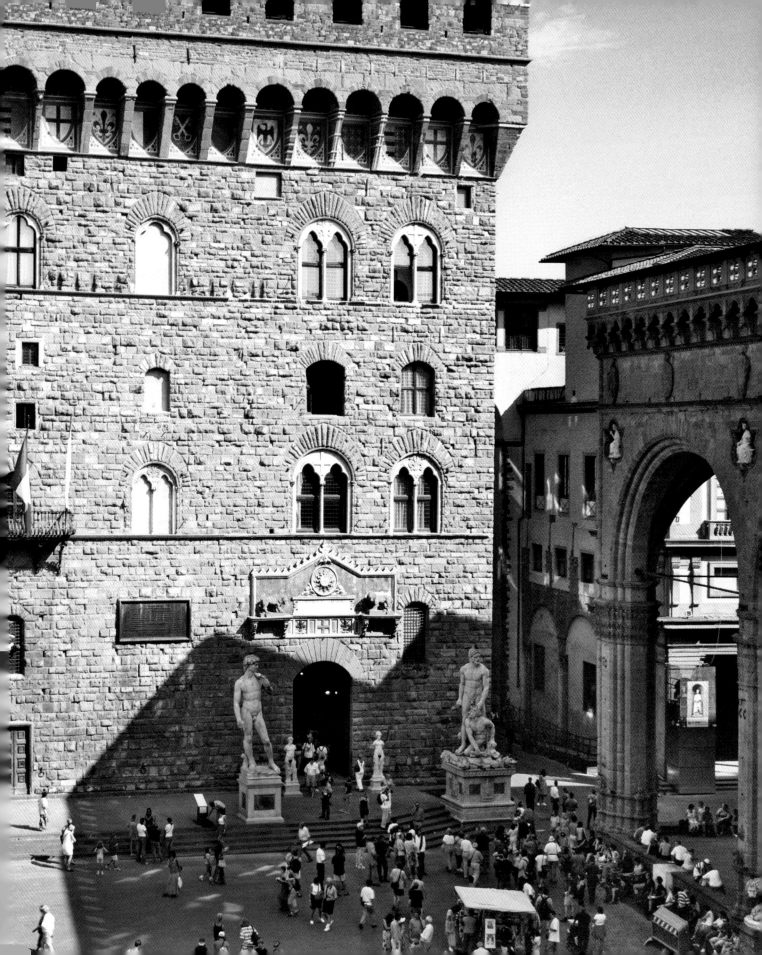

monumental statues from antiquity, many of which came from Rome and Lazio. This beautification project for Florence was one of the main reasons why the Medici became such great art patrons.

With the encouragement of his relative the pope, Duke Alessandro had started early on what can be defined as a dynastic program and which went on to include every type of statuary, whatever the style. For example, look at the *Virgin and Child with St. Anne* group commissioned in 1522 for the church of Orsanmichele, and executed by Francesco da San Gallo (1494–1576). It is one of the most interesting examples of religious statuary from the first quarter of the century and a prelude to many works that Cosimo I would entrust to the artist.

There is already a concern with creating a statuary group in which well-known formulas are avoided, a concern that would keep most of the Florentine sculptors increasingly busy as can be seen in the Pierino da Vinci work (c. 1531–54) entitled *Samson Defeating the Philistine.* This is interesting not only for the artist's interpretation of Michelangelo's work, but also because it recalls Roman versions of the Greek statuary group, *Menelaus Supporting the Body of Patroclus,* popularly known as the Mastro Pasquino, which were already circulating in Florence. One of these, which at one time was to be found at the head of the Ponte Vecchio and which now is located in the Cortile della Fama, one of the smaller courtyards in the Pitti Palace, underwent restoration on various occasions. It was only in the 19th century that it could be openly compared with the version installed under the Loggia de'Lanzi in the Piazza della Signoria.

Thus Florence celebrated itself as a new Rome, a place of cultural rebirth and civic splendor. It even became the cradle of the papal authority after the Sack of Rome, when the Medici popes found themselves at the helm of the western world and not only in religion. The push toward urban magnificence overlapped with Michelangelo's artistic career, a coincidence that led to his work being emulated by other artists as they had in the time of the Medici in Via Larga. The tribute paid to Michelangelo reached its highpoint in the funerary monument built to him in the Franciscan basilica of Sta. Croce. It placed a moral seal upon his greatness.

The story of how the famous statuary monument came about is interesting. Following the solemn funeral of Michelangelo held in the church of S. Lorenzo on 14 July 1564 (for which Benedetto Varchi composed one of his greatest sermons), Vasari began his project for the structure of the monument starting, in part, with the catafalque designed with Agnolo Bronzino and Benvenuto Cellini. Vasari's plan called for a crowning ornament featuring a marble statue entitled *Architecture* by Giovanni Bandini, also called dell'Opera (1540–99), an artist, like Michelangelo, from Caprese, who had already made a model of the statue destined for the sculptor's catafalque. The elaborate allegorical decoration for the project was drawn up by Vincenzo Borghini and included contributions by Battista Lorenzi (1527–94) who sculpted the statue of *Painting* and the bust of Michelangelo, and Valerio Cioli (1529–99) the statue of *Sculpture.*

Apart from its artistic value, the monument carries significant allusions. It places Michelangelo's artistic genius on the same level as that of the greatest creative minds in the fields of literature, politics, and religion.

It was feasible to create a monument of this grandeur in Florence at that time because of the artists supplied by the Accademia delle Arti del Disegno. This institution was inaugurated by Cosimo I in 1563 and still exists today, its main reason being to bring creative artists together under the same roof. Indeed, one cannot ignore the fact that the monument to Michelangelo reflects one of the basic theories formulated by the artists of Florence—Vasari being the foremost of these—who had been arguing over which of the visual arts should take precedence. The debate was eventually extended to include all the human sciences. Its main aim was to exalt the image of the artist, a figure who had always played second fiddle to philosophers, writers, magistrates, and even doctors. The last of these had early aspired to the same status enjoyed by the nobility. (During the Middle Ages, doctors had set up their own faculties in the universities or had organized their own corporations that had eventually led them to receiving social recognition.)

Mario Scalini

For the aggrandizement of the prince

Opposite:
Benvenuto Cellini, bust of *Cosimo de' Medici*. Museo Nazionale del Bargello. Considerably larger than life-size, this heroic bust of the first Florentine grand duke would at one time have been highlighted with silver and gold. It was kept for a long time on the island of Elba, displayed on the fortress of Porto Ferraio as a symbol of the authority and of the benevolence of Cosimo.

One of the functions that statuary, in the sense of plastic art, was expected to fulfill long before Mannerism, was the design of what we would now call "complementary decoration," which became a favorite method of work for a number of distinguished artists in particular during the 16th century.

The artistic liveliness of Florence, consequent to the Medici dynasty rising to power and the crucial role of the dukedom and then the grand duchy in shaping the regional states of the peninsula under the aegis of the empire, persuaded various artists to pass through and in some cases stay in the Tuscan capital.

This phenomenon was especially evident in the artistic circles, which had had little or no recent tradition in Florence—like tapestry hangings, metalwork, and glyptics—but it was also true of the fields in which the city had previously excelled. A considerable number of painters from other areas, Italian and foreign, and a few statuary sculptors, usually returning home from Rome, found hospitality in Florence. The result was a lively cultural ambience, internationally up-to-date, which cultivated a debate on classicism—the rediscovery of classical art was compared with the principally northern idea of formal virtuoso

Benvenuto Cellini (attributed), gold and enamel medallion depicting *Leda and the Swan*. Museo Nazionale del Bargello (Strozzi-Sacrati collection). This jewel was intended to be worn in a hat.

skill in the on-going pursuit of technical excellence, which had been the foundation stone of the artisanal mentality presiding over artistic development in Florence since the Middle Ages. There was a particularly welcoming attitude in Florence toward artists who, whether by their own natural inclination or simply complying with requests from patrons, took up the art of casting and working in miniature. Just after the war with Siena, which brought about the surrender of the "Sienese Republic in Montalcino," there were many craftsmen available who were skillful in casting and had up to that time been employed in supplying a growing number of cannons of medium and high caliber for campaigns and for arming the fortresses of Cosimo I. The duke therefore did all that he could to retain this valuable workforce who were mostly German or Flemish. On the one hand there was the project to arm a considerable naval force to protect merchant trade—where the declining star of Genoa was creating opportunities for barbarian navies—and providing the employment of a large number of craftsmen in the casting of naval artillery, and on the other hand it was decided to increase the amount of metal statuary inside and outside the court. The techniques of execution were of course different for the casting of artillery than for decorative bronzework, but many bell-makers were able to assist the more specific craftsmen in both activities, since to guarantee an appropriate sonority in their bells they had to be able to produce homogeneous and durable alloys, keeping the thickness to a minimum. It was no coincidence, therefore, that it was in Florence that the first larger-than-life-size statue to be cast in a single pouring was created: Benvenuto Cellini's *Perseus* (1554). The allegorical subject was clearly intended as a statement, to underline the new political course of Cosimo I, at the same time highlighting the technological capabilities of the State. It was finally realized—after a long experimental phase in the study of alloys and clays for casting, demonstrated by several casts by Cellini himself—in the plaque with the Saluki hound, down to the figures on the base of the statue itself; and in the model-statuette of the main figure whose function as a table fountain was received with great enthusiasm at court. All of these works are now in the Bargello National Museum.

In later years Bandinelli and Ammannati experimented with the art of toreutics—metal embossing. As a result, a series of statues were created, about an arm and a half in height, to place in niches in the Studiolo (the Study),

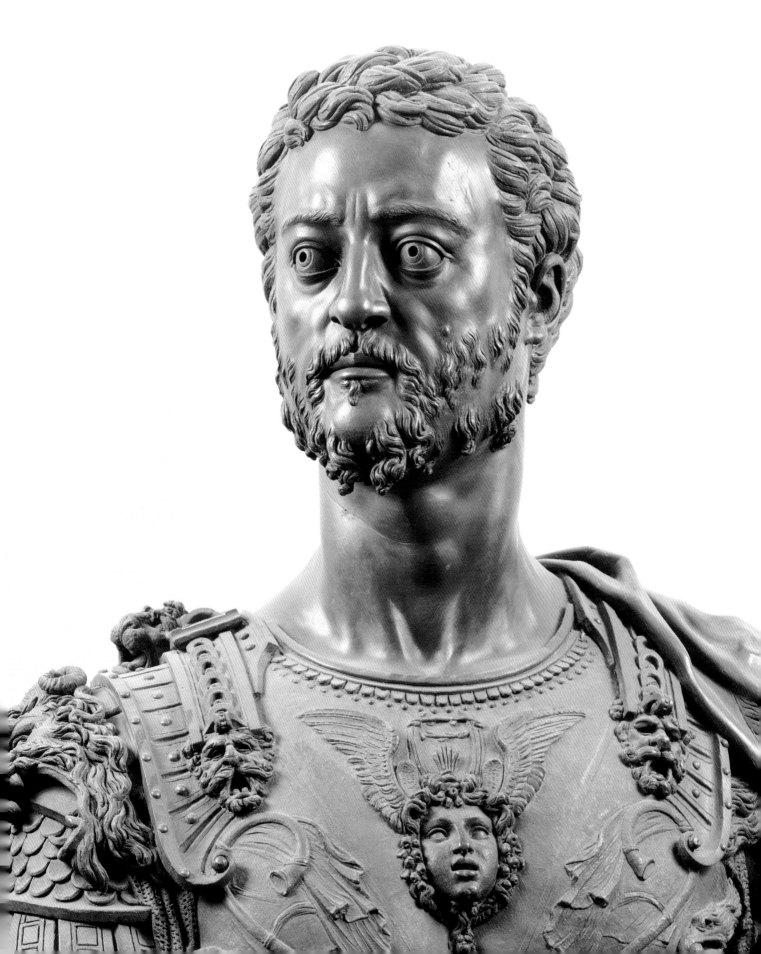

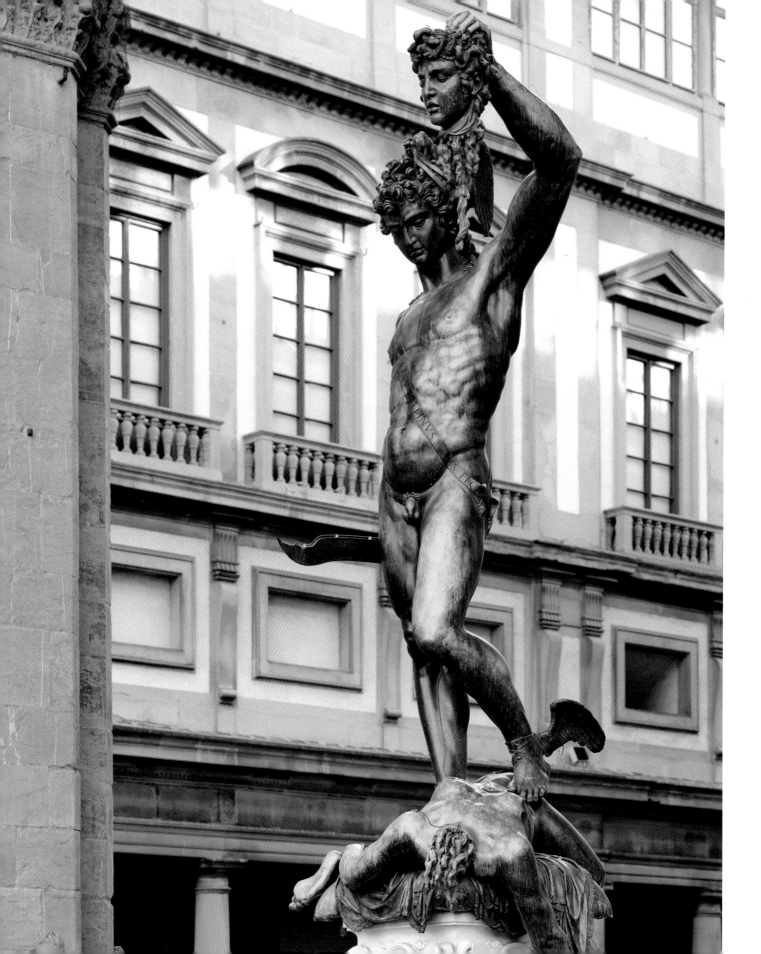

which Francesco di Cosimo I had built in a small chamber next to the Salone dei Cinquecento (Hall of the Five Hundred) in the Palazzo Vecchio.

These statues represent one of the creative peaks in Renaissance small-scale plastic art— their highly sophisticated torsion and their courtly grace, and the detail carried out with virtuoso skill. Each one was the creation of a different artist, each using his skill to the full in a sort of private competition in pursuit of extreme beauty, for individual pleasure and, most importantly, that of the prince.

Just a glance at the *Amphitrite/Galatea* by the little-known Stoldo Lorenzi (1534–83) shows that a perhaps mediocre artist could achieve such a fine result, placing the figure beyond historicism, as the innumerable copies of the work testify. While the collaborators of Bartolomeo Ammannati, working in the shadow of their principal, were engaged in producing satyrs and nymphs for the fountains in the squares, works were created like *Winter* for the pool at the Villa di Castello; *Hercules "exploding" Antheus* for the fountain with several basins one above another at the same villa; the admirable series of statues for the Studiolo mentioned above; and a larger-than-life figure that was declared to be a representation of a *Benign Mars*, but concealed a heroic portrayal of the future ruler, Francesco. This statue, directly attributed to Bandinelli in several documents, is of great importance when compared to the *Bacchus* made for Lattanzio Cortesi, which is the first monumental work of the Flemish Giambologna. From the waist down the resemblance between the two works, even from a technical point of view, is enough to suspect that identical wax impressions were used. The innovations of Giambologna in casting techniques for small as well as large bronzes was revolutionary to say the least, and certainly sufficient to make him the key figure in the revival of modern metal statuary. Beyond this, the master from Flanders was the one who knew better than any other how to respond to the wholly Mannerist request for figures artfully poised in space. The technical expression that indicates representation of the human body according to a compositional scheme that guarantees its full aesthetic appreciation, using approaches from several points of view, is the *figura serpentinata*, entwined figure. This exclusively formal theme kept Giambologna busy for a long time. The progress of his style can in fact be followed in the large number of statues and statuettes in bronze and in marble, of less than life-size, that he produced. Worth noting among his

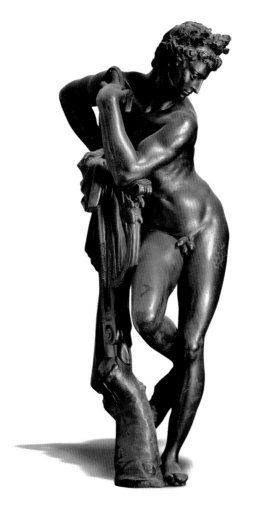

early works is a series of crouching *Venus* derived from the Hellenistic Venus in crouching posture, now attributed to Diodalsas, and which Giambologna studied in Florence in a mutilated version that he must have been engaged to complete. From these and various studies of the female figure, seated or standing, with one foot resting on a support so that the leg could bend, a number of sophisticated marble works emerged, including for example the *Venus of the Grotto* (described above) in the Boboli gardens. To the development of the entwined figure can be attributed the group *Rape of the Sabine Women*. Following in the footsteps of Michelangelo, Giambologna successfully applied the principles of spatial poising of the image to a group that included as many as three figures, creating the *Rape of the Sabine Women* (1583), which, under the western archway of the Loggia de' Lanzi, is a counterpoint to the unparalleled Cellini *Perseus* insofar as it is an exemplary work in marble statuary. Piazza della Signoria is therefore, by the wish of the Florentine republicans and the grand dukes, a real open-air gallery. Created to celebrate the political and moralistic content of the works that can

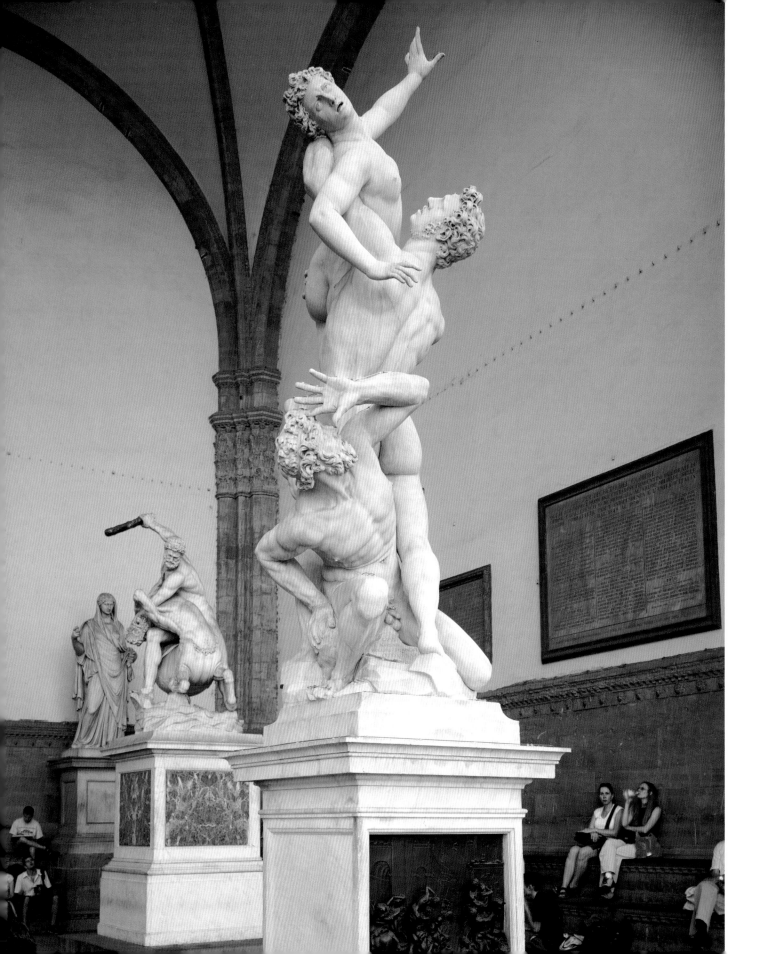

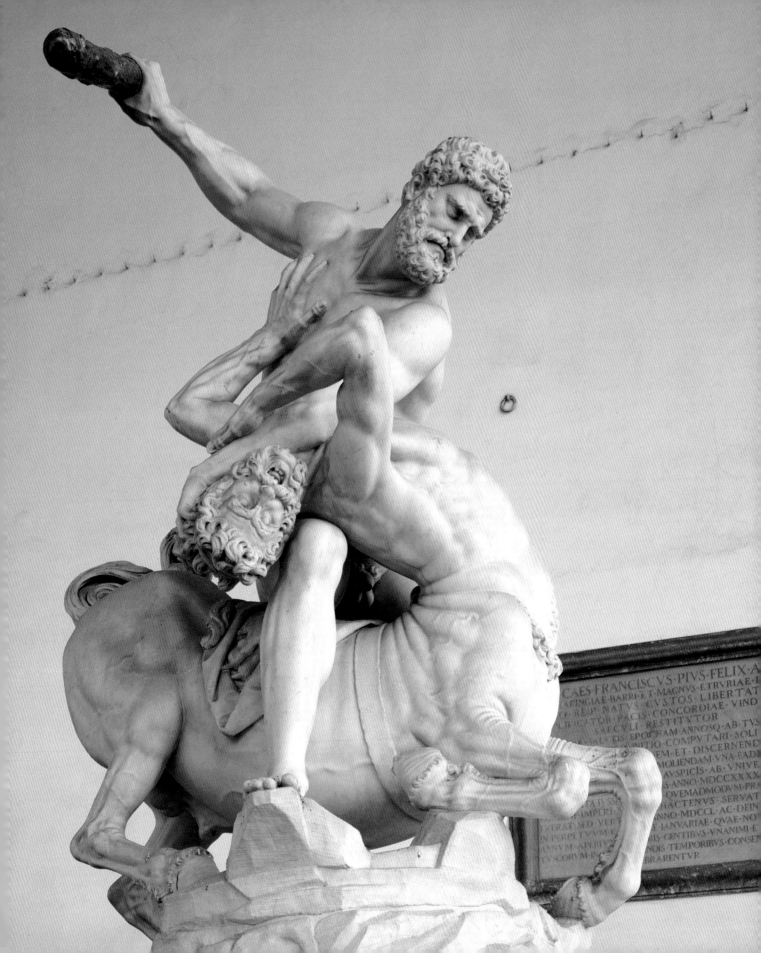

CAES·FRANCISCVS·PIVS·FELIX·A
ARINGIAE·BARRI·ET·MAGNVS·ETRVRIAE·I
REIP·NATVS·CVSTOS·LIBERTAT
LIBERATOR·PACIS·CONCORDIAE·VIND
SAECVLI·RESTITVTOR
SALA·EIS·EPOCHAM·ANNOSQ·AB·TVS
INITIO·COMPVTARI·SOLI
EM·ET·DISCERNEND
MOLIENDAM·VNA·EAD
AVSPICIS·AB·VNIVE
S·ANNO·MDCCXXXXX
QVEMADMODVM·PRA
HACTENVS·SERVAT
·IMPERI·N
VERAT·SED·VER
IN·PERPETVVM·E
ANNVM·APERIV
IS·GENTIBVS·VNANIMI·E
·NOIS·TEMPORIBVS·CONSEN
·CORVM·EV
BRARENTVR

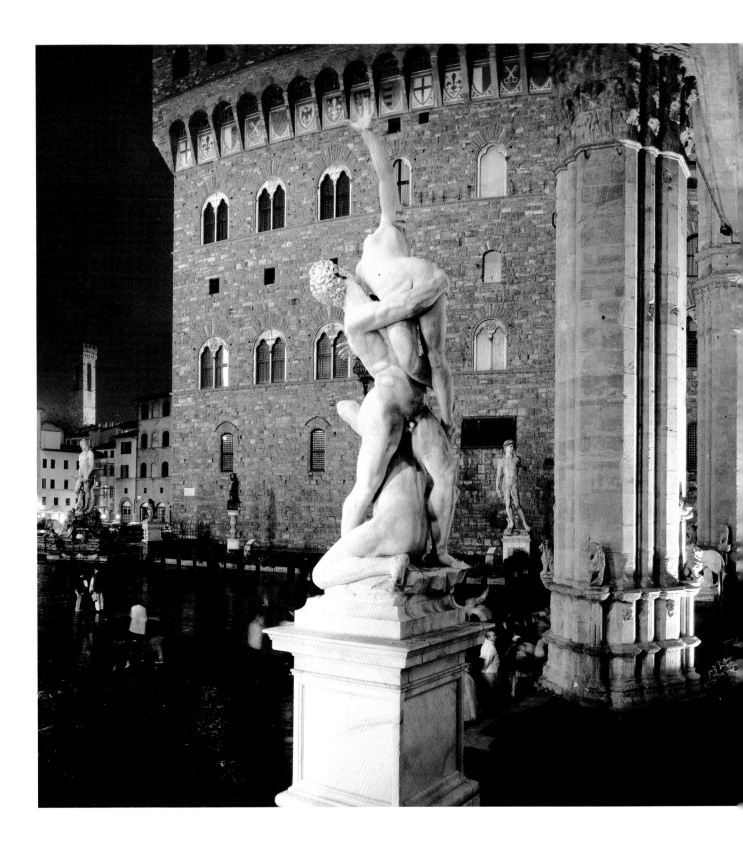

On the previous pages:
Ancient and modern statuary in the
Loggia de' Lanzi, a gallery to celebrate
classicism. Piazza della Signoria.

still be seen there, the square has also become
a kind of manual for excellence in the
sculptural and plastic arts. This secondary
message, less obvious to interpret, was a
feature of the square as might be imagined,
from the very time of Giambologna, and
beside the glories of ancient times prominence
was given to *Hercules Slaying Nessus* (1599) by
the same artist from Flanders, and later to the
Rape of Polissena (1866) by Pio Fedi
(1816–92). Despite these extraordinary feats by
Giambologna, who had shown great
sophistication in his technical skill—we must

Bandinelli, carried out for the Cathedral, but
now (due to purging during the Counter-
Reformation) in the Museo Nazionale del
Bargello. The figures represented in
Giambologna's compositions, at least those
dedicated to the *Labors of Hercules* are of
almost exactly the same scale as one another,
about one Florentine "arm" (27–28 inches/
70 cm) high—and indeed in his repertory this
does not appear to change greatly. The technical
process adopted, referred to as "*a cera persa*"
(lost wax casting), was based on individual
parts of figures that could be produced in series
using wax in single molds, and then assembled
by combining parts of statuettes that were
originally different to produce new studies or
variations on existing examples. This could be
repeated almost ad infinitum, since the partial
wax imprints taken from the single matrix could
be numerous and the individual components
could be modified during assembly, improving
details here and there if the result was not
satisfactory. High quality in the detail could
thus be achieved at reasonable cost for a much
wider market than for the ruling class alone,
without the need to sacrifice aesthetic pleasure
and the princely appearance of the product.
We may well imagine how this perception of
art, not only as an aesthetic experience, but
also as a commercial and technological
phenomenon, might suit Giambologna, born
and raised in a society with a decidedly
mercantile bent. Among Italian artists, only the
pupils and followers of Giambologna, heirs to
his workshop secrets and even the molds he
created, continued to produce this type of
decorative statuary, totally replacing sculpting
small pieces in marble. This practice had spread
throughout major courts in the first half of the
1500s and in Florence the artist who excelled at
it was Mosca (Francesco Moschino, 1523–78),
whose *Diana and Actaeon* is worth noting
(pre-1574), now in the Museo Nazionale del
Bargello. Sculptural "miniaturism" only survived
in alabaster or wood intaglio (engraving), and
more so outside the area of Italy, being
acquired more as a curiosity than anything else
in the settings of those "rooms of wonder"
(Wunderkammer), which were the origin of the
"theme" museums or science museums of
today. At the death of Giambologna in 1608, it
was Antonio (died 1624) and Giovan Francesco
Susini (1585–c. 1653), Pietro (1577–1640) and
Ferdinando Tacca (1616/19–86) who continued
bronze casting in the workshop that had
belonged to the Flemish artist. The
technological and applicational apex of all the
work carried out in this circle in Florence was
the equestrian statue of Ferdinando I de'
Medici in Piazza Santissima Annunziata in

Francesco Moschino, *Diana and
Actaeon*. Museo Nazionale del Bargello.
Charming sculptural work with
extremely subtle formal changes of
plane and a fine example of the kind of
hedonism that pervaded the private
commissions of the princes of the
later 1500s.

imagine the capacity for control he had in
working the material, to model such graceful,
slender limbs as those of the Sabine woman—
his fame was mainly associated with his work
in bronze rather than stone. Guaranteeing his
own considerable working freedom with
respect to the court, whose instructions he
nevertheless satisfied, Giambologna succeeded
in producing an incredible quantity of bronze
statuettes, medium sized and of excellent
quality, thanks to one of the best-organized
renaissance casting workshops known.
Whether these sculpted figures were created
singly or in groups, they respected the
aesthetic canons of international Mannerism
and may be considered the crystalization of
the much pursued formal relationships of
grace and elegance for which the precedent in
Florence was *Adam and Eve* (1551) by Baccio

Florence, representing the third grand duke of Tuscany, second son of Cosimo I. The wax impressions from the monument to Cosimo I in Piazza Signoria were skillfully remodeled and adapted—the face of the new grand duke was carefully modeled by Pietro Tacca and various castings survive. The resulting portrait, consistent with Giambologna's style, was a superb achievement. The pose and riding position were up-dated—no longer designed for war, as with Cosimo, but for leisure, to suit the more peace-loving ruler of the city. The typology of the work remained almost unaltered so that past and present were united in a composition that embodied, in a single expression, the power of the Medici, just as in ancient Roman times, togaed and loricate bodies were used to support the faces of many different emperors, a sign of the continuity of things, which was reflected, with no possibility of error or confusion, in the artistic expressions of that Renaissance patronage that dated back to Maecenas.

Mario Scalini

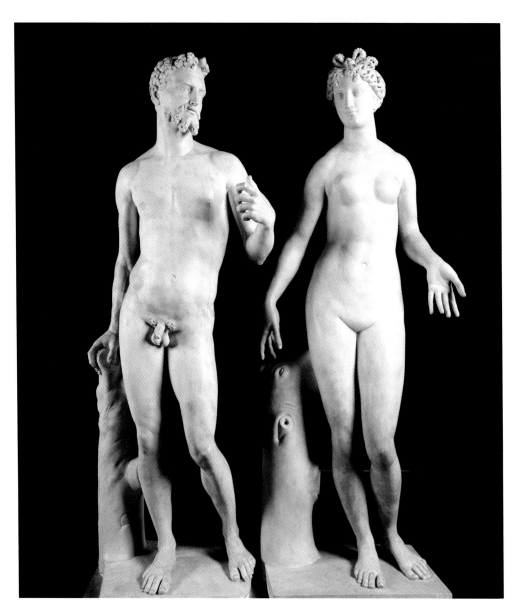

Baccio Bandinelli, *Adam and Eve.* Museo Nazionale del Bargello. Originally intended as an ornament for the presbytery enclosure of the Cathedral, to be placed in the area at the head of the cross. The statues were later removed because of their excessive sensuality, echoing the manner of Cellini.

Between saints and demons, classicism and "manner"

Background to the end of the fifteenth century, between the faith of the "Weepers" and bizarre invention

"At the end of the year 1500, during Italy's great turmoil, I, Alessandro…painted this": so runs part of the Greek inscription (translated here) inserted in Sandro Botticelli's *Natività mistica* (Mystic Nativity, London, National Gallery). Painted in 1501 (the Florentine calendar began on March 25), the work is one of the most exemplary of the later Botticelli (1445–1510). It is difficult to say exactly to which "turmoil" of Italy the painter referred at that time, given the sequence of dramatic events that followed one upon another in the last decade of the 15th century—the expulsion of the Medicis on 9 November 1494; the consequent declaration of a republic inspired by the ideals of Fra Girolamo Savonarola, prior of the monastery of S. Marco, the arrival in Italy and entry into Florence of Charles VIII king of France; the public execution in 1498 of Savonarola, condemned to burn at the stake in Piazza della Signoria; the military threat of Valentino. The Nativity, a widely chosen subject in 15th-century Florence, is represented by Botticelli

using an unusual language, strongly expressive and of immediate impact, tending to the archaic and grave, in harmony with the spirituality of Savonarola. The dense symbolism to be found in the composition, which features frequent references to Dante's *Divine Comedy* and to the book of Revelation, makes the *Mystic Nativity* emerge as a work that fluctuates between fear and hope, "imprinted with that eschatological ideology which marks the beginning of the century, at least up to the second decade" (A. Cecchi-A. Natali, 2000).

It is not however certain whether Botticelli was a fervent and unmitigated "piagnone" ("weeper," as the followers of Savonarola were called), whereas his brother Simone was. The fact remains that the last works of the artist, especially those with religious subjects or influenced by the late style of Donatello, reflect the austere climate surrounding Savonarola to the extent that the compositions painted in this particular period show none of the smooth elegance of former paintings, only dramatic and harsh qualities.

Besides Botticelli, other painters who came out of the school of Andrea Verrocchio had an important and significant role in transporting Florentine art from the 15th century to the next: we refer in particular to Leonardo da Vinci (who had been in Milan since 1482 and returned in 1501), Lorenzo di Credi, and Perugino. Lorenzo (c. 1459–1537), the favorite pupil and heir of the master, created paintings in a quiet, captivating style, combining sentimental sweetness, tidy, conventional settings, rhythmical symmetries, making use of a monotonous and often repetitive repertory. He was a "good, honest-living" man (Vasari, 1568), a strict follower of Savonarola, to the extent of keeping one of the friar's scapulars as a sacred relic.

In 1496 the "weeper" Jacopo Bongianni was present in the school of Credi when two Dominicans of S. Marco described the working of a miracle by Savonarola. According to Bongianni, in 1494–97 Lorenzo painted the *Adoration of the Shepherds*, intended for Sta. Chiara (Uffizi), with a composition based on that clear and unadorned narrative so often recommended by Savonarola for devotional art. Credi's pupils and assistants such as Antonio del Ceraiolo, Tommaso di Stefano Lunetti, and Giovanni Sogliani also shared the gentle and sober language of their master, remaining mainly anchored in the traditions of the 1400s.

In the Florence of Savonarola, Pietro Vanucci, known as Perugino (c. 1450–1523), lived by contrast a life dedicated to worldly pleasures, being "a person of very little religion" who "held all his hopes in the pursuit of fortune,

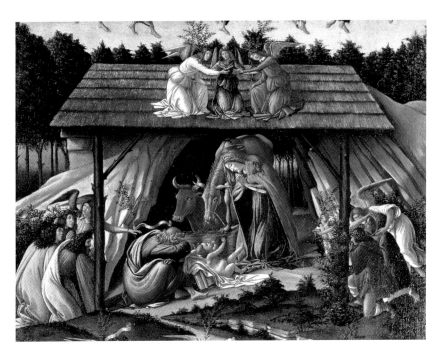

Sandro Botticelli, *Mystic Nativity*, detail. London, National Gallery. It is the only work signed by Botticelli, in the Greek inscription at the top. Here the artist records having painted the picture in the first months of 1501 (i.e. at the end of the 16th century according to the Florentine calendar), while the "turmoil in Italy" was raging.

and would have committed any wicked act for money," at least according to Vasari (1568).

He nevertheless succeeded, toward the close of the 1400s in Florence, in satisfying the demands of his patrons, keeping pace with changes in fashion and cultural evolution. As a valid exponent of the Laurentian artistic culture, after the death of Lorenzo the Magnificent he became renowned and was in great demand for paintings on devotional themes, simple and contemplative, that achieved the exultation of ideal, harmonious beauty. Paintings like the *Pietà* for S. Giusto degli Ingesuati, 1493–94 (Uffizi) communicated religious emotion that tended toward pathos and over-sentimentality (notice the faces running with tears and the red, swollen eyes), in which we may recognize the Florentine upper-class society impressed by the spiritual force of Savonarola's ideas.

Representing a rather different approach are Filippino Lippi (c. 1457–1504) and Piero di Cosimo (1462–1521), who were also thoroughly 15th-century artists both in training and style. Still active in the new century, they established the grounds for an artistic trend of "anti-classical" flavor, which favored artifice, curiosity, and eccentric touches over rules and balance. In this way these artists made a fundamental contribution to the 15th-century culture of "manner."

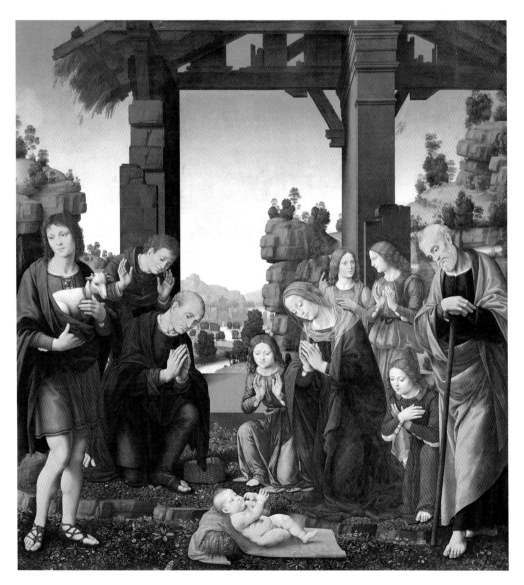

Lorenzo di Credi, *Adoration of the Shepherds*, c. 1495–97. Uffizi Gallery. Lorenzo painted the altarpiece for one of the side altars of Sta. Chiara, commissioned by Jacopo Bongianni who had left a considerable donation to the church in 1494. The artist and patron—both "Weepers"—conceived of a work that complied perfectly with the ideas of Fra Girolamo Savonarola, for its communicative spirit: simple, austere and edifying.

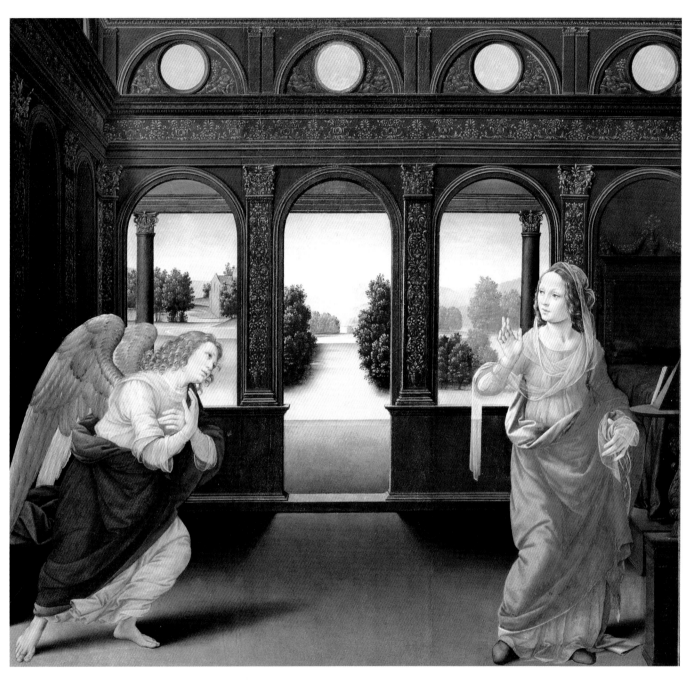

Lorenzo di Credi, *The Annunciation*, 1480–85. Uffizi Gallery. In the step below the scene: *Creation of Eve; Original Sin; Expulsion from the Garden of Eden.*

Opposite:
Piero di Cosimo, *The Incarnation of Christ*, c. 1500–05. Uffizi Gallery.

In 1502 Filippino Lippi affixed the date on the frescoes of *Scenes from the Lives of SS. John the Baptist and John the Evangelist* when they were finished for the Strozzi Chapel in Sta. Maria Novella, commissioned as far back as 1486. The exuberant decorative sections of these paintings—mainly candelabra, grotesque detail, and ornament conjectured

from the later ancient world—evoke an imaginative setting with uneasy spirits passing through. The classical rule seems to be bent in these frescoes in favor of vibrant dynamism; refined and bizarre decoration; minute description in faces and costumes; bold, scenic invention subtly played between fiction and reality.

374

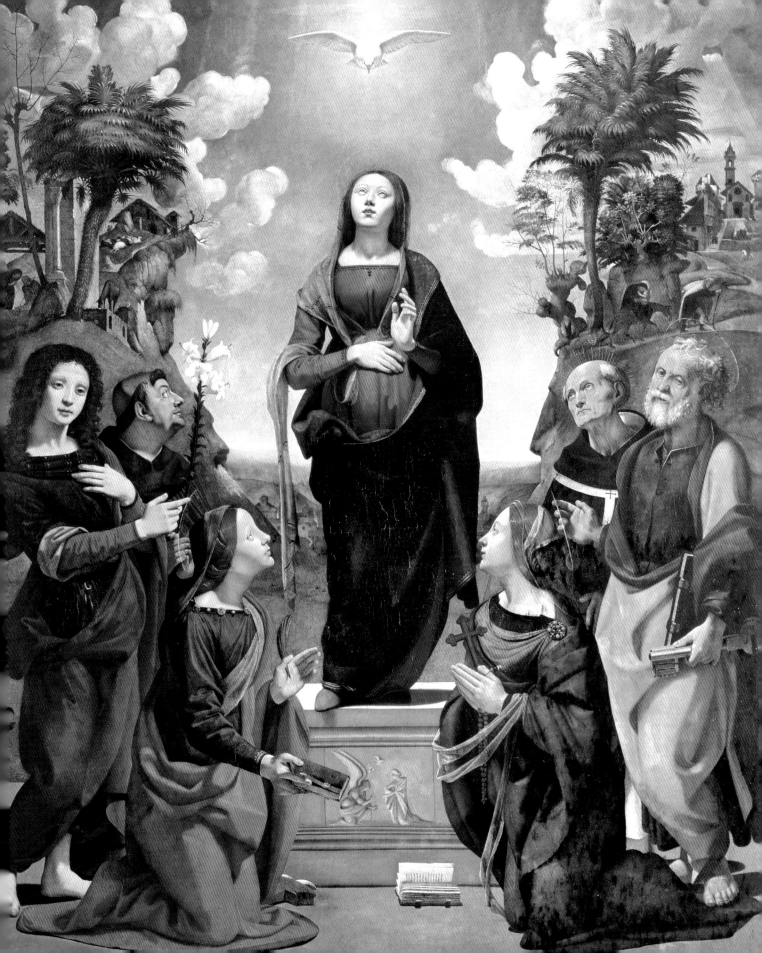

Fra Bartolomeo, *Portrait of Fra Girolamo Savonarola*, c. 1499–1500. Museum of S. Marco. The painter has expressed to great effect the spiritual intensity and pride in the character of Savonarola, of whom he was an ardent follower.

Fra Bartolomeo, *Vision of St. Bernard*, 1504. Uffizi Gallery. Vasari tells us that Bernardo del Bianco commissioned the painting from Fra Bartolomeo because he considered the artist to be the only one capable of painting a work adequate for his chapel, which was built to the design of Benedetto da Rovezzano in the Badia in Florence.

Fra Bartolomeo, *Madonna and Child with St. Anne and the Patron Saints of Florence*. Museum of S. Marco.

Opposite:
Fra Bartolomeo, *Sacra Conversazione (the mystic nuptials of St. Catherine)*, also known as *Pala Pitti*. 1512–13. Palazzo Pitti (Palatina Gallery).

Piero di Cosimo (c. 1461/2–1521), an artist of striking and singular personality, was the master of some of the heroes of 16th-century Florentine art: Andrea del Sarto, Jacopo Pontormo, and Andrea di Cosimo Feltrini. Described by Vasari as an excessive and solitary character (1568), Piero knew how to keep up the unmistakable stamp of his style over the decades—original and eccentric but at the same time lyrical and even deeply moving. The beautiful altarpiece of the *Immaculate Conception and Six Saints* (Uffizi), painted for the Tedaldi Chapel in the church of Santissima Annunziata, was probably an important point of reference for the paintings of Mariotto Albertinelli and Fra Bartolomeo in the first decade of the 16th century, possibly predating them, if only marginally. An elegiac and sentimental expression appears on the face of the Virgin,

bathed in the light of the Holy Spirit and the gentle profiles of St. Catherine of Alexandria and St. Margaret in the foreground; an accentuated descriptive popular style can be seen in St. Peter, while the background landscape appears extravagant and exotic with features that reappear in the early works of the pupils of Piero di Cosimo.

Fra Bartolomeo and the "School of S. Marco"

The death of Savonarola did not diminish the power of his words. On the contrary, the sacrifice of the Dominican friar, considered to be an unjust martyrdom by his disciples, increased interest in devotional art, which fulfilled the requirements of simplicity, rigor,

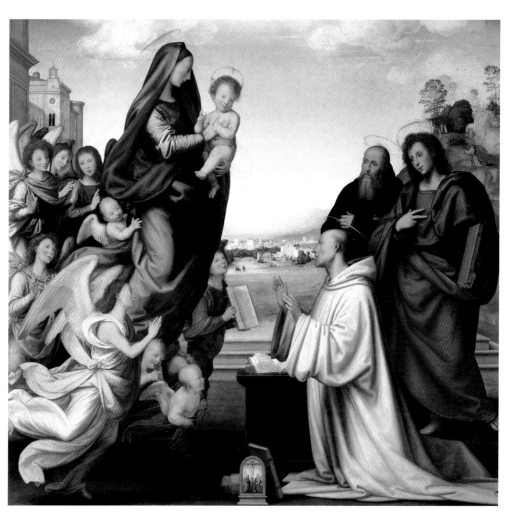

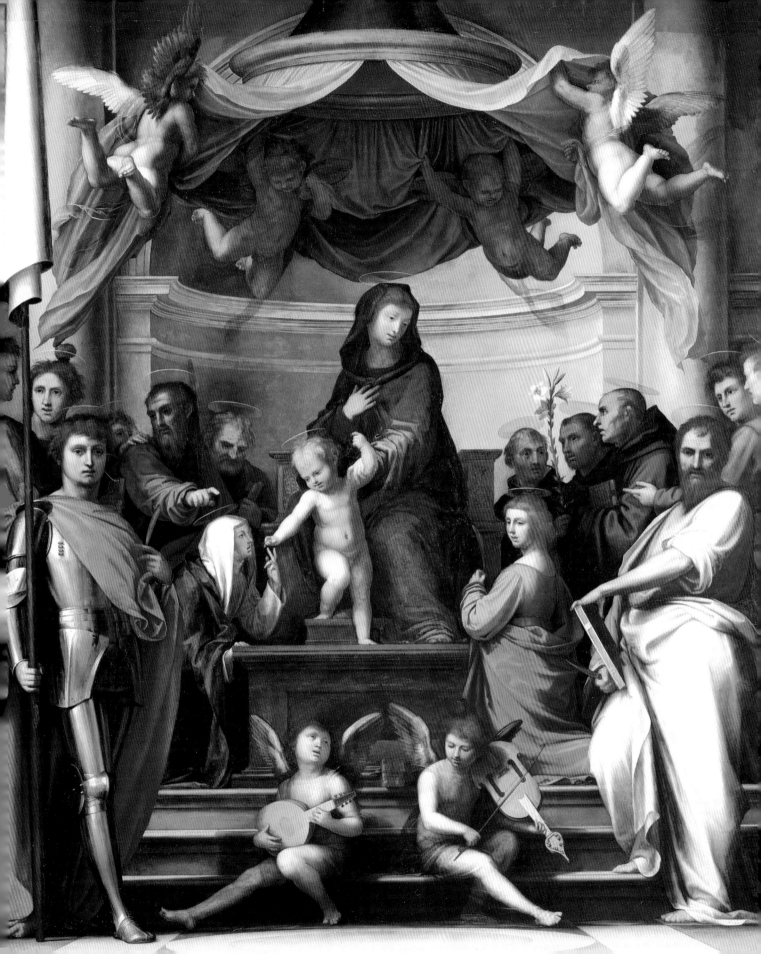

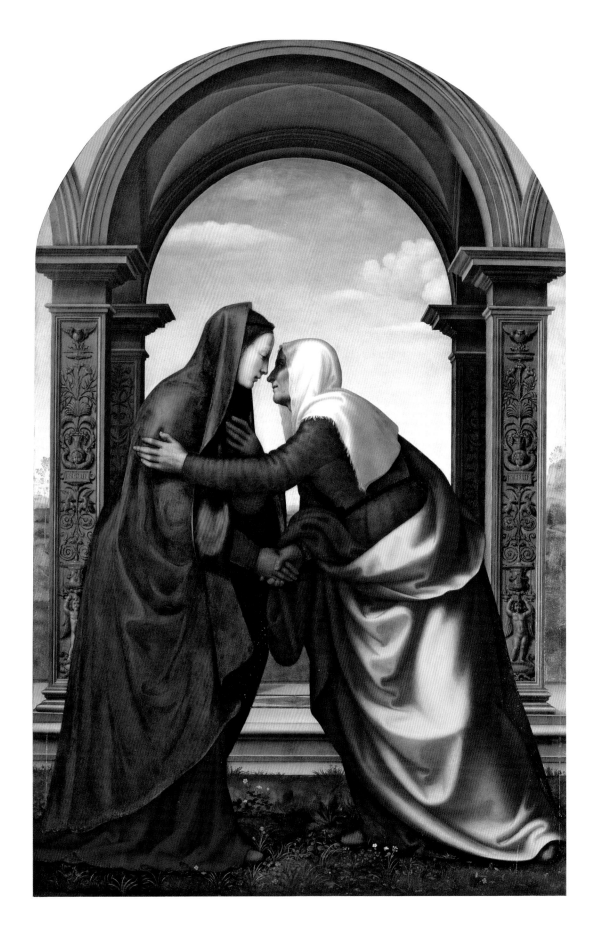

and fidelity to what was natural, and whose fundamental purpose was the moral and spiritual edification of the faithful. The principal interpreter of this conception of art was Baccio della Porta (1473–1517), pupil of Cosimo Rosselli, in contact during his training with Piero di Cosimo, Lorenzo di Credi, Domenico Ghirlandaio, and practiced in the study of Flemish art and the early Florentine works of Leonardo. He began activity in 1490 entering "society" with his friend and fellow disciple Mariotto Albertinelli. A fervent follower of Savonarola and shocked by the brutal martyrdom of the friar in 1498, Baccio decided from 1500 onward that he would not accept any further public commissions and left unfinished the fresco of the *Last Judgment* in the chapel of Gerozzo Dini in the Sta. Maria Nuova cemetery, which had been commissioned the previous year. The work was completed by his companion Albertinelli. Its characters of innovative monumentality, abundance, and harmonious synthesis is imposing in the contemporary artistic world, suggesting that "grand manner" (Vasari, 1568) which developed shortly after, up to the

Opposite:
Mariotto Albertinelli, *The Visitation*, from the church of Sta. Elisabetta, Florence. Uffizi Gallery.

Following pages:
Michelangelo Buonarroti, *The Holy Family with St. John* (Tondo Doni), detail and whole picture. Uffizi Gallery. Michelangelo painted the tondo for Agnolo and Maddalena Doni, probably on the occasion of the birth of their first child, Maria.

Raphael Sanzio, *Madonna of the Grand Duke*, c. 1506. Uffizi Gallery. The painting was acquired in 1799 from the antique market on behalf of the Grand Duke Ferdinand III of Lorraine.

This page:
Top:
Michelangelo Buonarroti, *Study for the Battle of Cascina*, c. 1504–05, detail. Uffizi Gallery (Drawings and Prints collection).

Bottom:
Anonymous artist of the 16th century, *Copy of the Battle of Anghiari*, pre-1563. Palazzo Vecchio.

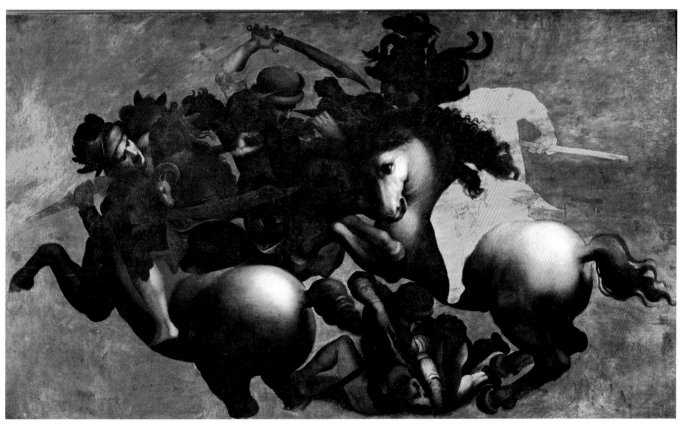

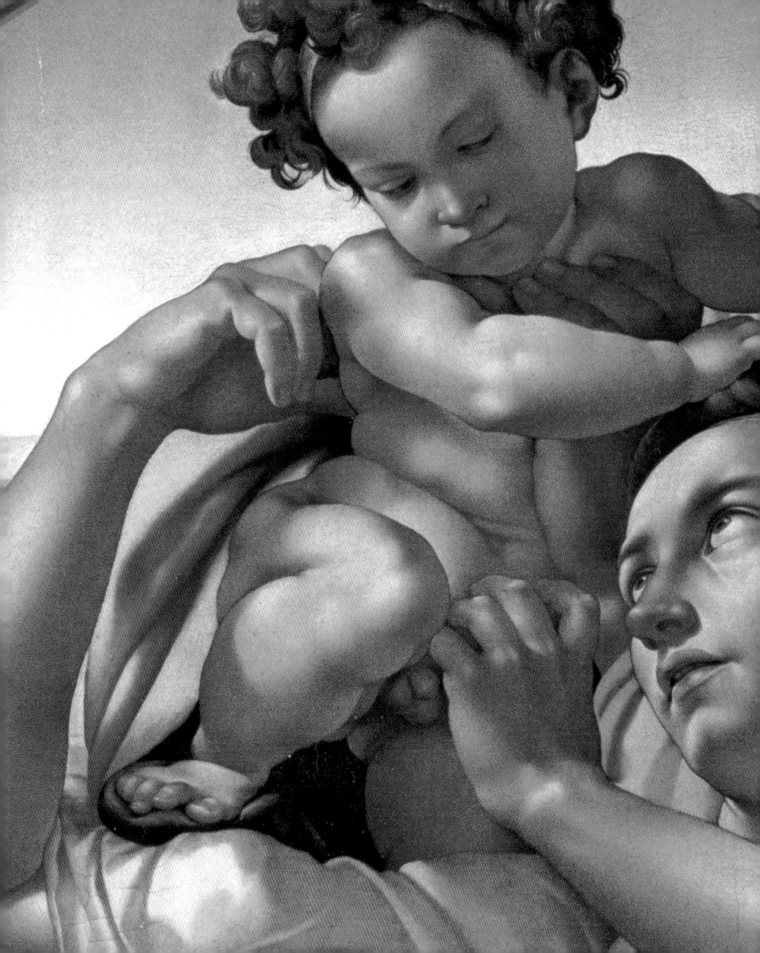

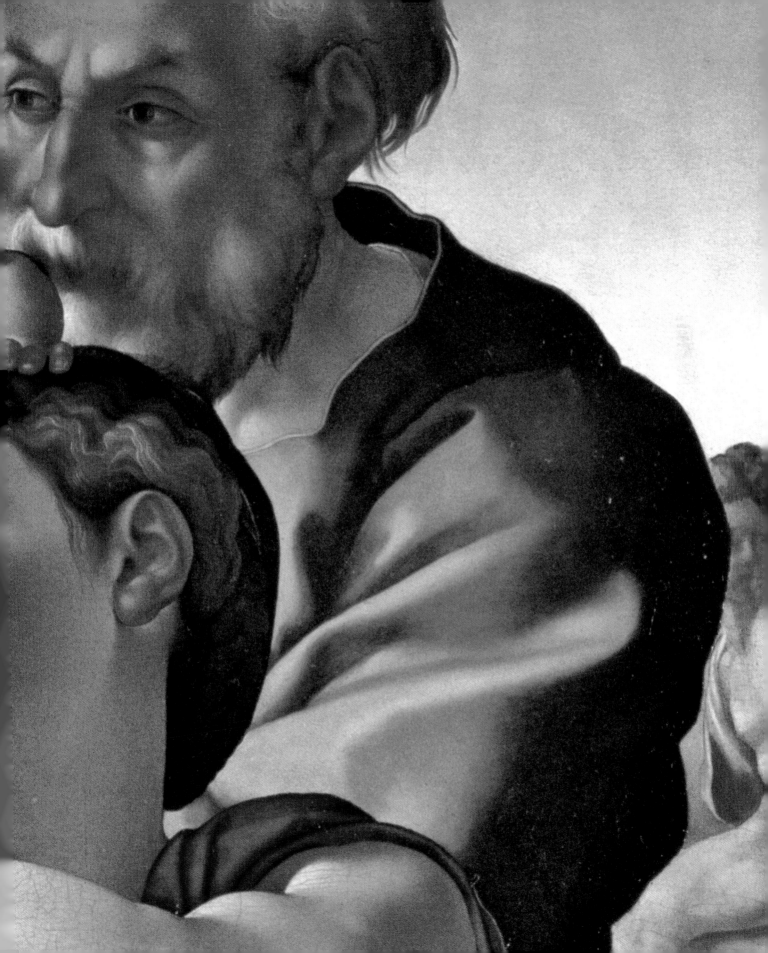

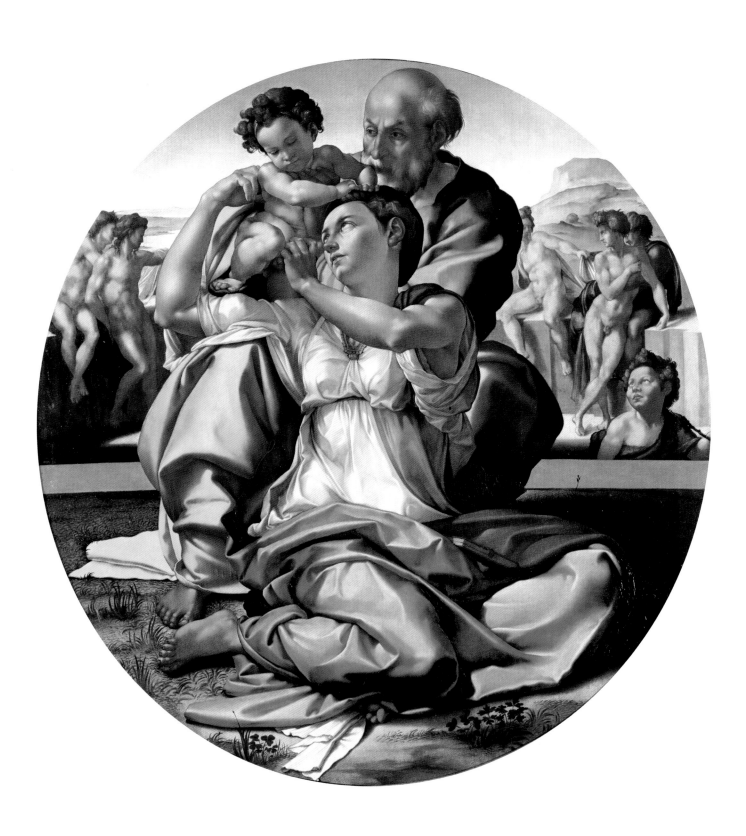

beginning of the next century, the grandiose visual language of the 16th century.

Baccio then became a friar, taking the name Fra Bartolomeo, in the Dominican monastery of Prato, and then moved to that of S. Marco, where Savonarola had been the prior. Here, in 1504 on the insistence of his friends and the prior, Fra Bartolomeo returned to painting and established his workshop in the monastery, where Fra Angelico had also been working half a century earlier. He launched this new phase of activity with the *Vision of St. Bernard* (Uffizi) for the chapel of Bernardo del Bianco in the Badia of Florence, in which Bartolomeo placed emphasis on the miraculous event (the Virgin is seen held up by a group of angels and cherubs in flight) and established an emotional relationship between the sacred image and the observer. After an important stay in Venice (1508) and having once again taken up the company of Albertinelli, the artist carried out altarpieces of ever-greater dimensions preceded by lengthy preparations, finally reaching his grandest work, the *Mystic Marriage of St. Catherine*, 1512, for the church of S. Marco (known as Pala Pitti, because it was transferred there in 1690; now in the Palatina Gallery). In this painting the Dominican artist revived the 15th-century arrangement of the altarpiece, which assumed ascending direction and an increasingly theatrical, airy construction. Composition on a broad, amplified scale, solemn and stately conception, with widely spread and coherent spatial layout, warm and gently fused colors, and harmonious balance of form: these became the features of the "devout classicism" of Fra Bartolomeo. In his workshop the friar gathered around him the so-called "School of S. Marco," artists who worked with the master and followed his teachings, continuing his style and composition formulas even after his death. When he died the friar bequeathed his assistants numerous drawings and notebooks from which they could pick motifs and compositional solutions. Among the painters who in various ways passed through the S. Marco School or were at any rate in contact with it, were Lorenzo di Credi, a sympathizer with the "weeper" ideas of the Dominican monastery, his faithful pupil Giovannantonio Sogliani, particularly close to the art of the friar in his work from the third decade—*St. Bridget Imposing the Rule* (Florence, Museum of S. Salvi)—and lastly the Dominican Fra Paolino da Pistoia, devoted disciple of Fra Bartolomeo and heir in *commodatum* to all the material in his workshop. The leading figure in the school of S. Marco was Mariotto Albertinelli (1475–1515), who was the partner and collaborator of Fra

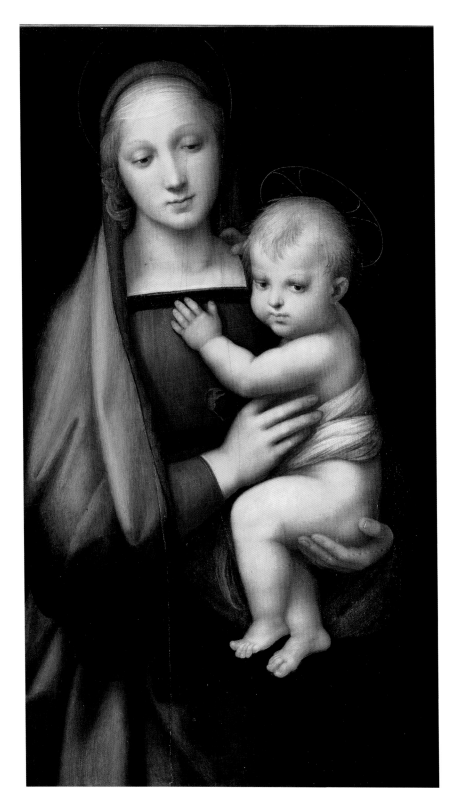

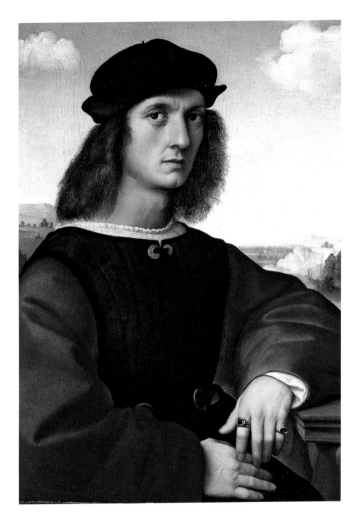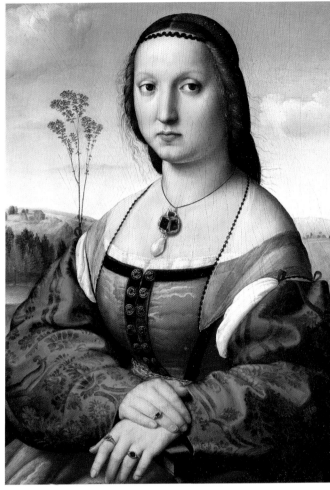

Raphael Sanzio, *Portraits of Agnolo Doni and of Maddalena Strozzi Doni.* Palazzo Pitti (Palatina Gallery). The two panels have been cut from the same wood and painted together (c. 1506–07). Originally, they probably made up a diptych within a single frame for the bedchamber of the couple, married in 1503.

Opposite:
Raphael Sanzio, *Madonna of the Baldachin.* Palazzo Pitti (Palatina Gallery). Commissioned in 1508 for the Chapel Dei in Santo Spirito, the work was left unfinished when Raphael was summoned to Rome by Pope Julius II.

Bartolomeo. Impressed with the monumentality of the Bartolomeo's *Last Judgment*, Mariotto dated in 1503 one of the first masterpieces of 16th-century classicism—*The Visitation* (Uffizi), a work of unprecedented grandeur and monumental emphasis, carried out for the church of Sta. Elisabetta, since destroyed. In the School of S. Marco, Mariotto was distinguished because his was the most original assimilation of the friar's language; he became a means of communication of this language even outside Dominican circles, through his independent workshops at Porta Gattolini and in Via Gualfonda, which was frequented in the first decade by his pupils Giuliano Bugiardini, Franciabigio, and Jacopo Pontormo.

The works by the School of S. Marco influenced the 16th-century pictorial trend, which kept itself apart from the expressiveness experienced by the artists who were trained

through the study of Florentine works by Leonardo and Michelangelo and antique art. This trend, which corresponded to the requests of a more traditionalist kind of devout clientele, was to be revived with renewed vigor under the influence of Santi di Tito in the second half of the century during the Counter-Reformation.

The birth of the "modern manner"

At the beginning of the 1500s the political scenario in Florence underwent a transformation. The republican government, attempting to remedy the extremely precarious political situation, instituted the life office of standard-bearer in 1502, which was assigned to Pier Soderini, a discerning and balanced man who boasted widespread support.

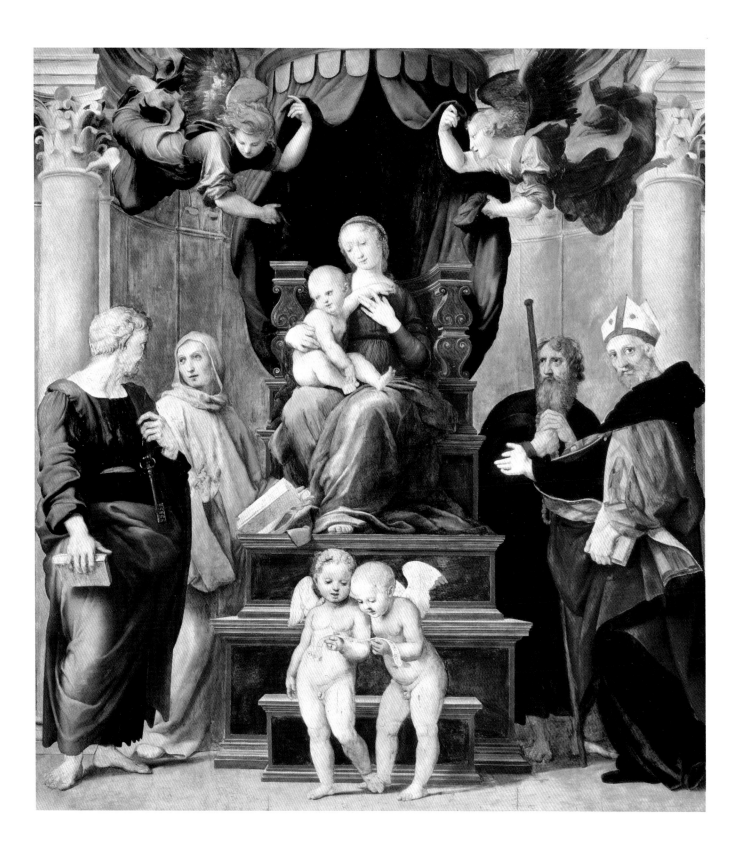

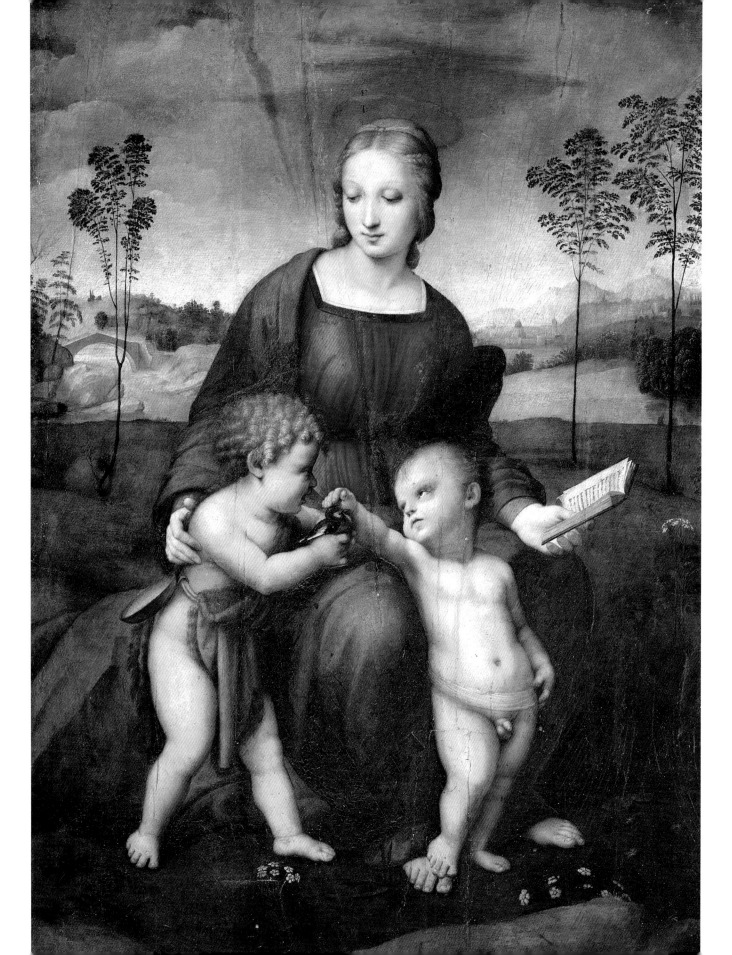

Soderini engaged in great artistic activity, intended to give a new and wider image to the republic of Florence. These were unrepeatable years for the Tuscan city, which brought together and in competition, some of the major artists of the period, whose fame even overshadowed the prestige of the contemporary papal commissions. Meanwhile both Leonardo (1452–1519) and Michelangelo (1475–1564) had returned to Florence, from Milan and Rome respectively, and were immediately engaged in carrying out work of great resonance and interest. In 1500 Leonardo had exhibited in the Santissima Annunziata his cartoon for *St. Anne*, since lost, which had attracted large numbers of amazed, admiring visitors; while the following year Michelangelo had begun his sculpture of *David* commissioned by the Opera dell' Duomo. Soderini asked these two renowned artists to collaborate on the decorations of the Sala di Maggior Consiglio in Palazzo della Signoria, the seat of the Republican government, which had been erected a few years earlier at the wish of Savonarola. Each was engaged to fresco a wall of the chamber, showing side by side two of Florence's victorious battles, the *Battaglia di Anghiari* assigned to Leonardo (1503) and the *Battaglia di Cascina* to Michelangelo (1504). But the two artists never completed these undertakings, both departing by 1506. They left in Florence the cartoons for the two Battaglie, which became the "school of the world" (as they were defined by Benvenuto Cellini), attracting artists from Italy and abroad to admire and study such innovative and stimulating works proposing revolutionary solutions. Vasari (1568) mentions that among those who had permission to enter the Sala del Maggior Consiglio to study the two outstanding drawings (since destroyed but still to be seen through copies and replicas) were Raphael Sanzio, and his friend Ridolfo del Ghirlandaio, several of the artists included in the restricted circle around Michelangelo like Aristotele da Sangallo, Francesco Granacci, and the Spanish Alonso Berruguete, and lastly the young Andrea del Sarto, Franciabigio, Rosso Fiorentino, and Jacopo Pontormo, who were to make their mark on Florentine art in the next two decades.

For the same council chamber in 1510 Soderini commissioned Fra Bartolomeo to paint the altarpiece for the altar dedicated to St. Anne and to the patron saints of the city, but this work also remained incomplete at the return of the Medicis in 1512 (Florence, Museum of S. Marco). This painting, the "battles" of Leonardo and Michelangelo, and the marble statue of the *Savior* by Andrea Sansovino (commissioned in 1502 but never carried out) were intended to form a decorative whole

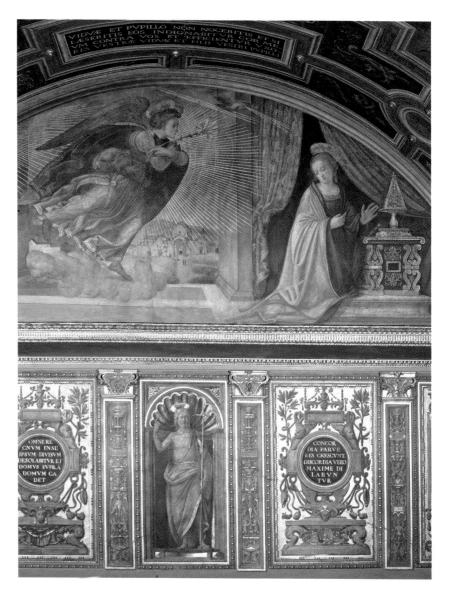

celebrating the republican city, dedicated to Christ the Savior and protected by St. Anne.

In 1511 Soderini appointed Baccio d'Agnolo to build the chapel destined for the Priori and Gonfaloniere Perpetuo (life office of standard bearer), and assigned the painted decoration to Ridolfo del Ghirlandaio, an artist who was highly esteemed by the Florentine upper-middle classes. The son of Domenico Ghirlandaio, Ridolfo (1483–1561) frequented the workshop of Fra Bartolomeo and was a friend and collaborator of Raphael.

Ridolfo's first public commission was the Priori Chapel, which he finished in 1514.

Ridolfo del Ghirlandaio, *The Annunciation*. Palazzo Vecchio (Priori Chapel). The chapel, dedicated to St. Bernard, was built between 1511 and 1514 by Baccio d'Agnolo and decorated by Ridolfo del Ghirlandaio. The fresco includes a view of the Santissima Annunziata.

Opposite:
Raphael Sanzio, *Madonna of the Goldfinch*. Uffizi Gallery. The work was probably carried out in Florence in 1505–06, on the occasion of the marriage between the patron, Lorenzo Nasi, and Sandra di Matteo Canigiani.

Bound to the illustrious family tradition, from which he inherited an acute descriptive ability, in the first two decades of the century the artist created clear, simplified compositions with a careful and conscious eclecticism. During this time the wealthier families of the republic (the Taddei, Pitti, Doni, and Nasi) were also giving their commissions to Leonardo, Michelangelo, and to Raphael, who had arrived in 1504 from Urbino. The masterpieces of these artists were seen from the outset to be remarkable works, using language that went beyond the local context and became universal, comparable to the mythical achievements of ancient Greece. The paintings and above all the drawings of Leonardo transmitted a strong impulse for renewal of full naturalism and a new expressive intensity, complete dominion over form in complex, dynamic articulation in space, and toward compositions conceived as a unitary synthesis, grand and coherent. This new attention for sympathetic and vibrant expression and for an elaborate, unraveled dynamism, which characterized 16th-century art, was for Michelangelo based on an impassioned personal comparison with ancient sculpture, in particular Hellenistic. A fundamental chapter of the "modern manner" regarding this quality is the famous Tondo Doni (Uffizi), representing *the Holy Family with the Infant St. John the Baptist*, commissioned from Michelangelo by Agnolo Doni and his wife Maddalena Strozzi

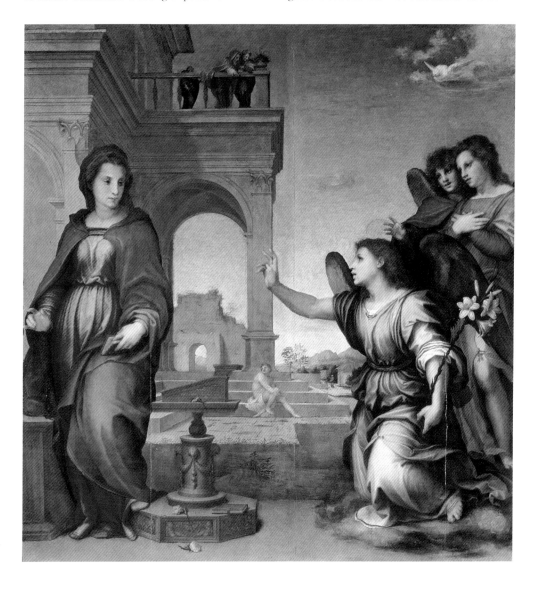

Andrea del Sarto, *The Annunciation*. Palazzo Pitti (Palatina Gallery). According to Vasari, Jacopo Pontormo and Rosso Fiorentino painted the predella, now lost, of the altarpiece intended for the Augustinian church of S. Gallo.

Doni, presumably in 1507 on the occasion of the birth of their first-born, Maria, according to what has recently been suggested (cf. A. Natali in *L'officina*, 1996).

Raphael (1483–1520) had not succeeded in receiving any public commissions from the standard-bearer Soderini, but gained esteem for extraordinarily well-observed private portraits and tender devotional images, in which he showed a formidable capacity for assimilating and understanding the works of past and contemporary art history, in particular Leonardo and Michelangelo themselves. In the portraits of *Agnolo and Maddalena Doni* (Florence, Palatina Gallery), Raphael takes up the formula established by Leonardo in the *La Gioconda*, the *Mona Lisa* (Louvre), slightly earlier, in which the description of the person reveals not only their social status, but also their high moral dignity, their own intensely expressive yet noble individuality. During his sojourn in Florence, the theme of the *Virgin and Child with St. John* was particularly dear to Raphael, and he tackled it in three monumental compositions (now housed in Florence, Paris, and Vienna) based on a pyramidal layout with complex spatial articulation. In these paintings the Urbino artist concealed his derivations (from Leonardo, Michelangelo, Fra Bartolomeo, as well as his master Perugino) in pictures marked by an ideal grace, by an absorbed concentration, and an "inimitable naturalism," in a "sort of conciliation and identification of the ideal image and the real image" (M. Gregori, 1984). At last Pietro di Bernardo Dei, a rich merchant who returned from Lyons in 1507, gave Raphael his first public commission in Florence: an altarpiece representing a *Sacra Conversazione*, commonly known as the *Madonna del Baldacchino* (Palatina Gallery), for the family chapel in Santo Spirito. On close terms with Fra Bartolomeo, Raphael created a work that was destined to instigate a new approach to the conception of the altarpiece between the 15th and 16th centuries. He left this work unfinished, however, leaving for Rome and the patronage of Pope Julius II in 1508. It was thus that in less than a decade Florence, having reached its peak as the active center of an inimitable figurative culture, with the departure of the three great masters now saw its role as the setting for artistic pre-eminence pass to Rome.

The "School of the Annunziata" and its circle

The year 1512 was a critical one for the history of Florence—the fall of the Soderini republic and the Medicis' return from exile. In September the sons of Lorenzo the Magnificent made their official entry to the city, Giuliano (later Duke of Nemours) who resumed possession of the family palace in the Via Larga, and Giovanni, who had become cardinal and papal ambassador. The following year the Medicis' power was further reinforced and ensured by the election to the papal throne of Cardinal Giovanni, with the name of Leo X. This important event brought about a change of office in the Medici house—in place of Giuliano, who joined his brother in Rome, their nephew Lorenzo (later Duke of Urbino), was elected captain of the Florentine republic, and thus assumed the responsibility for the fate of the city.

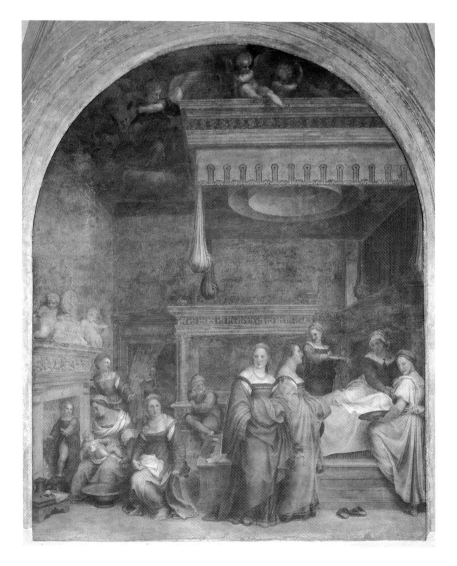

Andrea del Sarto, *Birth of the Virgin*. Santissima Annunziata (Cloister of Vows). In the Servite sanctuary at the beginning of the second decade of the 16th century, a group of artists were active (including Andrea del Sarto, Pontormo, and Rosso), schooled in the cartoons of Leonardo da Vinci and Michelangelo and in the work of Fra Bartolomeo. These artists were to become the heroes of figurative culture in Florence, until the advent of the principality.

The restoration of the Medicis to power coincided with the decline of the S. Marco School on the one hand (in 1513 Fra Bartolomeo and Albertinelli dissolved their partnership) and on the other the progressive assertion of the so-called School of the Annunziata, a group of young artists who were active in the course of the second decade within the circles of the Servite complex, situated not far from the Dominican monastery of S. Marco and especially dear to the devout population. In the Cloister of Vows in front of the church of Santissima Annunziata the preliminaries for Florentine Mannerism were unfurled: between 1511 and 1516 Andrea del Sarto, Franciabigio, Jacopo Pontormo and Rosso

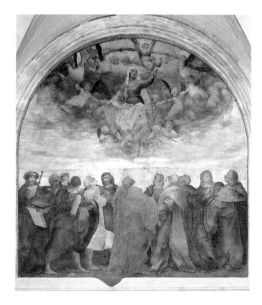

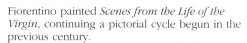

Fiorentino painted *Scenes from the Life of the Virgin*, continuing a pictorial cycle begun in the previous century.

In the group of the Annunziata the leading figure was Andrea del Sarto (1486–1530), pupil of Piero di Cosimo, gifted with a natural talent for drawing and a marked ability in the use of color. During his impassioned study of contemporary masterpieces, Andrea had met Franciabigio, with whom he formed a partnership. Among the first patrons of the two artists were the Servite monks of the Annunziata, with whom Sarto was to keep up a working relationship all through his career. Probably after a study visit to Rome, Andrea returned to the Servite cloister to work first on the fresco of the *Journey of the Magi* (1511) and then on the *Birth of the Virgin* (1514). Compared with his former work, even after only a few months, the new compositions display a different tone—amplified, solemn, and monumental. These features appear again in a contemporary altarpiece, the *Annunciation* (Florence, Palatina Gallery) commissioned in 1512 by the church of the Augustine monastery of S. Gallo (destroyed in 1530). In these works the painter shows a definite propensity to experiment with formal elements from different origins—from "Hellenistic pathos" (in the Annunciation, with clear references to ancient Rome) to "reverberations" of the extraordinary achievements in the Vatican by Michelangelo and Raphael, and finally elements "drawn from, if not actually literally quoted from, Dürer's prints" included in the *Birth of the Virgin* (A. Natali in *L'officina*, 1996).

These interests appear to be associated with references to the local figurative tradition, past and recent (an important comparison is to the statuary work of Jacopo Sansovino), translated and reworked into a personal, sensitive style whose chief characteristics are ease in drawing, rounded ample forms, soft shading in the Leonardo style, high color, affable pathos, and "linguistic regularity" (L. Berti, 1986). Andrea was an indefatigable draftsman of outstanding accuracy, impeccable in the layout of his compositions, whether for devotional painting, portraits or great histories, a painter "without error" (Vasari, 1568), gifted with supreme mastery of technique and of a controlled and measured style. In the Cloister of Vows of the Annunziata in 1513/14, Francesco di Cristofano, known as Franciabigio (1482–1525)—former pupil of Mariotto Albertinelli and partner of Andrea—frescoed the *Marriage of the Virgin*, accepting the appointment in place of Baccio Bandinelli, at that time an aspiring painter, before becoming court sculptor of the Medici.

Jacopo Pontormo, *Pucci Altarpiece*, 1518. San Michele in Visdomini.

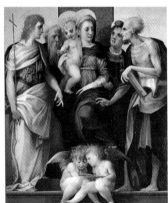

Rosso Fiorentino, *Madonna and Child among SS. John the Baptist, Antonio Abate, Stephen, and Jerome* (Altarpiece of the rector of Sta. Maria Nuova), 1518. Uffizi Gallery.

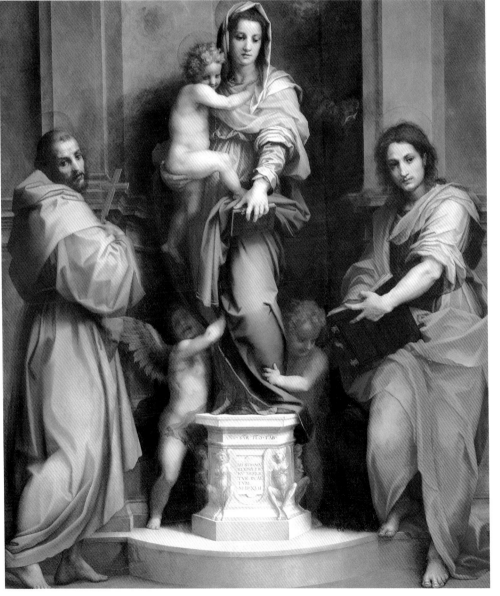

Andrea del Sarto, *St. John the Baptist Baptizing the Multitude*, 1517, detail. Cloister of the Scalzo.

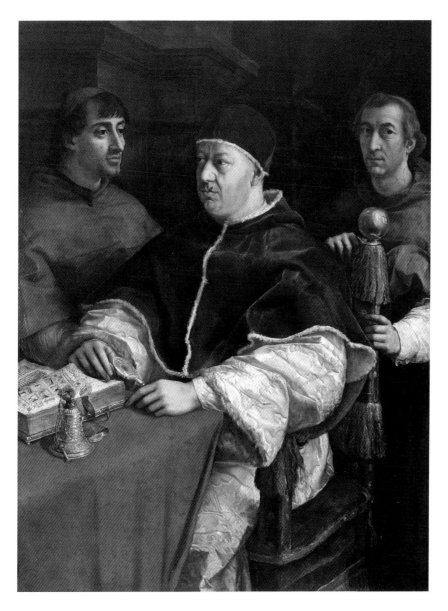

Raphael Sanzio, *Portrait of Leo X with Cardinals Giulio de' Medici and Luigi de' Rossi*, c. 1518. Uffizi Gallery. Recent diagnostic investigation has shown beneath the architecture in the background, a spreading of green color, perhaps a curtain. The figures of the two cardinals may belong to this first layer, slightly earlier than the definitive one, since there is no sign of any drawing underneath, unlike that of the pope.

Behind the church of the Annunziata, Franciabigio frequented the brotherhood of S. Giobbe, for whom he painted the altarpiece representing the *Virgin and Child between SS. John the Baptist and Giobbe* signed and dated 1516, where he portrayed himself in the face of St. John. Imitating iconographic and stylistic motifs from Fra Bartolomeo and Andrea del Sarto, this representation, with its rustic and intimate tones, meticulous in lighting and color quality, rejects artifice in favor of formal elegance, sober and controlled, which seeks its own source of inspiration in its adherence to

the natural. The poetical quality that is common to Franciabigio and Andrea del Sarto—quiet classicism and skillful drawing control, but also tender subjectivity, soft and vibrant transpositions—emerged during the work on the Annunziata altarpiece as an alternative to the boldness of Rosso and Pontormo. Nevertheless it was from Andrea that these two painters took their style when they carried out the altar step, lost from the *Annunciation* painted by the master for S. Gallo. Jacopo Carrucci (1494–1557), known as Pontormo, frequented the workshops of Leonardo, Piero di Cosimo, and Mariotto Albertinelli, before entering that of del Sarto toward 1512, from which he was expelled shortly after (Vasari, 1568). In the Cloister of Vows, in 1514, he began the fresco of the *Visitation*, finished two years later, rich in quotations from the main sources of reference of the artist—Raphael (Stanza della Segnatura), Fra Bartolomeo, Andrea del Sarto (the above-mentioned *Nativity of the Virgin* in the cloister). Vasari in his biography of the artist (1568) remembers his "beautiful lines," but his "melancholy and solitary" character, extreme and introverted, slovenly and austere, always immersed in his meticulous studies to the point of forgetting about his surroundings. Indeed an unquiet, bizarre quality and proud solitude exude from the works of Pontormo, starting from the fresco of the Annunziata, striking for the characters' penetrating expressions, their languid and distorted postures, settings closed in by imposing architecture swathed in shadow, and lastly the elegant, almost ambiguous formalism.

Heading in the same direction, but by different directions, was Giovan Battista di Jacopo (1494–1540), known as Rosso Fiorentino because of his tawny-colored hair. Compared with his contemporary Pontormo, Rosso had a very different character, being—according to Vasari—a convincing and elegant speaker, handsome, a lover of philosophy and music, invited and esteemed among humanist circles inclined to regret the republic. Nothing is known about the artist's training before he entered the workshop of Andrea del Sarto, although his early works show a careful, open-minded study of the Florentine tradition (Masaccio, Donatello) and contact with the School of S. Marco, with Fra Bartolomeo in particular: these interests are the basis of the formal austerity that marks Rosso's style from the fresco of the *Assumption of the Virgin* in the Cloister of Vows (1514). Yet the personal style of Rosso is inflamed, vibrating, and emotionally affected in the angular forms, the faun-like faces of the angels, the sneering, almost

caricatured expressions of the apostles, the bold, spectacular combination of bright colors. From 1509 the artists working for the Servites of Santissima Annunziata also included Baccio d'Agnolo, Nanni Unghero (both joiners and architects) and Andrea di Cosimo Feltrini (1477–1548). Feltrini, a specialist in ornament and "grotesques," designed decorations for interiors, furnishings, wall-coverings, crests, drapery, as well as decoration for the facades of palaces and villas. With his experience of skilled decorator, he completed and supported on many occasions the work of Andrea del Sarto, Pontormo, Franciabigio, di Ridolfo del Ghirlandaio, and Baccio d'Agnolo. Baccio, who was in the habit of hosting learned meetings of artists in his workshop, was a sort of link between the painters of the "team" of the Annunziata and patrons for important enterprises, for which the sculptor prepared the wooden frames. Like a competent entrepreneur, Baccio brought together talented painters to prepare pictures for insertion into the wooden entablatures for luxurious and elegant domestic interiors designed by him. These paintings on panels formed part of a whole iconographic series that alluded to the virtues of the patron and his wife. Possibly with an introduction by Baccio, Andrea del Sarto, Pontormo, and Francesco Granacci painted the panels with the *Scenes of Joseph the Jew* for the nuptial chamber of Pierfrancesco Borgherini and Margherita Acciaioli (1515–18). It has recently been suggested (A. Natali, 1995) that in the background of the panels for the Borgherini, Granacci used the collaboration of the Spaniard Alonso Berruguete, the most important of the "Spanish interpreters of the Italian manner" who arrived in Italy in 1508 (R. Longhi, 1953). Again Andrea and Pontormo along with Francesco Ubertini, known as Bachiacca—an expert in northern prints and an esteemed painter of "little figures" (Vasari, 1565)—carried out the paintings of various subjects for wooden wall panels by Baccio d'Agnolo destined for the ante-chamber of the banker Giovan Maria Benintendi (c. 1523).

Andrea, Jacopo, and Rosso, 1517–18: three altarpieces compared

Between 1517 and 1518 three important altarpieces were created, which clearly illustrate the religious and cultural climate of those years, full of spiritual fervor and anxiety for renewal: the *Madonna of the Harpies* (Uffizi) for the Franciscan nuns of San Francesco de' Macci, painted by Andrea del

Sarto; the *Pala Pucci* (Pucci altarpiece) by Pontormo for San Michelino Visdomini; the *Pala dello spedalingo di Sta. Maria Nuova* (Altarpiece for the hospital rector of Sta. Maria Nuova (Uffizi)) carried out by Rosso for the church of Ognissanti. A recent reassessment of the painting by Andrea del Sarto—one of the most celebrated of 16th-century Florentine art—has interpreted the monstrous figures that appear on the pedestal in the center as locusts (rather than the traditional harpies that gave the piece its name) and has linked the meaning of the work with the ninth chapter of

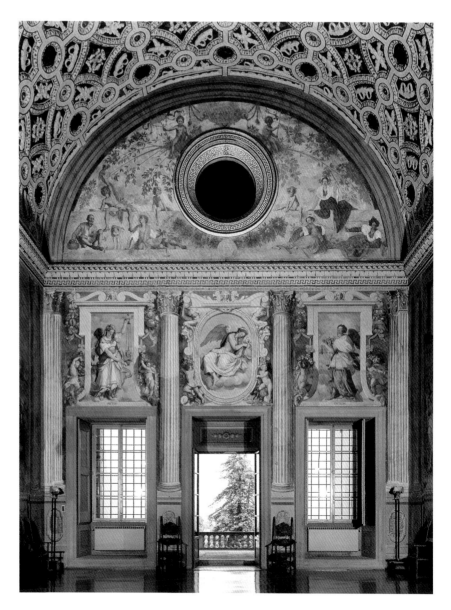

Jacopo Pontormo, *Myth of Vertumno and Pomona*, fresco, 1521. Villa di Poggio a Caiano (lunette, end wall of hall). The allegorical figures below were painted by Alessandro Allori c. 1580.

On the following pages:
Andrea del Sarto, *Tribute to Caesar*, 1520–21, detail. Medici Villa di Poggio a Caiano. The portion added some decades later by Alessandro Allori can be seen on the right.

COSMꟾ MED
ꟾCES·P·D
P

the *Apocalypse of St. John* and the *Legenda Maior of S. Bonaventura* (A. Natali, in *Andrea del Sarto…*, 1996). The work, so complex and dense with theological and eschatological references, reflects in the climate a fresh outbreak of "weeper" sympathy which began after the Medicis' return, and became so strong that Cardinal Giulio de' Medici (cousin of Pope Leo X) was forced to summon a provincial synod in which it was decided to forbid "free and inspired preaching" and "prophesying" terrible and extraordinary events.

Andrea del Sarto was evidently recognized as one of the best figurative interpreters of theological images with intense spirituality: in fact in the year in which he finished the *Madonna of the Harpies* the painter also received the commission for the *Disputing the Trinity* for the Augustinians of S. Gallo, "work featuring a visionary spirit and marked by apocalyptic tones" (A. Natali in *L'officina…*, 1996).

In 1518 Andrea married his beloved Lucrezia del Fede, whose face inspired many female figures in his paintings, and he departed for France, summoned to the court of Francis I where he remained, esteemed and appreciated, for about a year. During this period, the most renowned painters in Florence were Pontormo and Rosso. In the same year Pontormo dated and signed the *Pala Pucci* (Pucci altarpiece) for the funerary chapel of Francesco di Giovanni Pucci in S. Michele Visdomini. The work, representing a *Sacra Conversazione*, is set out along diagonals, bending the rules of rigorous symmetrical correspondence inherited from the Renaissance tradition, in favor of a more emotive layout arranged from left to right. The composition, set in the half-light of an interior, is rendered even more dramatic and emotive by the flashes of light and the agitated gestures of the characters. Again in 1518, Rosso Fiorentino painted the altarpiece commissioned by the Carthusian Leonardo Buonafede, rector of the hospital of Sta. Maria Nuova, for a chapel in the church of Ognissanti after a legacy was left by the Catalan widow Francesca Ripoi. Showing him his painting the artist disconcerted Buonafede, who fled, seeing those saints with such a "cruel and desperate air" as to seem like "devils" (Vasari, 1668). Rosso interpreted the compositional layout of a traditional *Sacra Conversazione* with his own modern sensitivity and the free expression of his own style, inspired in particular by the late works of Donatello (for example, the pulpit of S. Lorenzo). The result he achieved was shocking for its time—his rough, vigorous brush strokes, acidic colors clashing in juxtaposition, the

oppressive, saturated sense of space, the disturbed, gesturing dialogue of the characters and their gaunt, dismayed aspect, could hardly fail to appear unseemly and inappropriate for an altarpiece. The altarpiece, the first known to be by Rosso, marked the artist's detachment from Florentine circles and after the lack of success of this undertaking he worked outside the city, mainly in the Tuscany area (in Volterra he painted the beautiful *Deposition* in 1521) returning home about 1522 for a stay of just two years.

Rosso Fiorentino, *Madonna and Child with Saints*, 1522 (Dei altarpiece). Palazzo Pitti (Palatina Gallery).

Opposite: Jacopo Pontormo, *Portrait of Cosimo, Father of the Homeland*, c. 1519–20. Uffizi.

On the following pages:
Rosso Fiorentino, *Moses Defending the Daughters of Jethro*, c. 1522–23. Uffizi.

Andrea del Sarto, *St. John the Baptist*, c. 1523. Palazzo Pitti (Palatina Gallery).

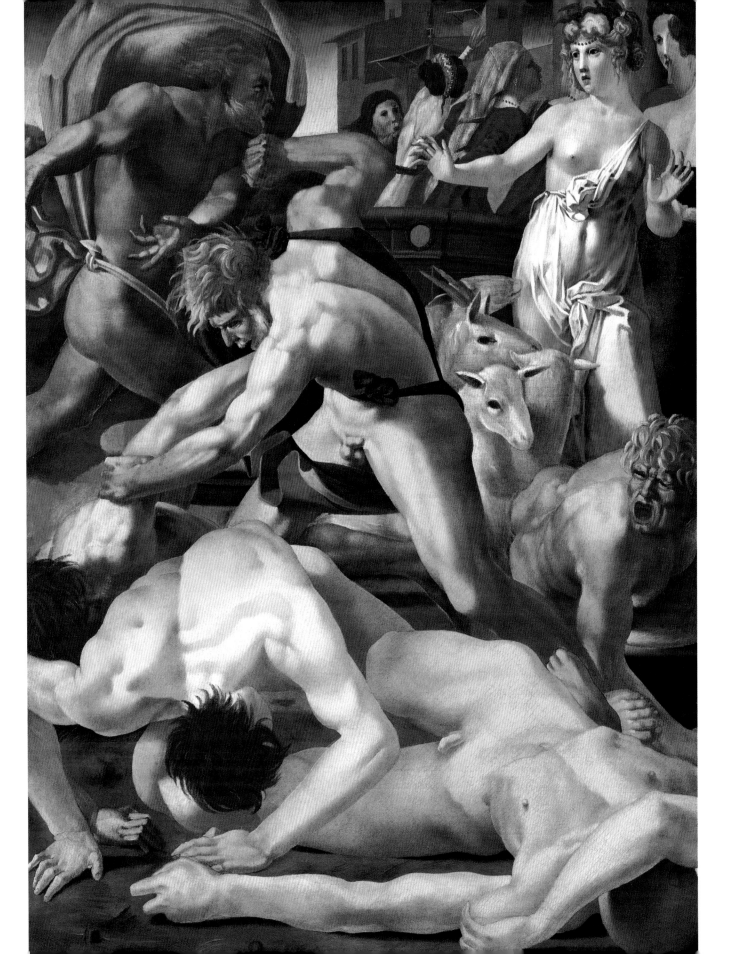

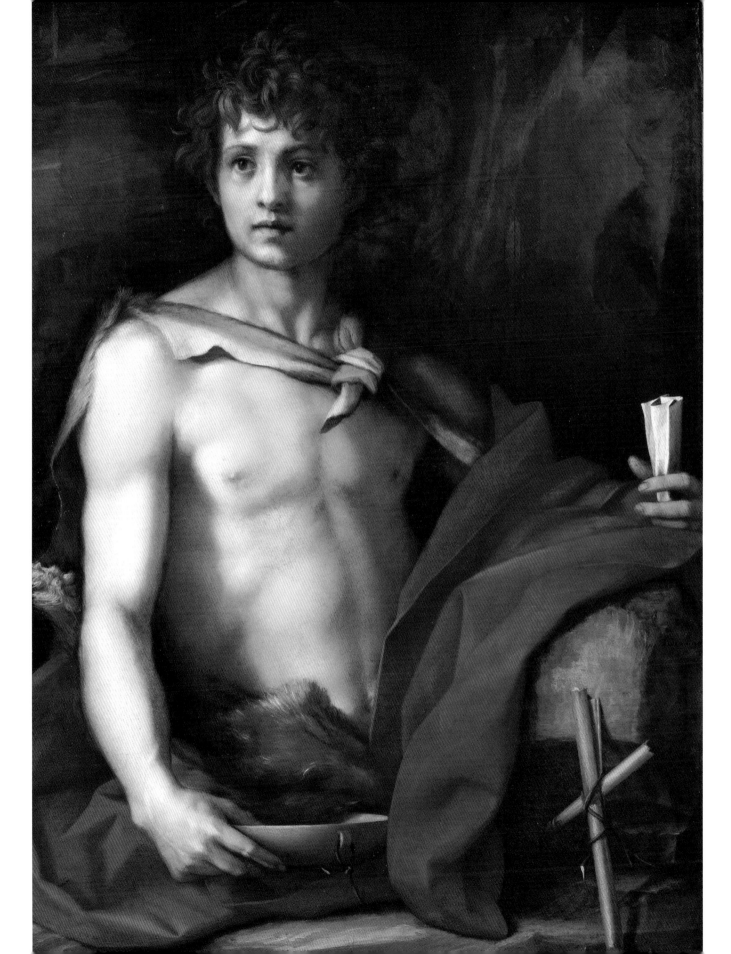

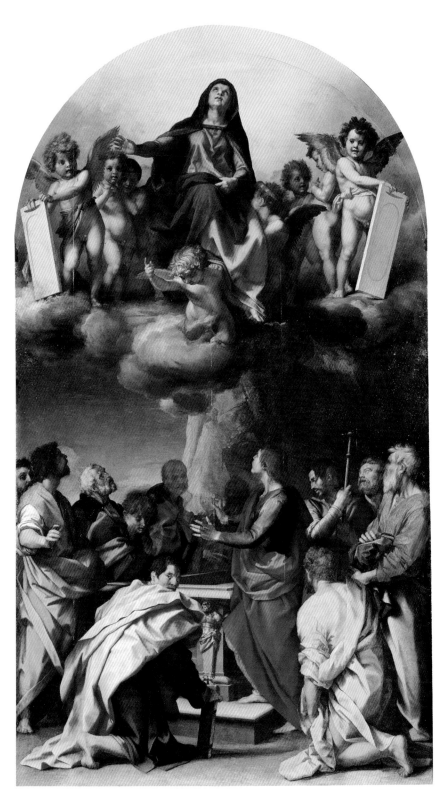

Pope Leo X and the return of the "golden age"

As soon as the Medicis had reasserted their
control over the government of the city, they
tried to reestablish the image of a Medici town
and renew the splendor of the age of Lorenzo,
by engaging in prestigious public commissions
and spectacular ephemeral structures. With
these intentions, Giuliano and his nephew
Lorenzo founded, respectively, the companies
of the Diamante and the Broncone—titles that
alluded to two heraldic missions of the
Medicis—which organized and decorated the
carnival of 1513, dedicated to the mythical
return of the "golden age," with evident
allusion to the return from exile of the
Medici family.

However the most spectacular public display
in the first decades of the 16th century was the
triumphal entrance into the city of Pope Leo X,
on 30 November 1515. All the principal artists
of the city contributed to this event, among
them Piero di Cosimo, Andrea di Cosimo
Feltrini, Andrea del Sarto, Jacopo Pontormo,
Rosso Fiorentino, and Baccio Bandinelli. In
Florence the pope resided in the papal
apartment in Sta. Maria Novella, and its chapel
was decorated for the occasion by Ridolfo del
Ghirlandaio, Pontormo, and Andrea di Cosimo
Feltrini. On 7 January 1516 during this visit,
Leo X consecrated the Basilica della Santissima
Annunziata, a place he particularly cherished,
where the leading lights of Florentine art had
just been working.

A variety of magnificent festivities were held
in Palazzo Medici, but the most memorable of
all was the celebration of the marriage of
Lorenzo de' Medici, nephew of Leo X, to
Madeleine de la Tour d'Auvergne (1518).
For the occasion there were theatrical
performances with scenery designed by
Aristotele da Sangallo, Franciabigio and Ridolfo
del Ghirlandaio, and a sumptuous banquet
was prepared dominated by the *Portrait of Leo
X with Cardinals Giulio de' Medici and Luigi
de' Rossi*, painted by Raphael in Rome and
sent by the pontiff. Meanwhile Leo X unfolded
his own plans for artistic patronage, both for
Rome and Florence, where he concentrated on
the three buildings associated with the glory of
the Medici family—Palazzo Medici, S. Lorenzo,
and Villa di Poggio a Caiano. After the deaths
of Giuliano, Duke of Nemours (1516), and
Lorenzo, Duke of Urbino (1519), Leo X issued
two important artistic commissions
superintended by Cardinal Giulio, who had
returned to Florence to take over control of
government of the city, and by Ottaviano

de' Medici. The New Sacristy of S. Lorenzo assigned to Michelangelo and the pictorial decoration of the hall in the Villa di Poggio a Caiano were projects intended to celebrate the Medici dynasty and its most illustrious members. At Poggio a Caiano, following the iconographic program dictated by the scholar Paolo Giovio, Andrea del Sarto, Franciabigio, and Pontormo carried out the frescoes on the walls, while Andrea di Cosimo Feltrini worked on the stucco decorations of the ceiling vault, with the coat of arms and heraldic symbols and devices of Leo X (1520–21). The scene of *Cicero Returning from Exile* painted by Franciabigio alluded to Cosimo the Elder's return home, and indirectly to Duke Lorenzo of Urbino's triumphal entry into Florence in 1512—as well as their similar destiny these two figures also share the same title of *Pater patriae* (Father of the homeland).

Similarly, the *Tribute to Caesar* by Andrea del Sarto commemorated the gifts offered to Lorenzo the Magnificent as a sign of deference by the Sultan of Egypt, and then in more recent times the homage sent to Leo X by the king of Portugal. In one of the two lunettes in the end walls of the hall, Pontormo portrayed the *Myth of Vertumno and Pomona*, taken from the *Metamorphoses* of Ovid. The composition has the stamp of a scholarly allegory, very different from the narrative of the scenes on the walls. As in the Medici heraldic symbol of the broncone (tree-stump), the laurel, which dominates the composition, shoots vigorously from the trunk, from which the dead part has been cut off. The youths on the branches bear signs with Latin inscriptions that entreat the gods to protect those shoots, by way of allusion, the descendents of the Medici line, so that they might perpetuate the glory of their forefathers. A new "shoot" had in fact appeared in the Medici household on 12 June of the same year, 1519, with the birth of Cosimo (future Cosimo I, duke and then grand duke of Tuscany), son of Giovanni of the Black Bands and Maria Salviati and last descendent of the cadet branch of the family, the only legitimate heir to the dynasty. Probably dedicated to this new offspring, the portrait of *Cosimo, Father of the Homeland* (Uffizi) was painted by Pontormo on the commission of Goro Gheri da Pistoia, possibly at the wish of Leo X, godfather of the newborn child. In this composition, next to the posthumous portrait of *Cosimo il Vecchio* (whose face in profile was taken from a medallion), the Medici heraldic symbol of the *broncone* is seen again with a scroll entwined around a sprouting laurel branch, bearing the inscription: UNO AVULSO NON DEFICIT

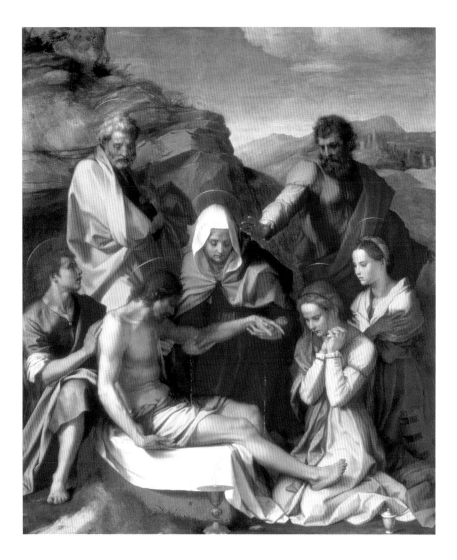

ALTER ("when a branch is broken, the other is not weakened" from the *Aeneid*, VI 143). The iconography of the painting is therefore linked to the theme that underlies the lunette with *Vertumno and Pomona* by Pontormo (cf. J. Cox-Rearick, 1984). On the death of Leo X in 1521, the work at Poggio a Caiano was interrupted, to be completed with different intentions at the end of the century.

Masterpieces of the twenties: from the era of Leo to the last republic

In the first years of the 1520s, two artists came to Florence who had been active in Rome: Giovanni da Udine and Perin del Vago,

Andrea del Sarto, *Pietà*, altarpiece for the monastery at Luco, 1524, complete painting, and a detail on the following pages. Palazzo Pitti (Palatina Gallery). According to sources, the face of the Virgin is a portrait of Lucrezia del Fede and that of Mary Magdalene is the effigy of Maria del Berrettaio, respectively the wife and step-daughter of the artist.

Opposite:
Andrea del Sarto, *The Assumption of the Virgin*, for Bartolomeo Panciatichi, 1522–25. Palazzo Pitti, Palatina Gallery. The kneeling figure, front left, looking over his shoulder at the observer is possibly a self-portrait of the artist.

Jacopo Pontormo, *Deposition from the Cross*, 1525–28. Sta. Felicita. The altarpiece was destined for the altar of the funerary chapel of Ludovico Capponi, dedicated to "Piety" because of the theme that is evoked with intense, moving spirituality in the pictorial composition.

Opposite:
Jacopo Pontormo, *Supper at Emmaus*, Uffizi Gallery. The painting, executed in 1525 for the guest wing of the Charterhouse of Galluzzo, shows the artist's keen interest in comparing his work with the painting of the German, Dürer.

On the following pages:
Jacopo Pontormo, *The Announcing Angel* and *The Virgin*, 1525–28. Sta. Felicita. The two frescoes are placed on the sides of the little window of the Capponi chapel, which was originally fitted with stained glass painted by Guglielmo de Marcillat illustrating the *Bearing of Christ to the Sepulcher* (Private Collection).

bringing direct testimony of a new "manner" inspired by recent work by Michelangelo and especially by Raphael, to whose entourage they belonged. Among the artists who admired these new arrivals, one was probably Rosso Fiorentino, who had just returned to Florence.

In his second stay in the city of his birth, Rosso entered an elite circle of aristocratic families, but remained excluded from Medici patronage. He carried out two altarpieces for important churches in the city: in 1522 he painted the *Madonna and Child with Ten Saints* (Palatina Gallery), for the Dei Chapel in Santo Spirito (where Raphael's unfinished *Madonna of the Baldachino* had never arrived) and in 1523 the *Marriage of the Virgin* for the chapel of Carlo Ginori in S. Lorenzo. In the two monumental works Rosso gave his provocative, exuberant style a courtly, aristocratic tone, characterized by formal clarity, elegant archaism recalling Florentine tradition (in particular Donatello) and visionary abstraction. In this way the artist tamed his youthful flare, but did not disown it, elaborating it in a more mature and conscious way. In both compositions, crowded with figures of sophisticated, solemn elegance, the rational and ordered layout of the 14th-century *Sacra Conversazioni* is permanently abandoned in favor of an unrealistic vision, in which refined artifice and emotion prevail over punctilious, lifelike description.

In 1523, on the election of Cardinal Giulio de' Medici as pope with the name Clement VII, Rosso set out for Rome seeking prestigious commissions and a more open-minded cultural circle. He would never return to Florence, not even after the Sack of Rome in 1527 when, like other artists, he fled and sojourned in various provincial towns in Tuscany and Umbria (Perugia, Arezzo, Città del Castello, Sansepolcro) before moving to Paris and the court of Francis I. Apart from Rosso, in the 1520s the Florentine artists—while they considered that repeated visits to Rome were an integral part of their artistic training, to study ancient art as well as the modern works of Raphael and Michelangelo—showed a certain reluctance to follow the example of the contemporary Roman "manner." The domestic situation seemed more attractive, with its discrete, reassuring charm, rather than measuring themselves against the "other investigations which discover, on touring the summits of Rome, other unexplored slopes" (L. Berti, 1981). Besides, the presence of Michelangelo in Florence up to 1534, working mainly on the New Sacristy, was decisive for development in Florentine art toward a fuller expression of the "manner." However, the

interests of the Florentine artists, as well as
looking to the ancients and supreme
contemporary models, were also directed
toward prints from the north, particularly
those of Dürer and Lucas van Leyden, which
had begun to circulate from the mid-1520s.
At this time, in fact, certain prints by Dürer
were in the hands of Andrea del Sarto who
derived from them some of the motifs used
in two scenes from *The Life of St. John the
Baptist*—the *Baptist's Sermon* (1515) and
Baptizing the Crowd (1517)—in the cloister
of the Company of the Scalzo. In the same
period Ridolfo del Ghirlandaio produced a
series of realistic and expressive portraits in
"transalpine" style in the *Miracle of St.
Zanobius* (Florence, Museum of the Cenacolo
of San Salvi) for the altar of the Company of
St. Zanobius in the rectory of Sta. Maria del
Fiore. Therefore the artists of Florence—
including Bachiacca and minor "eccentrics"
like Antonio do Donnino and the Master of
Landscape, Kress—looked toward northern art
because they were attracted by its descriptive
accuracy, by its emotive tendency in
narration, and by the formal solutions that
seemed "anti-classical" and extreme;
sometimes adopting the style, other times
lifting literal quotations that extended their
figurative repertory. Pontormo established an
increasingly close, dialectic relationship with
German graphic art, which reached a peak of
emulation and original elaboration in the
work carried out with the help of his pupil
Agnolo Bronzino between 1523 and 1525 for
the Charterhouse of Galluzzo, where the artist
had retreated while the plague was raging in
Florence. The frescoes with the *Scenes from
the Passion* (now in the Pinacoteca of
Certosa) and the canvas of *Supper at Emmaus*
(Uffizi) are clearly inspired for their style and
composition by Dürer's etchings on similar
themes. These paintings demonstrate such an
interest in northern art as to suggest a parallel
inclination on the part of Pontormo and his
patrons the Carthusians for the spirituality that
at the time of the Reformation informed
German figurative culture. From Dürer's
etching of the *Four Witches*, Pontormo then
derived his *Visitation* for the Pinadori altar in
the parish of Carmignano (1527–28), translating
the model into a personal poetic language.
The composition keeps its distance from the
harmonious and tenderly sentimental
classicism of the *Visitation* painted 20 years
previously by Albertinelli, and favors an
abstract, symbolic representation charged with
seductive mystery. Likewise, Jacopo showed
renewed interest in Michelangelo, in the
altarpiece with the *Pietà* in the funerary chapel

Domenico Puligo, *Madonna and Child with Saints* (Da Romena Altarpiece), 1527. Sta. Maria Maddalena de' Pazzi. In his work Puligo—according to Vasari, a talented artist but little inclined to study—showed a marked interest in the work of Andrea del Sarto, from whom he drew ideas and quotations, translated into a tender, suffused style.

of Ludovico Capponi in Sta. Felicita (1525–28). The painting, fitted with a frame by Baccio d'Agnolo, was an integral part of a fresco decoration program for the whole chapel, carried out again with the collaboration of Bronzino. In the Capponi altarpiece, the luminous colors, diaphanous and abstract, recall Michelangelo's palette for the Sistine chapel ceiling, while the figure of Christ with its pale, partly extended body and abandoned right arm derive from the Vatican *Pietà*, also by Michelangelo. Pontormo's composition lacks any form of setting, and all descriptive detail is cast aside in favor of emotive expression and spiritual concentration. Within a highly refined formal elaboration the figures placed "in bunches" seem suspended, to an almost dancing rhythm, in a spatial effect that has by now lost the rational dimension of the geometric perspective, but has the distortion of a dream. The artist's participation in the astonishment and dismay of the figures is demonstrated by his self-portrait on the far right. While Rosso was leaving for Rome and Pontormo was staying at the Charterhouse, in 1523 Andrea del Sarto and his family fled from the plague by sheltering in Mugello, guests of the Camaldolite nuns of S. Pietro at Luco. For the main altar of the Luco monastery Andrea painted an intense and moving *Pietà* (now in the Palatina Gallery), in which the artist probably used his beloved wife Lucrezia del Fede as model for the face of the Virgin and his step-daughter Maria del Berrettaio for that

of Mary Magdalene. In Florence Andrea had in the meantime become the painter in greatest demand both among the rich merchants and the ruling classes, as well as among clients of more modest social extraction, such as Beccuccio Bicchieraio di Gambassi who commissioned the artist to paint his portrait (Edinburgh, National Gallery of Scotland) and an altarpiece for a church in his native town (Chicago, Art Institute). Other loyal clients of del Sarto were the brotherhoods (as seen above, the company of the Scalzo, on whose frescoes the painter worked from 1509 to 1526) and the religious orders (Servites and Vallombrosans in particular). Many artists frequented Andrea's workshop, the undisputed model for generations of Tuscan artists— among them, Domenico Puligo, "friend" of del Sarto and indebted to him for schemes and layouts translated into a softly shaded, captivating style; Pierfrancesco di Jacopo Foschi, a rigorous interpreter of reformed spirituality; Francesco Salviati; and also Giorgio Vasari.

In Florence, in 1527, following the Sack of Rome, a people's insurrection subverted the Medici power once more, and imposed the republic, again based on Savonarola's ideas, but Pope Clement VII, having reached an agreement with Charles V, ordered the city to be held under siege by an enormous army. Artists with republican sympathies like Michelangelo, Andrea del Sarto, Pontormo, and Bronzino bore witness to this dramatic climate in Florence in some of their work. The city, exhausted by hunger, deprivation, and plague, collapsed in August 1530. Hopes for liberty and aspirations for the republic were dashed forever, and a new chapter opened in the history of Florence, with the ephemeral, cruel dukedom of Alessandro de' Medici. While Rosso was away in France, Pontormo, more confined than ever in his solitude, bitter and obsessive, was to become an isolated and misunderstood painter in the crowded and obsequious court of the Medicis. Andrea del Sarto meanwhile had caught the plague and, having been walled in alive by his own family to avoid contagion, died in 1530.

During the long siege one of his frescoes was miraculously saved: the *Last Supper* in the refectory of the Vallombrosan monastery of S. Salvi, defined by Benedetto Varchi (1546–47) as "one of the most beautiful paintings in the universe."

Elena Capretti

Between Church and State, rule and "rigueur"

On 5 May 1540, on the occasion of the feast of Santo Spirito, Duke Cosimo I de' Medici and his wife Eleonora di Toledo, in a solemn public ceremony, left their old home in Via Larga (built by his forefather and namesake Cosimo the Elder a century earlier) to take up residence in what had been for centuries, since its construction, the Town Hall, seat of the governing magistracy, the present-day Palazzo della Signoria. The refurbishing of the building was started for its conversion into the new ducal residence. While the court architect Battista di Marco del Tasso was directing the structural alterations, Agnolo di Cosimo known as Bronzino (1503–72) tackled the first significant pictorial undertaking—the decoration of Eleonora's private chapel, a small chamber created out of an existing room. Working in several stages up to 1564, the artist covered the walls with frescoes representing *Scenes from the Life of Moses* and the vault with *Saints and Virtues*, which constituted one of the foundation stones of Florentine "Mannerism," while for the altar he painted three panels with an *Annunciation* in the lateral panels and a *Pietà* in the center (carried out in two versions of which the first, now in Besançon, was gifted by Cosimo I to Cardinal Gravelle). The episodes on the walls representing the salvation of the people of Israel guided by Moses (1541–45) celebrated indirectly the patron, Cosimo I, and his elder son, Francesco, born on 25 March 1541—the heroic figure of the biblical leader alluded in fact to the Medici duke who, having assumed power, was then guiding the people of Florence toward "salvation," establishing order with his own policies. The anatomical study of the figures, the counterpoised postures, the marble-like skin surfaces, show how Bronzino having absorbed the teaching of Pontormo, found new, pressing points of reference in the sculpture of Michelangelo and Baccio Bandinelli, the latter working for Cosimo I during the same period. The cold, abstract painting of Bronzino, with lacquered, brilliant colors, juxtaposition without grading (almost like inlaid precious stones) with highly polished sculptural forms on a clear, precise drawing, was the most direct figurative expression of the taste and culture of the court toward the middle of the century. As the official portrait artist of the Medici entourage, here too, Bronzino knew how to interpret the celebrative aspirations of his aristocratic clients.

Agnolo Bronzino, paintings in the Chapel of Eleonora di Toledo in Palazzo Vecchio, 1540–45. On the walls, frescoes with scenes from *Moses,* the *Prophets* and *Sibyls*; on the vaulted ceiling St. Michael the Archangel, St. Francis, St. Jerome, and St. John the Evangelist; on the altar there was originally the *Pietà* (now in the museum of Besançon), flanked by St. John the Baptist and the patron, Cosimo I, but to be soon replaced with a copy of the altarpiece by Bronzino, still in place, but flanked by the *Announcing Angel* and *The Virgin*.

On the following pages:

Agnolo Bronzino, *Holy Family with St. John the Baptist*, c. 1540. Uffizi Gallery. The *Sacra Famiglia Panciatichi*, was commissioned by Bartolomeo Panciatichi (portrayed with his wife by Bronzino in works of approximately the same date). The Panciatichi coat of arms appears on the flag on the tower in the background of the composition.

Agnolo Bronzino, *Portrait of Lucrezia Panciatichi*, c. 1540. Uffizi Gallery.

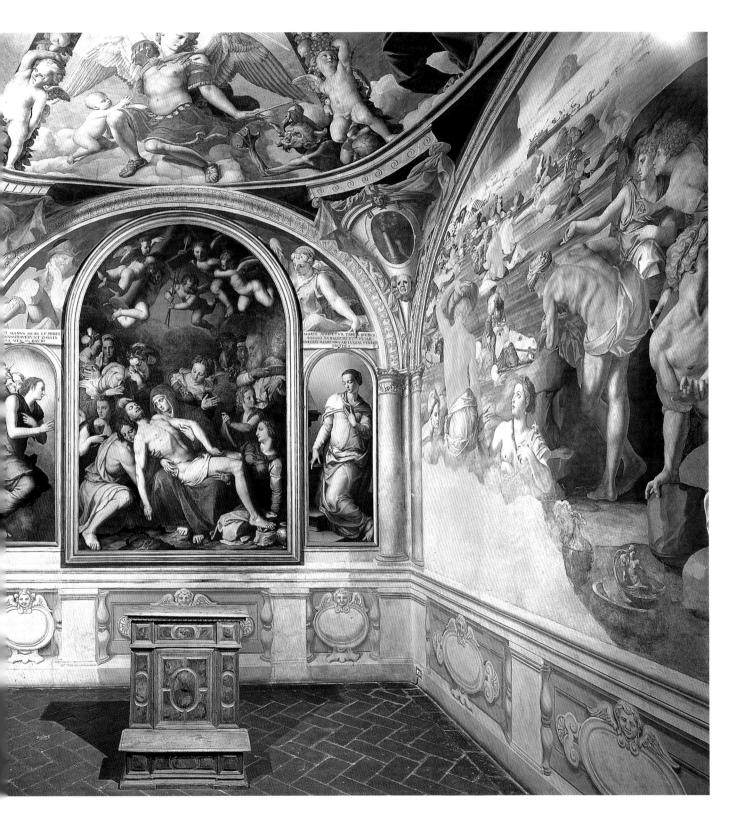

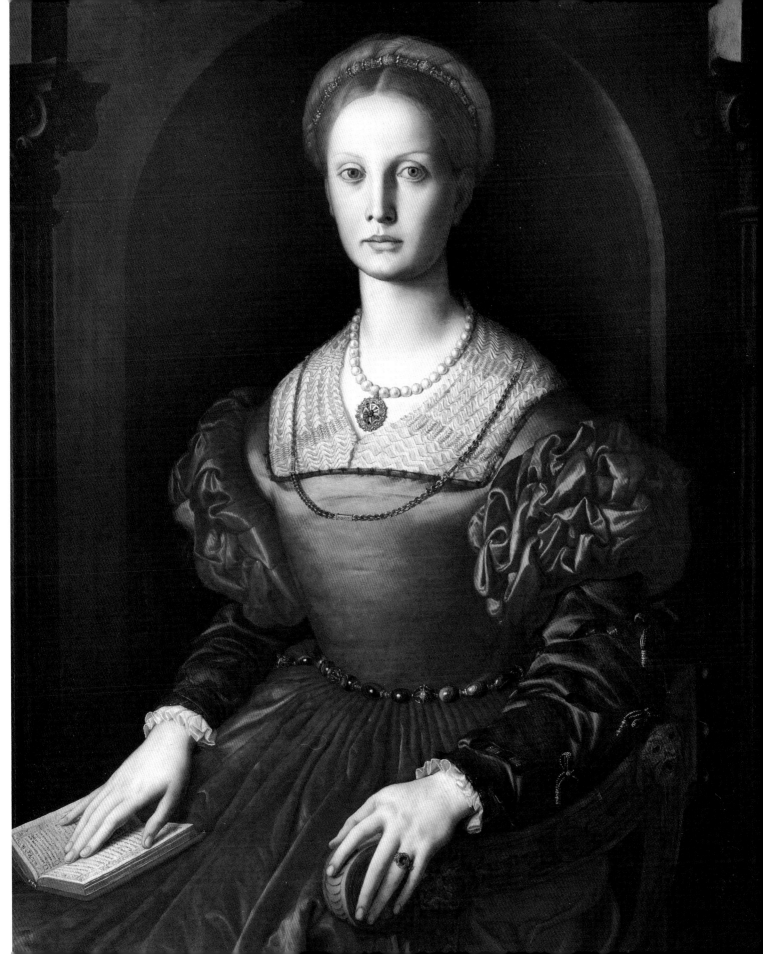

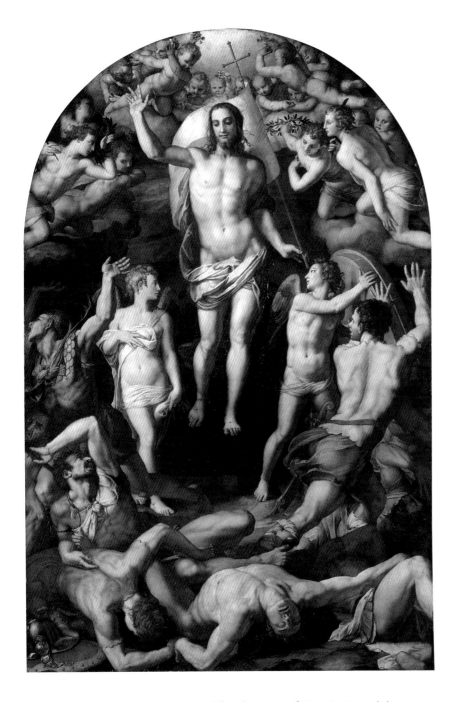

jewels, silks, pearls—rare and immutable with time, exalted in their formal, chromatic purity.

Meanwhile, in 1543, Francesco de' Rossi known as Salviati (1510–63) had returned to Florence. Florentine by birth, but Roman by "adoption," he was commissioned by Cosimo I to fresco the Sala delle Udienze in Palazzo della Signoria. The series includes *Scenes from the Life of Furius Camillus*, heroic Roman leader and conqueror of the Gauls, in whose appearance is hidden the Medici duke triumphant over the people of Tuscany. When it was finished (1545), Salviati's decorative complex was considered in the eyes of the patron and his court as the most innovative Florentine pictorial work of the decade. Thanks to his training in Rome, the artist had indeed formulated a modern and original style, kept up to date by comparison with the latest rooms in the Vatican and other works by the "school" of Raphael (Perin de Vaga, Giulio Romano, Giovanni da Udine, and Polidoro da Caravaggio). From this experience Salviati had learned to give a flavor of modern to ancient, blending into it vitality, spectacle, virtuosity, and joyful invention. Freely inspired by Roman low relief on sarcophagi, the principal scenes, *Triumph of Camillus After Taking Veii* and *Camillus Intervenes Against the Tribute of Gold Imposed by the Gauls on the Romans*, present a dynamic, heroic tonality, lit up by luminous, changeable colors, crowded with figures in movement in an imaginative layout, and in the background, a landscape dotted with ancient buildings. Salviati's frescoes are characterized

Agnolo Bronzino, *The Resurrection.*
Santissima Annunziata.
The altarpiece is signed, and dated 1552.

Agnolo Bronzino, *Portrait of Bartolomeo Panciatichi*, c. 1540.
Uffizi Gallery.

The characters of Bronzino's work betray neither sentiment nor thought, represented in their ideal, perfect essence, in architectural settings of rational conception, or against a monochrome background, like the precious blue lapis lazuli, the heads surrounded by a luminous halo. The lofty, impassive faces and the candid, slender hands, treated in the same way as the jewels, clothes, weapons, and furniture, as if they were precious objects—

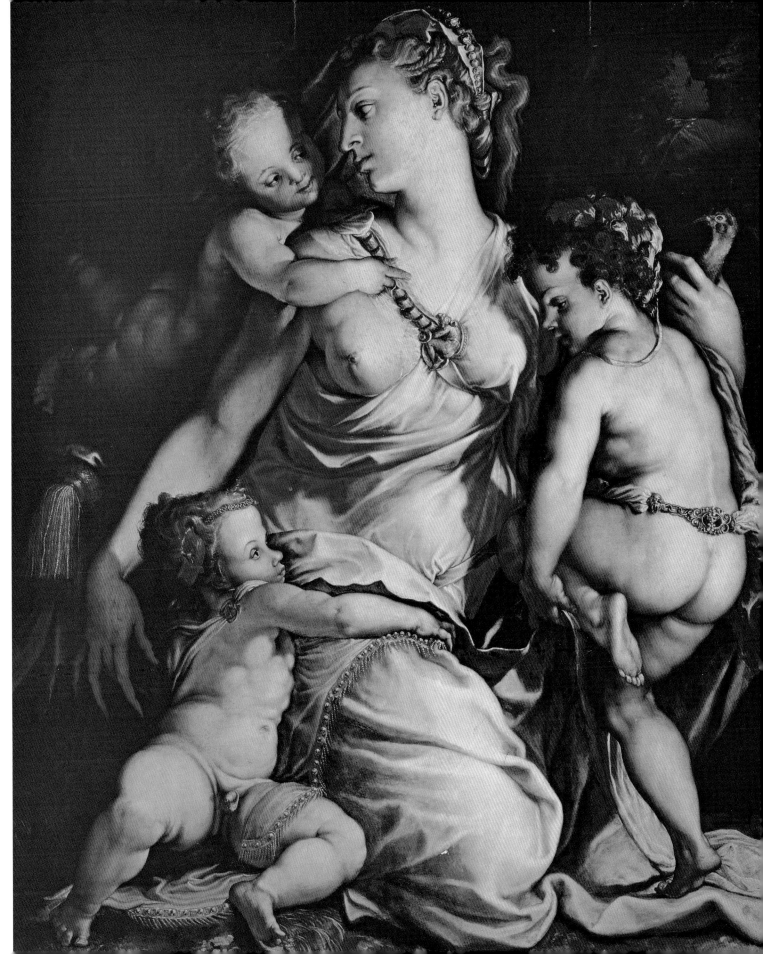

by a sort of decorative *horror vacui*, in which false insertions of the most varied materials— hangings, marbles, cameos, precious stones, stuccoes, gold—are juxtaposed to crowd the painted walls with the effect of a fine and artful trompe-l'oeil. The exuberant style of Salviati appeared far removed both from the stylized and uneasy forms of the elderly Pontormo, and from the abstract and idealized beauty of Bronzino. Compared with these artists yet another attitude was struck in the

entered as a youth into the Medici circle, and by 1554 had established a relationship of great understanding and friendship with Cosimo I. Within the ducal court he assumed a crucial role as the sole, unchallenged artistic entrepreneur. Employing a large group of first-rate collaborators, which formed the most important Florentine workshop of those years, he made himself the spokesman and eulogist of the political ideology of the duchy and later of the grand duchy (1569), accomplishing on

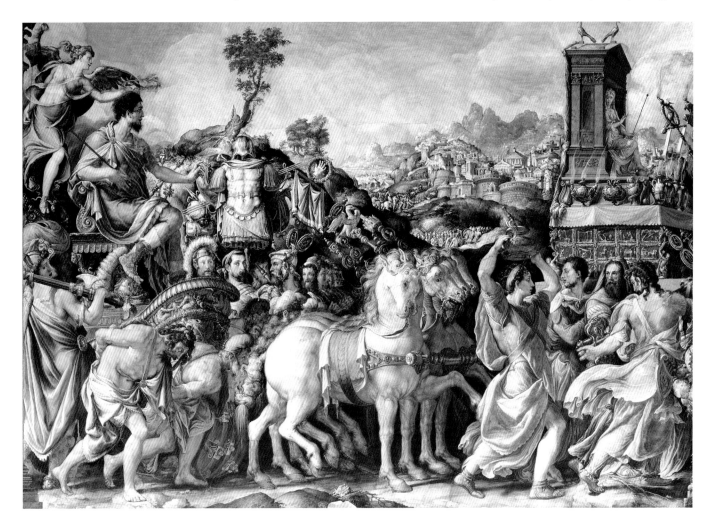

Francesco Salviati, *The Triumph of Furius Camillus*, 1543–45. Palazzo Vecchio (Sala dell'Udienza).
The history of Furius Camillus, frescoed by Salviati, alludes to Cosimo I, ruler of the subjugated Tuscan peoples.

work of Giorgio Vasari (1511–74), who was for two decades the most prominent figure on the Florentine artistic stage, inclining toward a more academic and magniloquent style, conformist and predictable in the results. Painter, architect, scenery designer as well as writer, historiographer and collector, he

behalf of Cosimo I wide-reaching artistic projects and introducing a new way of conceiving art as official art—of the State. From 1555 for nearly two decades, adopting the iconographic program dictated by court scholar, Cosimo Bartoli, Vasari planned the decoration for Palazzo della Signoria,

dominions of the Medici duchy, history of ancient Florence, episodes of the wars with Pisa and Siena; in the central oculus is the *Apotheosis of Cosimo* "triumphant and glorious, crowned by a Florence with a wreath of oak" (as Vasari himself wrote), in a halo of light surrounded by crests representing the Arts.

All those who participated in these collective enterprises fitted in with the "grand and beautiful manner" imposed by Vasari, who drew examples from Rome and Florence,

Giorgio Vasari, *Portrait of Lorenzo the Magnificent.*

Giorgio Vasari, *Portrait of Duke Alessandro de' Medici.*
Both portraits, which were commissioned from Vasari in 1534 by Ottaviano de' Medici, possess an accompaniment of allegories and symbols.

completely transforming some of the rooms of the earlier period, with the help of a vast multitalented team of painters, sculptors, joiners, architects, glass-makers, and others. Among the painters some were well established like Michele Tosini and Cristofano Gherardi, others were promising young artists like Marco da Faenza, the Flemish Giovanni Stradano, Giovan Battista Naldini, and Jacopo Zucchi. In the Quartiere degli Elementi, Pope Leo X's quarters, and in those of Eleonora, paintings and ornament by the Vasari team, coats of arms and heraldic devices follow one upon another, allegorical representations and mythological episodes, views of streets and squares in Florence and other Tuscan cities and fortifications, along with depictions of the main figures of Medici ancestry. In the sixties Vasari also finished the decoration of the Salone dei Cinquecento (Hall of the Five Hundred), the great hall built during the republic to hold the Maggior Consiglio (Council of the Elders). For this vast space the artist and his collaborators created a monumental pictorial and sculptural decoration, the eulogistic intent of which is still evident. On the walls are represented on one side scenes from the *War of Pisa*, won in 1509 by the republican government after 14 whole years, on the other, episodes of the *War of Siena*, crushed by the ducal troops in only 15 months. In the coffers of the wooden ceiling, divided into 42 sections, allegories are illustrated of the quarters of Florence and the

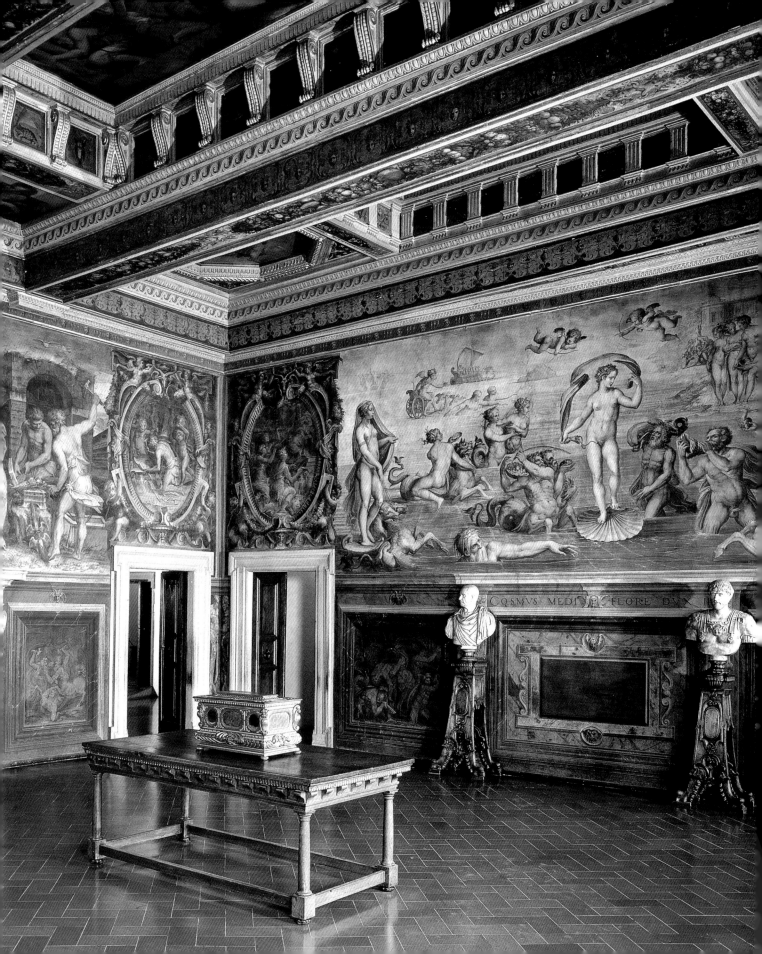

uniting them in a classical and academic way. The favorite source for this grandiose and magniloquent style was Michelangelo, emptied however of its deep moral valence and the high poetic aspirations of the great artist. The seventh decade was full of fervid activity for Vasari and marked the height of his glory as court entrepreneur under the patronage of Cosimo I. While directing the building of the Uffizi and the corridor linking it to Palazzo Pitti, the artist designed and directed the

years, with the literary consultancy of Vincenzo Borghini, the scholarly rector of the Ospedale degli Innocenti, Vasari superintended the work in 1564 on the decorative preparations for the solemn funeral obsequies for Michelangelo Buonarotti, and in 1565 the decorations for the sumptuous marriage of Francesco, first-born of Cosimo I, to Johanna of Austria. Lastly, in 1568, he published the second edition of *Lives of the Artists: painters, sculptors and architects from Cimabue onward*, extending and revising the

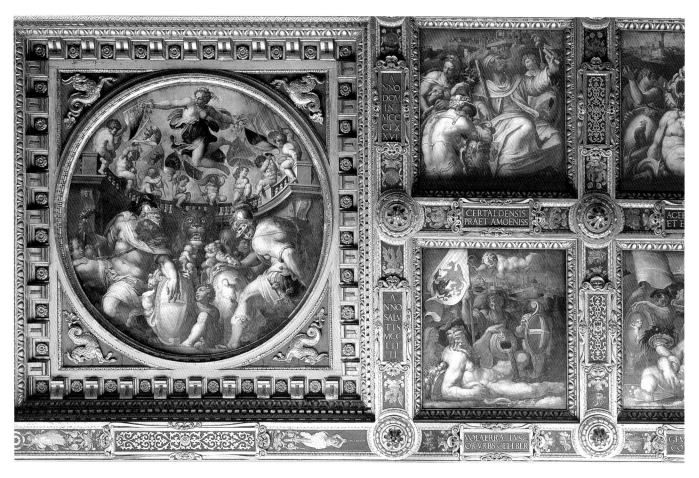

refurbishment of the principal churches of the preaching orders, Sta. Croce and Sta. Maria Novella, with new altars and altarpieces, according to the dictates of the counter-reformists. In 1563 he played an important role in the foundation of the Accademia delle Arti del Disegno, an institution, headed by the duke and a "lieutenant," which brought together painting, sculpture, and architecture as the sister arts, daughters of "drawing." Within a very few

earlier edition published in 1550 and including his own autobiography: with this literary work he inaugurated the modern practice of art historiography.

In Vasari's Florence of the second half of the century the strong and distinct artistic personalities of earlier decades were replaced by a "good average" (Berti, 1981), extended to a circle of artists who had different backgrounds and interests.

The Ceiling of the Hall of the Five Hundred, detail. Palazzo Vecchio, The decoration of the hall by Vasari represents the most complex chapter in the whole pictorial cycle that unfolds through the rooms of the palace.

On the following pages:
Giorgio Vasari and Giovan Battista Naldini, *Emperor Maximilian Relieves the Siege of Livorno*, 1567–71, detail. Palazzo Vecchio (the Hall of the Five Hundred).

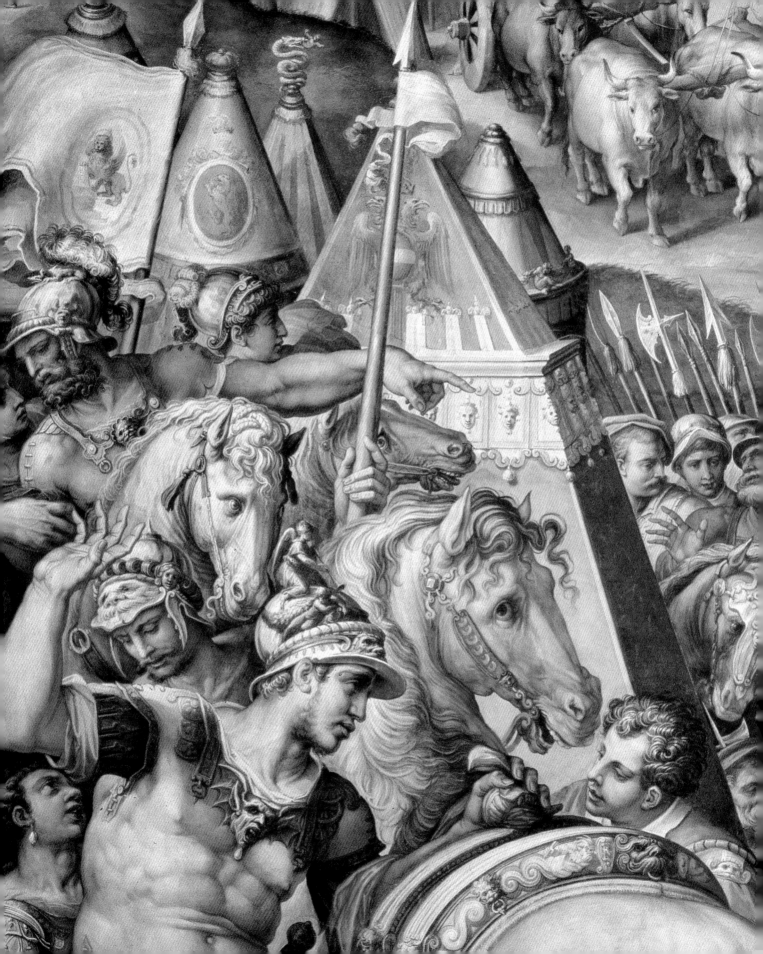

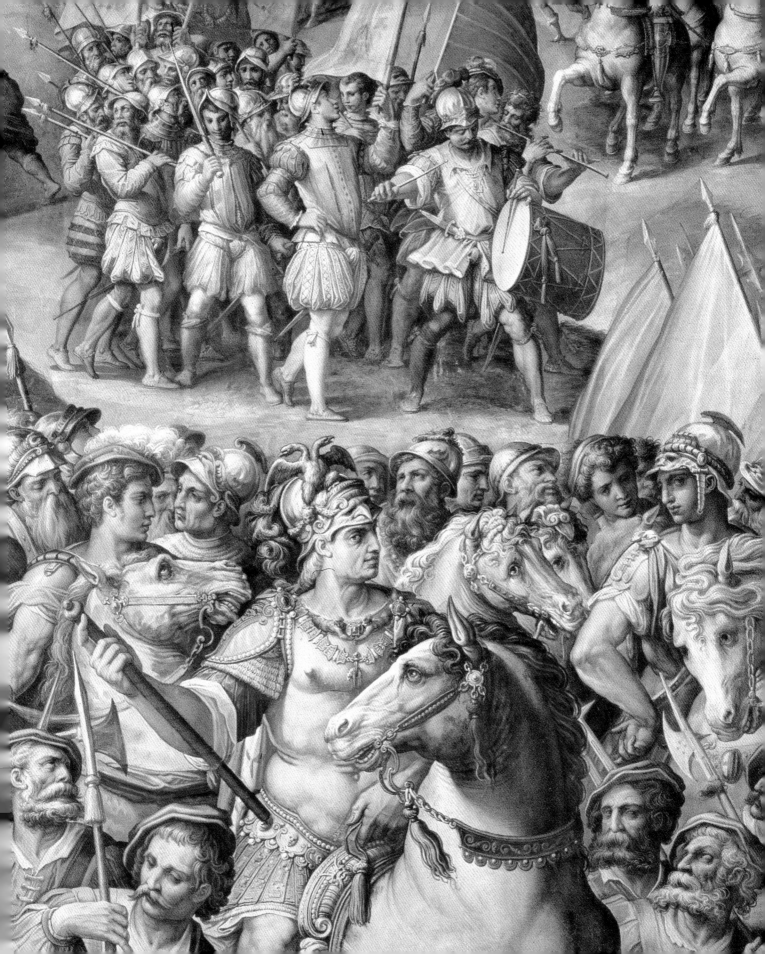

A case in point is the decoration of the
Studiolo (Study) of Francesco I in Palazzo
Vecchio, carried out in the first years of the
1670s, which seems to be a collection of
"minor" artists, but arranged in a manner
"more pompous than modest, with elaborate
nicety, in an fit atmosphere" (Berti, 1981).
Designed in 1570 by Vasari, the small room is
adjacent to the great Hall of the Five Hundred
and offers a contrast with it. The small, narrow
room, rectangular in plan with a little barrel
vault, is completely decorated with frescoes,
stuccoes, wooden ornamentation, bronzes,

paintings on slabs of slate fitted to the doors
of closets that originally held treasures and
rare objects. If the Hall of the Five Hundred
reflects the desire for splendor, celebration,
and grandeur of Cosimo I, the Study reveals
the sensitive and refined character of his son
Francesco, with his interests in natural science,
the arts, techniques, and collecting
("souignieus un peu de l'archemie et des ars
mechaniques," wrote Michel Montaigne, guest
in the Medici court in 1580, about the prince).
Not surprisingly, Francesco chose to be
painted by Giovanni Stradano for the Study
while mixing a potion in a pan over heat in
the workshop of the Alchemists. The
decorative complex of the Medici prince's tiny,
rare "chamber of wonders" corresponded to an
iconographic program, set out by Vincenzo
Borghini, around the theme of the gifts of
Nature and the inventions of the Arts—the
leitmotif, probably dictated by Francesco
himself, is announced in the scene in the
center of the vault, where Nature is seen
offering Prometheus a quartz crystal to work
on. The invention of the scholarly prelate was
played on the interweaving of subtle and
complex correspondence: the paintings on the
closet doors—with stories taken from
mythology, *Perseus and Andromeda or the
Gathering of Coral* by Vasari; *The Sisters of
Fetonte Transformed into Poplars or The
Creation of Amber* by Santi di Tito; scenes of
natural history, *Pearl Fishing* by Alessandro
Allori; *The Baths of Pozzuoli* by Girolamo
Macchietti; pictures of manufacturing, *The
Woolen Mill* by Mirabello Cavalori—were
situated in correspondence with the objects
which the prince had decided to place inside
the closed closet space.

IOÁNES
STRATENSIS

Each of the wall paintings is further linked to the four elements generating Nature: Air, Water, Earth, and Fire—represented in allegorical figurations in the vault—and in the divinities portrayed in bronze. In contrast with other undertakings of greater public impact, in the decorations of the Study Giorgio Vasari did not keep a strict control on the freedom of the artists involved, who consequently stuck to their own individuality of expression, although still with the common purpose of seeking the

Opposite:
Giorgio Vasari, *Perseus and Andromeda,* for the Study of Francesco I, 1570, detail. Palazzo Vecchio. Inspired by Ovid's *Metamorphoses,* the painting shows Perseus freeing Andromeda after defeating the Medusa and then killing the sea monster that had threatened the maiden.

The vault of the Study of Francesco I, Palazzo Vecchio.

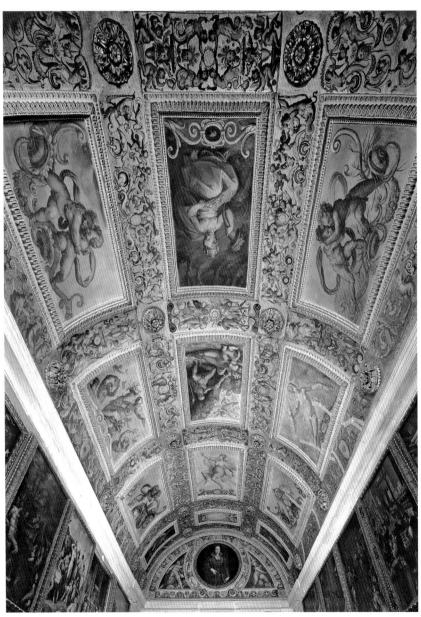

splendor and refinement that the destination, the reduced format, and the subject imposed.

Among the painters who participated, apart from minor artists about whom little is known, there were well-established personalities like Vasari himself, Giovanni Stradano, and Alessandro Allori, along with Vasari's closest collaborators like Jacopo Zucchi, Francesco Morandini, known as Poppi, and Giovan Battista Naldini. As well as these there were painters of the new generation who already had strong individual personalities, like Maso da San Friano, Girolamo Macchietti, and Mirabello Cavalori,

ready to react to the Vasari "grand manner" with imaginative works, obscure and steeped in poetic enchantment, interwoven with references to the models of the first mannerism (Andrea del Sarto, Pontormo, Rosso, Parmigianino). Lastly, artists who remained isolated but distinguished, like the now elderly and eclectic Carlo Portelli or the solitary Santi di Titio, who were already directed toward independent reformist objectives, key to the developments in art at the end of the century.

After the monotonous, official intonations of Florentine art under the control and leveling influence of Vasari, in the fertile ground that produced the Francesco's Study, germinated the first fundamental chapter of international mannerism, which was to ripen in the following decade.

In the same period in which the decoration of the Study was developed, Giorgio Vasari was engaged in other fields, in Rome and in Florence. Here he dedicated his attention to the design and realization of the frescoes for the inner surface of the dome of Sta. Maria del Fiore, commissioned by Cosimo I. This colossal undertaking was just the last chapter in an activity that had begun about 30 years previously, with the altar and choir by Baccio Bandinelli. In the years between 1570 and 1572, Giorgio Vasari and Vincenzo Borghini were again working together to plan the design for the series of frescoes and decide on its iconography. The work on the dome was clearly very different from that of the Study for its dimensions, theme, and public destination, yet they both brought together that same "systematic, rational clarity built on compact correspondence of figures" (Acidini Luchinat, 1997). The work on this immense task started in 1574, but was interrupted with only a third completed, since both Vasari and Cosimo I died in that year. It was then up to the heir to the grand duchy, Francesco I—whose nature had been revealed in the highly admired Study in Palazzo Vecchio—to choose a successor to finish the colossal assignment. After some uncertainty, possibly due to lack of interest, the grand duke consulted with his adviser Francesco Sirigatti and in 1576 assigned the task to Federico Zuccari (1540–1609). Originally from the Marche region, this painter had been an established decorator in Rome, and had come to Florence in 1565 to work on the decorations for the marriage festivities of Francesco de' Medici. Amidst surprise and disappointment expressing public opinion, the frescoes of the dome, finished and displayed in 1579, showed the difficult encounter between two distinct artistic trends: that of Vasari, indebted to the

Alessandro Allori, *Siface of Numidia
Receives Scipio*, 1571–82, detail. Poggio
a Caiano, Villa Medici (Hall of Leo X).
The frescoes by Allori in the hall of
Poggio a Caiano celebrate the power of
the Medici. The scene with the banquet
of Siface commemorates the voyage
made by Lorenzo the Magnificent to
Naples, guest of Ferdinand of Aragon.

lessons of Michelangelo, and that of Zuccari, tied to the legacy of Raphael and close to the urgings of the Counter-Reformation. In Florence Zuccari introduced a new language, which, in place of intellectual allusion, elegance, and "quest for iridescence and changeability," favored sentimental communication, clarity of composition and

the "simplification of coloring" (Acidini Luchinat, 1997).

After Vasari's death in 1574, his place in the Medici court was filled by Alessandro Allori, who became official artist and direct consultant for ephemeral decorative structures, as well as director for the design of hangings, instead of Stradano, in 1576. The adopted son and pupil of

Bronzino, from whom he inherited his workshop (1572), Allori completed the frescoes in the hall of the Villa di Poggio a Caiano between 1579 and 1582, a place where 60 years before Leo X had employed Andrea del Sarto, Pontormo, Franciabigio, and Andrea di Cosimo Feltrini.

The patron for this work was Grand Duke Francesco I who, after the death of his first wife

Johanna of Austria, used to retreat to the Medici villa for long spells with Bianca Capello, whom he had first loved in secret, then married in 1578. In that villa at Poggio a Caiano the two mysteriously died, within a few hours of each other, on 19 October 1587. Before this event, Allori redesigned the decorations on the walls of the hall (in a drawing still kept in the Drawings and Prints section of the Uffizi) with the aim of celebrating the power and prestige of the Medici dynasty. The artist applied a broader division to the wall spaces, including into his composition the existing paintings of Andrea del Sarto and Franciabigio with appropriate integration, redesigning the surrounding architectural support and devising other scenes from the history of ancient Rome—*Siface of Numidia Receives Scipio* and *The Consul Flaminius Speaks to the Council of the Achaeans*—and allegorical figures. The narrative contexts were conceived in a spectacular and unprecedented composition, where the artist's description lingers particularly over the preciousness of the objects, the opulence of the materials, on the detailed research for the settings (in particular the sumptuous banquet of Siface of Numidia in the first scene). The floral, zoomorphic, and anthropomorphic inventions which accompany the frescoes of Allori betray a taste for the bizarre, the fantastic or perverse "caprice," typical of the cultural climate that characterized the court of Francesco I. On the same lines were the inventions of the contemporary Bernardo Buontalenti, architect, sculptor, and favorite designer of the grand duke. On another front Alessandro Allori took part in important undertakings of the Florentine Counter-Reformation, as an artist in high demand for monumental altarpieces. For the church of Santo Spirito he executed no less than three, including that for the Cini altar representing *Christ and the Woman Taken in Adultery*, finished in 1576. According to observations from a recent restoration, after a first painted layer the artist corrected the figure of the protagonist, mitigating its sensuality and elegance, and moved the face of Christ to a profile position directly facing the woman. In this way Allori adapted to the requirements of narrative clarity, lifelike quality, and decorum imposed by the synod for sacred pictures, held in Florence in 1573 and repeated two years later by Bishop Alfonso Binarini, who had come to Florence to check on the application of the dictates of the Council of Trent (1563). It was a sign of the changing times. In the eighth decade of the 1500s, Florence's artistic world was also faced with significant crisis factors for the Mannerist tradition derived from the legacies of Bronzino and Vasari: the most determining influences

Alessandro Allori, *Allegory*

On the following pages:

Left-hand page:
Alessandro Allori, *The Annunciation*, 1603. Galleria dell'Accademia. The layout of the composition played on the beam of light directed behind the Virgin Mary and the vivid piece of "still-life" in the foreground are already features of 17th-century painting.

Right-hand page:
Jacopo da Empoli, *The Honesty of Eligio*, 1614. Uffizi Gallery. Eligio, protector of goldsmiths, accused of stealing part of the precious metal assigned to him, shows King Clovis how he has made two whole thrones with the amount given for just one. The scene gives the artist the opportunity to show the workshop of a contemporary court craftsman, dignified by the luxurious items on display.

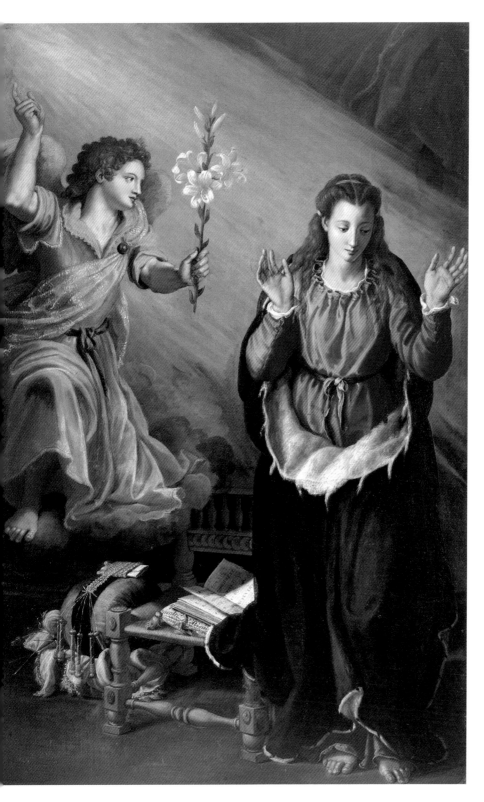

were the activity of Federico Zuccari in Florence 1575–79, the northern style—dramatic and somber—of Giovanni Stradano (so evident in the *Crucifixion* of 1569 for Santissima Annunziata), the anticipated reformation of Santi di Tito, which had already begun in the paintings for the Study, and the Venetian contributions of the Veronese Jacopo Lingozzi, added to those of even greater impact by Domenico Cresti, known as the Passignano, in Venice from 1581 to 1585 following in the footsteps of Zuccari. Under Grand Duke Ferdinand I, the artistic climate of the last Florentine "manner," with features like profanity, extreme refinement, bizarre curiosity, minute perfectionism, was finally extinguished, replaced by art steeped in renewed intellectual and spiritual rigor, with magnificence and monumentality, simplicity, and economy.

The artist who most successfully tackled this difficult and radical changeover was in fact Jacopo Ligozzi (1547–1627). Born in Verona into a family of painters and artisans, he arrived in Florence in 1577, where he was court master for four grand dukes, from Francesco I to Ferdinando II. For his great technical versatility, propensity for exquisite art in small format, and for his interest in nature, Ligozzi's tastes were compatible with those of Franceso I, for whom he did a series of scientific drawings with animals and plants in miniaturist vein (datable from 1577 to 1591, Uffizi, Drawings and Prints Section). Within the Medici court he had a multifunctional position: he was appointed to prestigious offices including drawing teacher for the court children (including Maria de' Medici) and superintendent of the Uffizi Gallery; he conceived the adornment regalia for solemn public celebrations; he designed wood engravings, embroidery, glass, work in precious stones, taking part in the new prolific manufacturing activities of the Medicis. As a painter he liked to engage on eccentric, courtly portraits, macabre allegories, and small paintings of private devotion, but in 1590 he moved on to the execution of works of large format, which suited the reigning cultural and religious climate—two monumental paintings on historical subjects for the Palazzo Vecchio (where he signed himself "miniaturist," 1591) altarpieces with effects suggesting the mystic and surreal, and the frescoed series with the *Scenes from the Life of St. Francis* in the cloister of Ognissanti (1600).

One of main contributors to the revision of the Mannerist tradition and its supersession was Santi di Tito (1536–1603) with his "reformed" paintings styled with a narrative tone, accessible and adherent to the facts, with quiet, sober naturalism and cordial, convincing

communication. His aims were didactic and morally edifying, in contrast with the artifice, obscure perfection, and captiousness of mannerism. One of the masterpieces of Santi di Tito, and of Florentine art of the end of the 16th century, is the altarpiece with *Il Crocifisso che parla a San Tommaso* (The Crucifix speaking to St. Thomas), executed in 1593, for the Dominican church of S. Marco. The composition depicts the miraculous episode in 1273 in the life of St. Thomas Aquinas, in which he is seen presenting his written work to the crucified Christ who pronounces: "Bene scripsisti de me Thoma." ("You wrote about me well Thomas.") It has been observed that "the painting claims to be an example of total verisimilitude" (A. Paolucci in *La comunità...* 1981), presenting the mourners and Christ crucified as "living" people who come out of the limits of the devotional icon and enter the space of the kneeling saint, framed in an illusionist way from below, a three-quarters view with rigorous perspective. Inciting them to practice drawing from nature and from "the good fresco," Santi di Tito taught his pupils to look back to the renowned painters from the beginning of the century, particularly Raphael, Fra Bartolomeo, and Andrea del Sarto. The artists who followed these influences and adopted them for their own were Passignano, Andrea Boscoli, Jacopo da Empoli, and Bernardino Poccetti. Poccetti (1548–1612), was a prolific and assiduous fresco painter, with an easy and accessible narrative vein, which appeared with particular success on the walls of various cloisters in Florence and around Tuscany. Alongside the trend established by Santi di Tito, which had a following up to and beyond the mid-17th century, another artistic wave was launched by Ludovico Cardi, known as Cigoli (1559–1613), who formerly frequented Tito's workshop with his friend Gregorio Pagani, which was to have important future consequences. Through the stimulating study of Federico Barocci and experimenting with ideas formed outside the Florentine circle (Correggio, Titian, Veronese), Cigolo reached an emotive and sympathetic conception of the supernatural, subjects viewed using unusual angles and depth, soft, suffused figures and a fluid, substantial pictorialism. At the end of the century it was Cigoli who emerged as one of the most outstanding figures not only in Tuscany but also in Italy generally—his *Martyrdom of St. Stephen* of 1597 for the monastery of Montedomini (now in the Palatina Gallery), merging the supernatural sphere with the terrestrial one represented the first example of "baroque hymnography" (M. Gregori, 1986).

Elena Capretti

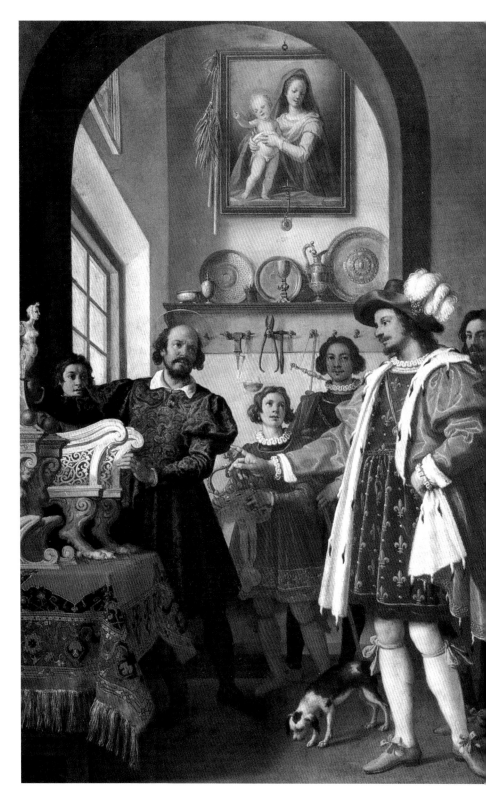

The Semiprecious Stones Workshop: a great artistic tradition seen through a small museum

If anyone in Florence, after visiting the galleries, museums, churches, and public buildings, still has the stamina to explore unusual avenues of individual interest, they might make a stop at the *Opificio delle Pietre Dure* (Semiprecious Stones Workshop) and its museum. While certainly of "minor" interest compared with

Detail of a tabletop decorated with bunches of grapes.

Opposite:
Detail of a table in black Belgian marble.

Tile with still life, designed by Ludovico Massai.

the temples of mass tourism that attract thousands of visitors every day, it is unusual and cherished for the objects in its collection and for the ancient origins of this craft.

The present-day Workshop, renowned internationally as a center specializing in the restoration of works of art, is the direct heir to the workshop dedicated to semiprecious stones, founded in 1588 by Grand Duke Ferdinand I de' Medici and which has never gone out of existence. In visiting the museum, which is the caretaker of that illustrious past, it is necessary to revise the history of this specialist workshop, which, during its long life, enjoyed international appreciation and renown. In the 16th century the passion for precious and semiprecious stones, as old as history itself, encountered a period of particular fame—the Renaissance culture considered these precious materials to be especially suitable for the regalia of princely courts, as these became more and more sumptuous. The fusion of the

craftsman's inventiveness and that of nature was much sought after in cameos and intaglios, and cups carved out of semiprecious stone where the Renaissance attempted to emulate the mastery of the Hellenistic and Roman worlds. If Florence was not the only place in Europe where antique objects in semiprecious stone were collected and created, it was certainly the first to establish and encourage the flourishing of a manufacturing works specifically dedicated to this difficult and costly art. The first Medici grand dukes invested enormous effort toward this, both in financial and operative terms, especially since there was no previous tradition in Florence in the difficult technique of fashioning the hard material. It was Francesco I de' Medici who created it, in the 1570s, summoning from Milan two

432

View of the Pantheon according to a design by Ferdinando Partini.

teams of master craftsmen skilled in the engraving of vases in rock crystal and other siliceous stones. The first Florentine creations were of the highest quality, as demonstrated by the famous vase of lapis lazuli, designed by Bernardo Buontalenti, engraved by the Milanese craftsmen and set in gold and enamel by the Flemish goldsmith Jaques Bylivelt (Museo degli Argenti). In this work the formula was applied that was to be so successful in guaranteeing the quality of work for the grand duke—the division of roles between the designers and the skillful artisans, each one called to contribute according to his own particular specialization. However, the passion of the Florentine grand dukes of that time did not concentrate merely on vases. Another area of application for semiprecious stones was also inspired by the ancient Romans who defined it as *opus sectile*, mosaic in sections, where the picture or pattern was formed by placing, side-by-side, numerous tiny blocks of stone, cut into different shapes and selected according to the desired color.

This kind of mosaic was revived in Rome during the 16th century mainly for application to walls and tabletops, with archaic marble combined in nonfigurative compositions. In Florence the Medici drew inspiration from these contemporary Roman forms of marquetry, but substituted the marble with costly precious or semiprecious stones, urging their craftsmen to tackle very varied and difficult subjects. After the first geometrical themes favored by Francesco I, his brother Ferdinando, who organized the stone-carvers' workshops in the Uffizi as a State manufacture, set as the objective of semiprecious-stone mosaic the widest variety of subjects, from vases of flowers to portraits, landscapes and stories from the Scriptures. *Pitture di pietra* (stone paintings) was the name that Ferdinando used for these artifacts, implying that they were worthy of competition with paintings, both for the variety and successful rendering of their subjects and for their colors. Taken from the infinite, magical, but natural palette of stone, these colors had the advantage over those used in painting because they would not alter over time.

Coat of arms of Grand Duke Ferdinando I de' Medici and Christine of Lorraine.

Detail of *Sculpture*, copied from a picture by G. Zocchi.

The choice of the correct tones of colored stone was in itself essential to the success of the Florentine mosaic that also depended on the extreme precision of the cut edges of the sections, so that the joints should be practically invisible. The result giving the spectator the illusion of an uninterrupted image, almost as if it were indeed a painting, and not a laboriously constructed mosaic of hundreds of tiny squares of stone.

The items at the beginning of the exhibition in the Workshop Museum date back to the end of the 16th century and the beginning of the 17th, when the art of working with semiprecious stone had only recently reached technical excellence, but they already demonstrate perfection, both in the cut and color of the stones. They were models for the extremely rich and varied production of successive centuries that the grand dukes of the Medici—and the subsequent Hapsburg Lorraine dynasty, coming to power in Tuscany in 1737—did not cease to cultivate and export throughout the rest of Europe.

Tabletops, cabinets, caskets, clocks, wall pictures, sculptures and the widest variety of furnishings created by the Florence craftsmen are today widely dispersed among numerous museums in Italy and in Europe, often coming from private collections of princes to whom these creations had been given as gifts by the grand dukes of Florence. Only a small part of the range of the most beautiful and prestigious works are in the Museum, the direct heir to this manufacturing tradition, which carried out the creative assignments that were then dispatched to the royal palaces and noble houses for which they had been ordered.

Cosimo I de' Medici, 1597.

Only in the workshop, however, is it possible to trace the entire three centuries of this specialist production, and understand how these complex creations were born, through the materials, tools, and technical procedures jealously handed down over the years within the workshop.

The first section, which is dedicated to the origins of manufacture, features items in porphyry from the time of Cosimo I, who delighted in this rich material, a symbol of royalty that was ideal for illustrating in grand works of art the magnificence of the new grand duke of Tuscany. Dating from the time of his son Ferdinando, and his taste for figurative subjects, is a portrait of

Cosimo I, composed symbolically of marble originating exclusively from Tuscany, and destined to surmount the tomb of the late grand duke.

One of the major undertakings tackled by Ferdinando I was in fact to create a new, magnificent mausoleum for the Medici family, entirely covered with sumptuous semiprecious stones in the center of a rich altar. The second section of the museum is dedicated to this ambitious project, with work executed between the beginning of the 17th century—when the Princes' Chapel, as the Medici mausoleum was called, was founded—and the mid-19th century, when this endeavor proved to be too ambitious and costly and was finally abandoned. While the studios were considerably occupied in the 17th century with the work on the Princes' Chapel, there was still a large and continuous production of furnishings, above all tabletops and

Detail of a sample for a wall.

Left:
Landscape in plaster.

cabinets, often decorated on the sides with panels of mosaic in semiprecious stones. The most popular decoration, in keeping with the naturalistic fashion of the 17th century, consisted of floral compositions often combined with fruit and birds, which the Museum has gathered together in a section entitled "Fiori di pietra" (Stone flowers). The fashion for these decorations continued until the 1700s, with fanciful design variations of rococo style, but always against a background of black Belgian marble, considered particularly suited to bring out the lively polychromatic effects of the stone. The section dedicated to the last of the Medici line, extinct in 1737, gathers together works from the Baroque period of the long reign of Cosimo III, who spent large sums on the manufacture of semiprecious stone objects, while his grand duchy was declining in importance, both politically and economically. He sent sumptuous gifts all over Europe, as if proudly declaring that his little kingdom could still produce these exquisite and costly masterpieces, like the *acquasantiera*

(holy water stoup, ordered for a room in the Pitti palace, which combines gilt bronze with precious stone. This object was executed with a precision that makes the hard material seem soft like modeled wax.

Another example of consummate skill is a large cameo, 7 inches (18 cm) long, which took ingenious advantage of the natural vein pattern of a block of chalcedony to represent the grand duke and the female figure of Tuscany, in front of the temple of Peace. The new dynasty of Hapsburg Lorraine, which succeeded

end of the 1700s, figurative subjects were gradually abandoned and replaced by sophisticated still-life subjects, often compositions with shells, coral, and pearls. This decorative theme was used on different objects and in different versions right up to the 1820s and 1830s, when the grand duke's laboratory, always intent on updating its repertory, began to return to floral subjects, which the taste for romanticism was reintroducing into decorative art. A real triumph of flowers blooms on a mid-19th-century tabletop,

stone, all with shapes showing the influence of oriental models, were popular items. This was, after all, the period in which the taste for "Japonaise" was spreading through Europe, and the Workshop was prepared to take up any new international artistic trend, despite being situated in a relatively provincial city like Florence. This can be seen, for example, in a tabletop decorated in a design of magnolias and convolvulus, dated 1881, where the fleshy vitality of the opening flowers and the restless curling of the stems already hints at the dawning Art

Landscape showing Jonah and the whale, inlaid in precious stones.

the Medici on the throne of Tuscany, continued to protect and give commissions to the workshop, though of lesser grandeur than before. An impressive undertaking, which lasted for over 20 years, was a series of more than 60 pictures in semiprecious stones, drawn from models by the painter Zocchi and destined for the imperial court in Vienna. For the Pitti palace in Florence a replica was made of the Four Arts— Painting, Sculpture, Architecture, and Music—where the pictorial models seem to have been transposed into stone with great technical skill in the choice of color and stone, using particularly tiny chips to give the figures a natural quality. Toward the

the last great achievement of the grand duke period ending in 1859. Floral and naturalistic subjects still continued to dominate the last creations of the Workshop, collected in the museum's 18th-century rooms, and produced in the last decades of the 19th century. After the end of the grand duchy of Tuscany, the laboratories continued to manufacture for sale to the public. The director at this time was the painter Edoardo Machionni, who designed a wide variety of items with precision and invention, from the most difficult tabletops and large panels to less costly objects, but always with the same exquisite taste and impeccable workmanship. Frames for portraits, small tiles for framing or for paperweights, engraved vases from a single piece of

Nouveau. The refinement and relative cost of the Workshop mosaics eventually exceeded the means of the middle-class clientele on whom it depended. However, rather than lower the standards of its artistic tradition, the management elected to specialize in a new and growing activity—the restoration of the national artistic heritage, which opened the way to a new era for the antique Medici workshop. Even today, though it employs few specialist craftsmen, the rare technique of mosaic in semiprecious stones survives, applied to the restoration of works of art from all over the world, which acknowledge the exclusive supremacy of the Workshop in this field.

Annamaria Giusti

The court art of the last of the Medici

Coat of arms of the city of Florence, created in semiprecious stone mosaic work, part of the decorations of the base band of the internal covering of the Cappella dei Prìncipi in S. Lorenzo.

Fountain in the Mannerist style, on the corner of Borgo S. Jacopo with Via dello Sprone.

Opposite:
Interior of the Cappella dei Prìncipi.

From the octagonal pantheon of the Medici princes to the Lorraines' triumphal arch

Until a few years ago, the public and private architecture created in Florence during the 17th century had not enjoyed particular attention or critical success. In dedicating rather summary and approximate information on the subject, the history of art and architecture books aimed to contrast 17th-century Florentine architecture with the triumphant examples of Roman Baroque, ending up blaming the designers working in the Tuscan capital for being "obtuse" and "insensitive" to Baroque style. The writers of these books, or of the compendia of Italian architectural events of the 17th century, had not the merest hint of a suspicion that what appeared to them as attributable to insensitivity, that is, dependent upon the limited sensibility of the architects concerned, was in fact due to the huge difference between the incomparable cultural and morphological realities of the two

cities in question. Rome was synonymous with the power—the universal authority—of the Counter-Reformation Church, and was therefore an expanding urban organism, a pole of attraction for Christians and the base for the training and dissemination of new religious orders. Florence, on the other hand, mirrored the modest pretensions of a political administration that had determined its metamorphosis—it was identified, that is, with the municipal command role of the Medici grand dukes who governed in succession during the 17th century. In other words, the usual interpreters of stylistic aspects in isolation had not considered that in a city such as Florence, in which an ideological motivation of significant substance and a farsighted political project were absent, and in the presence of an urban organism that had not grown, also on account of the objective restrictions constituted by a prevalently medieval building pattern, it was inevitable that neither high-profile ventures nor architectural "explosions" had occurred. It was equally inevitable that the architects did not feel obliged to express themselves in Baroque forms whose contents and dimensions were extraneous to the Florentine urban condition and to the culture of the local patrons, but rather sought an expressive self-control with an autonomous and appropriate meaning. While the Roman pontiffs also made use of the spectacular and stirring resonance of urban planning designs and then of unrestrainable architecture as persuasive means to reaffirm their spiritual dominion and reinforce their political prestige, Grand Duke Ferdinando I de' Medici (who succeeded his brother Francesco I) was forced to maneuver within the perimeters of rather circumscribed inclinations. In the last decade of the 16th century, the Medici grand duke was preoccupied with continuing to give preference to "ornate" interventions, such as the preparation (in 1589) of the significant yet ephemeral festive structures to celebrate his marriage to Christine of Lorraine (four triumphal arches conceived by Alessandro Allori, Giovanni Antonio Dosio, Santi di Tito,

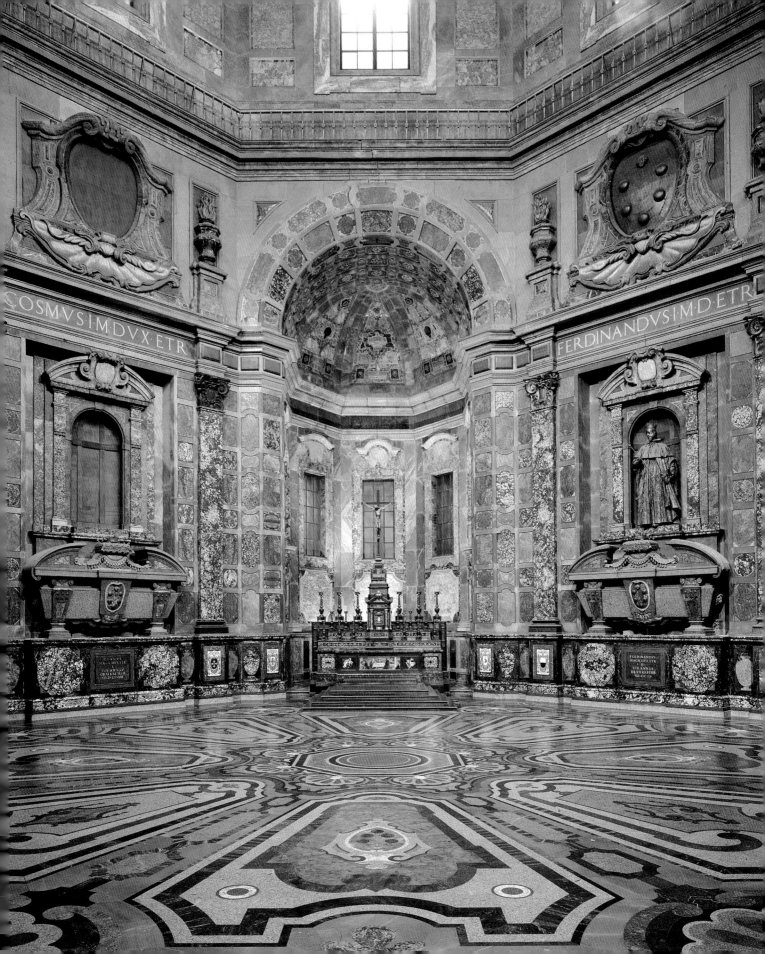

COSMVS·I·M·DVX·ETR FERDINANDVS·I·M·D·ET·R

Taddeo Landini, and the false "Corinthian" facade of Sta. Maria del Fiore), with the erection of the equestrian statue of Cosimo I in Piazza della Signoria (1594) and with the request for models for the facade of the Duomo, made to Giambologna, Don Giovanni de' Medici (stepbrother of Grand Duke Ferdinando) and Ludovico Cigoli.

The wooden model attributable to Cigoli is undoubtedly the only one in which it is

View inside the vault of the apse and the dome of the Cappella dei Prìncipi.

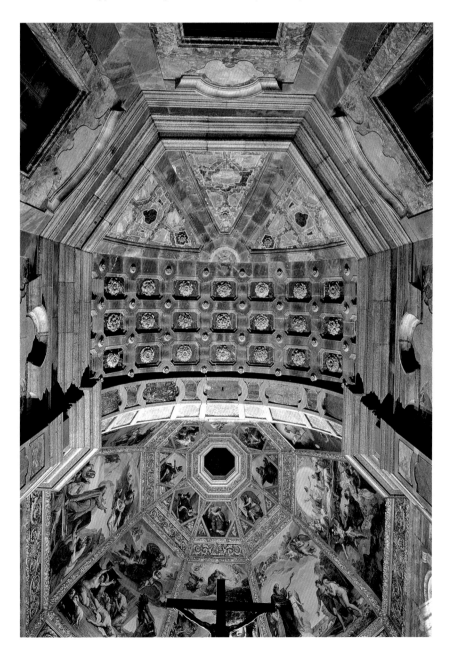

possible to read the intention to realize a facade system that, through the thickness—or rather the hollow—of the vaults of the three blind arches (the central one taller and broader), places itself in relation with the space of the church square corridor into which the Baptistery faces on the other side, by proposing a greater transversal expansion of it. Still in only the first decade of the 17th century, Ferdinando I insisted on ordering urban decorations such as the placing of the statue of the *Centaur* carved by Giambologna (1600) at the crossroads of Canto dei Carnesecchi, and the construction of displays, some provisional and others intended to last, for the marriage (1608) of Prince Cosimo to Maria Magdalena of Austria. These included triumphal arches designed by Cigoli and Jacopo Ligozzi; the false facade of Sta. Maria del Fiore "with mixed stones and of composite architecture"; statues of the four seasons, executed by Giovanni Caccini, Pietro Francavilla, and Taddeo Landini, positioned on the bridge of Sta. Trinità; and the equestrian statue of Ferdinando I in Piazza Santissima Annunziata; obelisks made of inlaid Serravezza marble in Piazza Sta. Maria Novella; and a fountain at the confluence of Via dello Sprone and Borgo S. Jacopo. Beyond initiatives of "public" effect, Ferdinando's personal ambitions were focused particularly on the lavish design of a monumental chapel–mausoleum, with a "secular" appearance, which served to commemorate and celebrate all the princes of the Medici dynasty. It was to be erected behind the chancel of the church of S. Lorenzo, to be the majestic conclusion of a temple that was identified with the lives of the Medici House. It was envisaged that, in order to be distinguished for its magnificence, the mausoleum—later called the "Cappella dei Prìncipi" (Princes' Chapel)—was to have its inside walls entirely encrusted in precious marble, this also to affirm the supremacy of the Florentine workmanship of semiprecious stones. To add further meaning to the symbolic contents of the family pantheon, the grand duke also saw fit to employ his stepbrother Prince Don Giovanni, a soldier and a dilettante-architect, for the planning of the building. Not by coincidence, the winner of the competition announced by Ferdinando I in 1602 was the proposal perhaps conceived by Don Giovanni and certainly implemented by Matteo Nigetti (the inscriptions on the crowns of two windows, on the ground floor of the Chapel, show Don Giovanni as *operis inventor* and Nigetti as *totius operis exsecutor*). The proposal hypothesized an octagonal structure crowned by a large dome (eight is the number symbolizing life that continues and, by extension, the afterlife).

The value of Nigetti's contribution to the design and construction work of the Cappella dei Prìncipi can be measured precisely in his ability to imagine, on a large scale, the chromatic result of the absorption and reflection of light from the continuous marble *specchiature* (recessed panels), to foresee the compositional effect of the face of semiprecious stones over a surface area not attempted previously and to succeed in animating—through the distracting variety, combination, and preciousness of the materials— the broad and severe scheme of the wall modeling, which appears to consist of minimal chiaroscuro reliefs given the limited overhangs of the architectural framework. On a wall layout where, more than the pilaster strips and niches, it was the volumes of the sarcophagi and the gilded statues that were supposed to stand out, the determination of the color combinations, the rhythms of the vertical divisions, and the design of the recurring geometric motifs became fundamentally important. Nigetti successfully envisaged the correct mix of these rather original ingredients; he succeeded in overcoming the difficulties inherent in developing a framework so large and therefore so new in terms of its formal rendering. It was Nigetti, and not Don Giovanni, who imagined and realized the calculated contrast between the internal and external features of the Chapel. The interior was precious, of astounding sumptuousness and highly original for the complete covering of all the surfaces and the enthusiastic use of semiprecious stone mosaic; an unusual space for the spaciousness and the potential offered by the shimmering colors. The exterior was solid, made of soft-gray "pietra forte" stone and white marble; though presenting itself as a projection of the interior volumetric plan, it does not betray the preciousness of the fabric inside the shell, in line with Florentine tradition. The custom of maintaining the manifestation of luxury within the internal perimeters of the "reserved" part, while avoiding ostentatious display on the outside, also applied for the buildings constructed during the 17th century by the emerging Florentine families.

This general practice was also confirmed in the extensions of stately or particularly symbolic residences, such as Palazzo Pitti and Palazzo Medici-Riccardi—whose extensions were obtained through the slavish reproduction of the external forms of the pre-existing cores. It is also symptomatic that in order to duplicate the external image of the grand duke's palace with the lateral additions (1620 and 1631), recourse was to rather mediocre local operators such as the Parigi brothers, while for the transformation of the interior, the creative and innovative contribution of a prestigious artist, then in vogue in Rome, was required, namely Pietro da Cortona (1637 and 1640). Similarly, the extension that the Riccardi family wanted (1687) to the former Medici dwelling in Via Larga was resolved in the continuation on the facade of the Michelozzi's original divisions, while the interior saw the construction of a gallery, with frescoes and mirrors, and a library that was noteworthy for its use of decorative elements in line with current tastes.

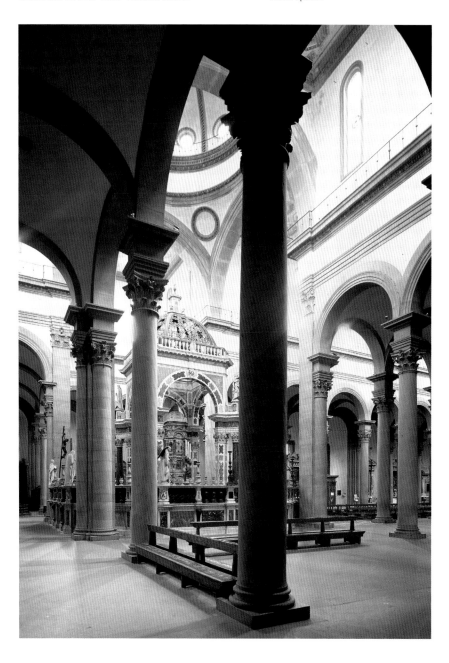

Giovanni Caccini, the High Altar, baldachin and chancel in the church of Santo Spirito.

The unadorned external features of the following buildings are also evidence of the custom: Castelli, then Marucelli in Via S. Gallo (1634); Guadagni in Piazza Duomo (begun in 1679); Incontri in Via de' Servi (1676–79); Orlandini in Via de' Pecori (1679); Panciatichi in Via Larga (1698); and Roffia in Borgo Pinti (1696). These buildings were only embellished by the number of windows that each had (attesting to the economic power of the families concerned) and the central portals with small balconies above (the so-called "poggioletto"). Inside, however, stairways adorned with statues, rows of rooms and halls on the *piano nobile* (main floor of a Renaissance building), galleries, alcoves, walls, and ceilings loaded with gilded stuccoes or enlarged virtually by the perspective effects of the painted architectural squaring, all demonstrated the desire to fall into line with a rapid succession of popular fashions. In religious architecture too the antithesis between interior and exterior features was revealed in numerous examples—we need only think of churches built new, such as Sant'Agostino and Sta. Caterina on Costa Scarpuccia (1642); S. Paolo Apostolo (1670); S. Frediano in Cestello (1689); or restructured, such as SS. Simone e Giuda (1630) and S. Giorgio dello Spirito Santo (1705), the incomplete facades of which were the sign of choices that gave priority to the execution of an ambitious interior, as opposed to an outside consisting of bare masonry left in a rustic state. For other Florentine churches, the adaptation of the elevations to suit Counter-Reformation precepts was resolved with painted decorations (as with Sta. Maria Maggiore in 1638 and Sta. Maria del Fiore in 1688), or through the

View of the interior, looking toward the High Altar, of the church of SS. Michele e Gaetano.

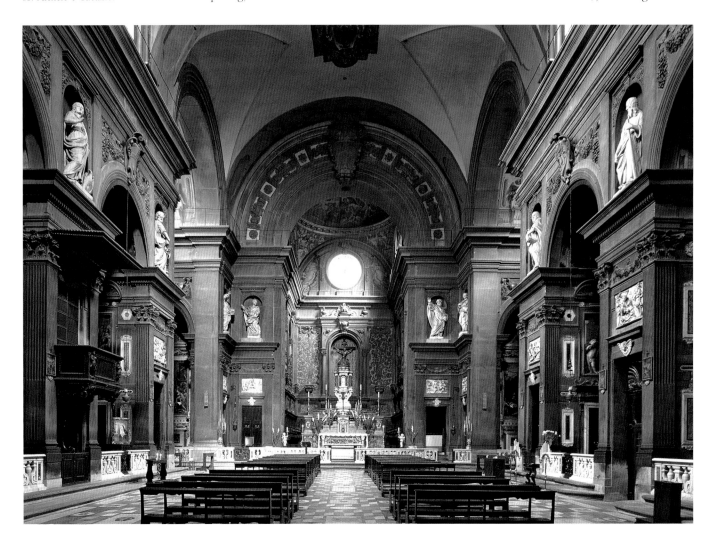

addition of a portico in front of the facade, as in the cases of the churches of Santissima Annunziata (1604), S. Domenico di Fiesole (1635); S. Pietro Maggiore (1638); Madonna della Tosse (1640); and Sta. Margherita in Sta. Maria de' Ricci (1640). We should not believe, however, that these projects, often so colorless and routine, represent the characteristics of all 17th-century Florentine architecture. We have already seen how and to what extent the Cappella dei Prìncipi, which Nigetti began to build in 1605, allows the results of the experimentation with the tectonic and spatial potential offered by the combinations of patterns and colors of the semiprecious stone mosaic work covering to be appreciated. But Nigetti also showed that he was capable of imagining spaces that were more dynamic than those of Buontalentian "Mannerism," and with more marked modeling of the wall fabric through new assemblages of frameworks that ignored the conventions of the five canonical "orders" of architecture. Clear cases of this are the church of the SS. Michele e Gaetano, designed and begun in 1604 for the Teatini fathers, and the facade of the church of Ognissanti (1637). Supervised by Nigetti himself, following his own design, until 1630 (when Gherardo Silvani took over), the church of the Teatini was a representation of an effective Counter-Reformation style. At that time the broad scope of the articulation of the interior space (with the different developments in height of the side chapels, the arms of the transept, the single nave and the chancel), together with the solemn unitary architectural phrasing of the wall organization, were signs of innovation in Florence. In the elevation of the church of Ognissanti (realized 40 years after Buontalenti's facade of Sta. Trinità), also taking account of economic factors, Nigetti divided and organized the wall plastically in a mediation between bas-relief and high relief, carefully calculating the graduated structure of the overhangs and projections over the street, as small balconies, the consoles of the niches, in turn marked, in juxtaposition, by inbuilt semicircular elements. He also had recourse to the original solution of the segments of pilaster strip, at right angles to the plane of the wall, which alongside the columns, act as an "invitation" to the entrance portal.

In the same years of the early 17th century, Giovanni Caccini designed and executed the chancel and high altar of the church of Santo Spirito (1606), and the aediculae in the tribune of the church of Santissima Annunziata (1606 and 1609). The octagonal ground plan and volume plan of the chancel of Santo Spirito revealed theatrical features that were functional for Counter-Reformist purposes; it imposed itself as a structure that liberated the prolongations of stairways and balusters punctuated with statuary episodes from the central core of the baldachin. The theatricality of Caccini's architecture surprised and seduced his contemporaries with the richness and decisive effect of the chromatic and decorative divisions, proposing a new relationship

Matteo Nigetti, the facade of the church of Ognissanti.

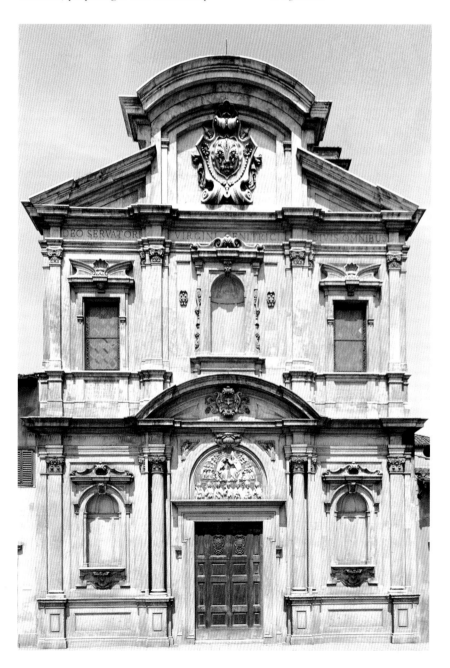

Detail of the fresco decoration of Palazzo Corsini.

between frames and ornamental accessories, with the introduction, in the practice of worship, of the sentiment of the stately and the striking that were typical of the 17th century. In the immobility of the Brunelleschian nave, ordered by the rhythmic sequences of competing views, the chancel and the baldachin conceived by Caccini as central nuclei that tend to open up into diagonal ramifications are inserted as substantial elements of counter-perspective, since they interrupt the vista of arches and place themselves as origins, as fulcra of irradiation, that, reverberating toward the observer, constitute the expressions of a transgressive and dynamic spatiality. The introduction of this colorful architecture into a context characterized by the colors white and gray, the columns placed in projection on the corners of the baldachin, attracting the attention, assuming more a prestige than a structural function, the perforated cupola, allowing the penetration of light from above onto the ciborium (by Giovan Battista Cennini) and onto the altar, the accompanying sculptures, the braided iron transennae, the votive candle-holding angels, all contribute to increasing the unrestrained chromatic and material energy of the whole. In the aediculae in colonnades placed against the pillars of the tribune of the Annunziata, the Caccinian architectural language was enriched with originally designed details, such as the frame surrounding the cavity of the niches,

which eliminates its thickness in the curved section so as not to loom over the heads of the statues, later regaining consistency in the vertical segments until it is prolonged and projected into an overhang at the base, connecting to the wall with spirals of consoles that find formal continuity in the reliefs of the scrolls below the niches. The aforementioned works by Giovanni Caccini and Matteo Nigetti are the expressions of the search for and achievement of an autonomous Florentine form of 17th-century architecture, freed from the burden of heritage, aware of the demand for a more animated spatiality, far removed from the passive conformity of the Parigi brothers (Giulio and Alfonso the Younger) and Gherardo Silvani, with whom they only had the age in which they were working—the 17th century—in common. The same path was followed by Pier Francesco Silvani (Gherardo's son) and Antonio Ferri. The former was author of the dignified facade of the church of SS. Michele e Gaetano (1648); the project for the S. Firenze church and monastery complex for the Oratorian fathers (1668); the construction of the pointed arch of the spiral staircase in Palazzo Corsini (1679); and the Corsini Chapel in the church of the Carmine (1683). The latter was responsible for the staircase and hall in Palazzo Corsini (1694) and the dome of S. Frediano in Cestello (1698). Two successive projects were executed by these two architects—the first was the construction of the

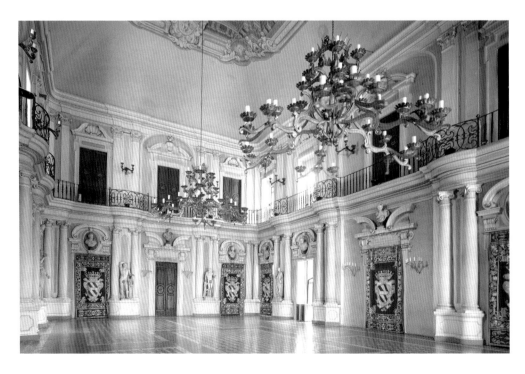

Palazzo Corsini, Throne Room.

unusual U-shaped plan of the central part of Palazzo Corsini, built between Via del Parione and the Lungarno, which is the only Florentine building endowed with authentic 17th-century spatiality, opening up at the front to an evocative view across the river, facing into which are its loggias and terraces offering high-level observation points. Then came the majestic interiors of the "Scalone d'Onore" (Great Staircase) and the "Salone del Trono" (Throne Room), the latter characterized by its walls with the repeated rhythms of the externally developing loops of coupled columns and of the gallery above. The desire to improve the

surface of the long facade of Palazzo Pitti, a few years after its expansion, to correct the unpopular appearance of the "huge pile of stones" laid by the Parigi brothers, and perhaps also the intention to transplant to Florence some stylistic elements of the architecture developing so successfully in Rome, prompted Grand Duke Ferdinando II, who had appointed Pietro Berrettini da Cortona to fresco some rooms in the same building, to ask Cortona to prepare a plan to renovate the facade of the palace (1640–47), a proposal of a stately exedra backdrop for the courtyard of the building on the Boboli side, and a design for the front of

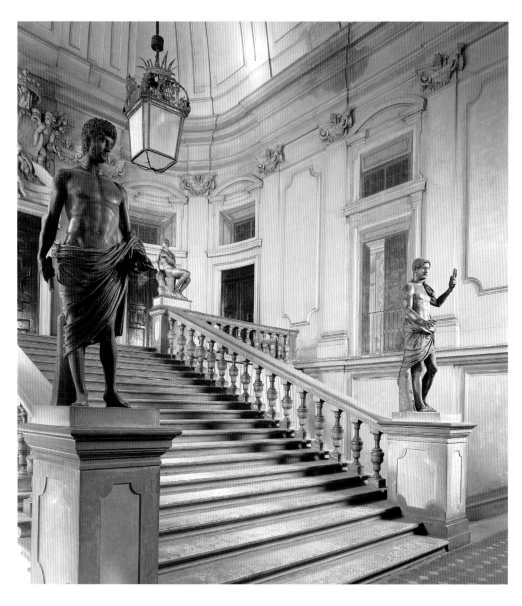

Palazzo Corsini, Great Staircase.

Pier Francesco Silvani, wooden model of the church of the Oratorians.

Jean Nicolas Jadot, Triumphal Arch of the Lorraines outside Porta S. Gallo.

Ferdinando and Giuseppe Ruggieri, bell tower of the church of S. Lorenzo and flared windows set in the drum of the dome of the Cappella dei Principi.

Sta. Maria del Fiore after the inconclusive competition of 1635 in which Gherardo Silvani and the Florentine Accademia delle Arti del Disegno had participated.

Pietro da Cortona's idea was to superimpose over the pre-existing facade components (particularly the rusticated columns) belonging to the walls of the Ammannatian courtyard, and so give the outside of Palazzo Pitti a vertically structured architectural characteristic and more intense modeling. On the other hand, the embrace of the scenographic exedra and the small temple above, released from any reference to the forms of the courtyard, were imagined as expansions and conclusions of the building toward the Boboli hill. But Cortoni's proposals remained on paper. In 1645 the chance arose again to import to Florence the architectural experience of a master of Roman Baroque, when Pietro da Cortona's project for the new church of the Oratorians of S. Filippo Neri prevailed over those proposed by Giovanni Coccapani and Gherardo Silvani. Except that the excessive dimension proposed for the church, including a tall dome the heavy costs estimated to build and install the huge "pietra serena" sandstone columns envisaged by

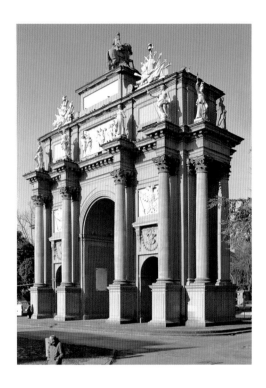

Cortona, persuaded the Oratorians to abandon the enterprise and make do with a proposal by Pier Francesco Silvani. This too proved to be too expensive, so was only partially realized (1668). To understand the limited success, or the boycotting, of the projects by the master of Roman Baroque, it is appropriate to point out that neither he, nor Bernini, nor Borromini, were invited to join the Florentine Accademia delle Arti del Disegno, the powerful local guild of artists. Not even the episode of the "Cappella Maggiore" (apse) in the church of Sta. Maria Maddalena de' Pazzi, executed (1677–85) from a design by the Roman Ciro Ferri, a student of Cortona, influenced the penetration of Baroque taste in Florence; leaving aside the richness and abundance of the decorations and the Cortonesque curvilinear connections, eliminating the angular meeting points of the walls, the underlying theme of the columns built into the thickness of wall had a more than illustrious precedent in Florence in Michelangelo's Biblioteca Laurenziana. Late, tired echoes of Baroque-style language were introduced into the capital of the Tuscan grand duchy by Giovan Battista Foggini, who trained as a sculptor and architect in the Medici Academy founded in Rome in 1673 by Grand Duke Cosimo III. The institute was established for "the study of the art of design," since the grand duke considered "that in Florence the

fine art of sculpture and statuary was gradually dwindling." Foggini's work had the short scope of a "chamber Baroque," which we can understand, to use a musical analogy, as a composition with minor contents with respect to the authentic and magnificent "symphonic Baroque." Lacking, therefore, was the fundamental substance of a complex orchestration of the space, articulated in the harmonious whole of a number of movements. This was a pseudo-Baroque, therefore, a stylistic *maquillage*, suited to touching-up the features of padded patrician alcoves, or of narrow chapels of the nobility. An example is the project commissioned from Foggini by the Feroni family in Santissima Annunziata and completed in 1693, in which the overcrowding of ornamental elements was such that, in the 18th century, Francesco Saverio Baldinucci described it as "so full of statues of every size that it seems more like a sculptor's studio than a holy chapel." It did, however, provide a source of models for those of his followers devoted to stucco decoration, such as the Ticinese Giovan Martino and Bartolomeo Portogalli, Domenico Felice, and Giuliano Rusca.

After the death of Giangastone, the last Medici grand duke, in 1737, Florence prepared to welcome Francis Stephen of Lorraine, who was to take possession of the government of Tuscany as established by the preliminaries of the Treaty of Vienna, signed in 1735. On the evening of 20 January 1739, Francis of Lorraine, accompanied by his consort Maria Theresa of Habsburg, Archduchess of Austria, solemnly entered the capital of the Tuscan grand duchy, passing under the triumphal arch specially erected outside Porta S. Gallo, designed by the architect from Lorraine, Jean Nicolas Jadot, and abounding with statues and trophies. The masonry triumphal arch with three barrel vaults, which constituted the first example of a revival of the classical Roman typology in the modern age, marked the inaugural act of an era that, on the basis of these pompous premises, might seem to herald sensational embellishments for the city. Yet the vocation of the Lorraine administration was manifested, from the Regency period onward, through provisions intended to improve and modernize the territorial resources and infrastructures (reclamation of the malarial regions, improvement of the road system, exploitation of natural resources), rather than the desire to distinguish itself with urban planning and architectural initiatives for the capital of the grand duchy. For Florence and the other Tuscan cities, the Enlightenment-style reformist policy of the Lorraines promoted the "useful," that is, the development of service structures

like schools and hospitals, preferably housed in the defunct monasteries, and the patronage of cultural facilities such as libraries and theaters. Some of the rare examples of buildings executed in Florence during the Regency were on behalf of the Palatine Electress Anna Maria Ludovica, last descendant of the Medici line, who also wished to leave the new bell tower of S. Lorenzo (1740–41) designed by Ferdinando Ruggieri and the exterior of Nigetti's dome for the Cappella dei Prìncipi (by the opening in 1740 of large elegant windows, flared at the bottom, designed by Giuseppe Ruggieri) in inheritance to the city.

The proposals put forward in 1763 by the Veronese architect Ignazio Pellegrini, an officer in the regiment of the Lorraine Dragoons, for a new monumental access to the Uffizi Gallery from the Loggia della Signoria, and an Imperial and Regal Chapel to be built in Boboli, were judged by the 18-year-old Grand Duke Peter Leopold to be useless ostentations and opportunities for squandering money, when he came to Florence in September 1765 to succeed his father Francis Stephen. Austerity, along with reformism, was one of the main features of the style of government of Peter Leopold, which was expressed in declarations like: "it is necessary to be careful and to distrust a great deal the designers...of works, constructions, etc., that, under the pretext of the public good...always end in projects of private and personal utility with serious costs to the public purse." Consistent with these principles, the Grand Duke of Lorraine, who was a patron not of art and architecture but of enlightened reformism, wished to live in a civil capital without pomp. He restricted the public measures for Florence (to be regarded, however, as aspects "of what is useful and convenient for the whole State") to the essential building of the Laboratory of Physics and Natural History (1775) with the addition in 1780 of the astronomical observatory (the "Specola" in Via Romana); the Niobe Room at the Uffizi (1779); the cemetery of Trespiano (1785); the Ospedale di Bonifazio in Via S. Gallo (1787); and the headquarters of the Opificio delle Pietre Dure (1790), allowing himself, within the sphere of the "private," the whim of the *Kaffeehaus* built in the Boboli gardens. This was a "country house of delight," an attractive belvedere looking over the city, conceived and built in 1775 by Zanobi Del Rosso, also responsible for the Oratory of the Congregation of S. Filippo Neri in S. Firenze (1772–75), the interior space of which remains one of the most valuable but little known—architectural episodes of 18th-century Florence and Italy.

Carlo Cresti

Zanobi Del Rosso, *Kaffeehaus* in the Boboli garden.

Ignazio Pellegrini, design hypothesis for the entrance from the Loggia dei Lanzi to the Galleria degli Uffizi by means of a large stairway of curvilinear ramps.

The commemorative statuary

For the Medici dynasty, more than for any other peninsular family, statuary was an irreplaceable vehicle of conceptual and political communication. Indeed, in the early Renaissance, the branch of the Medici family in Via Larga had nourished and supported Florentine sculptors and modelers, then exporting their genius, both physically and stylistically, creating a common humanistic formal language that was

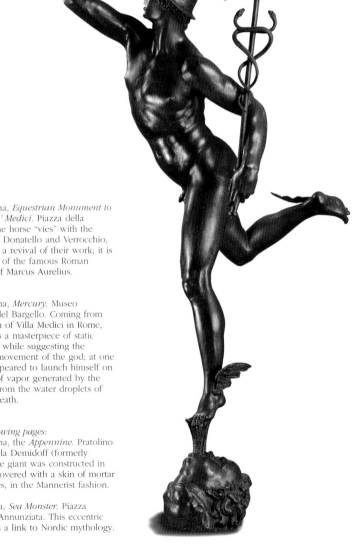

Opposite:
Giambologna, *Equestrian Monument to Cosimo I de' Medici*. Piazza della Signoria. The horse "vies" with the creations of Donatello and Verrocchio, constituting a revival of their work; it is reminiscent of the famous Roman prototype of Marcus Aurelius.

Giambologna, *Mercury*. Museo Nazionale del Bargello. Coming from the fountain of Villa Medici in Rome, the statue is a masterpiece of static equilibrium while suggesting the ascending movement of the god; at one time, he appeared to launch himself on a cushion of vapor generated by the fine spray from the water droplets of Zephyr's breath.

On the following pages:
Giambologna, the *Appennine*. Pratolino (Vaglia), Villa Demidoff (formerly Medici). The giant was constructed in brick and covered with a skin of mortar and sponges, in the Mannerist fashion.

Pietro Tacca, *Sea Monster*. Piazza Santissima Annunziata. This eccentric invention is a link to Nordic mythology.

only comparable to the birth of vernacular Italian, and capable of presiding in its own right over a national reunification that was quite distinct from the political particularism of the time. This enterprise was also sustained by the Roman popes of the family—this had in fact already borne conspicuous fruits, ensuring that the people of the peninsula felt in some way united, with common roots, dating back to the Roman tradition. The common descent from the Latin language into the spoken and written language was also felt among the upper classes. It was precisely due to these popes that a super-regional classicism was defined, whose strong points were the undisputed superiority of Raphael and Michelangelo. It is of no importance, then, if the excellence of the artistic fare, according to various theorists, also possessed a Titianesque rather than a Correggesque tinge. In the climate of early 16th-century Rome, a fervor for excavations undertaken on their respective properties by the cardinals of the Holy Roman Church, exchanged, traded, restored, and studied the finds that the bowels of the inexhaustible *Urbe* cast up without respite. The possession and appreciation of these works, rendered more desirable, rare, and surprising by actions to complete collections that we certainly could not define as philological, gave grounds for pride and prestige. This prestige had immediate repercussions on the cultural and also political credibility of the individuals concerned—let it not be forgotten, the Holy See occupied itself a great deal more with political and worldly matters than it did, at least in the reformers' view, with moral and religious matters.

It is no surprise, therefore, that the gifts that the supreme pontiff wanted to make to Cosimo I, invested with the title of Grand Duke and at the same time becoming a true defender of Christianity with the creation of the Order of the Knights of Saint Stephen, to a large extent included traces of ancient civilization; among many, the large wheel of imperial porphyry that was used to make Vasari's circular panel with wooden support heightened with gold, in the Audience Room in Palazzo Pitti, and also the spectacular one-piece granite column that, removed from the thermal baths and taken by river to Florence, was erected in Piazza Sta. Trinità, where it can still be seen, surmounted with evident allusive meaning by a porphyry figure of *Justice* by the Del Tadda family (1581). Cosimo was not content with this, acquiring the best the Roman "market" had to offer with all the means at his disposal, including an eloquent sarcophagus decorated with the Labors of Hercules, a character so dear to the

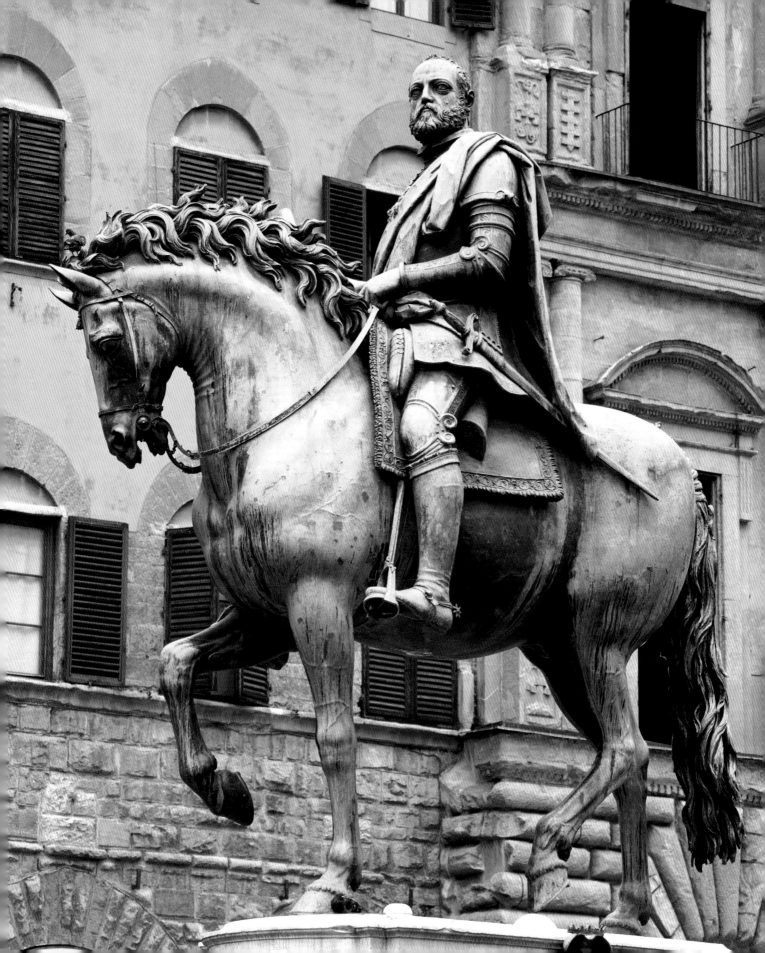

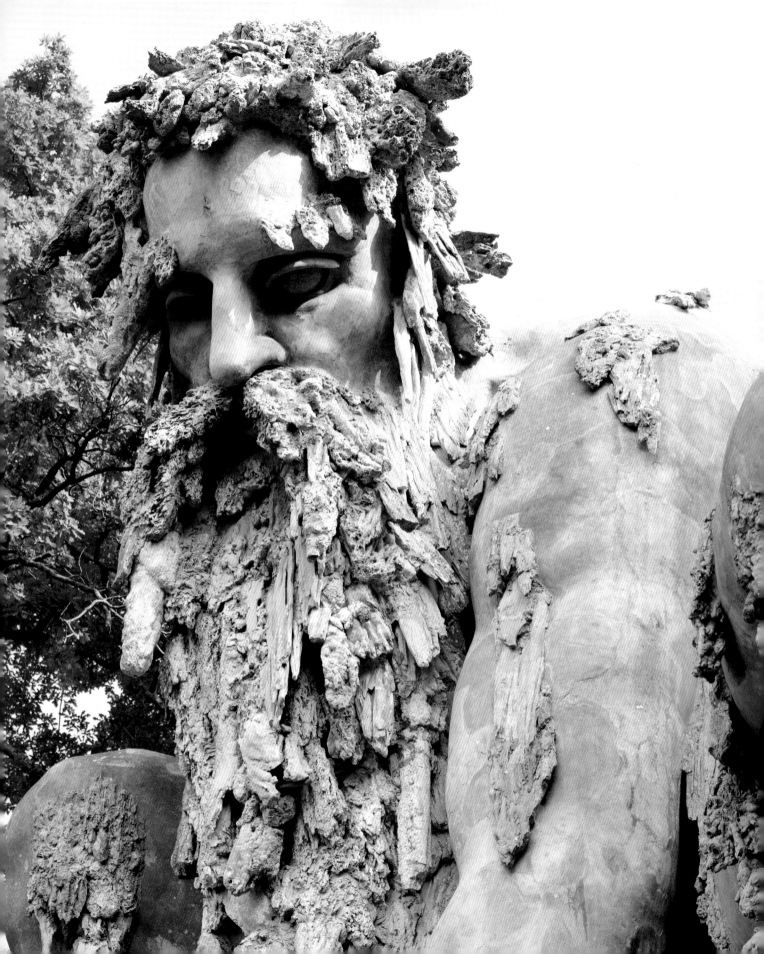

Florentines that he appears on the seal of the Medici dynasty, which must in turn have been a gift from Clement VII to the first ruler in Florence, Duke Alessandro. We could talk of a collecting "frenzy" underlying such manifestations of interest, had there not been all too clear propaganda intentions present. To collect antiquities and put them on display was also a good way of creating a large network of patrons who, if necessary, could change into informants and agents, not so much commercial as political. The person who understood the importance of these maneuvers better than anyone was Ferdinando di Cosimo I (Ferdinando I). From an early age he had grown up in the society of the Roman cardinals who wavered between the spectacular swings and roundabouts of the court of the Belvedere, in which they also had to take part, and erudite dissertations on classical remains or mysterious Egyptian finds, which occasionally appeared on the surface to show the existence of a more complex, variegated, and international culture than that of which the scholars of the time had managed to trace the contours. It was certainly not so much the abstract "dream" of recreating a Rome, and an Italy, with splendor to rival that of the imperial city, that moved the spirits of the leaders of the curial scene, as the very concrete ambition to bring the secular splendor of the pagan world back to life, translating it from the perspective and in the light of Catholic teachings. With his own means and those of the family, Ferdinando gathered together an impressive collection of marble statues. He positioned them in various parts of the Villa Medici (now the French Academy), above the Trinità del Monti, and here laid out the garden and the rear facade of the building in the style of an antiquarium, completing with modern pieces the splendid setting that combined the beauty of nature tamed and bridled by human endeavor with the fruits of art. At the very center of the open gallery, overlooking a pool to receive the water flowing from the mouth of Zephyr, the most admirable of the castings of the great Giambologna was positioned— *Mercury*, the winged messenger of the gods, protector of bankers and thieves, but also lord of the hermetic and alchemistic arts, taking flight in a cloud of suspended droplets that was certainly colored with the rosy and gold hues of the Roman sunset. The chorus of statues around this wonder of art, this weightless figure that still today seems to levitate into the air, even without its original setting (it has long been housed in museums and today is in the Museo Nazionale del Bargello), brought out and completed its symbolic meaning.

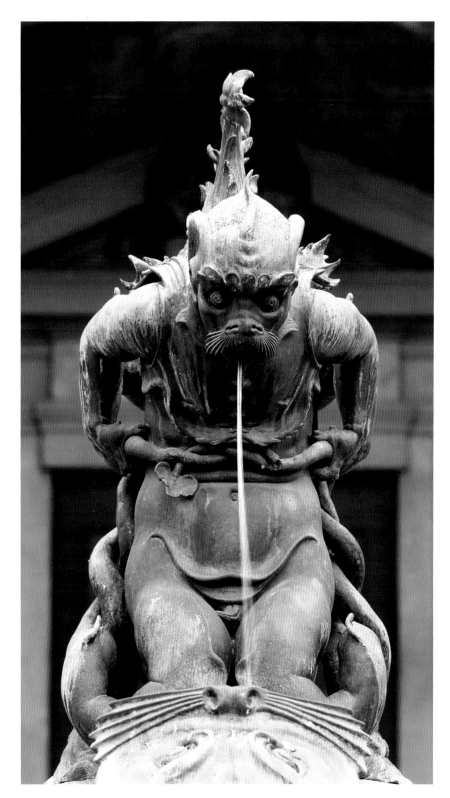

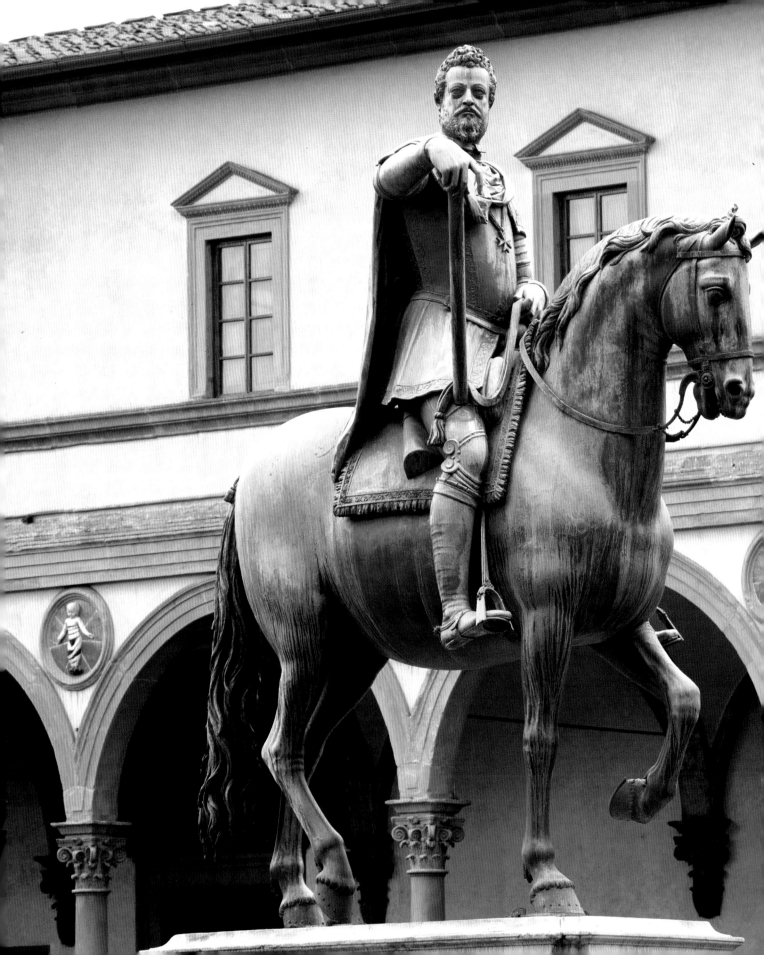

When Ferdinando became grand duke, succeeding his elder brother Francesco, he went to Florence and astutely took a wife to ensure offspring for the State, choosing Christine of Lorraine, thus guaranteeing himself a conspicuous fortune to manage, as well as a political opening toward France. As Florence had become the heart of his attentions, having put aside the papal dream of unification and carrying forward with clarity of vision the project for the emancipation of his house from the imperial meddling that had allowed the Medici limited capacity for maneuver until that time, Ferdinando felt the need to apply the Roman concept of civil magnificence to the Florentine court. So strong was the influence of Roman culture in Florence that some of the members of the court were greatly impressed by the splendor of the Roman marbles and their re-use in contemporary architectural contexts. We need only recall Giovanni di Angelo Niccolini, who, having obtained the authorization and the space for a family chapel in the complex of Sta. Croce from Grand Duke Francesco I in 1579, approached Giovanni Antonio Dosio (1533–post 1609) for the definitive project for the area. Starting in 1587, work began on what—even in the 18th century—was one of the noble chapels most appreciated by foreign visitors. Antique inlaid marble was sought to decorate it by excavating at Villa Adriana in Tivoli, at the time when the client was ambassador to the pontifical court, from 1588 to 1610. The sculptures were created by the Frenchman Pietro Francavilla (1553–1613), showing a style very much aware of the works of Michelangelo. This was one of the last enterprises poised between Mannerism and Baroque, which were followed by various outstanding works, many of which by the followers of Giambologna, and always characterized by a great formal equilibrium, not forgetting the classical example, so that, in their way, they were classicist. We need only recall those of Pietro Tacca, the most well known of the Florentines of the first half of the 17th century and author of the two fountains (c. 1633) surmounted by imaginative anthropomorphous sea monsters and covered with shellfish that today are to be found in Piazza Santissima Annunziata, rather than in the Piazza del Mercato on the Livorno dock, which was the original intention. Also in bronze are the doors of the Duomo in Pisa, which were worked on until 1604 by a team of masters that included Francavilla himself, Pietro Tacca, the Ticinese Gasparo Mola (c. 1580–1640) and various others.

However, it was undoubtedly the metal objects that guaranteed that the appreciation of

Pietro Tacca, *Equestrian Monument to Ferdinando I de' Medici*. Piazza Santissima Annunziata. Though it functions as a counterattraction to the monument to Cosimo I, this monument proposes his son in the guise of peacemaker, thanks to the adoption of a mount that appeared to his contemporaries to be "tamer" than his father's.

Giovan Francesco Susini, *Fraud*. Palazzo Pitti. A fine allegorical invention, part of an allusive and moralizing context that consisted in dotting the residence of the grand dukes with sculptures forming intentional counterpoints between ancient and modern statuary.

Florentine statuary went beyond the confines of the grand duchy, as is shown by the many projects for equestrian monuments sent to the rulers of the time: from the Spanish—which led to the creation of the statue for Philip III (1606–17) in Plaza Mayor and for Philip IV (1636–40) in the Plaza de Oriente in Madrid—to those never finished, but of which the models remain, ending with the splendid statuette on horseback of Charles II (1690) by Giovan Battista Foggini (1652–1725), which today is in the Prado.

The tendencies of the court in a strongly decorative and eulogistic vein, characterized by a grandeur that was not unaware of the splendors of the France of the Bourbons, with whom the Medici were also associated by family ties (Maria de' Medici had in fact married Henry IV), developed in certain precise directions. First of all, great prominence was given to the allegorical, rather theatrical, taste that the establishment of melodrama made ever closer to the daily life of the Pitti Palace. The result was paintings, but also sculpture, in which there was very often a playing with the meaning of the mask, of being and appearing, with references also to the reality of the court, or more broadly philosophical ones. Thus there was a plethora of statues with adolescents with the ephebic, sometimes even ambiguous air, of cupids, playful archer *putti*, with complex underlying literary or moralizing meanings, the obvious counterattraction to voluptuous, bare-necked women saints, who showed—also physically— the ardor of the Faith that characterized the impassioned handmaidens of the Lord, overcome by ecstasy. Of the many figures that still adorn the most pleasant and prestigious places in Florence, as were the courtyards of noble buildings or gardens, it is perhaps worthwhile to recall at least *Fraud* (prior to 1622) by Giovan Francesco Susini (c. 1585– 1653), which is still in Palazzo Pitti but no longer in its original position, in Boboli, where it was set in relation to other analogous figures, such as *Secretiveness*, *Penitence*, and *Desire*. Stylistically the statue is still permeated by elements reminiscent of Giambologna, but its presentation in looser and compositionally less affected terms shows a precise desire to appear clear and legible, in both aesthetic form and content. Despite this, one cannot fail to notice the quietly Algardian tone with which the drapery is partly moved and a profound knowledge of early statuary, from which, without excessive virtuosity, a certain transparency and "strategic" lightness are borrowed, rendering the image more alive and pulsating.

The practice of inventively adding to the remnants of Roman statues, which became one of the most demanding and best remunerated activities for sculptors, brought with it a renewed appreciation also for stone-like materials that were unconventional for sculptors, and a constant attempt—at least in Florence—to surprise the spectator with the chromatic variety of the acrolithic statue. Although this practice was known and widely employed in the ancient world, and particularly appreciated in Imperial Rome, the Italian Renaissance arrived at the rediscovery of the use of colored marble, cut and juxtaposed, through the knowledge of Roman finds, but also with the awareness that the East, and particularly the Indo-Persian area, had conserved the knowledge of glyptic techniques absorbed from Greco-Hellenistic culture. The use of semiprecious stones and inlaid marble was therefore valued as expensive and in a certain sense exotic. This explains the reason why so much attention was devoted to the possibilities of statuary composed of different qualities of stone and stone-like materials. If already from the end of the 15th century the Florentine masters were able to work porphyry and granite, a little later steel technology enabled tools to be obtained that were capable of working any type of stone. The Del Tadda family had specialized in working porphyry, but the documents of the grand duchy also mention other sculptors involved in carving this hard material, such as Tommaso Fedeli (bust of *Cosimo II de' Medici* from 1631, Uffizi), or Raffaello Curradi (1611–55), who in 1632 was paid for a porphyry head on a heroic armed white marble bust with ruff, now on display in all its finery at the Uffizi. The work, an example of technical virtuosity, but also evidence of a fantastic liberty and a learned but unbridled imagination, summarizes the courtly eclecticism of the Late Mannerist tradition, bending it to meet the needs of the formal, rigid culture of the court. Although episodes of contextualization of statuary in interiors were frequent in 17th-century Florence, and we need only recall the statues of Domenico Pieratti (1628–32) for the gallery of Casa Buonarroti, it was busts that were the most impressive and perhaps also most genuinely Florentine works of the first half of the 17th century. An absolute masterpiece of the genre, by the little known Giuliano Finelli (c. 1602–57), is the portrait of Michelangelo Buonarroti "the Younger," executed during the master's Roman stay, and highly praised by Cardinal Francesco Barberini and all the artists of the prelate's entourage. This inspired work is characterized by a certain Berninian haughtiness in the ample drapery of

the mantle, from which the smooth, meticulously executed torso of the subject emerges, sustained by chiaroscuro, almost as though floating in a rough sea. The hand, boned like a salt-worn branch, marks the contrast, while the beard, eyebrows, and hair move in the wind like foam breaking away from the crest of a wave. The final result is reminiscent of Northern ivories and it is no surprise that it appeared so astonishing precisely in the circle of refined collectors of international taste as were those of Rome. Among the many only apparently marginal aspects, in which the Florentine school operated particularly effectively, we cannot forget the results to be found in architectural decoration and in heraldic invention. Since the 15th century, that is, with the rediscovery of the

Giuliano Finelli, bust of *Michelangelo Buonarroti the Younger*. Casa Buonarroti. Great-nephew of Michelangelo, he conceived the idea in 1612 of creating a residence to celebrate his illustrious ancestor. The noble house with its exhibits at 70, Via Ghibellina, was achieved over a 30-year span. "The Younger" is portrayed here with that lively, arrogant style that characterizes the best Florentine statuary of the 17th century.

Francesco Mochi and collaborators, heraldic devices. Basilica of Santissima Annunziata, (Colloredo Chapel).
One of the most unbridled examples of sculptural decoration, intended to rival the best of Northern ornamentation.

ancient, Gothic decorative language had been profoundly renewed and the decorative aspect of architectural solutions not only revisited and adjourned, but also even revolutionized. Areas and spaces were discovered in which inspiration was able, if not to be indulged, certainly to be revealed in full. Friezes in particular had, as in the Corinthian order, entertained ample zones with figures, sometimes even with a narrative character. Sixteenth-century architecture had been less innovative and, with the 17th century, every idea of the genre was abandoned, as the intentions of architects had changed entirely, with a scale by now so monumental being preferred as to mean that the aesthetic and conceptual message of the building was entrusted to the simple structural frameworks. Rare illustrated medallions or palimpsests like folders were maintained in baroque bookbinding. Despite this, the 17th century saw a flourishing of heraldic invention and decoration generally, a real triumph of the most "masculine" Renaissance inventions, with the mounting of the coats of arms of the most prestigious Italian families in an imaginative succession of monstrous and fantastic creatures. These results were presided over mainly by architects who, after reducing the sculptor's role to a subordinate one, entrusted their extravagant and pompous projects to the attentions of meticulous stonemasons. Here we cannot hope to offer more than a rapid overview of these inventions, concentrating the attention—which is generally distracted by "greater" masterpieces—on details and episodes, sometimes even autonomous ones, of exquisite and noble decorative creation.

These creations have long remained in the shade, just as for a long time it has not been understood that the frames of paintings are often an integral part of the painted work, to the point of sometimes taking the place of their very contents and therefore meriting the maximum admiration. To give just a few examples, which may also enable us better to understand the value of the articles of the goldsmiths' craft of the time, we can recall the original plinths of the great statues.

Without returning to the 15th century, citing friezes such as that of the *Monument to Leonardo Bruni*—where even Desiderio da Settignano worked on one of the garland-holders—we can note the superlative handling of the marble base of the Cellinian *Perseus*. Designed by Cellini himself and probably created at least partly by his own hand, with the contribution of his own collaborators, such as Francesco del Tadda, it was adorned with the bronze sculptures and the narrative relief

that Benvenuto himself had modeled. Every detail deserves to be commented upon: from the sensual hermae inspired by the Artemis at Ephesus, to the masks with their magical and almost hypnotic empty eye-sockets, not to mention the scrolls with masks that are below the niches of the statuettes of the gods associated with the myth of Perseus. Particularly significant, from this point of view, were the special wooden creations for funeral displays, marriage festivities, baptisms, and other events, celebrated mostly with scenographic displays and the use of considerable means, which, in the early 16th century, saw the members of the Del Tasso family as prime movers. Nevertheless, the artist that catered to this taste for fantastic ornamentation was Bernardo Buontalenti, favored by Francesco I and Ferdinando I de' Medici. He is responsible for some extraordinary inventions, including the stairway—which seems to be the section of a rare oriental seashell—today in the church of S. Stefano a Ponte, but moved here from the church of Sta. Trinità, for which it had been executed in 1574. Other items equally permeated with an extraordinary zoomorphic vitalism are the telamones, in the otherwise severe framework of the Medicean Casino di S. Marco (1574), adorned with a Medici coat of arms on the balcony, which seems to evoke a primordial animal, a skate or a "dried basilisk." There is no doubt that the attention devoted by the court to botanical science, zoology, and any other manifestation of nature, was partly responsible for these examples.

The almost chaotic complexity of the culture between Late Mannerism and Baroque can certainly not be synthesized in formulas or resolved with simplified observations. Despite this, the repercussions of the new naturalistic knowledge on the plastic arts, combined with the fantasies and exoticisms also consequent upon the broadening of human cognitive horizons following the exploration of parts of the globe till then unknown, were immense. In Florence, after Buontalenti, with Giulio Parigi (1571–1635), he too an architect of the grand duchy, a kind of creative descent was created that—passing through Matteo Nigetti (died 1649), designer of the extraordinary organization of the wall tapestries of the Colloredo Chapel (1643–48) in Santissima Annunziata, with walls with Roman-style recessed marble panels and the exuberant plasticism of the coats of arms, executed by Francesco Mochi (1580–1654)—foretold what was to become the future of the fleshy vegetal elegance of Florentine three-dimensional ornamentation.

Mario Scalini

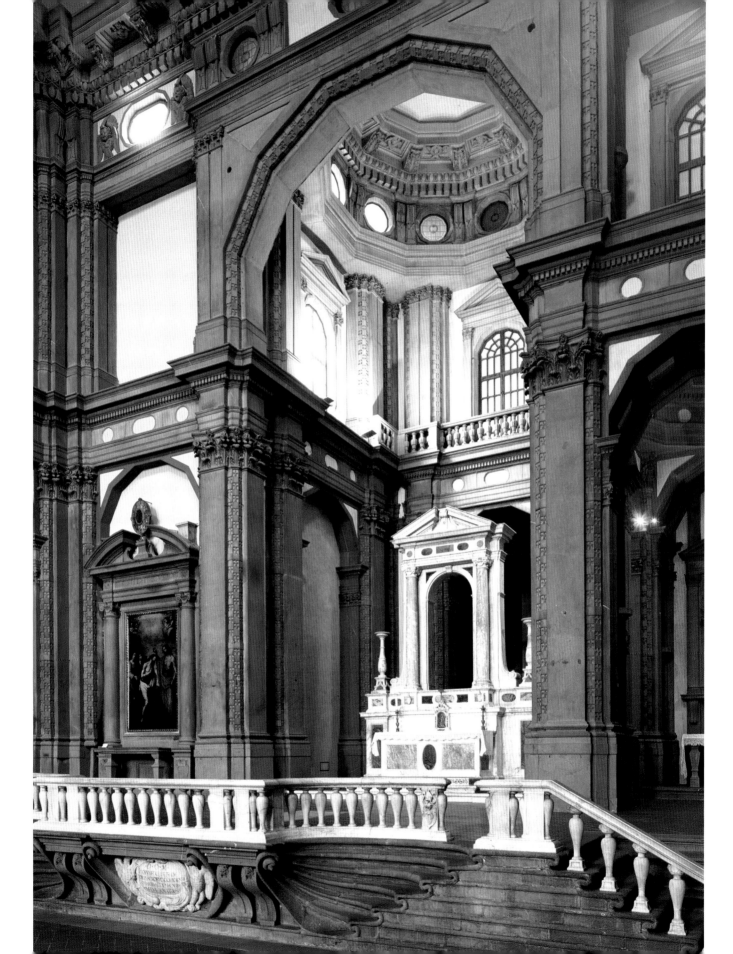

Giuseppe Piamontini, two erotes
(cupids) wrestling, from the apartment of
Grand Duke Ferdinando de' Medici; he
was one of the most sophisticated
members of the family, whose premature
death marked the decline of the dynasty.
Palazzo Pitti (Museo degli Argenti).

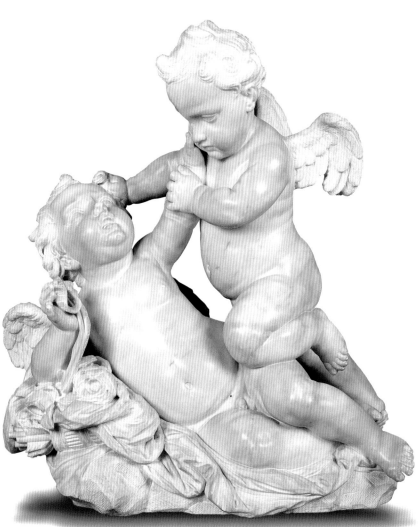

Statuary and furnishings

One of the most spectacular examples of the
application of statuary to the decoration of
architectural space in Baroque Florence is the
chapel of the princely Corsini family. The saint
of the dynasty, Andrea (1301–74), bishop of
Fiesole, had been canonized in 1629, and had
already found repose in the Basilica del
Carmine; but in 1675 Bartolomeo di Filippo
and Neri di Andrea undertook the construction
of a full-blown family chapel. Based on a
project by Gherardo Silvani, all composed of
statuary marble, white from Carrara, and
"stained" red from France, it was completed in
1681. There followed the painted decoration
by Luca Giordano (1683) and shortly after that
the sumptuous chiaroscuro sculptural

presence. On the high altar, above the urn of
S. Andrea, adorned by a silver antependium,
perhaps by Arrigo Brunick from a design by
Giovan Battista Foggini, is the marble
Apotheosis of S. Andrea Corsini, surmounted
by the Eternal Father amid angels by the
stucco artist Carlo Marcellini (before 1683),
one of the most active at the time and closest
to the style of his sculptor colleague. Giovan
Battista Foggini, whose patron was Cosimo III
de' Medici, who had allowed him a Roman
stay from which the artist had drawn a
profound impression of the work of Bernini
and Algardi, here was involved in a
monumental stairway, work that he shunned
for the most part over the course of time. The
other two great narrative figurations, in high
relief, were also part of his task—in one he
had to present the *Apparition of St. Andrew to
the Florentines During the Battle of Anghiari*,
in the other he proposed the *Mass of
S. Andrea Corsini*, completing the work in
1689, some six years after the transfer of the
uncorrupted body of the saint.

In 1693 came the inauguration of the Feroni
Chapel in Santissima Annunziata, an
unbelievable invention by Foggini, overloaded,
as Francesco Saverio Baldinucci has noted, at
the patron's wishes. An abundance of reliefs
and marble sculptures, which almost spray off
the walls, like the sea foam off the rocks, and
the white and gilded stuccoes of the dome,
which end up being muddled because of all the
petty details of ornamentation—these are all
new elements for Florence. The first
establishment of Rococo in its most
internationalist impact can perhaps be traced
back to these very walls, where no fewer than
eight artists were at work at the same time,
masterfully orchestrated by Foggini, to the point
of enabling us partially to forget the differences
of style that the historians have indicated and
the critics have been able to reinterpret.
However, if the sources are not mistaken in
mentioning the direct participation of Grand
Duke Ferdinando de' Medici (1669–1713) in the
enterprise, then it explains how there is such
evident formal luxuriance and, even in the
bronze vegetal spirals that adorn the small doors
or in the bronze furnishing of the altar, it is
possible to glimpse traces of the influence of
Flemish and Anglo-French goldsmiths of the
turn of the century. Although in fact the space is
not one of the largest, concentrated inside it,
almost like a repertory, are all possible forms of
creative expression: from the bronze, modeled
by Massimiliano Soldani Benzi (1656–1740), to
the marbles of Giuseppe Piamontini (1663–1744)
Thought and *Sea Fortune*; Carlo Marcellini
(1644–1713), *St. Dominic*; Giovanni Camillo

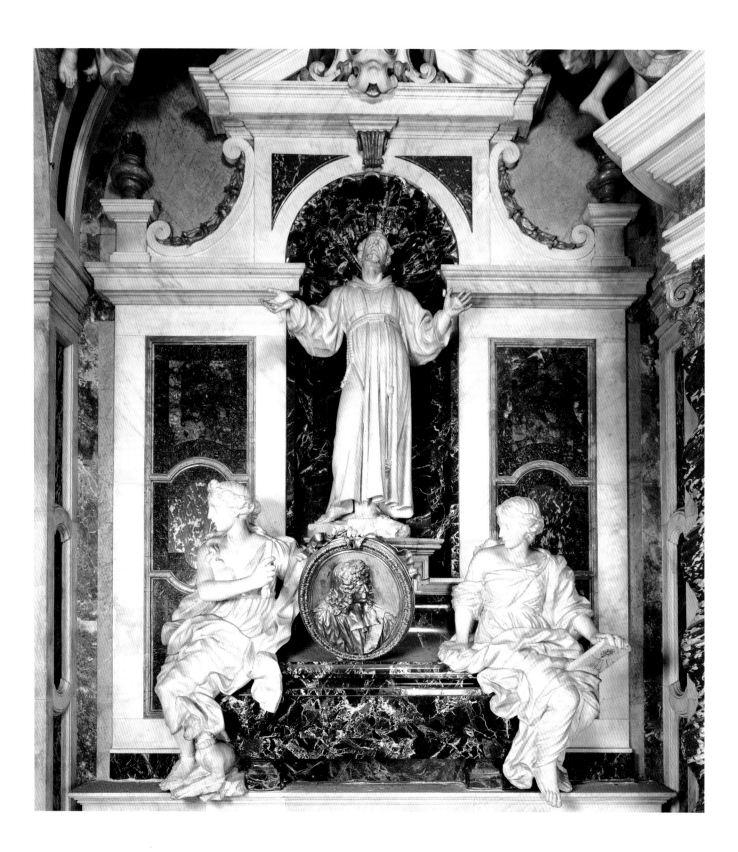

Giuseppe Piamontini, *Sacrifice of Isaac*.
Formerly Palazzo Serristori.
This splendid bronze group was given
as a gift by the Palatine Electress Anna
Maria Ludovica de' Medici to her
servant, himself a member of the
illustrious Florentine family Serristori.

On the previous pages:
Massimiliano Soldani Benzi, *Winter* (with
Venus and Mars visiting Vulcan's forge).
Palazzo Pitti (Museo degli Argenti).

Cateni (1666–1733), *St. Francis*; Anton
Francesco Andreozzi (1663–1730) and Isidoro
Franchi *Fidelity* and *Diligence*; from the
paintings of the Bavarian Johann Carl Loth
(1632–98), to the embossed silver by a still
unknown master from a design by Giovan
Battista Foggini.

It is easier to create connections with works
of applied art than with monumental
enterprises for the ineffably evocative casket
that—perhaps precisely in its references,
proposed by the critics as being to Baldassarre

Permoser, but which appear to be closer to
the Antwerp School—wished to take the
Northern culture that Feroni and the grand
duke had come to know in the United
Provinces as its reference point. It was a
different way of understanding sculptural
eloquence, testified to by artists such as
Mattheus van Beveren (1630–90), Pieter
Scheemaeckers (1652–1714) or Heindrik Frans
Verbrugghen (1654–1724), who were perfectly
at ease in making specific use of ivory, bronze
or marble on a monumental scale. The same
ductility in passing from one scale to another,
in developing a complex monumental allegory
or a precious room furnishing was required of
the masters active at the Florentine court. The
internationalist and princely tone that animated
every artistic manifestation did not fail to
permeate the bronzes of medium dimensions
for which the city was famous and that were
much sought-after souvenirs by the first
travelers of the "grand tour," having originally
been the first vehicle for classical images in
modern times. Foggini, Piamontini, and
Massimiliano Soldani Benzi—the latter in
particular—continued that tradition by
reproducing, adapting, and reinventing classical
compositions, but also creating new images and
allegories of great effect, such as the reliefs with
the *Four Seasons* (1708–11) that Grand Prince
Ferdinando sent to the Palatine Elector Johann
Wilhelm von der Pfalz-Neuburg (1658–1716),
his brother-in-law. Anna Maria Ludovica de'
Medici (1667–1743), the grand prince's sister
and the last of the dynasty, was a patron of
these artists, thus contributing to preserving an
activity of international level and exquisite
quality, as can be judged from the *Sacrifice of
Isaac*, designed by Piamontini in 1722 and
given by her to Averardo Serristori in 1743.

The years following the death of Giangastone
(1671–1737), the younger brother of Anna Maria
Ludovica, were far from prolific, as the stimulus
of emulating the court that had prompted many
Florentine nobles to commission sculptural
works came to be lacking.

Even the production of portraits—one of the
fortes of Late Baroque artists, as the restoration
of old pieces had been for those of the
16th century—ground to a halt. Those
representations, in their way pitilessly realistic,
but the result of an accomplished sculptural
ability, that had taken Tuscan statuary onto a
plane of excellence comparable to that of
Rome, very soon came to be abandoned in
favor of more stereotyped and formal proposals
that sometimes only achieve and communicate
the inspiration of the art in terracottas. Among
many, it is worthwhile to recall the bust,
executed posthumously in 1725, of the famous

bibliophile Antonio Magliabechi (1633–1714), which is now in the Biblioteca Nazionale in Florence. In it Antonio Montauti (1715–46) seems to have transfused the substance of a famous sonnet by his contemporary Benedetto Menzini that depicted the scholar as someone with the "face of a Pharisee, the appearance of an executioner." The taste for the exaggerated feature, the grotesque or burlesque detail, that pervaded the Baroque in a line from Callot and Stefano della Bella, in painting, to Faustino Bocchi, was a form of neo-Hellenism, prompted by the dreadful reality of the Thirty Years' War. There is little to highlight in the period of the regency of Anna Maria Ludovica de' Medici, known as the Palatine Electress, and about the mid-century the local school of sculpture does not seem to have been capable of offering work of a high-level, perhaps with the exception of the triumphal arch to commemorate the entry to Florence of the new ruler Francis I of Lorraine (1708–65) in 1739, completed from a design by his fellow countryman Jean-Nicolas Jadot (1710–61) in 1745, the same year that he became emperor.

In order to witness a true renewal of the Florentine language, which in those politically difficult years was capable only of producing replicas of ancient gallery statues for wealthy foreign patrons, we have to await the arrival of the Roman Innocenzo Spinazzi (1726–98), the author of the already cited angel (1792) that completes the *Baptism of Christ* by Sansovino on the east door of the Baptistery, and the *Monument to Niccolò Machiavelli* in Sta. Croce (1787), who also worked on the apse of Sta. Maria Maddalena dei Pazzi and on the figures in the White Room in Palazzo Pitti, along with the Albertolli brothers (1776–80).

Another personality whose training made him a significant representative of the rather difficult passage of the Florentine plastic arts in a Neo-Classical direction was Francesco Carradori (1747–1825), a restorer of antique marbles and the sculptor of two small groups with *Bacchus and Arianna* and *Cauno and Bibil* (cited in the inventories of Palazzo Pitti in 1786) in the renovated palace of Peter Leopold of Habsburg-Lorraine (1747–92), the new grand duke regent between 1765 and 1790, to whom the statue of the *Secret* (today preserved in the mezzanine of the Museo degli Argenti) was dedicated. A small figure, at whose feet are the symbols of the chancery and administrative power of the new grand duchy, but now shown in the terms of an ephebus or a young classical athlete, with Polykleitan features, which perhaps Winckelmann would have liked.

Mario Scalini

Francesco Carradori, *Cauno and Bibil*. Palazzo Pitti (Bona Room).
With its companion piece, this small composition is reminiscent of the woodland lovers of the classical tradition; it is a fine example of the by now neoclassical virtuosity of this sculptor.

The painting of the 17th and 18th centuries

The weight of the great 15th- and 16th-century tradition in Florence was such that the artists that embarked upon new paths toward the end of the 16th century always had to measure themselves against overwhelming presences, starting with that of Michelangelo, whose "cult" had been strongly promoted by Cosimo I and Giorgio Vasari. In this climate, which had also favored the growth of talents such as that of Cecchino Salviati, it was hard for artists to achieve a genuine renewal of the language of painting in the sense that it had been given by the Bolognese Carracci and the Lombard Caravaggio in the 16th century. The shifting of the artistic center of gravity to Rome was also not favorable to the creation of new Florentine artistic progress; it was in Rome that the two great personalities of the century, Michelangelo and Raphael became established since the first decade of the 16th century, under the shadow of the Church. The efforts, therefore, of the greatest Florentine artists between the two centuries were directed primarily toward the traditional painting of the great church

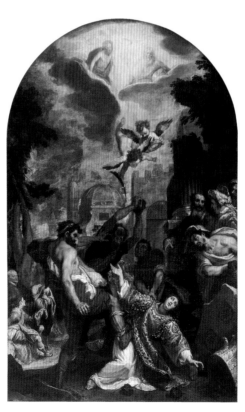

Ludovico Cardi, known as Cigoli, *Martyrdom of St. Stephen*, oil on canvas. Palazzo Pitti (Palatina Gallery). Inspired by Venetian painting, Cigoli concluded his 16th-century experiments with a work that was already projected into Baroque "Expressionism."

On the following pages:

Artemesia Gentileschi, *Judith*, oil on canvas. Palazzo Pitti (Palatina Gallery). Gentileschi, who painted this subject c. 1619, introduced contemporary Caravaggesque motifs first-hand into Florentine painting.

Cristofano Allori, *Judith*, oil on canvas. Palazzo Pitti (Palatina Gallery). Painted c. 1620 but left unfinished, the painting—the most emblematic of 17th-century Florence—shows the ascendancy of Caravaggio's example.

altarpieces and the fresco decoration of a purely decorative character in buildings. It was in the latter that Bernardino Poccetti (1548–1612) excelled, also in terms of his output—he successfully brought into the 17th century the traditional practice of the preparatory design that was typical of the Florentine Renaissance. The person who presented himself as the engine of renewal of 16th-century figurative language, though not forgetting its great formal academic tradition, was Ludovico Cardi, known as Cigoli (Cigoli, 1559–Rome, 1613), who excelled in the great Counter-Reformation altarpieces, into which he introduced new elements gathered from the Venetian painting that he knew through the works of Palma the Younger and Francesco Bassano, from Bolognese painting (Carracci), and above all from the Baroque as regards color. This gained him a certain renown, established for monumental works such as the *Martyrdom of St. Stephen* from 1597 (Pitti), which earned him his place as the most important personality among the handful of Florentine painters who, from the fame they had gained over time for the fresco technique, had gravitated toward Rome. His most important commission was the fresco decoration of the dome of the Paolina Chapel in Sta. Maria Maggiore (1611–12), but the most successful, a truly unique work in his career, was the profane fable of *Cupid and Psyche* in the destroyed loggia in the Del Bufalo garden, today in the Rome Museum, which was clearly inspired by Annibale Carracci. The renown as capable decorators gained by the Florentines had resulted in the summoning to Rome of a team of artists who, even if not on Cigoli's level, did contribute to the establishing of a new language in which knowledge of Florentine design was combined with that of Venetian painting and the Baroque. It was in this context that the painting of Domenico Cresti, known as Passignano after his place of origin (1559–Florence 1638) developed. His mixed style of chromatic substance and severe plasticism that made him so appreciated in the Counter-Reformation age of the Church was forged in Venice, where he stayed for a decade or so. In Rome, on various occasions between 1602 and the 1630s, he received commissions for many altarpieces for Roman churches, and above all the frescoes for Sta. Maria Maggiore reveal his expressive force in a "severe" style that was particularly suited for display to the public. Along with Passignano, we must mention Andrea Commodi (Florence, 1560–1638), who had been in Rome since 1592 and was to paint a series of frescoes three years later in S. Vitale that seem to pave the way for the young Pietro da Cortona, as well as

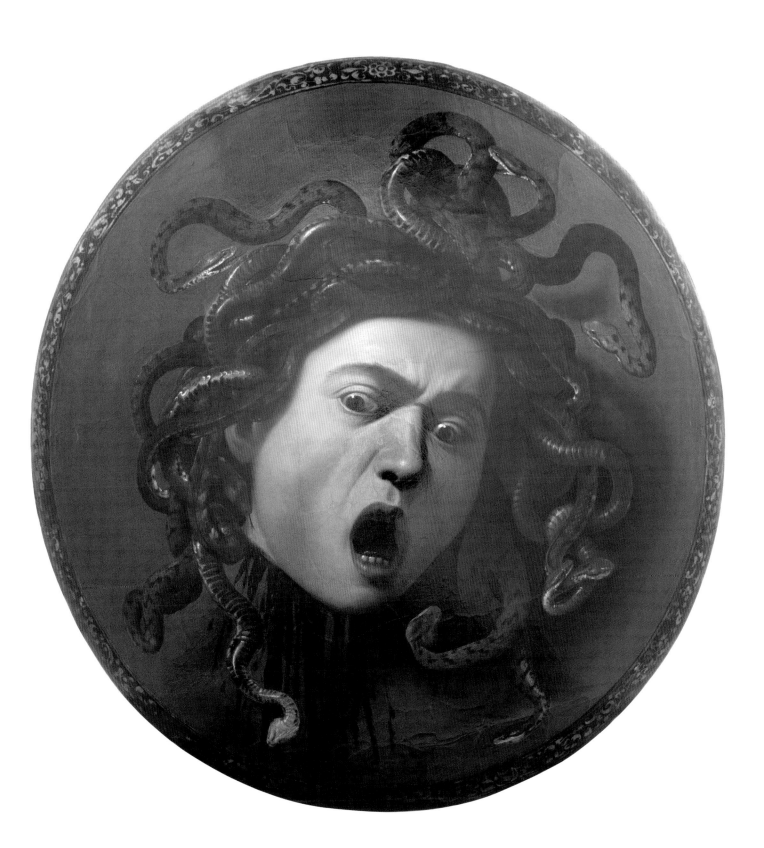

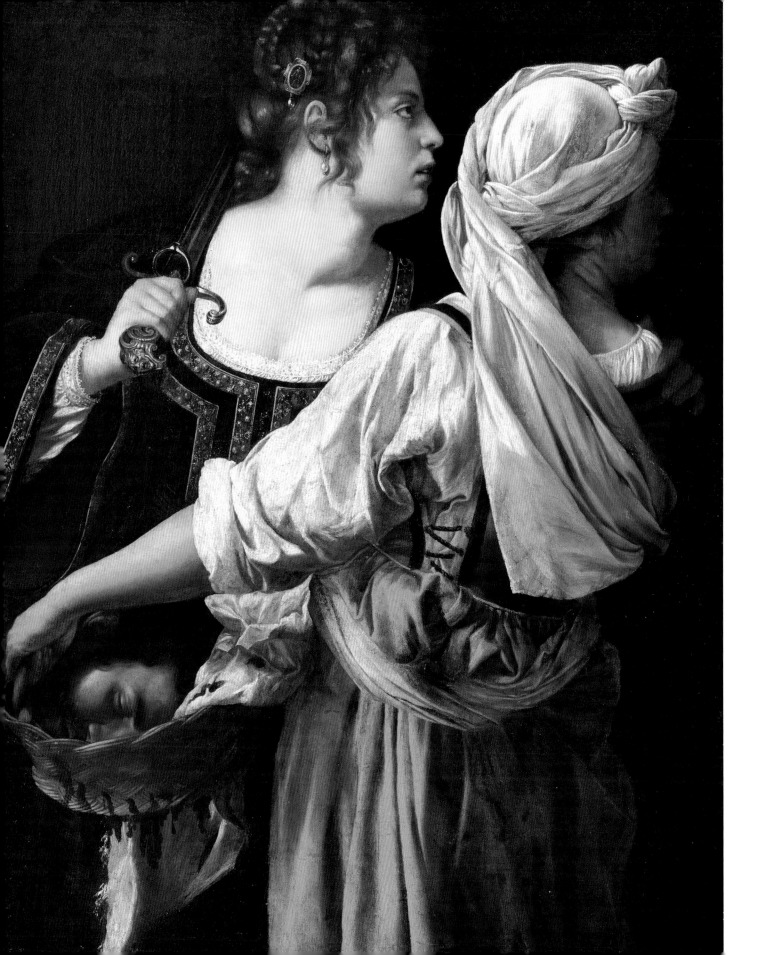

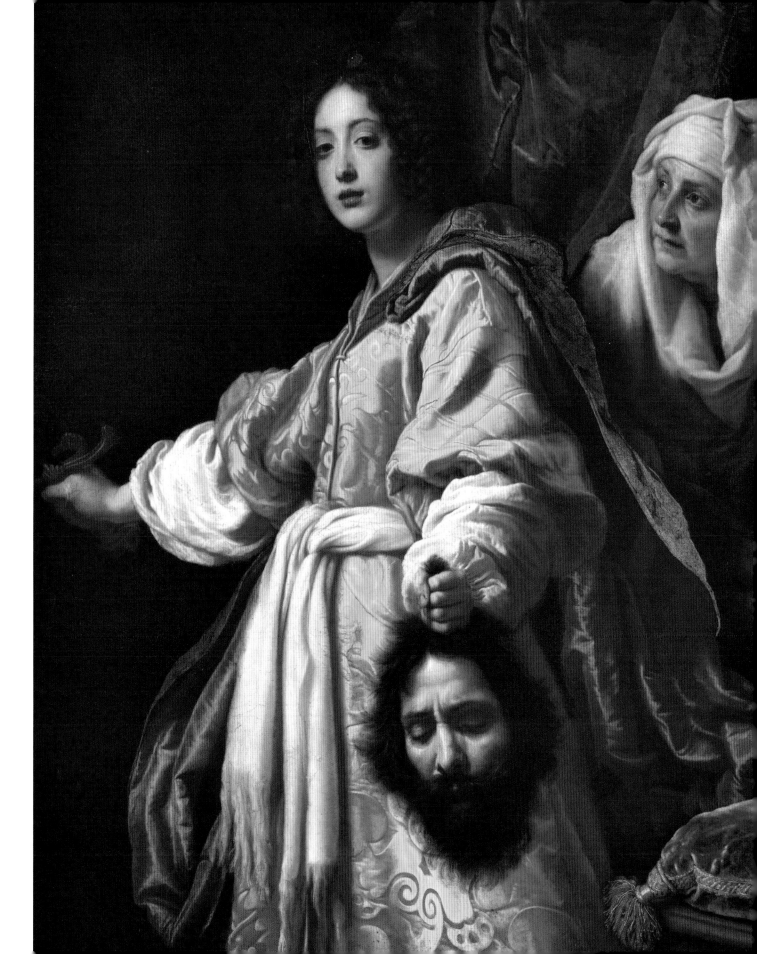

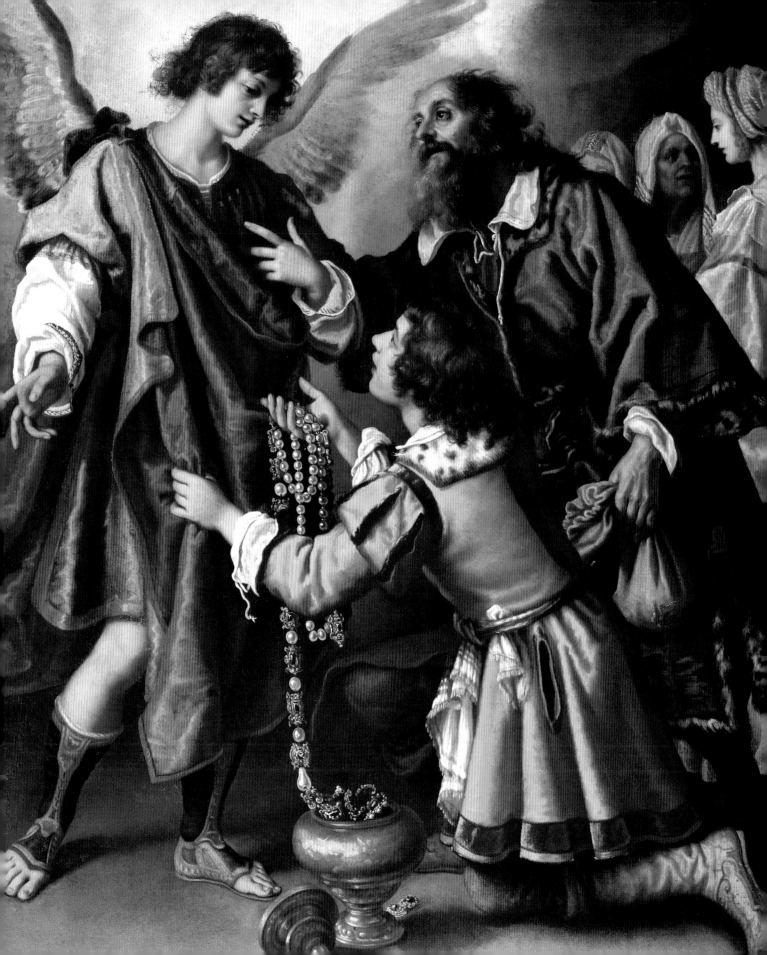

Agostino Ciampelli (Florence, 1565–Rome, 1630) who painted altarpieces for the main Roman basilicas and churches in a polished style that is reminiscent of his master, the "purist in advance" Santi di Tito. He also collaborated with Commodi at S. Vitale, beginning the fresco decoration of Sta. Bibiana, an enterprise completed by Pietro da Cortona. Anastasio Fontebuoni (Florence, 1572–1626), a student of Passignano, was also in Rome at the end of the 16th century where, in contact with Caravaggesque naturalism and the color of Adam Elsheimer, he forged a style that never forgot Florentine design, finding his best vein in the decorations of the Casino di S. Marco and Casa Buonarroti. The person who demonstrated the most personal inspiration was the great Florentine fresco painter of the first three decades of the 17th century, Giovanni Mannozzi, known as Giovanni da San Giovanni after his place of origin (S. Giovanni Valdarno, 1592–Florence, 1636). Between Florence and Rome he left some of the freshest, most original decorations on profane and ecclesiastical subjects that earned him important commissions in Emilia.

Touched by Carracci's reform but with his roots in the wittier aspects of late Florentine Mannerism (that of the Studiolo of Francesco I in Palazzo Vecchio), Giovanni created a style, eschewing his master Matteo Rosselli's gloomy academicism, in which his preferred metier, that

Opposite:
Giovanni Bilivert, *The Archangel Raphael and Tobias*, oil on canvas. Palazzo Pitti (Palatina Gallery). Color, exquisite detail, and eloquent gestures characterize the style of Cigoli's most gifted pupil.

On the following pages:
Volterrano, *The Practical Joke of Father Arlotto*, tempera on canvas, detail. Palazzo Pitti (Palatina Gallery). A witty evocation of a scene of contemporary life in the "playful" style that characterized one section of 17th-century Florentine painting.

Lorenzo Lippi, *Lot and his Daughters*, oil on canvas. Uffizi.

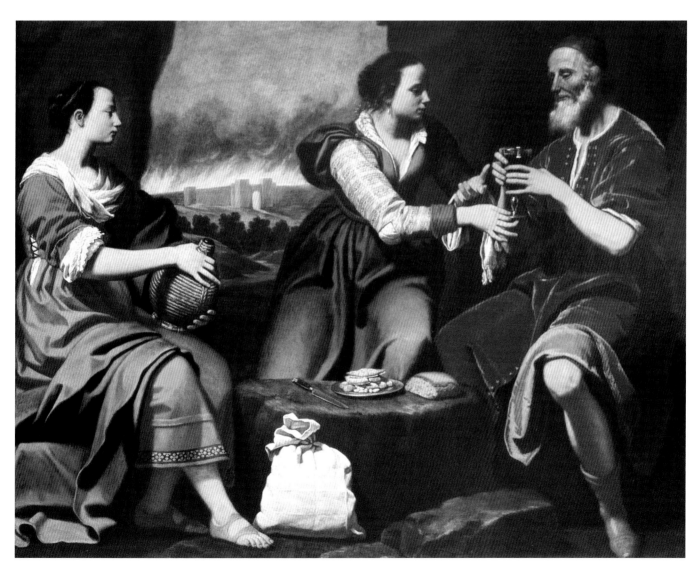

of the fresco, was imbued with the Roman and Bolognese innovations prevalent at the beginning of the century.

A tireless worker, he has left some memorable decorations in Florence's churches (Ognissanti, the Monastery of Sta. Trinità, Badia a Settimo), and in the palaces of Florence (facade of the Palazzo dell'Antella in Piazza S. Croce) and Pistoia (the chapel of Palazzo Rospigliosi) and of villas (Villa Corsini in Mezzomonte, Villa del Pozzino in Castello, Villa della Quiete). His Roman stay (1623–27) put him once again in contact with the most modern currents in Rome (Carracci, Caravaggio, Elsheimer), offering him the opportunity to express himself in other memorable decorations—he was the only one

among the Florentines to handle profane and mythological subjects with extraordinary freshness, even in pictures for small rooms—such as those in Palazzo Bentivoglio (later Pallavicini Rospigliosi) and in the churches of the Santi Quattro Coronati, Sta. Maria del Popolo, and Madonna dei Monti.

Once he returned home, he showed his Florentine colleagues the possibilities offered by Roman innovations in a variety of works including tabernacles and portable fresco paintings in which he showed—rather unsuccessfully, only finding echoes in Volterrano—the possibility of breaking away from the weight of traditional design in favor of an impulsive, fluid and transparent painting that he sought to apply also to a series of "genre" paintings (*Venus Combing Cupid's Hair*, the *Wedding Night*, both for Lorenzo de' Medici and today in the Pitti). The frescoes for the large ground floor room of the grand duke's apartment in the Pitti are masterpieces that remained incomplete due to his untimely death—they were later completed by Cecco Bravo and Francesco Furini. In some ways, he anticipated motifs in these that were to be taken up in the following century. Matteo Rosselli (1578–1650) was the master of a group of pupils that were to become famous: Francesco Furini, Giovanni da San Giovanni, Jacopo Vignali, Lorenzo Lippi, and Cecco Bravo. He was a prolific decorator, especially of churches and monasteries in Florence (Santissima Annunziata, S. Marco, S. Gaetano) and Tuscany, but without particular fantasy. His didactic painting,

however, demonstrated great drawing ability, which he passed on to his students.

Quite a different level was achieved by his contemporary Cristofano Allori (1577–1621), the son of Alessandro, who, drawn to Cigoli's methods when he was young, gave an interpretation of the master's emphasis on color in painting, which led him to paint what is perhaps the most beautiful picture of 17th-century Florence, the *Judith* that is today in the Pitti. Left incomplete, the painting is close to the painting methods of Domenico Fetti, with the use of rich, mixed colors, also revealing a Caravaggesque striation deriving from the presence in Florence in those years of Artemisia Gentileschi, who also painted a *Judith* (also in the Pitti) for Cosimo II de' Medici. Despite the fervor that pervades his highly personal work, his early death and the fact that above all he painted pictures as collectors' pieces, did not enable him to develop fully his reforming intentions in a "modern" direction; yet he did have considerable influence on numerous painters of the younger generation, starting with the Flemish Giusto Sustermans or Suttermans (Antwerp, 1597–Florence, 1681), who became court portraitist in 1619. The latter painter assimilated into his own Flemish background a formal objectivity derived from the Florentines and then, in his numerous travels in Italy and abroad, from the Romans (Baciccio), and from Rubens and Velazquez.

Yet the artist who until recently fulfilled the role of typical representative of 17th-century Florentine painting was Francesco Furini (1603–46), who became famous for his allegorical, biblical or mythological representations (*Hylas and the Nymphs*, Pitti) that were sensual in a veiled way, proposed in a soft chiaroscuro distantly reminiscent of Leonardo. His painting had a vast resonance locally, and painters such as Simone Pignoni, Felice Ficherelli, Vincenzo Mannozzi, and Cesare Dandini continued his manner until the end of the century. In the vast world of the painting of this period, we should also recall Giovanni Bilivert (1576–1644), the son of the court goldsmith and a pupil of Cigoli, some of whose works he completed. Despite a Roman stay in the retinue of his master, his style is the quintessence of Florentine decorative taste expressed in pictures on religious and sometimes mythological subjects. From 1630, the decisive influence of Furini, his most brilliant pupil, is manifested in these. However, a certain tendency to caricature on his part, especially in his drawings, launched a trend among minor artists, including Bartolomeo Salvestrini, Orazio Fidani, Agostino Melissi, and Baccio del Bianco. A follower of a

Pandolfo Reschi, *Attack on the Convent*, oil on canvas. Palazzo Pitti. Reschi interpreted in an illustrative vein the themes handled by Borgognone with intense realism.

certain ante litteram "purism" seeming to date back to Santi di Tito is Lorenzo Lippi (1606–65), the elegant champion of a linearism that was still Manneristic (*Triumph of David*, Pitti) in lively chromatic harmony, who was also a satirical poet and friend of the Neapolitan Salvator Rosa, with whom he

founded a theatrical academy in the years when his colleague was in Florence. Also the more famous Carlo Dolci (1616–86), renowned for his portraits, but in particular for his languid presentations of sacred subjects in paintings as collectors' pieces, in which technique he wished to rival that of Raphael,

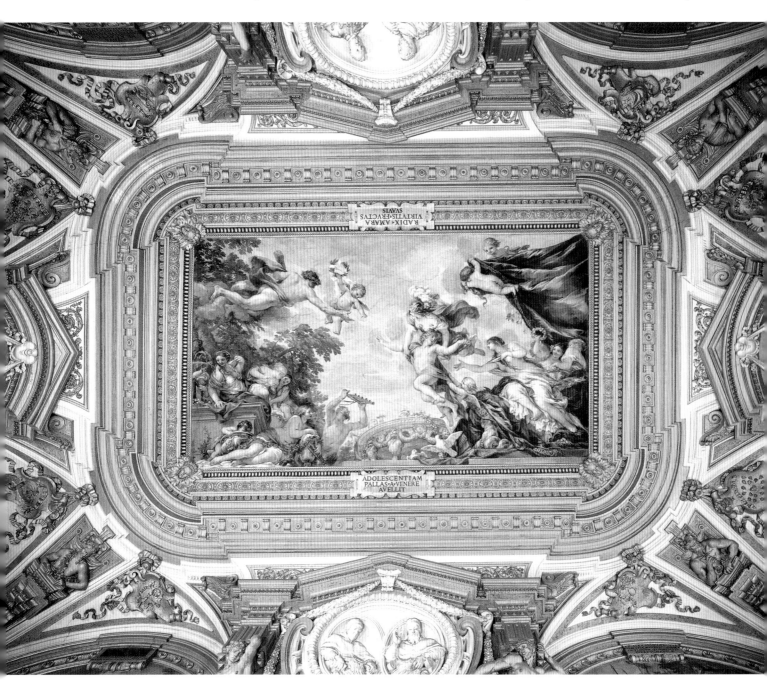

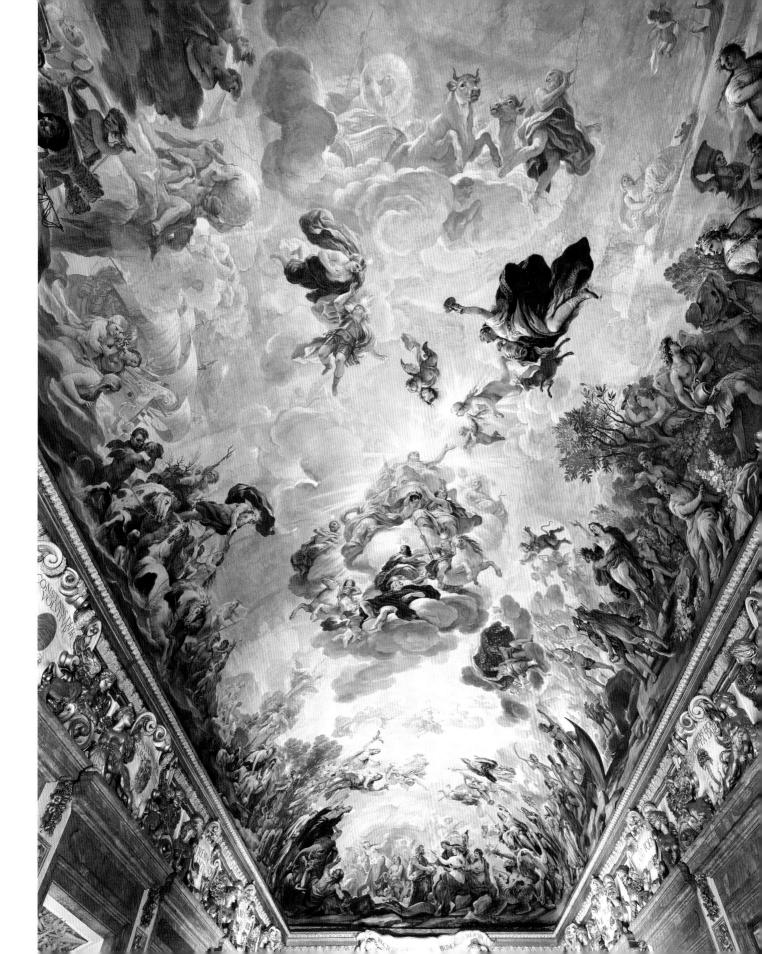

achieving a considerable level of highly
refined painting.

The shock represented first by the decoration
by Pietro da Cortona in Palazzo Pitti (1637–47),
then by the appearance on the Florentine scene
of the Neapolitan Luca Giordano (1683–85), who
astounded observers with his extraordinary
decorative openings of the dome of the Corsini
Chapel in Sta. Maria del Carmine and of the
gallery and library of Palazzo Medici Riccardi,
was soon to have its effect. From the second half
of the 17th century, the most gifted painter and
heir to the Florentine decorative tradition,
Baldassarre Franceschini, known as Volterrano
after his town of origin (1611–90), was active in
the city. Starting with Manneristic forms derived
from Giovanni da San Giovanni (frescoes in the
courtyard of Villa della Petraia for Lorenzo de'
Medici), he opened up what was by now a
baroque language in the decoration of the
Allegories Room painted for Grand Duchess
Vittoria della Rovere in Palazzo Pitti, where the
use of stuccoes and gilding combined with
fresco work was Cortonesque in style. The
assimilation of baroque language was more
limited in Antonio Domenico Gabbiani
(Florence, 1652–1726), a painter favored by the
Medici in their city and country residences, but,
also for them, of cycles of frescoes in Florentine
churches such as S. Frediano in Cestello (dome),
for the assimilation of their favor of a Venetian-
style interpretation of the work of Sebastiano
Ricci, active for the Medici and Marucelli families
between 1703 and 1706. This component was
also seen in the painting of Alessandro
Gherardini (Florence, 1655–Livorno, 1726) who
stressed a more volatile and restless use of
baroque language by combining it with the
chromatic transparency of Luca Giordano, from
whom he also borrowed the typologies of the
figures, reinforced by the knowledge of the
clear tonal passages of Ricci. His ceilings in
buildings and churches allude to the new
lightness imposed on wall decoration, availing
himself of the collaboration of the best
"quadraturists" (trompe l'oeil artists) of the time,
including the elegant Giuseppe Tonelli, who
had collaborated with Ricci. The influence of
Cortona and then Ricci had already shown
results in the decorative surface painting of Pier
Dandini (1646–1712) who employed emphasis of
bright red and blue, breaking with the 17th-
century tradition of Florentine painting still
present in the work of Dolci and his followers.
This trend was affirmed, at the turn of the
century, with Giovanni Camillo Sagrestani
(Florence, 1660–1731), a follower of Giordano,
but open to the Bolognese and Venetian painting
that he had come to know in his travels in
Emilia and the Veneto. His desire to align himself

with the great Venetian examples ensured that
the painter, who devoted himself to frescoes in
churches, palaces, and villas in Florence and the
surrounding countryside, used light and
transparent tones, lightness in his figures, freed
in undefined spaces that were appreciated for
their decorative grace. Assisted by pupils and
followers, distinguished among whom were
Matteo Bonechi (Florence, 1669–1756) and the
Pisan Ranieri del Pace (1681–1738), he created a
full-blown enterprise that, with the collaboration
of the "quadraturists" who derived from Jacopo
Chiavistelli (Florence, 1621–98), Giuseppe
Tonelli, Lorenzo del Moro, and Francesco Botti,
decorated the ceilings of churches, chapels, and
monasteries, as well as buildings of the gentry in
a bright style reminiscent not only of the
chromatic vivacity of contemporary Venetian, but
also Austrian painting.

A similar stylistic position was assumed by
Francesco Conti (1681–1760), who devoted
himself exclusively to oil painting on canvas. His
lively painting had its own traits in which there
were also echoes of Bolognese style, filtered by
Ferretti, the most well-known representative of
the Florentine 18th century. Giovanni Domenico
Ferretti (1692–1768) dominated the Florentine
scene from the third decade of the 18th century.
His approach was endowed with a grandiose
tone learned from Bolognese painting, but
lightened in a Venetian vein, grafted onto the
Tuscan drawing tradition from which he also
borrowed propensities for witty painting and
caricature. This brought him noteworthy results,
not only in fresco decoration, but also in oil
paintings for rooms, where he typically featured
Venetian themes, such as "harlequinades" or
mythological or satyr-paintings, where elements
of Venetian painting strongly emerge. A painter
with a robust touch, rendered vigorous by a sure
chromatic sense that is revealed in numerous
sketches, and in their transposition to fresco, he
was sought-after in Florence and elsewhere in
Tuscany, with his work in noble buildings and
masterpieces in the church of Badia in Florence
and SS. Prospero e Filippo in Pistoia.

The century closed with the significant—but
also powerful, like that of Ferretti, at least in
his Florentine successes—work of Giuliano
Traballesi (1727–1812), who moved to Milan
when he was almost 50, leaving behind
frescoes in the oratory of S. Filippo Neri, in
Sta. Maria della Sapienza in Siena, and the
dome of the sanctuary of the Madonna di
Montenero in Livorno, works that reveal his
knowledge of Bolognese, Roman, and
Venetian texts that gave strength and
spaciousness to his decorative conception.

Marco Chiarini

Neo-Classicism, the Academy and the "Reform"

Tower built from the design by Gaetano Baccani in the Giardino dei Torrigiani in Via del Campuccio.

Opposite:
Emilio De Fabris, facade of Sta. Maria del Fiore.

On the following pages:
Overall view of the facade of Sta. Croce designed by Nicola Matas and the bell tower designed by Gaetano Baccani. Projects for the facade of the church continued to appear for no less than six years (1861–67).

From the eclectic revivals to the architecture of the 20th century

Recalled to Vienna in 1790 for the imperial investiture, Peter Leopold left the responsibilities of the Tuscan government to his son Ferdinand III, who first had to endure the popular insurrection against the economic and religious reforms introduced in the period of Leopold, and then he too was forced to depart for Austria, when, on 7 April 1799, French troops entered Florence and raised the Liberty Tree in Piazza della Signoria, which they renamed Piazza Nazionale. Having become the capital of a Department of the Napoleonic Empire, Florence lived through a brief period of ambitious urban planning intentions. In 1810 Giuseppe Del Rosso designed the grandiose Foro Napoleone, to cover an area to the north of Piazzas S. Marco and Santissima Annunziata, destined to serve as a "pleasant walk for citizens, for every kind of spectacle and for military exercises". Envisaged for the following year was the widening of Via Calzaiuoli and Piazza del Duomo on the side of the bell tower. But the rapid succession of events did not permit these projects to be carried out. Only after the Restoration, with the return to Florence of Grand Duke Ferdinand III, did the enlargement of Piazza del Duomo take concrete shape (1824) with the design of the layout of the priests' houses behind the new facades designed by Gaetano Baccani. The architect, sensitive to the siren calls of the culture of Romanticism and the aesthetic canons that had their roots in the medieval spirit of the city (as the heritage of autochthonous values from which to draw in order to progress), introduced two neo-Gothic towers into the Florentine urban landscape: the Torrino in the Giardino dei Torrigiani (1821) and the bell tower of Sta. Croce (1845). It was Leopold II, who had taken over from his father Ferdinand in June 1824, who had to manage the political problems generated by the city's development, dependent

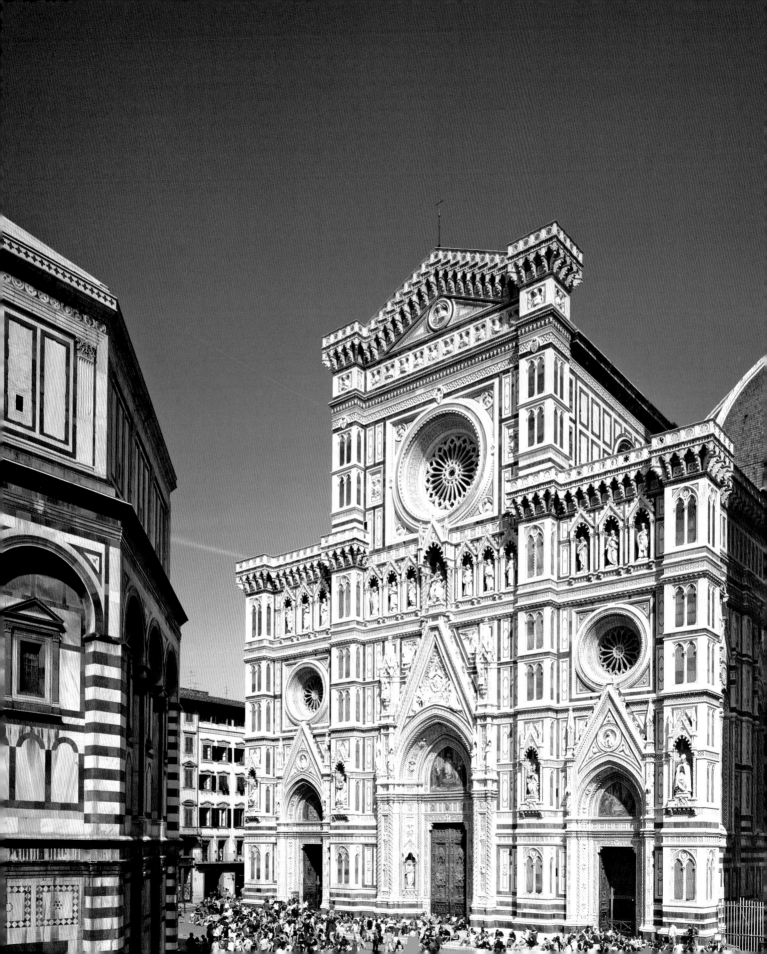

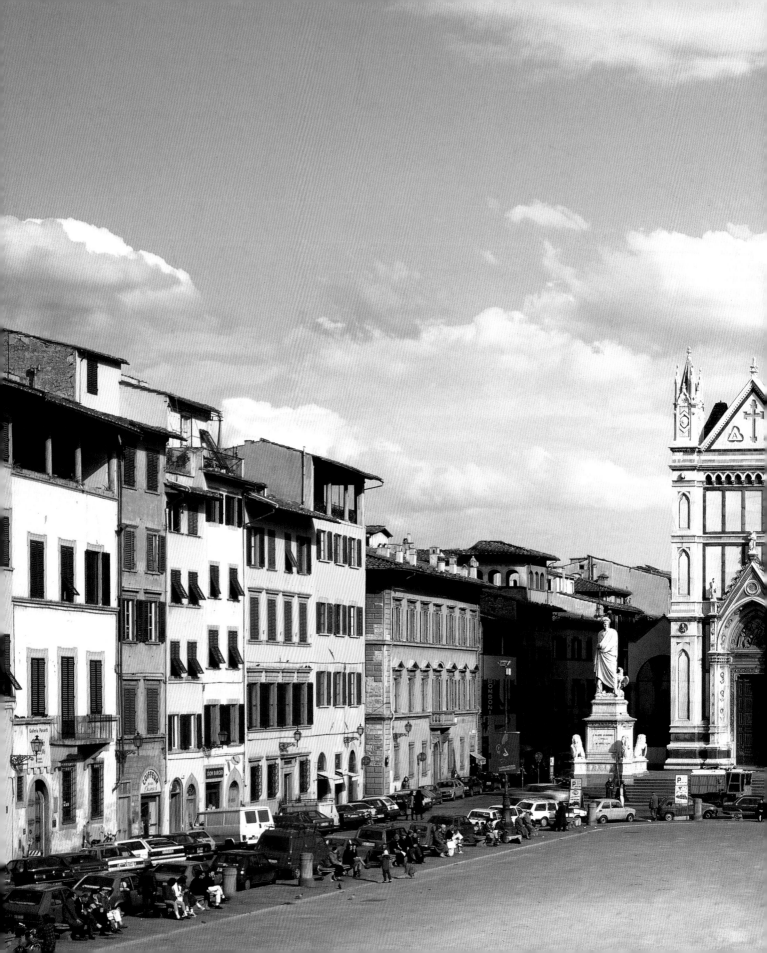

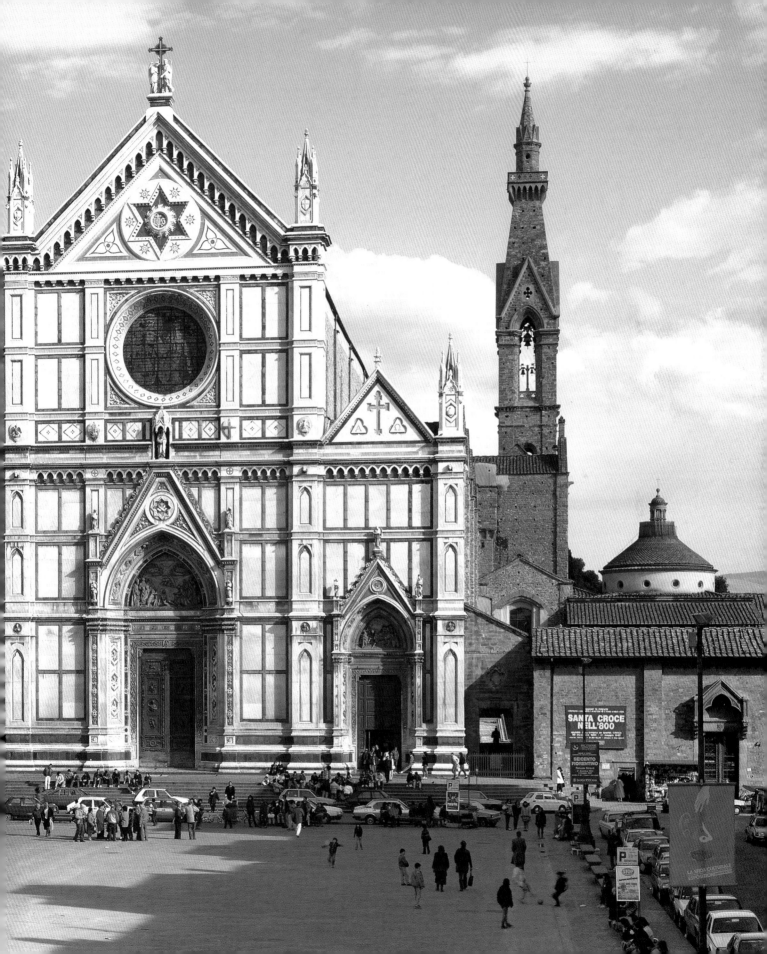

upon the tendency of the new urban capitalism
to direct its economic interests toward real estate
investment and building enterprises.

Between 1826 and 1830, the new Via
S. Leopoldo as a continuation of Via Larga and
the "cross-streets" of Via Salvestrina and Via
Sant'Anna between Via S. Gallo and Il Maglio
were opened. In 1836–37, at the initiative of
brothers Marc and Jules Seguin, two iron
suspension bridges were built over the Arno.
A few years later (1842), the enlargement of
Via Calzaiuoli was begun. In 1844 the project
was approved for a new residential district,
adjacent to Porta al Prato, by continuing the
Lungarno toward Le Cascine, and the
following year the urbanization of the new
district of Barbano proceeded. In 1856 the
architect Giuseppe Martelli proposed to
transform the Ponte Vecchio into an elegant
glass-covered pedestrian gallery, and in 1858,
the pompous "temple" of the Borsa (Stock
Exchange) was built, based on a design by
Michelangelo Maiorfi and Emilio de Fabris. In
1830, within the then Religious Institute of
Santissima Annunziata in Via della Scala,
Martelli was engaged in the feat of structural
virtuosity that was the spiral staircase, the
stability of which was guaranteed by the load
of the heavy lead statue of *Flora*, modeled by
Luigi Pampaloni, placed at the top of the
central column resulting from the overlap of
the 43 "pietra serena" sandstone steps. Nicola
Matas designed in 1837 and began in 1857,
using neo-Gothic stylistic elements, the

"completion restoration" of the incomplete
facade of Sta. Croce.

In the meantime, the grand duke, "though
not pleased to see that powerful means of
public communication," resigned himself to
granting permission to the bankers Fenzi and
Senn for the construction of the "Leopolda"
railway from Florence to Livorno, in 1841, and
to granting the authorization, in 1845, to a joint
stock company controlled by Prato financiers,
for the realization of the "Maria
Antonia" railway from Florence to Pistoia.

Consequently there were two terminal
stations: one, the Leopolda, designed by
engineer Enrico Presenti outside Porta al Prato,
inaugurated in 1848; the other, the "Maria
Antonia," created by the English engineers
Isambard Kingdom Brunel and Benjamin
Herschel Babbage, were built behind the apse
of Sta. Maria Novella. The two buildings
dispensed with the spectacular metallic
structures typical of the so-called "cathedrals of
steam," being satisfied with employing large
wooden trusses to support the roofs.

While the "modern fever" of the railway was
infecting Florence and involving part of the
Tuscan territory, Leopold II was witnessing the
rapid evolution of the situation almost with
resignation. He was aware that problems also
arose "from the hurry, from the precipitous
speed at which things happened"; he realized
that paternalism, even if enlightened, was no
longer sufficient to control events and past its
time. At the time when the capital of the newly
established Kingdom of Italy (1861) was
temporarily transferred from Turin to Florence
(1865), the Tuscan capital was obliged to
assume the burden of the representative role
provisionally assigned to it. A burden that, with
the transfer of the capital to Rome (1870),
provoked, like a maleficent meteor, "grave
damage," including the bankruptcy of the
municipal administration, since this had
shouldered the urbanization expenses of roads
and piazzas included in the expansion operation
to induce and facilitate the investment of private
capital in the building sector.

With the enlargement plan to host the capital,
designed by Giuseppe Poggi in just three
months (starting from November 1864), which
provided initially for the demolition of the
medieval walls, considered an obstacle to the
execution of the urban plan, Florence was
given a belt of avenues around the center (the
ring road for traffic flow thanks to which
today's city of cars continues—with a struggle—
to survive) and new piazzas hypothesized as
places of connection between the old urban
core and the peripheral districts that would be
developed from the avenues themselves.

The new piazza in the city center with
the "Arcone" (Big Arch) and the
equestrian monument to Vittorio
Emanuele II.

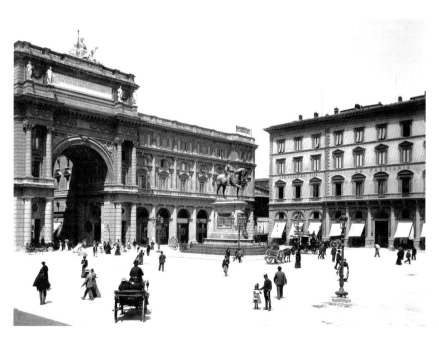

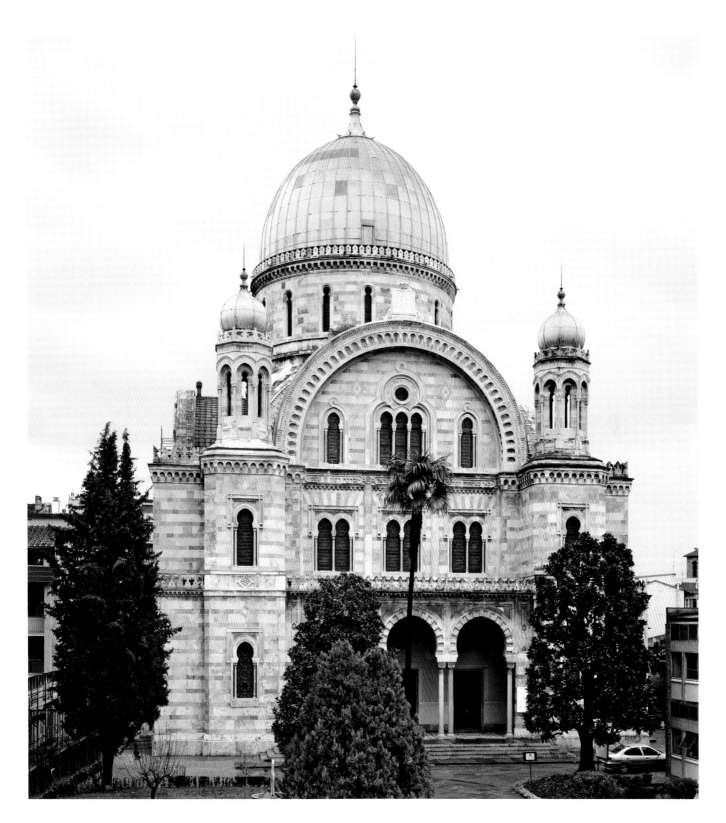

Giuseppe Martelli, helical staircase in the Religious Institute of Santissima Annunziata in Via della Scala.

In reality Piazzas Beccaria and S. Gallo (today Piazza della Libertà) resulted from the points of fracture, revealing, from the beginning, two spaces that were hard to live in and indeed were never lived in. Not foreseeing that the passage from a walled city to a city without a defined perimeter could prove to be a traumatic event, Poggi also planned a wide road for real estate subdivision beside it on the hill, which subsequently (having been cleared by building speculation) took on the appearance of an attractive tree-lined route (the Viale dei Colli), opening up at the top of which was the panoramic balcony of Piazza Michelangelo. From here it is possible to appraise—ironically—the disastrous results of the urban planning empiricism that characterized the impromptu municipal "enlargement," by an unprepared planner, in the absolute absence of ideological and cultural programs that should have come from the Savoy monarchy and the Florentine political class. One of the consequences of the enthusiasms aroused by national unification took shape in the announcement of an international competition (November 1861) for the new facade of Sta. Maria del Fiore. The problem of the incomplete front of the Florentine Duomo had returned to the limelight in 1842 thanks to a design by Matas. This was followed, the next year, by the projects by George Müller, and in 1859 it was decided to announce a public competition, which in fact was not run due to the end of the grand-ducal regime. The commission of experts called upon to judge the documents presented in the 1861 competition found themselves in the embarrassing position of having to choose between proposals of facades that were prevalently neo-Gothic, with single-cusp, three-cusp or basilican copings, and so they decided to defer their decision to the outcome of a second competition. In 1865 a new commission of judges awarded the victory to the proposal for a three-cusp facade presented by Emilio De Fabris. However, the polemics that followed placed the decisions in doubt again, thus requiring a third competition. In 1867 an umpteenth commission, chaired by Pietro Selvatico, gave the award to the three-cusp design by De Fabris, thus rewarding the project resulting from the suggestions and modifications that Selvatico himself had sent by letter to De Fabris. When in May 1887 the facade (with basilican coping by Luigi Del Moro) was inaugurated, it was affirmed, with a certain rhetorical flourish, that this creation was to be considered "the last great work of art to which Tuscan Florence had directed its thought, and the first on which the all-Italian Florence had laid its hand." Beyond the debatable

aesthetic aspect, we must nevertheless underline that the three competitions concerning the new facade, with their disputes on aspects of historicism, represented a parenthesis of vitality for the Florentine and Italian architectural culture of the period. The debate about the new facade of the Duomo showed that Florence, as well as enjoying renewed fame for a while, was still able to feel included in the European circuit of the circulation of ideas, if for no other reason than the presence on the judging commission of such prestigious personalities as Gottfried Semper, Ernest Forster, and Eduard van der Null, and due to the involvement of Eugène Emmanuel Viollet-le-Duc.

Although the facade of Sta. Maria del Fiore is undoubtedly a specimen of neo-Gothic excess, more valid episodes must also be recalled, with pure exotic tendencies, in the Florentine chapter of architectural revivals in a historicist vein, such as the synagogue inaugurated in 1882 and designed by Mariano Falcini, Vincenzo Micheli, and Marco Treves, as well as the Russian Orthodox church, begun in 1899 from a design by Michele Prebragensky and executed under the direction of Giuseppe Boccini and Giovanni Paciarelli. However, the event that had the greatest resonance, also on account of the dimensions of the scheme, was undoubtedly the planned (since 1866) clearance, with the aim of reclamation for social and sanitation purposes, of a large swath of the old city center, namely the area around the Piazza di Mercato Vecchio and the Ghetto. The "reclamation" operation (begun in 1890) involved the destruction of a picturesque yet deteriorating building fabric, dotted with structures of historical heritage and one or two valuable medieval towers. The plan also involved the compulsory eviction of 1,778 resident families, a total of 5,822 people. It was therefore an action implemented despite its unpopularity, and not without a certain cynicism on the part of the decision-makers. The cynicism of passing over local history and ignoring opposition; the decision-making that allowed the local administrative class to gain economic profit from the "reclamation" operation, the meaning of which would seem to be neatly summarized in the compliant epigraph dictated by Isidoro Del Lungo: "The old center of the city from centuries of squalor to new life restored." Ironically, today, to look at the shabby, depressing display of market stalls and hawkers that invade the central streets of Florence, the temptation would be to write—as Alessandro Parronchi has suggested—"the new center of the city to old squalor restored." As a result of the critical revisionism that reappraised the 19th-century architectural

Opposite:
Giovanni Michelazzi, staircase inside the Broggi-Caraceni small town house in Via Scipione Ammirato.

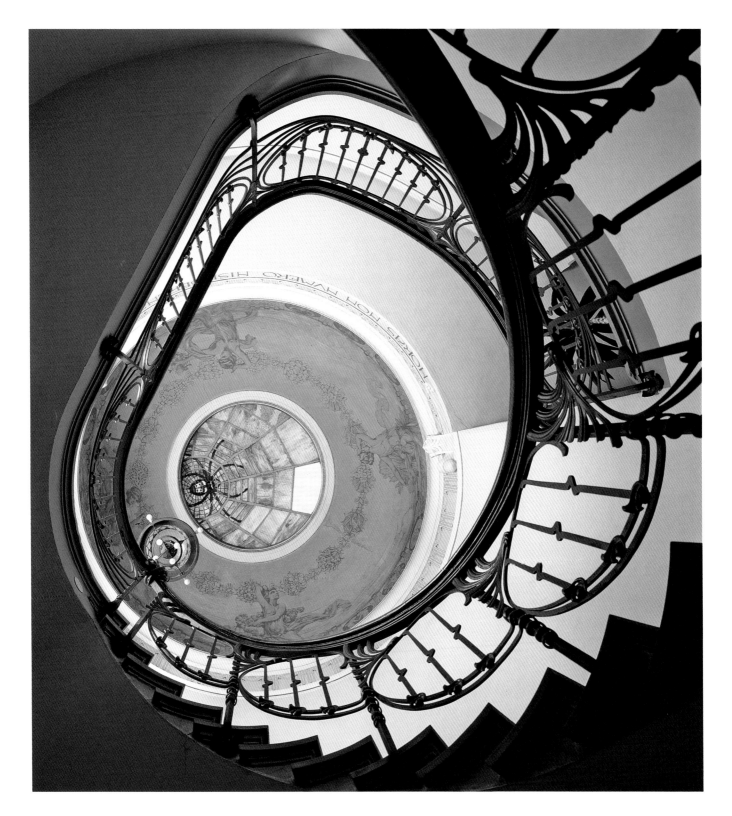

491

Pier Luigi Nervi, Municipal Stadium, access stairway to the tiers and the Torre di Maratona.

eclecticism, the designer (Vincenzo Micheli) who built the monumental and ill-famed "Arcone" (Big Arch) in Piazza della Repubblica (1895) intending to celebrate the reclamation of the Mercato Vecchio and the adjacent Ghetto, gained posthumous appreciation. Major real estate speculation maneuvers covered the city center, which in the meantime had been "restored" and "reordered" into so many large anonymous neo-16th-century buildings. Nonetheless, it is worth underlining that near to the "Arcone" in the square, in one of the streets resulting from the "reordering" (on the corner of Via del Campidoglio and Via Brunelleschi), there appeared, in 1903, the building of the Magazzino Pola & Todescan, that is, the first presence in Florence of an architecture used as an example of Modernism (Secessionist stylistic elements combined with the flowery Italian Liberty style). The season of Liberty was a brief one, but not without cultural legitimacy and noteworthy architectures: consider, in fact, the pleasing "heresies" of the small town houses in Via Scipione Ammirato, Via Giano Della Bella,

Giuseppe Mengoni, Central Market of S. Lorenzo.

and the gallery-house in Borgo Ognissanti, all works (1907–11), in tune with the extrovert ambitions of the middle class, the product of the designing qualities of Giovanni Michelazzi. The elegance of Liberty was followed by "the return to eclecticism" of Adolfo Coppedè, culminating in the neo-Moorish Alhambra Theater-garden (1921), destroyed by vandals (1960), and in the rejected proposal (1926) of the domed neo-15th-century 'Galleria Mussolini,' envisaged as connecting up Piazza S. Giovanni, Via Martelli, and Borgo S. Lorenzo; this was immediately mocked by Gabriele d'Annunzio, who defined it as "la terrile macchina arcimacchinata da non so quale arcimaiuscolo arcigocciolone" (which more or less translates as: "the banal arch-scheme schemed up by who knows what arch-major arch-drip").

It was necessary to await the 1930s for the return to a reconciliation with an architecture capable of honoring Florence. Angiolo Mazzoni designed in 1929 and erected in 1933 the "Constructivist" Centrale Termica (Technical Services Building) of the Sta. Maria Novella Railway Station. In 1932–34 Pier Luigi Nervi built the Municipal Stadium, characterized by the audacious overhang of the reinforced concrete cantilevered roof of its grandstand, and by its helical external stairs (which were unfortunately disfigured in 1990 by unsympathetic restructuring). In 1934 Gherardo Bosio gave an updated "Rationalist" character to the Ugolino Golf Clubhouse. Giovanni Michelucci, who headed the "Tuscan Group," designed and built the passenger building at Sta. Maria Novella Station (1935), which was unquestionably a masterpiece of contemporary architecture. After the Second World War, the balance sheet of Florentine architecture recorded the huge liabilities resulting from the reconstruction of the zones destroyed by the Nazis around the Ponte Vecchio in August 1944. On that occasion, rather than relying on "modern" solutions, it was preferred to call for an adaptation to traditional "taste"; this was translated into elements expressing the worse excesses of vernacular construction, such as the stone coverings of reinforced concrete structures, Florentine-style false eaves, false corbels, "old-style" roofs and shutters that were so strongly recommended by the self-styled guardians of the urban image. The few projects of value to be built in Florence in the fifties and sixties all bear the signature of Giovanni Michelucci. Take the residential and shop building in Via Guicciardini on the corner with Via dello Sperone (1957), an example of the intelligent modern interpretation of the "memory" of the tower-house, in tune with the

morphological and human character of the old building fabric of Oltrarno. Or, in conclusion, the church by the Autostrada del Sole motorway (1964); it is a continuous, dynamic space, reached from a number of directions and at various heights, all structured around the church hall, which is surrounded by places to rest in and walk in, with light and shade, alongside branched pillars alluding to trees, while the piazza is an ideal space for choral meetings and community assemblies.

Carlo Cresti

Giovanni Michelucci and the "Tuscan Group," the huge concourse (galleria di testa) of the passenger building of the Sta. Maria Novella Railroad Station in Florence.

Giovanni Michelucci, church of S. Giovanni Battista by the Autostrada del Sole motorway.

Neo-Classicism

The departure, in 1791, of the grand duke of Tuscany Peter Leopold of Habsburg Lorraine for Vienna, where he was to assume the imperial title, and the arrival on the throne of his son Ferdinand III, marked the beginning of a new and fertile historical period for Florence. It also had important consequences for the figurative arts. The continuity of the dynasty guaranteed the young Tuscan artists the certainty of work commissioned by the court and the nobility associated with it, and the presence in the city, from 1793, of numerous foreign artists who had fled Rome after the anti-French revolt, started a slow but decisive process of updating of figurative culture in a neo-Classical direction. In painting, the presence in Florence of artists such as Nicolas Didier Boguet (1755–1839), Bénigne Gagneraux (1756–95), François-Xavier Fabre (1766–1837), and the portraitist Louis Gauffier (1762–1801), to mention just the most well known, had a considerable effect on the local painters, who gladly welcomed them as members of the Academy of Fine Arts. In those years this prestigious institution, reformed by Peter Leopold back in 1784 from the ashes of Vasari's Academy of the Arts of Design following the model of those of other great cities—Milan, Vienna, Rome, and Venice— returned to being a center for the artistic education of painters and sculptors. The study of the Ancient, the basis of academic teaching, took concrete shape thanks also to the study

institutes in Rome. The eternal city, once again the center of international artistic interest, thus became a fundamental stage for the training of Tuscan artists, particularly Luigi Sabatelli (1772–1850) and Pietro Benvenuti (1769–1844), who stayed there for a long time. There is significant evidence of the knowledge and assimilation of Roman Neo-Classical style and language in works by Benvenuti such as *Judith Showing the People the Head of Holofernes.* The canvas, executed in 1798 for Arezzo Cathedral, but then sold to the well-known English collector Lord Bristol who had expressed a great admiration for it, was replicated by the painter a few years later (1803) and placed in the Cathedral again. In the picture, almost entirely executed in Rome, the influence of the late 18th-century painting of Jacques-Louis David, evident in the group of women to the left of Judith, is mixed with echoes of the great 17th-century classical painting of Raphael, Reni, and Poussin. The consequences of his Roman stay appear rather different in the work of Luigi Sabatelli, more directed toward that pre-Romantic culture in a philosophical mold that was prevalent in Rome in the last quarter of the 18th century among Northern artists, the best known of whom was certainly the Swiss Heinrich Füssli (1741–1825). The decision of the young Tuscan painter, a skilled draftsman, to paint the well-known series of engravings with the *Visions of the Apocalypse* was certainly no coincidence, as the study and knowledge of the famous etchings by Albrecht Dürer on the same theme are evident in this work. Finally, among the events that also contributed to the establishing of modern Neo-Classical aesthetics in Florence, we must not forget the Tuscan activity of the Lombard, Luigi Ademollo (1764–1849), whose decorative scenographic paintings on subjects drawn from mythology and Greek and Roman history, rich in grandiloquent archeologisms, certainly produced responses from local artists. Two representative examples of Ademollo's style and language are the painting decoration of the Palatine Chapel (1791/92) and of the later Sala dell'Arca (Ark Room) (c. 1814) in the Pitti palace. Spread across the walls are extended yet crowded compositions, with a strongly theatrical connotation, which though mindful of David's style are also reminiscent of Rome's pre-Romantic climate, absorbed by Ademollo during the years of his training in the capital. The passage from late 18th-century Classicist culture to Neo-Classicism in Florence gradually starting in the last decade of the 18th century, but established in the Napoleonic Age.

After the French occupation in the spring of 1799 and the consequent departure of the grand

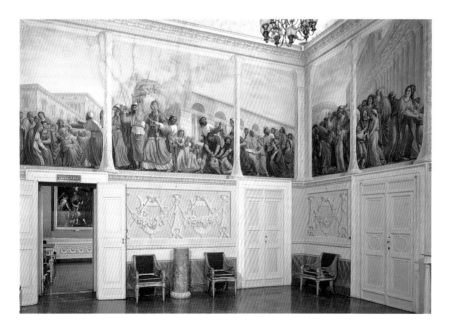

Luigi Ademollo, Sala dell'Arca (Ark Room). The walls of the room are painted in imitation of the pavilion that housed the biblical Ark of the Covenant.

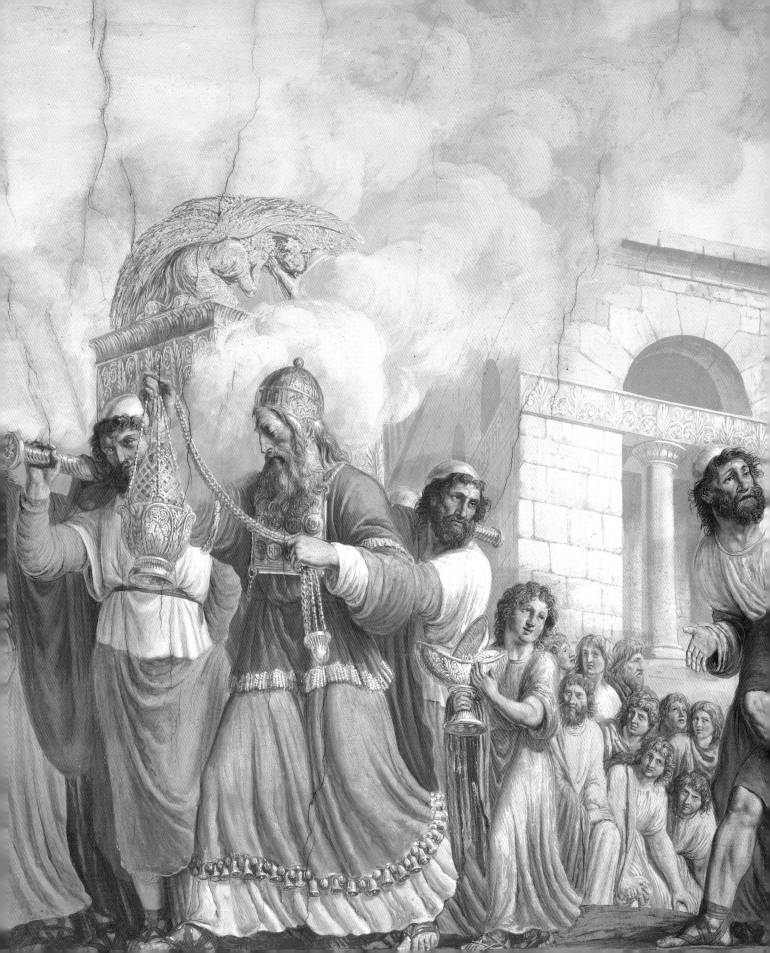

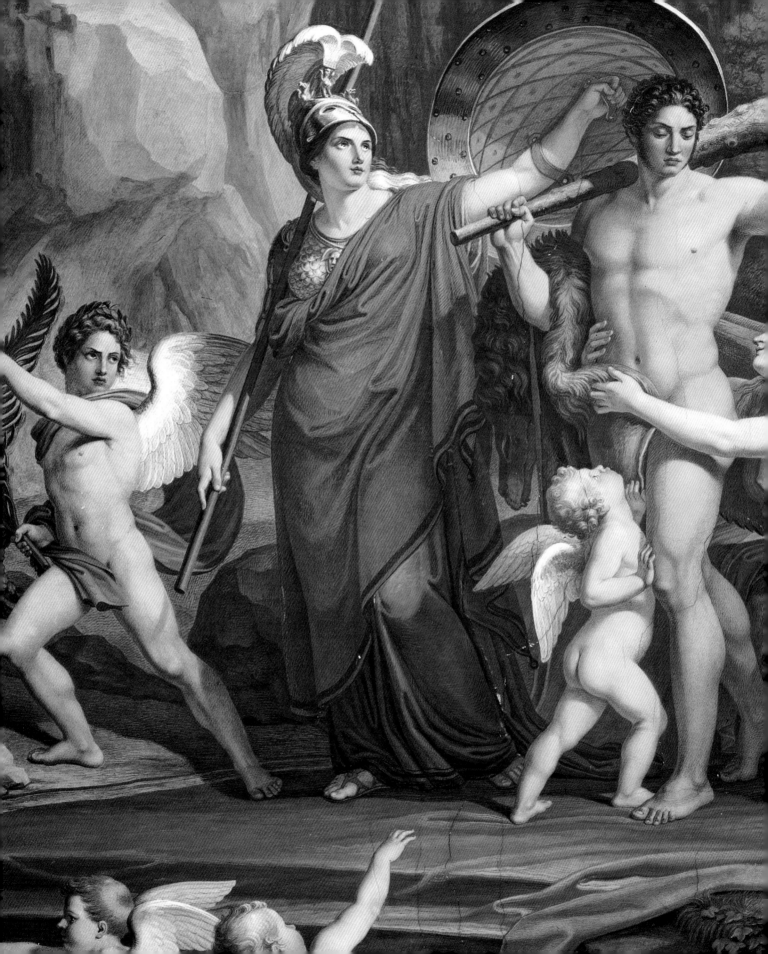

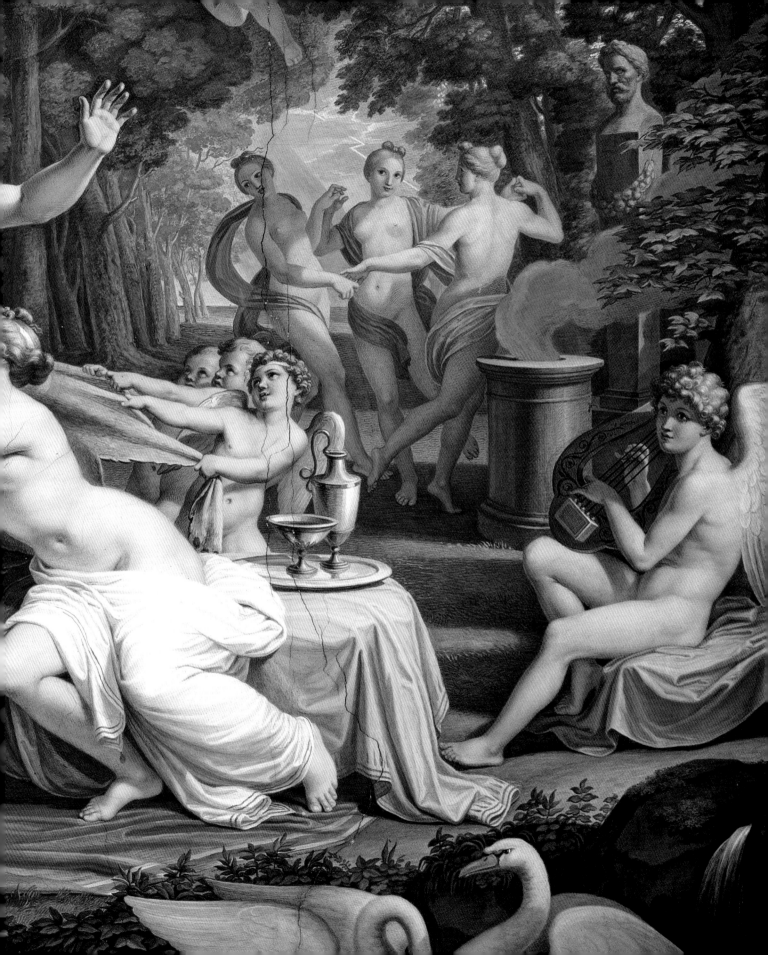

duke in 1801 Tuscany was transformed into the
Kingdom of Etruria under the regency of
Ludovico of Bourbon-Parma and his mother
Maria Theresa. In these years, despite the
slowdown in work commissioned by the court,
a work appeared that in my view very much
exemplified the emerging Neo-Classical
language: *Solomon's Dream*, a large panel
painted by Luigi Sabatelli in 1807 on the ceiling
of the queen's bedroom in the Palatine Quarters
of the Palazzina della Meridiana, shortly before
leaving the city for Milan, where he had been
summoned to teach at the Brera Academy. In
the painting the clear references to
contemporary French furniture, the large bed in
Empire style on which the beardless sovereign

lies, are combined with a much pondered
choice of theme, exemplary from the religious
and moral point of view, as required by Neo-
Classical poetics. The arrival on the grand-ducal
throne in Florence of Elisa Baciocchi,
Napoleon's sister, in 1809, after two years of
occupation by the Napoleonic troops, was an
episode of great significance also for the
evolution of the arts in Tuscany. The
Napoleonic court proved in fact to be an
attentive and sensitive patron. Benvenuti,
appointed "court painter" by Elisa and then
called upon in 1813 to run the Academy of Fine
Arts, was given the prestigious commission
directly by the emperor to paint *The Oath of the
Saxon Generals*. The painting, rich in evocative
nocturnal light effects, which was to hang in the
Gallery of Battles of Versailles and is today
conserved in the Galleria dell'Arte Moderna in
Palazzo Pitti, is an excellent demonstration of the
painter's familiarity with the models of David
and Gérard. The large canvas with *Elisa among
the Artists of her Court* (Versailles, Musée du
Château) commissioned by the grand duchess in
1811 but only finished in 1813, is a significant
homage to those who made the Florentine
artistic environment active and fertile in those
years; from Fabre and Benvenuti himself,
represented in the act of painting the portrait of
the grand duchess, to the great Canova, intent
on presenting Elisa's bust to her husband Felice
Baciocchi. The years of the Napoleonic grand
duchy also saw the resumption of a cohesive
plan for the decoration of Palazzo Pitti,
commenced by Ferdinand III. The project was
intended to transform the Florentine palace into
a kind of manifesto for the newly flourishing
Tuscan school of painting.

Participating in the enterprise was a large group of local painters under the aegis of the two masters, Benvenuti and Sabatelli. However, due to the tumultuous political events that saw the collapse of the Napoleonic Empire and the consequent Restoration (1814), the implementation of the program only went as far as the drafting of the contracts and the assigning of the themes. Despite this, on his return to the Tuscan throne, Ferdinand III did not disappoint the expectations of the many young artists involved in the project, as he relaunched it, only changing the subjects to be executed in the event that the reference to Napoleon's epic deeds was too compromising. For Florence the second and third decades of the century were years of renewed artistic fervor; in competition with what was happening at Pitti, many of the great Tuscan noble families also decided to renovate and adapt the interiors of their palaces and ancestral residences to suit the changing taste, very often using the same artists operating in the grand-ducal palace. Among the many, one high-profile personality was the decorator from Prato, Luigi Catani (1762–1840). Repeatedly and variously employed on the work at Palazzo Pitti, where he decorated the vault of a room adjoining that of the *Stove* by Cortona with the *Education of Jupiter*, he also had many private commissions, among which was the decoration of some rooms of the 16th-century Palazzo Ramirez Montalvo, in Borgo degli Albizi, and is worthy of mention. Today the huge ceremonial gallery on the *piano nobile* still shows the vault divided into compartments by elegant gilded frames, with the representation of the *Apotheosis of Apollo* at the center. Here Catani, who was a skillful user of colors and an attentive interpreter of mythological fables, even if with a less courtly and sumptuous tone than his more well-known colleagues, shows his propensity for the Neo-Classical language of the French tradition—close up, Apollo's gilded chariot, adorned by a procession of young dancing maidens and pulled by four fiery steeds, is reminiscent of similar creations by Gagneraux. The subdued tone of Catani's decorations is in marked contrast to the courtly and grandiloquent tone of the mural paintings executed by Benvenuti and Sabatelli in Pitti, which definitely consolidated the renown of both. In the large Hercules Room, created between 1817 and 1819, Benvenuti's solid Neo-Classicism is enriched by the use of bright colors, clearly reminiscent of Annibale Carracci and 16th-century Venetian painting. On the other hand, Sabatelli, who was commissioned to decorate the Iliad Room (1819–25), also shows a rediscovered vivacity of colors in the grandiose and crowded composition *Olympus* in the vault, while in the

lunettes with scenes from the Homeric poem, where he was also assisted by his young son Francesco, the suggestion of Michelangelesque painting is more evident. If the presence of the French painters in the city was decisive for Tuscan Neo-Classical painting, equally significant was the fact that some works by Antonio Canova (1757–1822) were present in Florence. As well as the well-known *Italic Venus* (Palazzo Pitti, Palatine Gallery, Venus Room), executed between 1810 and 1812, commissioned by Ludovico I of Bourbon to replace the *Venus of the Medici*, which had been temporarily moved to France as the spoils of the Napoleonic dispossessions, the sculptor had received the commission from the Countess of Albany, following the death of Vittorio Alfieri, to celebrate the greatness of the poet with an appropriate funeral monument. Created between 1806 and 1810, the great cenotaph, located in the church of Sta. Croce, met with enthusiastic approval, particularly for the stately and solemn figure of *Italy Weeping*, which was to signify the concept of the afflicted mother country. Canova's teachings had a great influence on Tuscan sculpture. As in the exemplary case of the *Monument to Giuseppe Pompeo Signorini* (who died in 1812), an adviser to Peter Leopold, by the no longer youthful Stefano Ricci (1765–1837), who was to be an interpreter of Neo-Classicism in a Canovian vein until his death; within clear and essential architectural profiles, the grieving female figure is intent on meditating on the ephemeral nature of life. The feeling of melancholic meditation on the loss of those dear to us was the source of inspiration for another work executed in those years: *Psyche Abandoned,* sculpted in marble by Carrarese Pietro Tenerani (1789–1869), today in the Galleria dell'Arte Moderna in Palazzo Pitti. Appreciated by Canova and Thorwaldsen for the smoothness of the marble and the delicate naturalness of the limbs, the sculpture met with such success that it was subsequently replicated in a number of other versions. Admiration for Tenerani's work also had another high-profile exponent in Tuscan sculpture, Lorenzo Bartolini (1777–1850). He trained in Paris with David and not only had a passion for 15th-century art, as did his friend and fellow pupil Ingres, but also an admiration for Canovian models. An example of this is the statuary group *Charity the Educator,* today in the Iliad Room in Pitti, commissioned in 1817, but finished in 1835, where Neo-Renaissance compositional equilibrium and Canovian essentiality merge in the definition of the facial features.

Clarissa Morandi

The Academy

When Grand Duke Ferdinand III died in 1824, leaving the throne to his son Leopold II, in the academic environment Tuscan artistic culture was already heading in a Romantic direction, even though the teachings of Pietro Benvenuti, firmly anchored to Neo-Classical principles, still represented the "official" culture. Though the success of mythological themes continued, in those years interest grew in the art of the Renaissance and the contemporary historical romance. The undisputed manifesto of these new tendencies was the famous picture by Giuseppe Bezzuoli (1784–1855), a young pupil of Benvenuti at the academy, where *Charles VIII Entering Florence*, finished in 1829, is represented (Palazzo Pitti, Galleria dell'Arte Moderna). The subject, taken from the *History of the City of Florence* by Jacopo Nardi, as well as alluding to more recent foreign invasions, underlines the progressive move away from the design abstraction of a Neo-Classical mold

through the choral layout of the composition sustained by lively color shades. With Bezzuoli's painting, history, with its teachings also providing examples for the present day, took the place of mythology. In those years the reconsideration of the Middle Ages and the early Renaissance also underlay the realization of sculptural works such as the well-known *Monument to Dante Alighieri*, executed between 1818 and 1830 by the already mentioned Stefano Ricci, for the church of Sta. Croce. This imposing monument still respects Canova's compositional scheme (consider the tomb of Clement XIV in the Roman church of the SS. Apostoli), with the sorrowful *Poetry* stretched out melancholy on the sacellum and the allegory of *Italy* on the opposite side, under the absorbed gaze of the great poet. A similar ethical value underlies many of the works executed in this period: a painting such as *Leonardo da Vinci Expires in the Arms of Francis I* (1828, Galleria dell'Accademia) by Cesare Mussini (1804–79) deals with one of the other themes dear to the emerging Romantic

Giuseppe Bezzuoli, *Charles VIII Entering Florence*, oil on canvas. The theme of the painting, completed in 1829, is taken from the *History of the City of Florence* by Jacopo Nardi, Palazzo Pitti (Galleria dell'Arte Moderna).

culture—the cult of illustrious men and the great masters of art. From this perspective, it is no surprise that the decision was made to place the two great statues of Arnolfo and Brunelleschi shaped in marble in 1830 by sculptor Luigi Pampaloni (1791–1847), the celebration of the two great Florentine artists, the immortal, never surpassed fathers of sculpture and architecture, on the facade of the Palazzo dei Canonici in Piazza Duomo in Florence, which had been restructured by the architect Gaetano Baccani (1792–1867). Beginning from 1835, no less than 28 statues of Tuscans famous in various

fields, from the Middle Ages to the 19th century, were executed and placed in the niches of the pillars of the Vasarian open gallery of the Uffizi, taking up an idea by Cosimo de' Medici. The 1830s and 1840s therefore saw the definitive establishing of historical Romanticism: *The Origin of the Sicilian Vespers* from 1839, a work executed by Florentine Giulio Piatti (1816–72), is one of the many examples of the success of this subject. In the episode of the Sicilian vespers, which Francesco Hayez (1791–1882) had already translated into painting in the 1820s, the explicit patriotic message is made by Piatti thanks also to a highly theatrical compositional choice. As Bezzuoli had already done in *Charles VIII*, the scene represented takes place, even though it is in the open air, on a carpet decorated with fallen leaves.

It was Bezzuoli, therefore, who was the true protagonist of the Romantic renewal of Tuscan painting, even if the painter was to have to await the death of Benvenuti, in 1844, to take up—and not without polemics—the professorship of painting at the academy. While the other painters continued to adorn the interiors of palaces and residences with mythological themes, Bezzuoli was to be one of the first to execute wall paintings with subjects taken from history and also from medieval and Renaissance literature (we need only recall the *Dance of the First Day of the Decameron* in Palazzo De' Rossi in Pistoia, from 1831, or the youthful *Stories of Angelica and Medoro* narrated on the walls of Palazzo dei Marchesi Pucci in Florence, c. 1820). In this regard, it must not be forgotten that Alessandro Manzoni visited Florence in 1827, to complete the linguistic revision of his already well-known novel. The poet, welcomed with admiration by the intellectuals was also held in high regard by the grand duke, who, in 1834,

Luigi Pampaloni, *Filippo Brunelleschi*, marble, c. 1830. Piazza Duomo, Palazzo dei Canonici. On the facade of the building, there is also the statue with the image of Arnolfo di Cambio, by the same artist.

Giovanni Dupré, *Abel Dying*, bronze. Palazzo Pitti (Galleria dell'Arte Moderna). This sculpture was executed between 1846 and 1851, commissioned by Grand Duke Leopold II, together with *Cain*, its companion piece.

commissioned a young academic artist, Nicola Cianfanelli (1793–1848), to paint the well-known cycle of frescoes with episodes taken from *I Promesso Sposi* (The Betrothed) to be executed in the Palazzina della Meridiana in Palazzo Pitti. In order to have an overview of the Tuscan painting of those years, we must remember that, alongside the success of historical Romanticism, there was also a sizeable production of paintings with bloodier subjects and themes— tyrannicides and ferocious crimes, and also representations of popular revolts and episodes of heroism. Examples of these are the *Killing of Lorenzino de' Medici* by Bezzuoli himself (1837–40, Pistoia, Museo Civico), and the *Murder of Alessandro de' Medici* (c. 1840, Pistoia, Museo Civico), a canvas by the Livornese Enrico Pollastrini (1817–76), where the choice of "nocturnal light" increases the tragic aspect of the representation. These episodes are of local history, but they are also exemplary and in some ways associated with a literary tradition that is different from that of Manzoni, more directed toward democratic, radical ideologies. During the 1840s, the arising of new political tensions also produced a rapid crisis in the official artistic institutions; academic teachings, still too closely tied to a culture that was considered outmoded, began to be forcefully challenged. Thus in Florence, in the studios of established masters, private schools emerged, among which that of Giuseppe Bezzuoli stood out. A fundamental element of the new tendencies was the reconsideration of the "natural," also prompted by theories on "natural beauty" and "truth." Having overcome the scandal aroused in 1837 by the gesture of Lorenzo Bartolini who, having taken up the chair of Sculpture at the Academy, took a hunchback into the school and had him copied by the students, Tuscan sculpture also moved in this direction. It is no surprise, therefore, that a work such as *Abel Dying* (1842) by the Sienese sculptor Giovanni Dupré (1817–82)—two versions of which exist: one in marble at the Hermitage in St. Petersburg, and a later one (1851) in bronze at the Galleria dell'Arte Moderna in Palazzo Pitti—caused a sensation in academic spheres on account of its "verism." Similar criticisms were aroused by nude sketches by Bezzuoli, who was even accused of immodesty by conservative critics. From mid-century, the definitive break with and transcendence of Romantic culture were to pave the way in Tuscany for Purism, which was to be an event of fundamental importance in the Italian artistic world of the second half of the 19th century.

Clarissa Morandi

Cesare Mussini, *Leonardo da Vinci Dies in the Arms of Francis I*, 1828, oil on canvas. Palazzo Pitti (Galleria dell'Accademia). With this work the painter won the main prize for painting at the Academy of Fine Arts.

The "Reform" of the Macchiaioli

In Florence in 1860, a number of young artists proposed to renew the meaning and values of figurative expression in an eminently formal way. To this end, with sound academic studies or years of apprenticeship with authoritative masters behind them, they went into the countryside of the Florentine Valdarno and onto the Ligurian coast to experiment outdoors with a method of transposition of painting founded upon experienced luminaristic and chromatic contrasts, capable of suggesting, with a concise and clear-cut language, the complexities of feelings and states of mind. The experiences of these artists were approached with an attitude of tireless scholars, in line with the positivist thought that the cognitive method of science indicated as being the most suitable in every field of study, including art, based on the continuous reviewability of results. Evocative testimonies remain of those experiences on the written recollections of Adriano Cecioni; the pages of his memoirs re-evoke the enthusiasm of those artists, as experimenters intent on obtaining the simplification of chromatic tones "mechanically" using black mirrors. "Look, look how well you can see the silhouette! Look at the shadows...." "Look, Banti, the beauty of that white in the background!—Look, Signorini, the tone of wheels on the white of the road!—Look at the force of the slamming [of color]! Pointeau, Borrani, come here. The sight of washing hanging on a line was enough for the white of the sheets against the gray or green background to send them into a frenzy." "People who have tested and retested in the open air," intent on an inexhaustible investigation into the effects of light and color, in "a continuous doing and undoing, trying and retrying, all to find the correctness of one [tonal] value above another, both as regards color and chiaroscuro." It is on the plane of an aware formalistic convention, therefore, that we must consider the research into the "macchia" (stain/spot) developed in Montelupo, then in Lerici and La Spezia, by Telemaco Signorini, Cristiano Banti, Odoardo Borrani, Vincenzo Cabianca, and Stanislao Pointeau, during the summer of 1860, which led to works such as *Fishmongers in Lerici* by Signorini or *Arch in Portovenere* by Cabianca, examples of that

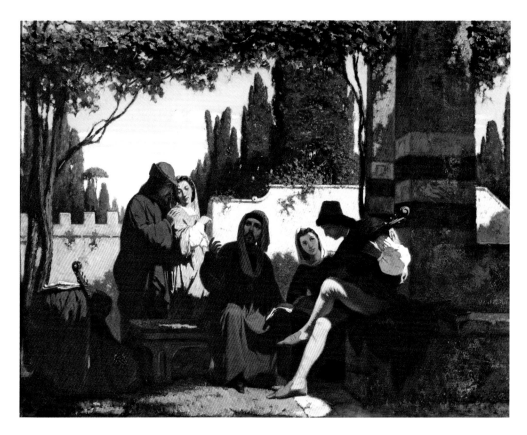

Vincenzo Cabianca, *Tuscan Storytellers of the 14th Century*, 1860. Palazzo Pitti (Galleria dell'Arte Moderna).

innovative formal approach conceived through clear-cut sequences of color, highlighted by the intensity of the sunlight and by the violence of the shadows.

"The beauty of a work," wrote Cecioni regarding the conception of art of those painters who were later to be known as Macchiaioli, "consists...in the fineness of the execution and not in the beauty of the original." He underlined how, in order to obtain a similar effect to that of nature, the artists had to impose a long and strict mental discipline upon themselves based on "a very fine analysis, by means of which it [was] necessary to become masters of the making of a picture by reminiscence." The "macchia," then, was none other than a formal solution capable of resolving, according to thought-out compositional syntheses, the "very fine analysis" with which the multiple and accidental aspects of the natural were investigated. Moreover, since it was a method applicable to the various

Giovanni Fattori, *Italian Field after the Battle of Magenta*, 1862, detail. Palazzo Pitti (Galleria dell'Arte Moderna).

Giovanni Fattori, *Rotunda at the Palmieri Bathing Resort*, 1866. Palazzo Pitti (Galleria dell'Arte Moderna).

Giovanni Fattori, *Signora Martelli in Castiglioncello*, Livorno (Museo Civico Giovanni Fattori).

genres of painting—history, landscape, scenes from contemporary life—the hierarchies between figurative themes and above all the moralistic and didactic implications connected with the subject that were typical of Romantic culture fell away, being taken onto a plane of unity by the question of form. From the mid-fifties, the research of the young Florentine artists—also spurred on by the accounts of friends returning from visiting the Universal Exposition in Paris in 1855—tended toward the renewal of their figurative language according to unusual relationships of light and color, capable of resolving the verisimilitude of the scene on the evocative and emotional plane. The presence in Florence of Domenico Morelli, from June to December 1856, provided a further incentive to experiment with new modes of expression founded upon formal values such as touch, impression, and chiaroscuro, as a means to resolve the *pathos* of the subject in the composition, and Telemaco

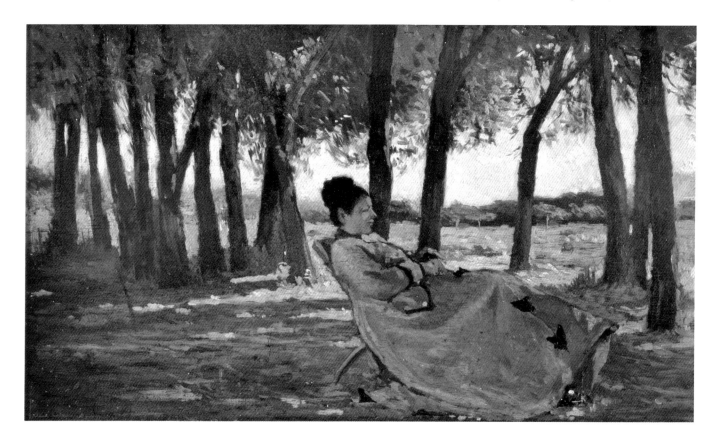

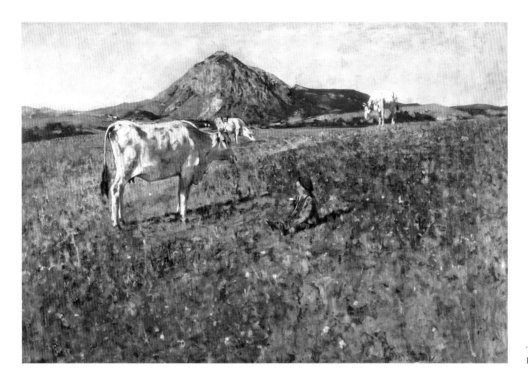

Telemaco Signorini, *Little Country Girl.*
Palazzo Pitti (Galleria dell'Arte Moderna).

Signorini very soon adopted this new manner, with its experienced contrasts of light and color, capable of rendering topical and captivating even the most well-known and exploited historical or literary themes, to paint scenes of contemporary life. There were therefore various motives and contingencies that, on the threshold of the unity of Italy, led to the definition of the strict, abstract-tending painting method that was the "macchia"; first of all, certainly, was the adhesion to positivism that prompted the artists to analyze and criticize, convincing them of the superiority of the values of form over those of content, and spurring them on to seek an expression capable of reflecting the aspects of the surrounding world analogically, and therefore formally. The essay by Jules Jamin, published in Italian in the magazine *Rivista di Firenze* in 1859, which underlined the impossibility for painting to render the naturalness of the landscape with artificial colors, so reality could only be translated according to analogical expression, contributed to no small degree to confirming the painting research of the Florentines, at that time also urged by Nino Costa, who, as Diego Martelli wrote then, "had abandoned the subject," and so directed artists toward absolutely new experimentation based on the careful preparation of form. Furthermore, we must not understate the sound academic education of

those artists, founded upon the formalistic substance of the design. The studies and paintings executed by Signorini, Banti, Borrani, Cabianca, and Pointeau in the summer of 1860 immediately became objects of reflection for other painters, who, like them, frequented the Caffè Michelangelo, the usual meeting-place for Florentine artists in the middle decades of the 19th century. One of the first to understand the innovative value of these formal experimentations was Raffaello Sernesi, a young student of Antonio Ciseri, endowed with a delightful artistic sensitivity, who, probably that same year, executed *Roofs in the Sun*, a view of a few, modest city houses standing out against a clear sky with only a single "fleecy" cloud crossing it. A work constructed through clear chromatic portions appropriately brought together and truly exemplifying the Macchiaiolo synthesis of form and color, which suggest in an almost yearning way, but with a concise and essential language, the feelings of understanding and tenderness for human frailty.

Meanwhile Giovanni Fattori too, intent on the realization of an imposing painting style to depict the *Italian Field after the Battle of Magenta*—with the sketch for which he had won the Ricasoli Competition, announced in Florence in September 1859—executed studies of soldiers with a fast, terse drawing style, indicative of his interest in the possibilities of

Giuseppe Abbati, *Cloister*. Palazzo Pitti
(Galleria dell'Arte Moderna).

analogical transposition offered by the
"macchia." In September 1861, the *Battle of
Magenta* was presented, not yet complete, at
the first Italian National Exposition, together
with a few other paintings by the Macchiaioli,
including *Pastures at Castiglioncello* by
Telemaco Signorini: a simple and solemn
interpretation of a pastoral scene, enhanced by
the clear light of a summer sunset that gilds the
countryside; this work was indicative of the
new course of the artist's research, which,
having left far behind the chiaroscuro
"slammings" experimented with the previous
year, was directed toward calmer, more solemn
expressions and attentive to an evocative
rendering of the natural subject.

From then on the Macchiaioli had a
preference for places of inspiration outside the
fast pace of a modern society so bent on
progress that, concerned with topicality at all
costs, it proved to be insensitive to human
values and history. Their decision to isolate
themselves and paint in solitary places on the
outskirts of Florence, such as Piagentina, or still
uncontaminated, such as Castiglioncello, far
from representing an intellectual withdrawal,
was dictated by the desire to come to grips

critically with a beloved universe besieged by
the materialism of contemporary life, by
applying the procedure of analysis and formal
recomposition to themes dear to the culture of
the Restoration—interior scenes, the portrait,
and the landscape, belonging to a recent past
and now evoked out of nostalgia. Their
awareness as modern men now prompted them
to seek an expressive completeness combining
the lucidity of vision with the subjectivity of
inner feeling, since "feeling and thought"
were—as Cecioni declared—indispensable
elements in the definition of a work of art.

In Piagentina, on the edge of the city, where
Silvestro Lega and Telemaco Signorini had
started to make real-life studies in 1862, soon
followed by Abbati, Borrani, and then Adriano
Cecioni, the Macchiaioli worked on scenes from
domestic life and views of humble slices of
countryside, of sustained beauty, through
reconsideration of the painting of 15th-century
Tuscany, and such as to arouse absorbing
feelings tinged with regret for the simplicity and
tranquility that belonged to a time only just
passed by, yet now inexorably lost. The artists
often spent long periods at Castiglioncello on
the Livornese coast, as guests on the vast

agricultural estate of Diego Martelli, the art critic and connoisseur of the Macchiaioli's painting, as well as being the affectionate friend of many of them.

They were reassured by the opportunity to compare and contrast their own research in a mutual and profitable artistic association. One of the most assiduous frequenters of that place of unspoiled beauty was Giuseppe Abbati, the Neapolitan painter who had established himself in Florence in the autumn of 1861. In that countryside, beside the sea, Abbati achieved "results of stupendous color where, with an apparent parsimony of means and with great knowledge, he obtained a light, a violently raw sparseness in the dark colors and great modesty of intonation." There, with Borrani and Sernesi, he achieved a happiness of exquisite expression, attentive to the anxious passage of Mediterranean light, to the sonority of whites on sun-drenched walls, to the airy changing skies, to the vast range of greens: from the blue-tinged green of the buds to the sour green of the tomato plants, from the dark green of the oaks to the ash-green of the tamarisks.

In the summer of 1867, a year after Sernesi had died as a result of a war wound, Giovanni Fattori joined Abbati and Borrani's research into transposing the airiness of the atmosphere and the changing tonal values in sunlight. There emerged such masterpieces as *Cart with Oxen* by Fattori, the *Wheat Harvest in Castiglioncello*

by Borrani, and *Cart and Oxen in the Tuscan Maremma* by Abbati.

That very year Fattori had returned definitively to Florence, having spent a number of years in Livorno, where, together with paintings with high formal content such as *Livornese Water-sellers*, he had executed a conspicuous and very interesting series of countryside portraits and studies, including *Rotunda at the Palmieri Bathing Resort*, a truly exemplary painting of Macchiaiolo syntax, constructed through rigorous chromatic matches according to a slow, highly meditated working process, yet capable of suggesting the freshness of an impression from real life.

However, by now the artistic association of the Macchiaioli was breaking up. At the end of the 1860s, the spiritual crisis that was being felt in Italian and European culture, accentuated by the loss of faith in the values of positivism, found them alone and struggling, each according to his own moral integrity, with a society that was changing fast. The desire to define a common style that had marked their research from the beginning of the decade was now challenged by a commitment to develop an absolutely individual expression, such as to highlight the differences in figurative results, obtained according to the force of their individual temperaments as artists.

Silvestra Bietoletti

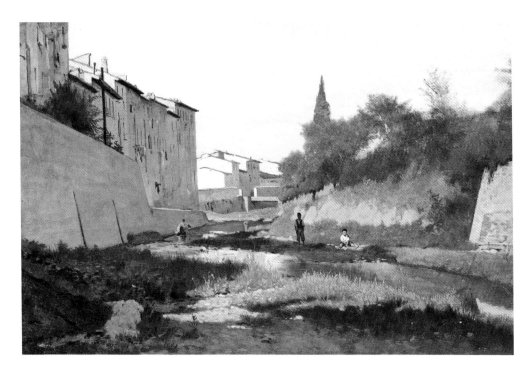

Odoardo Borrani, *The Mugnone*. Rome, Galleria Nazionale d'Arte Moderna e Contemporanea.

On the following pages:
Silvestro Lega, *A Visit*, 1868. Rome, Galleria Nazionale d'Arte Moderna e Contemporanea.

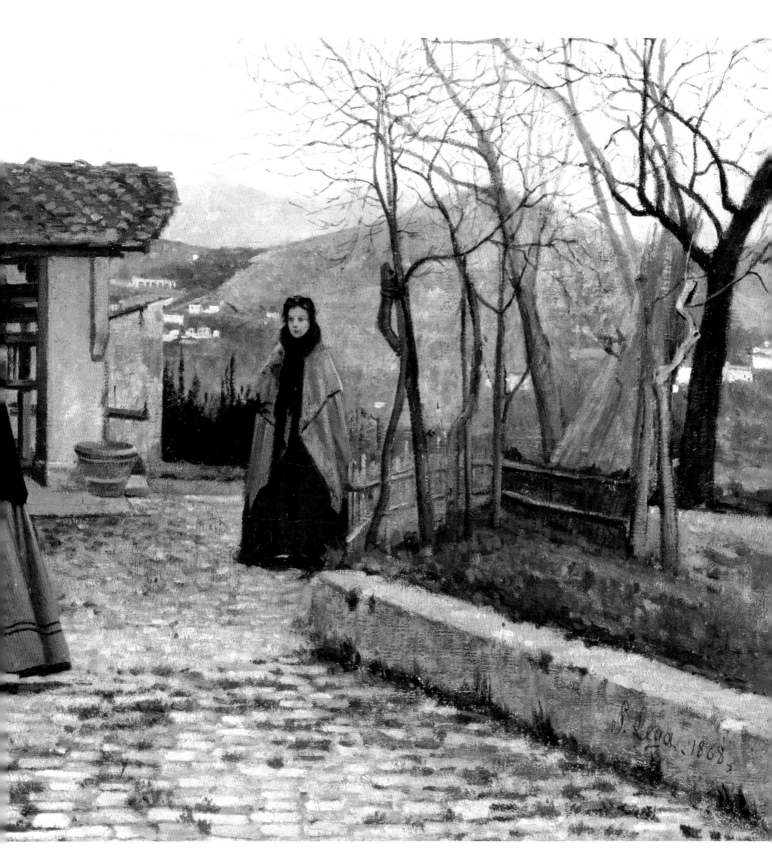

Glossary

aedicule: niche for a statue.

agora: marketplace, a place of assembly.

ancona: an altarpiece consisting of paintings within an architectural structure.

apse: semicircular area in a church, usually at the east end, which houses the high altar.

architrave: lowest part of an entablature resting on the capital of a column.

archivolte: one of the molded curves on the inside of an arch; a curved architrave.

ashlar: dressed and squared stone, as opposed to rough hewn.

baldachin: richly decorated canopy structure, usually over an altar.

baluster: single small pillar, with others, topped by a coping to form a **balustrade** or ornamental parapet.

basilica: originally the palace of a king, from the Greek, *basilios*, now a large oblong building, often an important Christian church, with double colonnades and an apse.

bas-relief: low relief sculpture or piece of carving.

campanile: bell tower, built beside a (usually Italian) church.

cantilever: horizontal structure projecting from a building, supported at one end only, like a balcony or canopy.

cappella: chapel.

cartoon: full-size preparatory drawing for a major painting.

cataphracts: soldiers in full armor.

chiaroscuro: the treatment of light and shade, mainly in painting.

ciborium: canopied shrine.

clerestory: windows set high in the walls of a church above the nave.

corbel: a stone or timber ledge protruding from a wall to support weight.

cornice: the uppermost part of an entablature.

cupola: a rounded vault or the ceiling of a dome.

dentil: small "tooth-like" square blocks, used in a row as a decorative feature.

dossal: ornamental cloth hung at the back of an altar.

en plein air: in the open air.

exedra: a recess, apse, a large niche.

festoon: carved or molded ornamental feature in the form of a garland or swag.

fresco: painting with watercolors directly onto wet, fresh plaster so that it is absorbed as it dries and therefore becomes permanent.

glyptic: art of carving or engraving on precious stones.

icon: in ecclesiastical terms, a holy image in traditional Byzantine style.

lacunar: ceiling consisting of a number of recessed panels.

lantern: structure on top of a dome with open or glazed sides to admit light.

loggia: gallery or arcade.

lunette: semicircular space above a door or in a concave ceiling, decorated with painting or sculpture.

matroneum: separate upper gallery for use by women.

miniate: to illuminate a manuscript.

mullion: a vertical structure of stone or wood within a window or separating consecutive windows.

narthex: entrance hall, lobby, or vestibule of a church.

nave: the main area in a church that accommodates the congregation.

oculi: pl. of oculus—a round opening, specially a circular window, or at the top of a dome.

opera: the official workshop, administrative and commissioning offices of a cathedral or palace.

papier mâché: material made from paper pulp and glue or size from which ornamental objects can be made; it is hardened by firing or air-drying.

pendentives: the concave triangles that form a dome.

pietra serena: gray sandstone; **pietra forte**: honey-colored sandstone.

pilaster: a shallow column projecting only slightly from a wall.

polygonal: many-sided.

portico: a covered porch consisting of columns holding a roof, often with a pediment; a colonnaded walkway.

predella: a painting or sculpture on the vertical face of an altar-step or platform.

Romanesque: 10th–12th-century European architecture, characterized by massive vaulting and round arches, echoing the classical Roman period.

rustication: heavy, rough-surfaced stone blocks separated by deep joins, which are principally seen on Renaissance buildings.

sarcophagus: stone funerary monument, usually elaborately decorated with sculpture, containing the coffin.

serliana: a tripartite structure (cf. Palladian windows), where the center section is arched and higher than the two side sections, which have flat tops.

sfumato: in painting, a technique for softening outlines so that tones and colors shade into one another.

silverpoint: the art of drawing using a silver-pointed stylus on specially prepared paper.

storiated: decorated with legendary or historical subjects.

stylobate: a continuous base supporting a row of columns.

telamon: pillar in the shape of a male figure supporting an entablature; **caryatid** is the female form.

tondo: a circular painting or a relief sculpture.

trabeation: horizontal beams or lintels as opposed to arches.

transept: an area in a church which crosses between the chancel and the nave, from overhead it forms a cruciform.

transennae: stone or metal screens that have been pierced.

transversal (ogive) arch: the diagonal rib in a vaulted roof, two of which will cross at the center of the vault.

trefoil arch: a clover-leaf shape, having three lobes.

triconch: three apses—to the left, right, and rear of the sanctuary (high altar).

triforium: a gallery above the colonnade at the sides of the nave.

trompe l'oeil: literally, "to fool the eye"— meaning a painting that renders its subject so realistically as to appear three-dimensional.

tympanum: the area between the lintel and the arch over a door; also the triangular space within a pediment.

volute: the spiral scroll on Ionic capitals in classical architecture, the inspiration for such ornamentation on later sculptures and carvings.

Bibliography

ANTONIO PAOLUCCI

Bacciotti E., *Storia di Firenze*, Florence 1881.

Bargellini P., *La splendida storia di Firenze*, Florence 1964.

Bec C., *Cultura e società a Firenze nell'età della Rinascenza*, Florence 1981.

Berti L., *Il principe dello Studiolo*, Florence 1967.

Borsi F., *Firenze nel Cinquecento*, Rome 1974.

Borsi F., *L'architettura del principe*, Florence 1980.

Bucci M., Bencini R., *Palazzi di Firenze*, Florence 1971.

Cappelle barocche a Firenze, edited by Mina Gregori, Cinisello Balsamo 1990.

Cardini F., *Storia di Firenze*, Florence 1997.

Cazzato V., De Vico Fallani M., *Guida ai giardini urbani di Firenze*, Florence 1981.

Chastel A., *Art et Humanisme à Florence au temps de Laurent le Magnifique*, Paris 1959.

Cinori Lisci L., *I palazzi di Firenze nella storia e nell'arte*, Florence 1972.

Davidsohn R., *Storia di Firenze*, Florence 1997.

Goldthwaite R.A., "The Florentine Palace and Domestic Architecture," in *American Historical Review*, LXXVII, 1972.

Guerrieri F., Mazzoni P., *La fortezza da Basso*, Florence 1990.

Guidoni E., *Arte e urbanistica in Toscana 1000–1315*, Rome 1970.

Marchini G., *Giuliano da Sangallo*, Florence 1943.

Millon H.A., Smith C.H., *Michelangelo architetto*, Milan 1988.

Paolucci A., Bietti M., Fiorelli Malesci F., *Le chiese di Firenze*, Cinisello Balsamo (Florence), 2003.

Paolucci A., Scalini M., *Firenze i secoli d'oro*, Udine 1993.

Rendina C., *I capitani di ventura*, Rome 1985.

Rodolico F., *Le pietre delle città d'Italia*, Florence 1953 (2nd edn. 1964, 3rd edn. 1995).

Ross J., *Florentine Palaces and Their Histories*, London 1905.

Sanpaolesi P., *Brunelleschi*, Milan 1962.

Sieni S., *I segreti di Firenze*, Florence 1995.

Silvano G., *Vivere civile e governo misto a Firenze nel primo Cinquecento*, Bologna 1985.

Trotta G., *Gli antichi chiassi tra Ponte Vecchio e Santa Trinità*, Florence 1992.

Zappegno G., *Le chiese di Firenze*, Perugia 1976.

Zimmermanns, *Florenz: Kirchen, Paläste und Museen in der Stadt der Medici*, Cologne 1997.

CARLO CRESTI

Bartoli L., *Il disegno della cupola del Brunelleschi*, Florence 1994.

Benedettucci F. (editor), *Il libro di Antonio Billi*, Rome 1991.

Berti L., *Il Principe dello Studiolo*, Florence 2002.

Borsi F., *Firenze del Cinquecento*, Rome 1974.

Brucher G.A., *Firenze nel Rinascimento*, Florence 1980.

Brunelleschi, various authors, Rome 1979.

Burckhardt J., *La civiltà del Rinascimento in Italia*, Florence 1955.

Cresti C., *Firenze 1986–1915. La stagione del Liberty*, Florence 1978.

Cresti C., *La Toscana dei Lorena. Politica del territorio e architettura*, Milan 1987.

Cresti C., *L'architettura del Seicento a Firenze*, Rome 1990.

Cresti C., "Lapidee metamorfosi. Buontalenti decoratore," in *FMR*, no. 94, 1992.

Cresti C. (ed.), "Architetture della Controriforma in Toscana," in *Architetture di altari e spazio ecclesiale*, Florence 1995.

Cresti C., *Firenze capitale mancata. Dal piano Poggi a oggi*, Milan 1995.

Cresti C. (ed.), "Altari fiorentini controriformati: lineamenti di fortuna e sfortuna critica," in *Altari controriformati in Toscana*, Florence 1997.

Cresti C., Cozzi M., Carapelli G., *Il Duomo di Firenze 1822–1887. L'avventura della facciata*, Florence 1987.

Cresti C., Nannoni D., *Architettura senza cantiere. Immagini architettoniche nella pittura e scultura del Rinascimento*, Siena 1989.

Cresti C., Zangheri L., *Architetti e ingegneri nella Toscana dell'Ottocento*, Florence 1978.

Degl'Innocenti P., *Le origini del bel San Giovanni. Da tempio di Marte a Battistero di Firenze*, Florence 1994.

Dezzi Bardeschi M., "Nuove ricerche sul S. Sepolcro nella cappella Rucellai a Firenze," in *Marmo 2*, Milan 1963.

Dezzi Bardeschi M., *La facciata di Santa Maria Novella a Firenze*, a critical study, Pisa 1970.

Fabriczy C.V., *Filippo Brunelleschi. La vita e le opere*, edited by A.M. Poma, Florence 1979.

Ficarra A. (ed.), *L'Anonimo Magliabechiano*, Naples 1968.

Ghiberti L., *I commentari*, edited by L. Bartoli, Florence 1998.

Giovanni Rucellai ed il suo Zibaldone, various authors, 2 vols., London 1960.

Goldthwaite R.A., *La costruzione di Firenze rinascimentale*, Bologna 1984.

Guasti C., *Santa Maria del Fiore. La costruzione della chiesa e del campanile*, Florence 1887.

La difficile eredità. Architettura a Firenze dalla Repubblica all'assedio, various authors, Florence 1994.

Landucci L., *Diario fiorentino dal 1450 al 1516*, edited by I. Del Badia, Florence 1883.

Lapini A., *Diario fiorentino dal 252 al 1556*, edited by O. Corazzini, Florence 1900.

Michelangelo architetto, various authors, edited by P. Portoghesi and B. Zevi, Turin 1964.

Pietramellara C., *Battistero di San Giovanni a Firenze*, a critical study, Florence, 1973.

Pietramellara C., *S. Maria del Fiore a Firenze. Il progetto, la costruzione*, Florence 1997.

Rocchi Coopmans De Yoldi G. (ed.), *S. Maria del Fiore. Piazza, Battistero, Campanile*, Florence 1996.

S. Maria del Fiore. Il corpo basilicale, various authors, Milan 1988.

Sanpaolesi P., *Brunelleschi*, Milan 1962.

Sanpaolesi P., *La cupola di Santa Maria del Fiore. Il progetto, la costruzione*, Florence 1997.

Vasari G., *Le vite de' più eccellenti pittori scultori ed architettori*, edited by G. Milanesi, Florence 1906.

Vasari G., *Lives of the Most Eminent Painters, Sculptors and Architects*, several editions in English.

Villani G., *Cronica*, Florence 1823.

MARIO SCALINI

Avery C., *Giambologna*, London 1993.

Bartolomeo Ammannati, scultore e architetto 1511–1592, paper at symposium Firenze-Lucca 1994, edited by Niccolò Rosselli del Turco and Federica Salvi, Firenze-Lucca 1995.

Battistero di San Giovanni a Firenze, Mirabilia Italiae 2, edited by A. Paolucci, Modena 1994.

Caglioti F., "Mino da Fiesole, Mino da Reame, Mino da Montemignaio: un caso chiarito di sdoppiamento d'identità artistica," in *Bollettino d'arte*, 1991, LXXVI, pp. 19–86.

Fiderer Moskowitz A., *Italian Gothic Sculpture c. 1250–c. 1400*, Cambridge 2001.

Gentilini G., *I Della Robbia, scultura invetriata nel Rinascimento*, Florence 1993.

Giambologna 1529–1608, sculptor to the Medici, London 1978.

Giambologna tra Firenze e l'Europa, paper at international symposium, Florence 1995, edited by Bert W. Meijer, Florence 2000.

Janson H.W., *The Sculpture of Donatello*, Princeton 1957.

Krautheimer R., *Lorenzo Ghiberti*, Princeton 1956.

Kreytenberg G., *Andrea Pisano*, Munich 1984.

Lankheit K., *Florentinische Barokplastik. Die Kunst am Hofe der letzten Medici 1670–1743*, Munich 1962.

Lankheit K., *Die Modellensammlung der Porzellanmanufaktur Doccia, Ein Dokument italienischer Barockplastik*, Munich 1982.

Lightbown R.W., *Donatello & Michelozzo*, London 1980.

Moskowitz A.F., *The Sculpture of Andrea and Nino Pisano*, Cambridge 1986.

Paolucci A., "Le porte del Battistero: lettura delle formelle di Andrea Pisano e Lorenzo Ghiberti," in *Alla scoperta di Piazza del Duomo in Firenze*, Florence 1992, pp. 53–74.

Pizzorusso C., *A Boboli e altrove, sculture e scultori fiorentini del Seicento*, Florence 1989.

Poeschke J., *Die Skulptur der Renaissance in Italien*, Vol. 1, *Donatello und seine Zeit*, Munich 1990.

Poeschke J., *Die Skulptur der Renaissance in Italien*, Vol. 2, *Michelangelo und seine Zeit*, Munich 1992.

Poeschke J., *Die Skulptur des Mittelaltes in Italien*, Vol. 2, *Gotik*, Munich 2000.

Pope-Hennessy J., *La scultura italiana. Il Cinquecento e il Barocco*, Milan 1963.

Pope-Hennessy J., *Italian Renaissance Sculpture*, London 1971 (first pub. 1963).

Pope-Hennessy J., *Italian Gothic Sculpture*, London 1972 (first pub. 1952).

Pope-Hennessy J., *Luca della Robbia*, Oxford 1980.

Pope-Hennessy J., *Cellini*, Florence 1989.

Romanini A.M., *Arnolfo di Cambio*, Florence 1980.

Scalini M., *L'arte italiana del bronzo 1000–1700, toreutica monumentale dall'alto Medioevo al Barocco*, Busto Arsizio 1988.

Visonà M., *Carlo Marcellini, Accademico "Spiantato" nella cultura fiorentina tardo-barocca*, Pisa 1990.

ANGELO TARTUFERI

Bellosi L., *Cimabue*, Milan 1998.

Boskovits M., *Pittura fiorentina alla vigilia del Rinascimento*, Florence 1975.

Boskovits M. (ed.), "The Origins of Florentine Painting (1100–1270)", in *Corpus of Florentine Painting*, sec. I, vol. I, Florence 1993.

Fremantle R., *Florentine Gothic Painters*, London 1975.

Labriola A., "Aspetti della miniatura a Firenze nella seconda metà del Duecento," in *Tartuferi-Scalini, L'arte di Firenze* 2004, pp. 184–207.

Labriola A., "Alcune proposte per la miniatura fiorentina del Trecento," in *Arte Cristiana*, XCIII, no. 826, 2005, pp. 14–26.

Tartuferi A., in *Uffizi e Pitti. I dipinti delle Gallerie Fiorentine*, edited by M. Gregori, Udine 1994, pp. 19–62.

Tartuferi A. (ed.), *Giotto. Bilancio critico di sessant'anni di studi e ricerche, exhibition catalog*, Florence 2004.

Tartuferi A. and Scalini M., *L'arte a Firenze nell'età di Dante*, exhibition catalog, Florence 2004.

MARCO CHIARINI

Acidini Luchinat C., "Gli artisti di Lorenzo il Magnifico," in *Per bellezza, per studio, per piacere. Lorenzo il Magnifico e gli spazi dell'arte*, edited by F. Borsi, Florence 1991, pp. 161–192.

Bellosi L., *Pittura di Luce*, exhibition catalog, Florence 1990.

Bellosi L., Ragionieri G., *Una scuola per Piero*, exhibition catalog, Venice 1992.

Berti L., Baldini U., *Quattro Maestri del Primo Rinascimento*, exhibition catalog, Florence 1954.

Berti L., Paolucci A., *L'età di Masaccio*, exhibition catalog, Milan 1990.

Borsook E., *The Mural Painters of Tuscany*, Oxford 1980.

Boskovits M., "Fra Filippo Lippi, i Carmelitani e il Rinascimento," in *Arte Cristiana*, LXXIV (1986), no. 715, pp. 235–252.

Cantelli G., *Repertorio della pittura fiorentina del Seicento*, Fiesole 1983.

Cappelle barocche a Firenze, edited by M. Gregori, Cinisello Balsamo 1990.

Castelfranchi Vegas L., *Italia e Fiandra nella pittura del Quattrocento*, Milan 1983.

Castelfranchi Vegas L., *L'Angelico e l'Umanesimo*, Milan 1989.

Chiarini M., "La pittura del Settecento in Toscana," in *La pittura in Italia*.

Ettlinger L.D., *The Sistine Chapel before Michelangelo*, Oxford 1965.

Gli Ultimi Medici. Il Tardo Barocco a Firenze 1670–1743, exhibition catalog, edited by M. Chiarini-F. Cummings, Florence 1974.

Gregori M., "Avant-propos sulla pittura fiorentina del Seicento," in *Paragone*, XIII (1962), no. 145, pp. 21–40.

Gregori M., *70 pitture e sculture del '600 e '700 fiorentino*, exhibition catalog, Florence 1965.

Gregori M., Paolucci A., Acidini Luchinat C., *Maestri e botteghe. Pittura a Firenze alla fine del Quattrocento*, exhibition catalog, edited by M. Gregori and others, Florence 1986.

Il Settecento, edited by G. Briganti, Milan 1990.

Joannidis P., *Masaccio and Masolino*, complete catalog, London 1993.

La pittura in Italia. Il Seicento, edited by M. Gregori and E. Schleier, Milan 1989.

Lee Rubin P., Wright N., Penny A., *Renaissance Florence. The Art of the 1470s*, exhibition catalog with bibliography, London 1999.

Marangoni M., "La pittura fiorentina nel Settecento," in *Rivista d'Arte*, VIII (1912), 3–6, pp. 61–102.

Mosco M., *Itinerario di Firenze barocca*, Florence 1974.

Petrucci F., "La pittura a Firenze nel Quattrocento," in *La pittura in Italia*, edited by F. Zeri, Milan 1987, vol. I, pp. 272–304.

Pittura murale in Italia. Seicento e Settecento, edited by M. Gregori, Bergamo 1998, pp. 34–53, 168–179.

Roettgen S., *Affreschi italiani del Rinascimento, Il primo Quattrocento*, vol. II, *Tra Quattrocento e Cinquecento*, vol. II, Modena 2000.

Rudolf S., "Mecenati a Firenze tra Sei e Settecento, III: le opere," in *Arte Illustrata*, VII (1974), 59, pp. 279–298.

Venturini L., "Firenze e la Toscana," in *Pittura murale in Italia nel Quattrocento*, edited by M. Gregori, Bergamo 1996, pp. 8–13.

Wittkower R., *Art and Architecture in Italy 1600–1750*, Harmondsworth 1958 (Italian edition, Torino 1993).

ELENA CAPRETTI

NOTE: In addition to the items cited in the essays, a number of exhibition catalogs and publications of a general character are indicated here, mostly recent ones, to which the reader is referred for more detailed bibliographies on the individual artists, their works, and the issues of the historical period under consideration.

Acidini Luchinat C., "La pittura fiorentina di corte alla fine del Cinquecento," in *Magnificenza alla corte dei Medici. Arte a Firenze alla fine del Cinquecento*, exhibition catalog (Florence), Milan 1997, pp. 370–377.

Allegri E., Cecchi A., *Palazzo Vecchio e i Medici*, Florence 1980.

Andrea del Sarto 1486–1530. Dipinti e disegni a Firenze, exhibition catalog (Florence), Milan 1986.

Barocchi P., *Scritto d'Arte del Cinquecento*, 3 vols., Milan and Naples 1971–1977.

Berti L., "Il primato del disegno," in *Il primato del disegno*, exhibition catalog, Florence 1981, pp. 21–38.

Berti L., "Un ottimo sartore," in *Andrea del Sarto 1486–1530. Dipinti e disegni a Firenze*, exhibition catalog (Florence), Milan 1986, pp. 14–25.

Cecchi A., Natali A., "Viatico romano per Botticelli illustratore," in *Sandro Botticelli pittore della Divina Commedia*, exhibition catalog (Rome), 2 vols., Milan 2000, pp. 26–39.

Cox-Rearick, J., *Dynasty and Destiny in Medici Art. Pontormo, Leo X, and two Cosimos*, Princeton 1984.

Fra Bartolomeo e la Scuola di San Marco, exhibition catalog (Florence), edited by S. Padovani, Venice 1996.

Franklin D., *Painting in Renaissance in Florence, 1500–1550*, New Haven and London 2001.

Giovinezza di Michelangelo, catalog, edited by K. Weil-Garris Brandt, C. Acidini Luchinat, J.D. Draper, N. Penny, Florence and Milan 1999.

Gregori M., "Raffaello fino a Firenze e oltre," in *Raffaello a Firenze*, exhibition catalog, Florence 1984, pp. 17–34.

Gregori M., "Tradizione e novità nella genesi della pittura fiorentina del Seicento" in *Il Seicento fiorentino. Arte a Firenze da Ferdinando I a Cosimo III*, exhibition catalog, edited by P. Bigongiari and M. Gregori, Florence 1986, 3 vols., "The painting," pp. 21–26.

Il primato del disegno, exhibition catalog, Florence 1980.

Il Seicento fiorentino. Arte a Firenze da Ferdinando I a Cosimo III, exhibition catalog, edited by P. Bigongiari and M. Gregori, 3 vols., Florence 1986.

L'officina della maniera. Varietà e fierezza nell'arte fiorentina del Cinquecento fra le due repubbliche 1494–1530, exhibition catalog with bibliography (Florence), edited by A. Cecchi and A. Natali, Venice 1996.

La comunità cristiana fiorentina e toscana nella dialettica religiosa del Cinquecento, exhibition catalog, Florence 1980.

La pittura in Italia. Il Cinquecento, edited by G. Briganti, Milan 1987, 2 vols., updated Milan 1988.

Longhi R., "Comprimari spagnoli della maniera italiana," in *Paragone*, 43, 1953, pp. 3–15.

Magnificenza alla corte dei Medici. Arte a Firenze alla fine del Cinquecento, exhibition catalog with bibliography (Florence), Milan 1997.

Natali A., *La piscina di Betsaida. Movimenti nell'arte fiorentina del Cinquecento*, Florence and Siena 1995.

Palazzo Vecchio: committenza e collezionismo, exhibition catalog, Florence 1980.

Raffaello a Firenze, exhibition catalog, Florence 1984.

Sandro Botticelli pittore della Divina Commedia, exhibition catalog (Rome), 2 vols., Milan 2000.

Storia delle arti in Toscana. Il Cinquecento, edited by R.P. Ciardi and A. Natali, Florence 2000.

Vasari G., *Le Vite de' più eccellenti pittori scultori e architettori nelle redazioni del 1550 e del 1568*, edited by R. Bettarini and P. Barocchi, 6 vols., Florence 1966–1987.

ANNAMARIA GIUSTI

Bartoli L., Maser E., *Il Museo dell'Opificio delle Pietre Dure di Firenze*, Prato 1953.

Giusti A., *Pietre Dure. L'arte europea del mosaico negli arredi e nelle decorazioni dal 1500 al 1800*, Turin 1992.

Giusti A., *Guida al Museo dell'Opificio delle Pietre Dure*, Venice 1995.

Giusti A., Mazzoni P., Pampaloni Martelli A., *Il Museo dell'Opificio delle Pietre Dure a Firenze*, Milan 1978.

Gonzàlez Palacios A., *Mosaici e Pietre Dure*, 2 vols., Milan 1981.

Gonzàlez Palacios A., *Il Gusto dei Principi*, 2 vols., Milan 1993.

Rossi F., *La pittura di pietra*, Florence 1967.

Splendori di pietre dure. L'Arte di Corte nella Firenze dei Granduchi, exhibition catalog, edited by A. Giusti, Florence 1988.

CLARISSA MORANDI

Morandi C., "Tra erudizione e intimismo: alcuni aspetti della decorazione pittorica d'interno a Firenze tra Sette e Ottocento," in *Gazzetta Antiquaria*, H, 1991, pp. 64–71.

Morandi C., "Luigi Catani e i bagni di Palazzo Pitti," *in Antologia di Belle Arti. Il Neoclassicismo*, nn. 43–47, 1994, pp. 116–123.

Morandi C., "Pittura della Restaurazione a Firenze: gli affreschi della Meridiana a Palazzo Pitti," in *Prospettiva*, 73–74, 1994, pp. 180–189.

Morandi C., *Palazzo Pitti. La decorazione pittorica dell'Ottocento*, Livorno 1995.

Pinto S. (ed.), *Cultura neoclassica e romantica nella Toscana granducale*, exhibition catalog, Florence 1972.

Spalletti E., "La pittura dell'Ottocento in Toscana," in *La pittura in Italia. L'Ottocento*, Milan 1991, vol. I, pp. 288–366.

SILVESTRA BIETOLETTI

Bietoletti S., *I Macchiaioli. La storia, gli artisti, le opere*, Florence 2001.

Cecioni A., *Scritti e Ricordi*, edited by G. Uzielli, Florence 1905.

Contributo a Borrani, exhibition catalog, Florence, Gabinetto Vieusseux, edited by D. Durbé, Rome 1981.

Del Bravo C., *Disegni italiani del XIX secolo*, exhibition catalog, Florence, Gabinetto dei Disegni e delle Stampe degli Uffizi (Dept. of Drawing and Prints, Uffizi), Florence 1971.

Del Bravo C., "Milleottocentosessanta," in *C.D.B., Le risposte dell'arte*, Florence 1985, pp. 271–284.

Diego Martelli. *Storia, critica, arte, atti del convegno Montecatini Terme 1996*, Florence 2000.

Dini P., *Lettere inedite dei Macchiaioli*, Florence 1975.

I Macchiaioli, exhibition catalog, Florence, Forte Belvedere, edited by D. Durbé, Florence 1976.

Dini P., Dini F., *I Macchiaioli e la scuola di Castiglioncello*, Florence 1990.

Dini P., Dini F., *Diego Martelli*, Turin 1996.

Durbé D., *Fattori e la scuola di Castiglioncello*, Rome, De Luca 1982–83.

Fattori G., *Lettere a Diego*, edited by P. Dini, Florence 1983.

Fattori G., *Scritti autobiografici editi ed inediti*, edited by F. Errico, Rome 1980.

Giovanni Fattori, exhibition catalog, *Palazzo Pitti*, edited by G. Matteucci, R. Monti, E. Spalletti, Florence 1987.

I disegni della collezione di Diego Martelli, exhibition catalog (Gallery of Modern Art, Palazzo Pitti), edited by S. Codemi and A. Del Soldato, Florence 1997.

I Macchiaioli. Opere e protagonisti di una rivoluzione artistica, exhibition catalog, Castiglioncello (Castello Pasquini), edited by F. Dini, Florence 2002.

I macchiaioli prima degli impressionisti, exhibition catalog, Padua (Palazzo Zabarell), edited by F. Mazzocca and C. Sisi, Venice 2003.

L'opera critica di Diego Martelli dai macchiaioli agli impressionisti, exhibition catalog, Livorno (Villa Mimbell), edited by F. Dini and E. Spalletti, Florence 1996.

Martelli D., *Scritti d'arte*, edited by A. Boschetto, Florence 1952.

Matteucci G., *Cristiano Banti*, Florence 1982.

Matteucci G., *Silvestro Lega*, Florence 1987.

Monti R., *Le mutazioni della "macchia"*, Rome 1985.

Monti R., *Signorini e il naturalismo europeo*, Rome 1984.

Piagentina. *Natura e forma nell'arte dei Macchiaioli*, exhibition catalog, Florence (Sala delle Reali Poste), edited by G. Matteucci, R. Monti, C. Sisi, Florence 1991.

Signorini T., *Caricaturisti e caricaturati al Caffè Michelangiolo*, Florence 1893.

Signorini T., "Il Caffè Michelangiolo," in *Gazzettino delle Arti del Disegno*, I, 1867, pp. 150, 174, 197, 206, 213.

Spalletti E., *Gli anni del Caffè Michelangelo 1848–1861*, Rome 1985.

Spalletti E., *Telemaco Signorini*, Soncino 1994.

Telemaco Signorini, exhibition catalog, edited by F. Dini, G. Matteucci, R. Monti and E. Spalletti, Florence 1997.

30 Macchiaioli inediti, exhibition catalog, edited by D. Durbé and G. Matteucci, Rome 1980.

Vitali L., *Lettere dei Macchiaioli*, Turin 1953.

General Index

Works Index

Photographic References

With the exceptions listed below, the images have been provided by ALINARI ARCHIVES, FLORENCE (© Alinari Archives, Florence; © R. Bencini/Alinari Archives, Florence; © N. Orsi Battaglini/Alinari Archives, Florence; © Index/Alinari Archives, Florence; © Finsiel/Alinari Archives, Florence; © The Bridgeman Art Library/Alinari Archives, Florence; © SEAT Archive/Alinari Archives, Florence) www.alinariarchives.it
The works that are the property of the Museo dell'Opera del Duomo, the Baptistery of St. John and the Cathedral of Santa Maria del Fiore in Florence are by permission of the Opera di Santa Maria del Fiore in Florence.
The works that are the property of the Archive, Libraries and State Museums of Florence are by permission of the Ministero per i Beni e le Attività Culturali.
Magnus Archive: pp. 8-9, p. 13, p. 29, p. 40, p. 44, pp. 54-55, p. 56, pp. 66-67, p. 68, p. 69, p. 70 left, p. 73, p. 80, p. 97 right, pp. 100-101, p. 110, p. 111, p. 157, p. 166, p. 171 right, p. 174, p. 177, pp. 178-179, pp. 186-187, p. 206,

p. 225, p. 261, p. 275, pp. 282-283, p. 316 bottom left, p. 316 right, p. 323, p. 325, p. 327, pp. 328-329, p. 331 left, p. 332, pp. 358-359, p. 385, p. 393, pp. 394-395, p. 401, pp. 402-403, pp. 410-411, p. 418, p. 419, pp. 428-429, p. 431, p. 446, p. 447, p. 449 bottom, p. 484, p. 490, p. 491.
Scala Archive, Florence: pp. 64-65, p. 71, p. 74, p. 75, pp. 76-77, p. 106, p. 156, p. 167, p. 193, p. 240, p. 251, p. 253, p. 302 top, p. 362, p. 443, p. 445.
Carlo Cresti: p. 58, p. 72, p. 173, p. 322, p. 448 top left, p. 448 bottom, p. 492 top.
Fondazione Casa Buonarroti: p. 457.
Nicolò Orsi Battaglini: pp. 42-43, pp. 62-63.
Simephoto: pp. 368-369.
Angelo Tartuferi: p. 89 left, p. 89 bottom right, p. 97 right, p. 107 right.
The publisher has made every effort to identify the copyright holders of the images in this book. Copyright holders who have not been contacted are requested to write to the publisher.